Thinkers

Hildebrandian Vision of Beauty

"How does the beautiful evangelize? Following Dietrich von Hildebrand, we should say that the truly beautiful is an objective value, to be distinguished from what is merely subjectively satisfying. This means that the beautiful does not merely entertain; rather, it invades, chooses, and changes the one to whom it deigns to appear. It is not absorbed into subjectivity; it rearranges and redirects subjectivity, sending it on a trajectory toward the open sea of the beautiful itself."

—**BISHOP ROBERT BARRON**
Theologian, author, and founder of Word on
Fire Ministries

"Dietrich von Hildebrand was among the first to recognize the magnitude of the intellectual crisis. He understood the centrality of beauty not merely to art but to philosophy, theology, and ethics. In his ambitious and comprehensive *Aesthetics*, now translated into English for the first time, von Hildebrand rehabilitates the concept of beauty as an objective rather than purely subjective phenomenon. His systematic account renews the Classical and Christian vision of beauty as a reliable mode of perception that leads humanity toward the true, the good, and ultimately the divine."

—**DANA GIOIA**
Poet and former chairman of the National
Endowment for the Arts

"In *Aesthetics II*, Dietrich von Hildebrand offers a thorough reflection on the distinctive characteristics of architecture, sculpture, painting, literature, and music. He guides the mind with clarity even if the reader is not used to systematic intellectual reflection on a topic often relegated to the realm of subjective taste. The objective splendor that lies within a work of art, somehow transcending its human

author, is one of many points worth contemplating in this volume. I am convinced that the section on music echoes not just my own experience but that of many performers striving to do justice to the works they bring to life. Whoever is looking for an aesthetic vision of the whole will find *Aesthetics II* deeply insightful, challenging, and encouraging."

—MANFRED HONECK
Grammy-winning conductor
Music Director of the Pittsburgh Symphony Orchestra

"I remember so well when, as a young priest in the early 1950s, I was invited to a house owned by the von Hildebrand family, which lay within the boundaries of the parish where I was assigned, to attend one of the conferences he was accustomed to give during his summer visits to Europe. Not surprisingly his theme was 'beauty,' and with great eloquence and enthusiasm he spoke of its philosophical and spiritual importance. The joy and freshness of his understanding of Catholic doctrine were contagious and stood in marked contrast to the dryness of a kind of scholasticism that seemed then to have become stale and brittle. Listening to him, one recognized that it was the transcendent beauty of truth that had captured his heart and his mind...."

—JOSEPH CARDINAL RATZINGER

"Most philosophers of aesthetics content themselves with a few examples from the realm of art, and make no attempt to explore the distinct disciplines or to catalogue all the parts that contribute to the overall aesthetic effect. One purpose of this second volume, however, is to show the completeness of the artistic enterprise, and the way in which it penetrates human life in its entirety, so that the idea of beauty enters our practical activity at every point. We are seeking harmony and order in everything we do, and even if the sublime effects of the most spiritual works of art are beyond our everyday competence, we will always be motivated in our everyday activities by a fundamental need for harmony and an aversion to ugliness."

—SIR ROGER SCRUTON
Philosopher and author

"Dietrich von Hildebrand's engaging studies of different art forms is a marvelous illustration of the way phenomenology is uniquely accessible to a wider readership. Here is philosophy for the sake of the world. The result is a voracious, encyclopedic exploration—one is almost tempted to say a 'romp'—through a range of concrete examples that would deepen anyone's appreciation for what the arts can do. Most importantly, in an age of flattening reductionism, this book paints a picture of what it might mean for humanity to find its fullness through cultivating the same range of aesthetic curiosity."

—JAMES K. A. SMITH
Professor of philosophy, Calvin College
Editor in chief, *Image* journal

Aesthetics

Dietrich von Hildebrand

Aesthetics

VOLUME II

❧

Dietrich von Hildebrand

—

Translated by John F. Crosby, John Henry Crosby, and Fr. Brian McNeil

Edited by John F. Crosby and John Henry Crosby

THE HILDEBRAND PROJECT

Originally published in German as *Ästhetik. 2. Teil. Über das Wesen des Kunstwerkes und der Künste. Gesammelte Werke Band VI.* Regensburg: Habbel; and Stuttgart: Kohlhammer. 1984.

English translation published 2018 by Hildebrand Project, 1235 University Blvd, Steubenville, Ohio 43952

Cataloguing-in-Publication Information

Von Hildebrand, Dietrich, 1889–1977 | Scruton, Roger, foreword author | McNeil, Brian, translator | Crosby, John F., 1944–, translator and editor | Crosby, John Henry, translator and editor.
[Ästhetik. English]
Aesthetics : volume II / by Dietrich von Hildebrand ; foreword by Sir Roger Scruton ; translated by Fr. Brian McNeil, John F. Crosby and John Henry Crosby; edited by John F. Crosby and John Henry Crosby.
Includes bibliographical references and index. | Steubenville, OH: Hildebrand Press, 2018.
LCCN 2018909970
ISBN 978-1-939773-10-4

Subjects: LCSH: Aesthetics. | Art—Philosophy. | Phenomenology and art. | BISAC: PHILOSOPHY / Aesthetics | PHILOSOPHY / Movements / Phenomenology | ART / General
Classification: LCC B3359 .V6 2018| DDC 701—dc23

Book design by Mark McGarry, Texas Type & Book Works
Typeset by Kachergis Book Design
Set in Adobe Caslon

Cover Design by Marylouise McGraw

Cover Image: Hall of the Seasons, by Robert Hubert, in the Musée du Louvre, Paris. Image from Wikimedia Commons.

Front Cover Font: Circular Bold by Laurenz Brunner

www.hildebrandproject.org

SUAVISSIMAE DILECTISSIMAE UXORI

To my most sweet and beloved wife

Contents

MUSIC

Dietrich von Hildebrand

Dietrich von Hildebrand was born in Florence in 1889, and studied philosophy under Adolf Reinach, Max Scheler, and Edmund Husserl. He was received into the Catholic Church in 1914. He distinguished himself with many publications in moral philosophy, in social philosophy, in the philosophy of the interpersonal, and in aesthetics. He taught in Munich, Vienna, and New York. In the 1930s, he was one of the strongest voices in Europe against Nazism. He died in New Rochelle, NY in 1977.

Hildebrand Project

We advance the rich tradition of Christian personalism, especially as developed by Dietrich von Hildebrand and Karol Wojtyla (Pope St. John Paul II), in the service of intellectual and cultural renewal.

Our publications, academic programs, and public events introduce the great personalist thinkers and witnesses of the twentieth century. Animated by a heightened sense of the mystery and dignity of the human person, they developed a personalism that sheds new light on freedom and conscience, the religious transcendence of the person, the relationship between individual and community, the love between man and woman, and the life-giving power of beauty. We connect their vision of the human person with the great traditions of Western and Christian thought, and draw from their personalism in addressing the deepest needs and aspirations of our contemporaries. For more information, please visit: www.hildebrandproject.org

Editorial Board

Special Thanks

We gratefully acknowledge the vision and generosity of the many friends who have supported the publication of this book.

EXTRAORDINARY SUPPORT

Howard and Roberta Ahmanson • Chiaroscuro Foundation • Cushman Foundation • Dana Gioia • Alice von Hildebrand • Robert L. Luddy • Patricia C. Lynch • James N. Perry, Jr.

PATRONS

Daniel and Teresa Cotter • Madeline L. Cottrell • Donald and Michele D'Amour • Frank and Sally Hanna • National Endowment for the Arts • Richard and Vera Hough • Robert Kreppel

BENEFACTORS

Hedy K. Boelte • John F. Cannon • The Rafael Madan and Lilian Casas Foundation • Allison Coates and Joshua Kneubuhl • Edward and Alice Ann Grayson • Shirley and Pistol Haley • Julia Harrison • Roy and Elizabeth Heyne • Timothy J. Joyce • Colin Moran • William and Robin Mureiko • Elaine C. Murphy • William H. Rooney • Dan and Annie Schreck • Stanley Stillman • Richard and Rose Tondra

FRIENDS

James D. Arden • Edwin L. Bercier III • Joshua Cole • Cheryl Daye • Maria Fedoryka • Paul Frank • Rabbi Mark Gottlieb • James A. Harold • Fr. Adam L. Hertzfeld • John Iverson • Douglas Keck • John Kelly • Aloysius Ju Hyeok Kim • Jake Lang • Ron Ledek • John Linn • Daniel Mark • Brent McAdam • Scott McCawley • Laura McCormick • Nora L. Metzler • Judy A. Miles • Gerard and Germana Mitchell • Barbara P. Murphy • George Nolan • Dan Rasmussen • Britt and Noah Riner • Fr. Fabian Schneider • Fr. Thomas W. Shaw • Roy A. Sheetz • Javier Sanz Latiesas • Stan Sienkiewicz • Joan Thomas • Fr. Jon Tveit • JWM van Keeken • Fritz K. Wenisch

Foreword
By Sir Roger Scruton

AESTHETICS AS A philosophical discipline came into being with the Enlightenment, and acquired its dignity and standing with Kant's *Critique of Judgment*. In Kant's taut and difficult work there is little mention of art, and no attempt to give the broader cultural context within which aesthetic judgment emerges. That context was the theme of Hegel's posthumous *Lectures on Aesthetics*, and those lectures were perhaps the first attempt by a great philosopher to see the arts as indispensable expressions of the human spirit, providing knowledge and insight that cannot be obtained from scientific experiment or intellectual argument. Dietrich von Hildebrand was far from being a Hegelian. But, like Hegel, he saw aesthetics as incomplete without a full exploration of the arts, and an attempt to say what each of them severally supplies to our understanding of the human condition. In this second volume of his treatise on the subject Hildebrand assembles the results of a lifetime's thought about the arts, and expresses his devotion to beauty in terms that the reader will find immediately engaging.

As the son of a famous sculptor Hildebrand naturally attached great

prestige to artistic creativity, and inherited the idea—made central to aesthetics by Kant and Schopenhauer—that a work of art should be the product of 'genius,' the unpredictable outcome of a faculty that has no rules for its employment. But he was not taken in by the fashionable idea that aesthetic value must always be a shock value, and that originality trumps discipline in every contest between them. He was a romantic, but also one with a classical sense of the place of art in the community. His wide taste did not extend to the extremes of expressionism and Dadaism that were fashionable in pre-war Germany. He was a disciple of Goethe and Schiller in literature and his taste in music was for the established classical repertoire. Indeed he was a persuasive representative of the culture of bourgeois Germany, in which the arts in general, and music in particular, formed the central object of leisure and reflection in every household.

In the first volume of his *Aesthetics* Hildebrand argues for the distinct place of beauty in the life of rational beings, and distinguishes two kinds of beauty: beauty of the first power and beauty of the second power. The first power belongs to those objects that, through their intrinsic form and harmony, attract an unreflective sensory delight: flowers, landscapes, the symmetries and harmonies of animals and plants. The second power is exhibited when a spiritual idea is expressed in artistic form. In this case our delight is not merely sensory, but involves an apprehension of deeper truths, and a sense of the correspondences that unite the parts and moments of our world. Often, when we encounter beauty of the second power, we are struck by the truth of the idea expressed by it, and in such cases beauty and truth seem to blend indistinguishably, as they do in the plays of Shakespeare or the Lieder of Schubert.

In applying those ideas to the study of art Hildebrand pursues a course that is uniquely his. Most philosophers of aesthetics content themselves with a few examples from the realm of art, and make no attempt to explore the distinct disciplines or to catalogue all the parts that contribute to the overall aesthetic effect. One purpose of this second volume, however, is to show the completeness of the artistic enterprise, and the way in which it penetrates human life in its entirety, so that the

idea of beauty enters our practical activity at every point. We are seeking harmony and order in everything we do, and even if the sublime effects of the most spiritual works of art are beyond our everyday competence, we will always be motivated in our everyday activities by a fundamental need for harmony and an aversion to ugliness.

This is brought out very clearly by the practice of architecture, and the long section on architecture that opens this second volume contains some of Hildebrand's most important contributions to aesthetics. Few philosophers have written about architecture as a distinct realm of philosophical enquiry, though Hegel devoted a section of his lectures to it, as mankind's first shot at giving 'sensory embodiment to the Idea.' Unlike Hegel, whose description of architecture concerns the monumental idiom of temples, Hildebrand recognizes the inescapable nature of the art of building, which is exhibited in all our attempts to settle. Buildings are our fundamental way of becoming part of the objective world, and they surround us in everything that we do.

Architecture, Hildebrand argues, does not have only one theme. It has the theme of beauty, and the theme of use, and the synthesis of the artistic and the practical dictates the quite special role that architecture plays in the practice of aesthetic judgment. Although in one sense building is the art of creating and molding space, this space is not the space explored by the natural scientist or the philosopher, but space as we experience it, space that encompasses us and which offers us vistas to every side. Space conceived in that way is both an object of experience and a subject of shaping and molding. We understand architecture not merely as a structure that encloses us, but also as a way of shaping, decorating and opening all the spaces where we conduct our lives. Unusually for a philosopher, therefore, Hildebrand breaks the art of building down into its many components, devoting separate sections to temples, staircases, towers, fountains and bridges. He writes in a penetrating way of streets and squares, acknowledging that streets have 'a "face" of their own that is distinct from the houses that enclose them.' He makes clear, what so few architectural critics acknowledge, that buildings are indefinitely sensitive to their context, and that even the most beautiful cathedral will not

remain undamaged if the streets above which it soars are mutilated or
developed at random. He notes that street facades in Tuscany have been
controlled by legislation since the Middle Ages, and that the modern
habit of inserting new additions to a street without regard for the style
or materials that surround them is a violation of the most basic aesthetic
norms.

The whole section on architecture proceeds in that way, with com-
mon sense observations that are also part of an original and comprehen-
sive view of what architecture means to us, and how its twofold nature
provides an opening to spiritual significance of an objective kind. As
Hildebrand points out, we need to acknowledge that the ordinary prac-
tical reasoning of the builder makes room for the idea of beauty, without
requiring that the builder have 'genius' or see himself as engaging in the
highest creative act. Getting things right is here far more important than
originality, which is often merely getting things wrong. At the same time
Hildebrand is hostile to the mere imitation of traditional styles and, like
so many of his contemporaries, in revolt against the meaningless encrus-
tations of the late Rococo style.

In writing about painting Hildebrand shows the same familiarity
with the topic as when writing of architecture. In both cases it is Italy
that has seized his imagination, and his description of the works of the
Italian masters—Titian and Giorgione in particular—shows how deeply
he was affected by them. As he recognizes, the heart of painting is rep-
resentation, and the represented image can be produced in many other
ways than with a paintbrush. He anticipates later philosophers in mak-
ing radical distinctions between the painted image and the photograph,
and his description of photography, what it can do and what it cannot
do, is a paradigm of philosophical insight. So too is his description of
landscape painting and portraiture, in which the beauty of the thing de-
picted is not carried over automatically into the beauty of the depiction,
but transposed into another idiom so as to acquire another meaning.
His account of this 'transposition' is fascinating and casts considerable
light on the thought once expressed by Wittgenstein, that it is no lon-
ger possible, in the age of photography, to obtain a real portrait of your

friend. Hildebrand was writing before the emergence of the 'selfie'. But he anticipated everything that one might now want to say about this mass assault on the art of portraiture.

The concept of transposition enables Hildebrand to address one of the most important questions of modern aesthetics, which is the question of evil and its aesthetic representation. Evil abounds in our world, in actions, characters, sentiments and plans. Yet evil, transposed into art, can be an integral part of beauty, as the evil of Mephistopheles is integral to the beauty of *Faust* Part I, or the degenerate sentiments of the poet are integral to the beauty of Baudelaire's *Les fleurs du mal*. Do we say that beauty redeems evil, so that it ceases to be evil? Or do we say that it reconciles us to evil, by showing it to be part of a greater good? This question is ever more serious for people today, given the quantity of art that depends for its effect on shock, terror or the fascination with nastiness. It seems that 'transposition,' as Hildebrand understands it, can enable us both to understand evil for what it is—a denial of our humanity—and also to recognize in evil the proof of our freedom and the avenue to a purer way of being. In this the love of beauty prefigures our salvation, and enables us to enter the darkest corners of our world shielded from their corrupting vapors. All this aspect of Hildebrand's thinking deserves the greatest attention from philosophers today, and even if he has no final answer to the question of evil and its representation in art, his fine observations will surely stimulate a discussion of which we are all greatly in need.

Like architecture, music invites special philosophical treatment and Hildebrand does not disappoint us. He argues that musical notes are not mere sounds, that they have dimensions—such as tone, height, penetration—which no mere sound can exhibit, and are combined in a way that resembles the grammar of a language. From the finite repertoire of 7 (or, with the accidentals, 12) notes composers in our tradition have produced works of surpassing sublimity, and Hildebrand sets out to examine some of their achievements, and the role of harmony, melody and rhythm in organizing the musical surface. In this long and detailed section nothing is more in evidence than the acuteness of Hildebrand's

musical perception, and the authority of his aesthetic judgment. Even if he does not always unravel the philosophical difficulties presented by music his descriptions of its effect—notably in the Wagner operas—are wonderfully perceptive and inspiring.

Many philosophers will dislike Hildebrand's easy-going style and relative lack of reference to other philosophers. They will wonder how this intelligent and cultivated survey of the arts can be squeezed into the categories of philosophical or phenomenological analysis that are familiar to them. And as a result they might choose to ignore a work that deserves to be widely known, not only by philosophers, but by the reading public generally. John F. and John Henry Crosby are to be congratulated in making this translation available, and so helping to establish Hildebrand's reputation as one of the last great representatives of the high culture of Germany, and one for whom art was not merely a topic of philosophical enquiry, but also a gift of the Holy Spirit.

Malmesbury, 2nd May 2018

Note on the Text of the Current Edition

WE WANT TO ALERT the reader to the fact that Hildebrand's *Aesthetics*, especially volume two, is in an unfinished state. Both volumes were written in a nine-month period from 1969–1970, when Hildebrand was eighty years old. He did not live long enough to work through and order the text of volume two in the way in which his other philosophical works are fully completed and structured.

But even in this unfinished state the work is full of deep and original insights into art and beauty. And not just scattered insights, but foundational insights. One of the richest ideas in volume two is that of "artistic transposition" (the idea that the full range of values, including moral values and disvalues, can be fully transposed into aesthetic values). We are fortunate that Hildebrand devoted an entire chapter to this theme (chapter 32), though it remains only a partial treatment. Readers will find significant uses of the idea of transposition throughout the work, with many notable instances in the section on music.

Other insights and themes in volume two that rise to the level of original contributions include the entire section on literature, which contains the elements of a philosophy of language, and the discussion of

architecture, which explores the "lived space" that we experience when we dwell in houses, palaces, churches, public squares.

The chapters of volume two are full of reflections on great works of art, such as Beethoven's *Fidelio* or Cervantes' *Don Quixote* or the Parthenon in Athens. These reflections may not be philosophical in the strict sense, since they concern in each case some individual work of art, but they are eminently phenomenological reflections which capture the spirit and genius of the individual work.

The treatment of music is philosophically perhaps the richest and most fully developed part of volume two. Hildebrand's phenomenological spirit is fully on display in his exploration of the basic building blocks of music. He is always in search of irreducible structures, whether of the most elemental variety, like the musical note and musical sound, or other irreducible but progressively more complex structures like melody, harmony, and the musical whole (all in chapter 33). His discussion in chapter 34 of pure musical expression (the ability of music without words to express emotions like love and sorrow) is not fully developed but lays the foundations for an original theory of musical expression. Readers will find him constantly in debate with various reductionistic efforts to explain the higher through the lower, such as explaining expression through association.

These remarks do not purport to represent or evaluate this second volume of *Aesthetics* exhaustively. They are meant only to underscore the fact that *Aesthetics*, and especially volume two, presents original and complete ideas despite remaining an incomplete text.

Volume two was published posthumously in 1981 (Hildebrand died in 1977) thanks to the efforts of Karla Mertens, founder of the Hildebrand Gesellschaft. She is almost certainly a source of the German editions subtitles and the editor's footnotes. In our translation of volume two, we have retained these subtitles and many of the footnotes, and we have added some more for contemporary readers.

Our English edition of Hildebrand's *Aesthetics* is the fruit of the extraordinary generosity and commitment of countless friends and benefactors. We are deeply grateful to Dana Gioia, then-chairman of the

National Endowment for the Arts, who provided the catalyst with a Chairman's Extraordinary Action Award. And we are forever indebted to Howard and Roberta Ahmanson for their enduring support which allowed us to bring this work to completion. We thank Sir Roger Scruton for contributing a foreword that places Hildebrand's *Aesthetics* within the broad tradition of philosophical aesthetics. We gratefully acknowledge Brian McNeil, whose initial translation provided the point of departure for our final English text. Copyediting was meticulously executed by Elizabeth Shaw, proofreading by Sarah Blanchard, while the entire production of the book, encompassing everything from contents to covers, was masterfully led by the Hildebrand Project's director of publications and marketing, Christopher Haley. Marylouise McGraw has adorned the book with a beautiful and thoughtful cover.

We hope that readers will not only have their aesthetic perspective enlarged by the phenomenological richness of Hildebrand's work, but will also be challenged by all that is unfinished in it, and will carry it forward and build on it.

John F. Crosby and John Henry Crosby
Translators and Editors

Preliminary Note to the German Edition (1984)

WITH THE PUBLICATION of Vol. VI: *Aesthetics, Part 2 (On the Being of the Work of Art and of the Arts)*, we have now completed the edition of the ten-volume *Collected Works of Dietrich von Hildebrand*. The author worked on this manuscript, which is published here for the first time, right up to his death, but he was not able to complete every part of it. Some problems could only be indicated; some artistic phenomena could only be sketched; and he was not able to analyze some forms of art, such as the epic poem. Nevertheless, the manuscript that he left contains a wealth of insights, original observations, and precious analyses (for example, of Mozart's operas) that are born of a lifelong study of works of art. We are convinced that this late work, the harvest of a whole lifetime, deserves its place in the *Collected Works*. It will also be very useful to those who teach art.

Unfortunately, the publication of this volume depleted the financial reserves of the Dietrich von Hildebrand Gesellschaft to such an extent that it was not possible to provide a complete index. We hope that the detailed table of contents will to some extent make up for this. Similarly, we were not able to print the bibliography that an American student of philosophy had prepared. But since we are convinced that the reception

history of Dietrich von Hildebrand's philosophy has only just begun, we are confident that later publications will bring to completion what still remains to be done.

Dietrich von Hildebrand Gesellschaft

Introduction

THE FIRST VOLUME of this *Aesthetics* studies the being of beauty, especially in nature and in the life of the human person. The object of this second volume is the essence of the work of art, the character of each of the various genres of art—architecture, sculpture, painting, literature, music—and specifically artistic beauty.

We begin with a number of topics that apply to every artistic genre. First of all, we study the ontological nature of the work of art. Next we refute the theory that the work of art is the objectification of the personality of the artist. We then point out incorrect attitudes to art, and finally proceed to discuss which genres of art collaborate with which other ones—in other words, which genres can unite to form a new artistic whole.

Finally, we will offer a detailed analysis of each individual artistic genre, which will also bring to a conclusion some of our general investigations.

Characteristics Common
to all the Arts

Various Attitudes
Toward Art

CHAPTER ONE

The Ontological Reality of
Works of Art

ALTHOUGH THE structures that we call "works of art" are ontologically very various, all of them also possess essential traits that distinguish them from all the other kinds of things that exist.

A work of art, whether it be a church, a palace, a statue, a picture, a novel, or a symphony, is always a spiritual "something" that is a curious quasi-substance of a spiritual [*geistig*] kind. It is always an individual, unified "something."

Although the relationship of a work of art to the material in the different artistic genres (for example, in architecture and in literature) may vary greatly, the work of art as such is a spiritual reality. When we speak of the beauty of the Town Hall in Perugia, of its tremendous seriousness and its unity, we are referring to the work of art, to a self-contained, unique, spiritual "something," not to the mass of stones of which this building is made up. In our discussion of the individual artistic genres, we shall look at the varying relationship between the spiritual work of art

and the physical something with which it is linked. We shall also answer
the question of how the individual work of art becomes real: what kind
of reality does it possess?

The term "spiritual" [*geistig*] has many meanings. It is used above all
in the sense of a personal conscious being. Accordingly, an act of know-
ing, and every act of the will, is something spiritual. The same is true of
every affective value-response (a fact that has often been overlooked).
Here the word "spiritual" implies the full individual, *conscious* being, the
being of the spiritual soul, of the person. Propositions and ideas are also
called "spiritual," though obviously this does not mean something that is
personal and that consciously exists. These have the following elements
in common with that which exists personally and consciously: incorpo-
reality, being articulated or structured, being full of meaning, and much
else. Nevertheless, one cannot emphasize strongly enough the radical
difference between these two meanings of "spiritual."

The non-personal spiritual quality that does not exist consciously can
belong to entities with very various forms of existence, including a work
of art. In this case, we are thinking of a form of existence that is very
different from that of a mere *ens rationis* ("a being of reason") or from the
ideal existence of an essence.

These essences too are spiritual structures. First of all, they are in-
corporeal. Secondly, they are eminently meaningful; in a certain sense,
they are the primal source of all meaning. However, they are essentially
general, not individual, whereas the work of art is definitely an individual
structure. Its ontological nature is thus completely different from the
form of existence of the essences.

The same is true of the spiritual quality of concepts, which is likewise
distinct from that of essences. Concepts do not possess the same onto-
logical dignity as the genuine necessary, uninventable essences. Concepts
have a much "thinner" form of being. But they too are essentially general,
and are clearly different from the spiritual form of existence of the indi-
vidual work of art.

One final difference between the spiritual form of existence of the
individual work of art and that of the genuine essences is that the latter

are eternal, while all works of art become real at one particular point in time. They are essentially something created by the human person. They do not have the ontological dignity possessed by the uninventable and eternal character of the essences. On the other hand, as individual beings, they possess a concrete reality that the essences lack.

The work of art is a quasi-substance. It is certainly no mere accident of something. We have listed elsewhere[1] the three perfections of a substance: first, the *inseitas*, the standing-in-itself; secondly, being the deeper and more serious level of a being; and thirdly, being one individual that, unlike all the artificial parts of a continuum (for example, unlike one single instant), is in sharp contrast to all surrounding being and exists as something of its own.

In the realm of being there are many degrees of being a substance: first, the lifeless, material substances, such as a stone; secondly, the plant organisms, such as a tree; thirdly, the more distinctive substance, namely, the animal; and finally, the human person, in whom the perfection of substance attains its fullest form known to us in experience.

There also exist entities that are substances only in an analogous sense, for example, communities such as the state and the nation. These are not in the least accidents. These quasi-substances lack the fullness of meaning of the full substances: but like genuine substances they are not accidents, and they constitute a unified, individual structure. In medieval terminology they are called "moral substances" as opposed to the physical substances. "Physical" here certainly does not mean "bodily," for in this terminology, a stone, a tree, an animal, and a human person—indeed, every individual being—is a physical substance.

Similarly, works such as Plato's *Phaedo* or the *Confessions* of Saint Augustine are non-personal, spiritual, individual substances. They too bear the stamp of something created by a human being at one specific point in time. They can be destroyed or get lost, as happened to writings by Plato and Aristotle. Naturally, getting lost and becoming inaccessible to all human beings is one particular form of destruction, different from

1. *Metaphysik der Gemeinschaft* (Regensburg: Habbel, 1975), chap. 1.

the burning of a picture or the smashing of a sculpture (for example, the Colossus of Rhodes).

Although philosophical works share many characteristics with the work of art, and each is a particular kind of "moral" substance, spiritual in kind, there is an ontological difference between them. The element of a self-contained whole is even more pronounced in the work of art. The individual philosophical work is part of a larger investigation of philosophical truth; and this cannot be said of the work of art. An individual work of art, such as Shakespeare's *King Lear*, Beethoven's Quartet op. 130, or Michelangelo's *Dying Slave*, is not in the least part of a larger whole. This difference is due to the difference in theme. Every important philosophical work in which metaphysical, ethical, or logical truths are formulated investigates a part of the whole truth and conquers a part of it. But the theme of the work of art is its beauty. It would be meaningless to regard the individual work of art as a part of the creation of beautiful things. Accordingly, each work of art is a much more pronounced individual.

There are objectifications of the human spirit that are completely different from philosophical works, such as great inventions of machines (for example, an automobile, an airplane, or a computer). These material structures also contain an enormous investment on the part of the human spirit. They differ much more strongly from works of art than do philosophical or scientific works.

First of all, while one individual automobile is indeed an individual, it is this as one particular material body. Besides, the invention of the automobile aims at the kind of objects that constitute a series, a type that can be repeated in innumerable individuals. Artistic creation never aims at a type that can be produced as a series. The decisive difference between a machine and a work of art can be seen precisely in the fact that it is possible to make a copy of a sculpture or a picture, and this copy is a *copy*. On the other hand, the Volkswagen that one purchases is not a copy of another Volkswagen, but the normal individualization of this type of automobile.

Secondly, the machine is a typical *factum* (that is, something made), whereas the true work of art is a *genitum* (something begotten). I have

already mentioned elsewhere[2] this difference between *genitum* and *factum*, which runs through every sphere of being. The words of the creed, *genitum non factum* ("begotten, not made"), point to the different genesis of things that exist on earth. The antithesis between that which has grown and that which is made artificially, between that which is organic and that which is mechanical, refers to this difference.

I have also drawn attention to the fact that the *genitum*, the organic, has many degrees. For example, something that is a *factum* when compared with something higher, to something that is more full of meaning, is a *genitum* when compared with something lower, something that is more mechanical. A physiological process is a *factum* when compared with a spiritual process such as the insight into an evident truth or a value-response of love; but when compared with a purely mechanical process, it is an organic process, a *genitum*. When compared with the cutting of a stone into pieces, the invention of the machine is a *genitum*; but when compared with a work of art, it is a *factum*. Both the investment of the human spirit in the invention of a machine (for example, the airplane) and the kind of expression of the human spirit in this machine are something made, something inorganic, when compared with the process of artistic inspiration and the shaping of the work of art, and to the expression of the human spirit in it. The work of art is definitely organic.

The distinction between *genitum* and *factum* confronts us with a very profound phenomenon, indeed, a primal phenomenon, that is to say, something that one must apprehend and understand intuitively through itself and that one cannot derive from other data.

2. *Metaphysik der Gemeinschaft*, chap. II, pp. 129f.

The Work of Art Is Not a Projection of the Artist

THE ATTEMPT HAS been made to interpret art as an objectification of the personality of the artist and to offer this as an explanation of the mystery of the spiritual beauty in the visible and audible work of art.

We find this viewpoint in Maritain's aesthetic writings too. Naturally, one can understand the expression "objectification of the artist's own person" in very various ways. If all that is meant is that every work of art bears the stamp of the artist, this can certainly not be denied. The specific character of the artist can find a stronger expression in many of his works, and a less strong expression in others. It is often possible to recognize at once that a work must be by Beethoven, Schubert, or Wagner, or that Goethe or Shakespeare is indubitably the author of a quotation. But a work can be of such a kind that it is not possible immediately to identify the author, either because it is not typical of him or because the author has undergone so much development that some early works are radically different from later works. It is often difficult to attribute a work unambiguously to an author, because one great master was the disciple of another great master, and the inner affinity between

the two makes it extremely difficult to discern which of them produced one particular work. The *Concert* in the Pitti Gallery was long held to be by Giorgione, but art historians today regard it as more or less certain that it was painted by Titian.

However, the thesis that Maritain and others maintain, namely, that a work of art is an objectification of the personality, a projection of the specific character of the inner life of the artist, refers to something completely different from the stylistic unity, the stamp of the artist in his works. The first implication of this thesis is that the artist projects himself into his work in his specific human character. This fails to draw the important distinction between the artistic and the human personality of the artist. The stamp of the artistic personality can be very pronounced; but it is also possible for the work in its own specific character, in its world, and in its value, to transcend entirely the artist as a human being, so that it tells us nothing at all about the artist as a human being, about his character. This is why it is incorrect to assert that the relationship of the artist to his work is that of an objectification of his personality, of his feelings, his experiences, etc.

The second implication of this thesis is that the objectification is intended, indeed is thematic, both for the process of artistic creation and even for the work of art itself. In the *Ion*, Plato calls the artist a seer.[1] Does not this position do better justice to the facts? Does not the artist apprehend something objective, something that remains closed to the non-artist? In this act of apprehending, it is not philosophical knowledge that is thematic, but artistic beauty, depth. He receives an inspiration, and his intention is directed to the objective shaping of this inspiration, to the creation of an object that is a bearer of beauty. If an artist wants only to present himself in his work, to "pour out his heart" or to "express his life" in art, this is a disadvantage, an inartistic tendency.

It is completely mistaken to try to explain the fact that the visible and the audible in art can be the bearer of a specifically spiritual beauty by speaking of the projection of the artist's soul into the work of art.

1. Chap. 5, pp. 533f.

As we have seen in the first volume, the beauty of the visible and the audible in nature can attain to a specific spiritual quality. The highest degree of beauty of the second power can be found in nature.

Although works of art such as a symphony or a quartet are composed of audible elements, they are as such definitely spiritual structures. A picture too is a spiritual structure, and although it is painted on canvas or wood, it is not a purely material, physical "something." It is a spiritual structure, although it is made up of visible elements. The same is true of a sculpture, a relief, etc. Now this spiritual quality of a work of art indubitably presupposes the spiritual person of the artist, since it could not otherwise come into existence. It is the product of a very specific, unique, creative gift which in turn presupposes an inspiration, a special act of receiving, a receptive act of welcoming a gift. But the spiritual quality of a work of art is not something consciously lived in a personal manner. It is itself not a conscious being. Rather, it is an analogous spiritual quality, like that possessed by a truth that is objectified in propositions. I say "analogous" because the ontological spiritual quality of true propositions is different from that of works of art; but both taken together belong to a radically different type of ontological spiritual quality from the person and personal consciousness.[2]

However, the fact that these works of art are essentially created by human beings is no proof that they are an objectification of the artist's soul. Not only are they objectively spiritual structures; if they are truly successful, they must "stand on their own feet" and possess their own specific character. They must not be merely an expression of the artist's soul. Works of art are not mere descriptions of the artist's feelings.

The relationship between the artist as a human being, his character, his moral status, his quality as a personality, and the depth of his human experiences, on the one hand, and his artistic personality, his artistic

2. In the course of history of philosophy, philosophers have often failed to draw a sufficiently clear distinction between these two completely different concepts of "spiritual" in the ontological sense. Both refer to non-material beings, but whereas ideas, propositions, sciences, works of art, and communities such as state and nation are non-personal structures, the soul of the human being is a concrete, individual, personal structure, something that exists consciously and possesses a completely new dimension of being, unlike everything impersonal.

depth, greatness, power, and brilliance, on the other, poses a very interesting problem.

One is inclined to suppose that there must be a close connection between the two; at the same time, however, it is undeniable that the quality, sublimity, and greatness of a work of art are scarcely to be found in an analogous manner in the human personality of the artist. Measured by the angelic tone in Mozart's music, by its sublime transfigured quality, Mozart would have had to have been a saint in order to possess such sublimity as a human being. But no matter how likeable he may appear to be in his letters and in what we know of his life, he was certainly no saint. The sublime greatness, the breath of God in the works of Beethoven or Michelangelo, far transcends what both were as men. The mysterious ability to create something so great and glorious is different from the being of the artist as a man. It is a gift of God, unique in kind, that neither presupposes the analogous perfection in human beings nor bestows it on them. This ability is analogous to the gift of profound philosophical knowledge. As I have frequently emphasized, exact philosophical knowledge certainly presupposes many decisive moral attitudes, but in order to have profound knowledge of the being of purity or humility, one need not possess these virtues in their ultimate perfection. In the same way, the artist is permitted to create works of a sublimity that far transcends what he as a human being accomplishes in a moral respect.

In this context, it is important to see that the theme of a work of art is not the person of its creator, but its own value, the beauty of the work of art itself. A work of art does not primarily make a proclamation about its author, but about the glory of the cosmos and, ultimately, about God's infinite beauty.

We cannot apply to a work of art Leonardo's observation about love: "The greater the man, the deeper his love." We cannot say: "The greater the man, the greater his ability as an artist." Great personalities, rich and profound human beings, indeed even saints, need not be artists. Even if they were artists, they need not be great artists; nor need great artists possess *qua* human beings the greatness and sublimity of their works.

A saint who works as an artist need not produce any great works of

art. Even a great spirit who was not only deeply religious but could also write in a unique way about religious and theological questions, namely, Cardinal Newman, did not create a true work of art with his novel *Callista*. He is certainly one of the greatest writers of all time, thanks to his style, to the depth of his ideas, and to his ability to let us breathe in the world of Christ and the supernatural fragrance of revelation. Nevertheless, he did not create an important work of art with his historical novel.

In addition, it is wrong to believe that the worldview of the artist is reflected in every great work of art, to believe that while his person, his character, and his human personality are not reflected in his work, his worldview is reflected in it. This may be the case, but it certainly need not be so. A great artist is guided in his work by the inner logic, the inner truth of the work, and this can coincide with his own worldview, but need not do so. In Beethoven and Michelangelo, we find a deep harmony of their worldview and with the inner logic that is objectively demanded by the work and with the standing of this work in the truth. Both are totally dominated by the artistic logic, and are at the same time "confessors" in all their works. In Bach, above all in the *St. Matthew Passion*, the peerless rendering of the world of the Gospel—indeed, one is tempted to say: the embodiment of this world—is completely filled by the inner logic of the work of art and by the world of the Gospel in artistic transposition, on the one hand, and by his profound religiosity, on the other. The work is truly a confession of faith, but what we encounter therein is primarily the world of the Gospel, not the personal religiosity of Bach. The work speaks, not of his religiosity, but of Christ, and in its quality it far transcends Bach the human being.

In many cases there is no concurrence between the worldview of the artist and the spirit of the work of art. One striking example is Part I of *Faust*. Goethe's personal worldview and his position with regard to God and to Christ are expressed in the answer Faust gives to Gretchen when she asks whether he believes in God and in Christ, but Goethe's artistic genius compels him in the matchless closing scene to locate the work entirely in the Christian world, in spite of his own worldview (the one

that he places on the lips of Faust). The angel's voice is the final, decisive word: "She is saved."

In an analogous manner, the profoundly religious and Christian atmosphere in *Crime and Punishment*, *The Idiot*, and *The Brothers Karamazov* is not an expression of Dostoevsky's personal worldview, quite apart from the question of whether and to what extent he himself was a believing Christian.

Since the artist mysteriously touches the truth of things through the inner logos of his work of art, he can be elevated above his personal worldview. Many artists whose personal worldviews stand completely in the truth, who are convinced Christians and great human personalities, are indeed in complete harmony with the demands made by the truth of the logos in the work of art; but even here the work of art can far transcend the stature of the man. As Plato says, the great artist is truly a seer, and God speaks through him.

This is why it is wrong to believe that biographies of an artist lead to a deeper understanding of a work of art. The true work of art must stand on its own feet. Knowing about the artist's life cannot offer us a better access to the genuine values of a work of art or make it easier to understand. If our interest in the artist's experiences at the time of the composition of a poem, a novel, or a piece of music increases our interest in the work, or even functions as a key to understanding the work, then we are being distracted from the word that the work of art itself speaks.

The opposite is true. If we have apprehended the greatness of the works of an artist without learning anything definite from them about the author as a human being, about his character and the kind of man he was, about his moral standing and his worldview, it is completely natural that we should take an interest in these matters. But in the case of many artists, we shall see that the world of their great works is far superior, in its value, its greatness, and its profundity, to the personality of the artist as a human being. The spiritual world of Dante's *Divine Comedy* or of Cervantes' *Don Quixote* far surpasses everything that we learn about these two authors in their biographies.

CHAPTER THREE

Wrong Attitudes to Art

REPEATED CONTACT with a work of art is often needed before we fully appreciate it in its essence and hence appreciate its beauty. This varies in accordance with the artistic understanding of a person, sometimes only in accordance with the understanding of the "language" in which the essence is given, and in accordance with the kind of work of art. Many works of art are easier to understand, others are more difficult. Mozart's *Laudate Dominum* is objectively easier to understand than Beethoven's *Great Fugue*, and the perception of their beauty is connected to this fact. This is why a clear distinction must be drawn between the first time we hear a piece of music and the moment in which it opens up for us. The same applies to a poem, a painting, a sculpture, or a landscape. The mere act of seeing these objects need not as yet be a full apprehension of their essence and thus of their beauty.

In the encounter with a work of art or with nature, however, many people are interested in something quite different from aesthetic value. The delight they take in the work of art or in nature is motivated by elements of a non-aesthetic kind. What they apprehend is not the beauty, not the thematic aesthetic value, but chance elements, often as a result of associations. In what follows, I shall attempt to discuss briefly these

non-aesthetic (and in the case of works of art, non-artistic) attitudes, since they are in fact highly important for many people. I shall clearly distinguish those factors that are substitutes for the true aesthetic value of a work and that distract people completely from this value, from those other factors that are only the preconditions that some people need in order to enter into the beauty of the object.

The two kinds of familiarity

First of all, there is the attraction of custom. For many people, the simple fact of being accustomed to something bestows a positive character on that object. A landscape that is itself not at all beautiful, but rather is boring and nondescript, can become attractive for some people because they are accustomed to it and see it again and again. They enjoy the familiarity as such. It is this that pleases them, not the aesthetic quality of the landscape. They substitute for the aesthetic value the satisfaction that the familiarity as such evokes.

We must distinguish here between two kinds of familiarity. The first is linked to one's native place [*Heimat*] and originates in the fact that we have invested much of our life in this landscape. The second kind is sheer familiarity as such. It is clear that neither of these is an aesthetic value. They have intrinsically nothing to do with the beauty of the landscape. The attraction of both kinds is completely different from the attraction that the beauty of the landscape exercises upon us. Nevertheless, we must draw a distinction between the two, since the familiarity of what belongs to one's native place is intrinsically much more legitimate than the attraction exercised by sheer familiarity. The first is much nobler, and as long as it does not usurp the place that belongs to the apprehending and enjoying of beauty, it certainly has a legitimate importance in our life.[1]

The attraction of sheer familiarity is much more peripheral, and ought not to play any genuine role. Whereas the attraction of that which belongs to our native place is related principally to nature, and perhaps

1. On this, see *The Nature of Love* (South Bend, Ind.: St. Augustine's Press, 2009), chap. 8.

also to architecture in combination with nature, sheer familiarity strongly influences our relationship to art as well.

It is clear that the joy that is expressed in the exclamation "Why, I know that!" has nothing to do with the beauty of the piece of music. It is a joy *sui generis*, the joy of recognition, the joy felt on encountering something that is known, as opposed to encountering something new, foreign, and inaccessible to us because we do not "know" it. In the act of recognizing and "finding a place" for this piece of music there is a kind of satisfaction, a kind of position of dominance that the "knowing" implies. Obviously, it is completely illegitimate for this satisfaction to interfere with the aesthetic experience, and even more illegitimate for this satisfaction to usurp the place of the aesthetic value.

Familiarity can, however, also be nothing more than a precondition for the apprehending of beauty. In that case, its function is not only legitimate, but to a certain extent also natural and human. In order to apprehend the beauty of a difficult piece of music, we must listen to it more often. The better we know it, the more its beauty discloses itself to us. The same applies to many poems, pictures, and sculptures. This may legitimately be more important to one person than to another, depending on the relationship persons have to the specific sphere of art. This familiarity has an ancillary function and is not in any way a substitute for experiencing the aesthetic value.

If, however, familiarity as such becomes thematic, so that the object becomes attractive independently of its aesthetic value or disvalue, this means that the joy caused by beauty is replaced by a satisfaction caused by familiarity. From the aesthetic standpoint this is a total perversion.

The unartistic interest in what is portrayed in art

In a second form of non-artistic attitude, one is interested only in what is represented. What counts is the quality of an event as historically important. Such an observer reads "The Death of Wallenstein" or "Victory over Attila" under a painting, and he is impressed by the illustration of this event; but the artistic value or disvalue of the picture is not allowed

to make itself felt. The observer enjoys two things. First, he enjoys the historical event and its dramatic character, to which many associations are linked, and the importance of a great historic moment. If he reads about this event in an historical work, he is rightly fascinated by a genuine aesthetic quality. However, this quality can have only a very secondary legitimate importance for the picture; it has this importance if the artist employs new means to reproduce in the artistic atmosphere of the picture something of this quality of the great moment. But the observer whom we have mentioned is interested above all in the title that stands under the picture. He substitutes for the beauty of the picture the aesthetic character of the historical moment that the title communicates to him.

Secondly, he enjoys the formal element of illustration. An event that he knows only from historical works, and about which he doubtless has some subjective mental images, is now accessible, given to him in a picture. His interest is satisfied not only by the title, but also by the fact that the event is intuitively presented and given to him, thus intensifying his contact with it. That is the point of illustrations.

In a book these are meant to intensify the contact with the literary content. In literature, however, illustrations with aesthetic value have a very modest decorative character.[2] The objective character of the artistic beauty of the literary work of art remains unaffected. The beauty of an illustration is not in the least supported by the quality of the content that is represented; this beauty can be attained only with the means of visual art. The agreement of the illustration with the literary content is decisive, for it has only an ancillary function. But the unartistic attitude wrongly treats the picture as a mere illustration of the event.

In an illustration the intensification of the contact in the visual encounter with the object comes into its own; the intensification by means of the word is much more indirect. Many things in a novel (for example, in Boccaccio's *Decameron*) are intolerable when they are depicted in a film. Compared with only hearing, reading, or knowing about an object, the act of seeing is a new dimension of encounter with the object. A

2. See chap. 23 below.

non-artistic, simple-minded joy is generated when one sees an illustration of an event about which one knows: "Ah, look! That is the death of Wallenstein!" For simple-minded observers of this kind, this formal element of the illustration also replaces the real artistic content, namely, the beauty of the picture.

Something analogous, but very different, happens when religious reverence for that which is depicted replaces a sense for the beauty of the picture. For unartistic people it suffices that a picture portrays Christ, the Mother of God, or some passage from the Gospel, in order for them to find it beautiful. They see it above all else from the perspective of an illustration of something holy, and the only theme is reverence for that which is depicted. They are filled by the response due to Christ and to the Mother of God, and they rejoice at the illustration of the object. All this takes the place of apprehending the beauty or lack of beauty of the depiction. As I have said, this is not the same as enjoying an illustration, but there is an analogy. For here the objects make unique demands on the depiction, and the beauty of holiness can become very important for the artistic beauty of the picture, if the depiction is appropriate.[3] The specifically non-aesthetic element is so much in the foreground for these people that they are not disturbed even by the most tasteless depiction, since they are sensitive only to the awe-inspiring holiness of that which is depicted. They are concerned with a completely different theme, and hence are so blind to the artistic value that the picture is nothing more to them than an occasion for thinking of the content.

Others enjoy only the aesthetic value of that which is depicted, not the aesthetic value of the picture. When one has a false attitude of this kind, one sees that a picture portrays a beautiful landscape, such as the Gulf of Naples or the Campagna, but one sees only this beauty, independently of the value of the depiction. One is indeed oriented to the aesthetic value of the beautiful landscape, but one bypasses the aesthetic value of the picture. The beauty of that which is depicted is certainly an important factor for the beauty of the picture, but it cannot salvage a

3. See also chap. 21 below.

bad picture. On the contrary, one who has an artistic attitude will regard an artistically poor picture as a particular disfigurement of the beauty of the landscape it depicts. The deficient depiction of a beautiful landscape makes the picture even more disastrous than the good depiction of a landscape that is inherently boring.

For those who look at the picture in the same way as they look at a photograph, it is not even a mere illustration, but a reminder, a visualization of the landscape and its beauty.

Fame and fashion

Another illegitimate element in the observation not only of works of art, but also of nature, is the fame of an object. The fact that a region, a city, or a building is universally admired surrounds it in some people's eyes with a halo, and this halo, together with satisfaction at having seen the famous object with one's own eyes, takes the place of joy at its genuine beauty. Very primitive elements commingle in this complicated phenomenon: being impressed by public opinion; the attractiveness that something acquires in virtue of its being "famous" and praised by many persons; the fact that one has heard so much about it, so that one's imagination has already received rich nourishment; and finally, sharing in what the others have seen and praised, and joining up with public opinion. For one who enjoys nothing but the more intimate contact with the halo of celebrity, it is a matter of indifference whether he is looking at the Palace of the Doges in Venice or the Eiffel Tower in Paris, although from the perspective of beauty there is a gulf between the two.

The fame of a work of art can have a legitimate function if it is not a substitute for beauty but only awakens our interest in seeing it. In this case the fame of the object must become unimportant once we see the beautiful work. The only thing that is entitled to interest us is its beauty; or else we must turn our back on the unbeautiful object, since we recognize clearly that its fame is unfounded.

If we have seen works by great artists such as Michelangelo, Leonardo, Rafael, Titian, Rembrandt, Rubens, Giorgione, or Piero della Fran-

cesca and have ourselves apprehended their greatness, it is legitimate and indeed imperative that we bring a "credit" to any other work of theirs when we see it for the first time. If a hitherto unknown work by Bach or Beethoven does not disclose itself to us in its beauty when we first hear it, we should assume that this is our fault. After we have heard it several times, perhaps we shall determine that this is a less important work by this great master. But when we encounter something new by him, we are completely justified in initially taking into account the greatness and importance of that master whom we know by personal experience. This must be kept quite distinct from the above-mentioned substitution of beauty by a fame derived only from public opinion.

It is a sign of especial superficiality and aesthetic perversion when what is involved is not a fame that has been established over a lengthy period, but the phenomenon of being fashionable. Just as certain ideas and ideologies take on a sociological-historical reality at one particular period, so that we can say that they fill the air, so too some artists are fashionable at one particular period. Because one person praises them, they are praised by others; people jump on the bandwagon. The attractiveness of the fashionable takes the place of the aesthetic quality of the object, surrounding it with a halo, which is the only thing people notice and enjoy. It prevents them from seeing the true character of the thing. Although this fashionableness is inherently illegitimate, it is of course possible for it to accompany a genuine greatness. In that case, the halo is justified and can help to open our eyes to the true value.

The prejudice of nationalism

Prejudices are completely erroneous, whether it be nationalism or the fact that something is modern or contemporary.

Nationalism leads many people to regard a work of art as much more important than it really is, especially in comparison to works of art from other countries. Although this utterly unobjective factor is brought to the object completely from the outside, it unfortunately often obfuscates the judgment of people who have a real affinity for beauty and are able to

apprehend the artistic value of a work. This factor is no substitute for the
aesthetic value, but is a typical prejudice. Its effect is not so much to oblit-
erate the difference between a good and a bad work, but rather to lead the
observer to offend against the hierarchy within the genuine works of art.
The fact that a work of art is by a Frenchman or a German is given extra
weight. Thus there are Frenchmen who rank Racine above Shakespeare,
without noticing that this judgment is colored by nationalism. But it is
not only the judgment itself that can be influenced by nationalism: the
same applies to immediately apprehending and enjoying the work.

A prejudice of this kind asserts itself very strongly with respect to the
beauty of nature in a country. How often are Germans or Frenchmen in-
capable of recognizing how much more beautiful the landscape in Italy is
than in their own country! It is of course true that precisely in Germany
great minds such as Goethe, Winkelmann, and many others have ap-
prehended in a special way this superiority of Italy; but we have in mind
here average persons, and within this group, above all nationalists. Pride
creates a prejudice against the beauty of the landscapes and the works of
art of other countries.

One must distinguish from this nationalism yet another factor that
restricts the apprehending of beauty, namely, the fact that the national
characteristic of a work of art, which is as such a secondary element,
makes it easier for the members of this nation to understand its true
value. We encounter here a kind of analogy to language. Even for one
who knows a foreign language well, poems in his or her mother tongue
are more comprehensible than those in the foreign tongue; and for many
persons, the cultural framework in which a work of art has "grown" is a
precondition for understanding it deeply. This is related to the familiar-
ity mentioned above. That which is marked by the nation to which one
belongs speaks the language that one understands better. This language
touches one's heart more strongly and facilitates access to a work and
to its beauty. Nevertheless, this is a definite restriction of one's spiritual
horizon, an encumbrance on the true understanding of art.

In exactly the same way, we understand the beauty of one type of
landscape more easily if we are familiar with it and with all the elements

that belong to it: the inhabitants, the cultural tendency, and above all the fact that it was here for the first time that the most universal bearers of beauty, such as the sky, the light, morning, midday, and evening, and the various seasons of the year disclosed themselves to us. On the other hand, the foreignness of other countries is an obstacle to doing full justice to their landscapes. But this too is an illegitimate factor, a lack of objectivity. From the perspective of an adequate apprehending of value, it is a restriction and an encumbrance.

Chronolatry

There exists a temporalism, analogous to nationalism, that has been given the appropriate name of chronolatry.

A special kind of arrogance leads one to regard the epoch in which one lives as especially important and valuable. The fact that one belongs to this epoch makes the idea that the achievements of this time are particularly great a source of satisfaction. This chronolatry also puts a halo around the works of art of one's own epoch, but it is nothing other than a prejudice that blinds one to true artistic value.

Naturally, the opposite prejudice exists too. Many people regard a work of art as the more precious, the older it is. They approach with suspicion everything that does not belong to the past, and this too is unobjective. We shall return to this subject below when we take up the extremely important difference between the beauty of the style of an entire period and the genuine artistic importance of an individual work of art.

Apart from chronolatry, modernity plays a great role for many people. In addition to the magical power of contemporary fashion, modernity contains a flavor of the new, the progressive, of that which points into the future. Many people think that the fact that something is modern at the present moment bestows on it a value, completely independently of its qualitative content. It is interesting that those who have this prejudice imagine that they are especially free of prejudice. They want to be open, free of all ties to what is customary. They want at all costs to avoid being old-fashioned and backward, and thus they feel especially free and un-

prejudiced when they have sympathy with all that is new and modern. Many are also afraid of being thought old-fashioned, and this explains their enthusiasm for something that is new and modern. As in Andersen's fairytale of the emperor's new clothes, their fear of being thought stupid or backward leads to an increasingly obsessive enthusiasm for something.

There are thus various sources of the unobjective approach to a work of art that favors its modernity.

Seeing a work of art too much in light of the period to which it belongs

At certain periods the style of an epoch possessed a high aesthetic value, but at others an aesthetic disvalue. The sublimity of the period style in Athens in the fifth century B.C. is well known; but the period style in the second century A.D. is rather negative and dry, and finds expression above all in architecture, sculpture, and painting, but is not so pronounced in literature. From the perspective of artistic understanding, it is very important to apprehend the aesthetic quality of the style of a period, and to distinguish clearly between its value and its disvalue. The Baroque style in music possesses in itself a great nobility. Curiously enough, the danger of an artistic gaffe is very slight in this style. There are indeed weak and boring works, but never trivial, mean-spirited, or disastrous works.

It is a great mistake to confuse the aesthetic value of an epoch with the artistic value of an individual work of art or with the artistic greatness of a master. This error contains a definite prejudice, which is sadly widespread today, though it is of a much higher order than the prejudice mentioned above. It does not indeed prevent one from understanding a work of art that comes from an especially beloved period, but it makes one more or less blind to the great masters of other epochs and is an obstacle to apprehending the true greatness of the masters within the period whose style one so loves. This is why there is a definite prejudice here, an illegitimate attitude to art, though on a different level from the attitudes discussed above. The Baroque style in music is certainly the bearer of a sublime nobility. But if one loves Handel, or even Johann Sebastian Bach, only

because of this "language," one has failed to understand them. There are many noble and important masters in this period, but also unimportant composers. What Handel has to offer far transcends the nobility of the style of this period. And one has understood nothing of Bach, this unique genius, if one loves him only for the sake of something he shares with many of his contemporaries, namely, the nobility of the "language" of the Baroque style. In truth, he has much more in common with Mozart, Beethoven, and Wagner than with any of his lesser contemporaries.

Finally, we must emphasize again that a distinction is to be drawn between a kind of academic interest that studies the person of the artist and his life, the influence that another artist had on him, or purely historical facts that concern an artist (all of which are inherently important and worth knowing), on the one hand, and the purely aesthetic interest, the apprehending of the beauty of a work of art, on the other. Santayana is among those who noted this correctly.[4] This historical theme, which is inherently weighty and important, does not in the least restrict or encumber the aesthetic impression, the understanding of a work of art. But it is something different from the artistic value of the work. Some people mistakenly believe that they come closer to the artistic value and understand it better through the study of this academic theme. Doubtless, there are ways of helping those who lack any vital access to an artistic genre, in order that the beauty of a work of art, its true content, and its importance may be revealed to them. But these paths do not lead via the study of purely historical themes.

A completely different and much more refined perversion of the relationship to beauty in nature and in art is found in the aesthete, as we have seen in volume I of this work.[5]

4. "If we approach a work of art or nature scientifically, for the sake of its historical connections or proper classification, we do not approach it aesthetically. The discovery of its date or of its author may be otherwise interesting; it only remotely affects our aesthetic appreciation" (*The Sense of Beauty* [1895], The Modern Library [New York: Random House, 1955], part 1, 2, p. 25). Santayana correctly draws a distinction between the academic and the aesthetic standpoint, but he employs this distinction in the service of a false thesis. On this, see my *Aesthetics*, vol. 1, chap. 5.

5. See *Aesthetics*, vol. 1, introduction, chaps. 2 and 13.

The Combinations between the Different Arts

VARIOUS ARTISTIC GENRES can join to form a unified artistic impression. Indeed, in some circumstances, they can form a "marriage" with each other. In one sense, the deepest and most important combination is that between sound and word in song, in opera, in musical drama, in an oratory, and in the liturgy, where they are deeply interwoven. This union thus becomes the birthplace of completely new artistic values, which neither music on its own nor literature on its own can generate. The only marriage comparable to this is that between architecture and nature,[1] which, however, unlike the marriage between sound and word, is not a union between two artistic genres.

The marriage between architecture and sculpture

In the union of architecture and sculpture, there is a collaboration between two artistic genres that speak the same language, since both belong to the realm of the visible. We shall speak in chapter 12 in detail about the possible kinds of this union.

1. See chap. 12.

The collaboration between sound and word takes place through two different "channels," whereas the collaboration between architecture and sculpture involves one and the same channel. As visual arts, they address the eye.

Like sound and word, architecture and sculpture work together in a variety of forms. Some sculpture is completely subordinate to the architecture: in this case, the statues and reliefs are decorative in nature. The sculpture abandons its full, serious specific character and takes on the function of decorating the architecture, enriching it with ornament. The sculpture can in itself possess genuine artistic values, but what it primarily does is to contribute to the beauty of the architecture.

"Decorative sculpture" covers a wide field with many subspecies. It includes the cherubs in many churches, the statues on bridges (for example, Saint John Nepomucene on many Baroque bridges), the sculptures on staircases and on the roofs of palaces, statues of animals on gates (such as the two greyhounds on the entrance gate to a palace in the Grünangergasse in Vienna), and many statues on fountains (for example, the glorious Fountain of Trevi in Rome). However, these often possess a complete value of their own as statues; indeed, they may be the principal bearers of the artistic value of the fountain, of its beauty and poetry. Examples are Giambologna's *Neptune* in Bologna, or the statues of the Tortoise Fountain in Rome.

We must draw a distinction between the collaboration between architecture and decorative sculpture, on the one hand, and the marriage between architecture and sculpture, on the other. In the latter case, the two arts are on the same level in thematic terms. The sculpture speaks the full, serious word that is its own, and works together with the architecture. This is exemplified in the highest form in the Parthenon relief. Similarly, the groups of Medici tombs are deeply united to the whole space in which they are situated, but the matchless beauty of these statues is even more thematic than the architecture of the room. The architecture helps to determine the unity of the statues.

This union is even more pronounced in the statues on the portals of medieval cathedrals such as Chartres, Rheims, and Strasbourg. The

beauty of the statues as such unites with the beauty of the glorious architecture, and their collaboration is a specific bearer of beauty. In this field, we can recognize various kinds and levels of the combination of sculpture and architecture. The equestrian statue in the cathedral of Bamberg works together with the architecture of the cathedral and fits the architecture, although its placement in the church means that it no longer demonstrates the same unity of sculpture and architecture that we find in the figures on the portals in Chartres and Rheims.

The union between the two arts is even less intimate when the statue stands in a niche. In the context of an appropriate architecture, a niche, which is often by itself a bearer of aesthetic values, can possess sublime beauty, as in the niches in the Hagia Sophia or (in a completely different manner) in Baalbek in Lebanon. If a statue stands in a niche and is not of a decorative nature, however, it becomes the main theme, and the niche forms its background.

A spatially looser union between architecture and sculpture comes about when a figure or an equestrian statue stands in proximity to an important architectonic structure, as when the statue presupposes the building as background, or when the statue has some kind of necessary relationship to the building. In that case, the statue possesses its own full value and has a great artistic beauty even independently of the architecture; and at the same time, the beauty of the palace or church is not dependent on the beautiful statue that stands in its shadow, so to speak. However, this externally loose union can become the bearer of a new artistic value. This working together intensifies both the beauty of the statue, in one particular direction, and the beauty of the palace or the church. Examples are Michelangelo's *David* alongside the Palazzo Vecchio in Florence, the equestrian figure of Saint Martin before the cathedral of San Martino in Lucca, the equestrian statue of Colleoni in Venice in its relationship to the church of San Zanipolo (Saints John and Paul); in a loose sense the same can be said of the equestrian statue of Gattamelata in Padua on the square before the basilica of San Antonio, the equestrian statue of the Great Elector before the Residence in Berlin, and Adolf von Hildebrand's equestrian monument to Bismarck in Bremen.

A different union of architecture and sculpture is found in bronze doors on a building that depict an entire story in relief, such as Ghiberti's reliefs of Saint John the Baptist on the doors of the baptistery of San Giovanni in Florence. The first characteristic of these reliefs is the small size of what is depicted; they are in a sense miniature sculptures. Secondly, they are a rarity in sculpture, since they present a continuous history. The sacred matter is admirably suited to the doors of a baptistery. In purely technical terms, these reliefs are almost like a goldsmith's work. Although in their own right a great work of art, they do not work together with the architecture of the building. The scale is too different; the relationship to the architecture is more ornamental, although the reliefs are a work of art that stands completely on its own feet and bears high artistic values.

There is a touching superabundance in this very specific type of union between architecture and sculpture. Although the function of the doors as a part of the architecture is modest, they are a great work of art in their own right, born of the religious spirit for which great artistic richness even for every single detail is not too much. Indeed, for such a spirit nothing is good enough for the decoration of a house of God.

Mosaics and frescos in union with architecture

Although architecture unites less closely, on the whole, with painting than with sculpture, there is an important and deep working together between these two as well. If we consider the mosaic as a form of painting, we find here the realization of the most intimate union between painting and architecture. Naturally, we have in mind the mosaic that has an imitative character, that is, the mosaic that depicts human beings, animals, plants, and other elements of nature.

In second place there is the fresco, which can unite with architecture in a wonderful manner if the painting appears in the fullness of its own dignity and the fresco is in itself the bearer of sublime artistic values. Examples are Masaccio's frescos in the Brancacci Chapel in the church of Santa Maria del Carmine in Florence, Raphael's *Liberation of Saint*

Peter in the Vatican stanze, the great *Crucifixion* by Fra Angelico in the chapter room of San Marco in Florence, and the frescos in the Sistine Chapel, especially those by Michelangelo.

Architecture as a whole can be by itself a bearer of great beauty. In that case the working together with the fresco is an additional bearer of a new artistic value. This union is slightly less intimate than that between mosaic and architecture, and still less intimate than that of the closest collaboration, namely, the one between architecture and sculpture. With the fresco there is a wide spectrum of collaboration. Often the fresco is the principal theme, while the architecture provides the ideal framework; in such an instance, the beauty of the fresco surpasses that of the architecture, which tends instead to have an ancillary function, although it remains an important background. If frescos are removed from their architectonic framework, as happened, for example, with the Botticelli frescos in the Louvre, they do indeed remain bearers of great beauty, but one misses the architectonic framework.

Often the architecture is no mere framework, but also as such possesses great beauty. In that case, there can be a similar thematicity of both arts, indeed an equivalent beauty, to which the beauty of the union is added as something new; we see this, for example, in the glorious fresco of Cimabue in the matchless Lower Basilica of San Francesco in Assisi.

Architecture collaborates to a much lesser extent with pictures. It is possible for them to belong together in an ideal fashion, but if the picture is a great work of art, it is always the principal theme, and the room or hall in which it hangs is naturally only the framework. It is, however, possible for the atmosphere of the interior space to be formed very deeply by the pictures that are in it, so that this atmosphere as such becomes much more beautiful. The greatest works of art in the genre of painting are not suitable for this enhancement of atmosphere, such as Titian's *Charles V on Horseback* in the Prado or his *Young Englishman* with the blue eyes in the Palazzo Pitti, Giorgione's *Tempest*, Rembrandt's *Jewish Bride* in the Rijksmuseum in Amsterdam, or the *Fall of Icarus* by Pieter Bruegel the Elder in Brussels. The intimate union between picture and

interior space can be found in a great number of genuinely significant pictures.

The union is completely different when it is unquestionably the architecture that is the principal theme and the paintings have a more ancillary, decorative character, like the ancestral portraits in castles.

The most intimate union, however, apart from that between sound and word, is between architecture and nature. This is not indeed a working together between two artistic genres, but an artistic working together comes about. Both of these, nature and architecture, are situated in the realm of the visible and thus speak the same language, as it were.

There is also a deep relatedness between nature and architecture because they belong to the realm of the real world that surrounds us and are not imitative. The uniting of nature and architecture can lead to the birth of a new and wholly unique beauty that is added to the beauty that each possesses on its own.

Architecture as the framework for other arts

All the arts, including literature and music, presuppose the human space that is created by architecture, but their relationship to architecture is not comparable to the relationship that exists between architecture and sculpture or painting.

With literature and music the task of the framework is in general much more formal. Music is not enhanced in its beauty when performed in a beautiful room, nor does the room appear more beautiful in virtue of the fact that the most glorious music resounds in it. The same applies to literature with respect to human space. The space is necessary, but really only as a framework. It works together with music or literature in such a way as to add no new beauty to the beauty that each possesses on its own.

This loose connection is found most of all in the theater. First of all, we have the stage. The scenery is a piece of architecture, though only in a remote sense. The work of the set designer is wholly unique and cannot be compared to that of an architect. Although the stage set is basically

a reproduction of nature of a special kind, it also contains architectonic elements in the design of the open space or of the interior space in which the play takes place.

The stage set is not only the framework in which something happens; it is also drawn into the illusionary "reality" of the play. This is why its beauty, and above all its suitability, contributes to the full realization of the drama or opera, to the realization that constitutes its performance. A tasteless production can severely impair the enjoyment of the drama or opera. Above all, a prosaic production, for example, a performance of Shakespeare's dramas in modern clothes and with modern scenery, changes the atmosphere in such a way that it is impossible to enjoy the presentation. Although the drama does not lose its beauty, its performance is utterly spoiled. Bad actors can "butcher" a performance; and the same thing happens here.

The stage, the production, the scenery, etc., have a much greater importance in a negative than in a positive sense. The prosaic, dull stage can gravely impair the performance; but the suitable, tasteful stage has rather the function of letting the drama or opera make its impact unhindered. Such a stage is itself an important bearer of beauty, but the union with the play possesses no new value. It possesses the value of the good, suitable performance, and this value is important enough.

The interior of the theater as a whole is a fully valid, genuine architecture. Some theaters are delightful architectural structures, such as Palladio's theater in Vicenza, the Cuvilliés Theater in Munich, and the Margravial Opera House in Bayreuth. The interior of the theater is something purely architectonic and thus cannot be compared to the changing production on the stage.

These architectures have a great artistic value. They are bearers of a festive beauty, a poetry of their own, and an elevated charm. But unlike the design of the stage, they do not unite with the work of art that is performed. They belong to the authentic reality in which we move, not to the illusionary world of the stage. The performance is not better and more suitable in a beautiful theater. We enjoy such a theater independently of the play that is performed. The various stages of reality do

not flow into one another: on the one hand, the theater in which we are sitting as real persons, perhaps in the company of people whom we love, or in which we meet someone whom we know and have not seen for a long time, and on the other hand, the illusionary reality of *Romeo, Hamlet, Don Giovanni,* or *Fidelio.* Indeed, they collaborate less closely than does a beautiful room with the string quartet that is performed in it. In the latter case, we remain in one and the same reality, no matter how loose the union may be; here there are not two realities.

Nevertheless, the architectonically beautiful theater also creates a framework in an analogous sense. The atmosphere of a Rococo theater can naturally be well suited to a play by Molière and to a Mozart opera. By chance, perhaps, a drama or an opera is performed that harmonizes well with the atmosphere of the architecture of the theater; even then, however, all one can say is that with regard to the enjoyment of the work this is subjectively a gratifying factor.

Apart from this accidental match, the architectonic beauty of a theater can scarcely contribute anything to the beauty of the drama or opera. They remain two separate sources of beauty. An architectonically ugly, prosaic, or tasteless theater can be disturbing in its own right, but when a performance is fully successful, the theater scarcely restricts the enjoyment of the drama or opera.

Architecture and sculpture represented in painting

It is clear that there is a radical difference between the union of a picture with the object it reproduces and the working together of various artistic genres, as well as the working together of architecture and nature. The pictures that represent architecture, such as those by Canaletto and Guardi, do not in the least involve a working together of two artistic genres. Certainly the beauty of this architecture is important here, but just like any other object that is depicted, it must pass through the artistic transposition in order to become the bearer of the artistic values of a picture. The architecture is a depicted object, not a factor that works together with the picture, as when the architecture forms the framework

for a fresco. The influence of its beauty on the picture is analogous to the influence of the beauty of a landscape on the beauty of a picture that represents this definite, concrete, real landscape.

The same is true of pictures that have sculptures as their object. Some pictures reproduce public squares with monuments, and here too there is no working together of sculpture and painting. We remain exclusively in the world of painting. What we see is a picture in which all the translations are present: first, the non-artistic formal reproduction, the move from three dimensions to two dimensions, and then the artistic transposition. The functions of nature, architecture, and sculpture as depicted objects of a picture are exactly the same. They are elements of the structure that is created in the composition of the picture, and they must likewise pass through the artistic transposition. The architecture or sculpture no longer speaks its own language as a work of art; it is only the picture that speaks. The only language we hear is that of the painting.

Before concluding, let us just add that there is no kind of artistic working together of sculpture or painting and music, but there are certain forms of working together between literature and paintings or drawings. These, however, are relatively peripheral and cannot be compared to the relationship between architecture and sculpture or between architecture and painting and even less can they be compared to the relationship between sound and word.

What we have in mind are drawings and pictures that function as the illustrations of a novel. We shall speak in detail of illustrations later on; here we mention them only as a completely different form of the union between various artistic genres. Apart from specific exceptions, however, this form of union has no essential importance in artistic terms.

The Claim Made by a Work of Art to Greatness and Depth

IN ALL THE ARTS, and especially in the imitative arts, the frame of reference [*Rahmen*] in which the work is located and toward which it aims is very important for its value. If the work envisages a standard of greatness, depth, and format that it is incapable of attaining, this is a mistake.

Eichendorff's *From the Life of a Good-for-Nothing* is a masterpiece. But if Eichendorff had envisaged the frame of reference of greatness and depth, strength and power, in which Dostoevsky's *Crime and Punishment* is situated, and had chosen a story corresponding to this aim, the work would be a failure. This is an important aesthetic problem for the artist: he must keep to the frame of reference that he can fully realize. What we have in mind here is not so much his subjective intention, as the intention that is contained in the work itself and that demands a certain standard.

In literature, the intention is largely determined by the story. In sculpture and painting, the frame of reference is the product of two very different factors. First of all, the choice of the object to be depicted influences the scale. A still life aims at a more modest frame of reference than

a picture with a landscape and figures. Secondly, a spiritual theme demands a certain depth, greatness, and power. Above all, religious themes such as the baptism of Christ, the Last Supper, the Crucifixion, the taking down from the Cross, and the Resurrection make great inherent demands of the artistic depth and greatness. The power that is sufficient for an object such as the landscape in a picture by Claude Lorrain does not suffice for a religious object. The work then bears in itself an inner antithesis between the spiritual theme and the artistic depth, power, and greatness. It is oversized [*überdimensioniert*] in the true sense of the word and appears hollow and weak.

Does this claim made by the spiritual theme exist only in religious objects, or indeed perhaps only in depictions from the life of Christ, or maybe the Mother of God and the apostles as well? At any rate, it is surely highly doubtful whether such a claim is made by the mythological theme of Aphrodite, Pallas Athena, Apollo, or Zeus. The title of a picture does not in any way involve a spiritual theme. A painting may depict the battle of the Catalaun Fields, Constantine's victory at the Milvian Bridge, or Scipio's victory at Zama; but the only demands this makes of artistic depth and greatness are those made by a battle in general, as compared with the demands made by a group of figures in a meadow or by a still life. Here we have only the first type of demands.

A disproportion between the frame of reference to which the work of art lays claim because of its object and in some cases also because of its spiritual theme, on the one hand, and the *de facto* artistic realization, on the other, is a definite artistic flaw.

We must distinguish this "oversizing" from the tension that arises when an artist aims at great depth but does not attain it in the work as a whole. There are some artists who tragically never attain their artistic goals. They are always dissatisfied with what they have attained, and often destroy their own work because it does not correspond to the goal they intended. Examples of such artists, who were in themselves great artists, are the German playwright and short story author Heinrich von Kleist, the German painter Hans von Marées, and in some ways the French composer Hector Berlioz.

The intention that aims at genuine depth is as such something artistically great. It does not betray any disproportionate claim, but rather a genuine artistic striving for depth and greatness. When this is attained only in some places (as with Berlioz), this is certainly a defect, a regrettable artistic failure. But although one wishes that the oversizing and its lack of wisdom had been avoided, one cannot wish that the artist had not had these high aspirations.

Naturally, the works of Berlioz, Marées, and Kleist are very different in this sense. Although many of Berlioz's works completely fulfill in one or many passages the greatness and depth at which he aims, many other passages of the very same works are relatively weak. In the opera *The Trojans*, we have the outstanding aria of Hylas and the powerful duet between Aeneas and Dido; in the symphonic work *Romeo and Juliet*, we have the deep, wonderful adagio; in *L'Enfance du Christ*, there is the outstanding aria of Joseph, and in the opera *Benvenuto Cellini* the brilliant carnival in Rome. *The Damnation of Faust* has several glorious passages. But all these works contain a large number of relatively nondescript passages. The tension between what the composer aims at and its realization is manifested in the fact that the great and noble aspiration is realized only in certain passages, while most of the work does not in the least do justice to this aspiration. The high standard cannot be maintained in the work as a whole. On the other hand, the opera *Béatrice et Bénédict* is more modest, but every note is exactly right, and the work as a whole is a precious masterpiece.

In Marées the tension between aspiration and realization found expression in the fact that he was usually dissatisfied with his work and painted over his most beautiful pictures; these were discovered only many years after his death, when the overpainting was removed. Another manifestation of this tension was the fact that he seldom completely finished a work, often avoiding putting the last touches to it.

Kleist too was never satisfied because of the tension between what he aimed at and its realization, but this sometimes led him onto false paths, for example, in his *Hermannsschlacht*.

A sketch does not involve this tension. It does not claim to be a fin-

ished work of art. One does not regret the absence of the finished work, but enjoys its beauty as a sketch. It can bear the same kinds of artistic values as the finished work: it can be poetic or grandiose, full of power and very deep.

Naturally, a sketch does not possess the value of full perfection in every detail. It does not have the specific value of a masterpiece. It does not provoke any tension, because it does not lay claim to anything that it fails to fulfill, and it does not aim at something it cannot reach. In a sketch the artist consciously renounces the completion of the fully finished work. A sketch fulfills what it intends to give. As a sketch it only points to the possibility of a finished work. It has a special charm of its own. The intentional omission of the finished work and its value is not an artistic mistake, but only the mere absence of the value of the fully finished work.

Finally, it is possible that, although a work as a whole may not be perfected and fully finished in every detail, it may nevertheless possess a great depth and beauty and may in some of its elements become supremely beautiful. The result is rather like an unfinished work. This is clearly not the case when a great depth is intended but is realized only in some passages (as in many works by Berlioz).

A comparison between Shakespeare's *Hamlet* and *Cymbeline* shows an ultimate perfection in *Hamlet*. Every word in this drama is like a sharpened sword, every sentence is profoundly important, full of meanings that point in many directions; everything has an ultimate inner necessity. In *Cymbeline*, however, not every word "sits" in this way; some things are unfinished and are much less convincing. And yet the figure of Imogen is perhaps the greatest of all the inimitable women in Shakespeare's dramas, possessing an ultimate greatness and poetry. Naturally, one cannot compare *Cymbeline* to *King Lear*, *Macbeth*, *Romeo and Juliet*, or *Othello*. It lacks some high artistic values and the consistent perfection that (with few exceptions) characterize all the dramas, comedies, plays, and tragedies of Shakespeare. But I mention *Cymbeline* as a work that is not a sketch. Nor is it a work in which greatness and depth of aspiration are fulfilled only in some passages. There is no tension in *Cymbeline* be-

tween the frame of reference and the greatness and depth of the artistic aspiration. It contains many glorious scenes, and no passages that lack fulfillment. It may not be a masterpiece, but it is a great, deep work that simply has not been worked through down to the last detail.

Architecture

CHAPTER SIX

Architecture in General

ARCHITECTURE OCCUPIES a unique position in art. Unlike the other arts, it does not have only one theme, namely, beauty. Like nature, it has two themes. Its first theme, the practical theme, is the creation of a dwelling place that protects the human being against bad weather, etc., for the whole of his private life. This practical theme extends further to the creation of places for public life and divine worship.

The second theme of architecture is the beauty of the outside of buildings and of the inner rooms. The fact that architecture has two themes, a practical and an artistic theme, gives it a unique place among the arts.

Unlike all the other arts, the architectural works of art (residential homes, palaces, churches, etc.) belong to the same reality as we ourselves and the nature that surrounds us, for example, rocks, trees, and animals. Architecture is a part of the real world in which we move. Unlike all the other arts, it is not a world of its own. In the case of architecture, we do not enquire about the specific kind of reality, as we do with a literary work, a piece of music, an opera, a painting, a relief, or a statue. It belongs to the sphere of reality in which our life takes place, that is, to the reality of the external world that surrounds us.

Another characteristic of architecture is its polarity of outer and inner: first, the external architecture, the face of a building; and secondly, the internal architecture, the face of the internal rooms in which we find ourselves, whether a hall, a small room, a large room, or the interior of a church. The other arts lack this polarity.

Finally, architecture has the basic function of creating human space, and thereby creating a presupposition for all the other arts. Dr. Anton Bergmann wrote very beautifully about the primal phenomenon of human space.[1]

Much could be said about the exceptional importance of space in nature. What we have in mind, of course, is not the statements of natural scientists about space in nature, or even a purely philosophical analysis of space. We are thinking of space in its primal significance for our life, of the beauty of three-dimensional space as such, of the phenomenon of being encompassed by it, of the splendor that a wide vista can have, of the grandeur of the sky that arches above our heads.

The practical and spiritual significance of human space

Human space, in the sense of the term "human" that we are applying here to architectural space, is self-contained. It separates us from the vast, unlimited space in nature. It encompasses us and protects us in a special way. This human space is the interior space of architecture, which has qualities that differ from those of free space in nature.

The feeling of space in this human space (which is different from the absolute space of geometry) is an experience all its own. The delight that one experiences in walking around in the noble space of a beautiful church is a unique experience. It is incredible what great and ample beauty an enclosed space can possess as such. Examples are the interiors of Hagia Sophia or of San Marco in Venice, or the interiors of Santa Croce in Florence, of Sant'Ambrogio in Milan, or of the cathedral in Chartres. We are surprised by the aesthetic values that the human space

1. Around 1930; this work was probably never published, since he was obliged to flee from Nazi Germany.

is capable of displaying. It can, as such, possess not only a distinguished breadth and greatness, and a stirring nobility, but also the beauty of a delightful intimacy.

Through its human space architecture also creates the basis for the unfolding of the other arts, as Bernhard Sattler has very aptly noted.[2] Through the creation of its human space interior architecture is not only a basis for sculpture, but stands in a close mutual relationship with it. This also applies to exterior architecture, as Bernhard Sattler observed: "The architecture is then complemented by sculpture, for which the architecture creates the substructure, the pedestal, the background, and the framing."[3]

Painting too presupposes architecture for the walls that it requires, for the correct light, and many other factors. This applies both to frescos and to paintings on a canvas or a wooden tablet. Bergmann rightly says that one cannot hang up pictures in a primeval forest. Pictures necessarily presuppose human space. Even the performance of music, that is to say, its full realization, demands a corresponding space if only for acoustical reasons, whether it be the intimate space in a house for chamber music, a hall for concerts, or the theater for operas and musical dramas.

The relationship is at its loosest between literature and architecture, with the exception of dramas. It is of course possible to read a poem or a novel even in the open air. Even the great tragedies were not performed in an enclosed space in classical antiquity, but under the open sky. However, the construction of the classical theater is a tremendous architectural achievement, an emphatically architectural space that is called for by the performance of the drama. The stage is a self-contained world, and the theaters of antiquity also display a great architectural beauty.

The relationship that architecture has to music and literature is naturally very different from the relationship to the visual arts of sculpture and painting. One must not exaggerate the extent to which architecture

2. "Architecture creates in this way a living space that belongs to a higher order, the living space of the civilized human being, the cultural space," from an unpublished lecture series entitled *Lebenswerte der bildenden Kunst,* delivered in Munich in the academic years 1949 to 1953.

3. Ibid.

is presupposed in each individual instance. One can give concerts in a loggia and even in a garden; but music and literature are at home in human space, and they come fully into their own in a cultural world, indeed, in a world that is formed by architecture.[4]

The first theme of architecture: its twofold purpose

The "practical" theme in architecture refers first of all to the real purpose that is in one sense the *raison d'être* of the construction of a building. The second theme is beauty. Although beauty is fully thematic in architecture, it must never be the exclusive theme. The architecture must also have a purpose, namely, a real theme. Within the real theme or purpose, we must distinguish two types, a purely practical and a spiritual purpose.

We have already pointed to the first purpose: the protection of the human person, providing him with a shelter in which his daily life takes place. Here we have in mind first of all the space required for external life. This applies to the simplest houses that often consist of one single room, as well as to those houses in which specific rooms are available for all the activities of life. Like all the objects of civilization, the practical theme can be developed and perfected from many different perspectives, such as hygiene, comfort, heating, or cooling. In the same way a factory has a purely practical, civilizational purpose that can be improved in various ways, such as rapid ventilation or a sufficient number of exits, especially for emergency situations like explosions and fires. One of these practical considerations is economy of space. Railway stations, airports, banks, administrative buildings, schools, and shops of every kind likewise have a purely practical purpose.

Nevertheless, the same buildings can simultaneously serve a spiritual purpose. For example, a residential home is not a mere shelter over a human being's head. It contains not only rooms in which one sleeps, cooks, eats, and so on, but also rooms in which one lives with one's family, in which many cultural events take place, in which the human being thinks,

4. We should note that the garden too is a human space, unlike an anonymous piece of nature and even less like a primeval forest.

has conversations with other people, reads beautiful books, has profound experiences; in short, rooms in which he spends a great part of his truly human, affective, and intellectual life.

A residential home is also meant to serve this cultural or spiritual purpose, which is not so indispensable but is nevertheless something much higher. The home should be structured in such a way that it takes account of the demands made by these higher purposes. The question whether a space is structured in such a way that it provides an adequate setting for the life of a human being as a spiritual person is very important within the real theme of architecture. The practical and spiritual requirements vary in kind, and the realization of the one does not guarantee the realization of the other.

Many buildings primarily serve a purely spiritual purpose. This is true above all of churches. It is indeed true that some technical requirements exist here too: lighting, a good acoustic, ensuring safety in emergencies, etc. But it is clear that these are completely subordinate considerations. The unequivocal purpose is the creation of a space for divine worship with a sacred atmosphere that helps us to recollect ourselves and fills us with reverence.

Profane buildings with a cultural purpose are theaters, concert halls and ceremonial halls, galleries, museums, etc. In all these buildings, the technical requirements are merely something that is unavoidable on the practical level. They do not belong to the purpose for which the building is erected.

On the other hand, their artistic beauty is always fully thematic, unlike a philosophical work such as a dialogue by Plato, where the great beauty is not thematic. One would misunderstand one of his dialogues and fail to do justice to it if one regarded the beauty of its style as thematic; for its theme is truth, and its beauty is primarily the metaphysical beauty of truth. The beauty of the style consists first and foremost in being the adequate form for the great truth-content of the work. This applies all the more to the *Confessions* of Saint Augustine, and in a unique manner to sacred scripture. These writings have only one theme, and their beauty is the emanation of the truth or of revelation, the emanation

of the holy. Architecture and nature possess two equal themes. Since one of these is beauty, it is completely appropriate, and indeed necessary, to experience their beauty as fully thematic and to be filled by its great seriousness and its profound utterance when we look at architecture and nature.

In the case of the purely practical requirements and purposes, it is especially important to bear in mind that until the beginning of the nineteenth century and the triumph of the machine, culture had not yet been strangled by civilization. The expression of the spirit, the gift of giving form in such a way that was not practically indispensable, penetrated all the practical spheres of life up to that time. A knife should not only cut well; it should also possess a noble form. A chair should not only be comfortable and solid; it should also be beautiful, in fact it should sooner be a little less comfortable than be sober and prosaic. Practical life as a whole possessed an organic character and was therefore united to a special poetry of life.[5] Related to this was the penetration of life by culture.

But as the practical life of the human being was robbed of its organic character and was mechanized and thereby depersonalized, so too the poetry of practical life was lost. The practical requirements in residential homes became a prosaic matter that was radically detached from the affective and intellectual life that we lead as persons. Railway stations, factories, airports, filling stations, and department stores were built to serve technical, neutral purposes. Cities like Phoenix and Tucson in Arizona largely consist only of such buildings, which are completely separated from the residential homes. In all these buildings, it is clear that there is no link between practical requirements and the spiritual requirements of the human being. The latter are neutralized in such a way that they no longer offer any artistic stimulus for the architectural shaping of these buildings and rooms. The building itself becomes an object of technology.

Many architectural tasks have disappeared as a result of the mechanization and depoeticization of practical life that go hand in hand with the triumph of the machine. The buildings for watering horses and the pools

5. See *Aesthetics*, vol. 1, chap. 15.

in small towns where women did their washing are no longer needed today. It suffices to recall the Porta delle Fonti in San Gimignano, with its architecture and its setting, to see the architectural expression of the poetry of life that existed in this activity. It is obvious that this development has far-reaching consequences for architecture. Buildings where the poetry of life unfolds alongside their practical purpose clearly make very different demands on architectural design than buildings with a completely neutral, lifeless, practical purpose.

The relationship between the two purposes is important for all buildings that have both a practical and a spiritual purpose. In residential homes that serve more or less the whole of human life, practical requirements are also completely thematic. Although the spiritual requirements are higher and ultimately more important, the practical requirements belong likewise to the *raison d'être* of this kind of building. In one sense, indeed, they are in fact more urgent and more indispensable.

The situation is completely different in those buildings that clearly have a purely spiritual purpose but, like everything on earth, must also fulfill certain practical requirements thanks to our nature as human beings who consist of body and soul. This can be seen most clearly in the case of churches. Their purpose is not only spiritual, but religious and supernatural. Divine worship is celebrated in them, and the Holy Sacrifice of the Mass is offered. Nevertheless, one must do justice to certain practical requirements. For example, the ventilation must be as good as possible, and there must be a sufficient number of exits in case of fire. These practical requirements do not belong to the purpose and are not the reason why the church is built. They are only general presuppositions for every building in which a large number of people come together. However, some general presuppositions or perspectives lie closer to the special theme of a building, for example, the requirement that as far as possible, everyone in the audience in a theater should have a clear view of the stage.

The second theme of architecture: artistic beauty

The artistic beauty of buildings depends on very definite means: forms, proportions, material, color, and many other factors. Our special task here is to look at these in detail, but we wish to emphasize explicitly that it is not our intention to indicate rules for the application of these means, rules that would guarantee the artistic value of a building if they were observed. That is not the task of aesthetics, where the situation is completely different from that in logic and in ethics. In logic Aristotle established rules for the syllogism, and a flawless conclusion is guaranteed if these are observed. In ethics one can lay down norms that guarantee the moral value of an action. This is not possible in aesthetics.

The beauty of a building, of a picture, of a statue, of a poem, or of a melody is grounded in the special inspiration of the artist. He is entrusted with a mystery that cannot be formulated in a norm in such a way that the artist's only task would be to fulfill that norm. The attempt has often been made to establish rules of this kind for beauty, such as the theory of the "goldenen Schnitt," but these have an alarming resemblance to the philosopher's stone.

It may perhaps be possible to formulate some reasons for the aesthetic disvalue of a building. The failure to fulfill certain conditions may impair a work of art. But the avoidance of these mistakes does not guarantee artistic beauty.[6]

When we emphasize that fulfilling the requirements of the purely practical theme certainly does not guarantee the artistic beauty of a building and that completely different factors determine its artistic value, we are not thinking of norms and rules, but of those factors that are available to the artist. But the correct application of these factors remains a fruit of the artist's inspiration.

It is sometimes asserted that a building is beautiful if it does full

6. Adolf von Hildebrand articulated conditions of this kind for sculpture in his book *Problem der Form in der bildenden Kunst*, 1st ed. (1893); 10th ed. with preliminary studies and additions in vol. 325 of the *Studien zur deutschen Kunstgeschichte*: Adolf von Hildebrand, *Kunsttheoretische Studien* (Baden-Baden and Strasbourg: Heitz, 1961).

justice to the concrete reality that it serves and if it fulfills all the requirements that are demanded by this theme or are indispensable if this theme is to be realized. Those who make such a claim usually have purely practical purposes in mind and affirm that the value of a building depends on how perfect it is in achieving this practical purpose. This theory reduces architecture to a mere object of civilization. At the same time, however, it maintains that civilizational perfection also grounds the artistic beauty. This functionalism, which found its chief representative in Le Corbusier,[7] is mistaken on many counts.

The artistic beauty of a building is not in the least a consequence of its perfect functionality. Principles of a purely artistic kind are decisive for the aesthetic value of a building. What beauty an arch can possess, or a tower in its form and color, such as the Campanile of the cathedral in Florence or the tower of San Marco in Venice! What could it mean to say that the unique beauty of the cupola of Santa Maria del Fiore in Florence is based on the perfect fulfillment of its practical purpose? All we wish to do here is to point out the absurdity of this theory, which confuses artistic beauty with purely technical perfection and reduces the various expressive possibilities of architecture—this world of greatness and beauty—to mere functionality, asserting that the aesthetic value of a building is determined by its functionality.

Practical reality and artistic beauty

Practicality makes certain demands of every building. A house must have walls, roof, doors, windows, etc., and the same is true by analogy of those buildings that have a primarily spiritual purpose.

The practical, real theme influences the architectural design, since it dictates the use of certain forms that are already available to the architect; he does not himself invent them. He must indeed give these forms a shape from a completely new artistic perspective, but they cannot simply be replaced by other forms.

7. See his *Vers une architecture* (1923), English translation: *Towards an Architecture* (Los Angeles: Getty Research Institute, 2007).

We cannot emphasize strongly enough that the fulfillment of these practical requirements has no influence on the second main theme, namely, beauty, or the artistic theme. Even if all the practical requirements are satisfied with the greatest perfection, the building can be deadly, ugly, or boring.

As long as we are speaking of the perfection of purely practical purposes, there is a very loose connection with artistic beauty. From the perspective of the practical requirements of daily life, a farmhouse in Tuscany that is very beautiful thanks to its noble proportions, the material employed, its color, the visible nobility and the poetry of its inner spaces, is certainly not the perfect solution. It is not built in such a way that it facilitates all the practical functions of everyday life, nor is it ideal from a hygienic point of view.

On the other hand, a modern building that fulfills all the practical requirements and is perfect with respect to civilization is usually a wretched construction from the artistic point of view. It almost always radiates an anonymous barrenness, a depressing prosaic character. It is true that it does not possess the triviality and pseudo-beauty of many houses from the second half of the nineteenth century, which are tasteless imitations of gothic architecture. But its absolute barrenness, anonymity, and soullessness, and the lack of any charm whatever, form an antithesis to artistic beauty that is just as great as the trivial.

If a building serves spiritual purposes, there exists a deep connection between its real theme and its artistic beauty. This is presupposed for the sake of doing justice to the spiritual purpose. The design of the building must also do justice to the genius of the spiritual purpose. A church should have a specifically sacred character. It is not enough for it to be a beautiful hall that presents the external aspect of a splendid palace. An essential element of the artistic value of a church is the atmosphere of the sacred, of consecration, of greatness, and of seriousness, all achieved by means of artistic factors. In this case it is certainly correct to hold that the artistic beauty cannot be detached from the real spiritual theme of the church and that in addition to general artistic conditions, the special character of the house of God must also be realized—but with artistic means.

In the case of a church, it is also meaningless to say: "Satisfy the requirements of the real spiritual theme, and then it is also artistically valuable." This is because if one is to do justice to this theme, one must do so by means of artistic beauty. The general architectural beauty is presupposed; but we also need the artistic means by which the specifically sacred theme is realized. In the case of a church the assertion "Satisfy the requirements of the real theme, and then the building is beautiful" would entail a vicious circle, because the real spiritual requirements are fulfilled only through the general artistic beauty and through the special artistic creation of the sacred atmosphere. It is only by means of artistic factors that a building can realize the true character of a church. The extent to which the artist himself is aware of this has no importance. He may be thinking only of the sacred theme and may wish to serve this theme alone, but if he is a true master builder and truly intends the church to be a sacred space, he will instinctively employ those artistic means that alone are able to realize this goal.

Where the spiritual purpose is much more indirectly linked to buildings than is the case with a church—for example, in a theater or a concert hall—its beauty is more independent of its spiritual purpose and is conditioned more strongly by the general bearers of beauty in architecture. Naturally, the beauty of a theater such as the theater of classical antiquity or the Teatro Olimpico of Palladio in Vicenza or the Cuvilliés Theater in the Residence in Munich implies a task completely different from the beauty of a residential house or a palace. A theater necessarily presents an appearance different from a ceremonial hall, thanks to the presence of many seats in one room, the box seats, the graduated staircases, etc. The practical purpose that as many visitors as possible should be able to see and hear what is happening on the stage dictates many tasks from the very outset. But the beauty depends not on the immanent technical perfection with which these tasks are fulfilled, but on purely architectural factors. The expression of festivity that is essential to a theater must be realized. This requirement of the spiritual theme can be achieved only by means of artistic factors.

In the case of a residential house the perfect execution of the purely practical living conditions certainly does not guarantee that it will

possess artistic value, since a residence should not only serve practical needs. Rather, its real theme entails being a worthy place for our intellectual and affective life: in a word, for our life as human beings. And this can be achieved only through the artistic beauty that elevates and nourishes the spirit. Architectural beauty also elevates the whole of our practical life and fills it with the poetry of life. But a residence must not only be architecturally successful in general terms and beautiful. It must also possess a tone that accords with the lifestyle of the person in question, from a simple, beautiful building to a palace.

In those buildings that serve purely practical purposes, in which the practical activities have been robbed of their poetry, buildings that are mechanized and depersonalized, technical perfection and pure functionality have nothing to do with artistic beauty. Railway stations and factories do not offer any artistic stimulus in their real theme. At most they can be built in such a way that they do not have an artistically negative effect. It is a very stupid argument to say that railway stations were uglier in the past because they were built not like railway stations, but like castles. Their ugliness and tastelessness were not based on the discrepancy between the purely pragmatic purpose of a railway station and the technical atmosphere of what went on there, on the one hand, and the castlelike architecture, on the other. The castles that were built at that period display the same tastelessness, which is a consequence of purely artistic, architectural mistakes.

The discrepancy between a purely technical purpose and an architecture that is suitable to a castle is certainly a mistake, but this mistake is not what makes the building tasteless. Rather it is impossible to erect a beautiful building that corresponds to the sober, neutralized atmosphere of a railway station. If one wishes to achieve congruence between the practical purpose and the architectural character, then the building can at best avoid being ugly. But it is not desirable that it should emanate a completely neutral atmosphere. Independently of its purpose it can have something monumental and noble, thanks to architectural factors alone. In any case, such a modest architectural value raises it above something that just emanates the world of a railway station.

This is even truer of factories and department stores. What happens in a railway station still has a relatively large amount of the poetry of life. How many great moments of human life take place there: the delight at reunion with someone, the painful farewell, the joyful expectancy at the start of a beautiful journey, the joy at arriving in a beautiful place that one does not know or that one longs to see again! Tolstoy has a fascinating description in his novel *Anna Karenina* of the atmosphere of a railway station and of a train traveling from Moscow to Petersburg.

In the past locomotives had a certain charm. The very act of traveling through many different regions, the whistling of the train and the echo from the mountains had a certain poetry of life. This is lacking in a factory, a filling station, or a department store, where the neutral, depersonalized rhythm of life is much stronger. It is foolish to make an ideal of constructing buildings that emanate this barrenness and that therefore are an expression that corresponds to the purpose of the buildings. It is much more important that these buildings should still emanate a certain architectural nobility and should not have a negative impact on the city in its architectural beauty. It is absurd to believe that it is untruthful when such a building, instead of emanating this barrenness, possesses beauty (no doubt, a very modest beauty) simply on the basis of its form and proportions, its materials and its color.

One regrets most profoundly that the beautiful palace of the Fabrica de Tabacos in Seville now serves a commercial purpose; but it does not cease to be beautiful, since as an expression it does not correspond to what is now its practical purpose. It would certainly be inappropriate to erect such a building explicitly for a factory. And yet this example shows how independent architectural beauty is of congruence with the purely practical purpose. In the case of buildings that are newly erected for such purposes, one should not aim at an expression that corresponds to a completely different purpose; nor should one aim at a barren atmosphere that is appropriate to the purely neutral, depoeticized purpose. A modest, simple, but noble architecture is appropriate here, an architecture that in its expression and its atmosphere does justice to the fact that human beings work in these buildings: human beings who are destined objectively

for a rich interpersonal and non-mechanized world full of the poetry of human life.

The dimension of reality in architecture

We began by pointing out that architecture is clearly distinct from all the other arts in virtue of the fact that it belongs to the concrete world that surrounds us and to the full reality in which we live and move, whereas all the other arts are a world of their own and have their own kind of existence.

This very important element makes possible the close link between architecture and nature, a "marriage" analogous to the one formed by sound and word. At the same time, it has a dimension of delightfulness that the other arts lack. We see this clearly when we walk through a city like Florence or Siena, or stand in the Piazza San Marco in Venice. The splendor, the nobility, the genuineness of the Palazzo Vecchio or of Orsanmichele in Florence shines forth from structures that are real, just as real as the hills of Fiesole and Monte Morello. They are parts of the world that really surrounds us and in which we live. This fact has an extraordinary ability to delight us. It signifies a new dimension of contact with this beauty. When we look at the church of San Marco and the Palace of the Doges, we can scarcely grasp that what stands before us is reality. This irruption of beauty into the world in which we live is a tremendous gift, similar to the beauty of a great and significant landscape. Nature too has this dimension of delightfulness. Its bearers of beauty are real entities; trees, animals, brooks, and rocks belong to the full reality of the external world around us. The landscape, the composition of these entities, is likewise a part of this reality. We have already written[8] about the role of the reality of the beautiful in nature and about the difference between a glorious chain of mountains and a conglomeration of clouds that looks like a mountain range. This applies to architecture as well.

One could object that while the reality of architecture is an important

8. *Aesthetics*, vol. 1, chap. 14.

factor for the delight we receive from its beauty, this being delighted is something subjective in its importance for us. It is not a factor for its objective value. To this, we must reply that the new dimension of being delighted is not a purely subjective experience. Being delighted certainly presupposes a person, it unfolds in the spirit of a person. Nevertheless, it is not an arbitrary, subjective experience, but something that is objectively grounded. Secondly, the experience of being delighted also serves to shed light on a completely objective characteristic of architecture. The value quality of beauty is certainly not dependent on it; a real building is in one sense not more beautiful than a sketch that is not realized. We see the sketch and apprehend the beauty of the building; we also regret that it was not erected as a building. Becoming real is the bearer of a high value, not only because of the artistic importance of this building for a square, a street, and the entire surrounding area, but also because of the full realization of this bearer of beauty. This full realization is an eminent value.

We mention the unique dimension of delightfulness in architecture, which it shares with nature, because it sheds a light on the high value that architecture possesses in the sphere of full reality. It is obvious that we do not refer here to the value that the fully realized work of art possesses over against the potential work of art, the opera that is staged over against the score, or the drama that is staged over against the drama that exists only in print. Rather, we have in mind the fact that architecture is a part of the reality in which our real life takes place and to which we ourselves belong. This fact objectively distinguishes architecture from the other arts and gives it a special character. It gives architecture unique possibilities of having an impact, and it is the bearer of a value of its own. This does not indeed intensify the beauty of the architecture, but it is a definite value.

⁂

CHAPTER SEVEN

Architecture as an Expression of History

ARCHITECTURE NOT ONLY belongs to the reality of the external world that surrounds us: it is also an expression and reflection of the zeitgeist, of an historical reality of the spirit. This is especially true of castles, villas, palaces, public buildings, and above all churches.

The expression of historically real cultural life, and purely artistic "life" in architecture

Let us suppose that it was possible today to build a glorious Romanesque church that was flawless in its proportions and in every detail, a building that breathed out a truly sacred world and did full justice to the religious theme of a church. The strange fact is that it would not be the same as an eleventh-century Romanesque church. Let us suppose that the building was so successful that it was full of life, no mechanical imitation. If we saw it, we would assume that it came from the eleventh century; but if we learned that it was built only a few decades ago, an element of disappointment would be inevitable. The difference does not concern beauty as such. What is missing is a dimension of reality, namely, the real life that stands behind the building.

The fact that the cultural life [*das geistige Leben*] that stands behind this building or finds expression in it belongs to the past does not rob it of any of its contemporary vitality. Nothing would be more foolish than to believe that a beautiful building has some kind of advantage with regard to reality because it is the expression of the contemporary life of the spirit. This is why San Marco in Venice was probably no less real for a Renaissance man with a truly great appreciation of art than the buildings of his own period; and the Baptistery in Florence was probably no less real than Brunelleschi's cupola. We prescind here from the influence that fashion has on many people who are caught fast in a momentary historico-sociological reality and are blind to everything that belongs to the past. The dimension of reality with which we are concerned here depends on whether the building grew out of the spirit that was alive at the time when it was built, not on whether it is the product of the cultural world that is alive today.

The connection between architecture and the cultural life that stands behind it is unique in kind. It is clearly distinct from the beauty of the building, which is conditioned by form, proportions, material, color, and many details of a purely artistic nature. But that cultural life has a legitimate importance. It belongs to the dimension of reality in architecture, to its organic rootedness.

The "vitality" that a building thereby acquires must be clearly distinguished from the "life" that separates a beautiful, artistically successful building from a weak imitation. The life missing in the mechanical building that is classicist in the negative sense of the term is completely different from the historical dimension of reality. This life is something that belongs wholly to the artistic value, to the beauty of the building. It can be missing in a work that is not in any way an imitation, just as it can be missing in a weak imitation. This life is also something mysterious, and it plays a very decisive role in artistic terms. It is found in every art form and must be clearly distinguished from the historical dimension of reality.

This dimension of reality is related primarily to the styles in architecture, and hence more to a "language" than to the specifically artistic factors on which the beauty of a building depends. Accordingly, one must

never forget that the general artistic conditions for the beauty of a work of art are independent of this relationship to the historically real cultural life. Above all, it would be completely erroneous to take the fact that a building grows out of one particular historical intellectual attitude, and to turn this into the source of its artistic values. That would be utterly absurd.

Architecture and today's zeitgeist

The presence of this dimension of reality is no guarantee for its artistic value. Indeed, it can exclude the artistic value, if the spirit of an epoch is depoeticized and mechanized or even leads to an artistic disvalue. This is why we must emphasize as forcefully as we can that it is a completely erroneous conclusion to affirm that one must create anonymous, barren buildings today as an appropriate expression of the depoeticization, mechanization, and depersonalization of our age. This zeitgeist of the industrialized world is itself a lie. It contradicts the true, genuine, valid rhythm of human life, a rhythm that is indissolubly linked to the objective essence of the poetry of human life. We must fight against this zeitgeist and redeem man from this curse.

This is why it is completely erroneous to hold that it is dishonest if this zeitgeist finds no expression in architecture today. It is indeed meaningful to say that the architect should not imitate any style of earlier periods. But at the same time, we must explicitly emphasize that the true artist should pay no heed at all to the zeitgeist. He should create a building in which the general artistic requirements are fully satisfied. He can employ many motifs, including those from earlier periods, but these will be inserted completely into the special invention of the specific building. The Insurance Company building in Munich by O. E. Bieber and W. Hollweck is very successful, although the theme of insurance does not specifically offer a poetical stimulus, and although the period in which it was built was mechanized and depoeticized.

Architecture is not only an expression of a living cultural world. It also has the eminent educational task today of liberating the zeitgeist from its

barren depoeticization and mechanization. What spiritual nourishment a noble building offers to every passerby! Even when the passerby does not explicitly look at it, something of its poetry penetrates his life through the pores, so to speak. This is why the task for contemporary architecture is very different from that in epochs in which the poetry of life still developed without hindrance and a rich cultural world filled their inner space. Today architecture must fight against the zeitgeist, not through imitation of older styles, but through the unchecked use of great architectural inventions of the past, in order to create something new that is nourished by the artistic inspiration of the architect—but not by the zeitgeist.

Architecture originates in the specific historical dimension of reality

The situation is completely different in the case of buildings that originate in the historical, living spirit of a period but as a whole bear the character of a renaissance; in other words, they draw on an earlier important cultural epoch. For example, there was a renaissance of the Byzantine spirit and style around 1200. One of the greatest masterpieces, one of the most beautiful churches of all ages, was built in this epoch: San Marco in Venice. In this work, the dimension of reality is completely present. The zeitgeist at that time was an inner revival of a zeitgeist that had existed 600 years earlier, but San Marco is not a copy or imitation of Hagia Sophia. Rather, it is a wholly new, original structure, completely different from the earlier church.

The nature of a true renaissance is a theme all of its own. This great artistic period from 1400 to 1600 is certainly not the typical case of a revival of a previous cultural epoch.

One could ask whether it is legitimate to be disappointed when one learns that a glorious Romanesque church was built only a few decades ago. Its outward appearance betrays nothing of this; is it right that this mere knowledge should influence us when we evaluate a work of architecture and are enchanted and delighted by it? Is this not a lack of objectivity?

My father, Adolf von Hildebrand, maintained that "knowledge" and

all historical information about a work of art must be excluded from any role in the immediate relationship to its artistic value. He regarded this as a kind of association, as behavior lacking objectivity, as getting involved in matters that do not belong to the work of art. We may leave aside here the question whether he himself unconsciously presupposed the dimension of reality in architecture. He was certainly correct to reject as subjective the lapse from the apprehending of the artistic values, namely, the beauty and the artistic potency of a building, into all kinds of associations. We have already pointed out (in chapter 3) how fatal this attitude to works of art is, as when someone focuses on the title of a picture and enjoys the literary associations rather than the picture. If "The Death of Wallenstein" stands under the picture, it becomes for him a mere illustration of this historical event, and in reality what he is enjoying (and usually as something sensational) is the fact that he is offered an illustration of this important historical event. We choose this extreme instance, which unfortunately is not rare, in order to show in a crass form the danger that pure associations can represent in relation to art.

But architecture has a different relationship to reality from that of all the other arts; and besides, the relationship between architecture and history is not a merely associative link. Architecture objectively possesses two themes, and it is also an expression of the life out of which it grows. When, for example, an old tower collapses and is then rebuilt exactly as it was before, the dimension of reality of the tower is not affected, since the reconstructed tower is a kind of resurrection of its predecessor. One example is the tower of San Marco, which was rebuilt at the beginning of the twentieth century. The purely physical identity no longer exists, but it still remains something born of the period when San Marco was created.

My father was certainly correct to deny that the historical dimension of reality influences the purely artistic beauty, but perhaps he did not do justice to a certain value that is linked to the building not by association, but in a profoundly meaningful and organic manner. Like reality in architecture, the relationship to history, to the entire sense of life that was dominant in an epoch, and to the cultural climate in which the buildings originated, is a legitimate factor. It is true that it does not in any way

guarantee the beauty of a building, even if the zeitgeist was organic and not depoeticized, inauthentic, or mechanized; the beauty is entirely dependent on the artistic gift of the architect. In a true artist, this organic growing out of a spiritual world with a positive value, a world that at this moment possesses a historico-sociological reality, is an important factor, a value *sui generis*.

Architecture is different from stage sets, which are intended to engender an illusion in us. They are an "as if." Architecture does not appeal to any illusion. It is no "as if": it is full reality. The historical epoch in which one particular zeitgeist with a positive value was dominant may belong to the past, but the beautiful building that originated in this epoch is completely present, and the statement it contains continues to exist with undiminished actuality. It remains forever equally alive and is a decisive factor in the world around us. There is indeed a mysterious link between the organic growing out of a cultural world that possesses a special sociological, interpersonal reality in one particular historical epoch, on the one hand, and its remaining fully present despite all the changes over the course of time, on the other.

The justification of second-rate buildings

In this context, we must emphasize one characteristic of architecture that sets it apart from all the other arts. In keeping with the nature of all the arts, there are genuine works of art of very various greatness, depth, and perfection. Not even all the works of a very great and sublime artist are on the same level. We must distinguish two things here.

Almost every artist, no matter how great he may be, has also created pale, unimportant occasional works. This is a toll taken on an artist by human weakness. This fact tells us nothing about his greatness and importance, nor does it discredit him. Such occasional works are not artistically negative (like, for example, trivial works). They are only unimportant, and one may say that their nonexistence would be no loss. They are invalid works, so to speak, and must be excluded from the hierarchy of the fully valid works.

Among those works whose nonexistence would be a definite loss, there are considerable differences in rank, both among the works of one and the same artist and (above all) among the works of various great artists. Eichendorff's *From the Life of a Good-for-Nothing* is a masterpiece, but it is obviously far from having the importance of Dostoevsky's *Crime and Punishment*. Goldoni's *La Locandiera* is a little masterpiece, but it is incomparably less important than Shakespeare's comedy *As You Like It*. Rossini's *The Barber of Seville* is a delightful opera, but there can be no doubt that Mozart's *The Marriage of Figaro* is far superior to it.

"Second-hand" works that lack all originality are unwished-for in all the arts except architecture. It is perfectly natural that not every house in a city is an original work of art. This is connected to the two themes of architecture. Houses must exist, independently of their artistic design. Their existence is justified by the simple reason of their practical purpose. If many of them have no artistically negative aspects and exude a general poetry without being an original architectural invention, their aesthetic purpose is fulfilled. If some important and eloquent buildings in a street unfold a glorious world, this is enough for the rest of the buildings, even if they are second-rate. Naturally, they must not be imitations, nor should they display any features that disturb the noble world of the important buildings. It is enough that they have good proportions and that they are able to receive the noble overall world that the important buildings exude and to function like an echo that lets this world resonate.

Something analogous applies to architectural groups that build up a situation in nature. Let us take the case of a little church that is neither original nor important; it contains nothing unbeautiful, and there is no disharmony in its proportions. Through its setting on a hill, surrounded by some cypresses and pines, it can already be the joint bearer of an overall beautiful, poetic situation. The same is true of many farmhouses that are adjacent to a beautiful villa. Naturally, we are not thinking here of the farmhouses found in many places in Tuscany, which in themselves possess a great artistic value.

It is of course a source of particular pleasure when a street such as the Via Garibaldi in Genoa is framed by nothing but glorious palaces,

or when a street such as the Via Maggio in Florence presents a sequence of one beautiful palace after another. However, the beauty of the city does not demand this of every street. It is in keeping with the being of architecture and with its overall function in human life that there also exist second-rate buildings that form a natural framework for the architectural works of the highest beauty.

The affirmation that not every building need be an original invention requires that we say something about the meaning of the term "original." The word "originality" is frequently employed in a very unfortunate sense, namely, to demand the presence of something completely new and unknown. True originality must never be a goal. It comes of its own accord in a true artist who has a word to speak. It is one of the values that one must never consciously aim at, for otherwise one inevitably goes astray. When we speak of originality, we mean the unintended originality that is synonymous with the presence of a special, artistically positive word that an artist speaks in one particular work. This applies from the highest masterpieces right down to modest works, if these are first-hand.

In contrast to such works are those that contain nothing negative— but also contain no word of their own. They are modest but second-rate.

What we have in mind here are not works that are second-hand because they are specific works by pupils who imitate their master. Rather, we have in mind all those works that do not completely stand on their own feet as works of art, for example, the pleasant ancestral portraits that look good as decoration but are not true works of art. The essential point with regard to architecture is that something that is a defect in other works of art—something that makes us say, "It would not be a pity if this work had never been created," in the case of a short story, a poem, a piece of music, a song, a picture, or a sculpture—is much more positive in architecture.

The mere fact that the objects of architecture really belong to our life creates a new situation in comparison with all the other areas of art, where we look into a distinct world that is different from our real life and of which the exclusive theme is artistic beauty. These other areas of art bear in their being a claim, and the failure to satisfy this claim contains a certain disvalue. But not every building makes an immanent claim. If

they are not unbeautiful, not dead and anonymous, if they emanate a general poetry of life, and many of them emanate the nobility possessed by a style that is noble in itself, then they can exercise a positive function by receiving and passing on the beautiful world of some potent, great architectural works. If they function as an echo of this kind for the great masterworks that give their city its true countenance, they certainly have a right to exist.

The two themes of architecture and its belonging to the full reality that surrounds us also mean that a building that is definitely trivial, or that emanates an anonymous, depersonalized, barren world, does much greater harm than bad, negative works in other areas of art. For we can ignore the latter. We need not accept their summons to get involved with them, to hear them, to read them, etc. They do not poison our daily, real life in the same way. Naturally, this is not as true of sculpture and painting, which are often united to architecture and therefore penetrate the reality that surrounds us and affect our real life.

The importance of the overall atmosphere of a country and of historical reality

Let us return to the link between architecture and history. Is it possible to deny that the overall atmosphere of a country, which is largely conditioned by its history, also forms an important background to its architecture? Is not the poetry of the history of a city important in the structure of the delightful "beautiful world" that it emanates? And is not this true also of the fact that this city lies in one particular country, and that we know about the overall atmosphere of the country?

We have already pointed to something similar in the case of the beauty of a landscape, namely, the importance of something that we do not see but that we know exists, for example, when we know what a glorious landscape looks like behind the mountains that separate it from our sight.[1] Here we must draw a clear distinction between the legitimate

1. *Aesthetics*, vol. 1, chap. 14.

and the illegitimate links between what we know about and what we directly perceive.

There is a danger that we may turn nature into a panorama; in the same way, we must refrain from treating buildings, considered as architectural works of art, like objects in a museum. Although such buildings are independent in their cultural value from their real theme, from the cultural atmosphere in which they came into existence, and from the testimony that they constitute as an expression of history, these other perspectives nevertheless belong essentially to them. It is true that the factors that bear their artistic value are of a very special kind. The fact that a building does justice to the real theme, and especially to the spiritual real theme, is likewise a decisive factor for its artistic value. The expression of one particular cultural atmosphere and the relationship to history do not indeed influence the beauty of a building and above all do not guarantee this beauty. Nevertheless, they make a legitimate contribution to our impression.

Some places receive a dignity of a special kind through their historical importance. It is completely legitimate that a city or a particular place where a great historical event took place should stand out against the surrounding region, that a monument should be erected there in memory of this event, and that this place remains linked to the "halo" of the event. This is no mere association, nor a link determined only by psychology. Rather, it is an absolutely real, objective relationship.

This link is of course much deeper and incomparably more important in a sacred place. This may be a place where Christ or the Blessed Virgin Mary lived, or a place where a miracle occurred or a saint is buried. *Dignum et justum est*, "it is right and fitting" to visit such places with reverence and to apprehend clearly the sacred radiance that they contain because God chose them for his working.

It would be illegitimate, however, to find a church or a monument artistically beautiful because of this sacred radiance. The religious atmosphere of Lourdes, which is extremely strong thanks to the processions of pilgrims, can overwhelm us despite the artistically tasteless churches that, as buildings, emanate no religious atmosphere. One must shut

one's eyes to their artistically dire architecture. If one were to find them beautiful because of the dignity of the place and its atmosphere that is generated by the miracles and the piety of the pilgrims, one would be projecting in an unequivocally illegitimate manner a value into the buildings that they do not possess.

Another illegitimate link exists if one travels into a country or a city that is venerable because of its historical past but no longer emanates anything of this earlier glory, and one now projects (or fantasizes) this glory into the country or city. If someone finds every building glorious and ascribes to the country and the city as a visible, present reality everything that we only know from history, this link is certainly illegitimate. The link generated by the historical identity of the country or city requires a reverent remembrance and justifies a response to the dignity imparted to this piece of earth thanks to earlier historical events. But such behavior becomes illegitimate as soon as the knowledge of this physical identity leads us to imagine that everything we can see still proclaims the past glory in a manner given to us in experience, and to enjoy this supposed atmosphere as if it still filled everything in a completely living manner. It is particularly illegitimate to regard the landscape or the buildings in this place as beautiful—simply because our imagination projects so much into them—although they are in fact unimportant or even ugly and prosaic. In that case, the object of our enjoyment is a pure product of the imagination that has nothing to do with the nature or architecture before which we stand. The correct objective response would be: "How impressive it is to be allowed to stand in the place where once such a great culture blossomed! How sad that nothing any longer speaks of this cultural world! What a pity that neither the landscape nor the architecture is beautiful, so that it is difficult for us to steep ourselves in the past glory of this culture!"

Our attitude has ceased to be objective as soon as we begin to find a landscape that is in itself unimportant more beautiful than a glorious, exceptional landscape, only because great historical events took place in the former landscape, but not in the latter.

On the other hand, it would be a great mistake to deny that history

is an important factor for the atmosphere of nature, and all the more of architecture.

The lack of an important history also generates a certain anonymity in nature, though not the anonymity that is a result of the lack of a landscape in the narrower sense of the term.[2] The fact that nature is inhabited, the traces of human life, are an important factor for the beauty of a landscape. The decisive point, however, is the extent to which nature and above all architecture still emanate something of the world and the atmosphere of the great culture of the past. In that case, this footprint of history contributes a new factor to the other factors that condition pure beauty. If one overlooks this or denies it, an important dimension of delightful beauty is lost.

The apprehending of "worlds"—
demonstrated by means of the unique example of Rome

The glory of Rome is not conditioned only by the artistic beauty of the buildings, squares, and streets, and by the beauty of the landscape. Rather, the fact that this city was once the center of the ancient world and is papal Rome, the seat of the Vicar of Christ on earth, is of supreme importance for its beauty and above all for the universality and centrality of the place where the heart of the world beats. The unique majesty of many of its buildings bears testimony to this. The fact that this historical reality *de facto* lies behind the visible architectural reality is an exceedingly important dimension of reality, and is a source of delight. When the Capitol, the Palatine, Castel Sant'Angelo, St. Peter's Square with Bernini's colonnades and Michelangelo's cupola speak to us in their visible, immediately given beauty, the historical reality that all this proclaims to our experience also resonates as an important factor for the unique greatness of this city.

If someone who was profoundly open to art and had never heard anything about the classical and Christian Rome came to the city, he

2. See *Aesthetics*, vol. 1, chap. 14.

would indeed be overwhelmed by the beauty and greatness. He would also sense something of the atmosphere of Rome as a unique expression of many rich cultural worlds. But there can be no doubt that his impression would be more adequate—not with regard to the purely artistic beauty of a palace, but with regard to the joy to be had from immersing oneself in the world of Rome—if he knew about these things.

The apprehending of the cultural "worlds," of this unique reality that is filled with genuinely artistic values, is an essential factor in the beauty in nature and in architecture, and above all in the beauty of cities and in the special cooperation between nature and architecture. It intensifies and elevates the acquaintance with all the factors that are bearers of these cultural worlds.

Classical Rome possesses a clearly defined spiritual countenance through its history and the life of the spirit that took place there, through its language, its great statesmen, and its gradual conquest of the world. This countenance emanates a very specific world that discloses itself to one who knows his history. This world is clearly different from that of Athens and from the atmosphere in Paris, Vienna, or London.[3] It can be reproduced above all in literature. We have in mind here not the literature of ancient Rome, which naturally, like all the other elements, shares in constituting this world, but rather its artistic reproduction, which we find with an immense intensity and vividness, for example, in Shakespeare's *Julius Caesar* and *Antony and Cleopatra*. The way in which this world lives on in architecture is not a presentation or reproduction such as we find in literature, but an expression of this cultural epoch that as such exudes the "world of the Roman." This world, which speaks to us in the landscape and the architecture, becomes much more concrete and intense when we know its other bearers, namely, the history of ancient Rome and its culture, at least to the extent that Rome is a familiar name to us and we have apprehended its "countenance," its world, and its beauty to some degree.

This does not in the least lead to an inorganic link between what

3. See also *Aesthetics*, vol. 1, chap. 15.

we knew previously and our impression when we see the city and the world that is expressed in the visible that surrounds us. For it is the one identical world that discloses itself to our spirit from all the sources when we see the city and spend time in it. There can be no doubt that we immerse ourselves in this world more deeply and more delightfully in this way than does one who spends time there without ever having heard of Rome before. He may fully apprehend the artistic beauty of the individual buildings, but he will scarcely apprehend the world that this city radiates.

This is true even more strongly of the "countenance" of Christian Rome. Although the world of early Christian Rome is very different from that of medieval Rome and the Rome of the Renaissance and the Baroque, they are all joined together by the unique, sacred world that Rome emanates as the seat of the Vicar of Christ. This world grows out of this religious position at the center of the entire Christian world. Historical knowledge, knowledge of Popes Leo I and Gregory I, communicates to us a specific atmosphere of great beauty.

The Rome of the martyrs, the age of the catacomb Church that was still locked in the struggle against the profane mistress of the world, exudes an especially strong and moving world of the highest beauty. There was a new atmosphere in the Rome of Constantine, in which the splendor of political dominion over the world was united to the transfigured splendor of holy Rome, the center of the whole of Christianity.

This early Christian world lives on in the architecture. It is still fully present. To know this and to apprehend its irradiation intensifies the delight in being surrounded by it when we spend time in Rome.

After Saint Peter and Saint Paul died there as martyrs, the various cultural worlds follow one another in a unique way, such that despite their specific character and atmosphere, they all basically share the world of greatness, of centrality, and of sacrality. The early Christian world is vigorously alive in the mosaics of the churches of Santa Costanza and Santi Cosma e Damiano; the medieval world in the inner courtyard of the Lateran and in the church of Santa Maria in Trastevere; the Renaissance world in the Palazzo Farnese and the Cancelleria; and the Ba-

roque world in Bernini's colonnades and in the façade of St. Peter's, in Sant'Agnese on the Piazza Navona, and in Borromini's palaces.

This collaboration in the visible form of Rome, in which even the majesty of ancient Rome unites with the wholly new and incomparable Christian Rome, is apprehended still more deeply in its beauty when all these worlds are a living reality for us even independently of the visible impression.

Doubtless, Rome is a unique case. But the principle involved here, namely, the legitimate contribution made by knowledge of the history of a city and of a country, and the acquaintance that we thereby acquire with its world, is applicable whenever we experience this world and immerse ourselves in it, whether we are looking at the city or spending time in it.

Types of Buildings

Residential houses and public buildings

ARCHITECTURE ENCOMPASSES a rich field of very different structures that can be works of art. The first we mention here is the residential house with its subspecies, which are new architectural types that present the artist with a variety of tasks. A dwelling can be a simple house in the city, but it can also be a palace, which is something different from an architectural point of view. We have in mind palaces that are not public buildings, but rather dwellings in which an aristocratic family lived, such as the Palazzo Strozzi and the Palazzo Rucellai in Florence or the Palazzo Vendramin in Venice. We must draw a distinction between the palace as a residential house and the castle, which usually is not in a city, but in the countryside. In the past, castles were often fortified and protected by a moat or walls.

Another type of residential house is the villa, the country house, which is widespread in Italy and above all in Tuscany. The residential houses for the servants, which are usually adjacent to the castles or villas, are a type of their own.

Finally, the farmhouse is a type of building that is widespread in every

country. Farmhouses play an important role in Germany and Austria, especially in the mountain areas, with styles that are typical of each region. Often they are built of stone and wood, and sometimes entirely of wood. The Italian farmhouse, especially in Tuscany, is a type of its own.

In countries ruled by a monarch, the king's castle or residence has a special place among residential houses. It is still a dwelling, but at the same time it is a public building. This gives it a unique character. It presents architecture with completely different tasks. Its outward appearance must distinguish it from all non-royal palaces.

Among the various types of residential houses, only the royal residence leads over to a new type, the public building. The first we shall mention is the city hall, which demands a special kind of representation, an impressive magnificence, and at the same time a public character. The wonderful Palazzo Vecchio in Florence and the Palazzo Pubblico in Siena embody what a city hall ought to be and what is required by the atmosphere that befits its purpose.

Other important public buildings are government buildings, schools, universities, hospitals, barracks, covered markets, etc. "Public" does not mean that these must be municipal or state buildings. In the past, universities, schools, and hospitals were mostly buildings that had been founded by a religious order and that belonged to it. Nevertheless, unlike residential houses, these are public buildings.

Theaters, concert halls, and museums are a different kind of public building. We mention only buildings that present something new as architectural types, not all the buildings that serve various purposes. For example, all shops constitute one type of building, independently of what is sold there, whereas banks and administrative buildings are different types; the same applies to drugstores. Frequently, it is only in the interior architecture that the difference in purpose comes into play.

Sacred buildings

Another type of building that is radically different from the residential house in all its forms and from the various kinds of public buildings is

the building consecrated for divine worship, whether it be the temple of classical antiquity or the Temple in Jerusalem or a mosque or a church. In this field architecture has reached its highest artistic development.

Monasteries are one type of sacred building in the broader sense of the term. They occupy an important position in the context of the great architectural works of art, and as Wolfgang Braunfels has shown in detail in an important book,[1] the rules and the spirit of the religious orders exercised a powerful influence on the emergence of a new style.

The temple of classical antiquity

One matchless type of building, in which the exterior and the interior architecture touch one another most closely, is the temple of classical antiquity. From the outside, one sees something of the soul of its interior architecture, namely, the columns. The classical temple—for example, the three temples in Paestum, or the temple in Segesta, or the Parthenon—is not a room enclosed by walls. Although there is a distinction between inner and outer in this building, the relationship of the two dimensions is essentially different from that in all other types of building. From the outside, one sees the columns, which unfold their splendor even when seen from this perspective. But when one enters the temple, the experience of being surrounded by the columns is a new and overwhelming impression.

In order to do justice to this matchless architectural structure, we must briefly pay tribute to the classical columns. What tremendous nobility there is in the way the columns rise up, what a mysterious holiness [*Weihe*]! The overall composition of the plinth, the columns, and the capital is a typical *mirandum*, something that evokes astonishment because of the fullness of its spiritual content, a fullness that can give to a form a beauty of the second power. Another important factor is the material and its color. But the column unfolds its true, full artistic greatness and importance only in a space filled with columns, in a temple.

1. *Monasteries of Western Europe: The Architecture of the Orders* (London: Thames & Hudson, 1993). German original: *Abendländische Klosterbaukunst* (Cologne: DuMont Schauberg, 1969).

It is only when one stands before a temple (for example, in Segesta or Paestum, or before the Parthenon) that one has an overview of the building that is "ruled" by the columns. But the exterior "face" of the temple too is characterized by its columns when it is seen from a distance; this is particularly true of the Parthenon. One sees the form of the temple, the total area it covers, and its roof, but instead of lateral walls one sees the columns, which of course move closer together the further one goes from the temple. The exterior aspect of the temples of Agrigento and Segesta and of the two well preserved temples in Paestum possesses an overwhelming beauty.

What a difference there is between these temples and their classicist imitations! The ancient temples possess the remarkable element of life that must fill a building from within; this is what is missing in the classicist imitations. In very general terms, the phenomenon of life is a very important factor in architecture and in every restoration. Why do glorious old monastic cloisters look dead and barren after they are restored, even when the attempt was made to imitate every detail exactly? How does one explain the difference between a capital that is an exact imitation of all the beautiful forms, and the original? No doubt, the patina is usually missing; but even with an artificially produced patina, what is imitated is a mechanical, soulless copy that is to a large extent dead. The same problem occurs in an analogous manner when the statues in cathedrals are restored.

Elements of a building (balcony, terrace, courtyard, portal)

In many of the types of building mentioned above, there are of course details that constitute a structure of their own, even from the architectural point of view. For example, the balcony is an architectural invention of a special kind, in which an elementary need finds expression. Contact with the outer world is established already in the window, both through the streaming of light into the building and through the possibility of looking at the street and the houses on the other side or out into the landscape; and this contact is intensified through the balcony that allows

one to emerge completely into the open air. The balcony unites the intimacy of one's own home with the "public space" and with the outer world under the open sky. This structure, which is desired for a number of reasons and which is an enrichment of the living space, can as such be the bearer of an artistic value, both in itself and for the house in question. Balconies can possess a great beauty through their form and through the way in which they are attached to the house.[2]

Terraces, a new architectural invention that is often a bearer of great beauty, are sometimes found at palaces, villas, public buildings, and occasionally even monasteries. The terrace shares with the balcony the element of extending the interior of the house, making it possible to go out without leaving the security of one's own home. But the terrace, which often begins at the mezzanine and then usually forms a transition to the garden, or which takes the place of the roof as in the Palazzo Corsini in Florence, corresponds to a different *Lebensgefühl* ("feeling for life") from the balcony. It has a grandiose, sweeping character and is open for many artistic forms that are attractive in their own right and also in their relationship to the building.

The courtyard is another formal type. It is sometimes attached to residential houses; in Spain and South America, it often takes the form of a patio. This courtyard can evolve in very different ways. In palaces, public buildings, hospitals, and universities, it is frequently linked to a loggia, that is, an arcade with columns. In monasteries the courtyard is usually enclosed by a cloister that gives it a special character, indeed, its highest elaboration. The monastic cloister primarily serves a practical purpose, namely, the recreation of the monks. What wonderful possibilities of expression are offered by the architectural notion of the monastic cloister![3]

Both the portals of churches and palaces and the gates at the entrance to the mostly parklike gardens that frame a house or a villa can possess high artistic beauty. Garden gates often have a stone framework that is joined to the garden wall. Gates are already a subject for architectural design. Both the framework and the door itself can exude great

2. The balconies of modern apartment blocks are often barren and look like cages!

3. See also chap. 10 below.

artistic beauty and a poetical world. Such gates are often wrought iron lattice work, objects made by a craftsman. They have a specific charm above all in Baroque architecture, in which the decorative element is predominant. The golden color of some parts, alongside the black of the rest of the gates, also engenders a high decorative effect.

Independent buildings:
staircases, towers, city walls, monuments, fountains, bridges

A staircase can develop its full architectural importance and be the bearer of great beauty not only as a part of the exterior architecture of a building, but also in its own right. One example is the Spanish Steps in Rome that lead up from the Piazza di Spagna to the monastery of Trinità dei Monti. Thanks to its form, its material, and the function it fulfills in its environment, it is able to realize high artistic values.

Naturally, the tower too is a primal type of architectural design. Its primarily vertical extension gives it a very special character. We must however draw a distinction between towers that are a part of another building, such as the bell tower of many churches, the tower of city halls (for example, the Torre del Mangia in Siena), or the tower of a castle, on the one hand, and the freestanding towers that are buildings as such, even when the latter form an artistic unity with the church (for example, the Campanile in Florence or the tower of San Marco in Venice).

We shall return to the tower at the end of the present chapter, when we speak of architecture as an outstanding mirror of the most varied aspects of human life, in which so many primal gestures and primal sentiments find expression. Despite their inherent connection with the beauty of architecture, we must draw a distinction between the high poetry and beauty of these primal elements such as the tower, which find their expression in the diversity of architectural structures, on the one hand, and both the bearers of artistic beauty and artistic beauty itself, on the other.

Architecture exceeds everything that we have mentioned up to now. City walls, which were very important in the past, are a completely different type of building, which is likewise often a bearer of great beauty.

Another architectural structure with a pronounced character is linked to the city wall, namely, the city gate. It offers a grandiose introduction to the city and a festive reception. At the same time, it is an element of protection: the gates must be constructed in such a way that if necessary, they prevent anyone from passing through.

Another very expressive architectural structure is the triumphal arch. It is very typical that the need was felt to give expression to the triumphant return after a great and victorious campaign. The general or emperor entered the city through a richly decorated arch, a freestanding gate that was erected specifically for this purpose.

Here we touch on many factors of historical remembrance and on the vast realm of monuments. Although they are often united to sculpture, to statues and reliefs, monuments are architectural structures. In an equestrian monument, however, the statue of the rider and the horse is so much in the foreground that one can scarcely still call it an architectural structure. Nevertheless, the equestrian statue always has a strong relationship to its architectural setting.

Fountains, on the other hand, are definitely architectural structures,[4] despite the fact that their statuary is often very important. The same applies to the water basins and watering troughs for horses that we have mentioned above, and to similar buildings.

Bridges have an unambiguously practical purpose. But what poetry lies in the way they cross over a river! This situation offers great possibilities for artistic composition. Bridges can be glorious in the form of their arches, their floating lightness, or their monumental power.

Streets and squares

Let us turn now to other architectural structures that are not buildings (in the widest sense of that term), namely, to streets and squares.

Streets are a creation of architecture, through the buildings that frame them and through their broad or narrow, straight or winding form. They

4. See also chaps. 9 and 13 below.

have a "face" of their own that is distinct from the houses that enclose them. Although they are strongly conditioned by the houses that frame them, they are in their atmosphere an entity *sui generis*. They have a beauty of their own, and it is a unique experience to walk through them, apprehending the special value that the sequence of the houses and their relative position can have. Naturally, one gets a better view of the roofs and their color from a tower or a hill. The paving too makes a contribution to the beauty of the street, but the use of asphalt reduces this. Of the many kinds of beautiful paving, the big smooth paving stones that one finds above all in Florence are among the most beautiful.

Streets can be extraordinarily expressive. There are triumphal streets that have a festive atmosphere. The palaces that surround them have a lordly character, a genuine greatness, and a true nobility. Important church façades can be situated between the streets, as in the Corso Umberto and Corso Vittorio Emanuele in Rome. Other streets do not have this grandiose character, but they possess a central importance in the city. They are, as it were, the elegant, lordly streets of the city; an example is the Via de' Tornabuoni in Florence. Other streets again are very narrow, and as such, they exercise a charm of their own. Examples are the Via della Vigna Vecchia and the Via Porta Rossa in Florence.

The streets of a city can be an invention of an architectural kind. In that case, they are not a chance result of the houses that have been built on them. In his outstanding book on Tuscan architecture,[5] Wolfgang Braunfels shows how strict were the regulations issued by the municipal council with regard to the streets, so that buildings that disturbed the unity of the appearance of the street with a balcony or an oriel window were forbidden. The form and the appearance of the street were an important theme. In many cities, there are particularly beautiful streets. For example, almost all the glorious palaces of Genoa are on the Via Garibaldi, where they constitute a matchless unity. The city center of Vienna contains an overwhelming number of important buildings. Such buildings are not found in the Bäckerstrasse, but it is enchanting in the

5. *Mittelalterliche Stadtbaukunst in der Toskana* (Berlin: Gebr. Mann, 1953), chap. 3: "Strassen und Plätze": "Bestimmungen über Erker, Arkaden, Außentreppen," pp. 110ff.

stylistic unity of its delightful buildings. And how beautiful the Annagasse in Vienna is! The Maximilianstrasse in Augsburg has a special beauty, with its fountain and its winding curve.

The streets in a landscape, their movement, their twists and turns, their meanderings or their straight lines—all these have likewise a beauty of their own.

Nor do we forget that a street has a deeper meaning in a very general sense. A street as such is furnished with a certain poetry of life, both in a landscape and in a city. It embodies the primal element of walking, of moving onward, in our life. It constitutes an analogy to our life as a whole, which is a continual moving onward from one moment to the next, from one hour to another, from today to tomorrow. Above all, our life as a whole is a pilgrimage, a *status viae*. A street embodies the delightful possibility of walking, of spatial extension, of being clearly led on to a further place.

In a city a street has one other function with regard to our lives. Much of our community life takes place on the street. Here are the shops where we make our purchases, and many people meet one another by chance or by intention here. In many regions, people like to sit on chairs or benches before their houses and talk with their neighbors. The streets are full of life in the evening, especially in Spain, France, and Italy! In Rome, people used to drive up and down in their own carriages on the Corso. Festive processions make their way through the streets of a city on a great variety of occasions. Descartes's ideal was streets arranged in a purely geometrical pattern, serving a sober, practical goal. But such streets are barren and artistically disastrous. Streets that are themselves something beautiful, both through the beauty of the buildings that surround them and in their own form and characteristic style, belong to the important factors in the beauty of a city.

Another architectural creation is the square, a structure of a special kind. There is a unique emphasis in the way in which the surrounding buildings enlarge the space and make room for it. This formed emptiness has a festive quality that is often intensified by monuments.

Squares are the expression of many of the primal situations of life.

Just as the street embodies walking, going further and further in space and in time—the spatial dimension in a literal manner, the temporal by analogy—so too the square is an embodiment of "now," of standing still, of putting up one's tent. Squares constitute a definite "now" that is analogous to important situations in life where we want to linger, situations that stand out against the stream of ongoing events as a deep breathing space, a true presence.

They too fulfill a special function in public life. Markets are held on squares, festivals are celebrated, demonstrations and other public events are organized. Their real theme is primarily cultural.

The square has the meaning of a human, individualized place, in contrast to any spot in anonymous nature. There are indeed individualized places in nature, either thanks to the artistically formed unity of a piece of nature or thanks to important historical events that took place there; but a city square has not only individuality, but also the character of a human space. It is a unique mixture of an inside and an outside, quite different from the monastic cloister. It is an inside, since it is surrounded by houses and palaces and is thus clearly different from the wide open spaces of nature. It gives the experience of being protected as one spends time in a city, the experience of being surrounded by houses and palaces in which people live or go about their daily activity. On the other hand, it is an outside that extends under the open sky. Unlike the monastic cloister, its character is not intimate but unambiguously public.

At the same time, there is something significant about the square. It is frequently the site of a monument that honors and recalls a great historical personality, or at least a prince. In this regard, it offers a special occasion for the collaboration between sculpture and architecture.[6] It is also a place for the development of a specifically artistic architectural structure of another kind, namely, the fountain. Another artistic function of the square is to permit a church or a palace of central importance, such as the city hall of Siena or the Palazzo Vecchio in Florence, to have its full effect, because the beauty of the façade comes into its own in quite

6. My father, Adolf von Hildebrand, pointed out that the center of a square is certainly not the best place for monuments, but rather somewhere close to architecture.

a new way when seen from a certain distance. Often, however, it is a definite mistake to isolate a cathedral or a palace. As we have said with regard to nature, a panoramic point of view is a great mistake.[7] It easily destroys the organic, living connection among the buildings. The wonderful cathedral in Florence is completely surrounded by beautiful, noble buildings, and this is a special advantage.

Naturally, the beauty of a square depends first and foremost on the buildings that surround it. But the form of the square and above all the artistic value of a monument or a fountain also have a decisive influence on its beauty. The charming fountain in Trent, for example, makes a great contribution to the charm of the cathedral square, and Bernini's fountains enhance the beauty of the Piazza Navona!

Each type of square has a "face" that is entirely its own and a specific atmosphere: the great, monumental, grandiose squares and the joyful squares that are characterized by a special poetry, but also the small, modest, beautiful squares that are definitely picturesque, with their intimate charm.

Examples of the grandiose squares are the Piazza del Popolo in Rome, the Piazza della Signoria in Florence, the Place de la Concorde and the Place Vendôme in Paris, the Plaza Mayor in Madrid, the Grand-Place in Brussels, and the Josefsplatz in Vienna. The joyful and especially poetical squares include the Piazza di Spagna, the little Piazza di Trevi, and the Piazza Navona in Rome, and the delightful Place Stanislas in Nancy. The picturesque squares include the Piazza delle Erbe in Verona and many squares in Venice, as well as the little Piazza Sant'Ignazio di Loyola in Rome.

The Piazza San Marco in Venice shows the beauty that squares as such can attain. It is formed above all by the beauty of the façade of San Marco and of the tower of San Marco, but also by all the palaces that surround it. What a unity, what an intimacy, what a powerful atmosphere emanates from this square! How uniquely suited it is to open-air concerts!

7. *Aesthetics*, vol. 1, chap. 14.

St. Peter's Square in Rome with Bernini's glorious colonnades is a high point of beauty. This is a square formed in a way that has no equal: the grandiose façade of St. Peter's, the two arms of the colonnades with the highly decorative sculptures, and not least the obelisk in the center of the square. What an immense architectural task it is to design squares, and what artistic possibilities it offers!

The beauty of a city as a whole[8] is largely determined by its location. Here we have in mind above all the question whether the city is on flat or hilly ground. The fact that Rome is built on seven hills strongly influences the form of the streets and squares. In other cities, many streets ascend or descend, or else the city has an upper and a lower part, as in Budapest. An ascending street has a different character from a street that runs on one level alone.

Many squares mark themselves off from their surroundings, so to speak, through their elevated site. One example is the Capitol, which rises up above the Forum on the Tarpeian Rock on the one side; on the other side, one ascends to the Capitol from the Piazza Venezia. Its site gives the Capitol a markedly closed quality, an emphatic position that is an essential feature of this square. However, the elevated site of a plateau does not suffice to create a square in the architectural sense. Rather, it needs to be framed by buildings, as is the case with Michelangelo's glorious buildings on the Capitol. The square, in this sense of the term, is always an architectural creation; nevertheless, its site influences its character, as we can see in the square before the Quirinal. It is an essential aspect of the Piazza di Spagna that it lies at the foot of the hill on which the grandiose Spanish Steps lead up the monastery of Trinità dei Monti. This glorious ascent is the soul of the Piazza di Spagna.

Quintessential architectural inventions

A category of formal structures that are not pre-determined by a practical theme, that is, by their indispensability, consists in the various

8. See chap. 12 below.

architectural inventions, which as such can possess a great beauty. These include pilasters, columns, arches, niches, vaults, cupolas, towers, etc.

The spatial structures that are dictated by practicality are materials for the architect, who can turn them into bearers of beauty by giving them their special form. But the architectural inventions are actual bearers of beauty, although this always depends on the special form of the concrete objects, such as a pillar, a vault, a cupola, or a tower. The invention of a formal structure of this kind is an artistic creation. It is assuredly not by chance that these inventions have developed in the course of history. Some of these highly expressive inventions are found in both exterior and interior architecture.

Pilasters are often used in the façades of churches and palaces, for example, on the front of the Palazzo Rucellai in Florence. Full columns are used for the atrium of palaces, churches, and temples, and often inside these buildings too.

The column is one of the greatest architectural inventions. The noble ascending movement in a king palm tree may have provided a model for the column, but we shall not discuss here the extent to which nature functioned as an inspiration for architecture; we simply note that there is an objective inner similarity. It is probable that flowers, leaves, and fruits provided a similar stimulus for many ornaments.

From the philosophical standpoint, what interests us is the radical difference between nature as inspiration and nature as an object that is depicted and reproduced in the imitative arts. In inspiration, nature prompts the creation of something completely new that in no way "reproduces" or "depicts" the natural phenomenon. As such, the architectural structure that is created in the mind of the master builder in a process of inspiration does not speak of the natural form, nor does it reproduce it. It is a completely independent form that is just as real as the natural one. It is not a reproduction, and still less a copy or imitation. Here the relationship is *sui generis*.

We have said that the column is one of the great architectural inventions. In all its various forms, it can be a principal bearer of artistic beauty. When we speak of "various forms," we mean not only the Doric,

Ionian, and Corinthian pillars, but also those in the early Christian basilicas such as Sant'Apollinare in Classe or Santa Maria in Cosmedin
in Rome, and in the Romanesque, Gothic, Renaissance, and Baroque
churches. Nor do we forget the various types of columns in the exterior
architecture of profane buildings.

The arch is particularly effective above the entrance door of a church.
This is especially true of those arches that are like reliefs that fit into one
another, from a large outer arch down to a small arch that frames the
doorway itself. This is a frequent motif in Romanesque churches.

Niches are usually the setting for sculptures, for example, the niches
on the exterior of Adolf von Hildebrand's Hubertus Fountain in Munich.
They have a much greater importance in interior architecture. Examples
are the deep niches of the temple of Venus in Baalbek in Lebanon, and
the unique niches in Hagia Sophia that have a recess analogous to that
found in typical niches, but they have an incomparably more powerful
effect and a beauty that fascinates.

Another architectural invention is the tower, which can give a building
a grandiose expression. It suffices to think of churches with a tower or of
cathedrals such as Chartres with two towers, or Speyer and Tournai with
four! As we have said, the tower is an object of great architectural possibilities not only when it is freestanding, but also when it is immediately joined
to a building. The towers of many castles, the tower of the Palazzo Vecchio
in Florence, the Torre del Mangia in Siena, or the Belfry of the Cloth Hall
in Bruges make a great contribution to achieving a special overall effect.

In addition to the tower, the cupola is a central factor in architecture.
It too is a primal invention. This formal structure constitutes a splendid
architectural invention, above all for churches and mosques. It contains
a unique expression: from the inside, there is the spatial experience of
being majestically enfolded; this is analogous to the vault of the firmament. From the outside, it emanates a kind of catholicity in its comprehensiveness. Its roundness also exudes a joyful solemnity, majesty, power,
and triumphal greatness. It proclaims in a unique manner a redemptive
harmony. The way in which it arches is very significant; this can contain
a high nobility. The cupola is also found in secular buildings, and the

overall conception of the architecture may indeed require it, but it has its primary function in sacred buildings.

Sources of beauty in exterior architecture
The link to physical reality [das Realthema]

It is extremely interesting to see that architecture in its form and its free invention is bound by the physical reality of a building in a completely different way from that in which the imitative arts are bound by nature. Architecture is not imitative. It contains no elements of the reproduction of nature, but is conditioned to a large extent by the physical reality of the building. In purely external terms, it is dependent on this reality in a certain sense, and it must do justice to the inner, deeper requirements of it. A residential house must be a residential house. Whether or not it is artistically beautiful depends on completely different factors. But the physical reality is a presupposition for the architecture and for the artistic task. A residential house should not be built like a theater. This is not only necessary for purely practical reasons; it is also required by the cultural purpose of each type of building that is erected. Both the exterior and the interior architecture of a building must express the specific atmosphere and the human quality that correspond to it.

In this regard, therefore, architecture is freer than the imitative arts, since there is no reproduction in it. And this means that architecture lacks the element of truth that derives from the congruence with what is depicted. On the other hand, it is bound to the physical reality of a building. The tie to reproduction is immanent in the imitative arts. Like transposition, it is a part of the process in which a work of art is created.

When we speak of the individual means by which architecture shapes its high spiritual content, we must to a large extent treat exterior and interior architecture separately. There are doubtless many important relationships between the two, but they are completely different aspects. Often, the exterior architecture of a building is extraordinarily beautiful, while the interior architecture is unimportant or definitely unbeautiful from an artistic point of view; the reverse also occurs.

This double aspect of interior and exterior exists only in architecture. There is nothing analogous in any other art. Naturally, this double aspect is conditioned not by the artistic theme, but by the nature of the building. The real building is the reason for these two different aspects. This, of course, does not apply to all architectural structures. Bridges, city walls, and fountains do not possess these two aspects. But in all buildings in the narrower sense of the term, these two different aspects are present. They have important consequences for the artistic form that is given to the architecture.

It goes without saying that an architect will plan the exterior and the interior architecture together from the very outset, and will integrate into the overall conception everything that occupies a position between interior and exterior architecture, namely, the courtyards, loggias, and so on. On the one hand, the courtyard belongs to the interior architecture, since it is surrounded by buildings. On the other hand, it also has one element in common with the exterior architecture, since it stands under the open sky.

The means for the realization of the artistic content

It is clear that we make no claim to give a full list of the various factors that contribute to the constitution of the overall beauty of a building. We can only point to central factors that serve to realize the fullness of the architectural beauty.

There are a number of principal means available for the outside of the various kinds of buildings: form, proportions, material, color, the surface texture. These serve to realize the artistic content, the beauty of the building, and all the cultural contents that characterize it.

Among the means on which the artistic beauty of a building depends, the first is its form. We have already spoken, in our discussion of beauty in nature, of the eminent importance that the form of a spatial structure has for its beauty.[9] Apart from the primitive beauty of certain formal

9. See *Aesthetics*, vol. 1, chaps. 5 and 8.

structures such as the circle and the triangle, the undisturbed realization of the inherent formal principle of rocks, hills, mountains, trees and plants of every kind, animals, and the human body can be a special bearer of beauty.

Each of the various types of building also possesses an organic formal principle, and failure to realize this makes the building ugly. The purely practical requirements of a residential house, a city hall, or a theater suggest certain forms. There is a rich gradation of beautiful forms that come into question. The outside of a residential house can possess a noble form through its unity, but parts that are added on inorganically deprive the overall form of its beauty.

The architectural formal principle of a church usually means that it extends more into height and length than into breadth, but there is considerable latitude with regard to this relationship, since the physical dimension of a church does not dictate any one particular form. The ground plan can also be octagonal, cruciform, or elliptic.

The general character of a building and its specific inner principle of form entail certain architectural norms and demands. Failure to observe these encumbers a building with an aesthetic disvalue, but it is obvious that their realization guarantees only a very primitive beauty. Much more is needed if a building is to be truly beautiful, and indeed to possess a beauty of the second power.

This also depends on the form of the roof, the windows, and the doors. The form of a window can be either noble or boring. Indeed, it can also be trivial in some way. The same applies to the doors. Even the form of the wall of a house often possesses a beauty of its own thanks to the way in which the line runs from top to bottom at its corners. The downward extension can give palaces, castles, and fortresses a special beauty.

A second principal means for the realization of the beauty of a building, in addition to the beauty of the form of all the individual elements and of the entire house and above all of the façade, is the proportions of the individual elements in themselves and in relation to one another.

If the pure basic form of a building is to be the bearer of a high artistic beauty, all the individual parts must be beautiful, and the proportions

must correspond to the inner principle of form. But most of all, a special artistic invention is required.

This applies first and foremost to the great architectural works of art such as the Palazzo Vecchio in Florence, the city halls in Perugia and Siena, St. Peter's in Rome, and the cathedrals in Chartres and Rheims. But it does not apply to just any building that is noble but not particularly demanding.

Things that are relatively external have an astonishing influence on whether a building is noble or petty, on whether the atmosphere that surrounds it is beautiful and poetic, or barren, vacuous, or indeed trivial. This is similar to a melody, which can take on a completely different quality and become sublime or trivial by ascending or descending. In both architecture and music, we encounter the discrepancy between the slight changes in the bearers on the one hand, and the height, importance, and profundity of the content that are the result of these changes, on the other—in a word, we encounter the mystery of the qualitative beauty of the second power that we have called (by way of a bold analogy) sacramental beauty.

A great deal depends on the proportions of a building. For example, a roof that is located too directly above a window has a cramping effect. However, the importance of the proportions must never be understood in the sense of a rule that can be formulated in general terms, such that the beauty would be assured if one applied the rule. This is not in the least true. The proportions are always a part of the artistic inspiration. Something that is a mistake in one case can have a special charm in another.

A third important means is the material that is used. Naturally, much depends on whether a building is constructed of wood, bricks, cement, or stone, and on the type of the stone that is employed. The material belongs to the overall composition here. Much that is artistically possible in one particular material is impossible, that is to say, infelicitous, in another. The beauty of a material also makes an essential contribution to the overall beauty of the building. Travertine is an especially beautiful material that has been used in Rome for the construction of many build-

ings of a lofty artistic nobility; but it cannot in the least save a building that is poor and disastrous in its conception, like the Palace of Justice in Rome. Indeed, the nobility of the travertine generates a special dissonance through its contrast to the tasteless palace. The importance of the material in architecture can to some extent be compared with that of the instrumentation in music.

The material is so important that a building in cement can never attain the artistic beauty of the Palazzo Farnese in Rome, the Palazzo Tolomei in Siena, or the Palace of the Doges in Venice. And although wood is itself a much nobler material than cement, certain boundaries are laid down in principle for a wooden structure too. The Palazzo Vecchio in Florence or the Palazzo Venezia in Rome would be unthinkable in wood.

Metals are not used as building materials for an entire building, but only for certain parts, such as roofs and cupolas. Copper, which takes on an enchanting green hue over the course of time, is an important factor in beauty, especially in many Baroque churches and some palaces in Austria.

This brings us to a fourth important means, namely, the color of a building. This is often given through the material, which is chosen not only because of its structure but also because of its natural color. Certain materials, such as marble and related stones, are found in a variety of colors, such as white, red, green, and black. Marble of varied colors is used for the façades and outside walls of the Romanesque churches in Pisa, Lucca, and Siena, as well as for Giotto's campanile and baptistery in Florence.

A fifth expressive means is the character of the surface, for example, of the outer walls of buildings, which can be smooth or rough. They can have a rusticated surface like the Palazzo Strozzi or the Palazzo Medici in Florence, or they can consist of flat slabs like the outer walls of the Palazzo Rondinelli in Florence. In addition to the form of the roof, the material that is employed and its color contribute to the beauty of a building. There are many variations in the form of roofs. Instead of a roof, a terrace sometimes covers a house or a palace, as in the Palazzo Corsini in Florence.

Windows too are an important bearer of beauty. Their specific char-

acter also gives expression to the difference between a residential house, a palace, a villa, a castle, and a public building, to say nothing of the completely different character of church windows. In residential houses that are not palaces, the level of refinement of the house can often be seen in the design of the windows.

From an artistic perspective, the form of the windows is important: their rectangular, oval, or round form, and perhaps a change of form and size in the various stories. It is very expressive and beautiful when the windows under the roof have a small rectangular, almost square form or, as is sometimes the case in Baroque houses, a round or oval form. Their number also influences the overall "face" of the building.

In residential houses, the form and color of the window shutters are not without importance for the overall atmosphere of the building. These are often lacking today, and this is a great disadvantage, for houses without shutters look mundane and prosaic.

Iron latticework on the windows of villas and palaces is often particularly beautiful. Its noble curve can give the house a specifically lordly character. And the various ornaments that frame the windows naturally make their own contribution to the beauty of the windows and of the entire wall of the house.

We encounter in architecture again and again the fact that all the individual parts that have a classical function in a building for practical reasons become the source of a rich artistic expression. These individual classical elements that are dictated by the physical reality of a building—such as doors, the doorway, windows, and the roof—supply a tremendous artistic stimulus. In Vienna, the windows of the National Library in the Josefsplatz are very beautiful, and the various palaces built by Fischer von Erlach are very glorious. In Rome, the windows of the Palazzo Farnese have a tremendous majesty, and the same is true in a completely different way of the windows of the Palazzo Venezia.

A window must be more than a mere opening in a flat wall. It must be prepared externally by an indentation in the wall, just as the bones of the eye socket frame the eye in the face of a human being. This is an important factor from the perspective of the beauty of the façade and the

function of its windows. Naturally, this component can be designed in many ways, in accordance with the overall conception of each building. In some regions, such as Engadin in Switzerland, the indentation for the windows is very pronounced, because the walls are extremely thick as a protection against the great cold. The external opening in the wall is much larger than the window, since the opening narrows down through slanting walls until it reaches the window at the bottom of the recess.

The staircases on the outside of some buildings, such as villas, and the steps that lead up to church façades make a tremendous architectural impact. They intensify the solemnity and the dignity of the building.

The expressive possibilities of exterior architecture

We have referred several times to the expressive possibilities of architecture, and this prompts the question: What kind of expression is this?

Expression (in the narrower sense of this term) plays an important role in the imitative arts. We have already investigated the relationship between the expressed metaphysical beauty and the purely artistic beauty of the second power that adheres mysteriously to visible and audible things in all its spiritual quality.[10] There is a particular expression in the sphere of opera and music drama, in which the expressed metaphysical beauty is united to the purely artistic beauty. Even in absolute music, we find expression in a broader sense of the term. The expression found in the radiant joy of a piece of music or in the profound, noble sadness of the adagio in Beethoven's *Harp Quartet* is unmistakable.

It is obvious that the forms of expression in the imitative arts are not a possibility for architecture. Architecture has indeed been called "frozen music," and this doubtless captures something very profound. But an expressed metaphysical beauty, such as exists in music, seems at least at first sight not to be found in architecture. And yet, it expresses many contents: the sacred atmosphere in churches, or the joyfulness in festive buildings such as the ceremonial rooms in the abbey of Ottobeuren and

10. See *Aesthetics*, vol. 1, chap. 9.

in many Baroque buildings. A profound seriousness can emanate from a church. It is clear that the term "expression" in these examples means something different from what we mean when we speak of the expression of a face in a portrait or the expression of pride and inflexibility in a person's bodily posture. An expression in this sense does not exist in architecture.

There are, however, general fundamental elements of life, fundamental attitudes of the human person, and primal phenomena of a very general kind that find an expression and are objectified in architecture, such as the quality of majesty that a building possesses or the seriousness, the festive or victorious character, the noble restraint, the intoxicating joyfulness, or the sacred holiness. Architecture does indeed lack the expressed metaphysical beauty that is highly important in opera and music drama, and to a certain extent also in sculpture and painting, but we find in architecture an expression of general fundamental tendencies and attitudes of the human being, and we encounter the *mirandum* that high spiritual qualities adhere in architecture to visible objects, and indeed to material objects, in a manner that is analogous to the way in which such qualities adhere to the audible in music.

To build towers is a primal need of the human person, and this form is based on a primal experience. The tower not only fulfills the practical goal of allowing a wide view, in order to protect oneself against enemies. It also provides the satisfaction generated by this elevation and a kind of victory against our earthbound condition. This is why a tower is frequently also an expression of pride. Building a tower also has its source in the primal meaning of "above" in our life, in the sense of life that strives upward, in the dignity and the sense of victory that lie in rising up above every other building. In the vertical extension there is an analogy to the noblest spiritual striving upward. A tower bears a spiritual quality of a special kind.

It is important to keep two different elements clearly separate. First of all, there are certain primal human tendencies that are "acted out" in the designing of buildings, tendencies that architectural structures can "express," but this is to use the term "expression" in a completely different

sense than we have done hitherto. This self-manifestation is an unconscious motive that leads to the construction of many buildings, or is an expression of these motives.

Secondly, and completely differently from this, we have the spiritual qualities that an architectural structure can bear. These are the specific fruit of artistic activity: beauty and many other values such as greatness, nobility, victorious splendor, profound seriousness, and sacred holiness. This is completely analogous to what we find in pure music. Like beauty, these qualities too adhere in a mysterious manner directly to the visible bearers. It is striking that these qualities also occur as metaphysical beauty, but do not function in architecture as expressed metaphysical beauty. Rather, like sacramental beauty, they appear indirectly in a mysterious manner on the visible bearer.

The general primal tendencies that find expression in architecture have a completely different relationship to the architectural work. They point to a connection between architecture and certain primal human tendencies and needs that are already expressed in the physical reality of architecture. Architecture can contain an important analogy to these much more general basic tendencies of the human being, just as rhythm, as a primal element of coming into existence and occurring, finds expression in musical rhythm, or as harmony, as a primal principle, finds expression in musical harmony.

How Architecture Combines with Sculpture, Mosaics, and Frescos

UP TO THIS POINT we have explained the means by which the architect realizes artistic beauty and the special aesthetic value qualities that correspond to the deep human purpose and meaning of the building considered as a real thing. These means are of a monumental kind. But the decorative too is in the highest sense of the term an essential factor in architecture.

The word "decorative" sounds unserious in many people's ears. They think of ornaments, of something that is almost playful. This, however, is wrong. The monumental and the decorative are two essential factors in architecture. The decorative is a central bearer of beauty. It is closely linked to the monumental and belongs to it. The basic quality indicated by the term "decorative" has a kind of analogy in music, for example, in the variations that (as is well known) are to be found in the most sublime passages such as Beethoven's Piano Sonatas, op. 109 and 111, or in the third movement of his ninth symphony.

This is why we wish to point to some very important decorative elements in both interior and exterior architecture. These include the ornaments on portals and windows. Another extremely important decorative

element is the rosette as a window over the portal of a church or in various positions in other buildings, such as the marvelous rosettes on the Orsanmichele palace. It is true that the lower part of this building, originally a place for storing corn, is now a church; but these various rosettes do not have the same function as the rosettes we see above the portals of innumerable churches. These round openings filled with filigree on Orsanmichele are not rosettes in the full sense. In all its forms, a rosette can contribute an important intensification of the beauty of a building.

The decorative element is even more pronounced in Gothic and Baroque architecture. Towers are given a filigree structure, and roofs display many decorative elements. It is interesting to note that in Gothic architecture, the decorative element even penetrates the monumental, for example, by means of the filigree in the monumental parts. This entails a risk, however, as the exterior of the cathedral in Milan shows.

In Baroque architecture, the decorative element likewise penetrates the monumental in the volutes, in the strongly decorative, curved style. The volutes on the façades give the buildings a unique animation in comparison with the static monumental character of Romanesque. The curved forms in Baroque tell us a great deal about the importance of the decorative element.

Another important decorative element—always taking "decorative" in the highest sense of the word—is the mosaics on many church façades. They belong in themselves to the realm of painting, of the imitative arts, since they contain a representation.

In one regard, it appears completely wrong to present mosaics in exterior architecture as a decorative element. As a depiction of the highest religious contents, they are almost always explicitly thematic. The massive mosaic on the façade of San Frediano in Lucca can scarcely be called decorative, not even in the highest sense of the term.

When architecture is combined with sculpture and painting, these can possess a decorative, purely ancillary function. But this certainly need not be the case. The combination can have the character of a "marriage" in which it is the sculpture, the fresco, or the mosaic that is the principal theme. It is only a certain type of sculpture that fulfills a decorative

function in architecture, namely, the sculpture that, detached from architecture, would not be sufficiently substantial to be able to survive on its own; but in its decorative, ancillary function it can make a considerable contribution to the beauty and the atmosphere of the building.

In other combinations of architecture with frescos and sculptures, these latter have their own fully thematic character independently of the architecture. This means that they must possess a much higher artistic importance in order to be able to survive artistically on their own.

Finally, the sculpture or the fresco[1] can in fact be the real theme, despite the fact that it is located in a building that was conceived for it and that was created by the same artist.

Many statues on the roofs of Baroque palaces in Vienna have a typically decorative character. This applies likewise to the two greyhounds on the portal of a palace in the Grünangergasse in Vienna, but not to the tombs of the Medicis in the Capella Medici in San Lorenzo in Florence. These tombs are the absolutely primary theme, although they are attached organically to the chapel in which Michelangelo's Madonna stands on the glorious altar between two saints. The same is true of Giotto's frescos in the Scrovegni Chapel in Padua.

Brunelleschi's wonderful crucifix and the frescos by Orcagna, both in Santa Maria Novella in Florence, are not decorative. They have their own theme. On the other hand, this theme does not dominate the architectural form of the church. They are combined organically with the architecture and enrich its beauty. But this does not give the sculpture and the painting a decorative character, nor does the architecture primarily constitute a framework for them, as is the case, for example, with the Medici Chapel of the Palazzo Medici-Riccardi in Florence and the frescos of Benozzo Gozzoli.

The same distinction must be drawn with regard to mosaics. The mosaic on the façade of San Frediano in Lucca does not have a decorative character. The mosaics on the façade of San Marco in Venice do, however, have a decorative character, unlike the mosaics in the narthex.

1. See chaps. 4 and 23.

The combination with sculptures is of course much more important for exterior architecture than the combination with frescos or mosaics. We have in mind here the decorative function of the sculptures on the façade of churches and Baroque palaces, whether these are statues or goblins and gargoyles serving as waterspouts on the roofs of Gothic cathedrals.

The statues on the portals of Chartres, Rheims, and Bamberg, and the figure on the Synagogue on the Minster in Strasbourg, on the other hand, constitute a full theme in themselves and possess a high artistic beauty. They are united to the glorious architecture. In this combination, both arts are completely thematic. The one does not serve the other; rather, both work fully together.

Not only does architecture supply the normal framework for this sculpture; a mutual enhancement and enrichment is generated by the combination of the two. Sometimes the sculpture has a decorative function, and sometimes, as in some fountains, the sculpture is itself the principal theme. But the primary importance belongs to the working together of architecture and sculpture in one and the same theme; here the comparison with a happy marriage is appropriate. These masterworks of sculpture possess in themselves a high artistic beauty, but they also gain something through the architectural surroundings that are required for them. If they were detached from the building and displayed in a museum, something of the beauty that they possess in their present location would be lost, and the architecture too would be deprived of an essential factor that determines the overall beauty of the cathedral when it is seen from the outside.

This applies above all to the reliefs of the ancient temples. One of the greatest works of sculpture of all times, perhaps the high point of all reliefs, is the relief on the Parthenon under the gable above the entrance. This relief is a full artistic theme in itself. It certainly has no purely ancillary function for the architecture; still less is it purely decorative. Its beauty is nonetheless intensified by the fact that it is located above the entrance to the matchless architectural masterwork that is the Parthenon. It forms a unity with the Parthenon. The Parthenon as a whole belongs to this relief as its background. In a museum, the relief would

indeed retain its ultimate poetry, its incomparable, victorious greatness and depth, but it would be robbed of a special splendor that is bestowed on it by this truly unique position. And its removal would certainly be a great loss for the Parthenon. Something analogous applies to many statues that were located at and in the ancient temples.

The joining of architecture and sculpture in the ancient temple is perhaps especially instructive, because both arts achieved an overall effect in unique highpoints. They are utterly autonomous, and yet they form an organic whole as they enhance each other. In one regard, the joining of architecture and sculpture forms a greater unity in cathedrals, where it is even less possible to remove the statues without impairment to both.

The situation is different with regard to masks. These are in themselves sculptures, but they are always a decorative element in the service of architecture.

In the case of bridges, it is clearly certain purely monumental factors—the way in which their individual arches curve and the form of their supporting pillars—that are decisive for their beauty. Another important factor is the material of which they are constructed. The decorative element, in the highest sense of this word, is often richly developed. Ornaments of every kind and decorative figures set their specific stamp upon bridges, such as the Baroque bridge that leads over the Tiber to Castel Sant'Angelo in Rome, or the glorious Charles Bridge in Prague with its statues of many saints and two kings.

The working together of architecture and sculpture is even more prominent in fountains than in the case of bridges. It is rare to find a fountain devoid of all sculpture, which indeed often occupies a very prominent place.

This does not mean that the sculpture makes its appearance as sculpture, as happens in an equestrian monument in which the architecture is often merely a pedestal for the statue. The equestrian statues of Colleoni in Venice, of Gattamelata in Padua, and of Marcus Aurelius on the Capitol in Rome are primarily pure works of sculpture. Their link to architecture arises principally through the situation, through the square on which they stand, and through the buildings that surround them.

It is usually impossible to separate the figures on a fountain from the overall architectural structure of the fountain. This applies, for example, to the Neptune on Giambologna's fountain in Bologna and to the smaller female figures. Although the figures play the main role, they are not autonomous sculptures like an equestrian monument. There are of course innumerable variations here in the different kinds of fountains. The glorious Trevi Fountain in Rome displays in a unique manner the essence of water in its joyful, effervescent power. Its sculpture occupies a prominent place. Mythical figures, horses, animals, and even trees in a vivid reproduction stand alongside the massive rocks, and yet the sculpture as a whole is decorative: it only serves the overall form of this fountain. On the other hand, the group of the Tortoise Fountain in Rome is an autonomous sculptural structure, although it was conceived as a sculpture for a fountain. The figures in the niches in Adolf von Hildebrand's Hubertus Fountain in Munich are certainly not decorative. Although they have an important function for this explicitly architectural fountain, they are completely figures in their own right.

Interior Architecture

WHEN WE STUDY interior architecture, we become once again aware of the indescribable richness of the artistic beauty that architecture offers. It is important to note that interior architecture too fully belongs to the reality we inhabit, and that what we have said about the relationship of architecture to history also applies to interior architecture. This is true above all of its outstanding ability to irradiate a "world."

The practical real theme of architecture shows itself above all in interior architecture. We shall now analyze the way in which this takes artistic shape.

The spatial experience of being encompassed [*Umfangensein*]

We began our remarks in chapter 6 by stating that it is architecture that creates the human space. This is above all true of interior architecture. The beautiful interior of a church or of a noble room in a palace, or a room in a residential house, encompasses us in a way that makes us happy.

When we speak of "spatial experience," we mean the primordial datum of being encompassed by a self-contained space that as such possesses a profound content. An important, indeed decisive, factor for this

experience is being received into a space, as well as the festiveness and beauty or the intimacy of this space *qua* space. It is obvious that the mere fact of a space that surrounds us does not suffice to guarantee a genuine spatial experience. A specific artistic shaping of this space is required in order to realize the spiritual beauty that is contained in the space as such.

We must draw a distinction between the artistic beauty of the space and the aesthetic value of being encompassed, the primordial experience of human space. We do not encounter this new architectural dimension in the same way in the exterior architecture. The spatial experience is given not only when we walk around in a space, but also when we look at it, for example, when we stand at the door of a beautiful living room or look into the interior of a church from the main entrance. What unique beauty there is in the interior of San Marco in Venice, of Hagia Sophia in Constantinople, of St. Stephen's Cathedral in Vienna, or of the hall of the National Library in Vienna!

Some primordial inventions of the architectural art can make their full impact only in the interior. We have already mentioned some of these, such as the column. As we have said, the columns in Greek temples attain an incomparable glory.

The corridor is an architectural invention that belongs purely to interior architecture. We often find extremely long corridors in palaces, villas, and public buildings, but above all in monasteries. These corridors are bordered by walls, windows, doors, and a flat or arched ceiling. A barrel vault or a cross vault can be very beautiful. These corridors often have an atmosphere that is all their own.

The interior of a residential house

But let us begin with the residential house. Not only the shaping of an individual room, but even the entire structure of the house, the division into rooms and their relationship to one another, the entrance, the staircase, the form of the windows, and many other elements can be misguided, unsatisfactory, and prosaic. But they can also be beautiful, a source of happiness, and poetic. We must therefore draw a distinction between two

different bearers of the artistic value or disvalue: the individual rooms as such and the interior of the house as a whole.

The shaping of the entry to a house or an apartment, whether it be a vestibule, a hallway, or a corridor, already influences the quality of the interior architecture. Other factors in the beauty of a residential house are the division into rooms and the form of the staircase, which can be very beautiful, but also ugly. Staircases in palaces and public buildings often possess an extraordinarily festive character and an enchanting nobility. It is true that staircases can be bearers of great beauty on the façade of a house, and even more so when they are on the façade of a palace; but a staircase in the interior of a house serves a different architectural purpose.

In the individual rooms of a residential house, the relationship between length, breadth, and height, the proportions of the windows and doors, and their type and size are also important means for achieving their beauty. The ceilings and floors in a room are also important elements. A ceiling and floor of stone, or a noble parquet floor, can make a great contribution to the beauty of a room. The kind of light that suffuses the rooms is also very important.

One specific feature of interior architecture is the furniture that corresponds to the use for which a room is designed. These belong to the realm of the applied arts, for which interior architecture offers many opportunities. From the artistic perspective, the beauty of the furniture, carpets, curtains, wall hangings, and so on has a very great influence on the overall beauty of a residential house. The practical real theme of this building demands that it be furnished. An unfurnished house is something incomplete and empty. It needs to be complemented by objects of the applied arts.[1] There is a collaboration (in the broadest sense of this term) between interior architecture and the applied arts that is analogous to the collaboration of various artistic genres.

The other types of interior architecture, such as the rooms in public buildings, do not have the same urgent need to be complemented by furniture. In churches, this need is more or less absent.

1. The glorious Renaissance stoves, and especially the majolica stoves of the Baroque period, belong to the furnishings, but a fireplace is a part of the interior architecture.

If a residential house is furnished in a tasteless manner, this can gravely impair its beauty and destroy the noble atmosphere that fills a beautiful house. On the other hand, furnishing that is congenial to the architectural character elevates the beauty of the entire interior.

Another medium that influences the beauty of an interior space is the color of the walls and the ceiling, in addition to the color of the floor, the furnishings, the curtains, and so on. The overall beauty can be greatly intensified not only by the colors of each of these elements on their own, but also by their harmony with all the other colors in the room. How glorious is the dark, almost black hue of some Italian furniture! How marvelous is the color of some curtains, of red damask, for example, that ennobles an entire room!

Naturally, the material too makes a contribution to the beauty of a room, especially the material that is used for the furnishings in the widest sense, for example, the wood of the furniture and the kind of fabrics that are used, such as damask, silk, velvet, or tulle.

The overall beauty of a room is significantly heightened by pictures and sculptures. It is true that their principal theme is their beauty in itself, not their function for the design of an interior space. But since they can be an important factor for the beauty of a room as a whole, we must mention them here, although they are not an architectural contribution to this beauty.

Let me point out, however, that the beautiful picture in a living room ought not to be a work of art of ultimate greatness. None of the following paintings would be appropriate to such a space: Titian's *Bacchus and Ariadne*, *Sacred and Profane Love*, or his portrait of the *Young Englishman* with the blue eyes; Giorgione's *Pastoral Concert*; or Rembrandt's *Jewish Bride*. If the picture is of such power and greatness that it must be the principal theme, so that the room in which it hangs ought only to serve the picture, it no longer fulfills a complementary function for the room. It is a very interesting problem to determine from what degree of greatness a picture excludes this collaborative, complementary function for the beauty of a room.

More modest works (for example, many of the ancestral portraits in

castles) and even important works can be a marvelous adornment for a living room or a parlor. Very beautiful pictures of this kind usually determine the atmosphere of the entire room and are a decisive heightening of its beauty.

If the picture is an exceptionally important work of art and lays claim to constitute the principal theme, however, the room just offers the opportunity to look at the picture in an appropriate manner. In that case, the picture can no longer be regarded as an important contribution to the beauty of the interior architecture. The same applies by analogy to sculptures in a living room.

The situation is completely different in the case of palaces, public buildings, and above all churches.

Public buildings and their rooms

Let us now turn briefly to the interior architecture of public buildings. The practical theme prescribes certain rules for the design of the various types of public buildings such as a town hall, a parliament, schools, universities, libraries, hospitals, museums, theaters, or the residences of local secular and ecclesiastical rulers. A town hall needs rooms and large spaces, and one or more meeting rooms. Similarly, a government ministry requires that its rooms be arranged in a particular manner. Schools need many rooms for various purposes. The theater needs one large room that is structured in a particular way, and many other spaces.

These buildings also have a higher, non-artistic theme. "Public," "private," and "intimate" are qualities that are important above all in interior architecture. Palaces are neither specifically intimate nor public; they bear a festive character, and magnificence and splendor belong to their cultural theme. The specific nature of this theme makes corresponding demands of the artistic design. It would be extremely interesting to investigate the question of the requirements made on the artistic design by the spirit of the various types of building, but this would take us too far afield here.

Some rooms are enchantingly beautiful in their very form, and they

give us a unique experience of space. Rooms in public buildings can be grandiose and overwhelming, or academic and boring. Once again, the form of the windows and doors, their relationship to the room as a whole, and the type of ceiling and floor all play a decisive role. Imposing a special structure on a room, for example, by means of columns, usually heightens the beauty of the whole.

The first question with regard to the ceiling, whether it is flat or arched, is how its form fits the rest of the room. In general, the decorative element has a more important position in public buildings than in a residential house, while the furnishings are less important. But in public buildings the material of the floor, of the walls, of the tapestries and carpets, and the combination of colors unfolds their full effect. A large room in palaces, town houses, and similar public buildings is meant to be a showpiece. Since such rooms are intended to be used for feasts, public assemblies, and important social acts such as the signing of treaties, splendor belongs to their spiritual theme.

There can be very great differences in the atmosphere of the interior rooms of palaces and public buildings. Romanesque and Gothic interiors irradiate a serious, recollected world, an invitation to a *habitare secum* ("to dwell with one's own self"), and an austere solemnity. The decorative element can scarcely be seen in these interiors. But in the great Baroque rooms there is a joyful splendor, an overflowing richness, such as the festal chamber of the abbey of Ottobeuren or of the National Library in Vienna. These invite one, not to relax and "let oneself go," but rather to make an elegant appearance in distinguished dress. The decorative element unfolds in all its fullness. The quality of festiveness, of making a display, is fully developed.

Palaces and public buildings offer many opportunities for collaboration between sculpture and painting (including frescos) not only in the interior architecture of the Middle Ages, but just as much in that of the Renaissance and the Baroque, Rococo, and Empire periods. Great works of art often suit these spaces well, but they make certain demands, and this means that the theme shifts. The fresco or picture becomes the main thing. The *mirandum* takes first place, as in the Vatican *stanze* with

Raphael's frescos or the Palace of the Doges with the huge oil painting by Tintoretto.

Churches

We now turn to sacred space and above all to churches, in which the interior space attains its highest possibility of expression and its greatest importance as space.

It suffices to think of a church like San Marco in Venice, Sant'Ambrogio in Milan, or Santa Croce in Florence, or a cathedral like Chartres, Bourges, and Rheims, St. Stephen's in Vienna, St. Peter's in Rome, or St Peter's in Salzburg, in order to apprehend the importance that these sacred spaces possess (in spite of all the great differences among them). The space as such irradiates a unique beauty and a sacred atmosphere thanks to its artistic style. We should not forget in this context that being secluded from the rest of the world and being taken up into a space that is clearly separate from all other rooms has a certain importance for the sacred atmosphere, and this for two reasons. First, so to speak, we step out of the world that surrounds us and enter a house of God. The world sinks away, and we are taken up into a completely different dimension. Secondly, the fact of being encompassed by this space offers a special occasion for the unfolding of the sacred. Its separation from all that is profane is what is capable of creating this atmosphere, together with many other factors that the sacred requires.

The means employed by the architect in order to give the interior of a church a beautiful and sacred design are, once again, the forms, the proportions, the materials, and the colors. But as with exterior architecture, the reason why he succeeds in achieving a true artistic beauty of the interior and in bringing about a sacred atmosphere remains a great mystery, the mystery of the artist. All we can do is to note the factors that are involved; we cannot state why they determine a lofty beauty and sacrality, or the lack of beauty and sacrality. In general terms, we can certainly define the sources of errors that must be avoided, but even if they are avoided, there is no guarantee of full beauty and true sacrality. We

must repeat this observation again and again, in order to set out clearly both the task of aesthetics and its limits.

<div align="center">

Principal factors of the interior
architecture of churches

</div>

In this section, we shall only indicate the various principal factors of interior architecture that are involved in the design of a church. When we enter through the main door of many churches, the view of the interior offers a marvelous beauty. The overall view of the interior, of the whole length of the nave and the flanking aisles, of the columns and the altars, can be overwhelmingly beautiful. Examples are the cathedral of St. Stephen in Vienna, Santa Maria Novella and San Miniato in Florence, or the cathedrals of Orvieto and Amiens. But the transverse view too is often delightful. There is splendor in a great wall that is supported by relatively small columns, as in Santa Maria in Cosmedin in Rome or in Sant'Andrea in Carrara.

We are continually astonished by the wealth of artistic expressive qualities that determine the form given to a space. The interior of a church can be filled by a lofty nobility, an explicit greatness and solemnity. Examples are Hagia Sophia in Constantinople, San Zeno in Verona, and Santa Croce in Florence. The space as such possesses great beauty in Santa Maria in Cosmedin or in the cathedral in Parma.

We have already mentioned columns, a grandiose architectural invention, and their lofty beauty. Columns have an outstanding importance in many churches too, but with a function that is completely different from their function in an ancient temple. First of all, the column is usually linked to another primordial invention, namely, the arch. Secondly, the columns do not support the roof. And thirdly, the central nave between the rows of columns is the most important space. Even in the side aisles, the space framed by columns is always of greater importance.

Naturally, there are churches with a boring and academic interior, such as we find in many a Baroque church in certain smaller Italian cities. These form a contrast to the interior of the glorious Baroque churches in Rome

and Venice, and, of course, above all in Austria and southern Germany.

There is an extraordinarily rich variety of columns, thanks to their height, their relationship to the overall space, their form, their color, their material, the way in which they are elaborated, and their capitals. Additional factors are round and pointed arches; the difference between these two gives rise to an important difference in aesthetic quality. In Romanesque and Gothic churches, the columns that are linked by arches have a high expressive power. What solemnity and greatness, what strength and nobility they can bestow on the interior of a church! Examples are the churches of Santi Apostoli and San Miniato in Florence, the cathedral of Chartres, the apse of St. Sernin in Toulouse, and the cathedrals of Parma and Modena. The short columns with the round arches and the long, flat wall that these support in Santa Maria in Cosmedin in Rome and Sant'Andrea in Carrara are also beautiful. The columns in St. Paul Outside the Walls must have been truly glorious before the church burned down. Their present state after the restoration allows us only to guess at this.

There are various possibilities for the columns in a church, whether in a basilica like Sant'Apollinare in Classe outside Ravenna, in a Romanesque church like Sant'Ambrogio in Milan, or in a Gothic church like Santa Croce in Florence and St. Stephen's cathedral in Vienna.

In St. Stephen's, the Baroque altars that are attached to the Gothic columns have a particular charm. They are an interesting example of something that often succeeds, namely, the happy union of different kinds of style.

Romanesque churches, especially in Italy, are often ruined by an uninspired Baroque interior. One example is the cathedral in Assisi, which has a uniquely beautiful façade and a marvelous tower. But inside the church is artistically conventional and weak. One must ask, however, whether the style is responsible for the lack of beauty in this particular interior, or whether the reason is its architectural weakness as such. Would not this dissonance exist even if the interior were furnished in glorious Baroque? Here we may recall Saint Peter's in Salzburg, a uniquely beautiful church in which the Romanesque architecture unites

in an outstanding manner with the Baroque-Rococo interior. Something similar is found in the monastery church in Rottenbuch to the south of the Ammersee, near the pilgrimage church in Wies.

Let us now mention various ways in which architectural styles are united to one another. We frequently find the transition from the Romanesque to the Gothic style, especially in many of the French cathedrals, in an organic juxtaposition that in no way impairs the beauty of the whole. In the Baroque furnishing of a Romanesque or Gothic church, the latter styles can form, as it were, a foundation that bears the Baroque interior. The Romanesque or Gothic foundation shares in this special beauty, as in St. Peter's in Salzburg.

In a purely Gothic church, we sometimes also find Baroque elements with a decorative function. These are an important enhancement of the beauty of the whole church, as in St. Stephen's in Vienna.

The collaboration of the styles in the Franciscan church in Salzburg is completely different. Here one enters in a Romanesque church and then steps into a Gothic space, so to speak. Finally, one reaches a grandiose Baroque space. Whether the collocation of different styles brings forth a beautiful result or an artistic dissonance always depends on the inspiration and the profound artistic sensibility of the architect. This architectural problem consists in adding on and employing other styles, not in the invention of a completely new kind of building. Stylistic unity is not in itself a sufficient guarantee of artistic beauty, and the combination of various styles certainly does not necessarily constitute an architectural error.

The ceiling naturally occupies a decisive place in the design of the room. The ceiling of a church can be formed beautifully, but also disastrously. Among the many kinds of ceilings, we mention the flat ceiling with wooden beams in basilicas such as San Lorenzo in Florence or St. Mary Major in Rome; the vaulted ceiling in the barrel vault or cross vault of many Romanesque and Gothic churches; and the ceilings that depict the interior of a cupola. This completely new form of vaulting gives an indescribable spatial experience. When one stands under the cupola in the cathedral in Florence, for example, one has a unique spatial

experience of being lifted upward. The many cupola vaults of San Marco in Venice, which form the ceiling of the church, are unique. They give the overall space an incomparable beauty.

The many cupola vaults in San Marco are linked to another sublime factor, namely, the mosaic. This is indeed also found in exterior architecture, but the true home of the mosaic is the church interior. The funeral monument of Galla Placidia in Ravenna exemplifies clearly the beauty that a mosaic can have in itself. In addition to its own beauty, it is a bearer of beauty in collaboration with the architecture. It can bestow a lofty, sacral solemnity on the whole church when it is located above the altar in the apse, as in the mosaic that depicts the figure of Christ in the cathedral of Cefalù in Sicily. Mosaics can also portray a series of figures and occupy entire walls in a church, as in the glorious San Vitale in Ravenna. They cover the entire interior of the indescribable baptistery of San Giovanni in Florence. What a unity is achieved here! What a solemnity they bestow precisely on this church and on San Marco in Venice!

Another important bearer of beauty in many medieval churches, especially in late Romanesque and Gothic churches, is the church window. This is characterized by a specific kind of representation that differs from the fresco, the picture, or the mosaic. The principal role is played by its colors, both by the individual color in itself and by the combination of colors. Church windows come into their own only in the interior architecture. From the outside, they usually look dark and gloomy; it is from within that they unfold a great splendor.[2]

They belong by their very being to the interior architecture of the church. They are dedicated to the sacred world of the church. In the church window, as in the mosaic, a certain stylization is the norm; but less stylized church windows, like those by Rubens in the collegiate church of St. Michel and St. Gudule in Brussels, also have a great beauty. Apart from the beauty that church windows possess in themselves, as in Chartres, they make an essential contribution to the sacred atmosphere, which in turn can be the bearer of a sublime beauty. The expressed meta-

2. Goethe expresses something similar in one of his poems: "Poems are painted windowpanes!"

physical beauty of the sacred is a decisive element here, but this beauty too has gone through the artistic transposition.

The sacred atmosphere of a church is required by the first theme of architecture; not indeed by the practical theme, but by the spiritual real theme. An unsacred church can indeed be beautiful, but as a church it has missed the point, and this means a decisive artistic imperfection.

A new artistic task of interior architecture is the designing of the principal altar and the side altars. In Catholic churches, the altar is dominated by an important real theme: the Holy Sacrifice of the Mass is offered on it. This is the most sublime meaning of a church, the high point of divine worship, the *raison d'être* of the church building. The altar is the center of Catholic churches. The reasons for its artistic beauty are, as always, of a purely architectural nature. But the demand made by the spiritual real theme must also be met, namely, the specifically solemn, sacred atmosphere, indeed, the atmosphere of mystery. Two very different aspects are involved in forming this atmosphere: the ascetical concentration on the invisible mystery, and the glorification of God through Christ's sacrifice on the Cross. Many possibilities of an artistic kind are available to both of these aspects, in order to do justice to this theme—to the extent that it is at all possible to speak here of "doing justice."

Rich possibilities are offered not only by the altar in the narrowest sense of the term, but also by the sanctuary as a whole. How much precious material, how much ornamentation of every kind has been employed for this purpose!

The tabernacle is a special object. Once again, there is an immeasurable distance between the lofty, sacred beauty that it can possess and the Body of Christ that is reserved in the tabernacle. In the present context, we wish only to mention the variegated artistic beauty that has taken shape in the form and in the decorative ornamentation of tabernacles.

The pulpit and the staircase that leads up to it are often a bearer of great beauty, thanks both to the form of the pulpit and to its ornaments and reliefs. Like the pulpit, the ambos in many basilicas and early Christian churches, one for the proclamation of the Epistle and the other for the proclamation of the Gospel, not only possess great beauty in them-

selves, but also are an enrichment of the overall beauty. The ambos are often made of gloriously colored marble. They usually form a unity with the sanctuary and intensify its beauty.

In some churches, the view from the apse backward and up to the organ loft and to the organ itself is extraordinarily beautiful, especially in collaboration with the overall architecture of the church's space. This is often the case with the glorious Baroque organs in Austria and southern Germany, for example, in Ettal.

Choir stalls are a counterpart to the furniture in living rooms. They do not belong to architecture in the strict sense. Something similar holds for confessionals. Like choir stalls, they often have an exquisite beauty in their form, their color, and their material, especially in Baroque churches, and they make a contribution to the overall beauty of the interior. Both of these can be congenial to the church interior or complement it, for example, when they themselves are Baroque, but the church is Romanesque or Gothic.

The pews are another analogy to the furniture in living rooms. The importance of their aesthetic values for the beauty of the church interior is relatively slight. They can be absent without impairing the beauty, whereas an unfurnished living room is "empty."

Sacristy and cloistered courtyard

The sacristy, in which the priest puts on his vestments and in which everything required for church service is prepared and kept, also belongs to the practical real theme of a church. Although the form of this room, its ceiling, the cupboards along the walls, and often an altar can be artistically insignificant, they frequently possess great beauty. One of the most beautiful sacristies, an architectural jewel, is that of the abbey church in Ettal. In this sacristy, one can study the factors that contribute to this beauty. Another sacristy that is even more important from the monumental architectural perspective is that of San Lorenzo in Florence.

Let me briefly mention an architectural structure that can be, and often is, a bearer of great beauty: the cloistered courtyard. It has a place

all its own in interior architecture. On the one hand, it is definitely an interior space. In order to be able to see it, one must "go in." As long as one is on the street and looks at the monastery from the outside, the cloistered courtyard remains invisible. It possesses the intimate quality of interior architecture and its spatial experience, namely, an experience of being encompassed, of finding oneself in a space.

On the other hand, the cloistered courtyard (unlike the rest of interior architecture) lacks one dimension of the spatial experience: it is not closed off at the top. Usually, a part of it is open, and this is of course a decisive difference. In one sense, one is in the open air. The relationship to light and to the weather is completely different.

The cloistered courtyard offers unusually rich possibilities for the unfolding of the beauty of columns, arches, and vaults in its covered part. Examples are the cloister of St. Trophime in Arles, the Gothic cloistered courtyard in the collegiate church of Sant'Orso in Aosta, or in Santa Croce in Florence, the various cloistered courtyards designed by Brunelleschi, the cloistered courtyard of San Francesco in Assisi, that in Monreale in Sicily or of San Giovanni degli Eremiti in Palermo. These open up to us a whole world of glorious architectural inventions. A delightful fountain often heightens the poetical atmosphere of the cloistered courtyard.

These courtyards have a practical real theme. They offer the monks the possibility of recreation in a space where they can walk around. The spiritual real theme is the union of contemplation with nature, and the preservation of the monks' separation from the world. A particular emphasis lies on the seclusion of the monastery and on its having its own world. This is expressed precisely in the union of the open sky and the seclusion from the outer world. From the aesthetic perspective, the interesting point is the variety of factors that build up a structure of such beauty.

The Beauty of a City as a Whole

WE HAVE SPOKEN about the beauty of buildings of very various kinds, about fountains, bridges, streets, and squares, and about the beauty of the second power, the sublime spiritual beauty that all these can possess.

The individual face of a city

In addition to the architectural bearers of beauty that we have mentioned, a city as a whole can constitute a glorious symphony. The interior aspect of some cities offers a sequence of ever new surprises. This aspect unfolds before our spirit when we walk around in these cities. Sometimes, indeed, cities possess a unified overall atmosphere, that is to say, a genuine individuality.

What an individual face a city like Siena has! The specific atmosphere of this city wafts around us. What nobility, what poetry this overall face has, when it is seen from within! If we compare with Siena a city like Bruges, we see that its interior aspect is likewise very beautiful. But it has a radically different individuality! Cities can contain a whole world of beauty and have a spiritual style of their own, to which their history too makes an important contribution. How everything in Assisi speaks of

Saint Francis! How his spirit is alive in the architecture of this city that
has such a wealth of beautiful palaces and churches!

The beauty of the interior aspect that unfolds before us as we walk
through a city from square to square, from street to street, is found not
only in smaller cities but also in larger cities and even in big cities. Venice
possesses a unique individuality in its intoxicating beauty. The fact that
this city is built on 123 islands, and is mostly traversed by canals rather
than by streets, suffices to give it a unique character. What unity the at-
mosphere has! What an utterly extraordinary beauty, what nobility, what
depth do we encounter in this city!

Florence has a similarly unified atmosphere. A glorious world sur-
rounds us when we go down the Via Maggio to the Ponte Santa Trinità,
then through the Via del Tornabuoni or the Lungarno to the Ponte Vec-
chio, and from there to the Piazza della Signoria and on to the Piazza
del Duomo. We begin by being overwhelmed already in the Via Maggio
by the sheer number of beautiful palaces, and then by buildings of the
highest and indeed ultimate beauty like the Palazzo Vecchio, Orsanmi-
chele, the baptistery of San Giovanni, and finally the Campanile and the
cathedral, Santa Maria del Fiore, with Brunelleschi's cupola. Is such an
accumulation of great architecture possible?

Each of these buildings, taken on its own, speaks an ultimately valid
word. The whole is permeated by an atmosphere that is constituted as a
reality of its own, despite the individual character of the most important
buildings and the difference of styles. This reality is the bearer of a lofty
beauty, namely, the specific world of Florence with its mysterious unity
and harmony.

There is a strong contrast to this in Rome, where a "holy" disorder
reigns, a variety that never ceases to surprise us. Here we have in mind
Rome before the First World War, a city with a world all its own, a world
that from another perspective is just as unique as Venice. The core of the
city as a whole bears the stamp of a tremendous universality, the charac-
ter that belongs to the center of the world. This universality is the bearer
of a special beauty.

Rome's buildings also have the character of fulfillment. They present

themselves like a symphony by Beethoven; not as *a* symphony, however, but as *the* symphony as such. It is clear that the influence of history on the atmosphere of a city reaches its high point here. The greatness, the universality, the consciousness of being in the center of the world: all this generates an atmosphere that is the absolute antithesis to everything that is provincial or local-bourgeois. This atmosphere is indeed grounded in the type of architecture and in the overall structure of the city, but the highly important stamp of history is an additional factor to this visibly given world. There is a deep qualitative relatedness between the atmosphere that is grounded in the architecture and the atmosphere that derives from history.

As the seat of the head of the Catholic Church, Rome is profoundly marked by the religious world. This preeminence of Rome in relation to the entire world has also formed its soul, and it finds an unambiguous expression in its visible face.

These various elements make a wholly legitimate contribution to the special beauty of Rome. The mere knowledge of the existence of its beautiful palaces, churches, and buildings plays a role even when one does not see these from the place where one is standing at the moment. This knowledge is highly important for the full reality of the world of Rome. One aspect of Rome's glory and the reality of its splendid overall atmosphere is the fact that we stand on the Capitol and know about the beauty of the Palazzo Farnese, Ponte Sant'Angelo, St. Peter's, and the Piazza del Popolo, even though we cannot see these from the Capitol.

There is an analogy in music to this contribution made by mere knowledge. There is an important link between the beauty of the first movement of a symphony and the beauty of its second movement, although the first movement is no longer perceived when the second movement is played. If we hold fast in our spirit to the quality and specific character of this first movement, this suffices to let us experience its influence on the beauty of the second movement. This is of course only an analogy, since the totality of the symphony constitutes a unity in a more explicit, intentional, and marked manner than a big city in its interior aspect. But this analogy suffices to shed light on the legitimate

artistic function of that which is held fast only in the spirit and is no longer perceived directly.

In addition to the number of beautiful buildings and squares, the beauty of a city as a whole depends on whether the individual beautiful buildings unite organically to form an overall picture, on whether the city as a whole has a distinct face in its interior aspect. This does not mean that a city must be based on a definite overall composition of an artist, or that the overall aspect is the result of a conscious architectural composition. A beautiful city can also have grown organically. This dimension of beauty occurs much more frequently in small cities than in big ones. It is scarcely possible in megacities with millions of inhabitants.

Let me also mention how strongly the overall beauty of a city can be impaired by tasteless or soulless buildings with a uniform anonymity. The damage is already great when one single tasteless or soulless building, full of deadly neutrality, has sneaked its way into a square that is framed by glorious buildings. If whole quarters of a city are architectural kitsch or architectural "cemeteries," however, this gravely impairs the overall beauty of the city. As a whole such a city can no longer be a bearer of beauty.[1]

The exterior aspect and overall face of a city

In their exterior aspect, small and medium-sized cities often have a unified overall face. Very small cities sometimes crown a hill in Italy and almost present the appearance of one single building. An outstanding example is Orte, eighty kilometers north of Rome. When one passes this city in an automobile or a train, the vista of the city makes an overwhelming impact. The houses huddle so closely together that they look like one single glorious dark building.

Each of the following Italian cities possesses a unified face, though sometimes only when seen from one particular side: Pitigliano, San Gregorio, Fiesole, Fosdinovo, and Pistoia. For example, Pitigliano must be

1. Some cities are filled with an atmosphere of intense life. As a whole, they possess a charm despite the predominance of architecturally disastrous buildings. This charm is based on the cultural and social life in these cities, such as Berlin and New York.

seen from below, from the road that runs from the Tyrrhenian seacoast to Orvieto. When one then looks up at this little city, it presents itself as a magnificent architectural whole. The same is true of Anghiari when one travels from Arezzo to San Sepolcro. It is thus only from one particular aspect that some cities possess a lofty beauty in their overall picture, or indeed that they possess the individual face of an architectural unity.

Although the specific character of the Umbrian city of Trevi as a whole, which covers a hill, is visible from several points, it can be seen as a whole only from below, not from a higher mountain. San Gregorio, an unknown city that suddenly appears on the road from Tivoli to Palestrina, is another town that presents from various places a distinct face of enchanting beauty.

One is enchanted by the exterior aspect of all these cities, but their interior aspect is relatively disappointing, since no buildings or streets and squares of comparable beauty are to be found.

Nevertheless, there are many small cities that are architecturally beautiful in both their interior and their exterior aspects. As a whole, they possess a face that is definitely "for display" and can be seen from one or more places. For example, if one travels from Pitigliano to Orvieto, the overall vista of the latter city is incomparably more beautiful than that of Pitigliano. Besides this, Orvieto is an architecturally important city that contains a number of beautiful palaces, as well as a cathedral that is very beautiful both inside and outside. If one comes from the hill that lies to the west of Orvieto down to the road that leads from Montefiascone to Orvieto, the city as a whole forms a self-contained unity from one place (and only from this one place). This overall face is breathtakingly beautiful. Above all, one looks directly at the façade of the cathedral, which appears even more beautiful at this distance than when one stands before it and apprehends all its details.

Another example of a supremely beautiful city is Salzburg. The towers and cupolas of the city unite with the Hohensalzburg fortress to form a distinct individual face that possesses a character of convincing necessity in its tremendous poetry.

Florence, however, is the high point of a self-contained individual

picture. Despite its relatively large dimensions, this city, which is so rich in great architectural masterworks and has many glorious streets and squares, is genuinely an architectural composition that varies in its great beauty, depending on the place from which one looks down at the city, but always presents itself as a unity. The dominating cupola by Brunelleschi forms a unique middle point with an extraordinary long-distance impact. The other glorious buildings, especially the Palazzo Vecchio, then the Campanile and the towers of Santa Maria Novella and Santo Spirito, form groups of various kinds around the cathedral, depending on the position from which one looks down at them: from San Miniato, from the Fortezza, from Bellosguardo, or from Fiesole.

Albi in southern France has also a distinct face, irrespective of whether one looks at it from below or from nearby hills. This overall picture is indubitably the bearer of a special beauty. A similar case is the small town of Collioure on the Mediterranean, near the Spanish border, which possesses a great picturesque beauty. The position of the church at the end of a rocky area that juts out into the sea gives this delightful city as a whole an enchanting unity.

CHAPTER TWELVE

Architecture and Nature

THE COLLABORATION between architecture and nature is one of the greatest sources of beauty, since all buildings are inserted into the external world that surrounds us, and thereby into nature in the broadest sense. While it is true that the buildings of a city are not necessarily surrounded immediately by trees or other plants, they stand under the blue or cloudy sky, they stand in a light that varies from region to region, and they share in the alternations between the hours of the day and the seasons of the year. In short, even those cities that are a "sea of houses" without gardens and trees, such as Florence in the Middle Ages,[1] still retain a link with nature in the broadest sense. The weather and the light are an important factor for their beauty too. To begin with, certain buildings need a specific light. A building that is created for Greece or Morocco does not suit Scotland, Norway, or Sweden. This is true both of its form and of its color. How beautiful is the white color for houses in the South, for example, in southern Spain, southern Italy, Morocco, or Algeria, and how little would it suit the North! Secondly, beautiful weather in every

1. See Wolfgang Braunfels, *Mittelalterliche Stadtbaukunst in der Toskana* (Berlin: Gebr. Mann, 1953), chap. 3, pp. 115 and 130.

part of the world allows the beauty of a building to emerge more prominently. The blue vault of the sky above it or the light on a special day elevates every architectural beauty, whether it be a church façade like that of Rheims or Vierzehnheiligen or the Municipal Chambers of Perugia.

The collaboration between nature and a city

Many cities are situated on a river, which is an important piece of nature in the heart of the city. The houses on the riverbanks have an additional link to nature. This situation makes certain demands of the building and of its collaboration with the river. In Venice, this collaboration of the architecture of the palaces with the canals is a wholly unique source of beauty.

In cities on lakes, such as Constance, Geneva, or Lucerne, there are some buildings situated directly on the lakeshore that are inserted to a large extent into nature. The lake is usually framed by hills and mountains; in this way, nature is also represented by the landscape, which collaborates in a substantial manner with the architecture of the buildings that are located by the water. This is all the more true of all the buildings of a city on the seashore. Here we have in mind first of all the cities that themselves lie on the seashore, and above all those that are situated on a bay.

Sometimes high mountains form the background when we look at certain buildings, as in Innsbruck. In that case, the profound collaboration between architecture and nature that affects the entire city also has an effect on individual buildings. Apart from this collaboration, however, there are innumerable other forms of cooperation that are specific new bearers of beauty.

First of all, there is the highly important unity between a city as a whole and the surrounding nature. This already comes into its own in the location of the city. For example, the city may crown a hill or a little mountain, as is frequently the case in Italy. A city at the foot of a mountain range or on a bay is sometimes framed by hills or mountains in such a way that a unity is formed between nature and architecture. If the nature and architecture are not only of great beauty but also qualitatively congenial, this can produce an overall unity that is a bearer of the highest

beauty, for what we then see is one of the most important bearers of the beauty of the second power, a unity that is capable of giving us special delight through its reality.

Frequently, however, the beauty of the architecture stands on a higher level than that of the nature that surrounds it. Even more frequently, the nature is much more beautiful than the architecture of the city that it frames. In these cases the beauty is not intensified by the collaboration between the two. Rather, the more beautiful part of the overall unity predominates, and its beauty is not elevated by the contribution of the less beautiful part.

The overall unity of nature and architecture cannot be the bearer of a greater beauty when the qualitative congeniality is lacking—even when both are of great beauty.

We can thus distinguish various types of collaboration between a city as a whole and the nature that surrounds it. First, there is the collaboration between the overall picture of the city and the surrounding nature; the most distinctive expression of such a collaboration is the various vistas of Florence. Something similar is true of the vista of Assisi from Santa Maria degli Angeli, in which the overall face of the city and the surrounding landscape collaborate, or the vista of Toledo when one looks from the other side of the Tajo across to the hill on which the city spreads out in its upward ascent. One could mention many examples of the collaboration between the overall face of a city and the surrounding landscape, for example, the vista of Salzburg and its wonderful environs from the Kapuzinerberg or from one particular spot on the Mönchberg. In each instance, there exists both a pronounced beauty of nature and of architecture and a qualitative congeniality of the two.

We experience a second type of collaboration between the architecture of a city and nature when we look from a tower or a lofty palace in the city over a part of the city and its background, for example, when we look from a window of the Palazzo Vecchio in Florence over to the cupola of the cathedral and to the hills with Fiesole in the background. The collaboration is no longer between the overall face of the city, which presents itself when we look from outside at the city, and nature. Now,

the collaboration is only between the face of one part of the city and one part of the surrounding nature. Besides this, the fact that we are in the city gives a new note to our impression, since an interior view of the city is an additional element. This collaboration too can be a bearer of sublime beauty. The distant view and the interior view collaborate in such a way that we take great delight in being enfolded by the reality of this high cultural world.

Cities and landscapes

A third form of collaboration arises when, for example, hills in a lengthy stretch of landscape are crowned with little towns. In this case, the entire region is the theme. A piece of nature is ennobled and enriched by many small towns. This is a special characteristic of Italy. Whether we travel from Viareggio via Camaiore to Carrara, or through the Arno Valley between Florence and Arezzo, or through the region between Orvieto and Città Castellana, the glorious landscape is always animated and transfigured by the beautiful little towns on the hills. In addition, a small town (for example, on the last mentioned road) sometimes looks like one single building. In other words, it possesses such uniformity, and is adapted so perfectly to the hill, that this "single building" in turn is a specific bearer of a special beauty.

In all these cases, the piece of nature or the special landscape is the principal theme. The architecture is only a second theme. But it is impossible to overestimate the contribution made by the architecture to the beauty of the whole.

Another unique collaboration between architecture and nature can be found in the region of Narni, Terni, and Spoleto (Umbria). Especially in Terni, we encounter an interesting phenomenon, to which we have already referred: the beauty of the external aspect of a city, its face as a whole, can be much more beautiful than its internal aspect. In such a city, one finds neither buildings nor squares of great beauty. On the other hand, there are many cities that display great beauty in their internal aspect and have no real face in their external aspect.

If nature takes the first place and architecture the second place, it is the external aspect, the face of the entire city, that collaborates with nature. The Bay of Naples is far superior to the architecture. The Gulf with Vesuvius is uniquely beautiful. By comparison, the city as a whole is architecturally unimportant; but it is of such a kind that it does not impair the beauty of the nature but rather intensifies it. If the Bay were uninhabited, one factor of beauty would be lost. Where it is the architecture that makes the principal contribution to the overall beauty, however, the nature must indeed be beautiful and congenial, but it need not in itself be the bearer of great beauty. In Piacenza and Parma, the beauty of the architecture is superior to that of nature, which is modest. Nevertheless, it is far from being a disturbance! The Po Valley has its own beauty and is a fitting framework for these cities.

Nature and individual buildings

In a completely different type of collaboration between nature and architecture, individual important buildings are surrounded by beautiful nature, or else stand out against the beautiful nature that is their background. The Alhambra in Granada is an example of both. A beautiful park surrounds the glorious building. It is true that the park itself is architecturally formed nature, but architecture and nature also collaborate, and the Sierra Nevada bestows a unique beauty on the view of the Alhambra from Granada. The building is surrounded by glorious, tall cypresses, and in the background is the wonderful mountain range with its particularly beautiful form. Thanks to the perpetual snow, it presents an incomparable color contrast to the foreground.

The union between architecture and architecturally formed nature is, of course, a rich field. We find it in the Villa d'Este in Tivoli, in Versailles, in Sanssouci, in Schleissheim, in Schönbrunn, and in countless other castles with parks, especially in Bavaria and Austria.

Monasteries and churches often have a location in which nature and architecture collaborate gloriously. Examples are Melk, the Charterhouse of Galluzzo to the south of Florence, Monte Cassino (before the Second

World War), the glorious Baroque church in Dürnstein high above the Danube, surrounded by the wonderful Wachau, the church of the Madonna di San Biagio by Antonio da Sangallo the Elder a little way outside Montepulciano, the pilgrimage church of Santa Maria della Consolazione by Bramante near Todi in Umbria, or the wonderful church by the sea in Trani in Apulia.

Another type of cooperation between nature and architecture occurs when their union has the character of something that has grown organically, not of something that was deliberately intended: an intimate piece of nature, two cypresses beside the church, and further down at the halfway point a farmhouse with a few trees. The whole is not the result of a real union, and it is not in the least consciously intended (not even from an artistic perspective). And yet, everything comes together to form a convincing necessity. Often, this is nothing exceptional; rather, there is a sequence of such situations along a lengthy stretch of road. On the one side lies a villa with its *campo*, on the other a grove of evergreen oaks; next comes a hill with a little church, a little town that is still encircled by its city wall, then an avenue of pines, and again a church with a cypress alley leading up to it. Such a unity of nature and architecture builds up a glorious overall landscape, and this type is found in Italy more than anywhere else in the world. Naturally, something similar is found in Spain, but much less frequently and usually in a poorer fashion; it is also found in France, and often in Austria. In the present context, the important point is the remarkable union of that which is unintended, that which has grown, and that which is convincing and indeed necessary. This impels us to exclaim: "Yes, that is how things must be!"

We have said that the marriage between nature and architecture is comparable to that between sound and word; but it is even closer, since nature and architecture both appeal to the eye, whereas the musical note appeals to the ear and the word to our understanding. In both unions, the beauty of the one part can be gravely impaired by the triviality or soulless barrenness of the other. Dreadful architecture can ruin beautiful nature, and kitschy music can spoil a beautiful poem.

The great difference between the two marriages is that the one of

word and sound is soluble, whereas the one of nature and architecture is not. In a song, a wretched melody may spoil a beautiful poem. In that case, all one needs to do is to drop the music and read the beautiful poem without thinking of the music. But if a soulless factory or a tasteless castle is inserted into a beautiful natural site, the only way to free nature is to tear down the ugly building. Since doing so is impossible for someone to whom the building does not belong, the beauty of nature remains spoiled by the disastrous building.

Sadly, nature has been disfigured in innumerable places over the last 150 years by tasteless buildings, industrialization, or the imposition of a soulless uniformity. The glorious enrichment of nature over millennia by congenial architecture contrasts with its destruction over the last 150 years.

Promenades, green spaces, parks, gardens

The architecture of a city is often complemented by avenues, green spaces, the gardens of private houses, and parks. This, in other words, is not a genuine collaboration between architecture and nature, such as is brought about by the background, the special setting or a city, its immediate surroundings, or its overall face.

Promenades and green spaces usually have a very practical importance in terms of public health. From the aesthetic perspective, they bring the universal charm of nature and the wonderful rhythm of the seasons into the city. Above all, they make a contribution to its human and cultural atmosphere. This is the main point, rather than either the constitution of a new "picture" or a purely artistic intensification of the beauty. Promenades and public green spaces have a much greater importance for the internal than for the external aspect of a city.

Two things must be distinguished. On the one hand, a tree or a group of trees alongside a palace or on a square can present an extraordinary collaboration between architecture and nature, producing an artistic unity and a new bearer of beauty. This is the effect of the cypress on the great square in Todi near the place where one has a view of the plain. This is

the effect of the cypresses in San Miniato al Monte in Florence, and of the linden trees on the great square in Dijon.

A tree can have a great influence on the beauty of the external aspect of a city in another way, when it is, so to speak, an antiphon to the city and to the surrounding nature, like the celebrated pine trees on the Gulf of Naples when seen from one particular place. We have already referred to this function, when we spoke of the importance of the foreground in nature, since this antiphonal function of intensifying the beauty of the whole is found not only in the collaboration between nature and architecture, but also within nature.[2]

On the other hand, promenades, green public spaces, and parks in a city give it an element of freshness and completion. They do justice to the human person's elementary need for a direct contact with nature and to the yearning for something that architecture as such cannot give him. This type of nature does not unite with architecture to form a new artistic unity. It only complements the architecture, in such a way that the city-dweller can find nourishment in more than what beautiful architecture can give him.

Besides this, nature has a great influence on the atmosphere of a city. The promenades, green public spaces, gardens, and parks have an important influence on the charm of life, thanks to the simple fact that the city is drawn into the rhythm of the seasons. What would Vienna be without its green public spaces, without the Prater and the City Park, without the nature in Döbling, Sievering, and so on! What a unique charm the spring in Vienna has! But it is clear that the importance of the parks at the Belvedere and the Schwarzenberg Palace and in Schönbrunn consists primarily in the genuinely artistic unity between the palaces and the parks—which in turn enriches the overall atmosphere of the city. Think of the importance of the trees in the Au in Munich, of the linden promenade on the Prinzregentenstrasse, of the Hofgarten, and the English Garden! The atmosphere of Dijon is strongly marked by the wonderful linden trees on the main square, which fill the air with their glorious fra-

2. See *Aesthetics*, vol. 1, chap. 14.

grance in the springtime! The various promenades in Paris complement each other so wonderfully, above all those of the Champs-Élysées that run from the Place de la Concorde to the Arc de Triomphe! They do not collaborate with the architecture in the same way as the Tuileries Garden collaborates with the Louvre, with which it forms a new artistic unity.

Finally, let us also mention that a window or an arch can cut out a segment from the surrounding area. This segment sometimes forms an artistic unity of the exterior architecture or of nature. An artistic unity can likewise come into being in the case of such a segment, through the collaboration of nature and architecture. A glorious view from a window also influences the beauty of the interior architecture.

The Architectural Forming of Nature

WE HAVE SPOKEN of the bond, often deep, that exists between nature and architecture, of their importance for each other, and of the marriage that they can enter into. In its artistic importance and intimacy, this is comparable only to the marriage between word and sound.

In this perspective, the architectural forming of nature occupies a very special place: parks, the various kinds of gardens, and also the singular union of a park with a field that has an agricultural function, the *campo*. This union is very widespread in Tuscany and is usually connected to a villa.

The park

Let us begin by looking at the park, which is the most pronounced expression of the architectural forming of nature. Most of the material is taken from nature: trees, bushes, flowerbeds, brooks, and lakes. Often, pure architectures such as fountains and decorative statues are introduced. All this is brought together to form a whole. It constitutes an

arrangement; it has a structure and is an architectural work of art. A specific talent is required for this forming of nature, since the appropriate ideas are of a very special kind. Not every great architect has this gift; similarly, the creators of the most wonderful parks, such as Vignola, are not necessarily equally great as pure architects like Brunelleschi, Bramante, or Fischer von Erlach.

We find a great variety in the types of parks, such as those in Versailles, the Belvedere in Vienna, and the Villa d'Este in Tivoli. The specifically architectural element is developed with particular fullness in the Belvedere type. The whole park can be taken in at one glance. It has a markedly architectural face. What an invention: the type of flowerbeds, the lawn, the place where the stairs begin, the stairs themselves, the water, the trees that border it on both sides! The beauty of this park is of course heightened by the buildings of the Upper and Lower Belvedere and, as a special element, by the glorious view of the city and the Vienna Woods. The Belvedere is more architecture than nature. The dimension of formed nature does not play the same important role here as in the castle park of Schönbrunn, where the promenades, the interweaving of the trees, and their architectural forming are more in the foreground; this is why the park character is even more pronounced in Schönbrunn than in the Belvedere. Nevertheless, we have chosen the latter as our example because of its specific unity. One can take in everything, and the artistic idea of whole, with a single glance. This is one of the two considerations to be borne in mind for the shaping of a park. The other consideration is that when one walks in the park, its wholeness, its overall idea, unfolds gradually before one's mind.

The composition of a park as a whole offers an incalculable variety of artistic possibilities. These include the artistic unity, the ordering, and the interweaving of the individual elements: the avenues, the flowerbeds, lawns and fountains, the water, the statues, and the other decorative sculptures. All these elements can be treated in various ways, and can be more or less emphasized.

The pruning of the trees and bushes is also important. The invented form makes them a specific element alongside those trees that are left in their natural state.

We have already pointed out the important source of beauty that lies in the congenial union between nature and architecture. Our present theme is the architectural forming of nature. There is already a certain artistic forming in agriculture: cornfields, fields of maize, and so on, arranged in a particular form, with orderly boundaries; a path that leads to these fields; fruit orchards planted in a way that allows them to develop undisturbed; wine-growing on the plain or on terraces that climb up hills; and many other things. This is a completely different intervention in nature, one that is carried out by human beings for practical considerations, and it can be the bearer of aesthetic values and indeed of the greatest beauty, for example, in the *campi* in Italy (especially in Tuscany) that sometimes have the character of a park.

Now, however, we are interested in the work of art that is the product of architecturally formed nature. We shall present the invention both of the whole and of its details by means of the example of perhaps the two most beautiful parks, the Villa Lante in Bagnaia near Viterbo, and the Villa d'Este in Tivoli. Water plays a principal role in both. In the Villa Lante, by Vignola, there is an extraordinary variety of aspects of water, and all of its potential poetry is given form in a great number of situations. The water flows down from the square with the two beautiful palaces and the delightful fountain, and undulates gently as it is given expression in very varied forms in the park. One can see the great artistic possibilities for architecturally formed nature, and one can experience the poetry, the beauty, and the strong and noble world that can be achieved here. In this park, it is the lyrical dimension of water that predominates.

In the Villa d'Este, the theme is water, with the fountain in its enchanting brilliance and its festal splendor. This aspect of water presents itself in the most grandiose manner. Additional factors are the architecturally formed grottoes and walls from which the water wells up, and the glorious trees; and all this is held together in a sublime unity. This park too, in its breathtaking glory, can be taken in at a single glance. We apprehend the incomparable source of the artistic beauty of this architectural forming of nature. It gives rise to a realm all its own.

The natural element of water also enables the artistic forming of more modest parks with simple water basins, either with a small lake as in the Retiro in Madrid, or with many little basins as in Versailles, Schleissheim, the Tuileries, or in the park of the Villa Falconieri in Frascati that once belonged to Emperor Wilhelm II.

Fountains are not an architectural shaping of nature or of water as an element of nature. Rather, they are predominantly architectural and sculptural structures in which the water is not the only artistic theme, although it belongs essentially to the theme. As we have said, fountains are works of art in their own right and are very important on squares in the heart of a city. The Fountain of Trevi is a great work of art in the center of Rome, and is attached to a building. The Tortoise Fountain, the beautiful fountains by Bernini, the glorious fountain by Giambologna in Bologna, the Wittelsbach Fountain and the Hubertus Fountain in Munich, both by Adolf von Hildebrand, have nothing to do with the architectural shaping of nature, which is what interests us here, although the water is indispensable to them, belongs to the practical function of the fountain, and is employed artistically as material.

Things are completely different with the fountains in a park. Naturally, they too have a purely architectural and a sculptural task, but their function is primarily decorative. They are intended principally to collaborate in the fashioning of the park, and they fulfill their artistic purpose even when they are much less important in themselves than a fountain that, as such, is the artistic theme.

The same is even more true of the decorative statues in a park. They are much more unassuming than the statues of a fountain in the heart of a city, to say nothing of the sculptures on a building such as the relief on the Parthenon or the statues on the façades of the cathedrals in Chartres and Rheims, or equestrian statues.

The decorative statues in a park are no longer a mere union between architecture and nature. Rather, they cooperate directly with the nature that has already been given an architectural form. There are obviously great differences among these decorative statues, both with regard to their artistic value as sculpture and with regard to the importance of their

decorative function for the park. What a wonderful idea the *Pegasus* in the Mirabell Garden in Salzburg is!

However, the statues and groups in a park are not only purely decorative. But they have an even more unassuming character and a less demanding function than the decorative statues on palaces and churches.

The union between sculpture and architecture is much closer than that between sculpture and nature. The decorative statues on a building form a complete unity with it; they belong to it, and one cannot separate the one from the other. Although they are in themselves sculptures, they are architectural structures, parts of the architecture.

The union between decorative sculpture and nature is by comparison much looser, more secondary, and only a part of the overall architectural shaping of the park. This sculpture has a position all its own, such that one can take liberties with it that would be either impossible or artistically intolerable in the case of a sculpture that is as such the theme.

The campo

The *campo* is something completely different from the park in the broader sense. The general union between architecture and nature, which we discussed in the previous chapter, plays a prominent role in the *campo*. Its first element is the villa, a grand type of country house that is completely different from a bourgeois country house. The building can be modest or grandiose, but it always has a markedly artistic conception.

The second element is the farmhouses, which are very simple buildings, but are usually artistically superior and noble. As is generally known, the farmhouses in Tuscany are a great artistic treasure.

The third or fourth element is the union between the villas or farmhouses and nature. Thanks to their location and the vista that is linked to it, many of these villas are outstanding examples of the union between architecture and nature. Examples are the Villa Bombicci near Florence and, farther off, the Villa Artimino near Carmignano. In both instances, the beauty of the location and of the surrounding nature, together with the close and distant prospects, interweaves with the architectural beau-

ty of the villas in a congenial, total harmony. Even when a villa does not have a special location on a hill and does not possess a vast view, the beauty of the surrounding nature forms an important harmony with the architectural beauty of the villa. The type of enrichment differs, but the result is a source of special beauty. Both the contribution of the surrounding nature and the contribution of the architectural beauty of the villa are indispensable to the overall beauty.

The architecture must be congenial to the landscape. Something that fits one particular beautiful piece of nature, for example, the landscape in the Inn Valley between Innsbruck and Kufstein, would not be appropriate to Tuscany (and *vice versa*). In addition, a very special and intimate congeniality between a villa and the specific landscape is required for this general cooperation between architecture and nature. This individual place makes specific demands of architecture. All this belongs to the general relationship between nature and architecture.

A new factor that belongs to architecturally formed nature is the avenues that lead from the road to the villa. There is an enormous gradation in such avenues that are specifically planted for a villa, from glorious, lengthy avenues of cypresses to intimate, short ones. They possess the universally important character of an entrance, this primordial phenomenon of the transition from the public road into the intimate world of the villa and of its garden or park. They lead to the villa and into its world.

Another element is the immediate environs of the villa: trees and lawns, sometimes small fountains, water basins that form the parklike part of the *campo*. This part is sometimes large, and sometimes very small. Sometimes it is given a glorious form through the trees that are planted there: cypresses, pines, holm oaks, great chestnuts, and often trees of a simpler kind.

The rest of the *campo* is no longer typical architecturally formed nature. At any rate, it is not a conception of a unified whole by a great artist; it is something that has grown, something that has arisen organically out of a profoundly artistic *sensus*. Great cypresses and pines interrupt the agricultural surfaces. Roses, irises, and tulips form the borders of the paths, but they also grow inside the cornfields. All this unites elements

of agriculture with elements that are planted for the sake of decoration and of beauty. This results in an organic whole with a lofty poetry. Naturally, there are many gradations here. Sometimes there are no flowerbeds; sometimes a little brook makes a contribution to the overall picture.

Among the trees that are planted for use in agriculture, olive and fig trees are particularly beautiful in themselves, and they heighten the overall beauty. In this way, they diffuse an atmosphere all of their own. The leaves of the fig tree, the glorious grey color of its trunk, and the form of the tree are surpassed in their beauty by the silver-grey leaves and the form of the olive tree. This pure, natural beauty is, of course, not an element in an architectural forming of nature, but it intensifies to a great extent the overall beauty of the *campo*.

The union between the farmhouses and the surrounding nature likewise belongs to the general cooperation between nature and architecture in the *campo*. Here and there, a picturesque draw-well stands alongside a farmhouse, and often a little flower garden has been planted. In a curious manner, the farmhouse, the parklike part of the *campo*, and the nature that is used for agricultural work can all together possess a special beauty, a strong world, in a great spectrum of individual variations.

The English garden

Another type of park, the English garden, lacks architecture and statuary art. It is architecturally formed nature, but without the cooperation of buildings, fountains, and sculptures. The entire park forms an organic whole. Trees, bushes, lawns, water, etc. unite in its construction. The trees are not pruned into a special shape. Rather, the pure natural elements are brought together in a special composition to form a whole.

In this new type of architecturally formed nature, the word "architecturally" is misleading. We ought, rather, to say that this is a piece of nature that has been given artistic form by human beings. We reserve the term "architectural" for the deliberate artistic forming of nature, which just represents as such an analogy to architecture. In the English garden the intervention is limited to the composition of the various elements

of nature. The special choice of trees is already an essential element of the composition, but the same is also true of the meadows, paths, bushes, groves, brooks, and little lakes. Sometimes little bridges and a small decorative building are included in this type, but only as a completely subordinate element in the overall complex.

CHAPTER FOURTEEN

Applied Art [*Das Kunstgewerbe*]

APPLIED ART COVERS a wide field in which aesthetic values find their realization. We must begin by noting a decisive difference between the applied arts and works of art in the true sense of the term. Not only is it possible to replicate innumerable times an object of the applied arts: it is in fact meant precisely for this purpose. A type of tableware, such as Meissen porcelain, is the invention of a type, not of an individual thing. A picture can indeed be copied, but the copy is only a copy; it is something secondhand, and even if it is a very successful copy, it can never replace the original. The distinction between original and copy does not exist in the applied arts. Meissen porcelain, as distinct from Nymphenburg or Wedgwood porcelain, is the designation of a type, and the individual exemplars of any one of these types are on the same level. The invention of such a type is meant to recur in innumerable individual structures. It is not possible to call one of these the original and to designate the others as copies.

Something analogous occurs in good reproductions of certain works of art, for example, in copper engravings. There are many prints of equal value of the Piranesi engravings, since the invention of copper engraving is oriented to the printing of many exemplars of equal value. In copper

engravings, first and later prints take the place of the original and the copy. The later prints come from secondhand copper plates.

The distinction between an individual object that bears artistic values, such as a statue, a picture, or a drawing, and a type of object that is meant for replication (so that there is no "original" and no "copy") is very characteristic of art in the proper sense and of the applied arts.

The two themes of the applied arts

Like architecture, the applied arts possess two principal themes, a practical and a purely aesthetic theme.

A part of the applied arts has a close link to interior architecture. Although such things have functions of their own, their relationship to interior architecture and their importance for the beauty of interior space is so great that the applied arts become a part of the interior architecture as furnishings. This includes above all the furniture in a residential house, the curtains, carpets, and mirrors, as well as the vases and flowerpots that decorate a room. In churches, the choir stalls, the confessionals, the kneelers, and other fittings are a counterpart to these furnishings.

The other part of the applied arts does not belong to interior architecture but enters into specifically practical life. Examples are cutlery, crockery, glasses, tablecloths, and above all clothing and jewelry.

Objects of the applied arts can be bearers of beauty to varying degrees.

With the exception of carpets and jewelry, their primary theme is obviously not aesthetic but practical, in the narrower sense of this term, unlike architecture, which has both a real theme that belongs to life and an artistic theme. A dining table, a writing desk, a chair, a cup, a plate, or a fork has first and foremost a markedly practical purpose. They are instruments for various activities in our daily life, or else they serve, like a cupboard and a chest of drawers, for the storage of various objects.

In architecture, the two themes are equal, and they are indeed so much independent of each other that the beauty is conditioned by factors that do not depend on the real purpose. On the other hand, the two themes are closely linked, and the real theme, for example, of a residen-

tial house, a town hall, or a church, makes specific demands of the artistic form. Failure to meet these demands is a grave defect even from the artistic point of view. And the failure to meet a demand that concerns only the real theme is an even graver defect: for example, when a church looks like a beautiful reception hall.

In the field of the applied arts, the practical theme is much more radically separate from the aesthetic theme. An object in the applied arts can be very beautiful without fulfilling the practical purpose; similarly, a knife can cut excellently and be ugly, or a chair can be very comfortable and yet unbeautiful. This possibility does not in any way alter the fact that the fulfilling of both themes is desirable. If the whole of practical life is permeated by beauty, this results in a great value that continually nourishes our spirit through the contact with a higher world—with culture in the specific sense as opposed to mere civilization. As soon as the practical perspective gains the upper hand completely and decides everything, life is stripped of its poetry, with much more serious consequences for the happiness and the health of human beings than one imagines. The victory of comfort over beauty, which we have mentioned in the introduction to the first volume of the present work, manifests itself here in a special way.

A completely new situation arises in the industrialized world, of course. We shall discuss in the final section whether machines (as opposed to tools of every kind) can be beautiful in the same sense.

The relationship of the applied arts to interior architecture

If a cupboard, a chest of drawers, a table, or a chair is in itself trivial and tasteless, it spoils a room that is in itself noble and poisons its atmosphere. In order to fulfill their function in interior architecture in a genuinely satisfactory manner, not only must such objects be beautiful in themselves; also, their dimensions must fit the room. They must be set up in the correct position in the room. They must be placed in a light that is advantageous to them, and so on.

The relationship of these objects to interior architecture is a very im-

portant factor. A cupboard has not only the practical purpose of storing clothes, and it is not only essential that its doors should not rattle and creak when they are opened and closed, but it also must necessarily stand in an interior space. Its practical theme requires that it does not stand in a woods or in front of the door of the house. The same applies to the other furnishings.

As practical structures, a cupboard and a chest of drawers have not only their immediate purpose, but also the task of contributing to the form of a house that is initially empty. The same is true of their aesthetic theme. They should be beautiful in themselves. At the same time, they have a specific function for the beauty of the interior space or the interior architecture.

A similar situation exists with regard to curtains and carpets. And large vases of every kind can possess in themselves a noble beauty, and can be important for interior architecture.

Clothes, on the other hand, do not belong to interior architecture. It is true that splendid costumes made their contribution in olden days to the elegance of a festal hall, but this possibility does not make them a part of the interior architecture. They do not form the enduring aesthetical character of an interior space. Their practical function is unambiguously that of clothing human beings in a way that is appropriate to one specific situation. It is clear that jewelry likewise possesses no function for interior architecture.

Factors giving rise to beauty in various kinds of objects

Since this is a work in aesthetics, the following questions interest us: What factors influence the beauty of these objects? What kind and degree of beauty can these individual types attain? How important are they in comparison to pure works of art? As we have seen, the fulfillment of the practical purpose in objects of the applied arts is largely independent of the aesthetic value. This, of course, does not mean that a knife should not look like a knife (rather than a spoon) even from the aesthetic point of view. In other words, whether a knife is sharp and cuts well, or wheth-

er it can be taken hold of easily and comfortably, is completely unimportant for its aesthetic value. But its function, which largely determines its appearance and its form, is naturally important for its aesthetic value. A chest of drawers that is much too low and too long is no longer a chest of drawers. Even when one can comfortably store the same things in it, it is nevertheless a different structure. And this clearly influences the aesthetic value. But whether the chest of drawers is practical, whether it is easy to move its drawers in and out, whether they groan and creak when one does so: this does not change its aesthetic value, which depends on factors such as form, proportions, material, color, and ornaments. With sofas, armchairs, and chairs, of course, the quality of the material with which they are covered matters, as well as its pattern; with damask, it is the design that matters. But here too the main aesthetic point is the form of the individual objects, of their legs, armrests, and ornaments. With curtains, not only the material and color but also the kind of weaving and the design are important.

With carpets, the situation is completely different. They offer many possibilities for creative imagination and genuine composition. Here too, of course, the quality of the material plays a role. Above all, however, the color and design are important and closely interconnected. The kind of creative imagination we find in a carpet includes essentially not only the design imprinted on it but also its color or the combination of colors. This is an indispensable part of the composition of the carpet, and it is on this that its beauty largely depends.

The beauty of vases is conditioned above all by their material and form. Vases of porcelain often bear very beautiful designs. Old Chinese vases, in which the design has a prominent place, are further examples of this type.

There are also vases that no longer count as applied arts but are pure works of art, such as many ancient vases, which constitute only the basis for real paintings. The factors for the beauty of such vases are the same as in the sphere of painting.

With plates and dishes we find again that the beauty depends on form and material as well as on pattern and decoration. How charming is English earthenware along with the form of the plates and their pattern!

Naturally, we cannot answer here for every type of object the question of the factors giving rise to aesthetic value or disvalue. All we are doing is to highlight those types in which these factors are very varied.

Here we must above all mention clothes. There are various styles in the individual historical periods and countries, and this is why, in addition to the beauty of the material (such as wool, silk, satin, linen, or cotton) and the color, one must adduce the specific style as a decisive factor for the beauty of the clothing. Some styles are more beautiful than others. A man's garment from the Baroque period, for example, from the reign of Louis XIV, is much more beautiful than a suit from the Empire period.

An additional factor is the way in which an individual suit is made and how well it fits one particular person. This is the special achievement of a tailor, and distinguishes a good tailor from a bungler.

Over the course of the past century, the style of clothing that had existed in all previous periods and that showed aesthetic imagination ceased to exist. By adopting long trousers, men's clothing abandoned fullness of expression and aesthetic imagination. This kind of clothing is a typical product of a world deprived of poetry. A suit like this cannot be beautiful in the genuine sense of the word. It can indeed bear the quality of elegance, which is indubitably an aesthetic value, but elegance is clearly distinct from every type of beauty. Elegance moves, so to speak, on the edge of the aesthetic realm of value, which has beauty at its center.[1]

In women's clothing, even after the death of the styles of clothing in the full sense and their replacement by mere fashion, there remains much more room for aesthetic values. Such garments can be not only elegant but also beautiful.

The situation with hats is analogous to that with clothing. The importance of the material of a hat in comparison with its form is much smaller than in the case of clothing, but otherwise all that we have said applies by analogy, including the replacement of beauty in men's hats by elegance.

1. See *Aesthetics*, vol. 1, chap. 18.

With regard to the factors that determine aesthetic value, jewelry is in a class by itself. The material occupies a completely new place. The importance of the jewels is obvious here. Not only gems and semiprecious stones but also gold and silver are particularly valuable materials. They stand out from the other metals, even from the aesthetic point of view. The setting of the jewel is decisive for its beauty. It is surprising to see how a setting can make the most beautiful gem and every jewel, whether ring, brooch, or pendant, tasteless, giving it a markedly negative value. On the other hand, a noble setting can make a jewel with modest semiprecious stones something markedly beautiful.

Jewelry does not belong to the realm of the applied arts, because its theme is purely and exclusively aesthetic, although it is not only an entity in itself, but is meant to adorn the human being.

Hierarchies of beauty in the applied arts

It is not difficult to see that furniture can attain a higher type of beauty than every other kind of applied art. A genuine Bologna table or an original, perfect Louis XV chest of drawers can attain a high degree of beauty and nobility and irradiate a noble atmosphere that in turn has a corresponding influence on the beauty of the interior architecture. The weight of the "word" of a piece of furniture is greater than that of all the other objects in the field of the applied arts. The disvalue of a tasteless, excessively ornate, or boring piece of furniture is likewise more important and weighty than that of other objects from the applied arts.

This is why it is more important in the case of furniture than in other areas to specify how they differ from a work of art. The possible artistic beauty in furniture is so lofty that it is much more difficult to draw a boundary line between it and a work of art than in the rest of the applied arts. Let us ask ourselves why we do not speak of a splendid Baroque display cabinet as a work of art in the full sense. What is the formal difference between the display cabinet and a beautiful piece of architecture, a picture, or a statue? Is it only that the cabinet also serves a practical goal, and is also an object meant to be used? No, since that would apply

to architecture too. Is it the fact that the cabinet can be replicated in nu-
merous exemplars—not indeed in a mechanical manner but on the basis
of the sketch of the artist who has designed it? This is certainly one char-
acteristic difference between works of art and the applied arts in general,
and it is important here too. Another factor in pictures and statues is that
they do not have two themes. Their *raison d'être* is artistic beauty. But ar-
chitecture too has two themes, and yet a house, a palace, a town hall, and
a church can be a real work of art in the highest sense of the term.

We must understand that a piece of furniture has in any case a more
limited possibility for artistic beauty than an architectural structure. It
can never possess the same fullness and depth that we find, for example,
in the façade of Santa Maria Novella in Florence. In principle, furniture
(and even the most beautiful pieces) are more modest entities. Indeed,
they must possess this modest character if they are to be truly beautiful.
If one were to design a piece of furniture, such as a cupboard or a chest,
in the same way as a palace, it would immediately lose any possibility of
being beautiful.

Can furnishings ever attain a beauty of the second power? This is
undeniable. Nevertheless, this beauty never stands on the same level that
a work of art can attain, nor would it ever make such a claim. Its possi-
bilities are more limited, and it need not possess the beauty of a work of
art in order to be perfect.

Although furnishings indubitably have the first place among the ap-
plied arts with regard to the rank of the beauty that is attainable, many
other objects in this sphere do not have such a marked hierarchy of
beauty. Damask curtains can possess considerable beauty above all in
themselves, but also in their function in interior architecture; and car-
pets often possess in themselves a fascinating beauty. But apart from the
precedence of furniture, it is not possible to observe any marked hierar-
chy. Nor is the beauty of vases unambiguously different from that of the
other objects we have mentioned, with the exception of the ancient vases
that undoubtedly belong in the realm of art. The same applies by analogy
to lamps and lights of every kind.

There is a marked difference in rank in the case of glasses and table-

ware. Their possibility of attaining beauty is more limited than, for example, the possibility of carpets. Even the most beautiful tableware, such as that of Meissen, Nymphenburg, etc., can never attain the beauty of precious carpets. This possibility is even more modest in the case of knives, forks, and spoons.

Jewelry occupies a position of its own. Since its beauty goes in a completely different direction, it is difficult to integrate it into this ranking. It is fairly easy to see that its beauty cannot attain that of furniture, but a comparison to all the other products of the applied arts is almost impossible. It is clear that the size of a jewel also plays a certain role. A crown or a tiara has more space for the elaboration of aesthetic values than a ring or a necklace. But the beauty that a jewel can attain in general terms is so various that it is hard to answer the question of its ranking.

It is easier to define the ranking in the case of clothes and garments. We must emphasize above all that in earlier periods, when garments had a definite style, there was a much richer elaboration of beauty. In these styles there sometimes existed a beauty similar to that of curtains.

Beauty and elegance as found in machines

We have already mentioned the difference between a tool and a machine,[2] which is the subject of a masterly discussion by Theodor Haecker.[3] He emphasizes the differing role of the person in the production of objects with tools and with machines. This, of course, is also the source of the great difference in the objects. The painter needs a brush for a picture, and the sculptor needs chisel and hammer for a statue; but razor blades or banknotes are produced with machines.

Our question concerns a completely different problem: Can machines, as distinct from tools, be beautiful: a locomotive, an automobile, an airplane or a modern ship, a truck and machines of every kind? Do they too belong to the sphere of the applied arts?

It cannot be denied that many kinds of machines look like monsters.

2. See *Aesthetics*, vol. 1, chap. 10.
3. *Was ist der Mensch?* (Munich: Hegner-Bücherei im Kösel-Verlag, 1948), pp. 36ff.

From the aesthetic viewpoint, they are dreadful. We shall not discuss here the question whether it would be possible in the course of time to achieve the same goal by means of a machine that was less monstrous, or at least aesthetically neutral.

We are interested in the kinds of machine that can possess an aesthetic value. An airplane, especially during its flight, can have an aesthetic charm, and a locomotive can communicate an impressive expression of strength and possess a certain kind of beauty. Automobiles can certainly be divided into neutral, ugly, and elegant, but what we see in a car is not the machine, not the motor, but the external form of the vehicle, the proportions of the bodywork, and so on. It would be wholly wrong to assert that unlike a horse-drawn carriage, an automobile is aesthetically neutral. It no longer possesses the beauty of the carriage, but it can be either elegant or inelegant.

In the same way, a modern ship with its chimneys never attains the beauty of a sailing ship. Nevertheless, when it is compared with another ship, it can possess elegance through the way in which it is constructed.

In the field of the applied arts, of tools, and of practical objects of every kind, beauty in the full sense of the word is a theme. Throughout the field of technology, the aesthetic theme has become peripheral. Where an aesthetic value is present, however, beauty is replaced by elegance.

It is of course impossible to define elegance, any more than one can define beauty. We can employ examples to indicate it or to give an indirect description of this quality. The beautiful elevates us and inspires us, it speaks to us from above; the elegant charms us and pleases us, but it does not speak to us from above. It can never take hold of us.

In contrast to beauty, fashion and the zeitgeist play a role in the quality of elegance. An automobile from 1910 looks comical, stiff, and clumsy today, but it did not in the least make that impression on us in 1910. This is not at all to deny that elegance is an objective, lasting quality of an object, and not merely a subjective impression that changes in keeping with fashion. All we wish to underline is that the influence of the zeitgeist and of fashion, an influence that is completely missing in the case of beauty, plays a role in elegance.

There are, of course, time-conditioned prejudices and obstacles to the full understanding of beauty. But the influence of fashion is not present when we look at works of art. This influence is present when we look at clothing and machines, where the fact that we are no longer accustomed to something leads us astray into an act of seeing from the outside, at least in the first moment.

Two dimensions must be distinguished in elegance. First, there is the elegance of the good fit of a garment in an individual case, or the fact that an individual automobile such as a Cadillac or a new Mercedes is well made. Secondly, there is the elegance of a type of automobile, such as a Lincoln or Mercedes. Elegance naturally plays a greater role in garments than in automobiles. Apart from the manual work involved in making a suit, as opposed to the mechanical production of an automobile, the entire dimension of fitting well, of adaptation to the shape of the individual human being, plays no role in an automobile.

Elegance is only marginally present in nature.[4] It does not in any way possess the spiritual fullness of the beauty of the second power.[5] It does not "sing" as all beauty sings (even the beauty of the first power). It contains neither the greatness and depth nor the poetry of beauty in the proper sense.

4. See *Aesthetics*, vol. 1, chap. 18.
5. Ibid., chap. 10.

CHAPTER FIFTEEN

Representation in the Imitative Arts

ARCHITECTURE IS, in a certain sense, the presupposition for all the arts, though in a very special and intimate manner for sculpture. There exists a radical difference between architecture and the art genres of sculpture, painting, and literature: unlike these, architecture is not an imitative art.

The phenomenon of representation [*Wiedergabe*]

The being of imitation or representation is very different in these three arts. The principal difference, obviously, lies between literature, on the one hand, and the arts of painting and sculpture, on the other. In literature, the representation of life, of events, of human persons, and of nature comes about by means of language, of sentences and concepts. It thus employs a highly intellectual channel; it speaks of what is depicted, and it transmits a knowledge to us rather than a perception. Philosophical and scientific writings use the same channel, which is of fundamental importance both in understanding what is communicated as well as in life.

It is obvious that representation in painting and sculpture, which

address our mind through the eyes, is completely different. The representation that underlies painting is essentially different from the representation in sculpture, since it includes the transition from spatial three-dimensionality to two-dimensionality and is a much more remarkable phenomenon than the representation in sculpture, which generally does not include this step.

Here, however, we are interested not in the possibility of depiction in the various arts, but in the very general relationship between that which is represented and the work of art that represents it, and in the importance of an exact representation for the value of an individual work of art.

We prescind in the present study from those types of art that explicitly do not keep to that which is represented, or that eliminate representation. An example of the former is the art of Picasso, who intentionally changes in a wholly arbitrary manner the forms and things that he depicts, so that the nose of a female form suddenly appears in profile, although the face is depicted frontally. The latter, the elimination of representation, takes place in so-called abstract painting, in which colors and forms, without depicting anything from nature, are meant to communicate a specific content directly in their composition, somewhat like the pattern in a carpet. We prescind here from structures where one can discuss the extent to which they deserve to be called a "work of art," and from Dadaism in poetry, that is to say, from poems with words that mean nothing.

In our discussion of the problem of representation, or of the relationship between that which is represented and the work of art, we limit ourselves to the art of earlier cultural epochs up to the period before the First World War. With regard to literature, we continue the discussion down to the present day.

Representation in painting and sculpture

It goes without saying that a work of art is no mere representation of nature or of life. A picture, a fresco, or a drawing was never merely a faithful representation of nature, as in photography.

It is true that the correctness of the representation may be the real goal for a child who draws something, or among certain peoples; and the more they succeed in doing so, the greater their satisfaction. If they draw a face, the resemblance is the decisive point for them. But even a painter in the golden age of Greek art, Apelles, is said to have painted pictures with such a strong resemblance to nature that the birds wanted to pick the grapes depicted in one of his paintings. This story is absurd, because only human beings are able to recognize something that is depicted in a picture; animals cannot do this. Nevertheless, it shows that for the naïve onlooker, the resemblance to what is represented counts as a sign of the perfection of the image or of the painter's skill.

Those who understand something of art know that in all the great cultures a work of art is incomparably more than a mere faithful representation of nature. It may be that the artist has not attained the consciousness that would allow him to give a full account of the completely new element in the work of art and of its value. Nevertheless, if he is a true artist, he aims at this new element, which is the real artistic content, and in any case he gives it expression in his picture or his sculpture.

Our interest lies, not in the consciousness of the artist in his creative process, but in the objectively new element of the true work of art, the element that goes beyond a pure representation of what is depicted.

In most of the significant frescos and pictures (apart from portraits), only elements of nature are employed: trees, rivers, mountains, meadows, animals, and human figures. That which is depicted, including the clothed or naked figures, is made up. Usually these are fictitious landscapes and fictitious figures. The element of resemblance, which is important in a portrait, is not present here, and these images also differ from pure representations and photographs by the fact that they are made up. This making up is a central element. But even if they are not made up, the artistic transposition nevertheless remains.

Besides this, the task of adequate depiction remains, since trees must be recognizable as such. The same applies to everything else in nature that is depicted, and all the more strongly to the figures in pictures. In

naked figures, it is important to reproduce the nobility of the human
body, its proportions, and so on.

In its composition, the picture or fresco is a fruit of the inventive
imagination, of a completely new creative process. This is true of all the
other elements, such as the type of colors, of the light, of the contrasts,
and of many other things.

The artistic value of a picture and of a sculpture, their importance,
beauty, depth, and poetry, the inner truth and the spiritual riches that live
in them, are determined by factors completely different from the mere
correct representation of nature, of human figures, and so on.

This does not mean that representation makes no contribution to the
beauty of a work of art. Above all, it has the character of a presupposition.
Many things in a picture may be distorted. For example, human legs may
be too long, or the legs of horses may have strange proportions, as in im-
portant paintings by Hans von Marées. But this cannot undermine the
artistic beauty of the painting. The very imprecise representation of the
naked human body on medieval crucifixes does not destroy the moving
beauty of their expression. Indeed, some intended abnormalities, which
however remain completely within the framework of the representation
of nature, can express a specific artistic content and are required for this
purpose, although one is entitled to wonder whether the exact represen-
tation of the human body in its mysterious beauty is not an advantage,
even from the purely artistic standpoint. The depiction is invariably and
necessarily an artistic transposition; this decisive factor must always be
present, if a picture is to be a work of art at all.

Resemblance, in the sense of a merely correct representation as in
a photograph or—I shudder to mention it—in a waxwork that we ini-
tially take to be a real human being, is out of the question in a work of
art. However, the deep understanding and penetration of the structure
and the anatomy of the human body, such as we find in an artist like
Michelangelo, is certainly a bearer of high aesthetic values, or at least an
important contribution to the beauty of the whole.

In view of the ultimate, moving beauty of Michelangelo's *Dying Slave*
in the Louvre or of his Medici tombs in Florence, we cannot overlook

the important function that the profound penetration and indeed the exact knowledge of the human body, as well as the perfection of its depiction, possesses for the beauty of these works of art. Other examples are Giorgione's *Venus* and his *Tempesta*.

We shall return to all these questions when we discuss painting and sculpture. Here we wish only to draw attention to the great importance of the exact representation of that which is depicted in these arts, of course always presupposing the artistic transposition, which is always more than a flat reproductive resemblance, but is a drawing forth of the mysteries that already lie hidden in the nature of what is depicted.

The correspondence with reality in literature

The agreement with reality in literature is of a completely different kind. The novel and the play deal with human characters, with events, situations, and conflicts of human life. Mostly, of course, these are fictitious persons, events, and situations, unless the works have a purely symbolic character. But that does not prevent the description of human beings, their characters, their feelings, their joys and sufferings, and of tragic events and dramatic situations from being filled with psychological truth in the highest sense of the term. The element of fiction does not entail a distortion of life in its depth. It is clear that the agreement with reality is of supreme importance. When we speak of "reality," we do not mean that the characters must be persons who truly lived, or that the work of art must be in accordance with the typical sequence of real events in the manner of an inartistic and awkward realism.

What we have in mind here is the delight we experience when we read Dostoevsky's *Crime and Punishment*, when we encounter the profound psychological truth even of minor characters like Luzhin or Marmeladov's widow. What a wealth of psychological differentiations comes to meet us in Dostoevsky's novels! No one has ever equaled the mastery with which he renders the phenomenon of a young man in puberty letting himself be impressed by another and at the same time desiring to impress others. We see this in the figures of Kolya Krasotkin in *Crime*

and Punishment, Ippolit in *The Idiot*, and in the protagonist of the novel *The Adolescent*. This profound psychological truth is a decisive factor in the artistic greatness of these works.

There are many characters in literature that fail to convince only because they are either colorless or psychologically off the mark. But how impressive is the profound psychological truth of the figure of Oblomov in the novel of the same name by Goncharov. This figure is presented in a way that includes a specifically Russian character trait.

This brief look at the realm of novels and plays can already show us the great importance of the correspondence with reality.[1] The artistic vitality of the characters, which makes them convincing, is of course something completely new in relation to the psychological truth.

One certain requirement for the artistic perfection of a novel or play is also the "probability" of its "story." This does not of course apply to literary works of art that explicitly possess the character of legend or fable, or to a play like Shakespeare's *The Tempest* or *A Midsummer Night's Dream*. In a novel, on the other hand, the plot must not be improbable, either in the sense of a *deus ex machina* or in the sense of being far-fetched. A story may be surprising and unusual, but it must retain a certain relationship to reality, and one can call this relationship (doubtless inadequately) probability. Certainly, much more is required for a true work of art. Just as the artistic vitality and the successful representation of the characters in novels and plays depend on elements completely different from mere psychological truth, so too the inherent necessity and convincingness of the *fabula* (the story) of a novel or play far exceeds its probability. This is indeed one condition for a literary work of art, but is not a sufficient ground for its value. But improbability is a flaw.

We are not yet concerned with the factors that are responsible for the artistic value of a novel or a play, but only with faithfulness to life and reality, with the phenomenon of exact representation and its importance

1. Kierkegaard says: "Thanks be to you, great Shakespeare, you who can say everything, everything just as it is ..." ("Problemata," "Problema 1," in *Fear and Trembling*, trans. Howard V. Hong and Edna H. Hong [Kierkegaard's Writings, 6] [Princeton: Princeton University Press, 1981], 61).

for the play or novel. This faithfulness does not shackle the imagination and the creative talent of the artist.

The importance of the truth of the spiritual cosmos, of the fundamental worldview, is of course much more important for a literary work of art than this faithfulness in relation to reality.[2] This worldview is concerned not with representation but with the spiritual space into which the work of art is inserted, and it intervenes profoundly in the course of the plot.

Transposition and the metaphysical dimension in literature

One important factor in the relationship between an imitative work of art and that which it represents is the artistic transposition that essentially distinguishes a work of art from any mere representation. This is very mysterious, but it manifests itself clearly in certain facts.

In a novel, a play, or an epic that is a literary work of art, metaphysical beauty can be of great importance for the overall artistic beauty of the whole work. Examples are the characters of Cardinal Federigo Borromeo and Fra Cristoforo and the conversion of the Unnamed in Manzoni's masterpiece, *The Betrothed*. The metaphysical beauty of the moral values of the characters as a whole makes a decisive contribution to the artistic greatness, depth, and beauty of the novel. But this metaphysical beauty of the characters would be artistically useless if they were not presented as convincing, living figures. Cardinal Newman's novel *Callista* also deals with noble figures, but this work is not an important and beautiful novel, because it lacks the artistic transposition.

As we shall see in our discussion of literature, transposition is much more than merely the living creation of personalities. In his biography of Saint Francis of Assisi,[3] Johannes Jörgensen fully succeeds in drawing a living, genuine picture of this personality (this is unfortunately not the case in many biographies of saints). Nor can one deny that Jörgensen succeeded in this because he possessed certain artistic abilities. The living

2. See chaps. 30, 32, and 35 below.
3. *Saint Francis of Assisi*, trans. T. O'Conor Sloane (New York: Doubleday, 1959).

creation of a personality always implies an artistic gift. Nevertheless, this biography is not in the least a novel, nor is it a work of art. Its theme is not an artistic value, but the exact historical representation of the figure of Saint Francis. The truth is its theme, namely, the demonstration that such a man genuinely existed and that all the utterances of this saint are in fact authentic.

In Manzoni's *The Betrothed*, artistic greatness and beauty are the theme, and the metaphysical beauty of the figure of the Cardinal is at the service of the overall beauty of the work. It is true that the first step is the living depiction, which is also achieved in Jörgensen's work and, as we have said, includes an artistic ability. But the transposition goes far beyond the living, satisfying elaboration of the personality. It implies integration into the world of the novel as a whole, which is a distinct structure.

The literary work of art is a completely new world in relation to life and reality, and this can be seen most clearly when we reflect not only that the metaphysical beauty of a great, noble character in a novel or a play does not in the least heighten the artistic beauty of the novel or play if the artistic transposition is lacking, but also reflect that the metaphysical ugliness of a monster such as Don Rodrigo in *The Betrothed*, Iago in *Othello*, or Richard III in Shakespeare's play of the same name makes an outstanding contribution to the artistic beauty and greatness of the work of art.

If we encounter a monster in real life, or Hitler and Stalin in history, they are nothing but repellent. Their existence is a terrible evil, and their metaphysical ugliness is a pure antithesis to all beauty. The trivial, tasteless human being and the banal, mediocre person are likewise in reality a marked antithesis to all beauty and poetry, due to the distinctly deadly atmosphere that they diffuse. But the depiction of such a person (in contrast to others) in a novel or a play can make an outstanding contribution to the beauty and importance of the work of art.

This radical difference between reality and the world of the literary work of art makes it possible for something that has a purely negative value in reality to share in bearing the artistic value of the work, provided

that it is not only accurately reproduced but has also gone through the process of artistic transposition. And this difference sheds an important light on this process. Let us attempt to list the elements on which the transposition is based.

First, there is the difference between reality (for example, a person who exists in real life) and the mere representation [*Darstellung*] of a fictitious personality.

Secondly, and closely linked to this, there is the difference between a person who is concretely present, or an event that genuinely occurs, and its mere representation.

Thirdly, there is the radical difference in the theme. For a real human being, the moral values or disvalues through which God is honored or offended are thematic. The real existence of a morally wicked deed is itself a disvalue, a great evil. And every error that is committed by a real human being, his mediocrity, his shallowness, and triviality, are definite evils. Besides this, the states-of-affairs of the existence of these evils are definitely disvaluable. In the representation of all this, however, the evil of real existence is lacking. The theme is no longer the moral or intellectual disvalue but the artistic value of the representation.

This value must not be understood to mean that the theme is the mere perfection of the representation, the success of the representation, the agreement with reality. Rather, the theme is the beauty of the whole work, its artistic greatness and depth.

The difference in theme is of great importance and explains why a figure like Richard III inspires only horror in real life and meets us only as pure evil, whereas in the play, he is no less terrible but is nevertheless an important bearer of the greatness and beauty of the drama. In a work of art, we are looking in a completely different direction, namely, to the thematic artistic value. It is essential here that we apprehend the moral wickedness of Richard III. The artistic theme and the fact that we are looking at the artistic beauty do not in any way exempt us from the full apprehension of moral values. They do not compel us to take an amoral position. On the contrary, an amoral position, an indifference to the categories of good and evil, would be fatal for our understanding of the work

of art. The artistic importance of the representation of evil presupposes a particularly clear apprehension of the moral abomination and of its dreadfulness. In a true work of art, good and evil are called by their real names, and the whole work is permeated by this primal tension. Besides this, there is an unambiguous elaboration of the dreadfulness of evil, in order that we may apprehend its metaphysical ugliness with particular clarity; indeed, we can often apprehend it here more clearly than in real life. Nevertheless, the theme in a play lies elsewhere.

Fourthly, a work of art displays a curious distance from what is represented. The character that is created does not capture the spirit of the entire work. The wretched hypocrite Tartuffe is only represented, as one figure among others; the play as a whole is not permeated by the spirit of Tartuffe, and it is not the expression of his spirit. Rather, Tartuffe is characterized as a despicable hypocrite, and Molière nowhere identifies with him.

We shall return to all these points. Here let me only point out how much is included in representation in the imitative arts, and especially in the decisive artistic transposition. The spirit of a work of art is essential to it, as is the spiritual world into which it leads us. This is not at all synonymous with the spirit of the artist and with his personal worldview. Even less is it synonymous with the spirit of a person who is portrayed.

At the same time, we have seen that the concept of imitation in painting, sculpture, and literature varies considerably in many respects. All this will become clear in the separate discussion of these arts.

Sculpture

The Artistic Importance of That Which Is Represented in Sculpture

THE GREAT THREE-DIMENSIONAL works of art are typical bearers of a beauty of the second power. Their lofty spiritual beauty is attached to visible structures.

It is clear that by far the most intimate relationship among the arts is the one that exists between architecture, which creates the human space that is the presupposition for all the other arts, and sculpture. Not only does architecture form a base for sculpture, as it does also for music and drama and (in a new sense) for painting; architecture and sculpture can contract a marriage that presents a certain analogy to the marriage between sound and word.

Unlike literature, in which the work of art is given to us through words and sentences, rather than on the immediate path that is also formally given in experience, architecture, sculpture, and painting address our spirit through the eyes. Their content is a visible structure. We emphasize this, because we wish from the outset to restrict those elements that are not of a visible nature, such as the title that is given to a statue.[1]

1. See chaps. 3 and 21.

The question whether a classical statue depicts Apollo or Mars has no influence on the artistic value of the statue. In general, the importance that a three-dimensional work of art acquires when it is given a name, such as the name of a great and famous man, is of a non-artistic nature. The question whether it is a monument to Louis XIV of France, Napoleon, or Prince Eugene does not influence the artistic beauty; in a bust, however, the person of the one depicted is doubtless important. A bust is meant primarily to reproduce the specific personality of the one depicted, and it is definitely a defect when it does not fulfill this requirement.

Does this makes it legitimate, when we look at a bust, to rejoice in the historical importance of the one depicted, and to think of all that we know about him from other sources—in other words, to include the pleasure that comes from literary sources?

On the one hand, there is the legitimate interest that is owed to an historical personality. On the other hand, one must ask to what extent our concentration on what we know about the personality of the one depicted is permitted to be a source of artistic pleasure. But what is given in the bust or statue in such a way that we apprehend the charm and the atmosphere of the personality, even without knowledge derived from other sources, belongs of course to the work of art and is not in the least the product of external association.

A monument to Louis XIV should convey and make visible something of the splendor, power, and "breadth" of his personality. If it depicted him as a harmless, modest person, that would be an artistic error. This, however, is an error of a kind completely different from the boring representation of horse and rider; it is what might be called an "inner-sculptural" error.

With regard to the depiction of Christ, the situation is completely different, because both the artistic beauty and the religious dimension are thematic. Since a crucifix is not present in a church only in order that it may be looked at as a work of art, but in order that Christ may be adored, the focal point in the overall theme of the crucifix is shifted. The artistic beauty is at the service of the adequate contemplation of the form of the crucified God-Man and of the sacrifice of the Cross. In a

depiction of the Child Jesus, the artistic beauty is at the service of the mystery of the Incarnation; in a depiction of the scourging, it is at the service of the Passion of Christ; and in the figure of the Risen Jesus, it is at the service of the mystery of the Resurrection. The question is not the extent to which the religious element *may* be thematic but, rather, the extent to which it *must* be thematic.

It goes without saying that the religious theme can never replace the artistic theme in the sense that the religious object would suffice in order to bestow an artistic importance on the work of sculpture. The opposite is true! A religious object makes particularly high demands of the artistic composition. On its own, it certainly does not make the rendering beautiful. There are many lapses precisely in this field. In addition to the triviality and sentimentality that undermine the artistic value, another factor can be the objectively almost blasphemous failure to fulfill the demands that are generated by the religious theme. We say "objectively blasphemous" because the subjective intention of the pseudo-artist may be excellent and indeed thoroughly pious.

This applies by analogy to depictions of the Mother of God and the saints as well.

Despite what we have said, however, it remains true that both in sculpture and in painting the artistic value is conditioned by the visible element, including the visible expression of the personality, and that the title as such is not a source of the artistic value.

Imitation and copy

Unlike architecture, sculpture is an imitative art. It presupposes visual reproduction, but not the step from three-dimensionality to two-dimensionality that is undertaken in the depiction of an object in a picture and a photograph.

The formal relationship between an equestrian statue and the figure of the real rider and the real horse is different in principle from the relationship in painting. It is only in the relief that we find a certain resemblance to the formal element of reproduction in painting, since a transition is

made to two-dimensionality (or better, to semi-two-dimensionality). But even in the relief, the way it differs from the depiction in painting is even greater, from a formal point of view, than the way they are like each other. To begin with, however, we prescind from the relief and limit ourselves to the formal depiction in statuary, including busts.

With formal imitation, we certainly do not yet touch the much deeper problem of artistic transposition, which is decisive not only in sculpture and painting, but also *mutatis mutandis* in literature. It is through this transposition that the individual work of art becomes a specific structure with a meaning and a value that go far beyond every imitation.

With regard to the purely formal non-artistic and preartistic relationship between a statue and the object, the first difference from painting is that a sculpture is three-dimensional and a picture two-dimensional. The second difference is that the statue, as a physical structure, possesses a formal resemblance to what it depicts; this is not the case with a picture. The statue has this resemblance in common with the doll and the waxwork, for they too are three-dimensional.

The figure in a waxwork museum possesses a type of resemblance that aims at a confusion with reality. Such a figure intends to mislead us into believing that we see a genuine human being. Its resemblance is meant to serve an illusion. The same is true of artificial flowers and fruits that are arranged as a decoration.

In all these examples, the relationship between the artificial and the real is a pure imitation that in fact does not intend to be a depiction or representation, but wants to be confused with the real object and to play the role of the real object. This imitation is no longer a representation. The relationship between the imitation and the imitated object belongs to the family of illusions, of fake jewels, imitation silk, imitation fireplaces, and so on. The decisive point is that the representation is replaced by an alleged identity.

The relationship to the original that underlies the copy of a picture, of a statue, or of a ring is of a kind completely different from an imitation that aims to deceive. The distinction between the copy and the original remains; the copy does not intend to be the original.

It is important for us to draw a distinction between a pseudo-reproduction, such as we find in a doll, and a genuine reproduction. The quasi-illusion of a child—dolls are meant for children—is not the confusion mentioned above, since the child definitely distinguishes the doll from a real human being or animal. It does not take a rubber dog for a real dog. What is involved is an "as if" reality, when the child plays with a doll or a toy bear. But the "being a depiction," "being a representation" is not so strongly emphasized, since this quasi-illusion exists.

The relation between that which is depicted and nature

The formal type of relationship between representation and nature that is present in every statue, apart from the relief, is indeed different from the type that serves a deceptive illusion and different from the type that serves a playful illusion, but as in these types, the step from three-dimensionality to two-dimensionality is not taken. This step is taken to a certain degree in the relief, and is carried out in a very pronounced manner in all pictures and drawings, and even in photographs. In contrast to this representation, there is a certain resemblance in a statue between the image and that which is portrayed: we find the same kind of object in both. But only human beings can make this form of depiction, and only they can understand it.

We prescind from all those sculptures that do not in the least represent nature but are formal structures that symbolize something or other. It is more than doubtful whether these types of structure can still be regarded as genuine statues.

Nor shall we discuss the statues of some expressionists who distance themselves completely from nature by arbitrarily putting together a few elements of nature, for example, only a head on two feet, or other inorganic combinations. Every attempt in art to ignore the "language" laid down by God, in which visible and audible things, or sentences in literature, can be bearers of artistic values, seems to us to be doomed to failure. Poems with words that are devoid of meaning are stillborn children.

Dadaism is a disastrous dead end. In our analysis of the being of the various arts, we therefore prescind from attempts of this kind.

It is clear that important differences exist within sculpture in the relationship between a work of art and nature, quite apart from the wholly decisive artistic transposition.

To begin with, the representation of nature means the dependency on nature in general, in keeping with which a figure that depicts a naked body takes account of the inner formal principles of the human body. Clearly, what is involved here is neither the reproduction of one individual body nor the relationship that a bust has to the head of an individual human being. This same general dependency on nature is also found in a statue that depicts a horse or a bull.

Within this relationship to nature, the artist has a great freedom. He can go in various directions, if this is artistically motivated. Thus, Michelangelo's figures on the Medici tombs have superhuman dimensions, but they respond in a unique way to nature, they penetrate deeply the inner formal principle of human bodies. It is well known that Michelangelo attributed great importance to anatomical knowledge.

Some medieval crucifixes display a freedom of reproduction that goes in a completely different direction, but they never breach the formal principle of the human body, unless this is due to an inability to represent it correctly.

This dependency on nature in general must be distinguished from the representation of an individual personality in a bust or in a portrait, in which both a dependency on an individual face and a dependency on an individual personality are thematic. The bust must not only display a resemblance. It ought also to represent the expression, so that it lets the entire personality of this human being shine forth.

In many statues, it is a defect when the face has an excessively individual character. This is required in a bust, but it would be a defect in a statue such as Michelangelo's *David*.

A further difference in the relation to that which is depicted is the fact that sculpture—for example, a statue or an equestrian statue, but not a relief—enters the reality that surrounds us in a manner complete-

ly different from that of a picture, a drawing, a fresco, or a mosaic. In this regard, sculpture is closer to architectural structures. Nevertheless, sculpture differs from architecture much more strongly than it differs from painting, because like the latter (but unlike architecture), sculpture belongs to the imitative arts.

The canvas and wooden tablet are structures that stand completely outside the relationship of depiction. As objects, they are a world away from the objects that are represented in the picture. In a statue, on the other hand, the real object is completely integrated into the relationship of representation. The figure of marble or bronze is a material object, a spatially extended body. It is in the same real space that we occupy. It is of course true that as a lifeless material structure, it is radically different in an ontological sense from a real human being or animal. But the difference in the type of representation in sculpture and in painting is obvious.

In a picture, and even more in a drawing or a photograph, the real object is completely outside the depiction and representation. This is why, in a picture, it is only the completely independent basis, such as a canvas, that enters into the world that surrounds us, whereas both a sculpted figure as a whole, in its capacity as bearer of the representation, and indeed the deeper content of the work of art enter into the real surrounding world.

The canvas or wooden tablet on which the picture is painted has a relation to the painting that is entirely different from the relation that the material mass of bronze, stone, or wood has to the sculpted work of art.

In the latter, the relationship to the work of art is much more intimate, and this is also why the spiritual structure, the sculpted work of art, is more strongly integrated into the human space that surrounds us. A work of art like Michelangelo's *David* or Donatello's *Gattamelata* is located in the reality that surrounds us.

This entrance into the reality that surrounds us is similar to what happens in architecture, and it is of course particularly pronounced when a statue belongs to a square, as in the case of a monument, or is united to architecture, as in the case of figures on a fountain or decorative figures

on a building. The closer the relationship to the architecture, the more strongly does it project into reality.

As we have indicated, the situation in a relief is different. Since it is a semi-two-dimensional structure, the formal representation is closer to what we find in painting. As an ontological structure, the relief is more closely related to what is depicted than is a picture, a drawing, or indeed a photograph; but it is much further removed from what is depicted than is a statue or a bust. A relief does not possess the ontological similarity (which lies outside the representation) that statuary has to what is depicted.

The Various Types of Sculpture

I N T H E P R E S E N T C H A P T E R, we shall first present briefly the various types of sculpture, and then the types of objects that are depicted in sculpture. We conclude with a discussion of the means employed in the production of sculptures.

Types of sculptures include an individual statue, a group of figures, a monument, a decorative statue that is closely linked to architecture, a relief, and a bust. Coins with heads or figures form a family of their own.

The objects that are represented in sculpture

These types lead us deeper into the world of sculpture. In sculpture representing the naked and the clothed human body, we encounter the question of the extent to which the latter is artistically viable. The clothed human body is a very rewarding object for sculpture when there is a decorative garment, as in Bernini's *Ecstasy of Saint Teresa* in the church of Santa Maria della Vittoria in Rome, or a decorative uniform, as in Schlüter's equestrian statue of the *Great Elector*. But modern clothing, especially men's long trousers, is not suitable for three-dimensional

reproduction. It suffices here to recall the dreadful ugliness of the numerous monuments to Vittorio Emanuele in Italy.

Another important object for sculpture is a group of figures. Here we have in mind above all Michelangelo's *Pietà* in Saint Peter's, his Medici tombs in Florence, and his unfinished *Deposition of Christ* in the cathedral in Florence. The organic combination of several figures is one of the most important types of sculptural works. What is depicted is interconnected with the type of sculpture. The group is not a juxtaposition of figures that face each other (a representation that is possible in a picture). It must, rather, be a genuine sculptural composition, a unified structure that is made up of various figures, for otherwise the result is a dangerous realism that treats the figures like the images or scenery on a stage. The *Last Supper* in Bologna is very interesting in this regard. This is a three-dimensional representation in which the figures attain a reality that shatters the distance involved in a representation, creating a stagelike illusion.

Typical monuments likewise often depict a group. The same is often true of equestrian statues, which are particularly suited to a sculptural representation.

Besides this, many animals are objects of sculptural works of art, for example, Bernini's delightful elephant in front of the church of Santa Maria sopra Minerva, and the stag in Adolf von Hildebrand's Hubertus Fountain in Munich. Not all animals are suited to being represented in sculpture, of course, but very many are, such as the glorious horses that we find, for example, in the equestrian statues of *Marcus Aurelius*, *Gattamelata*, and *Colleoni*. On the other hand, plants and landscapes are unsuitable to sculptural representation.

Trees and other plants can be reproduced in a relief, however. This offers a much larger scope than statuary for the objects that can be depicted.

Among reliefs, those in glazed clay by the artistic family of the della Robbia already constitute a transition to decorative sculpture. Only specific objects (not, for example, naked human figures and landscapes) are suited to this type of semi-decorative relief. The material that is used, and the blue-white color that is frequently employed, suggest a certain

stylization. The reliefs where what is depicted surpasses what a relief can give, such as the depiction of Jesus and Mary Magdalene in the side corridor of the courtyard of Santa Maria Novella in Florence, are interesting.

The objects that are depicted find their widest scope in the decorative sculpture that forms a component of architecture. Examples are the three-dimensional depiction of trees and landscape elements in the Trevi Fountain, the masks found at many fountains, the gargoyles serving as waterspouts on the roofs of many cathedrals, and the humorous three-dimensional figures that are linked to architecture.

As we have already said, the decorative sculpture that is completely integrated into the architecture is a specific type in relation to the other types of sculpture, and it is governed in many respects by other laws. The same is true of the decorative sculpture in parks: this too is something all its own in relation to the authentic great world of sculpture. The sculptures in parks can have a definite artistic value, although they never attain the depth of other sculpture. This decorative sculpture often has an enchanting charm and bears witness to great brilliance. One example is the delightful *Pegasus* in the Mirabell Garden in Salzburg.

The discontinuity that separates decorative sculpture from other types of sculpture is not at all due to the fact that this sculpture cooperates with architecture in a special manner; for architecture is the normal home of all sculpture. The supreme achievements of sculpture, in which it fully unfolds its intrinsic value, such as the incomparable relief on the Parthenon, make their appearance in union with the most glorious architecture.

We shall see how much more can be depicted in painting than in the realm of sculpture. The reasons for this are connected with the completely different form of representation and depiction, which we have mentioned above. In sculpture there is no counterpart to a still life, nor is there any representation of architectural works and cities, as in painting. There could not be a Canaletto in sculpture. Landscapes are an important object of painting, but they too are not an object for sculpture; the same applies to ships and city squares, and to much of nature.

We end the list of the various possible objects of sculpture with a consideration of the human face. This sculptural object offers many possibilities for lofty artistic values. The representation of a concrete, individual personality has a great influence on this type of three-dimensional works of art. The relationship to that which is depicted is closest here. The resemblance is also an artistic requirement, even in the peripheral sense, and above all in the deep sense of representing the personality. If the resemblance is lacking, the bust may otherwise be very beautiful, but it is unsuccessful in one respect. This factor has an influence on the artistic value of the bust that is similar to the influence that the sacred atmosphere of a church or the festive atmosphere of a reception room has on the artistic value of these rooms.

The material of sculpture

This has already brought us to the factors that influence the artistic value of a sculpture. Before we discuss these in the next chapter, let us speak briefly about the means employed by sculpture.

First of all, we must mention the material of which a statue, a bust, or a relief is made. This can be marble or some other kind of stone, bronze, terracotta, or wood. All these materials are definitely destined for sculpture, but sculptures of clay or plaster of Paris are made of a provisional material. Clay is an indispensable medium for modeling and designing, while plaster of Paris is a provisional medium in a completely different sense. It is not a material for designing sculpture. It is not the medium in the narrower sense of the term, it is not what that one needs in order to work. It is used only to give a work of art a provisional form. With the exception of decorative sculptures, a statue is never made of plaster of Paris, but cherubs in churches or decorative figures in halls and on pillars can be produced in this material.

In the materials that are finally chosen, there is a definitive inherent relationship between the sculptural work of art, the underlying artistic inspiration, and the material. It would be great mistake to believe that one could simply make a statue or a bust of any material at all: for ex-

ample, that a marble bust or statue could just as well be cast in bronze. The particular material and its aesthetic character belong to the artistic creation. A specific statue is conceived for marble or stone, and not for bronze (and *vice versa*).

The relationship here is similar to that found in a piece of music. If this is created as a violin concerto, it cannot simply be turned into a piano concerto. Sometimes this is possible, as in violin concertos by Bach, who himself also composed these as piano concertos; but this is an exception. No one would think of transforming Beethoven's Piano Concerto No. 5 into a violin concerto, or of performing one of Mozart's great piano concertos as a violin concerto.

Sometimes a statue or a relief can attain its full artistic effect in stone, marble, and terracotta. In general, however, each individual sculpture is conceived in view of one special material. This means that a statue or bust destined for marble should not be made in another material, especially not in bronze (and *vice versa*).

Wood too is a possible material for statues. Wooden sculptures occupy an important place in the work of some artists, such as Riemenschneider. In the late Middle Ages, wood was used in Northern Europe above all for crucifixes and statues of the Mother of God. Here there is a particularly close bond between the invention and the material. A creation that is very beautiful in wood would often be impossible in marble or bronze. This connection between the sculptural creative idea and the material is very intimate and mysterious. It is one of those connections that we can unambiguously discern, but no philosophical analysis can explain. Michelangelo's *David* in the Accademia in Florence or his *Dying Slave* in the Louvre must be in marble—the artist feels this, indeed he knows it with absolute certainty. The artist who created it knew that the equestrian statue on the Capitol must be of bronze, not of marble. But it is not possible for an aesthetics to explain what qualities and elements in the creative idea and the composition are responsible for the fact that a statue or a bust demands one particular material, or at least is suited to this material.

Secondly, color plays a certain role. It too is a medium that is em-

ployed to achieve specific artistic qualities. A completely white marble is tinted in order to avoid an excessively harsh white. A tinting of this kind is necessary for Carrara marble, but not for Greek marble. Bronze too has various shadings. A special color can make a statue more effective or can be more appropriate to it.

Color has a different task in statues of wood in a particular setting, above all in clothed figures of a sacred kind. The gold in many garments of the Mother of God shows clearly how the artistic idea for such a statue, including its function on an altar, has a deep relationship to certain colors.

The size of a sculpture is another means that must be mentioned. Some sculptures have a specific size. This not only applies to all monuments, which must possess a certain size because of their function and because of the surroundings in which they are placed. If one were to give a figure the natural size of a human body, the monument might perhaps look ridiculous. This, of course, also applies to the figures on a fountain, which can appear in very different sizes. We have already mentioned Michelangelo's statues on the Medici tombs. Here there is a profound link between the special creative idea of the figures, their artistic character, and a size that far exceeds the natural dimensions of the human body.

CHAPTER EIGHTEEN

Factors Determining the Artistic Value
of a Sculpture

AFTER THIS BRIEF ANALYSIS of the means used in making a sculpture, we now turn to the most important factors for the construction of a sculpture, namely, the factors with an influence on its artistic value. We must repeat once more that the indication of such factors does not in the least constitute a recipe that would allow the artist to accomplish his task successfully. Aesthetics is not a normative discipline like logic and ethics. It cannot specify what guarantees the aesthetic value, nor does it supply rules that the artist need only obey in order to create a genuine work of art. All that aesthetics can do is to indicate the factors that guarantee a genuine work of art, if they are applied properly; but it cannot specify what the correct application of these factors consists in. This is the mystery of the creative artist, and it cannot be formulated in rules.

Transposition: the working out of the natural formal principle

As in all the imitative arts, the first decisive factor is the transposition, mentioned above, of the depicted object into the world of art.[1] The act

1. It is scarcely possible to articulate directly the essence of transposition. The specific act of

of artistic creation forms the work of art into an object all of its own; and this is completely different from the pure representation in a photograph.

Only when the representation carries out this transposition does the work of art become a structure of its own, the bearer of completely new aesthetic values that the represented object does not possess.

We come closest to this factor when we investigate the function that the beauty of the represented object has for the beauty of the work of art.

It would be incorrect to assert that the beauty of a naked body *in natura* has no influence at all on the beauty of a statue that depicts this body. There is no doubt that it contributes to the beauty of the statue, but only provided that the transposition has taken place. If the statue were a mere replica of the body like a photograph, or if it were a mere cast of the body, it would not exist as a work of art. It would be absorbed into the function of pointing to the beauty of the body. Only through transposition can the statue as such become an independent bearer of new artistic values, to which the beauty of the represented body *in natura* contributes.

This beauty not only differs according to the art genre (sculpture, painting, or literature). It also varies in keeping with the represented object within one art genre. For example, the function of the beauty of a represented naked body for the beauty of a statue is different from the function of the beauty of a face for the artistic value of a bust.

A badly built body that is deformed *in natura* is a definite obstacle to the beauty of a sculptural representation. On the other hand, the bust of an ugly person can be very beautiful. There are certainly nondescript, pathetic faces that are not only ugly but also completely lacking in significance, and these are not suited to a bust. But all the same, the aesthetic quality of a naked body is much more important for a sculpture than the aesthetic quality of a face is for a bust.

The representation is much more important in a bust, because its theme is the depiction of one particular, individual personality, whereas

artistic forming makes use of that which is represented in order to construct something new, but from sources other than merely successful representation. The importance of this new thing goes far beyond the representation of the represented object. On this subject, see chaps. 15, 20, and 32, footnote 12.

the representation of an individual personality is normally not thematic in a statue. Rather, the artist forms the human body in general. Nevertheless, a human body lacking in beauty is a much greater hindrance to the artistic value of a statue than is the ugliness of a head for the artistic value of a bust or a portrait. The emptiness and lack of significance of a face are of course a definite hindrance for a bust. But even the greatest beauty of a body and a face *in natura* does not in the least guarantee the artistic value of a sculpture, even if it were a perfect likeness. Here we clearly see the full importance of the transposition.

Hand in hand with transposition goes the working out of the principle of form in nature, and the deeper penetration into the mystery of nature. The true artist understands nature more deeply than the non-artist, and this is another reason why his work of art goes beyond any mere representing and copying. He apprehends more deeply the underlying true principle of form in the divine "invention" of a natural entity, and realizes this in the statue. In one sense, he builds on the *natura naturans* (the "creating nature") rather than on the *natura naturata* (the "created nature"). Konrad Fiedler has emphasized this in several of his writings, pointing out the deep formative power that is exercised by the artist who opens people's eyes for the fullness of that which is contained in nature. Fiedler rightly says that we see much more deeply into the mystery of nature after the sonnets of Shakespeare, the poems of Goethe and Hölderlin, and the great paintings and statues have opened our eyes for nature.

On this background we can unmask the betrayal of nature by some modern artists who want to introduce a new "language" instead of the language prescribed by God. Instead of penetrating more deeply into nature, they despise it or else present a pseudo-nature.

The creative intuition of the figure [*Figur*], the word that is spoken in this work of art, is perhaps even more important than the transposition. What a great, decisive word is spoken in Michelangelo's *Dying Slave*! What mysterious greatness and moving intensity, indeed what ecstasy lives in this work! We can compare this spiritual content only to the adagio of Beethoven's ninth symphony. The vision of this sublime

spiritual content, the creative intuition that discovers and invents it, and the ability to realize it, to "condense" it in a figure, are of course the soul of the process of artistic creation. It is clear that this goes far beyond transposition.

The first of the factors that bear this ultimate artistic content, or of the means in a wider sense of this term, is the represented body and the transposition of its natural beauty. The second factor is the represented movement or position of the figure.

Body-feeling [das Körpergefühl]

A third factor is the body-feeling. By this we do not mean sensations such as the pain or pleasure that one experiences in the body, but the way someone feels in his body. For example, one may feel safe and "at home" in one's body, or one may feel helpless, so that one does not know where to put his arms and legs, so to speak. One can enjoy oneself in one's body. One can be natural or stilted in one's bodily reactions.

There exists a noble relationship to one's own body, and there exists a vulgar, base relationship; there is a modest and pure relationship, as well as an immodest and impudent relationship. There exists a relationship to one's own body that sinks down into matter, and there exists a relationship that is so spiritualized that it reaches ethereal dimensions. There is a poetic relationship, and there is a specifically prosaic relationship. The kind of body-feeling that is represented in a statue has a great influence on the artistic quality of the statue. An embarrassing body-feeling can strip a statue of all poetry, and can indeed be a fatal error in artistic terms.

This body-feeling finds expression in movements and gestures, in a person's walk, and in specific bodily postures that a person often takes, and it is of course linked to traits of his character. A certain kind of self-importance is linked to a specific body-feeling and is expressed in the gestures and movements of the body. Vanity often goes hand in hand with a certain way of being satisfied with one's body. As a general character trait, letting oneself go is closely linked with a body-feeling: with "flopping down," with feeling comfortable like a pig in its sty. A noble

spirituality is paired with a noble body-feeling, with a *habitare secum* (a "being at home with one's own self") of the spirit in the body. An unaffected, natural state of being at home in the body is linked organically to a definite restraint with regard to distinctly bodily dynamisms.

The bust and its expression

After discussing body-feeling, we must now mention a fourth factor, namely, expression. We do not only mean the expression of the face in the narrower sense; we shall speak of this when we discuss the bust. Rather, we mean the expression in the broader sense that the whole form can have, including the facial expression. For example, the *Dying Slave* expresses a terrible pain that is reflected in the overall gesture. But it is also the metaphysical beauty of this unparalleled ecstatic intensity of the pain, of the nobility and depth of this dying, that has a very profound influence on the artistic value. The artistically transposed metaphysical beauty works together with all the other factors.

In the individual areas of sculpture, we must focus on the importance that expression in the narrowest sense has, namely, expression in the human face of particular inner mental processes.

Let us begin with busts. The representation of an individual personality is one of the elements that belong to the artistic theme, and thus the expression of one individual personal act, such as joy, pain, love, fear, hatred, outrage, or horror is undesirable. This would contradict the special character of an individual personality that is to be represented in the bust. There would be a fatal displacement of the theme, tying it down to one special, concrete situation. Something accidental would force its way in, analogous to an embarrassing photograph of a person who laughs or opens his mouth wide while he is giving a speech. A realism of this kind contains a lie. To tie a person down to one particular moment contradicts the innermost requirement and theme of a bust.

On the other hand, however, the expression of enduring characteristics of the personality ought certainly to be reproduced. Purity, innocence, intelligence, vitality, vigor, nobility, and refinement ought to be

alive in the bust, when these are qualities of the real person who is represented. This expression is an artistically essential factor. Without an expression in this sense, a bust could not exactly reproduce the face, since this necessarily has an expression of some kind or other.

Several questions arise at this point: First, what is the importance of the expressed metaphysical beauty of such traits for the artistic beauty of the bust? To what extent does that beauty contribute to the artistic value of the bust, if the exact representation fully succeeds?

Secondly, what about the case in which the person who is portrayed is neither pure nor innocent, but is instead impure, vulgar, stupid, or superficial? His face shows the expression of his personality, but this expression need not agree with his real personality. Some people are less intelligent than they appear, while others are more intelligent. There are angelic faces that belong to persons who are not angelic, but are mundane, vain, and indeed impure.

Granted that the expression on the face corresponds to the negative character of the personality, ought then the bust to represent this expressed metaphysical ugliness? What influence does this ugliness have on the artistic value of the bust? Is the exact reproduction of the personality more important artistically than the expression in the bust of a metaphysical beauty that does not exist *in natura*?

The situation in literature is completely different from that in the visual arts. In the former, the artistically perfect reproduction of a trivial, banal, stupid person can be a bearer of high artistic values, whereas the expression of these negative qualities runs contrary to the artistic beauty of the portrait and the bust.

This brings us to an interesting but difficult problem. We have already seen[2] that the degree of metaphysical beauty and ugliness wholly corresponds to the rank of the value and disvalue of which it is the irradiation. Wickedness is an incomparably greater disvalue than stupidity and baseness.[3] Its metaphysical ugliness is therefore much greater than theirs.

The situation with a bust is different. The wickedness that is expressed

2. *Aesthetics*, vol. 1, chap. 2.
3. On this, see my *Graven Images*, chap. 7.

in the face restricts the artistic value of a bust to a lesser degree than do stupidity and baseness. It thus seems that certain types of metaphysical ugliness, independently of their greatness and depth, have a closer relationship than other types to the artistic value of a bust. It is obvious that some other factor must be responsible for the fact that the expressed stupidity restricts the beauty of a bust more than the expressed wickedness or heartless harshness. The exact relationship between moral and aesthetic values is a difficult problem. Why, for example, does Macbeth's wickedness not possess the repulsive aesthetic quality that we find in Iago's baseness?[4]

The following question is interesting in this context: Must the artist keep to the characteristic traits that are expressed in the face when he creates busts, even when he knows that these traits are deceptive and that the person in question does not in reality possess these traits? It seems that he must represent them if the apparent traits are bearers of metaphysical beauty. But if an intelligent person looks unintelligent, ought he not then to attempt to express the intelligence in the bust somehow?

The expression of naked and clothed figures

Expression has a different importance in the field of statues, groups, and reliefs from that in busts.

Let us turn first to naked figures, whether an individual figure or a group. We have already said that an excessively individualized face on a naked figure would pose a risk. In all naked forms Greek sculpture leaves the face rather general and typical, avoiding every portraitlike individualization.

In this respect, a great discretion is required with naked figures; but the expression of individual personal acts and concrete experiences is certainly possible here, unlike with the bust, and in many instances is a bearer of lofty artistic beauty. It suffices to recall the expression of pain in Michelangelo's *Dying Slave*, which necessarily belongs to this

4. The solution may lie in the fact that wickedness is often linked to willpower and intelligence, that is to say, to values that possess a metaphysical beauty.

unique work. It is interesting to note that the connection to an individual personality, which is very important in a bust, is lacking in statues and groups. On the other hand, the representing of a momentary expression is not only possible here, but is often of great beauty, whereas this is something that must be avoided in a bust.

Naked statues are created figures that lack the link to one individual human being. But there can exist in them a deep linking to nature and to the human body and its inherent principle of form. This is possible even with statues such as Apollo, Mars, Venus, and Diana. The statue of an ancient god does not have a link to any real human being that would give it the character of a portrait. The mythical personality and his or her characteristics are to be displayed in the facial expression of the figure. In Apollo, this expression is radiant and filled with light; in Mars, it is martial and victorious; and so on. Obviously, this is a completely different kind of expression.

The situation with the naked figure of Christ cannot be compared to this. Here the expression is of the utmost importance. There exists a certain tradition with regard to the type of face. Since the religious element is the principal theme, the overall expression has a decisive importance. This face ought always to irradiate a sacred atmosphere. The specific expression of the crucified, the dead, and the risen Christ may vary greatly in accordance with each specific situation, but even if the entire body is naked (something that seldom occurs), the face ought always to have a corresponding form and a transfigured sacred expression. The expression of one concrete personal experience, such as the suffering of Christ on the Cross, is, of course, not only not undesirable: it is explicitly demanded.

The state-of-affairs with regard to clothed statues is completely different. In groups such as Michelangelo's unfinished *Pietà* in the cathedral in Florence, the profound pain on the face of Joseph of Arimathea has a moving greatness and makes a supremely important contribution to the unique beauty of the group.

The expression of a concrete experience is also required in statues of the Mother of God: for example, the expression of pain and of the

devoted acceptance of suffering in Michelangelo's *Pietà* in Saint Peter's. Even the individualized form of the face is acceptable here, provided that a certain beauty of the form and above all a sacred, spiritually sublime expression are always retained.

Let us now leave the special situation of religious sculpture and return to the expression of clothed statues and groups. If the representation of an individual personality is involved, as in many monuments, similar rules apply as in the case of busts. The equestrian figure ought to resemble the historical personality in his face. It ought to reflect his character, but not individual experiences such as joy, pain, rage, and so on. We find this realized in the glorious equestrian figures of *Marcus Aurelius* on the Capitol, of *Gattamelata* in Padua, of *Colleoni* in Venice, and of the *Great Elector* by Schlüter in Berlin.

What we have said about the expression in three-dimensional sculpture (statues, groups, and monuments) applies by analogy to the relief. Here too both the expression of abiding characteristics and the expression of concrete personal acts play a legitimate role in the forming of the face. The same is true of the overall expression of the figures and of the body-feeling. In this regard, there is no difference between the rules for a relief and those for three-dimensional sculpture, although the difference between these two realms of sculpture is very great in other respects (for example, as we have seen, some natural objects can be represented in relief but not in sculpture).

Inner unity

A fifth requirement for a three-dimensional work of art, which is very important in statues and especially in groups, is the inner unity. This is a fundamental requirement for every art genre. If the inner unity is lacking and the parts disintegrate, this is a grave artistic defect. Within this unity, there are many degrees, all the way up to inner necessity.

This inner unity goes hand in hand with a potency that distinguishes the genuine artistic unity from an academic, empty unity. There is a cheap, quasi-geometrical unity that, unlike the inner life of that which

is vigorous and is united from within, has an element of emptiness and boredom.

The inner unity of a statue or a group also demands an autonomous space that belongs to sculpture. This has been expressed as follows: the statue or group came into being through the removal of parts of the marble or the block of stone. This process exposed the statue or group, as it were; it did not construct it. This interpretation underlines the uniformity of the spatial structure.

This spatial unity is expressed even more precisely in Michelangelo's demand that three-dimensional sculpture must be such that one can roll it down a hill. Nothing may protrude from the inner space that it possesses. It may not leave the immanent space of the sculpture in any part that projects outward, for example, in an outstretched arm or a bent knee. This unity is of a very particular kind. It is based on the fact that the statue or group is a spatial structure that is placed in the great, all-encompassing realm of space and yet possesses a space of its own. The unity of sculpture is different from the unity of a picture, a novel, a drama, or a poem.

Composition, inner logic, and depth

One decisive factor in sculpture, as in every art genre, is the composition. This is very deeply connected to the creation of the work of art, which is always at the same time a discovery.

The composition can be conventional, and the word that is spoken through the composition can be superfluous. But the composition can also be filled with warm life and possess a convincing necessity. There is a broad scale in this necessity. The more necessary the composition and creation are, the higher is the work of art.

The inherent necessity depends on the type of composition and creation, but it is in itself already a specifically artistic value quality. This brings us to the qualities that are of decisive importance in sculpture, as in all the arts, for the artistic values and especially for the beauty of the second power.

We have already spoken about inherent necessity when we discussed the beauty of nature and of the landscape in the narrower sense.[5] This necessity, which is distinct from the necessity of the laws of being, is a great artistic value. The more necessary a three-dimensional sculpture is, the more important it is, the more it stands on its own feet, the more autonomous the work of art is, then the more potent the creation. The opposite of necessity is, on the one hand, an unnecessary randomness. Such a work prompts the remark, "It could also have been otherwise," or even, "It has no *raison d'être*; not much would be lost if it did not exist." Another antithesis to necessity, and especially to the necessary unity, is the conventional unity that is boring and is imposed from without, so to speak. It goes hand in hand with a weakness of creation. This unity lives from mere facticity.

We shall see below that there is an inherent logic in music. Both the melody and its development and the overall construction of a piece of music must demonstrate a kind of necessary connection that represents an analogy to the logical procedure in a philosophical work. The question is: Is this artistic logic restricted to those works of art that, like music and literature, have a temporal extension, or does there also exist something at least analogous to this in those arts that have a spatial extension? Does this inherent logic also exist in architecture, in a palace, a church, or a bridge? Can we find this element of logic also in a picture, in a statue, a group, or a relief, so that through one part certain other parts either are impossible in themselves, or else constitute a logical consequence?

It certainly seems to be the case that we can find an inner logic in these arts too, and that illogicality constitutes a definite artistic defect. Logicality would therefore be an artistic requirement. As with unity, however, we must make a distinction here between a cheap and a deeper logic, for although some "works of art" do not have an illogicality, their logic is a commonplace, a cheap logic that is not only conventional and boring but, like truisms, also contains an element of the shallow and superficial.

5. See *Aesthetics*, vol. 1, chaps. 8, 14, and 17.

Another fundamental quality is the depth of a sculpture. Many of the factors that we have already mentioned are responsible for this depth, of course: first, the deeper penetration into nature and into its principle of form, reaching the *natura naturans*; secondly, the potency of the creation; and thirdly, the expression in the narrower sense and the overall expression of the statue.

The artist can consciously aim at a deep sculpture, or at a poetical, lovely sculpture. There is a great and wise discretion that we find in some artists who place their work in a relatively modest framework. They do not aim at ultimate depth, greatness, or sublimity, but give what they are able to give. In his great artistic wisdom, Haydn would never have attempted to fill out the framework of Beethoven's ninth symphony. He would never have attempted to speak such a word. Rather, he created symphonies that completely filled out their framework, such as the "Oxford Symphony," the twelve "London Symphonies," and many others that are masterpieces. The choice of the framework is thus equally a factor that helps to determine the depth and greatness of a work of art.

Besides this, the type of sculpture influences the depth and greatness of the individual work. In this regard, certain types of sculpture narrow down the framework. For example, a medallion can never give the same depth and greatness as a relief or a three-dimensional sculpture. The external format of the sculpture also exercises an influence in this regard. A Tanagra figurine can never attain the depth and the inner, explosive greatness and power of a statue like Michelangelo's *Saint Matthew* in the Accademia in Florence or Verrocchio's *Colleoni* in Venice, the *Dew-Sisters* from the eastern gable of the Parthenon,[6] or the relief of *Orpheus and Eurydice* in the National Museum in Naples.

We have already mentioned the importance of the size of sculptures. Here we wish to point out how important this too can be for the potential depth and greatness of the spiritual structure.

Needless to say, decorative statues never possess the same depth and inner greatness as a sculpture that stands on its own feet. We do not

6. Lord Elgin had them brought to the British Museum in London.

intend to assert that architecture together with decorative sculpture can never attain an analogous depth and greatness, but only to note that decorative statues as such cannot do this.

This is no defect of decorative sculpture. It can be charming and delightful, but only when it refrains in principle from aiming at something that non-decorative sculpture is able to give. It forms a realm of its own, in which, as we have seen, many things are possible and permitted that are impossible in the realm of non-decorative sculpture. It has its own genius and is meant to realize other artistic qualities. Its general purpose does not aim at an ultimate depth and greatness; and this is already determined by its explicitly ancillary character. We could indeed say that decorative sculpture has an artistic mission all its own. But even its perfect masterpieces exclude the depth and greatness that are attained in the summit of non-decorative sculpture.

CHAPTER NINETEEN

Comedy and Grotesqueness

WE HAVE ALREADY pointed out that transposed comedy can be a bearer of lofty artistic values in a work of art.[1]

Comedy can occur only in certain arts. It is clear that it is most important in literature.[2] Here we find it everywhere: in the novel, the short story, the play, and the poem. It has its place even in the framework of the most serious works. It suffices here to recall the king of novels, *Don Quixote*. Literature is the domain in which the comic is important.

Comedy is completely lacking in architecture. A comical building that would make us laugh is a nonsensical idea.

It occupies a modest place in absolute music. One can speak only in a very analogous sense of comical turns or phrases in symphonies, quartets, or sonatas. There are indeed some jokes in pure music, but this does not amount to a comedy that would make us laugh.

Comedy plays a great role in the union between word and sound in operas and songs. This possibility does indeed derive from literature, in which comedy is an important element, but the music of the opera and

1. *Aesthetics*, vol. 1, chaps. 15, 16, and 19.
2. See chap. 32.

the music drama shares fully in this and realizes a value that the word cannot give in the same way independently of its union with sound. Think of Leporello in Mozart's *Don Giovanni*: the music has a decisive share in the forming of this figure, who is characterized by a profound comedy. We need only recall the glorious passage in the second act, "For it is unfortunately only his clothes," when Leporello exposes the deception, or the scene in the cemetery, or many passages in *Così fan tutte* and in *Figaro*, as, for example, when the Count lifts the blanket in the first act and discovers Cherubino underneath, while the music goes backward, so to speak! Another example is the completely different kind of comedy of Mime and the music in the first act of Wagner's *Siegfried*, which aptly brings to expression the trembling body-feeling of Mime: "I raised you up as a sucking child."

There is also comedy in songs, for example, in Beethoven's song *Der Kuss*: "I was with Chloe all alone"; or in Hugo Wolf's settings of Mörike's poems: *Nimmersatte Liebe* with its conclusion, "And Lord Solomon the wise was not in love in any other way," and *Abschied*, in which the reviewer is thrown down the stairs.

Besides this, operetta largely lives from comedy. This is true both of the works by Gilbert and Sullivan and of the operettas of Offenbach and the Viennese operettas, above all those by Johann Strauss. This comedy is, of course, much more superficial.

Comedy does indeed occur in sculpture, painting, and drawings, but as a whole it never has the same rank and the high artistic importance that it has in literature, opera, and music drama. In the realm of painting, its place is limited mostly to one particular type of work: illustrations,[3] such as Doré's illustrations to *Don Quixote*, or drawings that have an exclusively comical intention, as in the works of Wilhelm Busch.[4] It is also found, however, in a wider sense of the word in pictures that are neither at the service of comedy nor mere caricatures. Their full artistic meaning is as satire, such as Goya's *Family of Charles IV* in the Prado in Madrid. In general, however, comedy is lacking in all the great paintings from

3. See chap. 23.
4. Ibid.

Giotto to Tiepolo, from Van Eyck to Rembrandt. It appears at most in some genre paintings. Comedy in painting is not only much rarer than in literature; it is also of a completely different kind. It does not reach into the heart of this art or into its great, profound works.

This applies all the more to sculpture. The important reliefs and statues, whether equestrian statues like the *Bamberg Horseman*, *Colleoni*, or *Gattamelata*, naked figures of classical antiquity, or Michelangelo's *Dying Slave* and his huge statues in the Medici funerary chapel, stand in a world in which there is no place for comedy. Only in caricatures, in figures of monsters and demons, and in animal sculptures does comedy enter in. On the other hand, comedy is dominant in the realm of dolls, marionettes, and Punch and Judy puppets. It is obvious, however, that this realm lies outside of sculpture proper.

There is a striking difference between the appearance of comedy in literature, opera, and music drama, on the one hand, and in the visual arts, on the other. In the former, the comedy and the other artistic values appear in one and the same work. But sculptures that are bearers of the comical belong from the outset to another type than sculptures that are bearers of beauty, greatness, and depth.

Comedy in sculpture is found in one very specific type: in goblins on church roofs, in some statues along streets and in parks, and in the masks of fountains. Such figures are much more unassuming than serious sculpture, and they have a function and a theme other than this. They do not want to be taken so seriously, and they eschew from the outset any idea of giving artistic values in the way that serious sculpture does.

There are, however, some exceptions within serious sculpture. Figures on fountains, for example, can have a humorous element, as Father Rhine on the Reinhard Fountain by Adolf von Hildebrand, which was formerly in Strasbourg and is now in Munich. It goes without saying that comedy can also unfold in decidedly decorative sculpture.

There are many qualities that are related to the comical but are completely different from it, such as the humorous, the amusing, the witty, the sarcastic, the satirical, the caricature, and the grotesque. The humorous is not comedy in the strict sense of the word. It is not like the Beckmesser

scene in the third act of Wagner's *Die Meistersinger* that makes us laugh, and even less like some scenes in Verdi's *Falstaff.* Father Rhine does not in the least make us laugh. Rather, we delight in the humorous form that is given to this mythical figure.

What we see in the figures of some goblins, or in some statues such as the Kindlifresser Fountain in Bern, is not the humorous but another quality that goes much further in the direction of what is genuinely comical, or of the grotesque. But these are not figures that make us laugh.

We must also draw a distinction between the quality of the comical in the true sense and the lighthearted in decorative sculpture. Once again, our example is the delightful *Pegasus* in the Mirabell Garden in Salzburg. Its stylization contains an element of the cheerful, the funny, indeed we might almost say the witty. This quality is different from the humorous, but it too belongs to the sphere of cheerfulness [*Heiterkeit*] in the broader sense, which has the comical at its center. There are many qualities in decorative sculpture that are related to comedy. But sculpture can never be comic in the way in which the works of Molière or in which (to take the highest type of artistic comedy) Sancho in Cervantes' *Don Quixote* is comic.

Unlike literature, opera, and music drama, those statues that are bearers of a quality that is close to the comical in the full sense of the word never possess an ultimate artistic beauty. In the former case, the transposed comedy can be an exceptional artistic value, but this is impossible in sculpture.

The artistic value of satire in sculpture is likewise limited. One could object at this point: What about the satyr in classical sculpture? While he possesses an element of the comical, can he not also be a bearer of lofty artistic values that are not inferior to those of serious sculptures?

This may be granted; but the satyr is not comical like (*mutatis mutandis*) Sancho, Leporello, or *Le bourgeois gentilhomme* of Moliere. He does not make us laugh, and there is nothing comical in his humor, which distinguishes him from other statues such as those of Apollo, Poseidon, or Athene. Rather, if we may employ a very bold comparison, his humor is similar to the cheerfulness of a fool in one of Shakespeare's plays. The

satyr has something grotesque about him. His deviation from the formal principle of the human body in general does not go in the direction of the ugly and deformed, but in that of a created type that has its own formal principle. This is even truer of the centaur.

The grotesque element in the satyr also has a touch of the cheerful and humorous that is lacking in the centaur. But this element of the humorous, which the satyr possesses in a manner that is analogous to the humorous figure of a river-god, is different from the comical and even from the comical aspect of some gnomes, goblins, and of statues that are meant as a joke. This is why such figures can also be bearers of lofty artistic values and can appear in the company of serious sculpture, as, for example, in Adolf von Hildebrand's relief *The Drunk Dionysus* on the house where the artist once lived in Florence.[5]

5. This house was originally the monastery of San Francesco di Paola.

Painting

CHAPTER TWENTY

Representation [*Darstellung*] in Painting

Representation [Wiedergabe] as distinct from similarity
[Ähnlichkeit] and image [Abbild]

THE PRESUPPOSITION for the arts of painting and drawing is the remarkable phenomenon of the representation of visible reality. This also exists in photography. Hans Jonas has analyzed representation in a fine essay.[1] He shows that wherever we find drawings, human beings have been there, since, unlike many other traces that could also derive from animals, the ability to make a representation presupposes the human being as a spiritual person. Moreover, the ability to recognize and understand a representation also presupposes the human being as spiritual person. A dog will not recognize its master in a photograph or a portrait.

The union between the picture on the canvas and a landscape that is depicted on it is a union of a very distinct kind. The same is true of drawings and photographs. We shall now investigate the specific character of this union. It is presupposed in the case of painting and drawing,

1. "Homo Pictor: Von der Freiheit des Bildens," in *Organismus und Freiheit* (Göttingen: Vandenhoeck & Ruprecht, 1973), chap. 9; also in earlier publications: "Homo pictor und die differentia des Menschen," *Zeitschrift für philosophische Forschung* 15, no. 2 (1961); "Homo pictor and the Differentia of Man," *Social Research* 29 (1962); *Zwischen Nichts und Ewigkeit* (1963).

although both of these, as works of art, go far beyond representation. But for now we are interested only in the phenomenon of representation that a painting and a drawing share with a photograph. Afterward we will look at those elements that distinguish these two from the photograph or, in other words, that mark them off as works of art.[2]

In order to understand the phenomenon of representation, which is the unique bond between the depiction and that which is depicted, we must distinguish it from other relationships that are in some way akin to it.

The first of these is the fundamental and important relationship of similarity, which permeates every area of being. It is much more general than representation. There are similar colors, sounds, faces, figures, characters, atmospheres, talents, and so on. The similarity always exists between two objects. It can be present in various respects, but we always compare two objects that belong to one and the same sphere of being. This is why similarity in the strict sense is completely different from analogy, which exists between objects from different spheres of being.[3]

A photograph is a piece of paper on which we see something that unites us to a completely different sphere of being. It depicts a landscape, a human being, and so on. Is this relationship of depiction, this relationship of representation, a similarity between the depiction on the paper and the landscape, the human being, and so on?

We do indeed say sometimes that a photograph is good and that there is a similarity. But the term "similar" is not used here in the strict sense. It does not refer to the similarity between the photograph as a real object—a piece of paper—and that which is reproduced in the photograph. The term "similar" already presupposes the relationship of representation here. In this context, "similar" means that the representation was successful and that the photograph correctly represented what was intended to be represented. It is obvious that we mean something different with this word from what we mean when we say that someone is similar in appearance to his brother.

We must also distinguish the visible representation from another

2. See also chap. 25, footnote 1.
3. See *Aesthetics*, vol. 1, chaps. 7 and 9.

centrally important relationship, namely, the relationship of the *causa exemplaris* ("exemplary cause") [to that which images it]. Above all, God is said to be the *causa exemplaris* of all being. Saint Bonaventure, for example, draws the classical distinction between *imago* ("image") and *vestigium* ("trace"). This *causa exemplaris* has two aspects. First, there is the relationship of showing forth, or reflecting, which is akin to a special kind of analogy. In everything that exists, there lies, within an immense gradation, an analogy to the absolute being of God. Secondly, there is the dependence of the lower on the higher when something is created by God in accordance with Him as archetype.

We do not have in mind this relationship between the creature and the Creator when we use the term *causa exemplaris* in a broader sense and say that one human being as a personality is a model for another—one artist a model for other artists, one statesman a model for other statesmen, the conduct of war by one general a model for other generals. In every instance, one being is higher and is the pattern on which another being depends in a specific way.

This dependence must be sharply distinguished from the dependence implied by the *causa efficiens* ("efficient cause") as well as that implied by the *causa finalis* ("final cause").[4]

If one thing is seen as a model and another thing as its copy, or if this is in fact the case, there exists a relationship in which the one is treated as superior and the other as inferior, or a relationship in which the one is objectively superior and the other inferior. This kind of dependence is not limited (like dependence in the strict sense) to things that belong to the same sphere of being. It refers, in the primal meaning of the *causa exemplaris*, to the relationship between the finite and the infinite, the absolute; and it often refers also to different spheres of being. It always includes the difference that is constituted by the superiority of the one in relation to the other.

The *causa exemplaris* entails a dependence of the lower on the higher.

4. If, for example, a philosopher is accused of having made the relationship of finality the *causa exemplaris* of all relationships of dependence, this means that he sees all relationships in the light of the relationship of finality and that he risks interpreting them all as variations of this one relationship.

This dependence goes beyond pure similarity. In an objectively exist-
ing relationship of imaging an archetype, this dependence is real. In a
relationship of imaging that is merely posited by a philosopher as an
assumption, something that is lower is reinterpreted to become the *causa
exemplaris* of something that is higher. In reality, of course, the higher
does not depend on something lower, since this is only an alleged depen-
dence that is wrongly and arbitrarily posited.

One could object that, although it may be conceded that the rela-
tionship of representation between a photograph and that which is rep-
resented by it is not a strict, pure similarity, is not the photograph none-
theless an image [*Abbild*] of that which it represents? Does not the term
"image" [*Bild*] itself indicate that this relationship of representation is a
form of imaging?

To this, we must reply that we may concede that the word *Bild* ("pic-
ture") is used in the concepts of *Urbild* ("archetype") and *Abbild* ("im-
age"), and thus points in some way to the relationship between the pic-
ture (*Bild*) and that which is depicted (*abgebildet*). In a genuine visible
representation, however, we have something completely different from
what we find in the much more general relationship of imaging that is
found in the very various spheres of being. The linguistic allusion is based
only on a distant analogy. In reality, what we have here is a completely
different and much more special relationship.

Photographic representation

In the case of a photograph, we are speaking of a kind of representation
that is in fact different from the general representation found in all the
imitative arts. Representation in literature is of a different kind from that
in painting; and even in sculpture, it is not the same as in painting and
drawing. Besides this, we are not yet speaking of the specifically artistic
representation that exists in all the imitative arts, with its own specific
transposition. We are speaking of the mere phenomenon of representa-
tion that painting and drawing share with photography.

This bond between the visible representation—photograph, drawing,

or painting—and the object represented is completely *sui generis*. It is not correct to speak of dependence, as in the case of imaging. An image is a real object that, as such, depends on a higher, superior object, namely, the archetype. A photograph is not a lower real object, but is, as such, not a real object at all. It is a real object as a piece of special paper with a smooth surface. But what one sees on it is not a distinct object. It is subsumed wholly into its representation of a real object.

Moreover, this dependence is of a completely different kind. A photograph exists only in its function of representation. If one wishes to speak of dependence here, the dependence goes incomparably further. Nor can one speak of a superior and an inferior object. It would be absurd to say that a photograph was the inferior object and that what was depicted on it was the higher object. Who would ever compare the photograph, as an object, with the real landscape and the real human being?

In reality, that which is represented in a photograph—a landscape, a house, a human being—is three-dimensional. The representation of the reality in a photograph is two-dimensional. The first point to be made is that it is astonishing that this two-dimensional picture allows us to recognize the three-dimensional objects. Besides this, we can come into contact with the real objects through the sense of touch, which communicates their reality to us, though only with the collaboration of the sense of sight. Many things also speak to us through a typical smell: not only flowers but also fruits and trees, etc. All this is lacking in the photograph and the picture, which are accessible only to the sense of sight.

Despite all these differences, however, photographic representation gives something that is fully present. This is not a link to the object that passes via the intellect, as with the word. The recognition of a landscape in a photograph does not require the specific act of understanding that is essential as a central factor of language in reading and hearing what another person says. This act of recognition is based on an act of understanding in a much wider sense, which is very important in the perception of the visible and audible, namely, the purely receptive spiritual capacity that animals lack. This is why a dog is unable to recognize its master in a photograph.

Our primary interest here is not in the acts that are presupposed in order to recognize or to come to know that which is depicted in a photograph, a drawing, or a picture. This ability is already well developed in small children, long before they can read and write. Rather, we are interested in the objective relationship between a photograph and that which is depicted in it, the bond that exists between photograph and reality, this very specific relationship, the phenomenon of representation.

Copy, replica, doublet

The specific character of this relationship emerges even more clearly when we demarcate it over against other relationships, such as that between a copy and its original. When we do so, the first thing that is missing is the difference between the two-dimensionality of the picture and the three-dimensionality of that which is depicted.

Secondly, we do not find here the relationship that a picture has to reality, namely, the representation that constitutes a leap from one object to an entirely different kind of object: from the photograph as paper or from the canvas with its colors, on the one hand, to the real object that is depicted, on the other. The copy of a picture is entirely the same type of object as the picture that is copied; the leap that we have just mentioned does not take place. If the copy is very good (as is seldom the case), one could confuse it with the original. But no one can confuse a picture with the reality that is depicted in it. There is a pure relationship of dependence between the copy and the original, although this is a special type of dependence, because it is a similarity driven to the point of sameness. The relationship between the two goes in a direction completely different from the relationship of representation.

The copied image shares in the relationship of representation that the original has. It too represents a landscape, an animal, or a human being; but the relationship to the original is obviously completely different from the relationship of the representation. The term "copy" is the correct name for this relationship.

The situation is already different with the photograph of a picture.

Once again, the distinction between two- and three-dimensionality, which is characteristic of the representation, is missing, as is the step from the photograph to reality. Nevertheless, a photograph is not a copy. No matter how perfect it may be, no one could ever confuse it with the picture. An element of the relationship of representation is present, however, not only the distinction between a copy and the original. To present the copy as an original would be a forgery. The photograph of a picture could never be an "original" in the same sense. It can only be a photograph, good and adequate or poor and inadequate. It cannot claim to be the picture itself. It occupies the much more modest position of a representation.

In one regard, the original is a definite *causa exemplaris* for the copy, since the copy is wholly determined by the original. The original is the archetype, not for the creation of something new but for an exact imitation.

Although the copy constitutes a maximum of representationality in its dependence on the original, this relationship is radically different from the dependence that exists in the genuine type of *causa exemplaris* relationship, since the new is no longer a genuine structure of its own. In the case of a copy, the original is not only a model, not only something that gives direction, not only the pattern when something new comes into being, but a copy is a repetition of the original that is intended to be so similar to the original that the one can be confused with the other. When we say that a copy is not a new structure, we do not mean that it is not a new thing on another canvas or that it is not another concrete individual. We mean that it is nothing new in its essence [*Sosein*]. If it does not attain full similarity in its essence, it is only its imperfection that distinguishes it qualitatively from the original—not something new that is inspired by the model. This is why it is a pure representation. Let us suppose that the copy is totally similar to the original. The essential difference is that the original came from the hand of the master who created it, and is for this reason incomparably more valuable, even in financial terms.

A special artistic ability is presupposed even for the act of copying,

although the goal that is achieved is only modest, and the artistic value of the copy is far less than that of the original. A copy is not a mechanical replica; it presupposes a special talent. In this regard, copies of great masterworks created by a painter of much more modest gifts are very instructive.

This is why we must also distinguish the relationship between a copy and the original from the relationship between pure replicas and an original. One ring that is exactly the same as another and is indeed made of the same material is not in any sense in an inferior relationship, even as a pure replica, to another ring that is exactly like it. It has the same value in every respect. It is another instance of the ring.

If the material only appears to be the same (for example, if only pinchbeck is used instead of gold, or a rhinestone instead of a diamond), the copy has the character of a forgery. It is indeed true that one can speak of a real forgery only when the seller passes off a fake as genuine. But the objective relationship between the golden ring or the jewel and the imitation is definitely that of a pretense. The appearance, which is exactly identical, aims at a deception. It looks as if it were something that it is not in reality. There is thus a relationship of deception in addition to the relationship of a replica.

Another instance of a thing is completely different from a copy of it. Many articles that are produced *en masse* by machinery are completely identical. They are indeed different individual things, but they are more or less identical in their essence. This is not the relationship between original and copy, between archetype and image. There is no precedence of the one over the other, unless one article happens by chance to have turned out less well. In such a case, a forgery is impossible.

Demarcation of the photograph from the drawing and painting

After demarcating the relationship of representation from all the similar relationships, we can now turn to the distinctions within representation that separate the picture and the drawing from the photograph. We move in this way from the pure phenomenon of visible representation in

the narrower sense to the completely new artistic representation that is present in the painting and the drawing.

The first difference, of course, is that the mere representation in a photograph is entrusted to a technical process, whereas the representation in drawing and painting derives from the activity of an artist. It is true that a photograph is not produced mechanically: in a real photograph that a human being takes of a landscape or of something else, the activity of taking the photograph is an important factor. We exclude here the purely mechanical representation of manuscripts and printed material. Theodor Haecker has pointed out the important difference between a tool and a machine.[5] A tool such as a brush, a pen, a chisel, or a hammer, is only a *causa instrumentalis* ("instrumental cause"), while the human being or his activity is the *causa principalis* ("principal cause"). A human being makes use of the instruments in order to create something. A machine, on the other hand, functions as the *causa principalis*, and the activity of the human being who sets the machine in motion is only a *causa remota* ("remote cause"). The human being makes use of a tool, but he operates a machine. Haecker emphasizes that this is why a human being can thoroughly animate the causal effect when he employs a tool, bestowing an organic character on this effect, whereas a machine does not animate the causal effect, and bestows on it a mechanical instead of an organic character. What the human being can create with tools is a *genitum* (something "begotten") as opposed to the typical *factum* (something "made") of things produced by machines.

We have said that a camera is not a machine. But we can affirm even more strongly that it is not a pure tool. Like the machine, it is the *causa principalis* of the pure representation. Strictly speaking, however, the light and the special sensitivity to light are the *causa principalis*. The light is the true *causa principalis*. It has the function of the *agens*, the active power, and the material with a special sensitivity to light has the function of the static precondition of the effect. It goes without saying that the human being and his activity are not the *causa principalis* in this process,

5. *Was ist der Mensch?*, 36ff.

but only the *causa remota*. Nevertheless, his activity is radically different from what happens with a machine. It is true that one who presses the button of the camera acts only as the *causa remota*. But he assumes a leading role in the entire preparation, not only in the choice of the correct light but also with regard to the photogenic possibilities and many other factors, and this role determines the whole photograph in its quality, in its effectiveness, and so on. A photograph always contains an element of interpretation of the real object. The "art" of taking good photographs is a subject all its own, which goes beyond our theme here.

In a drawing and a picture, it is the human being who produces the representation. It is he who carries out the process of representative art. For this he needs not only his hands but also certain tools. But the entire process, from the will to depict something, through all the acts of the mind, down to the skillfulness of the hands and the correct use of the tool, is an activity on the part of the human being, and drawing or painting is a special human gift. The function of the tool is completely subordinate, a pure *causa instrumentalis*.

It is impossible not to recognize the difference between a drawing or a picture, on the one hand, and a photograph, on the other, with regard to the way in which they come into being.

Before we discuss this difference as it concerns the phenomenon of representation, let us briefly point to certain features of representation as such.

When we apprehend on a photograph the vista of Lake Geneva from Vevey, this does not contain any element of the illusion that the stage demands of us. It is of course true that this illusion ought not to go so far that what is depicted on the stage is confused with the reality that surrounds us. We ought not to regard what is depicted as something that takes place in our real life. Rather, we should only be drawn out of reality for a short time and transposed into a world in which we participate in everything that happens during the play. We do not confuse this world with reality, but in one sense it temporarily replaces reality for us. The illusion consists in the fact that we live completely in this world and do

not perceive it as the mere depiction of a fictitious event. A certain illusion of a different kind is required when one reads a novel.

Illusion plays no role at all in the photographic depiction of a real place. We see the representation and apprehend the beauty of this landscape. The consciousness of being there is not in the least necessary. This kind of representation is radically different both from that in literature and from the visible representation on the stage. The specific kind of illusion demanded by the stage is not present in the photographic representation. This applies to the picture and the drawing too, even when a concrete reality is represented. If we see the portrait of a person whom we love, we need no illusion in order to apprehend the beauty of the portrait and to delight in the expression of his or her beloved face.

Another characteristic of visible representation is even more important than the absence of illusion. The act of seeing a photograph, for example, of Lake Geneva, is a perception that also communicates to us a perceptual apprehension of the object. There is clearly a great difference between perceiving Lake Geneva while we are in Lausanne or Vevey and looking at a good color photograph that reproduces this view of the lake. In the factual perception, the lake itself is present, disclosing to us not only its essence but also its existence. We are in a full, real union with it, in a contact of a specific kind for which there is no substitute, and this is why the delightfulness is very different from what we experience when we only look at the photograph. We can fully apprehend the beauty of the lake on the photograph. It will naturally kindle in us the longing to see this landscape in reality. But it is astonishing that a photographic representation allows us to see and get to know Lake Geneva (at least from this point in space) and to perceive its essence. This is more than a mere acquisition of knowledge about the character of the lake from a description of it. Its essence, that is to say, its appearance and the appearance of its surroundings—for example, how Les Dents du Midi rise up behind it—is given to us in the photograph too as fully present.

This is why getting to know Lake Geneva through the photograph is a species of perception and not merely a representation or a knowledge that is acquired through a description that is communicated to us.

A representation in the strict sense is a "consciousness of" in which we represent the object in our mind in such a way that it is fully present. But we must already know it in order to be able to represent it.[6] This representation differs from perception not only because—as Hume in an almost incredible naïveté assumed—the perception is more intense than representation, or because the object is more intensively given to us in perception. Rather, we have here two radically different types of "consciousness of."[7] First of all, the object itself is present in perception: it is present *in persona*. Secondly, it discloses and reveals itself to us in its essence and its existence. It fecundates our spirit, informs us, and communicates to us a knowledge about itself. Thirdly, the object is spread out before us as fully present, unlike all the knowledge that we acquire through an inference.

The representation lacks both the first characteristic, namely, the presence of the object, and the second, namely, the fecundation of our mind, the receptive apprehending, being informed, getting to know the essence and the existence of something. Representation in this strict sense already presupposes knowledge. The only thing it has in common with perception is the immediate givenness, although in this regard there is certainly not only a difference of degree between representation and perception.

We recall the distinction between representation and perception only in order to indicate the unique relationship to the object that exists in the act of looking at a photograph of a landscape or of a human face. As in perception, we get to know the essence of an object in the "consciousness of" the object that we look at in a photograph without ever having seen it before. However, the object itself is not present but is there only by proxy, so to speak; the disclosure of its existence does not take place.

In the case of a photograph, however, the "consciousness of" is radically different from the "consciousness of" in the case of an imaginative representation. The photograph communicates to us knowledge of the

6. The mental image in this strict sense must be completely separated from the fictitious mental image in this process.

7. See my *What is Philosophy?* chap. 6.

depicted object. We do not hold up something to the mind's eye, as with an imaginative representation, nor do we merely actualize a knowledge that is already present. Rather, the intuitive immediacy proper to perception is present. The photograph shares this full presence with the imaginative representation, but the radical antithesis to the imaginative representation is decisive. What we receive when we see the photograph comes to us from the outside. In the imaginative representation, what we receive does not come from the outside; rather, we actualize one particular form of knowledge. We must employ a certain effort to spread out before the mind's eye the object that is known to us. Through a photograph, we can come to know something unknown; this is impossible through an imaginative representation in the strict sense of the term. Whenever we see a photograph of something known to us, the object comes once again to us from the outside. The contact with the object is always completely different from what happens when we imaginatively represent something that is known to us.

Naturally, we perceive the photograph itself in the full sense. This entity that depicts is given to us in its essence and its existence, and is itself present. We know that this photograph is a reality and that it exists, because we perceive it in a normal manner. What interests us in the photograph is the contact with the depicted object that is not itself present. We can speak of a perception by proxy, as it were.

All of this also sheds a light on the wonderful reality of visual *artistic* representation, this unique and important phenomenon that is not present in a photograph but is presupposed in a painting and a drawing.

The difference between a photograph and a drawing with regard to the way in which they come into being representation is also found in a drawing that has been made for some practical reason and has no artistic pretension. Such a drawing is also the pure product of a human activity and is the same type of representation even when it neither claims to be a work or art nor possesses any artistic value or disvalue at all.

Artistic representation yields a new reality

Something completely new is present as soon as a drawing aims at an artistic value and thereby in principle goes beyond mere representation. This brings us to the incomparably more important and decisive difference that separates photographs, as well as all drawings made for the purpose of pure depiction, from artistic drawings and pictures. Every visual work of art is a new reality *sui generis*. The representation, the so-called imitative element, is merely a substratum. The theme is not the imitation but the artistic beauty that is conditioned by many other factors.

Only a small percentage of pictures and drawings reproduce definite real landscapes and real figures. We prescind initially from these portraits in the broader sense, not only from the portrait in the narrower sense, which is essentially linked to the rendering of a real person.

Most of the landscapes and figures in painting are imaginary. The type of landscape that is given in a picture may be more that of Bologna or of Tuscany, may be more Flemish or German. But this does not alter the fact that the picture as a whole does not reproduce any concrete, individual landscape, or that it is not a portrait. In most cases, the factor of representation refers to those elements that can be seen in an invented composition in the picture, namely, the human figure, the human body, the figure of an animal, or the form of a tree. In imaginary creations, the link to nature and to the entire visible reality extends only to the general formal types of the things that are present in the picture. A tree must be recognizable as such, and this is even more true of a human figure; a horse must do justice to the figure of a horse and must not look like a calf.

This first striking difference between non-artistic and artistic representation also exists within art, between portraits in the narrower or broader sense and all other kinds of pictures and drawings. This is, accordingly, not a factor that separates non-artistic representation from artistic representation. But it is, at any rate, a characteristic of most pictures and drawings in their relationship to nature, as opposed to the pure representation that we find in a photograph.

The second factor is much more important. The picture or drawing—including all portraits—never lives from the pure representation of nature. It constructs with its own means a completely new, distinct entity. Representation is indeed employed, but it is never the real theme. Even in a portrait in the narrower sense, where the representation is much more important than elsewhere, the similarity to the face and the success in depicting this individual personality are subordinate to the artistic greatness and importance of the portrait in itself. But all other (non-portrait) pictures lack the pure representation of something concrete, and the representation of the elements that are employed is a means to the construction of a new entity of its own.

We are not speaking of the reality of a material thing, such as the canvas that belongs to the new entity, to the picture, with its *sui generis* reality. The picture as such is a self-contained structure that is inseparable from the function of depiction. But there is more to the picture than this function, and more than the representation of an invented landscape or reality. It is something completely new in itself, and this newness is a bearer of artistic values. We have emphasized in the first chapter the special form of reality that the picture as a work of art possesses. There is a distinct form of existence of works of art, which varies specifically in literature, music, painting, and sculpture, as opposed to the architectural works of art that possess the full reality of other real objects such as trees and rocks. All we need do here is to underline that the picture, independently of its function of representation, is a distinct, self-contained structure.

A picture penetrates more deeply into nature

A successful photograph of the Gulf of Spezia makes it possible for us to enjoy the beauty of the Gulf. This is the theme, and the *raison d'être* of the photograph is to be an adequate representation of the Gulf and of its beauty.

But the beauty of a picture that makes use of this landscape must not be exclusively the beauty of the Gulf. It must be the bearer of a new,

distinct beauty. Its *raison d'être* is not the faithful representation of the beautiful landscape. The spiritual process of representation always contains an element of interpretation. When we analyze more precisely the representation of nature in a picture, we find something that is surprisingly new. The picture does not live exclusively from the representation of reality. Its beauty is not only the representation of the beauty that is possessed *in natura* by what is depicted. It is at the same time also a deeper penetration of nature. The representation brings forth from nature treasures that are hidden in it. Both Conrad Fiedler and my father, Adolf von Hildebrand, have drawn attention to this aspect on various occasions.

A picture is thus not only a distinct structure. Its beauty does not live only from the representation of the beautiful thing that it depicts: it is derived from many other sources too, since a work of art is not a sheer representation. It also contains a deeper view of nature and brings forth the poetry and greatness that are hidden in nature. The object is more deeply apprehended and understood in the artistic representation than in the way it discloses itself to the eye of the non-artist.

This is why the relationship of representation is in principle of a different kind than in a photograph. A genuine work of art shows the elements that are to be represented, such as trees, houses, clothed and naked figures, animals, and so on, in a truer and deeper representation of the world of natural forms. A work of art that reproduces the female body, such as Giorgione's *Venus*, is not the depiction of a model, but penetrates the depth, the greatness, and the poetry that the mystery of the form of the female body contains.

This deeper penetration of nature does not, however, consist in an arbitrary alteration of that which is given in nature. On the contrary, it is filled with a great reverence for nature and for the special invention of God that each natural form constitutes.

The pure representation of some model is the specific antithesis of this deeper penetration into the specific principle of shape and form. Equally antithetical, though in a different direction, is every attempt to replace these forms and formal principles of nature by arbitrary inven-

tions, thereby disfiguring the formal principles of nature. This deviation from nature is held to be a sign of creative power, but that is a fundamental error and a great self-deception. One who is incapable of respecting the formal principles in his relationship to nature, and of going beyond reality by representing this world of forms in such a way that its entire depth, greatness, and poetry shine forth in an even more concentrated and unambiguous manner, lacks the true artistic gift. He seeks to attain newness (as opposed to a mere representation) by ignoring nature, and he employs pseudo-inventions to make up for his lack of the power to represent in the work of art the true mystery of forms in nature.

It is deplorable that a painter like Picasso, who created genuine works of art in his early years, later succumbed to the monstrous error of ignoring the given language for the representation of nature, and of giving a new content in what we might call meaningless sentences.

Representation is completely absent in innumerable other so-called contemporary artists. The forms are arbitrarily distorted, and that which is represented is no longer recognizable. This ignoring of nature is an unequivocal sign of their inability to understand the true nature of artistic representation and the irreplaceability of the means through which aesthetic values in nature and art can be realized. This is a pure analogy to Dadaism.

Something completely different is involved in genuinely abstract painting, which prescinds in principle from the representation and depiction of nature. The artist's aim is to achieve a particular artistic content without any representation. But he forgets that by renouncing representation in principle, he deprives painting of an essential field of activity and limits himself to the artistic content that a carpet can give. An additional factor is that a carpet, which can be a bearer of lofty aesthetic values, is meant to be integrated decoratively into the interior of architectural spaces. As a product of the applied arts, it also possesses the beauty of the material, and this does not come into consideration in the case of a picture.

Transposition

Let us return to our analysis of the difference between the phenomenon of representation in a photograph and in a painting or drawing. We have seen that with regard to the pure representation of nature and of human figures, there is something new in the painting and the drawing, something that is incomparably deeper than in the photograph. The representation in the painting and drawing is an act of forming that allows the genius of nature, its content of beauty and of expression, to shine out in the individual work, but never by means of an arbitrary alteration of the figures and formal principles of nature.

It is, of course, true that the factors that condition the beauty of a work of art are not limited to representation, even in this lofty artistic sense. The beauty, greatness, depth, and poetry of a picture or of a drawing depend on many other factors besides representation. While the artistic representation—or, as we could say, the deep inner union with nature, the congeniality with nature—is indeed indispensable, many other things are involved, since the picture or drawing becomes a new structure, a distinct world that is something completely different from every mere representation of reality.

The soul of representation in painting, and by analogy in all the imitative arts, is transposition, which is a mysterious element that finds expression above all in the fact that the beauty of the depicted landscape or bodily form does not in the least guarantee the beauty of the picture or drawing. Some pictures are downright disastrous or completely insignificant in artistic terms, although they reproduce a glorious landscape or a beautiful human body. Portraits of beautiful, noble faces can indeed be similar to these faces in a peripheral sense, but as works of art, they can be nonexistent or even definitely embarrassing and trivial.

The fact that this is possible, above all in the representation of a beautiful landscape, shows clearly the central importance of transposition into a new world. It also shows how much the picture constitutes a distinct structure over against the photograph, which has as its soul and its *raison d'être* the adequate, pure representation of its object. For the beauty of a

photograph, the essential thing is the beauty of the landscape. The landscape may be photographed in a way that is better, more favorable, and more adequate, or in a way that is less adequate, but the theme and the meaning of the photograph are primarily to do full justice to the beauty of the landscape. It is the beauty of the landscape that we want to enjoy.

On the other hand, it would be incorrect to assert that the beauty of the landscape that is to be depicted is not also a factor that contributes to the beauty of a picture.[8]

Once again, let me explicitly emphasize that it is certainly not my aim in an aesthetics to develop a program that would guarantee the value of a work of art, provided that one followed it. Such a project is fundamentally hopeless. One can identify philosophically certain elements that are essential for a genuine work of art, quite apart from many phenomena of an aesthetic kind that are important both in art in general and in the individual arts. But it is not the task of aesthetics to give directives for the creation of true works of art, in the way that ethics can give directives for a morally good life.

The process by which a great artist creates a significant work of art remains a great mystery. Even outside of aesthetics, there is no manual that if followed guarantees the realization of a work of art. Doubtless, a master can contribute much to the artistic development of his pupils, but this happens more through concrete counsel and instruction than through rules. Besides this, he is able to inspire the pupils and to introduce them into a lofty artistic world. But the question of which of the pupils will then be capable of creating genuine, significant works of art depends on the artistic gift that God has bestowed on them. And this is precisely the element that cannot be explained or learned through directives. An aesthetics is utterly unable to communicate it.

8. We discuss this theme in chaps. 21 and 22 below.

CHAPTER TWENTY-ONE

Subject Matter [*Stoff*] and Form

The question of the extent to which artistic value depends on the choice of subject matter plays a great role in the history of aesthetics. Some scholars emphasize that if a picture depicting a sublime object, such as the Annunciation or the miraculous catch of fishes, is artistically successful, it is necessarily more beautiful than Rembrandt's *Slaughtered Ox*. Others take the standpoint that all that matters is the artistic form: if this attains the summit of perfection, the choice of subject matter cannot have any influence on the artistic value.

Some affirm that a tragedy is necessarily more important and possesses greater artistic weight than a comedy, or that sacred music is deeper and more sublime than all non-sacred music, provided that the former is fully successful in artistic terms.

Others dispute this and assert that only the beauty of the music as such decides its artistic value. They say that a comedy can be just as deep and artistically beautiful as a tragedy.

The various meanings of "subject matter"

We must begin by clarifying the concept of object or subject matter, since different things are usually confused here. Above all, the varying importance of the subject matter in the different arts is not taken into consideration. Accordingly, we shall treat this problem in each of the arts separately. We begin with painting.

A closer look immediately discloses the ambiguity of the concept of subject matter. This always refers to that which is depicted, not to the kind of depiction or to the picture as a distinct artistic object. But "subject matter" can refer to very various things in the context of that which is depicted.

First of all, it can refer to the content expressed in the title of a picture. For example, a picture can depict a well-known historical event: the victory of Constantine at the Milvian Bridge, the death of Alaric, the surrender of Breda, and so on. The subject matter is important, completely independently of the picture. As such, it irradiates a specific atmosphere, if we are informed in some way about the event. Inartistic persons who are interested primarily in this are satisfied when they see such a picture and observe: "That is the victory of Constantine!" They are completely blind to the artistic content of the picture and regard it as merely an illustration. The interest they have in the event depicted is in fact literary or historical; the historical content and its atmosphere make the event attractive. The picture gives them pleasure through the intensification of this atmosphere when they see the event, instead of only living off a mental image. We mention this inartistic attitude because it unambiguously demonstrates what we envisage as the first possible meaning of "subject matter." It is clear that there are innumerable pictures with a subject matter that does not have a literary theme.

A picture may depict an historical event or a mythological object, or have a religious content. But neither the value that the historical event as such possesses, nor the poetic content of the mythological object, nor the lofty sacred value of the religious content, influences the artistic beauty of the picture in such a way that it guarantees that this beauty will have

any kind of artistic value. A picture does not become beautiful and artistically valuable through the importance and the value that the depicted object as such possesses. Not even the fact that it depicts Christ, the Mother of God, a saint, or an event from salvation history can, as such, make a picture beautiful and artistically valuable.

This does not in the least mean, however, that the subject matter in the sense of that which is depicted does not place certain demands on the picture and on the depiction, and that the fulfillment of these demands is not important for the artistic value too. Nor does it mean—provided that these demands are in fact met—that what is depicted has no influence at all on the value of the picture. As long as this is an historical event, the demand that is made by the title of the picture is relatively slight. It is indeed true that the picture of a battle ought to reflect the world and the atmosphere of a battle. But if a picture depicts the victory at the Milvian Bridge, it is not decisive whether the apparel is in accordance with that period, with the Middle Ages, or with the Renaissance. Diana ought not to look like Venus, nor Amor like Mars. But it goes without saying that the artistic value of a picture does not depend on whether or not this requirement is fulfilled. A picture can still be a great masterpiece even when it contradicts what we are told is the theme depicted. Nevertheless, agreement with this theme is an advantage.

"Literary" and purely artistic requirements of the subject matter

We must distinguish two requirements that apply both to the depiction of an historical event and to a mythological motif. The first concerns the historical content or the mythological theme of such objects. We can call this the "literary" requirement.

The second requirement concerns the form that is united to the theme. This also exists in the depiction of a landscape with or without figures, in which the "literary" demand is completely lacking. There are several dimensions with regard to this second requirement of the subject matter. The depiction of one particular type of landscape can belong to them. If a painter wants to reproduce in a special way the Dutch land-

scape, its cachet, its specific character including Dutch life, this demands that this atmosphere, this specific quality, should in fact be present in the picture. Many Dutch painters were outstandingly successful at this.

Our glorious landscape pictures, such as those by Rubens, entirely lack this portrait-like theme. In such pictures too, however, the theme of the landscape in general has certain artistic requirements. This brings us to the artistic importance of nature in the graphic arts, and especially in painting. Unlike the demands made by the "literary" theme, we have here artistic demands that are deliberately ignored in some modern painting, for example, by Picasso. If the nose lies athwart the face, or one side of the face is depicted frontally and the other in profile, the expressive possibility of the face is destroyed and a path is taken similar to that in a poem the words of which have no meaning.

Clearly, this is something completely different from a caricature, a hideous grimace, or something similar. This ignoring of nature and of its requirements of an artistic kind claims to produce a deep and serious picture, and there is no trace here of the theme of caricature or of humor, of the decorative theme of a mask, or of the monstrous that is meant to be monstrous (as in the pictures of Hieronymus Bosch).

If one wishes to portray directly one particular expression, an atmosphere, or an impression, without taking into consideration the requirements that have their origin in nature—a very dubious undertaking, in artistic terms—the so-called abstract painting is the given path. The requirements of nature no longer come into question along this path, and all depiction is abandoned. This means renouncing a world of artistic possibilities. It is true that carpets, on which nature is seldom depicted and which are restricted to a decorative theme, can be very beautiful. But as soon as one employs objects from nature—landscapes, trees, animals, human figures and faces—this ignoring of the requirements of nature means not merely a resigned withdrawal to a small body of artistic contents but also a definite disvalue.

It is, at any rate, important to distinguish the subject matter in the sense of the "literary" theme from the subject matter in the sense of that which is depicted. The general requirements posed by nature in its forms

include requirements deriving from a portrait-like theme. Each of these various requirements has a specific importance for the artistic value of the object.

Requirements deriving from a sacred subject matter

The situation is completely different in pictures whose subject matter has a sacred character. Many of these pictures, especially frescos, are intended for a church and are meant to fulfill a religious function. It is clear that this function requires certain things of a work of art, and that the fulfillment of these requirements is important for the picture. If the picture or fresco does not adequately represent its subject, or if it does not irradiate a sacred atmosphere, it sounds a false note in the church. It may possess other artistic qualities, but the failure to fulfill the requirements of the sacred subject matter (and in the case of a church, the failure to fulfill its goal) is a definite flaw even from an artistic standpoint, a failure in an important respect.

Even where this service of a religious and cultic goal is not present, the sublimity of the subject makes high demands of the purely artistic capacity in general and of the special ability to represent the sacred world artistically. A picture that depicts Christ or the crucifixion of Christ, the taking down from the Cross, or any scene from the life of Christ, and has a profane character, depicting Christ like a mediocre, average man or like a worldly figure, is an artistic faux pas. It may be beautiful in its composition, its colors, and so on, but the failure to fulfill the profound requirements of the subject matter clearly denotes an artistic disvalue.

The portrait

The portrait, in which the depicted person is the subject matter in a completely different sense of the term, is a separate type. Here it is clearly an important artistic task to do justice to the face and to the personality. All the great portraits in painting, whether by Raphael, Titian, Tintoretto, Holbein, Rembrandt, Velazquez, or other great masters, represent in an

incomparable manner the personality of the person depicted. It suffices to recall the portraits of Thomas More,[1] Erasmus,[2] or Pope Julius II.[3]

One must do justice to the requirements of the subject matter, if the portrait is to be successful and to possess artistic value. This is possible only through purely artistic means, however. The fame of the personality who is depicted, the "literary" aspect of the object, may not play any role as such. On the other hand, it is indubitable that one aspect of an artistically perfect portrait is the truthful rendering of the personality whom it depicts, in full artistic transposition.

Unartistic similarity

Another inartistic attitude reduces the depiction of the subject to a copy that is as exact as possible. However, a mere similarity to what is depicted is not, as such, an artistic value. This attitude is typified in the story that the Greek sculptor Apelles had the ability to depict grapes in such a way that the birds picked at them.

In this instance, the being of artistic depiction is completely misunderstood and is reduced to mere similarity in reproduction. Besides this, the purely technical depiction is made the only theme. This is certainly just as mistaken as the attitude of those who are interested only in the title, and to whom a picture means nothing more than the illustration of an object whose "literary" value is the only theme.

The beauty of that which is depicted and its influence on the work of art

The visual aesthetic character of an object is clearly something completely different from all its "literary" values, its sacred meaning, and the demands that the subject matter in this sense makes of a picture.

The question is: What influence has the beauty of that which is depicted, its aesthetic value *in natura*, on the artistic value of a picture?

1. By Holbein: Frick Collection, New York.
2. By Holbein: Kunstmuseum, Basle.
3. By Raphael: Palazzo Pitti, Florence.

We must reply that the beauty of that which is depicted does not guarantee any kind of artistic value in a picture, even in the most lifelike depiction. Even when a picture depicts a beautiful landscape, beautiful human bodies, or beautiful faces, it can be utterly devoid of value. As a picture, it can possess no beauty at all.

This does not, however, answer the question whether the beauty of that which is depicted can have an influence on the beauty of a picture.

The first point is that the landscape in many pictures is made up, and its forming belongs entirely to the creation of the work of art. There is thus no subject matter in the portrait-like sense of the term.

Secondly, it would be absurd to deny that the beauty of a landscape, although it constitutes only one part of the composition of a picture, has a very great importance for the beauty of the picture, for its artistic value, and for its deep poetry. As a part of the composition, the beauty of this made-up landscape shares in bearing the poetry and the beauty of the picture itself. An invented landscape that was prosaic, boring, and featureless would be an artistic error, a failure on the part of the artist. This would eliminate the problem of identifying the influence exercised by the beauty of the depicted object.

The same applies to the architecture that is reproduced in a picture. A picture of thoroughly tasteless architecture or of a barren, prosaic factory can never possess the same poetry and beauty as a picture of architecture of great nobility. Nevertheless, the Impressionists succeeded in achieving a definite poetry *sui generis* in their paintings, even when they depict a relatively barren nature and architecture of doubtful quality.

A new problem arises with the depiction of the naked human body. Except in the case of caricatures or an intended humorous effect, or of pictures that depict monsters or grotesque figures, the choice of a mis-shapen naked human body constitutes a grave impairment of artistic value. Caricatures, humorous pictures or drawings, and pictures meant to be grotesque are placed in quotation marks, so to speak. In every other picture, the choice of a deformed body, of a fortuitous corruption of the formal principle that goes hand in hand with a naturalistic tendency, is a death blow to the work of art. A whole world of difference lies between

the creation of something grotesque and a naturalistic inability to get be-
yond chance deformations. The grotesque has certain boundaries. It can
indeed possess a genuine artistic value, but it can never attain the same
artistic depth and beauty as Giorgione's *Pastoral Concert*[4] or his *Venus*.[5]

The naturalistic depiction of a naked body has nothing in common
with the grotesque. It is not stylized like the grotesque; on the contrary,
it claims to be truer and more lifelike than the "idealized" beautiful body.
Deformation is neither grotesque nor humorous. It is the depiction, un-
translated in artistic terms, of a depressing, prosaic reality that lacks po-
etry. The immanent claim to be "more lifelike" because of its accidental
character generates a specifically prosaic atmosphere. Our attention is
simply drawn to the misery of the model who was used by the artist. The
body seems undressed rather than naked.

It is a wholly false alternative to hold that a body must have an aca-
demically idealized quality, schematized in every detail, thin, and lack-
ing the fullness of life, or else that it must be naturalistically accidental,
unbeautiful, and misshapen. Both of these are grave artistic errors. The
beauty of the human body that is required in artistic terms is certainly
not one specific ideal type. Innumerable variations are possible, and they
must never be forced to fit a schematic criterion. What must be avoided
is the accidental, the definitely misshapen that does not approximate to
the comic and the grotesque. The special demands that a picture of the
naked body makes of the artist are extremely interesting. They are much
more pronounced in sculpture. In clothed human figures, on the other
hand, a figure that is unbeautiful in its proportions is no impediment to
the artistic beauty.

This applies even more strongly to portraits. An unbeautiful face can-
not affect the greatness and depth of a portrait. But whether a person has
a good head or an interesting, expressive face, and what kind of personal-
ity is expressed in it, certainly has an influence on the artistic possibilities
of a portrait.

4. Louvre, Paris.
5. Gemäldegalerie, Dresden.

The choice of the subject matter

From the artistic standpoint, the choice of subject matter is important. The object that is depicted can be a face, a pure landscape or one with human figures, something architectural (for example, a city), or a still life.

It is clear that even the most beautiful still life can never attain the same artistic sublimity that we find in some of Rubens's or Rembrandt's landscapes. This applies all the more strongly to nature with human figures, and especially with naked figures, as in Giorgione's *Pastoral Concert* and his *Tempest*.[6] Pictures that have the human body as their principal theme, such as Giorgione's *Venus*, can likewise attain a depth and greatness that no still life can match. Many portraits too possess an ultimate depth and a moving greatness, such as Leonardo's *Mona Lisa*,[7] Titian's portrait of the *Young Englishman* in the Palazzo Pitti, and several of Rembrandt's self-portraits.

6. Accademia, Venice.
7. Louvre, Paris.

The Artistic Means Employed in Painting

WE SUBSUME UNDER the artistic genre of painting the entire field of two-dimensional representation, provided that this derives from an artistic activity and does not take place mechanically, as in photography.

The various types of painting

This artistic genre encompasses, in the first place, colored and colorless drawings. We apply the term "colored" to an unpainted drawing executed with a colored pencil. There are many great works of art in this field.

The second type is the picture painted on canvas or wood, which is in a sense the very heart of this artistic genre.

Thirdly, a related type is the fresco painted on stone or on a wall. This type is different from the picture, both in the underlying technique and in its artistic statement, in its special style.

A special type of picture can be seen on ancient vases, for example, in Greece and Pompeii. High artistic values were attained in this genre. The vases as such belong to the field of the applied arts, but this is not true of the pictures painted on them.

The fourth important type of painting in our list is the mosaic.

A fifth type, the woodcut, is completely different from those we have mentioned hitherto. It is much closer to the drawing, which is likewise non-colored, than to the picture or fresco.

The copper engraving, the etching, the lithograph, and other types are related to the woodcut.

The last type we must mention is the various kinds of illustration.

Colors

When we speak of "means," we do not mean the paper and pen for the drawing, the canvas or wooden tablet for the picture, or the wall for the fresco and the materials for the mosaic, the woodcut, and so on. We understand this term to refer to the factors that are indispensable for the creation of a work of art. Through these factors the work is determined in its specific character and its content.

In a drawing these means are the composition, the invention in the assembling of the landscape, the figures, or whatever the depicted object may be.

In pictures, mosaics, and frescos, the colors too constitute an extremely important factor. What a world of beauty can be attained in them through colors.

We point first of all to the high aesthetic value of the colors in themselves. What nobility an old red satin can possess! Doubtless, the beauty of the material is an additional factor, as well as the great gradation within the various kinds of satin. But we are thinking of the beauty that only colors can display. Colors are already in themselves bearers of a great aesthetic value, though not of a beauty of the second power. The "word" that is spoken in the various colors, the whole qualitative dimension of being in them, is profoundly important. How beautiful and noble a red, a green, a blue, or a yellow can be—but also how vulgar, intrusive, and kitschy they can be.

Much more important than the beauty of the color in itself is its beauty in nature. What an outstanding factor this is! Let us imagine just

for one moment a nature devoid of color, without the blue of the sky, without the white of the clouds, without all the various kinds of green of the meadows, the trees, and the bushes, without the world of the colors in the realm of the flowers, without the colors of the rivers, the lakes, and the sea, without the blue of the distant mountains! Then we fully realize what a great gift colors are, and we apprehend how much more beautiful they make the world.

In relation to all this, the function of colors in painting means something completely new. Here they are a central factor in bringing about the specifically artistic content. We are speaking here not of the general type of color that is prescribed by the depicted object but of the special variety of color within this species.

We cannot mention the importance of colors without referring to the relationship of the various colors to one another. One cannot judge the quality and the beauty of one color in a picture independently of the other colors that are present. In addition to the color that is prescribed by nature for the object in question, its relationship to all the other colors of the whole picture is decisive for its special nuance. This is why the colors in a picture belong to the special artistic creation, to the extent that they are not prescribed by the depicted object.

Color contrast is frequently also an important factor in the realization of specific artistic values, and is analogous to the contrast in the other artistic genres.

The difference between a color contrast that is the bearer of an aesthetic value and the clashing of colors is of particular artistic interest. Both of these, the contrast and the clashing, contain an antithetical element, unlike colors that complement one another in a special way. In a contrast there lies a great difference of colors, but this is a kind of contrary antithesis in which their appearance together emphasizes the specific quality of both.

This brings us to a point that is central for all the arts, as well as for the beauty in nature, namely, the relationship of different elements to each other. First of all, we have their belonging together that is "logically" required. In the construction of a melody, one note calls to the other.

In a poem, one comparison gives birth to another. The size of a door or of a gate is a meaningful and necessary consequence of the size of the building and of many other elements that characterize the building. Similarly, in the realm of colors, one color can call for working together with another color.

It is not necessary, however, for the colors to follow one another in a "logical" sequence. It suffices when they fit one another in a good and normal way—for example, when red and yellow harmonize, or black and white.

Colors can also contrast strongly, yet in such a way that this antithesis does not disturb the unity but rather allows them, despite their radical difference, to shine out in a special manner in their depth dimension. A contrast of this kind is clearly different from the clashing of colors. In the latter case the difference of colors is usually smaller; it does not form an antithesis, still less a fruitful antithesis.

Clashing comes about through a fatal combination that is the bearer of a very specific aesthetic disvalue, which seldom occurs in the realm of painting, however, even in pictures that are artistic failures. On the other hand, it frequently occurs in garments.

Contrast has a very important function in all the arts. How important the contrast between good and evil, or between the tragic and the humorous (or indeed the comical), is in literature! How effective is the contrast in music between piano and forte, adagio and presto, between pain and joy, passionate movement and rest! We find many kinds of contrasts in painting too, both the contrast between bright and dark and the contrast in the realm of the colors. What a wonderful contrast there is, for example, in Tintoretto's *Susanna and the Elders* (in the Kunsthistorisches Museum in Vienna) between the white female body of Susanna and the colors of the garden that intensify to reach a high point in the blazing heat of noon! This contrast is the bearer of a great artistic beauty.

The colors in painting can serve a completely different element, namely, expression. Colors often unite in a mysterious way with the expression of a person. The white of the garment of the Mother of God in Grünewald's *Crucifixion* on the Isenheim Altarpiece in the Unterlinden

Museum in Colmar serves the expression of her being struck with grief. It helps to express this pain that reaches into inconceivable depths. This expressive function of colors is found relatively seldom, and only in artists who possess an immense intensity in their work, coupled with an expressionistic element. The word "expressionistic" is not intended here to denote any kind of negative value. We would be carrying coals to Newcastle if we were to spell out the meaning of "expressionism" when the term is applied to Matthias Grünewald. It is important to point out, however, that the expression that a color is capable of possessing can be the bearer of a high artistic beauty. In that case, the color attains an extraordinary depth and gives something that goes beyond its normal function.

Light and dark

When we speak of means, we must go on, after discussing colors, to speak of light and darkness. This contrast too allows an important artistic word to be uttered. Many things that were emphasized when we spoke of colors are not present here. This contrast often makes it possible to attain a moving depth and an immense dramatic power.

We can see the potential of this contrast in artistic terms when we look at Rembrandt, who places the principal emphasis in many of his works on light and dark rather than on colors. One could object that light and dark presuppose colors, since these qualities are revealed by all colors. There is a light red and a dark red, and a light green and a dark green, and so on. But it is clear that when we compare light and darkness with colors, we regard them as something different from colors. We do not believe that pictures in which the light plays a principal role are devoid of color or are monochromatic. Rather, we have in mind the light that falls on one particular place in a picture, so that the colors of these objects are lit up and the light, *qua* light, has a greater importance than the colors. We also have in mind pictures in which the colors are unimportant, with the exception of white and black, which are of course also basically colors, even if they differ in several respects from the other colors.

Light and dark can, as such, be specific artistic means. Let us compare many of Rembrandt's paintings, such as *The Supper at Emmaus* (in the Jacquemart-André Museum in Paris), *The Burial of Christ* (in the Art Gallery in Glasgow), or *The Man in a Golden Helmet* (in the Kaiser Friedrich Museum in Berlin), with paintings by Titian, such as his *Sacred and Profane Love* (in the Borghese Gallery in Rome) or *Bacchus and Ariadne* (in the National Gallery in London). We cannot avoid seeing how much is entrusted to color in Titian's paintings, what an enchanting artistic world is given through the colors, and how important they are for the beauty of the pictures; on the other hand, we cannot avoid seeing the great importance that light and darkness have in the constitution of the artistic beauty of Rembrandt's pictures.

Artistic beauty and the beauty of what is depicted

In many cases, as we have seen, the beauty of a work of art in painting often does not require that what is depicted should be beautiful *in natura*.

Here we must ask: How are we to interpret the fact that a picture that reproduces an object that is not beautiful is capable of bearing high artistic values? Does this mean (always presupposing the indispensable transposition) that the beauty of the object that is depicted cannot influence the beauty of the picture?

The least degree of influence appears to be exercised by a beautiful face that is depicted in a portrait. Is one of Rembrandt's great self-portraits less beautiful than the portrait by Hans Holbein of *Sir Thomas More* (in the H. C. Frick Collection in New York), who was beautiful *in natura*? This does not appear to be the case. On the other hand, if Leonardo had painted a portrait of an ugly woman, could this be just as beautiful as his *Mona Lisa*?

When it is a question not of portraits, however, but of the depiction of nature, architecture, and figures the beauty of that which is depicted appears to exercise a great influence. It is true that there are masterpieces by Cézanne and by Impressionists such as Renoir and others that depict

unbeautiful objects. But no one can deny that the depiction of a glorious landscape with figures, for example, in Giorgione's *Pastoral Concert* or in the *Allegory of Purgatory* by Giovanni Bellini (in the Uffizi), attains an artistic value that is not matched by even the most beautiful Impressionist painting.

The various types of landscape paintings

We must, however, draw a fundamentally important distinction here. One particular type of landscape painting reproduces the special atmosphere of a real landscape. The relationship of the painting to this landscape is analogous to the relationship that exists in a portrait, but it is not identical, since the relationship between a portrait and the real face of the human person is much closer. The analogy consists in the fact that the theme is the representation of a real, specific object, turning with full attention to something that is given in nature, and entering into the artistic transposition of an individual object. The intended link to a piece of nature, which sometimes discloses itself from one specific viewpoint, is thematic for these landscape paintings.

Landscape paintings of this kind can also include architecture, and the artistic transposition is, of course, indispensable, if the picture is to be a bearer of artistic values. At any rate there is, in a manner analogous to a portrait, a link to the object; one of the aims of the picture is to represent the special poetry and the specific qualitative character of this type of landscape. Thus there are many paintings that have the character of the Dutch landscape, while others express the character of the Tuscan or Greek landscape. Corot painted several pictures of Italian cities, while Canaletto and Guardi portrayed many situations in Venice. Let me repeat as emphatically as possible, however, that transposition, this mysterious gift of the artist, plays just as great a role in these pictures of landscapes and of architecture, as in pictures of purely invented landscapes or buildings.

In addition to these landscape paintings that are similar to portraits, we find much more frequently depictions of invented landscapes

and buildings, with or without human figures. These may be naked or clothed. In landscape pictures of this kind, there is a completely different relationship to nature, and there is no analogy to the portrait. The given link extends only to the forms that occur in nature, such as that of a cypress, a bush, a river, or one particular animal in general, and above all to the form that is intrinsic to the human body. Everything else is invented.

If the landscape that the painter depicts is not real and individual but invented, its beauty is a fruit of the composition and meets us only as transposed artistic beauty. For example, the landscape in Giovanni Bellini's *Allegory of Purgatory*, in Giorgione's *Tempest* and his *Pastoral Concert*, in Rubens's *Landscape with Odysseus and Nausicaa* (in the Palazzo Pitti in Florence), and in *The Fall of Icarus* by Pieter Bruegel the Elder (in Brussels) is the fruit of a composition by the artist, and its beauty is already an artistic beauty. We can wish that we might find such a landscape in real nature; it would be the bearer of a great beauty, since the beauty of a landscape in the narrower sense is also an artistic beauty *in natura*.[1]

We must, however, mention one further important difference. In the context of pictures with an invented landscape, there are pictures (like all those mentioned above) that depict not only a landscape but also human figures, animals, and buildings. In these pictures, the landscape is only one element, which usually forms the framework, the background, for everything else. There is a great gradation with regard to the importance of the landscape. The landscape in Rembrandt's *Polish Knight* (in the H. C. Frick Collection in New York) or in Titian's equestrian portrait of *Charles V at the Battle of Mühlberg* (in the Prado) is much less thematic than in Bellini's *Allegory of Purgatory* or in Giorgione's *Pastoral Concert*. The landscape likewise plays an important role in Velazquez's *Surrender of Breda* (in the Prado).

In other paintings, such as those by Claude Lorrain, the landscape is so thematic, and the human figures are so much in the background, that they almost border on pure landscape pictures.

Despite the extraordinarily varied function of the landscape, the hu-

1. See *Aesthetics*, vol. 1, chap. 14.

man figures, the animals, and the buildings, this type of picture must in general be distinguished from the pure landscape pictures that also depict an invented landscape. The meaning and the specific character of the latter pictures consists solely in the representation of a piece of landscape. The fact that this is the exclusive theme forms a very specific type of picture and affects even the special character of what is portrayed in the picture. Thus a human figure would be a disturbance in a picture such as Rembrandt's *Landscape with a Stone Bridge* (in the Rijksmuseum in Amsterdam) or Ruisdael's *Ray of Sunlight* (in the Louvre). The exclusive landscape picture corresponds to a specific artistic intention and inspiration. In the pure landscape, there lives a dignity all its own—we are tempted to say, a silent praise of God. It is a special artistic task to render this in a picture.

The decisive point here is the difference between pictures that reproduce a real landscape, and so have a certain analogy to the portrait, and pictures that depict an invented landscape, either a landscape by itself or a landscape in combination with human figures, animals, buildings. This difference is highly important for a philosophical analysis of the work of art, because the beauty of the invented landscape is always a transposed artistic beauty, and the question of how significant the beauty of the depicted is for the artistic value of the whole does not arise. This question could be posed at most in the case of the elements that constitute the landscape, such as trees, rivers, and mountains. But the choice of trees and of the form and color of a mountain or a river is also completely entrusted to the transposition, to the invention of the painter.

In paintings where human figures are decisive, we encounter a remarkable influence of their beauty *in natura* on the artistic value.

The depiction of the naked human body

The naked human body makes certain demands on the artist, or, more precisely, imposes certain requirements with regard to painting a picture. Failure to fulfill these requirements restricts the artistic value of the picture.

First of all—and this applies perhaps even more strongly to sculpture than to painting—the naked body must not be deformed, it must not be damaged in its inherent formal principle. It is true that monstrous figures in which the true formal principle is replaced by a different, invented formal principle are possible in sculpture and painting. But the depiction of a misshapen naked body is inartistic. A naked woman with pendulous breasts, disproportionately fat buttocks, or jutting shoulders can never be represented in a sculpture or a painting without reducing the artistic value. The figures of witches and bodies that are distorted in the manner of a caricature can, if put in the proper quotation marks, have a positive artistic effect. But obviously this invented deformation, which always has an element of the grotesque and presents itself as grotesque, is completely different from a female or male body made ugly by disproportion. If a naked body of a man with far too short legs, drooping shoulders, a fat stomach, or a head that is too big or too small, were to function in a picture as a human figure claiming to depict the special contribution made by the naked human body, to depict its poetry and its beauty, the result would be incompatible with the artistic value of the picture.

There are many naturalistic painters who feel that they are being particularly truthful by depicting unbeautiful human bodies and who believe that they, in contrast to all classicistic idealization, remain true to living reality. They misunderstand the inherent artistic demand that is made by the naked human body. They confuse a naked human being with one who happens to be unclothed. They replace the deep penetration into the *natura naturans* with the representation of a model skewed by disproportion.

There is an additional requirement. The naked human body that is depicted in a work of art cannot tolerate an overall situation that is prosaic. A naked figure whose facial expression has a definitely prosaic character is intolerable. In a clothed figure, the same expression would not be particularly felicitous, but it would at any rate be endurable; it could be motivated by the overall event that is depicted in the picture. In a naked body, on the other hand, a prosaic facial expression is a defect in the artistic transposition, a naïveté with regard to the mystery of the naked

human body. In the facial expression of the naked figures in Giorgione's *Pastoral Concert* and his *Venus*, or in Titian's *Danaë* (in the Kunsthistorisches Museum in Vienna), or in the naked figure in his *Sacred and Profane Love*, we always find poetry and nobility, never anything prosaic or soulless.

To do justice to these two artistic requirements is an element of artistic transposition and of invention. These requirements are not derived from the relationship between the work of art and the given nature that it depicts, in the sense of a limit on the possibility of transposition. They do not mean that the beauty of the depicted object is decisive for the beauty of the work of art, independently of the transposition. These requirements are derived precisely from transposition and from artistic tact. To go against them is a definite artistic error.

Body-feeling and the expression of human figures in artistic depiction

In our discussion of sculpture, we have already mentioned the quality of the body-feeling in the depicted figures. This is important in artistic terms. It is most pronounced in naked figures, but it has a decisive effect in clothed figures too. This of course applies just as much to the realm of painting, to drawings, pictures, or frescos.

The body-feeling, the way someone feels in his body, can be raucous, shameless, or impudent. But it can also be bashful, pure, innocent, or graceful. The character of sinking down into matter is possible, as is the character of spiritualizing matter. The body-feeling covers the whole spectrum from letting oneself go, all the way to a dignified *habitare secum* ("dwelling with oneself"). It can be prosaic, bourgeois, homespun, and flat. But it can also be poetic and lovely.

It is interesting to note that the quality of the body-feeling of a human figure, and especially of an unclothed figure, strongly influences the artistic value of a picture or fresco. If the figure that is depicted has an embarrassing, prosaic, awkward body-feeling, this largely destroys the artistic value of the picture. The body-feeling of the figures in each picture is a part of the invention; it has already undergone artistic transposition.

If its quality has disvalue, this is an artistic disvalue. The depiction of human figures with a poetic, pure, and noble body-feeling is the fruit of a specifically artistic act. What nobility of body-feeling is possessed by Giorgione's *Venus*!

We must draw a distinction between body-feeling and expression in the narrower sense.[2] It is a true *mirandum*, a source of wonder, that the human face is able to express both concrete, affective experiences and abiding characteristics of the person. A visible being, namely, the face of a human being, discloses to us something that exists in a personal manner, such as pain, joy, fear, love, or hatred. In this visible, material being, something is revealed that exists personally in a wholly immaterial manner, something like the experience of a person, his or her meaningful response, which is something that is consciously lived through and thus radically different in its mode of being from the visible face of the person. The face is likewise capable of expressing abiding characteristics of the person, such as kindness, gentleness, or intelligence. The metaphysical beauty and ugliness, both of the concrete experience and of the abiding characteristic, are also given in this expression.

The question that we have already investigated in the case of sculpture, and that now concerns us again, is the function that this expressed metaphysical beauty has for the value of a work of art. The expression, for example, on the face of Michelangelo's *Night* (in the Medici Funeral Chapel in San Lorenzo in Florence) or on the face of his *Dying Slave*, is an essential part of the artistic creation of these sculptures and is accordingly, in union with the overall expression of the figure and the body-feeling, a bearer of high artistic values. The beauty and above all the expression of Jesus's face in Leonardo's *Last Supper* in Milan is an exceptional artistic creation. Here we do not find the difference between nature and its representation, which exists when a portrait is made of a body that is exceptionally beautiful in its build. For such a picture, the object is already given, and its aesthetic values are transposed in the picture. This does not occur in Leonardo's *Last Supper* and in the sculptures

2. *Aesthetics*, vol. 1, chaps. 5 and 7 discuss expression in the narrower and broader senses.

mentioned above, however, or in pictures such as Raphael's *Miraculous Draught of Fishes* and his tapestry cartoon *Feed my Lambs, Feed my Sheep* (in the Victoria and Albert Museum in London). In each of these cases, the face and its expression are invented by the artist. They constitute an essential part of the artistic process itself and are not a transposition.

Let us return to the difference between the body-feeling and the expression in the narrower sense of the term. The expression of a momentary experience or of an abiding characteristic of the person manifests itself above all in the face, whereas the body-feeling manifests itself in the body, in the gestures, in the posture that someone adopts, and so on. Another decisive difference is due to the special qualities that manifest themselves in expression or that characterize body-feeling. Spiritual significance, kindness, and so on express themselves in the face; they do not manifest themselves in the body-feeling.

One final point: a general characteristic of the human person reveals itself in the body-feeling seen in a momentary posture and movement. In body-feeling we do not find the difference between concrete affective experiences such as pain, joy, yearning, or anger that are expressed in the face, and abiding characteristics of the person such as kindness, nobility, intelligence, or purity.

Despite the difference between the facial expression and the expression of the body-feeling, the two work closely together in the overall characteristics of the personality.

We can also speak of expression in a broader sense that is different from expression on the face of a human being. When we speak of the victorious quality of the *Winged Victory of Samothrace* in the Louvre, we refer likewise to a quality that is intuitively expressed, a quality that manifests itself in the overall figure. Clearly, it would be absurd to say that this is nothing more than an association evoked by the name "Nike" ("victory"). There is likewise an expression of what is grand and superhuman, as well as of power, in Michelangelo's four figures on the Medici tombs. The expression of the figure as a whole is clearly distinct not only from the expression in the narrower sense (that is, of the face) but also from the body-feeling. This expression is of a much more general nature;

it is not concerned with how someone feels in his body. This expression in the broader sense can also be found in animals and, in a completely analogous manner, in the joyfulness of the blue sky when it is lit up by the rays of the sun.

In the present context, where we are discussing the factors that decide the artistic value of a picture, or that possess a quality that is important for the artistic value, it suffices to mention, alongside the body-feeling, expression in the narrower and broader senses. How unique is the facial expression of Saint Anne in Leonardo's *Virgin and Child with Saint Anne* (in the Louvre) and of the Child Jesus in his unfinished *Adoration of the Magi* (in the Uffizi)! What a world of artistic beauty lies in the expression of Saint Peter in Masaccio's fresco of *Saint Peter Healing the Sick with his Shadow* (in the Brancacci Chapel in Santa Maria del Carmine in Florence), or in the expression of the Mother of God in the *Crucifixion* on Grünewald's Isenheim Altarpiece! What unmatched depth is attained by many of Rembrandt's self-portraits, thanks to the expression!

Composition

The most decisive of all the factors in painting is composition. In sculpture this is limited primarily to the form of the figure, to its position, its movement, its body-feeling, and its expression; in the relief, it is limited to placing together many figures, to an entire situation, and to scenes of very various kinds. It is in painting (with the exception of the portrait) that the composition of figures and landscape has the greatest importance. The difference between the object that is depicted, and that can be depicted, in sculpture, on the one hand, and in painting, on the other, naturally has an effect on the framework of the composition, on the kind of creation, and on the combination of various elements. The composition of the *Concert* in the Palazzo Pitti, formerly attributed to Giorgione and now to Titian, has a profoundly moving beauty and depth. What inspiration there is in the placing of the various figures! What an unmatched composition there is in Leonardo's *Adoration of the Magi*! Everything that the picture shows concentrates on the Mother of God and

on the Child Jesus in her lap! What inspiration there is in this unity and intensity! How glorious is the variety of everything that is going on in the background! There is an unmatched wealth of inspirations, yet these are incorporated into the whole in such a way that this picture is one of the most outstanding examples of a unity that is absolute and indeed necessary.

We clearly see the importance that composition has for a picture, a fresco, and a drawing. We also see the extent to which artistic value depends on the kind of composition. This determines whether the picture constitutes no unity, or a merely fortuitous unity—or else a unity that is inherently necessary and convincing. It decides whether a picture is boring or is filled with inner riches. It goes without saying that when we emphasize composition, we do not in any way wish to diminish the importance of other elements, such as the body-feeling, the expression, and (in another way) colors.

Whereas colors have no importance in many drawings, in woodcuts, and in copper engravings, composition is everywhere decisive. Precisely the absence of colors entrusts the realization of such works of art above all to the composition.

CHAPTER TWENTY-THREE

Drawing, Fresco, Mosaic, Illustration

The drawing

A SIMPLE DRAWING can attain an artistic greatness and depth that are astonishing. Here, of course, colors are not available as a means; but composition, body-feeling, and expression can construct a great work of art.

At this point, an interesting question arises: Does a drawing ever make the same claim to be a definitive and fully realized work of art that is made by a painting or a fresco?

Many drawings by great masters are in fact preparatory work for paintings or frescos, but some do not have this preparatory function. They are intended as a definitive work of art that stands on its own feet, and they do full justice to this claim.

With regard to their beauty, there is no doubt that many drawings, such as those by Leonardo, Raphael, and Michelangelo, attain an absolute height. There are an enormous number of artistically important drawings. One who looks at them does not seek something that is more realized, something for which they were only a preliminary study.

Drawings possess a special immediacy and an intimate unfolding of

the artistic genius. In themselves, they are more modest than a painting or a fresco. This modest character means that less is required for their perfection. It makes possible a lofty freedom and boldness, a great freshness and unconventionality.

Apart from the question whether a drawing can possess an ultimate artistic perfection, we are primarily interested in whether it bears the character of a preliminary stage of artistic realization. It seems that the drawing is just as much an analogous subspecies of the overall artistic genre of painting as the woodcut and the copper engraving, and neither of these is a preliminary study for a picture or a fresco. It is certain that the striving for artistic depth and greatness can go just as far in a drawing as in a picture and a fresco. The framework in which the work is placed can be equally large. Many drawings are executed down to the finest detail.

A great many drawings are, however, sketches. This is a special type of work of art, which we must mention briefly here.[1]

Sketches can be bearers of a great artistic beauty. They often have more momentum, a greater immediacy and boldness, than fully executed drawings and paintings. It is as if they were especially close to the inspiration rather than the product of arduous toil. Important sketches of genius often breathe an enchanting breath of spiritual freedom.

Naturally, a sketch lacks a dimension of completeness, since it is by definition not an artistic final stage. Not everything in a sketch is completely realized and executed, and this is itself a defect. It would be utterly mistaken to interpret the element of final execution down to the smallest detail as something conventional, as an inevitable loss of boldness and grandiose inspiration. Completion is an important factor in all the arts, and a masterpiece that is executed down to the smallest details is an outstanding bearer of high artistic values. Besides this, it is a characteristic precisely of the true masterpiece that it loses nothing of the freedom, boldness, and freshness that often belong to the sketch.

1. See chap. 5 above.

The fresco

The first difference between paintings and frescos is the much more inti-mate link between the fresco and architecture. A fresco is meant for one particular place in a building, and this means that it enters into a close union with architecture.[2] We may mention as examples Cimabue's fresco in the Lower Church in Assisi, Fra Angelico's *Crucifixion* in the chapter room and his numerous frescos in the cells of the monastery of San Mar-co in Florence, Ghirlandaio's *Last Supper*, likewise in the monastery of San Marco, Michelangelo's frescos in the Sistine Chapel, and Raphael's *Liberation of Saint Peter* in the Stanze.

The fact that the fresco is painted on a wall has a special charm. But not only this: the union with architecture makes it an especially noble type of painting. In a certain sense, it is a counterpart to chamber music, and above all to the quartet. It is remarkable that some painters have reached a much greater depth, a much higher poetry, and a greater nobil-ity in their frescos than in their paintings. This is true of Ghirlandaio, of Botticelli, and for Raphael in the Stanze (though with the exception of his cartoons in the Victoria and Albert Museum in London). And none of Michelangelo's paintings matches the beauty, the greatness, and the nobility of his frescos on the ceiling of the Sistine Chapel. A philosoph-ical analysis of the artistic genre of painting is unable to indicate why this is so and what elements determine this special position of the fresco. Accordingly, we content ourselves with drawing attention to this fact.

The mosaic

The mosaic is, as such, an idiosyncratic structure that is radically differ-ent from the fresco, and still more from the painting. The form of the reproduction, the relationship to that which is depicted, and the kind of artistic transposition are completely different. The mosaic is a specifically stylized form of painting that goes hand in hand with a remarkable fes-

2. See also chaps. 4 and 9 above.

tiveness. The mosaic is suitable above all for the reproduction of religious objects and for the realization of a sacred atmosphere. There is a specific relationship between the formal type of reproduction and the correlation with one specific material atmosphere. This correlation is not found in drawings or paintings.

One final point: although the mosaic does not have the same relationship to architecture[3] as the fresco (to say nothing of the painting), it is certainly no mere decorative element. Its union with the interior architecture is of a completely different kind from that of a tapestry or carpet. The simple fact that the mosaic is also found in external architecture shows us this difference. Apart from this, however, the mosaic becomes a part of the interior architecture in a much more intimate manner than is possible for a fresco. If a fresco is of great beauty, such as the frescos by Masaccio in the Brancacci Chapel in Santa Maria del Carmine in Florence, its function as painting is much more thematic than its function for the architecture. This is never the case with a mosaic.

Mosaics realize an exceptionally glorious world of beauty, whether in the mausoleum of Galla Placidia and the church of San Vitale in Ravenna or in the Baptistery of San Giovanni in Florence. This form of pictorial reproduction, this great, deep, specific kind of painting in the broader sense of the word, is one of the high points of beauty. Its volume is much smaller, however, than that of paintings and frescoes.

The illustration

There is a kind of marriage between visual art and literature in the illustration of novels, fairy tales, poems, and fables such as those of La Fontaine. This unique union does not possess the intimate co-penetration of word and sound, nor is it in any way the birthplace of high artistic values. It is, of course, completely different from the union between a picture and its mere title. If a picture depicts Constantine's victory at the Milvian Bridge, it goes without saying that the title under the painting, which

3. See also chaps. 4, 9, and 10 above.

indicates this historical event, does not have its origin in a collaboration between literature and painting.

There are at most some analogies to the reproductive art in music and drama. The great difference is, first of all, that the novels, fairy tales, and every other type of literature that can be provided with illustrations do not in any way require these illustrations for their full realization. Literary works of art do not even become more real, as such, through illustrations.

Besides this, the kind of union between illustrative drawings and paintings and the text is completely different from that of genuine reproductive art. The illustration stands alongside the text as something new. It is not united to the text in such a way that it reproduces the text with the means that belong specifically to the artistic genre of the text itself (as is the case with an actor, through words and gestures, and with a pianist). The illustration makes use of the means for drawing or painting, not of words, which are the medium of literature.

The analogy consists only in the fact that the illustration has an ancillary character that presupposes the literary work of art and lives from the relationship to it. Clearly, however, this analogy too is very remote. The kind of service that is rendered is radically different.

Let us take as our example Doré's celebrated illustration of Cervantes' *Don Quixote*. This great literary work of art needs no illustration. It is completely realized in itself as a novel; the unique world of this work of art rises up before the spirit of the reader. On the other hand, it is a literary work of art that does not suffer through good, important illustrations. It possesses the potential for meaningful illustrations, unlike many other novels and literary works of art. The special poetry of *Don Quixote*, its specific poetic character must be able to support illustrations as something organic. But it would be going too far to say that it somehow demands illustrations. It is important to note here that the illustration remains a separate structure, an ancillary work of art that addresses our eye as an artistic structure.

Its artistic value depends primarily on whether it is successful and poetic as a drawing or a painting, whether it employs the means of the

visual arts to irradiate purely a world that is beautiful and noble. A new factor here, not found in all the paintings and drawings that depict something but do not possess any illustrative character, is the question whether the illustrations adequately reflect the world of the book and of its various situations. Do they present humorous passages in a humorous manner? In other words, do they employ the means of the visual arts to reproduce the spirit of the literary work?

The illustrations to *Don Quixote* are a particularly felicitous case. The literary work of art inspires the visual artist, in this instance Doré, to create something of his own. It is true that these paintings and drawings do not stand on their own feet. Rather, in keeping with their own meaning, they are thought of as illustrations; they have an ancillary function. Nevertheless, they are in themselves an artistic structure and, apart from their own independent value, they irradiate above all the atmosphere of the literary work of art: a noble, poetic world in which a central role is played by comedy in its highest literary expression. Comedy is an especially appropriate object for illustrations.

Alongside this poetic form, there are many book illustrations that are wholly devoid of artistic value. The need they satisfy is in fact markedly inartistic, since they offer an infelicitous complement to the idea that is generated by a literary work. They destroy the idea that has been generated legitimately through the use of literary means, tying it down in a way that is not only illegitimate but also utterly inadequate. They satisfy only the inartistic person, who has the feeling that he is becoming better acquainted with the story, the scenes, and the characters. This kind of illustration makes people curious, so that they want to read the book. It also satisfies the reader, since it confirms what he or she has read. It does not make the literary work of art more real. All it does is to make the pure material of the story more real.

This kind of illustration does not demand the conditions that we have mentioned in the case of Doré's illustrations. In order to fulfill this illustrative function, such drawings and paintings need not possess any artistic value. This does not mean that they are allowed to be artistically negative, that is, decidedly trivial, prosaic, or tasteless. Nor do they need

to reflect the spirit of the book. Their task is simply to intensify the content of the events by adding the visible depiction of these events to what is communicated through the word.

A newspaper photograph, which gives us information about an event that is related in words, has a similar function. This, of course, is the crassest instance of acquiring a more intimate knowledge of an event. Besides this, the information here concerns a genuine event. This can hardly still be called an illustration, since the ancillary character and the artistic activity are lacking. But it is precisely this instance that sheds light on the character of non-artistic information, since it displays a crass intensification of the knowledge of an event. Since these inartistic illustrations do not belong to the visual arts, we shall not discuss them here.

Illustrations in children's books have a completely different function. Such books require the collaboration of the visible in order to make the content of the story come fully alive for the child. There is a wide spectrum of children's books, right up to the genuinely poetic and artistically valuable illustration of fairy tales. A number of children's books were produced in England and France in the eighteenth and nineteenth centuries with illustrations that were so delightful and in themselves poetic that they made an essential contribution to the artistic charm of the books. Examples are the illustrations in the Caldecott children's books, where the drawings and paintings are just as essential as the stories in the books. The poetic charm and the special atmosphere are realized both in the illustrations and in the stories. They employ the means of the visual arts to impart this artistic charm, but they have a specifically narrative character that the pure visual arts do not possess. They are completely oriented to the narration of the stories and to collaboration with them. In order to be perfect, they must irradiate the same spirit. They restrict themselves entirely to illustrating, in the broadest sense of this term. They have no ambition to be independent works of art. But their function is not exclusively ancillary. They are equal in rank to the stories, although that which is depicted is determined by these stories, or by the text.

It is much more likely that a genuine marriage will take place in these children's books than in a typical illustration. They involve a narration

through drawings and pictures (though in close collaboration with the word) rather than a mere illustration. This collaboration with a story that is told in words is an essential element; a story that is offered only in pictures is something else again.

In addition to the children's books that have pictures with a definitely poetic charm, there are others that contain one short story, or several, that are comic rather than poetic. Their pictures are an impressive illustration of the text in a naïvely stylized manner. Examples are *Struwwelpeter* and *Pinocchio*.

We must mention one further union between image and word, which is clearly distinct from the illustration. It is rather rare, but it is a typical union of a specific kind, namely, the works of Wilhelm Busch.[4] In his stories or "epics" such as *Max and Moritz*, the *Knopp Trilogy*, and many other works, there is a unique union between literature and drawing, which are equally important in the construction of the whole. It is of course true that his iambic rhymed verses are devoid of poetic value; but they do not claim to possess this. Their whole foundation is the humorous and witty. They are light fare, but within this framework they are masterly. The same is true of the drawings: their artistic value is slight. The verses and the drawings belong so closely together that they suffer immensely if they are separated from each other. The artistic goal is modest. It does not aim at beauty or at deep and genuine poetry, or even at the profound comedy that we find in Shakespeare, Molière, or *Don Quixote*, but rather at a very specific kind of comedy and a much less artistic humor. But in their own way they are brilliant. They are highly accomplished and possess an aesthetic value all of their own. This type of genuine marriage between image and word is interesting. It recalls the marriage between music and word in the operettas of Gilbert and Sullivan.

The glorious illuminated manuscripts of the Middle Ages are a fur-

4. Unfortunately, Busch was not very tactful, and he sometimes bordered on the embarrassing and crude. His lack of reverence is much worse. In addition to many witty and very successful stories, he wrote appalling anti-religious stories such as *Der heilige Antonius von Padua* and *Pater Filuzius*. His hatred of Holy Church led him to sink down to a wretched, tasteless level and to deny the talent he otherwise possessed.

ther type of illustration. The images and the gems, which are works of art in their own right, stand alongside the sacred text, but they serve it and are, so to speak, a costly vessel in which it is presented. On the one hand, this type is less of an illustration, since the other functions of illustrations are not found here. On the other hand, the way in which it serves the text is different from the other types of illustration, and goes much further. These illustrations are an expression of profound reverence, and themselves bear a definitely sacred character. They have a much greater independence with regard to their artistic importance, and a much higher artistic goal.

Literature

The Form of Existence of the Literary Work of Art

IT IS MUCH MORE DIFFICULT to grasp the form of existence of a literary work of art than to grasp the reality of its effects, whether the effect that it has in the history of ideas or, even more strongly, in the political sphere, or the effect in one individual soul, namely, joy, enthusiasm, or affection.

In the present context, we shall not examine this effect, since it is something that exists in a personally conscious manner, and is unambiguously different from the literary work of art itself. Novels (to take one example) are unambiguously different from personally conscious experiences. We now wish to look briefly at their unique form of existence.

It is clear that the form of existence of a book—a material object with a binding and many pages that are covered with printer's ink—is completely different from that of a novel. There are many printed copies of one and the same novel. Its being is completely independent of the reality of the material thing, the book. This, of course, also applies to the content of a philosophical book.

From the ontological point of view, however, the work of art, the

novel,[1] is also a structure different from the philosophical book. It is a much more coherent whole, and it is a much more pronounced individuality. Even the most beautiful of purely philosophical works, such as Plato's dialogues *Phaedo*, *Phaedrus*, or the *Symposium*, do not have the same organically self-contained unity, the unique individuality that we find in a drama, for example, *Hamlet* or *King Lear*, or a novel, such as *Don Quixote*.

This brings us to an important point in the ontological structure of works of art in general, and of literary works of art in particular: like many other structures in the human and interpersonal sphere, they are, of course, also objectifications of the human spirit. They presuppose a human personal spirit. But as we have seen in chapter 2 above, they are not in the least a mere objectification of the personality and the spiritual world of the artist. They represent something completely new in relation to the artist as a human being in his life and in his character.

Artistic inspiration has the character of a pure gift and a receptive discovery. This is what Plato meant when he called the poet in *Ion* a "seer." When we speak of the objectification of the human spirit, we are not referring either to the value or to the "world" of a work of art, but only to the formal fact that it is not discovered as nature is discovered, but presupposes a human spirit that is endowed with specific abilities, with a special talent that is given to only relatively few persons.

A literary work of art possesses the ontological character of a mental structure. Despite all its autonomy, its objectivity, and (once it is born) its independence of the human spirit, it nevertheless bears the stamp of having been created by the human spirit. This does not in any way affect the beauty of the work of art, since beauty, like all other values, reaches beyond the human sphere into the metaphysical sphere that is objective in a new sense.

There are many things that presuppose a human spirit or, more correctly, a personal spirit. Much of what has been termed *ens rationis* ("a being of reason") belongs in this category. This expression can have

1. [Editors' note: In Dietrich von Hildebrand's writings, "novel" often stands for prose literature as a whole.]

several different meanings. When we think of concepts such as "noth-
ing," this is obviously a very meaningful concept. But there is no genuine
"something" that corresponds to it: there is no "nothing." An imaginary
number, and indeed already a negative number, are *entia rationis* in a
special sense.

A proposition, this structure of subject, predicate, and linking verb
that consists of words, likewise presupposes a thinking mind. Unlike an
objectively existing state-of-affairs, it can still be called an *ens rationis*,
but in that case, this term has a completely new meaning. We must above
all emphasize that the truth of a proposition is completely independent
of every relationship to a human spirit. This truth depends exclusively on
the *de facto* existence of the state-of-affairs that is meant in the propo-
sition.

There is of course a widespread view today that the truth of a propo-
sition is somehow relativized by the fact that the existence of the prop-
osition presupposes a human spirit. This, of course, is sheer nonsense.
This view introduces, in a purely dogmatic manner, the presupposition
that because a human person is a limited being, every formulation of a
proposition must be relative. In reality, the formulation in a proposition
of absolutely certain, supremely intelligible, and essentially necessary
states-of-affairs, which are either evidently given in experience or else
can be strictly deduced from evident propositions, is not in any way a
relativization by the human spirit, but is rather an actualization of the
glorious human capacity for transcendence. The human spirit is limited
and unable to know a relatively large number of things, and there are
many questions that are impossible for it to answer. Most importantly,
the supernatural mysteries are not accessible to the rational knowledge
of the human spirit. But none of this alters the absoluteness of the *ver-
itates aeternae* that are evidently given to it in experience. Nor does it
alter the absolute truth of the formulation of such states-of-affairs in
a proposition. The formulation, or the propositional character, is not in
the least an inevitable relativization that contradicts its absolute truth.
The fact that the human person is a limited being is indeed the reason
for the falsehood of innumerable affirmations or for an inadequate and

defective formulation. But this limited character does not in the least mean that this must always be the case. Moreover, we should note that the concept of "relatively true" is highly dubious, and is at any rate used in an equivocal manner.[2]

Works of art possess a kind of existence that cannot be covered even by the broadest version of the concept of *ens rationis*. But like an *ens rationis*, they presuppose a human spirit, and one endowed with very special abilities, in order that they may be called into being.

We do not in any way claim to have given a complete answer to the question of the ontological structure and form of existence of the work of art. We have only pointed out this extremely interesting problem, and we hope that we have clarified this question by excluding false answers and by indicating the difficulty and depth of the problem. If we have to some extent succeeded in doing so, these observations have fulfilled their purpose and have opened up the path for a deeper investigation.

2. Even in the case of facts of which we can acquire knowledge only through revelation, their formulation in a dogma does not entail any kind of relativization of the truth of these propositions.

CHAPTER TWENTY-FIVE

The Medium of Language

THE MEDIUM THROUGH WHICH literature conveys its artistic content to us is language, the read and the spoken word. Here we encounter one decisive difference from all the forms of art with which sense perception brings us into immediate contact. In the latter case, the artistic content is mediated to us through the senses, which are marked by a specific immediacy. In language, on the other hand, the contact is very complicated. Literature differs from all the other arts through the fact that the senses have an unimportant and indirect function. We see the sculpture, the picture, the palace, or the church; we hear a symphony. We do indeed see the letters of a novel, and we do indeed hear the words of a poem, but a novel or a poem is brought before the eye of our spirit only through the meaning of the words and sentences. The contact with the object that bears artistic values is not brought about immediately through the senses. Rather, it presupposes a complicated, indirect process, namely, the understanding of the words and propositions.[1]

1. I wish to point out explicitly that there is a sharp distinction between the relationship of depiction or reproduction in sculpture and painting, on the one hand, and the highly intellectual relationship that exists, on the other hand, between a concept and the intended object, or between a proposition and the intended state-of-affairs (and even more, to the asserted state-of-affairs).

Whereas the relationship of representation is given in experience, the relationship of meaning

In order to grasp this medium for conveying the object in literature, and in order to explain the surprising fact that a fully present, immediate contact with the object can be attained in literature despite the indirectness of the medium, we must look briefly at the specific character of this form of experiencing in general.

Understanding and informing

This experiencing through language is obviously different from all knowledge in the strict sense, whether it be perception, rational intuition, or inference. What kind of experiencing is this?

This form of experience too begins with certain sense perceptions, namely, the hearing or seeing of the words and propositions. But unlike every other perception, neither hearing nor reading is a contact with the object. The function of the senses is limited to bringing us into contact with the medium through which we come into contact with the object, an event or a fact. A deaf person cannot hear the words and propositions, and thus cannot acquire any knowledge of the event that one communicates to him. A blind person is likewise unable to learn through reading what is written in a book, a newspaper, or a letter.

As long as we do not know a language, it is useless for us to hear the sounds of the words and to see the signs of the letters. We must know the meaning of the words or of the language, if we are to apprehend the content of what is said or written, rather than merely hearing particular sounds or reading certain letters. Knowledge of the meaning of the words, and knowledge of the language, make possible a very specific type of experience, namely, an act of understanding, which is not in the least a mere associating.

and assertion is not given in experience but is explicitly intellectual. The word whose meaning is a concept does not in any way depict the object. Rather, it aims at the object in a completely different way. The proposition aims at a state-of-affairs, and the affirmative proposition presents this state-of-affairs as something that exists. The proposition can be true or false. The representation can be similar or dissimilar, successful or unsuccessful, but it is never true or false.

Alexander Pfänder correctly demonstrates in his *Logik* (3rd ed. [Tübingen: Max Niemeyer, 1963], sec. 1, chap. 5, p. 80) that a proposition is not a depiction, although people sometimes tend to call the relationship of meaning and assertion a depiction.

Understanding is a meaningful intellectual process, not a mechanical-psychological process. Association may have an important function in learning a language, especially when one learns something by heart, but understanding as such is a much more spiritual process, a counterpart to the highly intellectual act of meaning [*Meinen*], in which we aim at states-of-affairs with the words and the propositions we employ when we assert something or communicate something to someone. The meaning of the word functions here as a medium. The act of meaning is, of course, completely different from that of understanding, since it is a spontaneous act, not a form of knowing in the widest sense.

Understanding is, by contrast, an expressly receptive act, a receiving. Like meaning, it implies the awareness of the rational link between the word in its meaning and the object, or between the proposition and the state-of-affairs. There are distinct matters here that one must separate. First of all, there is the awareness of the meaning of a word, that is to say, of the object at which it aims. If someone tells me that *cheval* in French means the same as *horse* in English, I learn the state-of-affairs that the word *cheval* aims at this particular animal. Learning this instructs me about the meaning of this word in French.

Secondly, if I wish to go beyond this and apprehend the meaning of *cheval* in such a way that I am able, as it were, automatically to make use of it in the process of meaning, and I repeat this word often, I appeal to association.

Thirdly, the association enables me to have the link between the spoken word and its meaning available to me in such a way that when I make an affirmation or a communication with the word *cheval*, I can target the object by meaning it.[2]

We must, therefore, distinguish three separate stages: learning about the meaning of a word; stabilizing this knowledge until it is familiar to me; and finally, using the word both when I mean the object and when I employ a proposition to affirm a state-of-affairs.

The two first stages are presupposed in the same way both in under-

2. See *Aesthetics*, vol. 1, chap. 1.

standing and in meaning. But while meaning runs from the person to the object, understanding is a receiving, a learning. By understanding, I learn what the other person means, that is to say, I learn the content of his statement. But we go beyond understanding when we learn of the existence of an event or of a state-of-affairs, which is a specific form of apprehending. Someone calls out to me: "The house is on fire!", and I understand what he says; but in addition to this, I am informed about a real state-of-affairs. I receive knowledge of the fact that the house is on fire.

This is where the function of language or of communication in literature differs from the function of language in history, in life, in science, and in philosophy. This acquisition of knowledge through experience does not exist in the case of fictions, for example, the content of a novel. The propositions have no assertive character. They do not aim at the reality or truth of that which is communicated. The state-of-affairs that is brought before our eyes in the act of understanding does not make any claim to exist. It is not a case of a "This is how things are." And this is why no reality is experienced here. What remains is the act of understanding, on which completely different things build. A completely new theme begins.

Before we discuss the function of understanding in literature, let us refer briefly to the many-sided kinds of "experiencing" that are built on the basis of the statement of another person, since this experiencing is one of the principal sources of our knowledge. We must begin by distinguishing two completely different cases.

If the content of what is communicated or asserted is an essentially necessary state-of-affairs, the act of understanding enables us to know this in its evidential character. The act of understanding makes possible a rational intuition[3] of the objective existence of this state-of-affairs. A direct contact to this state-of-affairs is established, and it discloses itself to us in an evident manner, in exactly the same way as when we know it independently of the statement of another person. The state-of-affairs directly shows itself as existing. This is why the communication is only an

3. See *What is Philosophy?* chap. 7, sec. 4.

occasion (not the source) of the act of knowing and of our knowledge of its validity. The existence of the state-of-affairs is guaranteed by its being, and our knowledge of it is nourished by this source, not by the statement of the other person.

If the content of what is communicated to us or of what is asserted is not an essentially necessary state-of-affairs but a contingent law or a concrete real fact, however, our conviction of the existence of such a fact is based upon the fact that we have been told about it or that it was written down by someone. An additional factor, of course, apart from the credibility and competence of the person or the authority that posits the statement or makes the communication, is the probability of the content. The more obvious, the more probable, the less remarkable and surprising the content is, then the less credibility and competence on the part of the speaker are required for us to accept this fact as genuinely existing. At any rate, this act of understanding is not only required as a basis, in order that a rational intuition may be possible; it is on this act of understanding that an experiencing is constituted by means of the relevant statement, an accepting of the claim this statement makes about the reality of what it conveys. This is the typical instance in which experiencing through other persons becomes a specific source of knowledge.

We must draw another important distinction among the facts that are experienced through other persons. There are states-of-affairs that we can know, in principle, only through a statement; and there are states-of-affairs about which we can, in principle, acquire information also through perceptions and inferences. We can observe a thunderstorm, or we can learn from others that it took place somewhere. We can see foreign troops crossing the border and hear them shooting, and we can draw the inference that a war has broken out. Usually, however, we learn of such events through the statements of other persons in a newspaper, on the radio, and so on. There are also many things that we know only through communication, things that we can never perceive, inspect, or deduce. These include, for the non-historian, everything that we know of history, and, for the historian, a large part of what he knows. For the historian, they include everything that he cannot deduce from archeological

or other discoveries. Most importantly, these things include, for every
person, the knowledge of who his parents are and when he was born.
Much of what is going on in the mind of other persons, much that is
not expressed in some way or that can be deduced, is known to us only
through communication.

The declaration [Verlautbarung] of affective responses

In the interpersonal sphere, language, or the word and its meaning, also
serve to make known affective responses. When a man expresses his love
to his wife in words, continually assuring her of how he loves her, this is
not the communication of a fact. He does not want to inform her about
something that is going on within him, as he does when he communi-
cates to her that he is worried about a friend or that he has a headache.
This declaration of an affective response[4] is possible only vis-à-vis the
one to whom the response relates.

All the various functions of language are found in literature, and in
particular the declaration. The passages in which language is the "ex-
pression" of affective responses, or indeed is their declaration, are linked
above all to the person who speaks.

Like every act of speaking, communication naturally presupposes a
human person. Its theme is the state-of-affairs that is communicated,
and this can deal not only with this person but also with the weather and
much else besides. In the objectification of states-of-affairs that have
become known in science and philosophy, the theme is likewise exclu-
sively the truth of the proposition, not the person who utters this truth
or writes it down.

Where language is an "expression" of feelings or a declaration, how-
ever, the theme of these propositions includes the person who speaks. In
this case, more is involved than the connection with the person that is
found in all spoken or written words (namely, the fact that they presup-
pose a human being). Rather, in those propositions that are exclusively

4. On this, see my *Metaphysik der Gemeinschaft*, chap. 2, pp. 24ff.

an "expression" of feelings, the fact that an individual human person utters them is the central theme.

In this case "expression" means neither expression in the strict sense of affective experiences and personality traits that show themselves immediately in the face of a person, nor expression in the broad sense, such as the joy manifesting itself in music or even in the joyful blue sky.

The word or proposition establishes contact with the expressed content through the unique, eminently intellectual, but not immediate character of the meaning of the word and the proposition. We have drawn a clear distinction between this relationship and expression.[5] In propositions that are exclusively the "expression" of feelings, this term does not refer to the type of link between an audible or visible datum and an intellectual content, but to the formal theme of the proposition and to the motivation of the act of speaking. Through a communicative proposition, one person informs another about a matter of fact, whereas in a proposition that is an "expression" of feelings, the speaking is motivated by the overflowing intensity of an affective experience. Without abandoning their function of meaning, the words are a mere effusion of the feeling; in this respect, they are analogous to shouting for joy or lamenting. We may recall here the words of the young miller: "I would love to carve it into the bark of every tree!"[6] This whole poem is a flowing over, an eruption, of his heart that is full to the brim; but at the same time, it is a sequence of meaningful propositions. In order to apprehend this expression of feeling, this flowing over of the mouth with that which fills the heart, one must understand the meaning of the words.

They are neither a shout of joy nor a shout full of fear. In such instances we cannot speak of expression by way of meaningful words, since such shouts do not use any words, and the joy or fear manifests itself as immediately given to us in experience, as a specific, typical expression in the strict sense of the term.

The "expression" of feelings with which we are concerned here is carried out through meaningful words that are neither a communica-

5. In my *Aesthetics*, vol. 1, chap. 7.
6. "Ich schnitt' es gern in alle Rinden ein": from Schubert's song cycle *Die schöne Müllerin.*

tion nor an objectified formulation of states-of-affairs that have become known. Rather, they are an eruption of the heart that is full to the brim. We call this type of propositions, which have a meaning—as do all other propositions—an "expression" as opposed to a communication or an assertion, or as opposed to the objective formulation of states-of-affairs that have become known.

The same applies by analogy to the declaration of affective responses in the uttering of whole propositions. Here too the meaning of the words and propositions is irreplaceable. The declaration of love presupposes that the beloved understands the meaning of the words. If this declaration is made in a language that she does not understand, the tone of voice and above all the face of the one who makes the declaration of love may perhaps express his love in the literal sense of expression, but the declaration would not really come about, since speaking is an essential element of declarations. That which is spoken penetrates the consciousness of the beloved as if it were love made audible, and the ray of love reaches her soul in a manner that is real and not just intentional. Although the declaration is radically different from every mere communication—even from the communication that one loves someone, a communication that one can make to many other persons—the beloved's understanding of the words and of their meaning, and the lover's meaning intention in declaring his love, are presupposed or implied.

The experience of the one who is affected by a declaration has an immediate character. He is not informed about a state-of-affairs, as when he receives a communication from another person. Rather, he experiences for instance a ray of the love of the other person. The theme is not an act of knowing but being affected by the love of the other. Even when one receives knowledge of this love for the first time through a declaration of love, what is involved is an immediate experience, a being affected by this love. This is much closer to a perception than to the acquisition of the knowledge of a fact that is communicated by another person.

Even when the word or the proposition has the function of the "body" of an act, as when a promise is made, the receiving of the promise is an immediate experience, not the indirect acquisition of knowledge about a

matter of fact. This applies to all social acts. Adolf Reinach was the first to investigate the specific character of these acts.[7] But even when it is certainly not a question of merely being informed about a matter of fact, a mere source of knowledge, the understanding of the words and of the propositions is presupposed.

7. In his book *The Apriori Foundations of the Civil Law*, trans. John Crosby (Ontos Verlag, 2012), chap. 1.

The Contact with the Object in Literature

THE FUNCTION OF LANGUAGE in literature is completely different in kind from its function in a communication that serves as a source of knowledge. It is true both in literature and in communication that a state-of-affairs is presented to our mind and that an indirect contact arises, but in literature this occurs without the relationship to reality, without the theme of truth, without the acquisition of knowledge in the sense of "That is how it is."

When we read a novel, we do not assume that we are being instructed about reality through communication from other persons. The question of competence and credibility does not arise, since what is involved is not the truth of that which is communicated. Rather, a world of events, figures, ideas, and deeds is presented to our mind. This world captivates us, thrills us, moves us deeply, takes hold of us, and enriches us through its quality. It enchants us through its depth, vitality, and truthfulness. It convinces us through its inherent logic and elevates us by the beauty of its poetic content.

The principal problem that concerns us here is how the contact with the object that comes about through the understanding of proposi-

tions—as opposed to a perception, such as the hearing of music—leads
to a contact with the artistic qualities that is given in experience.

First of all, it seems that the imagination [*Vorstellung*] plays a very
important role in the person who apprehends the literary work. This is
not in any way an associative imagination, which can take various direc-
tions in the readers. The act of imagining that is intended and directed by
the author makes the content present in a visual manner, and it consti-
tutes a new degree of contact between the reader and the literary object.

The important point now is the kind of contact with the object, the
step from the indirect contact through the act of understanding, to
the living givenness, to the qualitative self-unfolding before the mind of
the reader. We must draw a distinction between the givenness of the
aesthetic qualities of the poetic, the grandiose, the profound, etc., and
the content of the novel, the events, figures, descriptions, and so on. The
immediacy of the value-givenness is generally not tied to an immediate
givenness of the content that displays the value. The nobility of morally
good conduct such as magnanimity, purity, or kindness can be just as
immediately given to us when we read a biography as when we ourselves
witness such an attitude. This, of course, is not to deny that the two types
differ in other respects.[1]

What form of spiritual apprehending is present, when a short story
or a novel fascinates us and we fall completely under the spell of the
events that are narrated, the figures that are described, and so on?

First of all, we must note that it is also necessary to ask this ques-
tion when we read about a real event in the newspaper or hear about
it in some way. It is not only in literature, but in life too, that the mere
knowledge (or the mere acquisition of knowledge) of something through
communication differs from the living realization of the facts in ques-
tion. This distinction goes hand in hand with the difference in the con-
tent that is communicated. The nature of that which is communicated is

1. To be a witness is, of course, even more delightful and includes a special intimacy, something
that penetrates into the course of one's own life. This is not present when we read or listen. But this
does not mean that when we read or listen the value of the conduct necessarily shines out in a less
fully present or less immediate manner before our spirit.

decisive. The important point is the extent to which an event touches and moves us; or more precisely, the effect that an event has on us depends on its value in itself, or on its importance for us and for others. If a person communicates to us something that is neutral, something that is important neither as such nor for us, it will not move us or affect us. But if we hear on the radio that a war has broken out, or if we receive a telegram with the news that a beloved person has died, we are deeply affected. This being affected naturally includes an immediate confrontation with the event in question, but its exclusive source is the nature of the event and its value or disvalue in itself, or the greatness of its importance for us. The event is given to us in a manner that is analogous to the aesthetic qualities just mentioned.

When we think of the way in which the events, situations, personalities, and landscapes present themselves before our eyes when we read a novel, such as Cervantes' *Don Quixote*, Manzoni's *The Betrothed*, or Tolstoy's *War and Peace*, we cannot deny that all this unfolds before our mind in a manner that is much more experiential than the mere acquisition of knowledge that comes about through an act of understanding words and propositions. The mere fact of being informed about something through a communication, the resulting knowledge of a state-of-affairs, is a more indirect contact with the object than the contact in literature.

We must draw a clear distinction between different things here. First of all, the spiritual reception of the content of a novel differs from the acquisition of knowledge that comes about through communication, because in the latter case, the decisive theme is the truth of that which is communicated, whereas this theme is not present in literature.

Although we have already mentioned this difference, it must be emphasized that the theme of truth also has a decisive influence on the act of reception of that which is communicated. Communication entails a form of receiving information, of acquiring knowledge, through an act of understanding. The state-of-affairs that is communicated claims to exist genuinely, and we receive it saying, "That is how it is." Both our expectation, when we put questions to someone or read the newspaper,

that we will be informed about something that interests us, and as well as the process of acquiring knowledge, aim at knowledge of reality. The experiencing of a state-of-affairs is formed in real life through the theme of reality or of truth.

Secondly, in literature, the imagination [*Vorstellung*] of all that we read (for example) in a novel has a much greater importance than in the acquisition of knowledge through communication in life. We are not now investigating the question of the extent to which the content in many communications is given as more fully present before our mind than is the case in mere knowledge. As we have said, this largely depends on the nature and the importance of the content. In literature, however, it is thematic to spread out before our mind the content in a living and intuitive manner.

If we are tempted to use the term "imagination" for this more intuitive consciousness of the content in literature, it must be clearly emphasized that this is a very special type of imagination, which is sharply distinct from mere associative images.

Various meanings of "imagination" [*Vorstellung*]

The term "imagination" is employed with a great variety of meanings. In Schopenhauer's celebrated work *Die Welt als Wille und Vorstellung* (*The World as Will and Representation*), it is synonymous with every type of a "consciousness of" as opposed to the will, by which he refers to all forms of desiring, taking a position, and volitional acts. In Franz Brentano, too,[2] "imagination" means a cognitive "consciousness of"—as opposed to every kind of response, as well as to every act that we have called a lateral consciousness,[3] that is, a "conscious being" in which the specific content lies not on the side of the object, but in our act.

We, however, understand "imagination" in a much narrower sense. It is the special form of "consciousness of" which is typically different from

2. In Brentano, *Psychology from an Empirical Point of View*, book 2, chap. 1, §3, and chap. 6, §3.
3. See my *Aesthetics*, vol. 1, chap. 1.

perception.[4] In perception the object itself is present. It discloses itself, and it reveals to us its essence (at least up to a certain degree) and its existence; it bestows on us knowledge and is given to us as fully present. In imagination, on the other hand, the object itself is not given. It does not reveal to us its essence and its existence, nor does it inform us about these. It bestows no knowledge. But it stands before our mind and is given to us as fully present; that is to say, it unfolds its essence before us. We possess the object in a rational way. We have a consciousness of it as being given to us in full presence, as opposed to the merely intellectual link to an object that arises when we only aim at it intentionally, or acquire knowledge of it through a logical inference.

Imagination in this sense is not possible in relation to all objects. The typical instance of imagination in this sense is visible things.[5] We can clearly envisage in the imagination something that we have once perceived and that we know, such as Brunelleschi's cupola on the cathedral in Florence. The same applies to the face of a person whom we know. But imagination must be clearly distinguished from remembering. The imagining of something audible is already slightly modified. In the case of states-of-affairs, there no longer exists this "consciousness of" in which the object is given as fully present and unfolds before us. Rather, there is a spiritual making present of a different kind, namely, the actualization of our knowledge.

We must also draw a distinction between imagination, in the sense in which we are using this term, and the "consciousness of" that is present in fantasizing and in every kind of "inventing."

Let me refer briefly to the concept of imagination that Adolf von Hildebrand uses in his book *Problem der Form*[6] and in many of his essays, in which his concept of imagination—more exactly, artistic imagination—plays a fundamental role. But imagination does not at all refer

4. See my *What is Philosophy?* chaps. 6 and 7.

5. Hedwig Conrad Martius set out very important insights into imagination in this precise sense in her first published work: "Zur Ontologie und Erscheinungslehre der realen Aussenwelt," *Jahrbuch für Philosophie und phänomenologische Forschung*, vol. 3 (Halle an der Saale: Max Niemeyer, 1916), 345–542.

6. On this, see chap. 6 of this book, footnote 6.

there to the special kind of "consciousness of" that we have in mind
when we draw a distinction between imagination and perception. Imag-
ination in our sense is a specifically reproductive act in which we make
present to ourselves once again something that was perceived previous-
ly, in such a way that it is given as fully present. Imagination does not
acquaint us with something new. All that we do in imagination is to
actualize something that is known.

The artistic imagination, as Adolf von Hildebrand uses this term, is
completely different from this reproductive making present of something
that is already known. He uses the term to designate a special ability,
which assuredly not everyone possesses. This is not the ability of fantasy
or of fictitious invention but is a matter of mentally digesting what has
been perceived—a digesting that contains a special relationship to na-
ture.[7]

Up to this point, we have spoken only of the expressly reproductive
ability of the imagination, which is imagination in the narrower sense of
this word.

It is, of course, true that the word "imagining" is sometimes also used
in the sense of "supposing." If we say, "I could imagine that in such a
situation, I would react in a manner similar to this person," the verb
"imagine" simply means "I suppose that I would react in a similar way."
In the negative we say, "I cannot imagine that I would ever do something
like that." It is obvious that this meaning of "imagination" is completely
different and has nothing to do with the reproductive intuitive "con-
sciousness of."

The receptive imagination in the apprehending of a literary work of art

When someone tells us about a landscape, or describes the appearance of
a human being, and we say, "We can imagine how the landscape or the
person looks," the communication of the other person includes elements
that are known to us from our own perception and that are combined

7. Since this concept of imagination is important primarily for the visual arts, we can only refer
briefly to it here.

with the other person's description in such a way that we can visualize the concrete whole and its distinctive character. The actualization of something known, which characterizes imagination in our strict sense of the term, is present; but there is something here that goes beyond this. Through the description, we learn something new, and we are able to visualize that which is described.

Is this picture that we make for ourselves a variant of the imagination in the strict sense, something purely reproductive? Or is there also present a new ability to combine, an ability that does not produce fiction?

What happens is not the same as in all fictions, still less in inventions. Rather, the act of combining is guided by the narrator's description and reproduces what he has built up by means of his description, in which he employs material that is known to us in order to present something new to our eyes.

This ability of receptive imagining has a decisive function in the apprehension of literary works of art. It goes far beyond the mere understanding of sentences, becoming acquainted with the plot of a short story or a novel, or receiving information about the events, the characters, and the situations. It transcends all mere knowledge in that it is given as fully present.

It is clearly distinct from imagination in the strict sense, since we are not acquainted with either the landscape in which the individual parts of the plot take place or the faces of the characters who appear. We cannot have any idea of Lucinda or Dorothea in Cervantes' *Don Quixote*, nor ought we to have any such idea. We cannot have any idea of the face of Sonya in *Crime and Punishment* or of Manon in Prévost's novel *Manon Lescaut*, nor ought we to have any such idea. Illustrations in such books may attempt to do this, but they are never the fulfillment of the picture of these characters that we acquire through the novel. It is extraordinarily interesting to note that these characters stand before us, alive and given as fully present, although we cannot visualize them precisely in the way that we can visualize something that we have previously perceived.

Someone may link some specific face in a purely associative manner

with such a figure in a novel, but this has nothing to do with the process of genuinely apprehending what the novel presents to us. It is purely arbitrary, coincidental, and unobjective. From the perspective of the artistic experience, it is disruptive. Through such associations, we detach ourselves from the true content of the work of art, we wander away from what is truly disclosed to us in the work of art. This associative picture is a substitute, a pseudo-presence. It blurs the true artistic picture.

The principal point concerning this receptive imagining is that all the essential qualities that characterize a figure or the atmosphere of the landscape and of the situations are immediately given as fully present to us.

We have already shown that the moral values of an action are wholly given as fully present to us even when we learn about this action from others or read about it. They are, indeed, just as immediately accessible to us as if we were eyewitnesses of the action.[8]

What is involved here is something analogous. The moral greatness of Sonya and the villainy of Luzhin in Dostoevsky's *Crime and Punishment* are given to us just as immediately as if we had personally been witnesses of their behavior. The miraculous conversion of the Unnamed in Manzoni's *I Promessi Sposi* is immediately given as fully present to us, just as if we ourselves had been there. This applies not only to the moral values but to many other values as well, such as to the poetry of the situation in *Don Quixote* where Dorothea washes her feet in the Sierra Morena and is taken by surprise by Cardenio and the parish priest, or to the unique charm of the scene in the tavern where the parish priest reads aloud the short story about imprudent curiosity and Dorothea, Carden-

8. See *Aesthetics*, vol. 1, chap. 3.
 What is involved here is the general fact that the values are directly given as fully present, but that this is not the case with their bearer. The heroic greatness and beauty of the deed of Saint Maximilian Kolbe are alive and given as fully present for us even when we learn about it only indirectly, through a narrative. In this case, the value is not given in imagination but rather in perception.
 It is clear that the question whether the bearer of the value is given as fully present largely depends on the type of representation. The receptivity of the reader or hearer also plays a role. But this kind of being given as fully present—unlike the way in which the value qualities that are borne are given as fully present—leaves large problems open, for example, the reproduction of faces, figures, and landscapes.

io, and the others listen to him. The fact that the events, situations, and persons are not immediately given to us does not prevent the aesthetic qualities of these events and situations from being directly given to us, nor does it prevent the charm of the being of the characters or their repulsive villainy from being directly apprehensible.

One special example of such an immediately given quality, independently of the givenness of its bearer, is comedy. It is obvious that the comedy of a character or of a situation in a novel is directly apprehensible and is given as fully present. We need only recall the numerous scenes of classical comedy in *Don Quixote* in order to recognize the full immediacy of this comedy.

This means that the indirect givenness of the bearer of the values does not apply to the value qualities themselves. Despite the indirectness of the contact with the bearer, innumerable value qualities, and even more, the overall beauty of the work of art are given for us with the same immediacy in literature as in music and in the visual arts, in which there is an immediate contact with the bearer.

In this respect, things are somewhat different in a play that is performed in a theater. In addition to the content of what is said, which is communicated through the meaning of the words and propositions, we also have the expression that is given as fully present in the face and in the gestures of the actors. Besides this, we are witnesses of what happens. We see the characters; the situation is made present through the scenery on the stage.

Sound [*Laut*], Tone [*Klang*], and Rhythm

A LETTER IS A SIGN for a phonetic structure. The relationship between the word and the letters of which it consists is that of a whole to its parts. It is obvious that the specific combination of the numerically limited letters yields a practically unlimited number of words. This relationship between the whole and its parts refers to phonetic structures; but a word is not only a phonetic structure. It also has a meaning and refers by means of a concept to an object.

The relationship between the sentence and its words, which is a relationship between the whole and its parts, occurs not only on the phonetic level, but also on the basis of the meaning. The words have a meaning, just as the sentence has a meaning in an even more proper sense.

The word is a much more independent structure than the letter, precisely because it has a meaning. It is, accordingly, a part of the sentence in a completely different sense.[1]

1. The relationship between the written characters and the sounds is not that of meaning; similarly, the relationship between the written and the spoken word is not that of meaning. The written character is not the same as a sound, nor is the written word identical with the spoken word. We must draw a clear distinction between these relationships and the specific relationship of meaning, which is extremely intellectual and rational.

Sound [Klang] and meaning [Bedeutung] in words and sentences

In contrast to the meaning of words, there is one element in literature that is emphatically directly and intuitively given, namely, the phonetic character of the words and sentences. Sound is a quality of the word as a specific phonetic structure, while the meaning of the word constitutes a purely intellectual structure and is certainly not given as intuitively present.

Words are clearly distinct in purely phonetic terms from noises of other kinds, from musical notes, and from the tone of an instrument. When a language that we do not know is being spoken, we can recognize that what we hear is words rather than coughing or sneezing.

It is not difficult to distinguish the word, as a purely phonetic structure, from its meaning. We can understand the meaning only when someone speaks a language that we know. But it is possible to apprehend the phonetic quality that distinguishes a word from a whistling, even when we do not understand the meaning of the word.

Whether the sound of words is beautiful depends on the combination of the vowels and consonants. Some languages sound more beautiful than others. A language in which the pure vowels have a dominant place vis-à-vis the diphthongs, and even more vis-à-vis the consonants, has a more beautiful sound. Here too, however, there are many nuances. The sound of one language can be more musical, more powerful, or more elegant than the sound of another language.

Even within one and the same language, there are great differences with regard to the sound of the words. Some words sound more beautiful than others. Finally, the combination of certain words, the sound of a whole phrase, can be the bearer of a markedly positive aesthetic quality, or also of an aesthetically negative quality. It is clear that this has an important function in literature, above all in poems and epics.

The term "sound" has, of course, different meanings with regard to words and with regard to musical instruments. There exists a specific and unambiguous difference of sound within the family of instruments, for example, between the violin, the flute, the horn, and the trumpet. In

the case of words, the expression "sound" is used in a broader sense, as an audible, immediately given phonetic quality that goes beyond that which distinguishes words as such—and we speak here of words in any language—from noises of a quite different kind.

This quality is more similar to the phonetic phenomenon that we find in rhyme as opposed to writing that is not rhymed, and that we find in the tonal phenomenon that one particular poetic meter possesses, although it is rhythm that predominates in meter.

We mention in passing that consonants possess a tone [*Klang*] with a more explicit meaning than all vowels. The difference between the vowels is not a difference of tone [*Klang*]. The vowels possess a phonetic quality *sui generis* that is clearly distinct from that of the musical note and of the tone. The consonants are phonetic qualities of a completely different kind. The rolling of the "r," the hissing of the "s," and so on, is first and foremost a kind of noise, but it is much more articulated, indeed, one is tempted to say, more unambiguous than other noises such as the rushing of a river, the surging waves of the sea, the rumbling of the thunder, or the thud of a heavy object when it falls.

In comparison with these noises, the consonants are closer to tone, but they are clearly different from tone in the true sense. That which distinguishes the tone of the flute from that of the horn or the cello is not the same as that which constitutes the difference between the consonants "s," "r," "p," and "t." The consonants too are a phonetic quality *sui generis*. Although they are closer to tone than the various vowels, their quality is distinct from tone in the true sense.

In a wider sense, we can speak of the tone of the words and of their tonal difference, either within one language or in relation to the difference between languages.

The analogous use of the term "tone" is completely justified when it is applied to words, sentences, and languages. This quality of language comes into its own above all when a literary work of art is spoken, not only read. The written word has, of course, no immediately given tone.[2]

2. There is a very distinct process that leads from certain visible signs to the word. Usually, it is through the word that is read, through its meaning, or through the sentence that is read, that we

On the other hand, the tonal beauty of a poem, an epic, or a drama is somehow apprehensible even when we read it. One hears it only in one's mind, but one can at least apprehend the value quality of the tone. This obviously presupposes a special understanding of this aspect of literature.

One is tempted to draw a comparison to a musician who reads a score and clearly recognizes the musical character and value of the work. There is, nevertheless, a great difference between hearing and reading [a score], since the word is only a medium, a means for the spiritual presentation of a situation, or a story, a person, and so on. The score points directly to the musically audible structure, so that the specific content is an audible content. Although the path from the score to the piece of music is not immediate, it is nonetheless much more direct than the path from what is read to the content of a literary work of art. Reading a score is more difficult and presupposes more than is involved in the reading of written characters, but for the one who can do this, the path to a mental apprehension of the audible content runs more directly than in the reading of a written text. When one reads it is not even necessary to hear in one's mind the words and their sound. In order to attain to the content of the work, it suffices to understand the words and sentences.

There is no doubt that sound in a broader sense plays a role in literature. It can be a bearer of beauty, and it can make an important contribution to artistic beauty.

It is interesting to compare the function of sound in music and in literature, that is to say, in the narrower and in the wider senses. In music, sound is united to other audible qualities, such as the note, the melody, the harmony, the piece of music as a whole. In literature, on the other hand, sound is only a quality of the word and of the sentence as phonetic structures. But the true soul of the word and of the sentence is nothing phonetic: it is their meaning, their ability to make objects, actions, situations, and human beings present to our mind. This highly intellectual function is nothing audible, and sound cannot be directly united to it.

attain to the state-of-affairs. The word does not appear before our mind as a tonal structure. Reading is not a process that leads through signs to a hearing of words. Normally, the act of hearing does not take place. This, of course, does not apply to reading aloud.

The qualities that are united to the object that the word communicates to us through its meaning adhere to the content of which the sentence speaks (it is remarkable how immediately present this content is to us). It is obvious that sound is not a quality of this object: it is a quality of the word and of the sentence as phonetic structures. The same applies to rhyme. Words rhyme; meanings do not. Nevertheless, the sound of the words and sentences works together with the content at which they aim with their meaning, in order to realize artistic value qualities. This is a very remarkable kind of collaboration.

In order to do justice to this collaboration in its specific character, we must ask whether it is possible to say that the sound of one particular word is more appropriate to its meaning than another tone, and whether any kind of direct relationships can exist [between sound and meaning].

This is certainly the case with onomatopoeic words, in which there is not only the meaning but also a certain imitation of the sound of the thing that the word means. *Plätschern* ("splashing") sounds somewhat like the sound that a dog or a child creates in water when they romp around in it. The sound of the word imitates an action, and this is clearly a connection completely different from that of meaning, of the meaningful act of intending.

This kind of phonetic imitation is possible only in the case of objects that themselves possess a phonetic quality. It is completely impossible for mental contents, which cannot have any phonetic quality. There is no onomatopoeic word for a virtue, whether it be justice, gentleness, humility, purity, and so on. In the same way, there is no onomatopoeic reproduction for a stone, a tree, or any object that is not a bearer of sounds. An event must itself possess a phonetic quality, for example, the hissing of a snake, the croaking of a frog, or chomping when one eats. But there are not onomatopoeic expressions for everything that has a phonetic quality; their sphere is very small and narrowly circumscribed. We cannot discuss the specific character of onomatopoeic words in greater detail here.

The first thing that interests us is the complete difference between this representation of a tonal object and the relationship of meaning. The meaning is certainly not a representation of the object that is given as

fully present. Rather, it is a highly intellectual relationship of a complete-
ly different kind. The second thing that interests us is the collaboration of
both of these, in the sense that while it is only through the meaning that
we can know unambiguously what one is talking about, the onomato-
poeic imitation of the tonal event imparts to the word an immediacy and
liveliness.

But is there not a relationship of appropriateness between the tone
of the word and the object that is meant, a relationship that is not on-
omatopoeic in nature, that can appear also in objects that do not have
a specific phonetic character? Do not certain words somehow reflect in
their tone something with a negative value, while other words reflect
something with a positive value? Does not the verb *verpfuschen* ("to make
a mess" of something) have a derogatory element in its tone that is not
possessed by the expression *missglücken* ("to be unsuccessful")?

This is a difficult question and an area in which it is easy to delude
oneself. One may project the meaning into the tone. One is so accus-
tomed to unite with the phonetic structure of one particular word the
object that this word intends, that one may attribute to the tone an ex-
pressive quality that, as such, it does not in any way possess.

A story offers a drastic illustration of this point. A German friend
who lived in Rome for a long time went to buy bread and was asked by
the baker what the German word for bread was. When the baker heard
that it was called *Brot*, he said, "But that is remarkable! When one says
pane, the bread stands vividly before one, one smells its scent, one sees
its color—*pane, pane*, the tone expresses all this. But *Brot, Brot* expresses
nothing of all this."

Let us therefore be content to note that certain words have a nobler
tone than others. This applies all the more strongly to sentences in which
the rhythm is united to the tone in an important manner.

We can also say that some words, without having an onomatopoeic
character, somehow fit well in their tone to the matter that they signify.
They fit a lofty matter through their beautiful, noble tone, and a base
matter through their unbeautiful tone. But we wish to leave open the
question of what kind of "fitting" this is, since, as we have said, the nobil-

ity of the matter can shed on the word, thanks to its meaning, a splendor that is not objectively founded.

On the other hand, the contribution that the beauty of the tone of the words and sentences makes to the artistic beauty of a poem, a short story, an epic, or a drama is of a completely objective nature.

Rhyme [Der Reim]

One very interesting phonetic phenomenon is rhyme. It possesses a certain distant analogy to harmony in music, but rhyme is far less important than harmony. It possesses only the formally analogous character of a delightful consonance, of the compatibility of two phonetic structures. From a purely external point of view, harmony in music involves sounds occurring simultaneously, whereas rhyme is sequential. It has a certain peripheral charm, but it can make a decisive contribution to the artistic value in a particular context when particular conditions are fulfilled.

Some rhymes are dull in themselves, and some rhymes are noble. The rhyme fulfills its function not only in serious, great poetic works. It can also have a delightful function in humoristic works, not exactly as a dull rhyme, but certainly as a plain rhyme. Another important factor is whether the rhyme occurs as a modest subsidiary phenomenon, or whether the choice of the words and what is communicated through the meaning occur for the sake of the rhyme. It is always a definite error to sacrifice a much more important factor for the sake of rhyme.

Christian Morgenstern's delightful humoristic poem can be applied to these cases:[3]

> *Ein Wiesel*
> *sass auf einem Kiesel*
> *inmitten Bachgeriesel.*

3. See "Das ästhetische Wiesel" in his *Galgenlieder*. [Editors' note: The footnotes give a strictly literal translation without rhymes.]

Wisst ihr,
weshalb?

Das Mondkalb
verriet es mir
im stillen:

Das raffinier-
te Tier
tat's um des Reimes willen.[4]

But the awkward, illegitimate character that results when the choice of the words is determined by the rhyme to such an extent that the poetical content suffers thereby, or the choice of the words becomes artificial in terms of their meaning, is not found in somewhat humoristic doggerel. In that case, the rhyme is allowed to play the kind of role it has in Wilhelm Busch's *Naturgeschichtliches Alphabet*, where the identical initial letter also plays a role:

Der Esel ist ein dummes Tier,
Der Elefant kann nichts dafür.[5]

Rhyme can carry out an important function in great, noble works. This phonetic phenomenon, which in itself is completely independent of the meaning of the words, and which has a value of its own that is relatively slight, can elevate the overall beauty of certain sublime poems. There are two interesting points here. First, there is the collaboration of a phonetic datum with the qualities that become spiritually present to us through the meaning of the words and sentences; secondly, there is the fact that something that in itself is a modest bearer of an aesthetic value quality that scarcely has the rank of a simple formal beauty, is integrated harmo-

4. "A weasel / sat on a pebble / in the midst of the trickling of a brook. / Do you know / why? / A mooncalf / disclosed it to me / in silence: / The refin- / ed animal / did it for the sake of the rhyme."

5. "The donkey is a stupid animal. / The elephant can't help it."

niously into a great work of art and makes a contribution to its artistic beauty, as in Goethe's poems:

> *Wie herrlich leuchtet*
> *Mir die Natur!*
> *Wie glänzt die Sonne!*
> *Wie lacht die Flur!*[6]

Or:

> *Meine Ruh ist hin,*
> *Mein Herz ist schwer;*
> *Ich finde sie nimmer*
> *Und nimmermehr.*[7]

Or:

> *Kennst du das Land, wo die Zitronen blühn,*
> *Im dunklen Laub die Gold-Orangen glühn.*[8]

The rhyme has a certain importance in all these structures of tremendous poetic beauty. It intensifies the overall beauty.

We must conclude that although it is true that phonetic phenomena play a role in literature, from the tone of the words, from the "music" of a phrase, to rhyme, it is dangerous to accord them too much weight. The emphasis on the phonetic is indeed sometimes fully warranted, for example, in Edgar Allan Poe, in Baudelaire, and in the highest form of poetry, in Saint John of the Cross. But in Shakespeare, Goethe, Dante, Hölderlin, Leopardi, and Keats, the phonetic is clearly less important in

6. "Mailied": "How gloriously nature / shines to me! / How the sun gleams! / How the meadow laughs!"

7. "Gretchen am Spinnrade": "Gone is my rest, / my heart is heavy; / I find it [my rest] never / and nevermore."

8. "Mignon": "Do you know the land where the lemons blossom, / the golden oranges glow in the dark foliage."

comparison with specifically poetic factors. When the phonetic becomes the main thing, we have to do with a definite perversion.

Meter [*Die Metrik*]

Meter, in which a phonetic element is united to rhythm, occupies a place of its own among the phonetic data in literature. Rhythm is a great, a central phenomenon. It expresses many things directly and can be the bearer of very various aesthetic qualities. It unfolds its full importance in music.[9] There is a noble and a brutal rhythm; a rhythm full of vigor and a zest for life, and a contemplative, recollected rhythm. Rhythm can possess many other qualities too, sometimes as their expression and sometimes as their bearer.

It is an important factor in literature too. An epic takes on a special character through the rhythm that is expressed in the meter, for example, in a hexameter or pentameter. What a difference there is between Homer's *Odyssey* and *Iliad* in Greek, with their poetic meter, and a French translation without poetic meter—quite independently of how good the translation is in other respects! Something decisive is lost. Although the German translation by Johann Heinrich Voss is unsatisfactory in other respects, it preserves the poetic meter, and this is a great advantage. The same applies to Vergil's *Aeneid* and to Dante's *Divine Comedy*. The poetic meter is an important factor that makes an important contribution to the beauty of poems, epics, and sometimes also of plays.

Meter too is a phonetic phenomenon, but to a lesser extent than the tone of the words and rhyme, precisely because rhythm has a decisive function in meter. Meter is an advantage for poems and epics, and it intensifies the artistic value. But poetic meter would be out of place in the artistic genre of the short story and the novel, which are meant to be written in prose. In many plays meter brings a great intensification; they cry out for meter. But in others, meter is inappropriate.

One cannot imagine the works of Racine without poetic meter. In

9. See chaps. 33 and 34 below.

Shakespeare, we find in one and the same play some parts in poetic me-
ter and other parts without it. It is interesting that the advantage of the
meter or of prose depends entirely on the kind of contents, but not in
the same way as the sound of a word fits its meaning. In the play, where
both prose and poetic meter are possible, a poet is led by expressly artistic
motives to choose one of these in the work as a whole or for certain parts
of it. The reason why they suit a play or one particular place in the play
lies in the overall atmosphere of the artistic conception or in the quality
of the special situations and in the character of the figures who are on the
stage. The use of poetic meter can be required for one particular work of
art simply because of its general type, for example, for the epic and for
most poems, but this may also be necessary in view of the style and the
ethos of certain plays. Sometimes the character of one particular situa-
tion in a play is elevated and ennobled by poetic meter, whereas other
passages would lose their vitality if this were employed.

Various kinds of "tone of voice" [Tonfall]

A new phonetic phenomenon is the tone of voice. To begin with, it dif-
fers from the pure expression that a cry can possess, such as a cry of fear,
of pain, or rage, or of joy.[10] These phonetic phenomena do indeed pre-
suppose a human voice, but they do not presuppose language.

"Tone of voice" does not refer to the emphasis that belongs to the
purely phonetic nature of a word. Rather, it is a factor that refers to sen-
tences that mean something and aim meaningfully at a state-of-affairs.

It is remarkable that the tone of voice, unlike the word, is not unit-
ed to the intended object through the meaning—this highly intellectual
contact that is not given as fully present. Rather, it expresses something
in an intuitive manner.

It is not difficult to grasp that the content of the sentence or the na-
ture of the state-of-affairs to which the sentence refers requires a certain
tone of voice. It would be ridiculous to reply in a solemn tone of voice

10. See *Aesthetics*, vol. 1, chaps. 4 and 7.

to the question "What time is it?" unless something very important and weighty was connected to this point in time. It would be equally ridiculous to communicate a joyful event in a tragic tone of voice, and it would be utterly inappropriate to announce a tragic event in a joyful—or worse, in a lighthearted—tone of voice.

In itself the tone of voice is an expression of our attitude. Its relationship to the objective state-of-affairs is not one of mentally aiming at something and meaning it. But unlike the other typical expressions, such as crying out, this expressive phenomenon cooperates in a special way with the meaning of the sentence. Since the tone of voice is an expression, it discloses to us the specific character of the underlying act. The meaning of the words and the intentional reference of the sentence to the state-of-affairs is not an expression. But the tone of voice is the objective expression of the act of questioning in a sentence that is a question, of the act of affirming in an affirmative sentence, of commanding in a sentence that is a command, and of requesting in a sentence that is a request. The expression in the tone of voice is united in an important manner to the meaning of the sentence.

It is usually possible to recognize from the word order, independently of the tone of voice, that we are confronted with a question rather than with an affirmation. In a written text, this is explicitly indicated by means of the question mark; the spoken question demands a specific tone of voice. This does not express the particular content of the sentence in a material respect, that is to say, whether it concerns something joyful or sad, something serious or jocular; it does not tell us whether the content of the question is indiscreet, tactless, and impudent, or reverent, discreet, and tactful. It expresses only the formal difference between a question and an assertion, a communication, an exhortation, a request, or a command. Sometimes it is exclusively the tone of voice that characterizes the act of questioning, for example, when someone says: "You were in Vienna?" The form of this sentence is that of an assertion. Only the tone of voice in the act of speaking shows (like the question mark in a written sentence) that this is a question.

There is always a difference in the underlying acts that corresponds

to the formal differences among sentences. Putting a question is a different act from affirming, communicating, exhorting, requesting, and commanding. What the tone of voice (unlike a question mark) not only indicates but also expresses is the specific character of the underlying act; this character not only finds expression in the structure of the sentence but also gives the sentence a formally new meaning.

One and the same state-of-affairs, for example, the red color of a table, can be thematic both in a questioning sentence and in an assertive sentence, but there is obviously a considerable difference between the question "Is this table red?" and the assertion "The table is red." But this difference of a formal kind clearly goes in a different direction from the difference that separates being red from being black or that separates a joyful and a sad event.

This leads us to analyze five different phenomena that can perhaps be termed a "tone of voice." We wish at this point to leave open the question whether we can and should apply this term to all five.

Expressive possibilities of the tone of voice

First, we can speak of the tone of voice that, as we have said, expresses in a spoken sentence the formal nature of the act. The relationship between the tone of voice in this sense and the formal character of the act is neither a relationship of meaning nor a relationship of indication. But if someone says, "I would like to ask you," the relationship between the word "ask" and the underlying act is the relationship of meaning [*Bedeutung*]. The word "ask" or the sentence "I would like to ask you" is united to the state-of-affairs that someone is asking a question, in the same way that all sentences are united to states-of-affairs, that is, through rationally aiming at the state-of-affairs.

But the tone of voice that expresses the act of questioning is completely different. This tone of voice is an immediate expression of the act of questioning. We must now compare this kind of expression of an act—an expression of its formal character, or of the questioning attitude—with the expression of the voice in crying out, when fear or pain

manifests itself in a cry. Is this the same type of expression in the strictest sense of the term, or is the expression of the tone of voice, in which something much more formal and not affective manifests itself, a new type of expression? Is the tone of voice something new in relation to the sound [*Klang*] of the voice?

We postpone this central question until we have presented the other kinds of tone of voice.

Secondly, we may think of the tone of voice in a sentence in which certain attitudes find expression. These attitudes are based on underlying responses such as mockery, making fun of someone, pulling someone's leg ironically, or harmless joking. The new element in relation to the first type of tone of voice is that it is no longer the formal character of the act that somehow belongs to the intellectual sphere, but rather a material qualitative specific character of the underlying act such as mockery, making fun of someone ironically, or harmless joking.

This also manifests itself as intuitively given in the tone of voice. An ironic question or communication has a different tone of voice from a neutral question that is meant seriously. Is this qualitative manifestation of mockery, of the ironical attitude, the same type of expression as in the first case? And above all, is it still the tone of voice in the same sense?

At any rate, both of these are phenomena that show themselves in the act of speaking and that express how what is uttered is "meant." This first phenomenon expresses the formal character of the act, while the second phenomenon expresses the attitude that lies behind it.

A third kind of tone of voice in a sentence, which is in many ways related to the second kind, is the announcement of an affective response. The tone of voice when one person insults another is obviously completely different from the tone of voice of praise or thanks. If someone speaks with a voice full of hatred, the tone of voice is not the same as when he makes a declaration of love. Do these examples still involve the tone of voice? Can one still call the sound of a voice that is full of hatred or rage, or a tender and loving voice, a tone of voice? Is this not a new form of expression? Is this not a much more immediate expression of

the voice, an expression that (unlike the tone of voice) does not contain a modification of the sentence but that stands, as it were, alongside the speaking of the sentence and reflects in an independent manner the attitude that is declared? The function of the words and sentences in an affective response enters into a new union with the words and sentences. It is clear that the declaration differs even more strongly from the assertion, the communication, the asking of a question, requesting, and commanding, than these differ among themselves.

In any case, the immediate expression of hatred, love, anger, or tenderness in the voice of the one who speaks is extremely important. Here the tone of voice presents the formal specific character of the expression, as opposed to the meaning of the words.

A fourth tone of voice, different from those we have discussed up to now, is the expression found in solemn recitation. This expression is demanded by the content of that which is said. Once again, this is a tone of voice in a much more appropriate sense. It is not the expression of feelings or of the speaker's disposition, nor any longer the act that lies behind the speaking, that demands one particular tone of voice, but the qualitative content of what is said.

The communication that someone has died demands a different tone of voice from the communication that a friend has been promoted or that his wife has given birth to a child. The tone of voice that corresponds to the communication that a war has broken out is different from the tone of voice that corresponds to the communication that it is two o'clock. A special tone of voice is appropriate to sadness or to a source of joy, to the momentousness and to the importance of what is communicated. This tone of voice, which is appropriate to the quality of the content that is communicated, is likewise an immediate expression.

A fifth kind is completely different from this appropriate tone of voice. We sometimes say that a declamation is not only incongruous but full of false pathos, embarrassing, or tasteless. Although the content is determinative, a falsification arises through this tone of voice. This falsification is not based on the affective experience that is really present in the speaker and that causes him to make one particular communication or

announcement; and it is based even less on the formal attitude of questioning or asserting. The excessively solemn tone of voice is not demanded by the quality of the content but derives from the negative quality of the recitation. False pathos is a disvalue of a qualitative kind that is found in the human attitude, and indeed has its primary home there. Gestures predominate in this attitude. This hollow affectivity falsifies and distorts the content, which is full of genuine affectivity.

The inadequate tone of voice that communicates a sad event in a joyful tone of voice and a joyful event in a sad tone of voice is an obvious dissonance that is the fault of the speaker and that cannot be overlooked, because it strikes the wrong note. Under certain circumstances, this tone of voice makes us laugh.

On the other hand, an excessively solemn recitation falsifies the content and greatly impairs a drama that someone hears for the first time. The blame for this flaw is then not only ascribed to the actor, but is incorrectly ascribed to the play as well. This false pathos is a pure disvalue that is projected into what is spoken. Its effect is specifically awkward.

A recitation marked by false pathos resembles a sentimental lecture in which someone presents in a sentimental tone of voice something that is, in itself, completely unsentimental and is full of genuine affectivity. One difference between the good and the bad actor is the appropriateness or inappropriateness of the tone of voice to the content that is spoken.

In the present context [of the fifth case], we are interested above all in the type of tone of voice that is indeed an expression of the specific personal character of the person who speaks, but that contaminates and falsifies the content in a special manner.

In all the cases we have mentioned, the following question arises: What type of expression is found here, and how does it differ from the expression of fear and of pain that we find when someone cries out in fear or pain, that is to say, how does it differ from the sound [*Klang*] of the voice outside the sphere of speaking?

It is clear that the immediate expression in the sound of the voice without words, for example, in crying out, is very limited, whereas there are innumerable possibilities of expression in the tone of voice [*Ton-*

fall] of spoken words—taking "tone of voice" here in the broadest sense, which includes all the cases we have mentioned. If the same kind of expression were present both times, it would be impossible to explain why the voice without words can express so little in comparison to the great wealth of expression of the tone of voice in its various functions. It is particularly interesting that completely new kinds of expression arise through union with the word. They are genuinely and unambiguously an expression; they do not live from a meaning, as do words and sentences. It is obvious that the voice acquires completely new expressive dimensions in the speaking of words.

Many animals can cry out. The cry of a dog can express pain, and its whining can express its dissatisfaction, or indeed its longing. But only the human being speaks. Speaking is an essential characteristic of the human person that presupposes the entire structure of the *animal rationale*, or the spiritual person.[11]

There is, of course, a whole world of difference between the cry and the groaning of a human being and the cry or the whining of a dog. But as soon as the human voice resounds in words and sentences, as soon as someone speaks, the tone and the color of the voice also acquire a new dimension in relation to a mere cry. The voice is enabled to make a completely different kind of expression, which, despite its necessary union with words and sentences, is a genuine expression in the sense of a datum that is given in immediate intuition.

Besides this, there is in speaking a direct expression in the voice that can no longer be called a tone of voice, for example, when someone

11. On this, see René Descartes, *Discours de la Méthode*, part 5: "Again, by means of these two tests we may likewise know the difference between men and brutes. For it is highly deserving of remark, that there are no men so dull and stupid, not even idiots, as to be incapable of joining together different words, and thereby constructing a declaration by which to make their thoughts understood; and that, on the other hand, there is no animal, however perfectly or happily circumstanced, which can do the like. Nor does this inability arise from want of organs: for we observe that magpies and parrots can utter words like ourselves, and yet are unable to speak as we do, that is, so as to show that they understand what they say; whereas men born deaf and dumb, and thus not less, but rather more than the brutes destitute of the organs which others use in speaking, are in the habit of spontaneously inventing certain signs by which they intimate their thoughts to those who, being usually in their company, have leisure to learn their language. And this proves not only that the brutes have less reason than man, but that they have none at all." [Translation: Project Gutenberg; slightly amended.]

speaks with a trembling voice that expresses his fear, his timidity, or his uncertainty.

The range of expressive possibility in speaking is very great. One and the same sentence can be uttered in a presumptuous and impertinent manner or in a reverent and humble manner. This, of course, is possible only with sentences that are not already impertinent or reverent in their content. One can utter the sentence, "I know that already" in a presumptuous, arrogant tone, but one can also utter it in a humble manner, as when another person tells me something in the belief that he is giving me new information.

Let us conclude by observing that in a play and a novel, if it is the characters who speak rather than the author who is narrating, the tone of voice, in the narrower and the wider senses, is very important for the characterization of the person who speaks. The tone of voice is, as such, an essential artistic means. Besides this, the content of the spoken word, both in a play on the stage and in a poem that is read aloud, makes specific demands of the tone of voice, and it is artistically important that these demands be met. Finally, as we have said, the appropriate tone of voice is a decisive factor for the actor's art. It must correctly characterize the figure who is being played. In a good production of Molière's *Les précieuses ridicules* ("The Affected Ladies"), the tone of voice must fully express their affectation. Above all, it must never distort through a false pathos that which is great and profound, or use plain prose to take the life out of something that is solemn and elevated.

CHAPTER TWENTY-EIGHT

The Expressive Qualities of Words and Figures of Speech

A WORD HAS A MEANING, but that is not all: in addition, many words also possess a character that expresses both the kind of attitude we have to the object and the light in which we see it.

This, of course, does not apply to all words, but only to those that mean specific kinds of objects. There are typically many things that are aimed at by certain words that in one respect have the same meaning but are completely different in their quality. There are noble and base words, drastic and reserved words, conventional words, neutral, technical expressions, and expressions that clearly reflect the attitude of the speaker to the object about which he is speaking, but not through the sound of the words.

If someone hears about the death of a person and remarks, "He has bitten the dust," or "He has croaked,"[1] he thereby betrays his attitude to death. His spirit, his lack of reverence, and his coarseness are reflected therein, but also his lack of love, his reductionistic way of looking

1. [Editors' note: The attempt has been made to translate the figures of speech in a way that corresponds to the quality of the German terms.]

at things, and his lack of restraint. If, on the other hand, one says, "He has died," or "He has given up the ghost," or "He was summoned into eternity," the choice of such a manner of speaking expresses a completely different ethos. Although the fact that is communicated, that is, the purely formal meaning, is the same, individual words or the combination of several words communicate far more than merely the naked fact.

It is of course true that someone who uses coarse, base expressions need not necessarily have an irreverent attitude to the fact in question. He may have adopted a base jargon through the influence of his milieu, without being genuinely conscious of the ethos that is expressed in this language. This does not alter the fact that such expressions objectively possess this quality.

It is remarkable that such words or sentences not only have the function of communicating a fact but also express an attitude to what is communicated. Even when we know that one who employs these expressions is not conscious of their quality, we are shocked by their objective baseness, and we will attempt to explain this to him and to get him to stop using them. These expressions not only allow us to draw conclusions about an inner attitude and are not only symptoms of the attitude of the person who uses them. They are, as such, an objective expression of these attitudes. They contain a special quality.

Such expressions or qualities are found in innumerable differentiations. If one says about a man who loves a woman, "He's nuts about her," this manner of expression does indeed inform us about his love, but it has a definitely irreverent and coarse, base character. Why is the expression "to puke" so much coarser than "to vomit"? The second word has a neutral, almost medical character, but the first has the character of losing all restraint, or indeed, of a delight in the unaesthetic quality of this physical process. Certain words aim in their meaning at an object that imposes a reserve on us through its specific character. We ought not to get too close to them and to rub our noses, so to speak, in their unaesthetic aspect.

There are intimate spheres that ought to be covered with a veil in public, and certain expressions do justice to this character, while others have a shameless character. Here there is a large spectrum.

Some words have an affected, "precious" character, an embarrassingly aestheticist coloring. The disvalue in these words lies not in the direction of the irreverent or the base, but in the direction of an over-refinement that makes for inauthenticity.

But it is not only the inner attitude toward the object that makes an expression appropriate or inappropriate. The situation too can make certain expressions appropriate or inappropriate.

In the case of medicine, a technical, neutral language is appropriate. No attitude to its objects resonates in the terms it employs for them, other than a general and purely scientific attitude. There is no expression of a personal attitude to the particular object and to its human character. This entire dimension of expression is avoided in the language of medicine. Everything is treated in the same way, as a purely scientific phenomenon. Medicine makes use of a language of scientific terms, not of normal language with all its various expressive dimensions. It is not by chance that there is in medicine a preference for the coining of Latin terms that aim in a plain and unambiguous manner at the phenomenon and that live simply from the meaning they express.

In all the other sciences too, of course, there are many objects with names that possess no expressive quality of any kind, since these objects by their very nature exclude this.

There are no polite or noble words for numbers, nor any base, frivolous, or slovenly words. In the case of phenomena that are not full of content and qualitatively rich, and of objects without a positive or negative aesthetic aspect, words do not possess expressive characters in addition to their meaning. Expressive qualities are not present when one speaks of a number of kilometers or of a period of time (a minute, an hour, a day). What we have in mind here, of course, is not the day as a human phenomenon but the purely quantitative indication of time.

It is obvious that the expressive qualities play a great role in a living language. They are also bearers of important aesthetic qualities. Strangely enough, they have a character that is given as fully present, whereas the pure function of meaning does not possess this character. They presuppose this function of meaning not only in the specification of the object,

of course, but also in all the words that describe the object. And yet, it is not the specific act of understanding with which we apprehend the quality of certain expressions, whether this is an individual word or a figure of speech, when it affects us positively or negatively.

If we compare information about an event or about some fact in frivolous, banal, or base expressions, or in noble or polite expressions, on the one hand, with a purely medical diagnosis, on the other hand, it is clear that the terms employed in the latter appear only in their pure meaning. The unfavorable diagnosis may have grave consequences for us and may strike us like a thunderbolt; if the diagnosis is favorable, it may take a load off our mind. But this does not alter the fact that the term amounts to no more than its meaning. It possesses no expressive qualities of any kind. The term adds nothing to the meaning of the fact; only the fact itself is capable of affecting us in a profoundly positive or negative way. It suffices to understand the meaning of the term and to apprehend the information that is given to us in it.

If someone communicates an event or a fact to us in customary language, however, and his mode of expression possesses a quality with a positive or negative value that goes beyond the pure information, a quality that adheres to the mode of expression and not to the object that is communicated, the act of apprehending this quality is different from the pure act of understanding. It has a more immediate character, although it presupposes just as much knowledge, or indeed even more knowledge, than the act of understanding the pure meaning.

This act of apprehending is not an immediate experience in the same way as the sound of a voice, the form of a face, or the color of a person's hair. It presupposes that one has been informed about the meaning of certain figures of speech. One who lacks an exact knowledge of the English language must not only learn through instruction the normal meaning of the words. A person who does not know English must learn that "kick the bucket" is a very frivolous, vulgar expression for "dying" in the same way that he learns the meaning of words.

Words and figures of speech that not only have a pure meaning, but are also capable of reflecting an attitude to the object that is intended

and communicated, are also employed in literature as an important instrument.

We must, however, distinguish these cases where a word possesses a quality that goes beyond its meaning from those cases where a figure of speech is employed to designate an occurrence, an event, or a fact.

Comparisons are used in the figure of speech for dying: "He has bitten the dust." It is meaningless to compare the dying of a human being to biting the dust, since there is no kind of analogy between the two. The disparaging view of the event is contained, not in one individual word, but in a circumlocution in which at least two different new things are employed as a pure meaning, namely, biting and dust.

If, however, someone says, "He croaked," it is one individual word that possesses the expressive dimension of the vulgar, the base, and the irreverent.

We must ask whether in both instances one thing is not reduced to another as a way of showing us the light in which the occurrence or the fact is seen. Does not the phrase "to bite the dust" contain a comparison with an animal? This seems not to be the case. This expression remains vulgar, although it is much less bad to use it of an animal such as a dog or a horse.

The verb *fressen* ("to eat") is completely appropriate to animals, but it is indubitably common, coarse, and vulgar when someone says, "Give me something to eat [*fressen*]!", or worse, when he says to someone else, "Here is something for you to eat [*fressen*]." The irreverent and vulgar character of this word is due to the fact that the act of eating by a human being is placed on the same level as the act of eating by an animal.[2]

As we have said, however, there are many common, frivolous, indecent, crude, affected, and embarrassingly aestheticist expressions with a quality that is not due to any reduction and that does not contain any comparison.

The expressive quality of the words and figures of speech in which, in a mysterious manner, the attitude to an object and the light in which

2. [Editors' note: The German language makes a distinction between *essen*, used of eating by human beings, and *fressen*, used of eating by animals.]

one sees it are revealed is a specific instrument employed in literature for the characterization of the persons in a novel or a short story, and also in a play. This aspect of the words and sentences is very characteristic of the style of a human being. It is obvious that we are not employing the word "style" here in the sense that is envisaged when one speaks of the good or bad style of a writer. We use this term to designate the mode of expression in which certain traits of a human being are reflected.

Up to this point, we have discussed how certain words and figures of speech present in themselves an expression of certain attitudes to an object, an occurrence, and so on. However, their use also characterizes the whole person who speaks. A slovenly mode of expression is a symptom of many of the speaker's traits. The tone of voice, the expression of the voice, and even the movements of his body and his whole behavior usually correspond to this mode of expression, and this is why words and figures of speech are an important means used in literature. An indecent manner of speech and taking pleasure in indulging one's impulses are essential aspects of Lucio in Shakespeare's *Measure for Measure*. In the same play one element in the characterization of Isabella is the nobility of her diction. The innocence and the poetic charm of Miranda in Shakespeare's *The Tempest* are brought to life both through the content of what she says and through her mode of expression.

Some expressive qualities show forth vividly even the body-feeling of a human being.[3]

The qualities that are manifested in a person's diction are uncommonly diverse: vulgarity, self-indulgence, irreverence, a crude lack of manners, aestheticist preciousness, over-effusiveness, inauthenticity, sentimentality, naïveté, good manners, conventionality, poetry, nobility, a noble reserve, and many other qualities. Certain standard phrases that particular persons use, or the words that they employ when they are furious, are also typical indications. Sancho is brilliantly characterized in his artlessness and in his lack of fine manners when he cries out in anger, "By the whore that bore me!" Dorothea or Cardenio in *Don Quixote* would never

3. See chaps. 18 and 22 above.

express themselves in this way, nor would Rosalind in Shakespeare's *As You Like It* nor Viola in *Twelfth Night*.

It is especially characteristic of simple persons that they continually repeat standard phrases, and the kind of phrases that they use tell us a great deal about these persons.

We can sum up as follows the principal characteristic of expressive qualities in words and in figures of speech. First, a word or sentence is capable of reflecting a conventional attitude to the object that is named. Secondly, a word can attempt to inhibit the complete presentation of an occurrence or of a thing by remaining at a distance from the object, as it were, and seeking to cover it over. Thirdly, a word can have a neutral character, like a technical term. Fourthly, a word can make an object fully present, allowing it to unfold vividly in the imagination. Fifthly, a word can look at the object from below or from above. Sixthly, a word can be reverent or contemptuous, dismissive, or impertinent. Seventhly, it can be drastic, critical, or aloof.

The choice of words is often demanded by the specific character of the object. Things that are objectively profound, or indeed sublime, require a response that corresponds to them. Accordingly, when one speaks of them, they require a reverent mode of expression.

In his excellent book *The Abolition of Man*, C. S. Lewis relates the well-known story about Coleridge.[4] Two tourists are standing at a waterfall. One cries out, "This waterfall is sublime!" and the other cries out, "This waterfall is pretty!" Coleridge underlines how appropriate the word "sublime" is and how inadequate the word "pretty" is. This difference far transcends the expressive quality of the words, of course. "Pretty" misses the mark, even in its pure meaning, since prettiness is a quality that a majestic waterfall objectively does not possess.

Some people use *nett* ("nice") as a typical word for all the aesthetic values, and even for many other values. This occurs less frequently in Germany, but the English word "nice" is widespread, above all in America, irrespective of whether one is talking about the Medici tombs,

4. (New York: The Macmillan Company, 1947), chap. 1, pp. 1–2.

Beethoven's ninth symphony, a dialogue of Plato, or about the congenial temperament of a person, or about harmless pleasures. It is obvious that this mistake is already present in the pure sphere of meaning. At the same time, the word "nice" is annoying in its expressive quality. Above all, it is a typical symptom of a general attitude to the world of values. If it is not being used merely because of a bad habit, it reveals that the person is stuck in an attitude of merely liking things, without suspecting that there is more to life and without any genuine value-response. This is symptomatic of a trivialization of the world.

The meaningful relationship that exists between the nature of objects and the expressive quality of the words is, of course, a reflection of the inherent relationship between the objects and our response to them, our attitude to them. It is a truism that a predicate depends on the type of object to which it is referred. To call something that is sublime "nice" is simply to make a false statement.

The point that concerns us here is that when the mode of expression contains more than the pure meaning and reflects our attitude to the object, this mode of expression is demanded by the specific character of the object. This demand makes possible appropriate expression. Intimate matters require a distanced, reverent attitude that comes into its own in the expressive quality, which ought to cover the object with a veil. Other objects, on the other hand, require that one uncovers everything and thus stimulates the imagination. We could point to many differences in the specific character of objects that make a mode of expression appropriate or inappropriate, stimulating and apt or slovenly and awkward.

An expressive quality reflecting a person's inner attitude characterizes the person who employs it to an extent that goes far beyond the expressive quality's appropriateness in relation to the object. It can reveal the utterly conventional mediocrity of a person. It can reveal his banality, vulgarity, or arrogance, the pleasure he takes in rolling around in the mud, his pleasure in being self-indulgent, and so on. It can equally reveal the opposite, that is, positive attitudes. It is clear that literature possesses a powerful means in the expressive quality of words and figures of speech.

The voice of the author and the voice of the persons who are depicted

We must now draw attention to a general characteristic of literature. There are two ways in which a novel can depict something. Either the author himself speaks and describes the characters, and indeed tells us about their inner life and about everything that is going on in them; or else he lets the characters themselves speak, thereby presenting them to us in a living way and characterizing them in their personality. In that case, two voices are interwoven in the presentation of persons, events, and situations, namely, the voice of the author and that of the persons who appear. There are no analogous possibilities in the two other imitative arts of painting and sculpture.

In a poem, it is generally only the poet who speaks, but sometimes he also places words on the lips of a fictitious person whom he depicts. Both voices are often heard in the novel and the short story, as well as in the epic, where they complement each other. In a play, only the persons who are depicted speak. Sometimes the author lets one person be described by another person, but the author himself never speaks directly.

The author thus has this double possibility of presentation. There are many things that he can give only if he makes use of both of them in one and the same literary type, such as the novel, the epic, or the short story.

We could call the author's voice the direct depiction and the other voice the indirect depiction, although the play, in which only the indirect presentation occurs, offers in another respect a completely new dimension of direct and immediate contact with its content.

These two channels of depiction allow various expressive dimensions. In many respects, there is an important difference between the situation where the author himself states something as his own opinion, and the situation where something is only the opinion of a depicted person. It is, of course, possible for the two to coincide. A character in the drama can say something that the author intends as his own valid statement. On the other hand, this may merely be something that characterizes the personal opinion of this character. In that case we must clearly recognize that the author does not share this opinion.

The link between these two channels has far-reaching consequences. It is decisive for the question of metaphysical beauty in a work of art and for the entire problem of the relationship between morality and art in literature. These two channels make it possible for metaphysical ugliness (whether that of moral disvalues, or that of a dull, superficial, base mentality, or the ugliness of inauthenticity) to make a contribution to the artistic beauty of a work.[5]

5. See chap. 32 below.

The Theme That Is Proper to Literature

LANGUAGE HAS A decisive function in several areas. It is a principal organ in our relationship to other persons. Only through language are our internal life and public life in common possible. Its place in our life is so central that we can say that without the word, without language, without the ability to speak meaningfully, the human being would not be a spiritual person. This ability is decisive for his character as a spiritual person. It is absolutely impossible that a mere living creature, such as a dog, a cat, or a horse, should ever use language. Scheler rightly said that if a dog spoke to him, he would be more inclined to take the dog for a bewitched human being than to believe that an animal could speak.[1]

But it is not only in life that language is a fundamental factor. Philosophy and all the sciences need it too. Even apart from the function of

1. On this, see Scheler's "Zur Idee des Menschen" in his collection, *Vom Umsturz der Werte* (Bern: Francke, 1955), 176: "If my dog were to do no more than hide behind a wall and look out from time to time, so that I saw that he did not want to be seen, and if he observed me at breakfast—I, at least, would bet any sum that he was a human being under a magic spell." On pp. 182f., he concludes by quoting Wilhelm von Humboldt: "Only words can be spoken. At the beginning of language was the word! The animal does not 'speak,' because it does not possess the word.... The word is a primal phenomenon.... 'The human being is a human being only through language; but in order to invent language, he had already to be a human being.'"

words and sentences in the act of reflection, it is obvious that the objectification of all types of knowledge is tied to language.

Fiction and reality

We must now ask ourselves: What is the new function of language in
literature?

One first element, for example, in a novel, is the character of the fictitious as opposed to all other uses of language. When we read a novel,
we are aware that its subject matter is fictitious. We do not receive information about something real, whether in the present or in the past. The
narrative speaks only of fictitious events and persons.

Although this is true in general, there are nevertheless many novels
and plays that have an historical event as their story. In Tolstoy's *War and
Peace*, Russia's wars with Napoleon are not fictitious events. Both the
Battles of Austerlitz and Friedland and Napoleon's invasion of Russia
are historical and real. Although many of the characters in the book
may be fictitious, Emperor Alexander I, Kutuzov, and Napoleon are not
fictions. The same is true of Shakespeare's plays *Julius Caesar* and *Antony
and Cleopatra*, and of Schiller's *Wallenstein*. Even in these works, quite
apart from the fact that they mostly contain fictitious persons, the theme
is artistic. The theme is not precise historical information.

An academic historical work ought to communicate adequately what
really happened. Its theme is the truth, not only in relation to purely
factual events and dates, but also in relation to the deeper understanding
of the historical figures and to the apprehending of the great historical connections. In order to communicate this truth, the author requires
from the outset both an exact and thorough knowledge and a deeper understanding that is a gift of a unique kind. This gift includes a phenomenological alertness. Why are there such large differences between the
wonderful depiction of the figure of Alexander the Great in Plutarch and
the depiction by many other historians? How much deeper is the understanding of great historical personalities in Mommsen than in Ferrero!

In order to reproduce the historical event in a living manner, more is

needed than this deeper insight and vision, and more is needed than an understanding that goes beyond a mere knowledge of facts and that contains a phenomenological view. Something that we might call an artistic power to paint a picture is required. Nevertheless, the truth remains the theme. Reality is the decisive criterion, and every vision of a great historical personality, no matter how fascinating it may be, loses its interest and its *raison d'être* when it contradicts the facts and is a fiction rather than an adequate rendering of the past.[2]

Sometimes it is not easy to determine which presentation is more in accordance with reality, for example, the depictions of the figure of Caesar in Mommsen or Ferrero. Mommsen's Caesar is much more attractive and interesting than that of Guglielmo Ferrero. Mommsen's presentation is much richer and more stimulating to read. But all of this is inessential and takes second place in comparison with the only question that is really thematic: Which presentation corresponds better to the truth? The adherents of Mommsen and of Ferrero will argue about which picture is true. Those who are delighted by Mommsen's view take up the cudgels on its behalf, because they regard it as true. If one could convince them that Mommsen's picture of Caesar was only a noble fiction, their enthusiasm for his presentation would be immediately undermined and reduced to a mere admiration of Mommsen's power to paint a picture. The historical importance of his work would collapse into nothing.

We thus see clearly the decisive difference between a novel and a work of history, namely, the differentness of the theme. The questions that are decisive for a novel are: Is it beautiful and alive? Does it stand on its own feet as a work of art? In every work of history, on the other hand, the decisive question remains: Does it correspond to reality?

We cannot discuss here how the ascertainment of historical truth is influenced by so many false psychological and philosophical views, by blindness with regard to deeper phenomena, by looking at things from the outside, by false ideals of objectivity, and by a prosaic, professorial attitude. Nor can we discuss how far the objective research into history

2. See *Aesthetics*, vol. 1, chap. 13.

is clouded and colored by false worldviews, such as the denial of the possibility of miracles. This is a particularly powerful factor in the exegesis of sacred scripture.

We do wish to note, however, that history makes certain demands of a literary work of art, although historical reality is not the theme even when the story is built on an historical event. For it is a definite error when the depiction in a work of art completely falsifies a great historical personality, or when the depiction goes astray. This error is, of course, all the more serious, the more important the position that an historical personality has in a novel or play.

It remains true, nevertheless, that the difference of theme separates the literary work of art from all the other spheres in which language is the decisive means.

Although the content of the literary work of art, and above all of the poem, novel, short story, epic, and drama, is fictitious, it nevertheless depicts reality. The individual story may be purely fictitious, and none of the characters may ever have lived; but they must be beings who feel, think, and speak like human persons. If the story is not explicitly transposed into a dream world, it must bear the character of the possible and the real. Let me sum up: literature is perhaps the most explicitly imitative art, and all the functions of language that occur in life also occur in the literature that depicts life.

The poem

Unlike all the other literary genres, the poem is not specifically imitative. There are indeed imitative forms of poetry, above all the ballad, which narrates something and speaks of individual occurrences, sequences of events, and persons. The ballad presents a piece of life and nature. The narrative is cast in the form of a ballad because of the content and the atmosphere of what is narrated.

A play addresses the public, and the same is true to a lesser extent of a novel, a short story, and an epic; but a poem has a definitely intimate character.

The poem aims above all at the quality of the poetic. This value quality is, of course, very important in the whole of literature, but the poem is associated with it in a very specific manner. There is a particularly profound connection between the form of the poem and the realization of the poetic. The poetic is primarily the type of value that this literary genre is meant to bear.[3]

Poetry in the strictest sense of the word is both the freest type of literature and the type that is most strongly bound in terms of form. It is free because (with the exception of the ballad) it is not bound by any story, and many dimensions of the imitative are not present. Unlike the play, the poem does not present any characters or tell a story.

On the other hand, form has a much greater importance in the poem than in all the other literary genres, with the exception of the epic. The elements of the sound of the words, the rhyme, and the meter come fully into their own in the poem. It is the most musical form of literature.

The poem draws us into its world in a completely unique manner. It speaks a different language from the rest of literature and addresses other strata of our soul.

On the one hand, poems stand on the highest artistic level. Examples are Shakespeare's sonnets and some of the poems of Keats and Hölderlin. They are often harder to understand than short stories, novels, and plays. They are more compressed than these genres; one might say that they are pregnant with thought. On the other hand, they are specifically direct. They give their content and their atmosphere in a particularly immediate manner. They appeal more to our direct intuition than the other literary genres.

3. See my *Aesthetics*, vol. 1, chap. 11, "The Poetic."

CHAPTER THIRTY

The Compositional Means Used by Literature

WHEN WE NOW concentrate on the means used by literature, we are not primarily interested in whether these means appear only in literature, or in life too. Nor are we interested in whether they occur in history, in biographies, and in newspaper reports. Now that we have identified the basic difference of the theme that separates literature as art from all the other domains of human life, we need not be surprised to find in other domains where language is used elements of language that literature employs as means for the composition of its work. Since literature deals with human life, and the depiction of reality is one of its aspects, it is inevitable that the same characteristics of the mode of expression that we find in life would also recur in literature.

The choice of words and decorative adjectives

The quality of words and modes of expression is an extremely effective means to give a living characterization of a depicted person by placing them on his or her lips. At the same time, these qualities are also important means when the author himself speaks; they give the ethos and

the atmosphere of the work as a whole. Both of these can be bearers of high artistic values.

These qualities acquire an importance of their own in a poem. The choice of words and their qualitative atmosphere can certainly play a positively decisive role for a poem, with the exception of humorous or caricaturing poems. These, however, are not genuine poems. They belong to another literary genre, which only has certain formal elements (such as meter and rhyme) in common with genuine poems. An example is the poetic form used by Wilhelm Busch in his *Fromme Helene* or in the *Knopp* trilogy.

The quality of the words and of the figures of speech that an author uses influences his style, whether that style is modest greatness or glorious splendor, or affected aestheticism, or its sober, boring, or crude and vulgar character. The last of these occurs seldom, since the author of a poem aims in some way or other at the beauty of his work. Some authors, however, are afraid of appearing affected and artificial, and believe that they must protect themselves against this danger by resorting to crudeness, irreverence, and coarseness.

Another important means used in literature are the *epitheta ornantia*, the decorative adjectives. The nature, the positive or negative value of a thing, can be expressed through the adjectives that are attached to the word that aims in its meaning at the thing. There is a wide field here for the unfolding of a depiction that is both poetic and vitally creative. There is an immense spectrum of decorative adjectives. On the lowest level, there are the adjectives that aim only to make the object that is mentioned, for example, a landscape, the rising of the sun, or the external appearance of a human being, more living and more intuitively present to us. Next come the *epitheta ornantia* that help in very varying degrees to shed light on the object in its deeper nature and to open our eyes to its true being. These too possess a corresponding quality, quite apart from their meaning. Simply as such they can be tasteful or tasteless, contrived, of a noble simplicity or affected, poetic or trivial. In their function as decorative adjectives, they can have an elevating, illuminating character or an awkward character. They can be noble or insipid. They can be pro-

foundly apt or unsuitable. They can be successful or unsuccessful in their pure descriptive function.

With this we have already touched on the outstanding position of analogies in literature. The *epitheta ornantia* often contain an allusion to an important analogy that not only permits the nature of a thing to shine forth in its depth, but also bears in itself a special poetic value and discloses to us a connection that is the bearer of lofty beauty. But there are a number of things that must be clearly distinguished here.

There are two dimensions of introducing us deeply to the nature of something and letting its beauty shine. The first dimension is the adequate illumination of a spiritual something, which is achieved by highlighting its specific character of a being, its typical traits, its effect, and so on. This is a means in the poetic art that often makes use of profound philosophical insights and truths. Portia's words about mercy in Shakespeare's *Merchant of Venice* are a glorious example of this:

> The quality of mercy is not strain'd,
> It droppeth as the gentle rain from heaven
> Upon the place beneath: it is twice blest;
> It blesseth him that gives and him that takes.[1]

The observations that mercy that transcends justice and is allied to pardon blesses both the one who shows mercy and the one who receives it are profound philosophical truths and possess, as such, a lofty metaphysical beauty that is placed at the service of the overall beauty of the play. The theme here is not truth but the metaphysical beauty of truth. Kindling a light that penetrates the mystery of a thing and allows its metaphysical beauty to shine forth fully is a fundamental means used by the poetic art. It is supremely important in the most sublime works of the poetic art, above all in Shakespeare, but also in Dante and in the drama of classical antiquity.

1. Act 4, scene 1.

Physical, cosmic, and historical analogies

Secondly, the illustration of the meaning and of the beauty of a phenomenon, allowing these to emerge completely, can be achieved by pointing to analogies.[2] We must distinguish various types of illustration or of opening up by means of analogies.

In very general terms, we need to have recourse to analogies in the physical world when we characterize all personal and spiritual entities, whether these are personal or apersonal. When we characterize the spiritual act of apprehending, of knowing, we make use of the analogy of seeing, of perception by the senses. When we speak of the glowing heat of love, we point by means of the expression "glowing heat" to the analogy to a physical phenomenon. These analogies to the physical world are often employed in literature, in order to make a spiritual phenomenon more alive and given as more fully present. This can be done both through *epitheta ornantia* and through an explicit comparison. Making something visible [*Veranschaulichung*] has a different function in literary language than in the language that is used in the various spheres of life, such as the practical and scientific spheres, or in mere communication and information.

There is a higher analogy in literature that is much more important than this analogy. This higher analogy can draw on physical or spiritual entities, but its task is to shed a light that penetrates into the deeper essence of a spiritual phenomenon, allowing the whole meaning and greatness of a virtue, of an attitude, of love, friendship, truth, and much else, to shine forth, and highlighting their metaphysical beauty.

The words of the Gentleman in *King Lear* about Cordelia are very apt:

> You have seen
> Sunshine and rain at once: her smiles and tears

2. [Editors' note: The author understands the term "analogy" here in the broadest sense, which includes a fluid transition to "comparison."]

> Were like a better day: those happy smilets,
> That play'd on her ripe lip, seemed not to know
> What guests were in her eyes; which parted thence,
> As pearls from diamonds dropp'd.[3]

What a characterization of Cordelia! It contains all the charm and nobility of her personality. How apt and beautiful is the analogy to simultaneous rain and sunshine! A deep and special phenomenon, the combination of rain and sunshine, is employed to capture exactly the interplay of laughter and tears! The comparison to pearls and diamonds is a unique analogy.

Here we see the two functions of analogies. First, they allow the beauty and the importance of the event (namely, Cordelia's tears) to shine forth. Secondly, there is the poetic splendor of the analogy as such. The link that is brought about by the analogy opens up a broad background. It discloses to us the mysterious greatness of the analogies that permeate the cosmos, these qualitative links that are completely different from the links expressed in terms of causes and goals. The shining forth of an analogy as such brings with it a unique breadth and greatness, and a specific poetry.

There are, of course, many kinds of qualitative analogies, such as those between light and truth, or between seeing with the eyes and the spiritual act of seeing in the apprehending of an evident relation. But there are also many analogies that are more hidden but no less true. One who is not a poet will not discover these so easily. When Keats compares the surging of the sea to the priestly "ablution" of sins in his glorious sonnet "Bright Star," he is alluding to the profound analogy that underlies the use of water in baptism. Water is elevated to the matter of the sacrament because, in the natural order, it is the purifying element *par excellence.* In Keats's poem, this analogy is reversed. He speaks of the surging of the sea and compares this inundation of the coast with the ablution in baptism or with the supernatural purification from sins. The wonderful

3. Act 4, scene 3.

light in which the surging of the sea is now seen not only throws a light of solemnity on this surging, and not only discloses its magnificence in a special manner; in addition, the analogy as such presents a vision that penetrates all the spheres of the cosmos and reaches into the supernatural sphere. This vision possesses a superb beauty.

Other comparisons are built on a much more tenuous analogy. In his poem "Mailied" ["May Song"], Goethe writes:

> Oh, love, oh, lovely,
> So golden fair
> Like morning cloudlets
> On that hill there.[4]

The analogy he draws between love and the "morning cloudlets" on the mountains is undeniably hard to grasp, and it could not be used in any purely philosophical context. Water and physical ablution have an analogy to every spiritual purification, and this analogy can also be grasped philosophically. But one cannot say the same of the analogy in Goethe's poem. Nevertheless, the comparison of the beauty of love to the beauty of the "morning cloudlets on that hill there" (naturally, these are morning clouds bordered by the sun) captures something that is very deep and true. The hovering, expectant quality of the morning clouds on the mountains and their special poetic beauty has a profound analogy to the beauty of love, to its impetus, to the soul's being lifted up in love, to the wings that the soul grows, and to the hope that is inseparable from love.

All these analogies must be true, and—this is an absolutely central point—something must be captured by means of them. The comparison must allow something that is objectively present and true to shine forth. The analogies must contain an element of discovery. They must not be artificially far-fetched—a modern temptation. Nor must they hint at purely associative, subjective links—an error of cheap poetry that is "romantic" in the negative sense of the word. Nor must they present the truisms that

4. [English translation by John Sigerson, The Schiller Institute. Original: "*O Lieb, o Liebe, / So golden schön, / Wie Morgenwolken / Auf jenen Höhn!*"]

trivial people often take to be poetic. "Ah, spring, roses, a bower, a pair of lovers!" is a cheap, short-circuited link that does not penetrate into that world in which the true, deep analogies can be found. It unites things only in a superficial, associative manner and constitutes a primal source of kitsch and triviality. It either caricatures or simply leaps over the true, deep analogies, which are replaced by purely subjective associations.

We touch at this point the general link between all genuine poetic art and truth. This is why Plato rightly calls the poet a seer. Precisely when we look at this important artistic means, namely, analogy, we must recall that an important part of the artistic gift of the poet consists in his deeper vision of the cosmos and of the plenitude of all phenomena.

In addition to cosmic or purely objective analogies, historical analogies often have a great poetic significance. In his depiction of one situation, the poet can allude to analogous situations in the course of history. In this way, an enormous expansion and a sublime view are attained by means of history. The importance and the content of the earlier situations shine forth, and the present situation receives a magnificent background. Once again, the enrichment of the present situation or of the present event comes about through an analogy, together with the poetry of the vast view of history and the link to all the analogous situations. This link is the bearer of a lofty poetic quality.

We turn once more to *The Merchant of Venice* to illustrate this situation:

> *Lorenzo*:
> The moon shines bright: in such a night as this,
> When the sweet wind did gently kiss the trees
> And they did make no noise, in such a night
> Troilus methinks mounted the Trojan walls
> And sigh'd his soul toward the Grecian tents,
> Where Cressid lay that night.

Jessica:

In such a night
Did Thisbe fearfully overtrip the dew
And saw the lion's shadow ere himself
And ran dismay'd away.

Lorenzo:

In such a night
Stood Dido with a willow in her hand
Upon the wild sea banks and waft her love
To come again to Carthage.

Jessica:

In such a night
Medea gather'd the enchanted herbs
That did renew old Aeson.

Lorenzo:

In such a night
Did Jessica steal from the wealthy Jew
And with an unthrift love did run from Venice
As far as Belmont.[5]

5. Act 5, scene 1.
We find something analogous in the glorious Tridentine liturgy of the blessing of the baptismal water on Holy Saturday. The vast view, the illustration of what is taking place, is brought about through the "history" of the water: "Therefore I bless you, creature of water, through the living God, through the true God, through the holy God: through God, who in the beginning separated you from the dry land; whose Spirit hovered over you; who made you flow from the spring of paradise, and commanded you to water the whole earth in four rivers; who introduced sweetness and made you drinkable when you were bitter in the desert, and who brought you forth from the rock for the thirsting people. I bless you also through Jesus Christ, his only Son, our Lord: who by his power, in a wonderful sign, changed you into wine in Cana of Galilee; who walked on you with his feet; and who was baptized in you by John in the Jordan; who brought you forth from his side together with blood; and who commanded his disciples to baptize in you the believers, saying: 'Go, teach all the peoples, baptizing them in the name of the Father and of the Son and of the Holy Spirit.'"

We find in these historical analogies the utter opposite of every dull, prosaic, Philistine pettiness. The vast view already has in itself a noble greatness, but there also shines forth something of the poetry of history as such, something of the analogy between great moments in history—not only between important historic moments that are a unique phenomenon, but also between classical intimate situations that need not have any remarkable historic consequences. The inherent significance of classically human experiences and situations stands before us in the historical perspective. The substantial depth and meaning of these experiences and situations unfolds, together with the fact of their recurrence in the course of history and their relationship to constantly recurring phenomena such as the glorious night that carries the event like an organ tone and that is indeed the starting point of the analogy. However, for understanding these historical analogies, which make an impression that is so vivid and immediate and which have a poetry affecting us so directly, a certain knowledge of history is presupposed.

This brings us to a question that we have often considered and that is particularly relevant in literature: To what extent does the immediate understanding of a work of art presuppose knowledge that derives from other sources? We prescind here from the knowledge that is already necessary in order to understand the words, that is to say, from the knowledge of the objects at which the words aim. This knowledge presupposes that one has learned from a variety of sources. We also prescind from the knowledge of the meaning of the words, from the knowledge of the language, and so on.

We have already spoken of historical knowledge in the case of architecture. In literature it is frequently an indispensable presupposition for the artistic impression. If someone has never heard of Troilus and Cressida, or never heard of Dido and Aeneas, the analogy is ineffective. These words mean nothing to such a reader. More is involved here than in the case of an incomprehensible allusion in Dante's *Divine Comedy* to some contemporary figure, since there the lack of knowledge only robs the allusion of its interest. And even when it is understood, it is not an essential bearer of a lofty poetry and beauty.

Where historical analogies are involved, however, as in *The Merchant of Venice*, a lack of historical knowledge prevents us from understanding the lofty artistic content of the analogy. The quality of the analogy is apprehended only to a lesser extent. In the case of architecture, one dimension of the "world" and of its poetry disappears, but it is still possible to recognize fully the pure beauty of a building; but in the case we are considering here, it is completely impossible to apprehend the poetic beauty of the analogy. But this knowledge does not in the least impair the reader from being entirely turned toward artistic beauty. It is not another source from which we draw joy; rather, it is a presupposition. This knowledge, with its poetic content, is employed as a means for the artistic beauty of the present situation. This wide perspective, due to history, is the bearer of a special poetic beauty. The poetry of the rhythm of history as such shines forth.

The recollection of earlier analogous situations is an important factor in life too. But it is not only things of the past that open up a special aspect that adds something new to what is experienced in the present. There is in fact an aspect of future events to which we look forward in joyful expectation. This is a very special aspect that is clearly distinct from the aspect of the same event that we experience in reality in the present. In the same way, the aspect of the same event is different when we hasten back to it in our memory. These three aspects allow one and the same event to appear in a varied light. They do not contradict but rather complement one another. Naturally, we are thinking here of joyful events; we need not repent of having striven to experience these. We are not thinking of events about which we allowed ourselves to be deceived and that contain some element of disappointment. We are thinking of the splendor that is possessed by a beautiful event that makes us happy, an event to which we look forward in pleasant anticipation. Everyone is familiar with the expectation that is full of joyful impatience. Nothing can take the place of this experience. It is superfluous to refer to the delight and glory of the present. But the recollection of such moments that made us happy gives us something very special, something irreplaceable, namely, the grateful reminiscence that is accompanied by nostalgic feel-

ing toward the past, and by the transfigured aspect that an experience retains in memory. This transfiguration resembles the transfiguration that the evening light spreads over a landscape. Each of the three aspects has a special poetic character.

We mention this comparison only in order to point to the special splendor of the historical past, in which everything is projected onto a grand plane. In this case, of course, the specific character of the intimate recollection of one's own past is not found, but the poetic transfiguration of the retrospective view remains, which acquires a new splendor through its grandeur. The light that falls on the analogous present situation through this retrospective view generates a unique solemnity and breadth and bestows a magnificent background on the present.

The necessary knowledge of history is a presupposition, just like the knowledge of the language in which a literary work of art is written. But the knowledge of the historical event does not suffice. A deep apprehending of its atmosphere is also necessary. The delightful experience of the grandeur of the historical perspective, and the apprehending of the poetic world, are pure responses to the artistic value that discloses itself to us immediately and intuitively, once all the presuppositions are fulfilled.

Genuine analogies must always capture something that objectively exists. But they ought not only to be true and to be genuine qualitative analogies (instead of a merely associative link). In order to contribute to the artistic beauty, they ought also to allow something deep and important to shine forth. They ought to shed a light that penetrates into the mystery of the object, and to bring to the light of day something that does not disclose itself to the ordinary eye.

In the case of something terrible, such as a sin or a great disaster, its negative irradiation must emerge in full through the analogy, in a manner that is living and intuitively present. All the more must the whole range of positive irradiations unfold in the case of something noble and good. There is one further point: as we have already mentioned, the analogy itself is often the bearer of a definitely poetic quality. Through the analogy the poetic quality of the object to which the analogy refers becomes visible and alive in a special way.

CHAPTER THIRTY-ONE

Composition and Storyline[1]

IN LITERATURE, as in all the arts, composition is, of course, a decisive element. It is no mere means. On the contrary, it a fundamental factor, on which the value of a work of art depends. From the outset, we must draw a distinction between two dimensions of composition; and we prefer here to speak of *compositio*.

The first dimension is the completely general principle[2] that is present wherever a new structure of a distinct kind arises out of different entities through their organic combination. This may be the combination of human beings to form a common body, such as a family, or the combination of words that form a sentence in a meaningful order. The same applies to a melody that comes into existence out of individual notes in a specific sequence and that constitutes a structure of a completely new kind.

The opposite of *compositio* in this sense is inorganic stringing together: the sum total of human beings, as opposed to a community; a number of words that do not make up a sentence; or a sequence of notes that do not form a melody. The ontological rank of the entities that form the

1. [Editors' note: In the present chapter, "storyline" translates "*fabula*." "*Geschichte*," which the author puts in inverted commas, is translated by "story." "Composition" translates "*Komposition*."]
2. On what follows, see *Aesthetics*, vol. 1, chap. 8.

335

new unit, in comparison to the new whole that is formed by them, varies greatly from one realm to another. As a substance, the person is superior to all natural communities, and therefore surpasses them in his or her value too. On the other hand, the melody is a more serious structure, in ontological terms, than the individual note. The same applies by analogy to the sentence in relation to the words.

This ontological dimension of *compositio* has, of course, a fundamental significance in art too. In this sense, however, it is present in every melody, whether it be sublime, beautiful, boring, or trivial. It can be found in one way or another in every musical whole, and it is equally present in every sentence, whether it be stupid or clever, false or true, profound or superficial.

The second dimension of *compositio* is related not to the formal structure of a new unity but to its qualitative character. In communities this dimension of *compositio* depends on the "name" in which all are gathered together, that is, on the realm of goods that unites them, and on the "theme" of the community.[3]

In a composition it is the "how," the kind of melody that determines the value of the new whole; in a sentence this is determined by the specific character of the state-of-affairs that the sentence intends; and in a short story, this is determined by the qualitative composition of the story, the type of construction, and so on. Both dimensions, the formal dimension of the composition and the material, qualitative dimension, have important functions in all the arts. It is above all the latter dimension that is the decisive factor in artistic invention.

In literature what interests us is not the general function of *compositio*, which is already presupposed in language as such. Accordingly, we are not interested in the formal *compositio* of the consonants and vowels in the individual word, or in the formal *compositio* of the words that leads to a sentence. This is presupposed just as much outside literature as within literature; it is presupposed in every essay and letter, in every academic work, and in every conversation.

3. See *Metaphysik der Gemeinschaft*, part 4.

The formal *compositio* in literature is related to the unity of a short story, a novel, a play, or a poem. This factor determines whether the literary work of art exists at all as a real structure, as a pure artistic entity. The qualitative or material *compositio* is even more important. It is the soul of authentic artistic invention. The artistic value of a literary work of art depends on this dimension of *compositio*, which recurs in many strata of the work of art.

In many literary works, in almost all novels and short stories, the storyline too is invented, unless historical events are used. In plays an already existing storyline or an historical event is often employed.

Where the storyline itself is not an invention, the choice of a contemporary or historical event is a first important step of the qualitative *compositio*. A kind of artistic activity already begins with this choice, which has important consequences for the artistic quality of the whole. How significant is the choice of the storyline in *The Merchant of Venice*, in *The Tempest*, in *Othello*, and in the historical dramas *Julius Caesar*, *Antony and Cleopatra*, and *Coriolanus*! It is true that, in comparison with what Shakespeare made of it, the choice of the storyline appears insignificant. But it represents a first important step.

It is not difficult to see that the function of the storyline in literature is completely different from the function of the subject matter in the visual arts. We have already seen that the historic event depicted in a picture, for example, the death of Wallenstein or Constantine's victory at the Milvian Bridge, contributes nothing *qua* historic to the artistic value of the picture. With the exception of sacred pictures, the literary significance of the title under the picture is not an artistically important factor. The only such factors are the visible contents that are determined by the choice of the title: the landscape, persons, human bodies, animal bodies, and so on.

But it is obvious that literature is not about a title. Rather, the storyline belongs inherently to the work. It has its important effect in the work, and it offers the opportunity for the unfolding of many artistic elements.

This applies all the more strongly to invented storylines, to which the

term "themes" can be applied much more appropriately. The course of
the story is linked to the further strata of the artistic invention in such
a way that one can no longer detach its skeleton, as a storyline, from
the work as a whole. What is the storyline of *Don Quixote*? The idea of
the hidalgo who has become mad through reading books about chivalry
and now himself wants to become an itinerant knight does not yet con-
tain anything of the real story, anything of Sancho Panza and the other
characters and all the adventures. This is not a storyline, but an invented
theme that belongs to the overall invention, and in which the mastery of
the author already reveals itself. But the story in its entire course is not a
storyline. Rather, it is in every step a bearer of artistic values.

It is impossible to make any incision between the storyline, the "ma-
terial," that an author like Shakespeare chooses, and the entirely new
thing that he makes out of it, as in *The Merchant of Venice* or in *Othello*.
There are, of course, examples of a storyline, such as the saga of Doctor
Faustus, that comes closer to a theme. But what could we identify as the
storyline in Dostoevsky's novels, such as *Crime and Punishment, The Idiot*,
or *The Brothers Karamazov*? It is, in fact, scarcely possible even to speak
of a theme here.

Let us sum up: In literature, it is possible to make an incision between
a mere storyline and the work as a whole, between the subject matter and
its elaboration, only in certain cases, for example, when a saga, an earlier
story that was invented in some form or other, or an historical event is
employed in a literary work of art. It is in other cases impossible to speak
of a storyline, because it is impossible to make the incision between the
storyline and the work of art as a whole.

This applies to Molière's comedies too. The titles—*L'Avare* ("The Mi-
ser"), *Les précieuses ridicules* ("The Affected Young Ladies"), *Le malade
imaginaire* ("The Hypochondriac")—express the theme. But nothing of
all that happens in these comedies is laid down in advance, even in the
most rudimentary traits. It is, however, also impossible to detach the sto-
ry from the overall artistic form. In Molière, unlike Shakespeare, Soph-
ocles, and Goethe, the progress of the story is relatively unimportant in
comparison with the characters, the situations, the incomparable *ésprit*

and the classical truth, the many allusions, the wonderful comedy, and so on.

The following steps of the *compositio* vary in accordance with the kind of work of art. In a play the typical *compositio* is expressed in the shaping and the sequencing of the scenes, in the construction of an act, and finally in the sequence of the acts that together form the drama as a whole. This *compositio* is similar to the *compositio* in music that determines the construction of the individual movement, the sequence of the movements, and the construction of the work as a whole. We have in mind here not primarily the formal *compositio* but the qualitative *compositio* that largely determines how dramatic a scene is and how an important situation arises through the combination of the characters. This may be a profoundly serious or an extremely comic scene, or a highly poetic scene such as that in *Romeo and Juliet* where Romeo is in the garden and Juliet stands on the balcony.

In a novel, this further step of the formal *compositio* takes effect in the construction of the chapters or parts, in the sequence of the events, in the shorter or longer treatment of individual parts of the story, and in the question whether there is any break in the thread that runs through these parts.

We can see the material *compositio* in a novel in how interesting the presentation of the story is, how the parts inherently fit together, which characters are introduced, whether their encounter is important, profound, beautiful, or comic, and how the situations in nature are put together—whether they are poetic, tedious, or nondescript. There are many other forms of the qualitative *compositio* in the play and the novel.

With the exception of the ballad, a poem is normally not based on a storyline, but situations and events do occur. The qualitative *compositio* is expressed in an important manner in the combination of the words and in the construction of the verses. Many elements, such as sound and rhythm, *epitheta ornantia*, and analogies, move completely into the foreground in the poem. They can scarcely be regarded any longer as subspecies of the *compositio*.

Contrast, on the other hand, is a typical element of the *compositio*.

It too can be used to bring out and illuminate the deeper content of an object. Contrasts are often in themselves special bearers of artistic beauty.

In analogies, we delight above all in the content of the poetic. In contrasts, we are impressed and shaken by the greatness, the depth, and the beauty of the confrontation between two opposite things. One classic example is the contrast in *Macbeth* between the scene in which the murder of King Duncan is carried out and the following scene with the porter: first the whole horror, the dark deep passions of the soul, the struggle between good and evil in Macbeth's personality, the great primal categories of good and evil; and then the fundamentally human external side of life, the humorous realism in the figure and in the speeches of the porter. And both scenes are played out against the background of the cold and stormy night. This contrast has an uncanny greatness and power.

Further important elements of the *compositio*, in addition to what is said directly in the novel and especially in the play, are those things that are only hinted at. In this indirect way an especially adequate representation is sometimes achieved. The greatness of certain characters, and especially of certain mysteries, is more adequately represented when this is done indirectly, since it is only in this way that they unfold their true atmosphere. An author possesses artistic sensitivity when he knows or senses when it is better for him to present a character indirectly, and when directly. How wonderful is the figure of Julius Caesar in Shakespeare! He appears only in the first three acts, and even there, his appearances are relatively few. After his death the full greatness of this figure is expressed much more strongly in the spirit of Brutus, against the background of the entire historical momentousness of the murder of Caesar. At the close of the first part of Goethe's *Faust*, the angel says, "She is saved." These words convey the mystery of heaven, the power and the mercy of God much more adequately than the "Prologue in heaven" in the second part of *Faust*, and indeed more adequately than the poetically beautiful closing scene in heaven.

The narrative rendering of things that have happened earlier on is often much more impressive than their presentation on the stage. We see the artistic sensitivity of an author when he refrains from bringing

onto the stage many elements in the storyline of the play that would be boring. In this way, he avoids weakening the succinctness and the dramatic intensity.

Similar to this is the way in which in some novels the author suddenly moves forward to a much later point in time in the story. This too can be a sign of artistic sensitivity. It is typical of other novels that they do not leap over anything. The continuous progress of what is narrated directly can be a requirement and a bearer of specific artistic values, as, for example, in *Don Quixote* and in *Crime and Punishment*.

Sometimes, when the characters relate events from their past, these are inserted into the *compositio*. This may even happen with narratives that have no connection at all with the storyline, such as the short story about incautious curiosity in *Don Quixote*. All these factors have important consequences for the artistic beauty, for the richness, the intensity, and the poetry of the atmosphere.

The Artistic Transposition of Evil, Repulsive, Tragic, and Comic Figures

As WE HAVE ALREADY emphasized,[1] metaphysical beauty can contribute to the overall beauty of a work of art only when it comes fully into its own through artistic transposition.

Metaphysical ugliness as a bearer of aesthetic values

We now wish to discuss an extremely remarkable fact that actually transcends the nature of pure transposition. In a literary work of art, it is not only morally superior characters and figures full of charm and poetry, with a metaphysical beauty that comes into its own through the corresponding transposition, who possess lofty artistic values. The same is true also of evil, base, ridiculous, and stupid characters. This means that metaphysical ugliness can bear great artistic qualities in a novel or a play.

This is easiest to understand in the case of the metaphysical ugliness of evil, since the contrast between good and evil—between these two primordial categories [*Urkategorien*] that are, so to speak, the axis of the

1. See chap. 15 above.

spiritual universe, and that even reach into the world of the supernatural—is the foundation of all suspense, of all that is dramatic, and also of the tragic. The shocking wickedness of Macbeth is also the bearer [*Mitträger*] of grand artistic values. The metaphysical ugliness of evil does not, of course, cease to be ugly. But whereas it is repulsive and outrageous in the encounter with a real human being, through the transposition and incorporation into this completely new structure of the play, it becomes the bearer of magnificent artistic beauty.

The first reason for this remarkable phenomenon is, of course, that what is involved is the *depiction* of something, not that which is depicted. We have already seen what a new theme depiction as such represents and also all the values of an accurate depiction that is psychologically true to reality.

Besides this, it is especially important that in depiction evil is given in the light of the great antithesis between good and evil. The evil person does not, as such, bear any value. Rather, he or she is placed within the glorious light of truth and within the antithesis of good and evil, which transcends all earthly limits. Depiction involves a singular distance to that which is depicted. There is an abyss between the evil person whom we meet in reality and a figure like Macbeth or Richard III.

One could justifiably object that in reality the evil person stands just as much in the great antithesis of good and evil. This is doubtless true. But in the depiction in a play we have a new object and a new theme. The play is a structure that does not belong to reality but to a realm of a distinct kind. The theme of this new object is completely different from the theme of what is depicted as this occurs in reality. Mephistopheles, or rather Satan, is the embodiment of all that is terrible, ugly, monstrous, and our only response to this can be decisive rejection: we must hate it, abhor it, and turn away from it completely. No less repulsive is Mephistopheles in Goethe's *Faust*, whether in the scene with the merry companions in Auerbach's cellar, or in his wanderings with Martha and his diabolical intrigues against Gretchen, or during Walpurgis Night on the Blocksberg. And yet he is also an important bearer of the overall beauty of *Faust*, Part I.

It is clear that moral wickedness and its metaphysical ugliness have a relationship to the overall value of a work of art radically different from the morally good and its metaphysical beauty. In both cases, the transposition is indispensable. When the artistic transposition is present, the metaphysical beauty of the great moral figures of Starets Zosima in *The Brothers Karamazov* and of Cardinal Federigo Borromeo in Manzoni's *The Betrothed* directly elevates, as such, the overall beauty of the work of art. This metaphysical beauty shines out in the overall beauty as one part of it, whereas the fully depicted metaphysical ugliness of evil contributes only indirectly to the overall beauty. A direct relationship would be impossible, a contradiction in terms. This ugliness could only cloud the beauty of the whole. But an indirect relationship allows the metaphysical ugliness to become a bearer of the artistic value of the overall beauty. It does not, as such, become a part of the overall beauty. Rather, it enters into the work of art in a completely different way.

When a great moral figure truly shines out in his or her metaphysical beauty thanks to the transposition, we are touched and gripped in a way that is analogous to the encounter with a real figure, whether in an historical depiction or in personal contact. But when the metaphysical ugliness of an evil person comes fully into its own through the artistic transposition, our response is completely different from the response we would make if we met him in reality. We are indeed indignant and disgusted at Iago's baseness, but we are deeply moved and enthralled by the play *Othello*. This is possible only because the light of justice shines over the figure of Iago and his baseness, and condemns this wickedness. The theme is the contrast between Iago, on the one hand, and on the other hand the figure of Othello, who is in himself noble and tragic, and of Desdemona, who is faithfully devoted to him.

In other plays, such as *Richard III*, in which no such contrast occurs and no moral antagonist appears, the tragedy of evil and its self-destructive power move into the foreground and are the bearer of a lofty aesthetic value. Richard III perishes, and on his last night on earth the spirits of all those whom he has murdered appear to him. What a tremendous drama! It is, as it were, the echo of the moral order of the

world, the glory of the good in the evil, that shines out in the work of art. And this overwhelming reality of the antithesis between good and evil is truly the bearer of a beauty that shakes us to the core. This is why we say that in literature the relationship between the metaphysical beauty of noble figures and the overall beauty of a work of art is completely different from the relationship between the metaphysical ugliness of evil figures and this overall beauty.

As we have already mentioned, in addition to this depiction of evil in the sublime light of the antithesis between good and evil, the spirit of the author stands between the spectator and what takes place on the stage. This brings about a situation that is completely different from the encounter with an evil or base person in reality.

Besides this, in a figure like Macbeth, and even in a more evil character like Richard III, certain formal values such as courage and strength considerably intensify the wickedness of the person. They allow the antithesis between good and evil to shine out even more strongly, while at the same time, the aesthetic qualities of these formal, technical personal values[2] also contribute to the overall beauty of the work of art, though of course without ever lessening or neutralizing the horror of the metaphysical ugliness of evil. These qualities also constitute a background against which the tragedy of the evil person emerges with particular forcefulness.

This tragedy is, of course, present in reality too, but the primary theme in reality is the dreadfulness of evil, the offense given to God. The horror evoked by evil is the response to the disvalue in itself; in addition, the Christian sees the terrible damage that the evil person inflicts on himself.

This tragedy is particularly thematic in a play or a novel. Since the overall beauty of the work of art is the real theme, the unique aesthetic quality of the tragic makes an important contribution to the overall beauty. This tragedy, of course, refers only to the specifically evil person, not to the malicious evil person such as Iago. The tragic aspect of wickedness plays no role for Iago himself. Othello's tragedy is that he listens to Iago, as Lodovico says:

2. See my *Graven Images*, chap. 5.

O thou Othello, thou wert once so good,
Fall'n in the practice of a damned slave![3]

The antithesis between good and evil emerges in its full extent in the figure of Iago. It also shows the tragedy of this world, in which such poisonous, base persons exist, as well as the danger that they pose to others. We have now said enough about the paradox that metaphysical hideousness, which is the metaphysical antithesis to all beauty, is one factor in the overall beauty of a work of art. Other factors are the great artistic values of the precise rendering of a character, the creation of a living figure, and the masterly sketch of a base person, in addition to the psychological truth in Iago and in many others, such as Rakitin and Smerdyakov.[4]

Repulsive characters as bearers of artistic values

How is it possible that characters in a literary work of art, despite the metaphysical ugliness of their stupidity, banality, triviality, and repulsiveness of all kinds, contribute to the artistic value of the literary work of art?

When we meet them in reality, these people appear repulsive and shocking, or oppressive and boring; the atmosphere they diffuse is anything but attractive and delightful. But as characters in a novel or a play, they are a source of great delight, since their depiction contributes to the artistic value of the work. Once again, the spirit of the author stands between us and them. Through his representation, he brings them into the light of the truth that reveals their true names. He places these characters in a whole that is itself a bearer of artistic values. The work of art demands a completely new attitude and appeals to a new cognitive organ.

We shall attempt to approach this phenomenon by means of concrete examples. We begin by looking at passages in which the depiction of something that is metaphysically ugly not only fails to detract from

3. Act 5, scene 2.
4. Characters in Dostoevsky's novel *Crime and Punishment.*

the "beautiful world" of the work, but actually contributes to its artistic greatness. We prescind here from the metaphysical ugliness of evil, which we have already discussed.

Let us take a figure like Polonius in *Hamlet*. He is the embodiment of the courtier, of the subservience of a morally hollow loyalty, of conventional propriety, and of the smooth personality devoid of substance. He is not stupid. On the contrary, he tells Laertes true and profound things when he gives him rules for his conduct before he departs to study at the University of Paris. But when we meet figures like Polonius in real life, we avoid their presence, because they do not diffuse a delightful and attractive atmosphere, and we cannot trust them. Their character is certainly no bearer of metaphysical beauty—and yet what unique genius there is in the invention of the figure of Polonius! If we were to imagine the play without him, an outstanding artistic factor would be missing in this unique, razor-sharp, sublime work.

The same applies to the less essential figures of Rosencrantz and Guildenstern. They are wretched scoundrels, and in real life we make a detour around smooth courtiers of this kind. But what fantastic artistic genius there is in the depiction of these figures in *Hamlet*! In reality, these types of person are definitely boring and tedious; but in the play, they are delightful. Their wretchedness has a potent artistic value. They belong to the network that surrounds the false king and to the world of untruth behind which lurks the horror of the evil deed against which Hamlet is fighting and against which he revolts. He sees through this evil deed completely, and it causes him great suffering. The whole tragedy of the noble figure of Hamlet shines forth against the background of this world of falsehood.

The theme of the play is his greatness, his beauty, and his deeply moving nobility, from which the tremendous, living, unerring truth of the characters cannot be detached. The depiction of persons who lack metaphysical beauty and who are definitely of negative value makes a substantial contribution to the artistic greatness of the whole, to its "beautiful world," and to its specifically artistic beauty.

In Shakespeare's plays, figures such as Malvolio, Sir Andrew Aguec-

heek, Sir Toby Belch,[5] and Falstaff,[6] who are themselves not strong personalities and who irradiate no metaphysical beauty, do not inflict even the slightest damage on the "beautiful world," on the splendor and nobility of the atmosphere. On the contrary, the elaboration of these figures substantially elevates the artistic values and the poetry of the entire work. Another important factor in such figures in a work of art is the comical.

On the tragic in life and in art

We must now ask: Is the tragic an aesthetic value quality that occurs only in the realm of art, or is there a difference between the tragic in art and in life that is at least analogous to the difference between the comic in art and in life? The answer must be that the tragic occurs not only in art. There is a definite quality of the tragic in events and occurrences in life, a quality that is clearly distinct from the merely sad. But like the comic, the tragic too is a high artistic value in a work of art, for example, in the figures of King Oedipus and King Lear,[7] whereas the tragedy of an event in real life would scarcely be a positive value.

The qualities of the tragic in life and in art are much more similar than the qualities of the comic in these two realms. In tragedy, the discrepancy goes in a different direction from that in comedy.

Like the sad, the tragic is primarily a disvalue. Suffering as such is an evil. The state-of-affairs that someone is suffering is in itself the bearer of a disvalue.

Suffering is often a bearer of great moral values through the way in which someone accepts it. It can also be linked to values if it leads a human being into his depth, and even to God. In that case, the suffering is indirectly, through its consequences, a bearer of lofty values. In itself, however, it remains an evil.

In suffering, a human being is in a weak, humbled situation. This is

5. These three characters appear in the comedy *Twelfth Night*.

6. A character in *Henry IV* and in *The Merry Wives of Windsor*.

7. [Editors' note: See Hildebrand's remarks about Othello, Richard III, and Hamlet in the present chapter, above. The tragic takes a genuine shape in music too: see, for example, chaps. 36, 39, 40, and 41 below.]

why the nobility of the human being as a spiritual person often emerges, independently of the way in which he endures the pains. His ontological value becomes particularly visible against the background of the suffering, and shines forth in a mysterious manner.

Although this is true, it does not in any way alter the fact that suffering, in itself, is an evil for the person concerned and is, as such, the bearer of a disvalue. Sad events, such as human distress, sickness of all kinds, persecution, and death, are in themselves bearers of disvalues.

In reality, the sad is qualitatively different from the tragic. It is certainly sad when a listener who has a great interest in music cannot hear anything of the performance of a symphony because he is deaf. But this is not tragic. On the other hand, it was not only sad, but also tragic, that Beethoven was the only one who could not hear a single note when his ninth symphony was performed.

It was certainly a tragic event when a young French soldier, who had come through the Second World War safe and sound, telephoned his parents when the troops marched into Paris to tell them that he would be with them in an hour's time—and then was shot by an insurgent. The fate of every soldier who falls in war is sad, but not necessarily tragic.

Unlike the sad, the tragic contains a contrast. For example, everything seems to be going well and to indicate a good outcome, but then, at the last moment, a completely unexpected factor brings disaster. As in the case of Beethoven, the contrast can also be the fact that while everyone heard his great masterpiece, he, its creator, was the only one who did not hear it. Other contrasts are possible, such as the moral failure of a basically noble person, or the fact that precisely the positive qualities of a person contribute to his fall.

Various qualities of the comic

Comedy constitutes a definitely aesthetic value in literature, opera, and music drama. Here the problem that we find in real life, namely, whether the comic is a genuine value,[8] no longer exists.

8. See *Aesthetics*, vol. 1, chap. 19.

It suffices to recall the figure of Sancho Panza in Cervantes' *Don Quixote*. Thanks to his comic ways, this figure bears a lofty artistic value both as a whole and in innumerable speeches that he delivers, as well as in scenes such as that in the tavern with Maritornes. Don Quixote's behavior too is often full of this great artistic comedy, which constitutes a genuine aesthetic value, a specifically artistic value. In this comedy, we encounter something that is important in itself, something brilliant, but also a beautiful poetic world.

We meet an extraordinarily rich spectrum of the comic in literature, not only in the sense that some things are more comic and others less comic, but above all in the sense of great qualitative differences with regard to its depth. The spectrum of the comic in characters goes from an inessential to a highly important comedy, and from a comedy that is not very lovable to one that is extremely lovable.

There are brilliantly constructed farces that amuse us immensely, so that we never stop laughing. But it is obvious that the comedy in a play by Molière is incomparably more profound and artistically more valuable. The comedy of Sancho in Cervantes' *Don Quixote* is profound, deeply human, and lovable. A great deal shines forth in this comedy, and deep insights into human nature are given.

The kind of comedy in each instance is closely linked to the overall artistic level of the literary work of art. Only some kinds of comedy fail to disturb the lofty atmosphere of the overall work of art. And only some qualities of the comic actually contribute to the poetry and beauty of the whole. A great artist is needed in order to produce the higher kind of comedy. The quality of the comic is, of course, also determined in its rank and in its value by the kind of transposition and depiction. The significance of the comic in the depiction of figures who are in themselves bearers of metaphysical disvalues, and who become bearers of artistic values in the work of art, is closely connected to the quality of the comedy.

Let me first point out once again that the aesthetic qualities of the comic in a literary work of art are fundamentally different from the qualities of the comic in real life. If the stupid, shallow, trivial person whom we meet in real life is for some reason also comic, the oppressive, re-

pulsive aesthetic quality, that is to say, the metaphysical quality of the
stupidity, shallowness, and triviality, is essentially changed. It is as if the
comic element of his pretentiousness and stupidity, and the manner of
expression and of behavior that makes us laugh, put brackets around the
negative aesthetic qualities and prevent the sense of oppression from
arising. Comedy has a kind of redeeming function in earthly terms. Its
liberating effect covers over the obtrusiveness of many disvalues. As soon
as we see the comic element of a situation, we become, as it were, on-
lookers. We suddenly stand above the situation in a subjective sense.

It is only by chance, however, that the comic in life adheres to such
unfortunate figures. Their comic quality has nothing to do with their
tastelessness and shallowness. Only a certain kind of naïve stupidity is
in itself primarily comic. Examples are the stupidity of Catherine in the
fairytale "Frederick and Catherine" by the Brothers Grimm, or the stu-
pidity of Inspector Bräsig, who called out in his speech to the assem-
bly, "The great *Armut* [poverty] in the city is due to the great *Poverteh*
[poverty] here!" and had great success thereby.[9] This non-aggressive,
naïve stupidity is not in any way oppressive, and has nothing aesthetical-
ly negative in the sense of an awkward atmosphere. It is primarily and
essentially comic.

In a literary work of art the depiction of arrogant stupidity, of shal-
lowness and triviality without any accompanying fortuitous comic qual-
ities, is often comic. Through representation and the new theme that
comes from the work of art, the comic can draw the poison from these
negative qualities.

The representation of metaphysically ugly figures
and the overall atmosphere of a work

We shall see these essential factors more clearly once we have further
developed the analysis, begun above, of the relationships between the de-
piction of such figures, which in themselves are not bearers of metaphys-

9. See Fritz Reuter, *Ut mine stromtid* (written in a German dialect, 1862–1864), chap. 38.

ical beauty, and the overall atmosphere of a work. We have spoken of the highest literary works of art, the tragedies and comedies of Shakespeare. In each of their scenes there reigns such a consummate transposition and depiction that everything contributes to the supreme poetry, greatness, and beauty of the work as a whole.

While other works of art do not display this ultimate poetry, depth, and overwhelming beauty, they do display the excellent depiction of wretched figures who are in themselves oppressive. In Kleist's *The Broken Jug*, the character of the judge is both the type of a morally lazy person and the type of a stupid, repugnant, and ridiculous person. In real life, we would find his presence oppressive and repulsive, but here he is a brilliantly depicted figure, and there can be no doubt that the work as a whole possesses a high artistic value. The wonderful *compositio*, the continually growing dramatic intensification that leads to the complete exposure and the collapse of the judge, is masterful.

This comedy does not irradiate the glorious world and the high poetry of one of Shakespeare's comedies. It remains in a different stratum, and it does not claim to possess that poetry. It would be unjust to compare the two. Nevertheless, the new theme that comes with a work of art is present in Kleist's work too. The depiction of metaphysical ugliness, its integration into the whole, makes the aesthetically negative figure of the judge a bearer of artistic values. Although the whole work is not truly poetic, it would be completely false to assume that this wretched personality does not make a definite contribution to the artistic value of the play as a whole through the way in which he is depicted and integrated into the play.

We find a completely different kind of comedy in Molière. Trissotin in *Les femmes savantes* ("The Learned Ladies") is a disagreeable and oppressive person. If we met him in real life, we would avoid him, because he diffuses a barren, disagreeable atmosphere. Trissotin and Vadius are boring aesthetes, mere windbags. But in *Les femmes savantes*, they are a source of artistic delight. The depiction of their hollow, pretentious conceit makes a decisive contribution to the overall value of the play. They occupy center stage. Rational, normal persons like Chrysale are

secondary figures. Trissotin is the chief attraction in the play as a whole.

This comedy involves not only a magnificent depiction that hits the mark but also a brilliant invention, a satire of the zeitgeist. Besides this, the comedy has a delightful atmosphere. Nevertheless, it lacks the high, unique poetry of Shakespearean comedy, in which figures of unparalleled charm and nobility always occupy center stage, such as Rosalind, Viola, and Portia. It is also something completely different from *The Broken Jug*. The latter play too has nothing of the poetry and the "beautiful world" of Shakespearean comedy, but it has an artistic transposition that is so perfect that it is a genuine work of art with a poetry of a special kind.

In Shakespeare's comedies and *The Broken Jug*, the storyline of the work plays a great role, but in Molière, it is the invention of the figures, the diction, and indeed the individual words, combined with the poetic "cultural world of the time [*Zeitwelt*]," that occupy the foreground. The overall artistic framework that encloses everything is a mysterious element. It is filled by a "noble world" that also manifests itself in the depth of the individual ways of speaking and of the comedy.

In distinction to these works, Brecht's *Threepenny Opera* is indeed brilliantly constructed, and it is a trenchant depiction of a sad, sordid piece of reality; but it lacks all poetry, artistic nobility, and also all comedy. This type of literature has nothing more to offer than brilliant depiction. There is still, of course, a different situation here than in the encounter with such a milieu in real life, but when we read the play or see it on the stage, it breathes out upon us all the depressing triviality of this milieu. This milieu is depicted in such a way that the triviality of what is presented may perhaps affect us more strongly than it would affect us in real life, although we take delight in the way Brecht hits the mark with his brilliant depiction.

Although this work is an opera, the text stands in the foreground, while Kurt Weill's music is brilliantly accommodated to the text.

Forms of depiction of the bourgeois, the trivial, and the mediocre

Ibsen's social dramas represent a new type. The figure of Hjalmar in *The Wild Duck* is depicted in his insubstantiality and hollowness in a masterly fashion, but, as in every one of Ibsen's social dramas, the artistic transposition is explicitly avoided in order to make the play more effective as propaganda for particular ideas. The play is meant to affect us as though we were experiencing everything in reality. Ibsen was certainly capable of artistic transposition, as he showed in his historical drama *The Pretenders*. But although the social dramas are characterized by a masterly depiction of reality, the triviality of the figures and the disagreeableness of the milieu do not at all contribute to any overall beauty of the works. They are at the exclusive service of the naturalistic effect of a tendency of a thesis. Ibsen wants to reform society through these plays. From the artistic point of view, all that remains are the aesthetic values of apt depiction, especially as regards psychology, and the brilliant and taut shaping of the plays. But there is nothing in them that is not indispensable for the unfolding of the play and the depiction of the characters; there is no poetry, no superabundant plenitude, no penetration into the great drama of human life, no "beautiful world"—only the intensive effect of barrenness being diffused, an effect that is produced by presenting a peripheral stratum of the universe, of society, of human mediocrity, and of the local milieu.

As we have said, we are interested here in the various relationships between the metaphysical ugliness of that which is depicted and the overall beauty of a work of art. Our question is: Is the same metaphysical ugliness depicted in the individual types of plays, or is there some variety in the aesthetic quality of that which is depicted? Do the artistic quality and the function of metaphysical ugliness for the overall artistic quality of the work help to determine the tremendous differences in the aesthetic value in the plays we have mentioned, or are these differences already due to the choice made by the one who depicts the metaphysical ugliness?

It is clear that the spirit of the author, which stands between that

which is depicted and the work as a whole, has a decisive influence. An
unbridgeable gulf yawns between Shakespeare and Brecht. In the case
of Brecht, one cannot avoid recalling what Barbey d'Aurevilly said about
Zola:[10] "Emile Zola ... this besmirched Hercules who wallowed in the
Augean stables, and even added a bit of muck to them."

Besides this, a comparison between Shakespeare and Ibsen clearly
demonstrates the weighty difference between the presence of an artistic
transposition and its absence, since Ibsen deliberately ignores the artistic
transposition in his society dramas.

In order to clarify the theme that specifically concerns us here, name-
ly, the paradox that the metaphysical ugliness of the shallow, the dull, the
base, the trivial, the perverted, the stupid, and the boring can make an
important contribution in a literary work of art to the artistic beauty of
the work as a whole, we must distinguish various categories of literary
works.

First of all, there are very accomplished depictions of stupid bour-
geois persons, of small and petty figures, where the author certainly is
not attempting to give something that is artistically beautiful and poetic.
These depictions aim from the outset in a completely different direc-
tion, namely, our amusement. Examples are the comedies of Labiche and
many farces. The most original works in this category are many of those
by Wilhelm Busch. We exclude here his unfortunate, blasphemous, and
repulsively tendentious works, namely, *Der heilige Antonius von Padua*
and *Pater Filucius*; we are thinking of the *Knopp* trilogy.[11] Knopp is
certainly the embodiment of the stupid, shallow petit bourgeois, but this
trilogy is a little masterpiece, thanks to the apt depiction of this figure,
his adventures, and the characters he meets, the diction that brims over
with classical wit, and all the aphorisms that have a meaning that goes
far beyond the momentary theme. And all this is accompanied by illus-
trations full of delightful humor. It can certainly not be called "beautiful,"
since it does not possess poetry of any kind, or anything that is irradiated

10. In *Le Roman contemporain*, cited by P. Dupré, *Encyclopédie des Citations* (Paris: Édition de Trévise, 1959), 111.
11. See also chap. 23 above.

by a genuine literary work of art. Its verses and rhymes have nothing in common with those of a poem or epic. Nevertheless, this trilogy is not only highly accomplished in the depiction of a type, and not only an excellent satire, but is also a work in which one particular kind of comedy is thematic, instead of beauty. The world of these verses is not negative, antipoetic, or trivial. What we have here is not a naturalistic depiction of trivial persons and milieus but a transposition of an artistic kind in which the comedy and the humor are thematic. Nevertheless, there is no poetry or beauty here. One is not in any way lifted up above the wretchedness of the petit bourgeois narrowness. Through the humor, however, this narrowness loses its aggressive character.

A second, completely different type of literary work is the admirably successful naturalistic depiction of depressing persons, base milieus, and so on. Despite all the potency in the depiction and despite the formal perfection, they lack the true artistic transposition. A whole world separates them from great, genuine works of art because they lack all poetry, the "beautiful world," greatness, depth, power, and comedy. Indeed, as far as real artistic beauty is concerned, they are far inferior to much less brilliant depictions of specific figures or to works in which this dimension is not even aimed at.

The entire metaphysical ugliness of that which is depicted is wafted toward us and oppresses us. All that remains is admiration for the achievement, which consists (apart from possible formal values of the style and of the enthralling quality of the story) in the success of the depiction. The works of Wilhelm Busch represent an essentially modest type of genuine originality and of a partly waspish and partly gentle humor, but these naturalistic works make a much higher claim. They are an artistic aberration. The metaphysical ugliness of the matter takes effect in them without any check.

A third type is the intentionally depoeticized and non-transposed but masterly depiction of reality, as in Ibsen's social dramas. These works have the same atmosphere as the sector of reality that they depict.

Finally, the fourth type is the depiction in which an artistic transposition occurs in novels that are true and potent works of art. Examples are

the works of Balzac, such as *Le père Goriot*. The figure of Père Goriot is a brilliant invention. In this novel, the problem of the metaphysical ugliness of evil does not occur at all. The boarding house, all the types of people at the lunch table, the narrow, petit bourgeois world of the landlady and the conversations that take place, diffuse a certain quality of everyday life and of mediocrity that is "on the ground floor" in metaphysical terms, a quality that is depicted in such a masterly fashion that a definite artistic value comes into being. Doubtless, this is not a "beautiful world" as in Mazoni's *The Betrothed*, or even in *Don Quixote*, nor is it a poetry as in Prévost's *Manon Lescaut* or (in a completely different kind) in Eichendorff's *From the Life of a Good-for-Nothing*. But there is a tremendous potency here, a force that brims over with ideas, and a definitely artistic charm.

In this novel by Balzac, for the first time, something that is certainly not beautiful becomes the bearer of a specifically artistic value through the artistic transposition. This milieu is not only presented aptly and brilliantly, through the noble transposition it has become the bearer of a genuinely artistic value, always in the framework of the work as a whole. Doubtless, such a work is not the bearer of a genuine poetry. It is not elevated, nor is it filled by the great, ultimate world of artistic beauty; but it possesses genuine artistic values.

A fifth type is constituted by the novels of Dostoevsky,[12] such as *The Idiot*. Its characters, Totsky, General Yepanchin, Ganya, Lebedev, Hippolite, and his friends, are all to some extent mediocre, hysterical, wretched, and spurious. Nevertheless, not only is the depiction of all this masterly and unparalleled in its psychological truth, but it also gives us an artistic analogy to the breakthrough of the love of neighbor. The author succeeds in displaying everything, even the hysteria, the spuriousness, the bourgeois mediocrity, and the lazy liberal propriety, in the light of

12. Dostoevsky's version of transposition is set out in *The Idiot*, chap. 39: "What are the novelists to do with commonplace people, and how are they to be presented to the reader in such a form as to be in the least degree interesting? They cannot be left out altogether, for commonplace people meet one at every turn of life, and to leave them out would be to destroy the whole reality and probability of the story. To fill a novel with typical characters only, or with merely strange and uncommon people, would render the book unreal and improbable, and would very likely destroy the interest. In my opinion, the duty of the novelist is to seek out points of interest and instruction even in the characters of commonplace people."

the great drama that is the "human being." Just as the love of neighbor penetrates through every kind of wretchedness that a human being has made of himself, to the *imago Dei*, the image of God that every human being is, to the beauty and greatness of a being who is called by God and destined for eternal fellowship with Him and who must give an account of himself to God, so in this novel the author brings everything into a sublime light. When one looks on one's neighbor with love, one can see the greatness, the beauty, and the loveable quality of even the most disgusting human being. This love penetrates into a sphere in which there is no boredom, triviality, spuriousness, pettiness, or shallowness, into that sphere in which the drama of the human being is played out before God, into the absolute reality and greatness of the world of God in which God calls out: "Adam, where are you?" In a distant analogy to this, an artist like Dostoevsky succeeds in placing all pettiness and metaphysical ugliness in the sublime light of this drama of the human being. This, of course, also requires great figures of a deep metaphysical beauty, figures such as the personality of the Idiot in this novel and of Zosima and Alyosha in *The Brothers Karamazov*. Dostoevsky's characters have a kind of transposition in which, despite the utterly lively depiction, all that is metaphysically ugly is incapable of diminishing the poetry and the profound and moving beauty of the work. Indeed, this transposition intensifies the richness, the breadth, and the greatness of the work of art.

We have already referred to a sixth type of literary works of art. The most important author of such works is Molière, who succeeds in integrating foolish, narrow, and affected characters into the primal situation of the human person, into the *comédie humaine*. He does this both through the magic of the whole stage into which these characters are inserted and also through his unique comedy. Unlike the comedy of farce and of Wilhelm Busch, this is a poetic comedy that contains a liberating, kindly touch. In a quite different sense from that intended by Balzac (for example, in his cycle of novels entitled *Comédie humaine*), Molière succeeds in making the metaphysical ugliness of narrowness, stupidity, vanity, hypochondria, and avarice contribute to a genuine beauty, to an enchanting atmosphere of the work as a whole. But *les précieuses ridicules, les*

femmes savantes, le bourgeois gentilhomme, Monsieur de Pourceaugnac, and *le malade imaginaire* are not trivial figures.[13] They are also far removed from a Lebedev and a Hippolite. Above all, their matchless depiction, although it is so lively, is in one sense stylized. Molière never draws us into an oppressive milieu, and we never find any kind of naturalism in his plays. Humor, wisdom, and the classical good health of the author unfold before our eyes. All the characters stand in this world before our eyes, lit up by this spirit.

Finally, we come to the literature in which that which is depicted does not, in itself, possess any oppressive, restrictive character. In this literature, the fullness of life, the tremendous struggle between good and evil, the whole poetry of life and of nature, and the classic comedy are depicted, together with the invention of enchanting characters with whom one could fall in love. It is the king of the stage, Shakespeare, who depicts this world.

Alongside him stands the king of the novel, Cervantes. Every page of his *Don Quixote* pours forth sublime poetry, in addition to all the fullness of life and the brilliant invention, and in addition to the profound, classic comedy that is without parallel elsewhere in literature. In the two figures of Don Quixote and Sancho, who are so different and each in his own way so lovable, the whole of humanity is given, so to speak, not in the conflict between good and evil, but in its spirit and the structure of its temperament.

We could mention other works that cannot be compared to these in the power of their invention, their potency, and their artistic greatness. Nevertheless, they belong to this category, since the choice of their matter means from the outset that the problem does not arise of how the living depiction of the boring, mediocre, and shallow characters and milieus, despite their metaphysical ugliness, not only fails to limit the artistic value in the work of art as a whole, but actually contributes to its value.

We can conclude by saying that in literature, the beauty of that which

13. [The figures in italics allude to titles of Molière's plays: *The Affected Young Ladies, The Learned Ladies, The Bourgeois Gentleman, Monsieur de Pourceaugnac,* and *The Hypochondriac.*]

is depicted never has a direct influence on the beauty of the work of art. It can make an outstanding contribution to the beauty of the work of art only if the full artistic transposition is present. The metaphysical ugliness of that which is depicted destroys the true artistic beauty as soon as a naturalistic depiction takes the place of the artistic transposition, no matter how brilliant the depiction, as such, may be.

The apt depiction in literature has an aesthetic value that presupposes a great talent. This value is, in fact, the manifestation of one particular talent, and it constitutes an achievement that we cannot fail to admire. But this value is completely different from the true, full, artistic value, from the greatness, the depth, the inner truth, the beauty and poetry—from the real meaning, the real theme of literature as art. We encounter this true artistic value in Homer, in the Greek tragedies, in Virgil, Dante, Shakespeare, Cervantes, Corneille, Molière, Racine, Goethe, Dostoevsky, Tolstoy, Stifter, Claudel, Bernanos, and many others.

This problem does not occur in the literary genre that no longer possesses the explicit character of imitative art, namely, in poetry.

Music

CHAPTER THIRTY-THREE

The Basic Elements of Music

MUSIC IS NOT AN imitative art. The element of the representation [*Darstellung*] of nature and of life is not found *per se* in music. We say "*per se*," for three reasons: first, because there is a type of representation in music too, although it is totally different from representation in the visual arts; secondly, because music sometimes even represents natural phenomena; and thirdly, because in union with the word in a song, and all the more so in an opera, music, like literature, has an important share in the representation of life.

To speak of a completely different kind of representation in music is to refer to the expressive dimension of joy, sadness, abundant life, the sacred world of recollection, and of much else that is found in all music. It also includes the representation of natural phenomena such as a storm, the rushing sound of a brook, and the chirping of birds. The third dimension of the representation, namely, the union of sound and word, needs no explanation. The relationship between music and the imitative, then, is far more extensive than, say, in architecture, which is itself reality and not imitation.

Music is characterized by the fact that it has a particularly direct

relationship to the world of the senses, while at the same time being the most spiritual of all the arts.

In painting, there are various steps between the visual impression on the senses and the apprehension of the artistic content. Already the perception of landscapes, figures, and so on in nature goes far beyond mere sense impressions. Then there is still the actual intellectual [*geistige*] process of understanding the artistic representation.

In music, on the other hand, the path from what is heard, in the strict sense of the word, to the artistic content is much more direct. Once again, many steps of intellectual apprehending are presupposed, from hearing the notes to apprehending the melody, and from apprehending the melody and harmony to understanding a complete musical entity, such as a movement, a quartet, or a symphony. But this progression moves in a different direction from that in painting and remains much closer to the sense impression.

Of course, regardless of the artform, the apprehending of artistic content and the beauty of a given work is a purely spiritual act of a special kind. It presupposes a specific capacity [*Organ*], and it is certainly not the case that everyone who apprehends the work of art, and even knows it well, will possess this capacity. Here it suffices to point to the paradox that music is in a certain sense the most sense-bound and at the same time the most spiritual art. The mystery of beauty of the second power is manifested in music in a particularly striking manner.[1]

We begin by analyzing the means through which the artistic content in music is given, and the material out of which the work of art is constructed.

The musical note [Ton] and sound [Klang]

There are an extraordinary variety of data in the world of the audible. We have already seen that vowels and consonants, and the words formed from them, are unique structures [*eigenartige Gebilde*]. We prescinded initially from the soul of the word, that is to say, its meaning, and distin-

1. [Editors' note: See Hildebrand's *Aesthetics*, vol. 1, chaps. 6, 9, and 10.]

guished between noises [*Geräusche*], such as the pattering of rain against the window or the crack of a gun, and the articulated and more formed structures of vowels and consonants, and even more from their composition in words. We are able to recognize that words are being spoken even when they belong to a language that we do not know. They are clearly different from a cry or a whistle.

Let us now turn to the audible structures in music, namely, the note [*Ton*] and the sound [*Klang*]. In a note, there is an articulate and formed quality that is different from what we find in vowels, consonants, and words. The note is a world of its own, clear, precise, and unambiguously different from a mere sound. There are a specific number of notes: seven, or rather, twelve. The same notes recur in the octaves, whether higher or lower. It is not by chance that music is often brought into connection with mathematics. The logic in the world of notes bears a relation to the logic of mathematics.

The most astonishing thing is the new dimension of the musical notes in relation to mere noises. When we speak of a new dimension, we refer to the spiritual quality and the nobility of the pure note. This nobility is expressed especially in the fact that a melody can be constructed only out of notes.

Another primordial quality [*Urqualität*] of music, namely, the sound [*Klang*], is always linked to the note. Sound also occurs independently of the note, as in the sound of a hissing snake or babbling brook, although it is obvious that no note is present.

Sound has a new quality in relation to the note. Even when both appear in combination, they remain clearly distinct from each other. There are obviously many more different sounds than notes. Musical sound has something much purer and more formed than the unmusical sound. The sound of the violin, flute, oboe, horn, trombone, or the human voice is purer than the sound of the drum and the cymbal.

We are, of course, interested only in musical sound in its combination with the note.[2]

2. Max Frischeisen-Köhler mentions three different qualities of the note: its height, its sound [*Klang*], and its vowel quality [*Vokalqualität*]. This is itself a valuable insight. It is doubtless correct to

One important difference between sound and the note is that while sounds can be bearers of beauty, the note, as such, is neither beautiful nor ugly.[3] The sounds of all the instruments are beautiful. They are not all equally beautiful, but each has its own charm. There are also downright ugly sounds. None of this can be predicated of notes. The note C is not beautiful; still less is it ugly. It is meaningless to say that the note G is more beautiful than C. It is indeed true that unlike noises of every kind, the note has a nobility and a spiritual quality of great beauty in its clarity and musicality. But this is an ontological value. Unlike a mere din or noise, all of the notes possess this value quality, but no one note possesses it more than another. All the notes in the scale have this dignity.

Melody, harmony, rhythm

Notes possess an eminent potential aesthetic quality, being capable in a particular sequence of building up a completely new structure: the melody. This is an outstanding bearer of qualitative aesthetic values. It can

say that these three different qualities exist. None of them can be shown to be reduced to the others; they are primordial phenomena in the broader sense of the term. But the question arises whether every note, which is necessarily linked to a sound, always possesses a vowel quality as well. This may be true of human song, but the sound of a piano does not present a vowel quality. It has neither the quality of the vowel "a" nor that of any other vowel. And this means that the vowel qualities in no way have the same fundamental importance for music as the note and sound, even though it is indeed correct to say that the vowel qualities are a structure *sui generis* in the realm of the audible, with their own irreducible qualities of the audible. They do not belong to the material or the means of music, nor to the primordial elements in the realm of the means of music. It is above all in speech that they play a role, while in music they play a role only when they are linked to the word.

The quality of the vowels is not, in itself, a bearer of aesthetic values, nor does the composition of pure vowels produce a new structure that can be a bearer of aesthetic values. The vowel, as such, does not belong to the means or the material of music. This distinguishes it sharply from the note.

One could object: let us grant that this vowel quality plays no role in music, but are not the individual vowels, in their differences [*Verschiedenheit*], something expressive? Is not their variety an enrichment? And does not this mean that they can bear a value, even if it is not the value of a musical beauty? Does not the spoken "a" in a poem have a special function that is different from the function of the "i" or the "o"? Does it not express something, and does it not also have an aesthetic importance, thanks to this expression?

However one answers this question, it does not change what we have just said. Vowels are not bearers of a value in music, nor does their combination constitute any kind of new musical structure. There are no vowels in a quartet, and a composition of vowels is not capable of building up a meaningful musical structure like a melody, still less, a structure that would be a bearer of beauty.

3. See *Aesthetics*, vol. 1, chap. 8, 196.

be beautiful or ugly, noble and sublime, or trivial and base. It can be convincing, marked by an inner necessity, or boring, impotent, and artificial. None of this can be predicated of a single note, or of a sequence of notes that is not a melody. It is not possible to build up a new structure out of noises, not even out of musical sounds. It is indeed true that, quite apart from the melody, the collaboration and sounding together of the instruments in an orchestra is a full bearer of possible beauty; but this "symphony" is a unity of a completely different kind from the melody. It is not a new unity. It is not what Spranger would call a "form quality" [*Gestaltqualität*]. It is a not an individual unity, like one melody that is clearly distinct from other melodies. Compared with the beauty of the sound of a single instrument, there is doubtless a great heightening of the pure beauty of the harmony when various instruments sound together, but this harmony does not create any new kind of bearers of beauty.

The various musical structures, such as the quartet, the symphony, the violin or cello sonata, the piano or violin concerto, differ as types through the combination of instruments, both in terms of their number and their kinds. The principal beauty in the glorious orchestration of a symphony is closely linked to its melodies and themes, for example, the choice of instrument to which a leading theme is entrusted, and how this theme appears in various instruments.

This must be emphasized in order to highlight the completely unique character of melody. It is a primordial example of the power of composition, which constitutes a primary factor in all the arts.

Another central element of music is the chord. A melody presupposes a sequence of notes, but the new unity of the chord is a simultaneous combination of particular notes. A single chord can, in itself, be a bearer of beauty, even if this is not comparable to the beauty of a melody.

Harmony too is a primordial type. Just as melody is the primordial example of composition, of the surprising birth of a completely new kind of structure through a particular arrangement of the sequence of notes, so harmony is a primordial example of fitting together, of the happy complement.

It is not by chance that the word "harmony" is employed in an analo-

gous sense for all spheres of being. It is the friendly agreement, *concordia* as opposed to *discordia*, but it is also the qualitative mutual complementing and fitting together, as opposed to a failure to fit together. The term "disharmony" is applied both to *discordia* and to that which conflicts, that is to say, a qualitative failure to fit together, which is expressed in French by *cela jure* and in English by "it clashes."

The aspect of musical collaboration, mutual complementing, and mutual enrichment is manifested in harmony and is a wonderful phenomenon. But harmony unfolds its full significance only in collaboration with melody.

The antithesis of harmony lies not only in dissonance, which in fact can sometimes be particularly beautiful, but in a cheap harmony that is wrong for a melody, its atmosphere, and its nobility. The inner relation between a melody and harmony is interesting. A noble melody is robbed of its nobility through a mismatched harmony, but the beauty of a melody can be further heightened through the right harmony. Sometimes a purely harmonic modulation is the bearer of exalted beauty and a significant musical idea. A harmony can engender a very particular atmosphere.

A completely different and highly important element in music is rhythm. We encounter it in an analogous manner in various fields. We speak of "rhythm" not only in a poem, which has a rhythm with a character relatively similar to that in music, but also, in an analogous sense, in life, for example, in the development of a human relationship or in the sphere of movement, such as in certain dances. Music, on the other hand, is the native land of rhythm, which in a certain sense is the life that animates a piece of music. It is a specifically vital element, though sometimes it possesses a lofty spiritual quality.

Can rhythm, as such, be a bearer of beauty? It is possible to indicate a rhythm simply by knocking on a table. Is there a noble and a base rhythm? Surely rhythm as such is already a bearer of aesthetic qualities. We have only to consider how it expresses a particular sense of life. In the popular music of a country, we often find a typical rhythm that is characteristic of the national individuality, such as the rhythm that is so characteristic of Spanish folk music and so completely different from the

rhythm of Viennese folk music. This rhythm is usually linked to dance. But it is only in collaboration with melody and, above all, in piece of music as a whole that it unfolds its full, deep significance.

Naturally, the role of composition emerges in an entirely new way in a movement of a sonata, a quartet, or a symphony—in comparison with a melody or a theme with its harmonies and its rhythm. The construction of the movement or the piece of music is one element of the beauty in music. The step from the invention of a melody or a theme to the piece of music, even if it is only one movement of a larger work, contains an invention all its own and represents a composition of a new kind. This differs from the composition of the melody not only because the step from note to melody creates a new type of unity, and it is only with this unity that the possibility of being the bearer of aesthetic values begins, but also because the step from melody or theme to the movement goes in a completely different direction from that of note to melody.

The musical whole [Ganzheit]

A melody itself can already be the bearer of beauty of the second power. But a musical work of art demands a new structure of an articulated kind, a construction, a new whole that includes not only the melody, harmony, and rhythm, but much else besides.

This whole can be of very various kinds, such as a march or a dance like a sarabande, gigue, gavotte, musette, or a larger whole that is made up of various small wholes, such as a piece of organ music that consists of a prelude and fugue, or a sonata, quartet, or symphony that encompasses several movements.

The relationship between a melody or theme to the piece of music to which it belongs is different from the relationship between the notes and the melody or theme, and also from the relationship between the individual movements and the larger unity of a sonata, suite, symphony, and so forth.

We have already pointed out the radically different relationship between the part to the whole in a melody, on the one hand, and that

between the melody or melodies, harmonies, and rhythm to the entire piece of music, on the other. The important thing now is, first of all, to see which other elements also belong to the construction of a piece of music, in addition to melody, harmony, and rhythm; and secondly, to work out the different relationship between the parts and the whole in a piece of music that has only one movement, and between the movements and the whole of a larger piece of music.

In every piece of music, and thus in the movement of a symphony too, we find not only melodies or themes, harmonies and rhythm, but also their treatment and modulation, the intertwining of various parts, the further development, the construction that possesses a very specific logic, and the counterpoint. The construction of this new totality, this musical structure, is complete in itself; it cannot be arbitrarily lengthened or shortened.

Tempo, staccato and legato, volume, crescendo and diminuendo, height and depth of the notes, major and minor

Other diverse means too are employed in a musical work of art. We are thinking here first of means of expression, not yet of the elements that go into constructing a piece of music.

A first essential means in a piece of music is the tempo. It is obviously very important whether a piece is played allegro, adagio, cantabile, or presto. There is a profound inner connection between the tempo and the melody or theme. A melody or a theme requires a specific tempo, which belongs essentially to its specific character. If one plays the theme that opens the fifth symphony of Beethoven largo rather than an allegro con brio, it becomes something completely different and its specific character is destroyed. If someone were to sing Handel's "Largo" as a presto, it would disfigure this unique melody. The whole wealth of musical means shines forth when we think of the various tempi: largo, adagio, cantabile, andante, allegro, presto, and prestissimo. How great the expressive possibilities in each; and how deeply the tempo belongs to the melody. A change of tempo in one and the same theme or melody can also be a bearer of special beauty.

Two other very important means are staccato and legato. Once again, there is a profound relationship to the melody or theme. When a legato melody is played staccato, its special content is destroyed. If one were to play Bach's "Air" staccato, it would be intolerable, indeed a desecration. The same is true, for example, if the fifth movement of Beethoven's Quartet Opus 131 is played legato rather than staccato.

Legato expresses in a special way a contemplative attitude, a musical line that unfolds in broad and solemn strides. Melodies and themes that have and ought to have this character require legato. Staccato, on the other hand, has something clear-cut. In one passage, it has something of the character of a solemn event, in another passage, something vivacious, and in yet another passage, something playful or even humorous. Staccato and legato have a tremendous wealth of expression—naturally, in connection with the melody. So much can be made present through them.

A further musical means is volume: forte and piano, fortissimo and pianissimo. They too are important bearers of artistic beauty. But unlike tempo, legato, and staccato, volume is not linked to the particular kind of melody or theme. Provided we are only considering a melody or theme, there is no definite inner link to a certain volume. It is, indeed, normal that one and the same theme in a piece of music occurs forte in one passage and piano in another. Piano and forte are determined by the inner structure of the entire piece of music. Volume reveals its significance in the framework of a piece of music, not in an isolated melody; it belongs to the construction of a musical totality.

Bound up with volume are crescendo and diminuendo, which number among the primordial phenomena. There are also many analogies to the crescendo. We can speak of a crescendo in literary works, both in a play and a novel. We have only to think of a scene like in *The Idiot*: the soirée for Nastasya Filipovna, who had promised to tell Ganya that evening whether she would marry him. Such an immense crescendo, such a growing intensification, such hastening to a dramatic high point!

In nature, we find this dramatic element of the crescendo in a tempest and a storm. In life too crescendo in an analogous sense is an important element, for example, in the inception and growth of a love relation. Above

all, we find the crescendo in an analogous sense in history, for example, in the development of a cultural epoch. There is a crescendo, though in a much narrower sense, in the dramatic and incredible rise of Napoleon to his zenith, and even more so in the Revolution of 1789 through the 9th of the month Thermidor, when Robespierre was overthrown. The spread of a plague has a crescendo, until a diminuendo sets in, as Manzoni describes in his masterpiece, *The Betrothed*. Many events take the course of a crescendo and a diminuendo in the broadest sense of the term.

There is a crescendo in pain. There is a crescendo in the biological growth of the human being until an apex is reached, and then a diminuendo in the biological decline. This crescendo, however, does not have the dramatic character of crescendo in the narrower sense, which manifests itself in music.

Other important musical means are height and depth. Qualitative height and depth are extremely important phenomena. The high note has a special quality, as does the low note. These qualities are different from the highly important metaphysical phenomenon of "above" and "below," where "above" represents the world that towers above us in its value, and "below" signifies a world the value of which lies below us, one that is often even marked by disvalues. Nor are the height or depth of musical notes analogous to the level of a value, which bears primarily on the levels in our soul where the antithesis of depth is not height but superficiality.

The depth of a note often has a sonorous, recollected character, while the height of a note can be brilliant, sublime. We are not speaking here of the pitch that every note possesses. The position of the notes alone will not permit the qualitative phenomenon of depth or of height to come to expression. This objective relativity of height must be clearly distinguished from the qualitative phenomenon of height and depth. If a theme or a melody with its harmony and accompaniment are entirely played in a lower range, the piece of music is particularly expressive. The specific quality here can vary greatly, for depth makes possible both a sonorous, serious character and a humorous character, whereas height usually possesses something ethereal, sublime, and often also tender.

We could almost say that depth, in general, has a masculine and height a feminine character. This is not just due to the fact that men's voices are deeper and women's higher, however. Rather, it is profoundly meaningful that men have a deeper voice and women a higher voice. The specific expression of depth—in this audible sense—is fitting for a man, and the expression of height fitting for a woman. This expression of depth and height corresponds with the general character of men and women. The simple fact that men in general have a deeper voice than women does not by merely associative means confer on depth and height their particular character. To believe this is to fall for one of the typical, widespread tendencies that in mediocre fashion reduce everything to associations.

The phenomenon of qualitative depth and height is linked in an important manner to a special sound [*Klang*]. There are specifically deep instruments, such as the double bass, and specifically high instruments, such as the violin or trumpet. An essential aspect of the cello is that it is deeper than the violin. The combination of a certain height or depth with a special sound enables the realization of a particular artistic content, for example, in a violin or cello sonata.

The link between timbre and height is, of course, especially pronounced in the types of human singing voices: bass, baritone, tenor, alto, and soprano. Each of these types of voice is already characterized in general terms by its tonal color, which varies greatly from one individual voice to another. We do not yet have in mind the difference between a beautiful and an ugly voice, such as a nasal or a forced voice, a shrill or a scratchy voice. We are thinking of the difference in timbre within the range of good and beautiful voices, such as those of Caruso, Gigli, Melchior, Pinza, or Chaliapin. This differentiation is usually not found in instruments, except as the difference between good and bad instruments, from which we prescind here. It is doubtless true that the bass has, in general, a markedly different timbre from the tenor, and the alto a different tone from the soprano. Much greater still is the difference in the tonal color between male and female voices.

What interests us here is the link between height or depth and tonal

color. Certain notes with objectively the same height can be sung both by a bass and a tenor. But when Sarastro in *The Magic Flute* sings, "Zur Liebe will ich dich nicht zwingen" ("I will not force you to love"), and then goes down to a very low pitch, the depth and the expression linked to this depth are crucial. When in certain tenor passages the voice ascends into the higher range, perhaps even to a high C, then the element of height is given in an evident manner. This qualitative element of height and depth also characterizes the difference between bass and tenor and is incorporated into their special tonal colors.

The soprano has a qualitative character of height while the alto has one of depth, even though its range is objectively higher than that of the tenor.

Naturally, the importance of the means of qualitative height and depth emerges only in the context of an entire piece of music. The phenomenon of qualitative height belongs necessarily to many melodies as they occur in particular parts of a work, for example, at the end of the final movement of Beethoven's ninth symphony.

Another factor is the modulation of a melody or of a theme that is taken up anew at a greater height in a later passage. The change in register occurs all the time, of course, for the simple reason, say, that a theme initially played by the violin is repeated by the cello. We are not so much thinking of this fundamental means in all pieces of music as the special passages in which the qualitative height has a decisive effect, such as the scherzo of Schubert's Quartet Opus 161, where the glorious theme of the minuet is suddenly taken up in the higher register.

A specific means in music is the difference between major and minor,[4] a phenomenon all its own: the bright and joyful character of major and the tragic, poetically recollected character of minor. There is a distant analogy in the comparison between the beauty of a radiant day, when the sun clothes the trees in gold and the blue sky shines above our heads, and

4. "But how marvelous is the effect of minor and major! How astonishing that the change of half a tone, the entrance of a minor third instead of a major, at once and inevitably forces on us an anxious and painful feeling, from which we are again delivered just as instantaneously by the major!" In Arthur Schopenhauer, *The World as Will and Representation*, vol. 1, trans. E. F. J. Payne (New York: Dover Publications, 1969), 261.

the beauty of a transfigured moonlit night. The difference between major and minor is closely connected to the domain of harmony and key.

The key is a new factor in relation to the individual note, and it is qualitatively much richer. Every piece of music is composed in a particular key that both suits and influences it. One can, indeed, transpose it into another key, but this is a compromise potentially motivated by practical reasons. In principle, each piece of music has one specific key, which adds a special quality to the piece and is doubtless, unlike the individual note, a bearer of aesthetic values. This does not at all mean that one key would be more beautiful in itself than another, however, so that one could say, for example, that C major is more beautiful than G major. The key has a precise aesthetic function, together with the melodies, harmonies, and the precise construction of a piece of music. Wherever it fits all the other elements and is indeed, as it were, required by them, the key represents a new factor for the beauty of the whole.

The major and the minor of the key in which a whole piece of music is composed must be distinguished from the major and the minor of an individual passage. The transition from major to minor in one and the same melody can be very arresting and beautiful. Schubert employs this device frequently.

Foreground and background, pause

Just as in painting and in nature, so too the difference between foreground and background is another important means in music. The foreground is the leading voice that performs the theme or melody proper, while the background consists of the accompaniment, for example, the orchestra in a violin or piano concerto, and not only when it accompanies the violin or piano but even when it precedes these instruments and prepares the way for them. The typical background is the accompaniment on the organ. At the close of the second to last movement in Mozart's Quartet no. 18 (K. 421), the cello suddenly carries out a very formal and strongly rhythmical accompaniment. The significance of the background is illuminated in a unique manner by the greatness of the effect of this

background voice and by the special beauty of the combination of this voice of the cello, unperturbed in its advance and, as it were, "objective," with the sweetness and bliss of the melody unfolding in the foreground in the other instruments.

Pauses, or rests, are another exceptionally effective musical means. Much that is important can be expressed when the music falls silent in a pause. Rests are not a simple absence of music, as when we are waiting for a piece of music to begin. Rather, they are an important part of the piece of music itself. This musical means is clearly distinct from lingering on a note that belongs to a melody, as this lingering pertains to the varied length of the notes. In a rest, the music in the construction of a piece suddenly stops. A great deal can be said through this pause. It is an element that possesses important analogies in other fields. In the pauses of a play, for example, we find everything that takes place between the acts, everything that does not occur on the stage and yet is "said." Consider how much lies between the second and the third acts of *Julius Caesar*. What brilliance on Shakespeare's part to refrain from bringing onto the stage the intervening events.

There are many other analogies to the musical rest. Many situations in human life require a pause. An important statement, having been uttered, can in certain circumstances demand a few moments of silence before an answer may be made, before the stream of life carries on. Certain passages in a speech require a brief pause to form them expressively.

The rest in music contributes to the articulation of the entire work. It can be an element in the overall rhythm of the work, or it can also be an important means of expression.

If we recall the great significance of the pause in Beethoven's "Leonore Overture No. 3" after the trumpet signal. The solemnity of this signal demands a brief pause. Certainly, the musical pause has an outstanding dramatic significance in *Fidelio* too,[5] but we choose the "Leonore Overture" because the pause in this work is of breathtaking beauty in purely musical terms.

5. [Editors' note: The "Leonore Overture No. 3," the last of three versions Beethoven composed as overtures to his opera *Fidelio*, is sometimes performed in the opera's second act.]

The many brief rests in the second movement of Beethoven's ninth symphony have likewise an important function. The pause in the overture to *The Magic Flute* has a character all its own.

Variations in the broadest and the narrower senses.
Coloratura, trills, mordents

Variations are a musical means of a completely different kind. We say of a "completely different kind," because we are no longer dealing with "means" in the strict sense, nor with musical elements that are not derived from something else [*Urdaten*], but rather with a form used in the construction of pieces of music, with the manner in which a theme or a melody is employed.

The variation is again an important primordial phenomenon that occurs by analogy in poetry and especially in life. It is a primordial mode of development. When we pursue the theme of love in poetry and in music, we discover how many variations on this theme exist. Again and again, new aspects of love are presented, illuminated, and emphasized, especially in the love between man and woman, or, as we usually say, in spousal love. We have only to consider the aspect of love in Mozart's operas, in Belmonte's arias in *Die Entführung aus dem Serail*, in the aria "Un' aura amorosa" ("A breath of love") in *Così fan tutte*, or in Tamino's aria "Dies Bildnis ist bezaubernd schön" ("This image is enchantingly beautiful") in *The Magic Flute*. In these arias we find manifested all the sweetness of love, its transfigured beauty, and its power to bestow happiness. In *Fidelio*, we find shining forth in the arias of Leonore, in Florestan's vision, and above all in the duet, "O namenlose Freude!" ("Oh inexpressible joy!"), the heroic character of love as self-gift, the full moral seriousness and nobility of love, and the faithfulness and profound bliss found in the mutual gaze of love [*Ineinanderblick der Liebe*]. In Wagner's *Tristan und Isolde*, we are gripped by the mystery of love, its ultimate yearning for union, its metaphysical depth, and its ecstatic character. In Shakespeare's *Romeo and Juliet*, we encounter the unique ardor, the reverence, and the purity of love, its spontaneous blossoming and its innermost poetry. In

Goethe's *Faust*, we are moved by the tragedy of Gretchen's love. All these examples unfold true and wonderful aspects, variations on the inexhaustible theme of love. In the broadest sense of the term, a variation develops all possibilities potentially contained in a great theme.

Variations in the narrower, literal sense are an important means in music, and they are often bearers of a sublime beauty. Consider the wonderful variations in Haydn's "Emperor Quartet" or in Schubert's "Death and the Maiden Quartet." There is such delight in this form of development, this illumination of a beautiful and important theme, this unity and diversity!

The variation also contains a decorative element in the highest sense of the word, an enrichment and embellishment of the theme. But above all, in its highest forms, the variation possesses the character of a contemplative unfolding. This sublime, contemplative element of the variation emerges clearly in the variations in Beethoven's Piano Sonata Opus 109, in his symphonies, especially in the third movement of the ninth symphony, in his late quartets, and in the second movement of his violin concerto. In such instances, the variation contains a blissful "taking one's time," a hovering, a special sort of immersion in the theme.

There is a type of formal variation that is a kind of achievement in which one shows what one can make out of an insignificant theme. This type has nothing of the nobility and depth of the variations we have just mentioned.

The beauty and depth of the theme on which the variations are based are, of course, a decisive influence not only on the beauty of the variations but also on the character of the variations as such. But a variation on a less significant theme can in fact be beautiful and delightful, even if it has the character of a brilliant game. Beethoven's "Kakadu Variations," Opus 121a in G major, based on a song in Wenzel Müller's opera *Die Schwestern von Prag*, are a typical example of this kind of variations.

Finally, there are academic variations that offer neither a sublime, contemplative unfolding nor a delightful development of the theme, which they in no way enrich. In this case, one is tempted to say, "Si

tacuisses, philosophus mansisses" ("If only you had kept silence, you would have remained a philosopher").[6]

Coloratura is a means related in certain respects to the variation. Of itself, coloratura is a decorative element and in the literal sense restricted to song. It often provides an opportunity to deploy the splendor, range, and suppleness of the voice. This is not sufficient, however, to make it the bearer of a specifically artistic beauty. Rather, it belongs to the sphere of the singer's technical accomplishment, not to that of the composer.

It would, however, be completely wrong to regard this as the only meaning of coloratura. It can also have the character of a sublime unfolding of a theme, going far beyond the purely decorative taken in the highest sense of the word. This kind of coloratura, which is a bearer of great, sublime beauty in Gregorian chant, has a contemplative character. The character here is one of lingering and deep breathing, drawing out and developing of all the possible modulations. The same applies to coloratura in many great works of art, for example, in the "Christe eleison" and even more so in the incomparable, glorious coloratura in the "Et incarnatus est" in Mozart's Mass in C Minor.

Apart from the purely technical accomplishment of the coloratura that is exclusively at the service of the full unfolding of a singer's voice, there is also a purely decorative and delightful coloratura in many operas. This is not a great invention of a musical kind; above all, it is not the bearer of high artistic beauty. It can possess a modest decorative beauty.

By contrast, the coloraturas of Mozart, such as in the two arias of the Queen of the Night in *The Magic Flute*, represent a grand musical invention—not a decoration but something intrinsically new of high artistic beauty. Similarly, the coloratura in the aria from Mozart's opera *Il re pastore* is a new invention and bearer of a great beauty.

An important factor we should not overlook is whether a melody or a theme calls for a coloratura, or if this is only a decoration added onto it. The words that are sung also play a role here.

Analogies to coloratura occur, of course, in purely instrumental mu-

6. This aphorism goes back to Boethius, *On the Consolation of Philosophy*, II 7.

sic, such as the cadenzas in violin and piano concertos, and in all works
for soloists with orchestra. These various types of coloratura play a lesser
role in instrumental music and do not rise to the sublime height of the
sung coloratura.

Let us conclude by pointing to one final musical means, the trill
and the mordent. These too are decorative elements, but they are some-
times of great significance. Both are closely linked to certain melodies,
to which they belong as a part of the melody. But in formal terms they
represent something new in relation to the melody, which grows out of
a composition of notes, out of a specific sequence of notes. The trill is a
structure *sui generis* and the bearer of a specific expression. The trill can
offer something that belongs to it alone. The mordent has an analogous
importance.

We are aware that among the elements of music we have present-
ed in this chapter are both those that represent the *material*, the build-
ing blocks, for a musical work, and also those that provide the *means* to
achieving specific effects, without having distinguished between building
blocks and means for a given effect. Notes, harmonies, melodies, and
themes are building blocks, the materials, although of very various kinds.
Volume, tempo, staccato, legato, coloratura, trill, and mordent are means
that serve a specific effect. This formal distinction, however, is not so
important for our present purposes.

Composition

In composition there are three different steps of decisive importance. The
first is the invention of a melody or a theme, the step from the individual
notes to the higher structure of the melody or theme. Unlike the indi-
vidual notes, these structures can be bearers of beauty or triviality, that is
to say, bearers of aesthetic values or disvalues.

A second step leads to the piece of music. This involves not only
harmony and the various other means, but above all a completely new
dimension, namely, that of composition. This is the dimension where
we see what can be made of certain melodies and themes, how they are

developed, and how an edifice of a musical kind is constructed. Both the structure, or the construction, as well as the edifice as a whole, can be an eminent bearer of aesthetic values. With the work of music as a whole, we arrive at a specific bearer of the beauty of second power. Sometimes melodies and themes already possess an ultimate beauty, such as Handel's "Largo," the national anthem of the Austrian empire, "Gott erhalte Franz, den Kaiser" ("God save our Emperor Franz") with its melody by Haydn, or the theme at "Freude, schöner Götterfunken" ("Joy, beautiful sparks of the gods") in the last movement of Beethoven's ninth symphony.

However, a work of art is created only when a musical edifice is erected.[7] In Beethoven's "Leonore Overture No. 3," we encounter a unique musical edifice, a completely new whole in relation to the melody and the theme. The structure of the whole as a new type of bearer of artistic beauty makes an important addition, revealing unforeseen possibilities and means for the beauty of the edifice. This includes the development of a melody or theme and the combination with other melodies or themes. Every step, every stage in the construction, is in turn the bearer of a particular beauty.

The real work of the great master takes place in this process of the composition of an entire piece of music, whether this comes by pure inspiration or the result of laborious artistic work. The decisive step in composition is taken here, and we can see whether this musical whole is just the elaboration of a theme or melody, whether a common general form is used, or whether the form itself is a significant artistic invention. We also find another difference of highest artistic importance for the construction as a whole shows, namely, whether the construction has an inner necessity or is just *de facto* and could also have been otherwise.

In the present context, we wish to restrict the term "composition" to the construction of a musical whole.

The element of invention extends both to the form of the whole and to

7. In considering this musical construction, it is, of course, impossible for us to examine individual details that presuppose the knowledge of a musician, such as a conductor or a composer, and about which we do not feel competent to speak. We limit ourselves to the analysis of a few important elements and to the significance, in a piece of music as a whole, of the elements that we have already examined.

the form that permeates the whole, to the treatment of the melodies and themes, to the harmonies, and to all the means that we have mentioned.

Another new dimension in composition is the construction of a whole that comprises several movements, such as a sonata, quartet, quintet, octet, or symphony. The connection of the various movements with the whole is different from the connection of the individual parts with a given piece of music.

Sometimes a single movement of a symphony or a piano concerto is of great beauty, while the other movements are unsuccessful. Although this is highly regrettable, it does not destroy the beauty of the one movement. The imperfection under which the beautiful movement suffers when the following movements are nondescript, boring, or even trivial consists in the fact that it is intended as part of a whole and does not possess in itself the self-contained character of an individual piece of music, such as an overture that is not followed by an opera. Nevertheless, the beauty of the individual movement is not destroyed by the disvalue of the other parts.

Although every movement, for example, in a symphony, is a self-contained whole with a definite endpoint, the individual movements are capable of being complemented. They have the ability to become parts of a greater artistic whole. They have the character of a member, in contrast to a freestanding piece of music. The invention of a greater whole, where the individual movements fit together and, in the highest instances, fit together necessarily, marks a new step forward, a new form of composition possible only through a definite inspiration.[8]

The combination of individual movements can be the bearer of a completely new beauty. This opens a rich field of mutual fecundation by the individual movements, a further source of beauty. In contrast to architecture, where we encounter a total construction in its spatial extension, in music the extension is temporal, and this total construction is its own bearer of beauty.

8. In his book *Ton und Wort* (2nd ed., Wiesbaden: Brockhaus, 1954; see "Beethoven und wir," 221–52), Wilhelm Furtwängler speaks with important insights about composition in the second and third senses, above all when he speaks of "form" in Beethoven (238ff.).

Representation [*Darstellung*] and Expression [*Ausdruck*] in Music

ONE SOMETIMES SPEAKS OF "expression" [*Ausdruck*] in music in the sense of "representation" [*Darstellung*]. In conjunction with words, especially in opera and music drama, there are tremendously various possibilities of representation that have a completely different character in music from that in the visual arts. Music is able not only to express the attitudes and experiences of the characters in a drama, such as Pizarro's hatred, Leonore's love and fidelity, Cherubino's infatuation, the sorrow of Orpheus, the fear of Leporello or Papageno, or Tristan and Isolde's ecstatic love in the second act and Tristan's joy in the third act, when he learns of Isolde's arrival. Music can also fashion [*formen*] characters, such as Figaro, Susanna, the Countess, Don Giovanni, Leporello, Zerlina, Don Ottavio, the Commendatore, Leonore, or Siegfried.

The music acts together with the poetic language, and usually has a much more important role than the poetry in the fashioning of a character and in the way he or she is represented. We find something similar in literature in the way Cervantes fashions Don Quixote and Sancho Panza, Goethe Mignon and the Harpist in *Wilhelm Meister*, Dostoevsky

Sonya in *Crime and Punishment* and Prince Mishkin in *The Idiot*, and Shakespeare the characters of Imogen in *Cymbeline*, Cordelia, Ophelia, Polonius, Rosalind, Viola, Perdita, Desdemona, Iago, Macbeth, and many others. Not only is music fully able to take part in this fashioning and representation of characters—itself already a brilliant invention and an important means for the creation of high artistic beauty—but in many operas and music dramas it has the principal share in this activity. This dimension in music is representation in a broader and deeper sense of the term, and it is entirely different from representation in painting and sculpture. While the designation "imitative" [*imitativ*] does not obtain in all the arts, it is completely inapplicable to this kind of representation.

Representation in this sense must be distinguished from expression in absolute music.[1] If we say that a piece of music is full of profound sadness or joy, this does not involve the representation of a character and of his or her feelings. Rather, the quality of sadness, seriousness, joy, or exultation emanates from the entire piece of music. This expression of the quality of human experiences represents a further dimension. We must not interpret this expression as a mere projection of the composer's feelings, because every true work of art involves the creation of an objective and inherently valid work, in which everything is at the service of artistic beauty.

To distinguish between the expression of feelings in absolute music and the representation of feelings in a cast of characters in no way denies that it is the expressive factor in music itself that enables the representation of characters. The expression of feelings in absolute music and their representation in opera and music drama are in themselves two different dimensions. Much of what transpires within a human being is meant to be expressed in this representation, thus serving the artistic value of the work as a whole. Were this representation to find expression in pure music, it would be something negative. In other words, for expression in absolute music, the metaphysical beauty of what is expressed has an important function for the overall beauty. For representation, on the other

1. [Editors' note: In contrast to "program music," which seeks to present or explore a theme, "absolute music" is instrumental music without any extrinsic theme.]

hand, even expressed metaphysical ugliness can be the bearer of lofty artistic beauty.[2]

As long as we are discussing absolute music, we will limit ourselves to the function of the metaphysical beauty of that which is expressed. Metaphysical beauty is often linked to beauty of the second power, which we discovered to be the real mystery of beauty in the sphere of the visible and the audible.[3] It is in music that beauty of the second power and the discrepancy between this lofty spiritual beauty and its bearer emerges most clearly. It is a great mystery that a melody of sublime beauty can be robbed of its beauty and even become trivial through the alteration of a few notes, a different conclusion, or the ascending or descending of the melody. A small, inconspicuous change can have an enormous impact, such as causing the deterioration of a sublime beauty into a trivial banality.

Although music is not an imitative art, and—unlike painting, sculpture, and literature—does not represent something that exists in reality, expressed metaphysical beauty can be of great importance in music and make a decisive contribution to the overall beauty of a piece of music. There are indeed pieces of music in which no expressed metaphysical beauty is present. Usually, however, expressed metaphysical beauty and purely artistic beauty collaborate. To understand this, we must analyze exactly the kind of expression that is possible in music.

First of all, we must draw a clear distinction between certain imitative possibilities in music of an outward kind, on the one hand, and the expression that we have in mind, on the other. This imitative element can take various forms. In the age of Monteverdi, when the text spoke of mountains or of deep valleys, some composers represented this in music through the difference in the musical phenomenon of height and depth. With this naïve imitation, the music follows the word without expressing what is meant by the word. It is more an illustration, and it works by means of an almost exclusively verbal analogy. Even so, there is no reason

2. [Editors' note: See chap. 32 "The Artistic Transposition of Evil, Repulsive, Tragic, and Comic Figures," above, pp. 343–347.]

3. [Editors' note: See *Aesthetics*, vol. 1, chaps. 6 and 9.]

to agree with Schopenhauer in regarding this charming naïveté, which
need not impair the beauty, as a grievous artistic error.

A second kind of imitation is completely different from this. It is not
dictated by a text, nor does it work by means of the meaning of the word.
Rather, it reproduces natural sounds such as the rushing of a river, the
rumbling of thunder, or the humming of a spinning wheel. But although
this form of imitation is much more serious and on a higher level, it is
not yet expression in the sense we have in mind.

This second kind of imitation is connected to the world of the audi-
ble, and the representation of all these phenomena works by means of
the audible. This kind of imitation is not only legitimate; it can also be a
bearer of great artistic beauty, such as the thunderstorm in Beethoven's
"Pastoral Symphony" or the storm at the end of *Das Rheingold* and at
the beginning of *Die Walküre*. This form of imitation mostly occurs in
operas, and sometimes in Lieder, but it is also possible in pure music, as
in Beethoven's "Pastoral Symphony." Schopenhauer maintains the view
that this mode of imitation must be rejected.[4]

The imitation of natural phenomena could never be the bearer of
artistic beauty if it were nothing more than mere imitation of the audi-
ble phenomena and possessed only a factual similarity. More is required
than this. First is the transposition that is indispensable for every artistic
representation. Secondly, beyond all audible similarity, the atmosphere
of what is represented must be represented with musical means. This is
a deep and mysterious task. Thirdly, the theme that is employed for this
purpose must itself be beautiful. We see, therefore, how many elements
must work together to make this form of the imitative a bearer of artistic
values. At the beginning of *Das Rheingold*, the flowing of the great river
is given in a unique manner, although the imitative element is com-

4. "But the analogy discovered by the composer between these two must have come from the
immediate knowledge of the inner nature of the world unknown to his faculty of reason; it cannot
be an imitation brought about with conscious intention by means of concepts, otherwise the music
does not express the inner nature of the will itself, but merely imitates its phenomenon inadequately.
All really imitative music does this; for example, *The Seasons* by Haydn, also many passages of his
Creation, where phenomena of the world of perception are directly imitated; also in all battle pieces.
All of this is to be entirely rejected." In *The World As Will and Representation*, 263–64. See chap. 33,
footnote 4, above.

pletely secondary compared with the representation of the poetry of the river—we could say, compared with the beauty of the flowing in itself and with the beauty of the musical theme.

This deeper representation already far surpasses imitation in the second sense, since the reproduction of natural elements [*Naturwelten*] is not tied to this imitation, and it can exist to a degree of perfection without making use of this imitation. We have only to recall the "Forest Murmurs" ("Waldweben") in *Siegfried* with the poetry of the forest and the life teeming within it. The poetry of the pastoral, an extremely important primordial phenomenon in nature, we find in many passages in Beethoven's sonatas and in the second movement of his String Quartet, Opus 132. Here we come to a dimension of expression in the broader sense of the term, but not yet to the expression we have in mind. The poetry, the special spiritual beauty of natural phenomena, is not represented here; rather, through purely musical means we are immersed in it. A particular quality is made present and its beauty speaks to us without requiring that we think of the actual natural phenomenon. There can, of course, be a reference to a natural phenomenon, like a thunderstorm, though in the much more general phenomenon of the pastoral, there need not be any relation whatsoever to a concrete pastoral situation in nature.

The expression of metaphysical beauty concerns above all the possibility of expressing through music human experiences like sorrow, joy, melancholy, cheerfulness, and so forth.

In another work, we indicated two fundamental types of affectivity, "tender" and "dynamic."[5] We are well aware that the terms we use for these two kinds of affectivity are not felicitous, since the adjectives "tender" and "dynamic" do not express everything that is meant. Nor could we find any better adjectives in English, the language in which that book was originally written. The English words "tender" and "dynamic" do not indicate unambiguously what in fact is a very clear, great difference between kinds of affectivity. Only examples and a full presentation of this difference can make it comprehensible.

5. *The Heart* (South Bend, Ind.: St. Augustine's Press, 2007), part 1, chap. 3.

Expressed tender and dynamic affectivity in absolute music

In our discussion of expression in music, we must take up anew our ex-
planations of this important difference, since both types occur in music.
The expression "tender" is certainly not meant to indicate a lack of ardor,
highest intensity, or power. "Tender affectivity" is the much more spiritu-
al type of affectivity; it is the voice of the heart. The *Confessions* of Saint
Augustine are full of it, as are the prayer of Saint Bonaventure, *Transfige,
dulcissime Domine Jesu* ("Transfix, O sweetest Lord Jesus ..."), the Song of
Songs, and the prayers of numerous mystics. The ecstatic love for Christ
that we encounter in the mystical writings of Saint Teresa of Avila, Saint
Catherine of Siena, Saint John of the Cross, and other saints, is charac-
teristic of this affectivity of the heart that we have called "tender affectiv-
ity," even though the expression "tender" is inadequate here.

On a completely different level, namely, the artistic, we find the ecsta-
sy of human love given artistic form in the duet, "O namenlose Freude!"
("Oh inexpressible joy!") in *Fidelio* and also in *Tristan und Isolde*.

As we have seen,[6] there is a kind of expression in the narrowest
sense of the term in the human face, in gestures, and in bodily postures.
A cry too can express fear, pain, or despair. This expression in the narrow-
est sense plays a great role in music. We presented various examples from
operas above, even though we will begin by restricting ourselves initially
to absolute music. This was necessary, in order to indicate more clearly
the phenomena that are relevant here. Now, however, in our discussion
of expression in the proper sense of the term, we restrict ourselves once
again to pure music, even if expression in this sense can of course be
found in Lieder, operas, and in every other combination of music and
word.

Without question the adagio in Beethoven's Quartet, Opus 59 no. 1
and the adagio of his "Harp Quartet" express a deep and moving sadness.
If one compares these quartets with the closing movement of his Quar-
tet, Opus 59 no. 2, for example, one cannot fail to see the difference in the

6. *Aesthetics*, vol. 1, chap. 5.

feeling that is expressed. The latter movement expresses an unsurpassed joyfulness. We also find a profound sorrow in Schubert's "Death and the Maiden Quartet," especially in the second movement with the variations. This expressed sorrow is obviously not the same type of expression that we find in the human face or in a cry full of fear, both of which express a real experience in the sphere of the visible or audible. It is not the sorrow or joy of one particular human being that speaks to us from this music, let alone, as is often assumed, the sorrow or joy of the composer himself.

In music linked to words, we find a kind of expression that is far more similar to expression in a face or a cry. In absolute music, by contrast, there is a type of expression entirely its own. It is not a pure quality, like the joyfulness of the radiant sky, nor is it the real experience of a particular human being. It is indeed primarily a quality of the sad and the joyful, but it is much closer to actually felt sadness and joy than to the joyfulness of the radiant blue sky. Somehow it is still the voice of the heart that speaks to us, though in a wholly general way.

Needless to say, it is not simply the quality of the sad or the joyful that speaks to us, but a deep, noble sorrow or joy that, thanks to its great nobility, already possesses a metaphysical beauty in itself. It is likewise needless to say that the artistic value does not consist in a correct representation of these feelings, which are bearers of metaphysical beauty. Rather, the real theme is the pure musical beauty of the second power, which possesses a quasi-sacramental character that we have already mentioned, in conjunction with the expressed metaphysical beauty.

A piece of music is also capable of expressing great passion, excitement, impatience, insistence, and many other kinds of "dynamic affectivity," which sometimes possess an expressed metaphysical beauty. The sheer power of passion has a metaphysical beauty, as does impatient expectation. But this expressed metaphysical beauty makes a relatively slight contribution to the overall beauty of a piece of music. That which is expressed is above all determined by purely musical requirements.

If we cease to consider absolute music but the combination of word and music, the possibility of expressing passions of all kinds, such as hatred, jealousy, ambition, and covetousness, becomes very important.

Dynamic affectivity plays a great role once the element of representation supersedes the expression dimension. Hatred and vengefulness, for example, can be conveyed through music in the fashioning of the characters and in the entire dramatic construction of the work. It is, of course, impossible to speak of the metaphysical beauty of these stances and attitudes, which have a morally negative value. Here it is not expressed metaphysical beauty that serves the artistic beauty; rather, because it is a question of a dramatic representation, not of a pure expression, that which is metaphysically ugly, in its artistic transposition, can be an important factor for the artistic greatness and beauty of the work.

Affective experiences are not alone in finding expression in music, but so does much else from the vital sphere as well. A piece of music can express a fullness of life. Thus, we find above all in Carl Maria von Weber a unique freshness and fullness of life, an element of youth and the freshness of morning, a special brightness. His music is specifically vivacious.

Music is also capable of expressing a specific exuberance. This is sometimes the case with Beethoven, and in another way with Mozart. Examples are Beethoven's "Rondo a capriccio," Opus 129 ("The Rage over a Lost Penny"), or the scherzo in his Quartet, Opus 18 no. 5, or in Lieder by Mozart such as *An Chloe, Der Zauberer, Die kleine Spinnerin,* and *Warnung.*

Body-feeling[7] [*Körpergefühl*] finds expression above all in rhythm. Trivial music expresses an embarrassing body-feeling, and this is, of course, a great artistic disvalue.

An opera can, among other things, represent the body-feeling of a character. In *Siegfried,* for example, Wagner has given a masterly representation of the curmudgeonly, timorous, and flaccid body-feeling of Mime.

The expressive possibilities in music are virtually unlimited, and it would be folly on our part were we to attempt to list all the contents and qualities that can be expressed in music, even if we restricted ourselves to the type of expression that we have in mind here and to the qualities that occur in the life and conduct of the human person.

7. See chap. 18, pp. 188–189, and chap. 22, pp. 247–250, above.

In its musical transposition, the expressed metaphysical beauty of a profound and noble sorrow, the splendor of a radiant or blissful joy, the charm of exuberance, a fresh and luminous life, constitutes an eminent factor for the overall beauty of a piece of music. It is linked to that beauty that adheres in a mysterious way directly to the music and that is not an expressed metaphysical beauty.

The capacity of music to express (in the broad sense of express) human experiences in their special quality and to make their metaphysical beauty present is also the basis for music to become expressive in the narrower sense through the union of music and word.

Within the representation of metaphysical beauty in music, there are still many types and degrees of expression, in the various senses of this term. For example, music can express love in a unique manner. This is seen most clearly, of course, in the union of music and word, through expression in the narrower sense. Absolute music too is capable of giving expression to the quality of love in its metaphysical beauty. This expression, however, has a character different from the expression of sorrow and joy. In many pieces of music, love is not expressed in the same way as sorrow and joy. There is no purely musical indication, analogous to "maestoso" and "allegro" for pieces of music that express love. ("Allegro" in its primary sense in Italian means "lively" [*heiter*] and is not just an indication of tempo.) When a piece of absolute music expresses love, this is a more general—we are inclined to say, a more indirect—form of expression. The expression of love occurs more in particular melodies and themes than in a whole movement. What finds expression in music is more one of the many qualities of love, one of its many aspects. The same is also true for yearning. We could more aptly describe this form of expression as "yearning music" [*sehnsüchtige Musik*], a yearning melody, music that is full of love.

It is not possible to discuss all the gradations of expression, nor all the affective qualities that can come to expression in music. We shall return to this in greater detail when we discuss the broad realm of the conjunction between word and music.

In summary we must emphasize that both expression in its various

forms and the metaphysical beauty of that which is expressed can be given only with purely artistic musical means. The mysterious process of artistic transposition must also occur in the case of expressed metaphysical beauty. The fact that a piece of music expresses great sorrow does not bestow any kind of artistic value on it. The general ability to express fear or pain—a cry is also capable this—does not in itself contain any artistic transposition. In order not simply to be sad, but to express the nobility of a deep sorrow and to make its metaphysical beauty present, a specifically artistic ability is required.

The expressed metaphysical beauty of moral values

Absolute music, as voice of the heart, is capable of expressing not just the affective quality of human feelings, but also a specific moral seriousness, moral nobility, great purity or piety. The metaphysical beauty of these moral values unites with the purely spiritual beauty of the melodies, themes, and harmonies, and also contributes in a supremely important manner to the overall beauty of the musical work of art.

While it is certainly true that an expressed metaphysical ugliness of moral disvalues must never occur in a piece of music, it need not always contain the expressed metaphysical beauty of moral values. Above all, there are many gradations in the significance of this beauty of moral values. This beauty appears in a unique manner in Beethoven.

Expressed metaphysical beauty has an ancillary function in relation to the overall beauty of the work. This does not mean that metaphysical beauty expressed with musical means ought not to affect us deeply and move us in its nobility. To speak of an "ancillary function" is not to assert that it is nothing more than a means. It is only to point out that the music does not direct us toward the metaphysical beauty that goes with moral values, and that we do not "think" of these virtues and occupy ourselves with them.

Our attitude ought to be one of drinking in the overall, specifically artistic beauty of a piece of music. We ought to apprehend fully the pure beauty of the melodies, themes, harmonies, and so forth, in their inde-

pendence of the expressed metaphysical beauty. In a word: we ought to remain in the world of art.

A whole world of spiritual contents [*geistige Gehalte*] can present itself to us in a piece of music, contents of great beauty, sometimes lacking even a name, which can no longer be called expression in the proper sense of this term and which are fully integrated into the purely musical beauty.

The Variety of Artistic Value Qualities in Music

Beauty in the narrower sense

MUSIC CONTAINS AN abundance of qualities that contribute to artistic beauty, that is, qualities that are bearers of artistic beauty.

We must begin by drawing a distinction between beauty in a narrower sense and the overall beauty [*Gesamtschönheit*] of a musical work of art. What we have in mind here is a beauty of the second power[1] whose quality is beautiful in a special sense. When we hear Handel's "Largo," to which we have often referred, or Mozart's *Laudate Dominum*, we are struck by its sublime yet specifically tender and heart-melting beauty. In Bach's mighty Toccata and Fugue in D Minor for the organ, on the other hand, we are moved and enthralled by an artistic beauty of a general kind: that of power, precision, might, and brilliance. The quality of beauty in the narrower sense, which usually adheres more to melodies than to themes, shows itself in Gluck's *Orpheus and Eurydice* and in innumerable passages in Mozart. Indeed, it permeates the whole of Mozart's music in an unparalleled manner, such as the adagio of the Fourth Violin Concerto in D Major, the adagios of the piano concertos, the first movement of

1. See *Aesthetics*, vol. 1, chaps. 9 and 10.

the Twenty-Third Piano Concerto in A Major (K. 488), countless arias, the *Ave verum*, and the whole of his chamber music.

Handel's *Messiah* displays this beauty more in the aria "I know that my Redeemer liveth" than in the famous "Hallelujah" chorus in which the beauty of the whole is determined by other qualities. Beauty in the narrower sense can have many degrees, stages, and qualitative differences, but it always has the character of a definite idea and an inspiration. It need not always possess the special quality of lovely sweetness; it can also be serious and deeply moving. We encounter this beauty in all its immediacy, mystery, and purity, in the adagio of Beethoven's Piano Sonata Opus 109, in the arietta of the C Minor Piano Sonata Opus 111, and in the adagio of the ninth symphony. All words fall silent before this beauty. Can there be a more beautiful inspired idea than the cavatina in Beethoven's String Quartet Opus 130 in B flat Major?

We drink of this inspired beauty with its gift-like character in Bach's "Air," in the second movement of his D Minor Concerto for two Violins, and in the aria "Erbarme dich" in the *St. Matthew Passion*. It speaks to us in the themes of Bruckner's symphonies, for example in the adagio of his seventh and ninth symphonies. The themes of the prelude to *Tristan und Isolde* are incomparably beautiful, as are those of the "Liebestod" and innumerable other passages. Many themes in *Der Ring des Nibelungen* and in *Die Meistersinger* likewise bear this beauty in the narrower sense. This beauty is a central element of music; the beauty of these ideas a unique gift.

This quality is not the only artistic value quality in music, nor does it suffice on its own for the overall beauty of a musical work of art. Thus, in this chapter we will attempt to indicate other value qualities that are important for the overall beauty. What we have in mind is not the kind of expression of metaphysical beauty that we have already discussed,[2] but the aesthetic values of other qualities.

We have already discussed[3] the spiritual qualities contained in beauty of the second power, and we have shown the disvalues to which this

2. [Editors' note: See chap. 34.]
3. In *Aesthetics*, vol. 1, chaps. 10 and 17.

beauty forms an antithesis. We also drew a distinction between beauty in the narrower and broader senses, and beyond them lofty aesthetic values such as strength, power, necessity, and depth.

Some aesthetic values are found only in the realm of the individual arts, and not in the same way in nature and in life. It is doubtless meaningful to speak of the "depth" of a landscape. For example, the beauty of the view from Portovenere to the Apuan Alps or of the Gulf of Spezia in the morning has a greater depth than the beauty of the delightful vista from Lausanne to Lake Geneva. The beauty of the vista from the Parthenon is deeper than the view from the Fraueninsel on Lake Chiemsee to the mountains. In the same way, one landscape can be more sublime, or more necessary and convincing, than another.

On the other hand, it is meaningless to say that a landscape is "brilliant" [*genial*] in the narrower sense of the word. When we speak of genius, we refer to something that possesses a quality of "hitting the mark" [*Getroffenheit*], and this is an expression of the human spirit.

Genius [*Genialität*]

The phenomenon of genius occurs not only in all kinds of art, but also in philosophy, scientific discovery, even in the field of military strategy, statesmanship, and in many other domains. We usually think here of a great general, statesman, or discoverer. Napoleon was a typical genius, as was Alexander the Great. But there is also the genius of a piece of music and of a formulated philosophical truth. This is a value of a specific kind, which in a work of art is an aesthetic value.

In describing a person as a "genius," one refers to the greatness of his or her gifts. The special value quality we have in mind, however, contains something more specific. Certain thinkers, like Pascal[4] and Kierkegaard,[5] have this specific quality of the brilliant. Great philosophers,

4. For example, when he says, "How comes it that a cripple does not offend us, but that a fool does? Because a cripple recognizes that we walk straight, whereas a fool declares that it is we who are silly; if it were not so we should feel pity and not anger." (*Pensées* II, frag. 80, trans. W. F. Trotter [New York: E. P. Dutton & Co., 1958], 23).

5. He aptly remarks, "[O]ur generation does not stop with faith, does not stop with the miracle

especially Plato, Aristotle, and Augustine, do not have it; in their case, it is superseded, so to speak, by other qualities. As thinkers, they are even greater than those we mentioned first, but the specific gift of genius in the narrower and proper sense plays a lesser role in comparison with other gifts that are even more important.

The fact that genius can be predicated not only of great personalities but also of achievements outside the sphere of art undoubtedly sheds light on the union of this quality and the human spirit. To call the Gospel "brilliant" [*genial*] would obviously be blasphemous and would betray a total misunderstanding, since the Gospel is an expression of divine revelation. This supposed praise would also be completely inapplicable to the letters of the Apostles. Far from being praise at all, it would be a radical failure to grasp the nature of these letters.[6]

When we call an artist a "genius," we intend to characterize his importance and greatness, in distinction to a less important artist whose gifts are indeed beautiful and gratifying, but who does not attain a certain greatness and depth.

The predicate "brilliant" [*genial*] can also be applied meaningfully and fittingly to a work of art, either as a whole or to a particular passage, say, in a play, an opera, or in absolute music, or even just to a particular phrase. In all these instances, "brilliant" designates a quality of artistic invention that comes to full expression in the work. It is an invention marked by the potency of inspiration, by boldness and unconventionality, by that quality of "hitting the nail on the head"—elements by which a work of art reveals its character as an expression of the human spirit.

In chapter 2 we wrote that it is wrong to see the content of a work of art as the expression of the artist's person. What we meant was that the meaning and value of a work of art do not consist in being the expression of an interesting and exceptional personality. We pointed out that the artist is a *vates*, a seer, as Plato shows in the *Ion*, a discoverer, a human

of faith, turning water into wine—it goes further and turns wine into water." ("Problemata. Preliminary Expectoration," *Fear and Trembling*, trans. Howard V. Hong and Edna H. Hong [Princeton, N.J.: Princeton University Press, 1983], 37).

6. On this see Kierkegaard, *Training in Christianity*, P. 1, "Halt!", i, c, trans. Walter Lowrie (Princeton: Princeton University Press, 1964),. 28–34.

being who receives a special inspiration that he attempts to capture in an object, namely, a work of art. The work of art is an expression of the artistic process, of the artistic discovery, invention, and rendering in objective form [*objektivierenden Gestaltung*]; but it is not primarily an expression of the artist as a human being, his character, ethos, virtues, and defects. As we have said, this affirmation is not at all meant to deny that the human ethos of the artist is also reflected in the work of art, more so in some artists than in others. This is not the central meaning of the work of art, however, and its values do not depend on the extent to which an artist has succeeded in giving objective expression of his personality within the work.

The genius of a work or a phrase, as in Schubert's String Quintet, Opus 163, is a specific expression of the artistic process. The boldness of the idea, the inner necessity, the ability to "hit the mark," all presuppose that such a work was created by a human spirit with special artistic gifts. Genius aims at a quality that has been fully objectified in the work of art, a quality that also reflects the value of the idea, the manner of its shaping, and thus reflects an artistic activity. This genius is a lofty value. It is a wonderful thing when the genius of a work or a passage shines forth, when this mysterious richness of a work of art gives us wings and fills us with enthusiasm.

The genius of Aristotle's *Organon* certainly possesses much that is analogous to artistic genius, yet it is not the same. Genius in the realm of art must be regarded as a lofty aesthetic value, in distinction, for example, to genius in the sphere of philosophical knowledge. The fact that beauty is thematic in all the arts, unlike philosophical knowledge where truth is the theme, means that genius as it occurs in both spheres differs also in a qualitative sense.

It is important to distinguish the value of genius in a work of art from beauty in the narrower sense. The special character of this value lies in the way it illuminates the connection between the creative activity and the work of art. This is not the case for the beauty of a work of art. The unparalleled beauty of Mozart's *Ave verum* or the "Et incarnatus est" in his Mass in C Minor, the adagio in Beethoven's ninth symphony, or

Michelangelo's *Dying Slave* does not at all present itself as the expression of an artistic activity; it simply appears on the pedestal of the visible and audible. In the case of genius, however, we enjoy the completely successful character and greatness of the artistic invention and achievement.

The aesthetic value of genius as such is usually united to beauty in the narrower sense, but it can also occur where this beauty scarcely appears. The genius of an idea, a modulation, or a kind of continuation or a conclusion is the expression of a special capacity of the spirit, a totally irreducible creative power [*uroriginären Geisteskraft*]. It is an element that enchants and delights us in a very particular way. Genius is like a flashing up of the spirit, an achievement of a special kind, which makes itself felt in a turn of phrase or a musical idea, and can possess a specific charm. It is related to *ésprit*, in the highest meaning of that word. Many passages in the music of Berlioz are full of *ésprit*. His jugglers chorus, "Venez, venez, peuple de Rome" ("Come, come, people of Rome") in *Benvenuto Cellini*—an opera with many weak and boring passages, by the way—is definitely a work of genius. His adaptation of the Radoczy March in *La damnation de Faust* and many passages in his other works likewise have this character of genius. Another typical expression of genius occurs when the music moves in reverse, so to speak, when the Count discovers Cherubino in the first act of Mozart's *Figaro*.

Power [Kraft], significance [Bedeutendheit], and depth [Tiefe]

In music we also find the beauty of power [*Kraft*], not in the sense of the depiction of power, like in a thunderstorm as we have already discussed, but of a musical sonority and especially the manner of its treatment, for example, in Bach's mighty Toccata and Fugue for the organ. Many of Bach's endings have this power. Two other examples, both in his *St. Matthew Passion*, are the double chorus, "Sind Blitze, sind Donner in Wolken verschwunden?" ("Have lightening, have thunder vanished into the clouds?") and the cry, "Barabbam!" The beauty of all this is breathtaking, but its quality is different from beauty in the narrower sense. Consider the power of the development in Bach's fugues and the trium-

phant strength in Beethoven! This triumphant beauty is also a different quality from beauty in the narrower sense. There is something glorious in its quality, as in the last movement of Beethoven's fifth symphony, his *Egmont* Overture, and his "Leonore Overture No. 3." In the "Ride of the Valkyries" in Wagner's *Die Walküre*, we are enthralled by the beauty of its magnificent power, the captivating power of its conception, its rhythm, the beauty of boldness, the intense, burning ardor coupled with the unique quality of coolness. This beauty of the triumphant, glorious, and bold adheres immediately to the music. We have here not an expressed metaphysical beauty but a beauty that adheres directly to the musical idea and its development in the musical work.

We come now to further lofty value qualities of an aesthetic kind: the significance and depth—we are tempted to say the *envergure*, or breadth—of a musical idea, and also the depth of beauty in the narrower sense mentioned at the outset of this chapter.

There are melodies that possess this beauty in the narrower sense, such as Tommaso Giordani's "*Caro mio ben*" and Martini's song, "*Plaisir d'amour*." Their beauty cannot be compared to the above-mentioned examples from the works of Handel, Bach, Mozart, Beethoven, Wagner, and Bruckner. Not only are the latter incomparably more beautiful, and not only is the kind of their beauty realized to a much higher degree, it is also much deeper and more significant. The "word" spoken in this beauty is incomparably more content-rich and necessary. The range within beauty in the narrower sense is so great that only from a certain level onward can one even speak in the full sense of beauty of the second power. On the one hand, the artistically important dimension of depth and significance shows itself in the degree of beauty in the narrower sense; on the other hand, it is also an element of beauty in the broader sense and an important bearer of the overall value of a work of art.

Significance, weightiness, and depth are themselves also high aesthetic or, rather, artistic values. They delight, impress, and enthrall us. They are an essential dimension of the work of art. But it would be a great error to suppose that these qualities are either identical with or necessarily linked to the beauty of power or of the triumphant. They also unite with beauty

in the narrower sense, and we can encounter them both in the tenderest, sublime melodies and in powerful melodies. They are present in their highest form in the theme of the first movement of Beethoven's ninth symphony and also in the adagio, the scherzo, and the last movement.

Perfection

Another dimension, namely, perfection, finds its specific expression in the masterwork. Perfection too is a decidedly artistic value, which occurs less in melodies and themes than in the new totality [*Ganzheit*] of the piece of music and in the larger totalities of the quartet, the sonata, and the symphony.

On the qualitative hierarchy of perfection we find both a relatively peripheral degree, a completeness, a precision, a complete execution and realization of what the composer wants to say, and also a perfection of uttermost depth. We do not mean a union of perfection and depth, which, of course, plays a great role, even though perfection and depth are in fact two different value dimensions, which certainly need not appear together. There are works of depth that do not possess a specific perfection. They are not masterpieces in the full sense of the term but are rather sketched out in broad lines.

In speaking of a deeper perfection, we mean neither the depth that can be coupled with perfection nor the new element in perfection that results from its union with depth. We mean a higher kind of perfection that has not only the character of being felicitous, well-made, and successful [*Geglückt, Gutgemachten, Gelungenen*]. This perfection is found wherever the unity of a piece of music remains fully preserved, no boring passages occur, the stream of ideas is uninterrupted, and everything fits together and is completely worked through.

This perfection can occur even when the individual ideas are not beautiful. If we consider the perfection of an operetta like Johann Strauss's *Die Fledermaus*, which is a masterpiece of its kind, many of its melodies lack any artistic beauty in the narrower sense and often border on the trivial. The same applies to a "masterpiece" like Bizet's *Carmen*,

which displays great perfection even though its overall world is by no means filled with a true poetry. Most of its themes are not beautiful in the narrower sense, and some come close to being trivial.

What a great difference there is between the perfection of Mozart's *Figaro*, its character as a masterpiece, and the perfection of *Die Fledermaus* or *Carmen*! *Figaro* is not just full of a lofty artistic world, its perfection not just linked with the sublime beauty of its musical melodies and themes, its perfection also possesses a further character, becoming a phenomenon that is simultaneously deeper and higher. A far more significant and developed artistic talent is needed to create a perfected masterpiece in this sense than to create a "masterpiece" in quotation marks.

Even among genuine artistic masterpieces, there is a considerable gradation. Rossini's *The Barber of Seville* is a genuinely artistic but still relatively peripheral masterwork. Carl Maria von Weber's *Freischütz* is a higher masterpiece, and Mozart's *Figaro* still much higher. Although we make recourse to operas in the illustration of the phenomenon of perfection, this phenomenon can be found equally in absolute music—both perfection *per se* and its qualitatively various degrees.

Perfection is a more formal element than beauty, which is a typical instance of a material, that is, qualitative, element. Nevertheless, in its higher form, perfection is a great value. As already mentioned, perfection refers only to the musical totality, not to individual melodies and themes as such. Perfection encompasses the element of unity, the logic of the whole work, the unbroken inspiration, the absence of boring passages, and the satisfying conclusion. It also includes the full unfolding and realization of the themes, convincing transitions, and the recapitulation of the themes. Beyond all of this, the higher form of perfection requires the unity of the atmosphere, the artistic "world," of the musical work.

Degrees of necessity and inner logic

We must draw a distinction between perfection and inner necessity [*innere Notwendigkeit*] which, unlike perfection, can already characterize a melody or theme, though naturally it is also a factor in the construction

of an entire piece of music. We said that perfection encompasses the logic of the musical execution, and one could be tempted to equate this logic with inner necessity. But this would be inaccurate. Inner necessity is also found in the other arts and even in a landscape. If a piece of music, a melody, or a theme possesses this inner necessity, we feel compelled to say, "Yes, this is how it must be! This is how it ought to be!" But when we hear a melody that is pleasant but not necessary, we say, "This is how it can be, but it could just as well be different."

There are two dimensions of artistic necessity. The first refers to the "word" that is spoken in a melody, a theme, or an entire piece of music, the second to its inner logic. We have just spoken about the first necessity. It contains a certain analogy to the necessity that is possessed by an essential law in distinction to a merely factual state-of-affairs. This, of course, is only a remote analogy, since what is involved in artistic necessity is not truth but beauty, and above all not something real but something invented, not the discovery of something that exists but an idea. Nevertheless, there is a profound analogy. Inventing also includes an element of seeing and apprehension of something that exists. Plato is not wrong to call the poet a "seer," and this applies equally to the composer. Artistic invention does not have the character of an arbitrary fiction. Rather, it includes an element of "hitting" on something. In artistic invention, something objective is seen, especially in the moment of insight, in the inspiration, which has the character of coming to the artist as a gift, a decidedly receptive element.

In addition, there is the development [*Ausarbeitung*] of the work, its realization, the uttering of its word. Doubtless, all of this in a much more general sense is also a gift from God, for development also requires a continuous inspiration. But with this development, an active element does come into play, a fashioning that is clearly different from inspiration, from the discovery of something for which we have no name. It is here, in the discovering of something that finds its realization in a melody or in an entire piece of music, that we find the distant analogy to the discovery of an essential law. The analogy is only distant since both discoveries are completely different. The nature of discovery is different,

the necessity is different, and the act of discovering is different in the two cases. Nevertheless, the fact of having hit upon something objective, the necessity of the word that is spoken in the work of art, bears an analogy to the necessity of an essential law.

This brings us to the mysterious fact that there is also, in an analogous sense, a truth in music, and indeed in art as a whole. Clearly this is not the truth that can adhere only to assertion and that involves a correspondence with an existing state-of-affairs. Rather, it is truth in a wider sense, truth that shares in the splendor and dignity of truth in the literal sense of the term.

This truth must not be confused with the exactness of depiction in the imitative arts.

As we have said, necessity can refer to the word spoken in the work of art, and naturally also includes the inner truth of this word. This necessity is the radical antithesis of all that is unnecessary, arbitrary, and superfluous. But it is also absent in a piece of music that is not lacking beauty and charm, but in which no necessary word is spoken. There are many degrees of necessity in music that belong to the domain of works wherein necessary words are uttered. Beethoven's ninth symphony represents an unparalleled zenith of this necessity, from the first note to the last.

One further important distinction must be drawn in the context of the necessity of the "word" spoken in a musical work. In some cases, the necessity of a word derives from its particular character [*Eigenart*]. Such a word differs from all the other "words" spoken in music. Unlike these, it derives its necessity not from depth, validity, and inner truth, but from its own particular character.

This necessity based on particular character is often linked to another necessity that derives from the fact that a piece of music embodies the spirit of an epoch in a special way and that its word can—and in a certain sense must—be spoken only in this historical moment. The necessity of the particular character of the word (which sharply differs from all other words spoken in music) is not identical to this historical necessity, though they often go hand in hand. Both must be distinguished from the necessity of depth, significance, and inner truth.

Carl Maria von Weber's *Der Freischütz* possesses not only the necessity of depth and inner truth but also the necessity of the unique word the qualitative character of which has no counterpart. Indeed, Weber's spirit, and thus his special character, is found in his other works. But as Furtwängler has so beautifully and correctly explained in his essay "Der Freischütz,"[7] this opera is an incomparable entity, a masterpiece, and moreover a very special word that had to be said at one time. It is a characteristic word of Romanticism,[8] not as this term is often used, but in the sense of the "blue flower" of the Romantic era, the world of Eichendorff's *From the Life of a Good-for-Nothing* and the poems of Novalis.

In *Der Freischütz*, the necessity of both the qualitative character of the word uttered and of the historical moment outweighs the necessity of depth and inner truth, although these are certainly not lacking in this delightful work. In *Figaro*, on the other hand, the inner necessity of the word that is spoken is much greater and deeper, although it does not possess either the particular character of a special word or a historical necessity. The word that is uttered in *Figaro* derives its inner necessity completely from the truth, depth, and significance of this work.

The works of Chopin are likewise examples of a "word" whose necessity derives from its particular quality, from its own special character. But there is also a limitation in this necessity, individuality, and focus on a particular qualitative character. While Chopin's works do not belong to those that reveal what is deepest and most authentic, having, so to speak, voluntarily accepted this limitation, their existence is a great enrichment. Of their kind of necessity, one can above all say: their word ought to be spoken; its absence would be a loss.

It is crucial that we apprehend clearly the necessity of depth and inner truth. The mention of the secondary necessity (that of particular character) is meant to let the first necessity (that of depth and inner truth) emerge all the more clearly. This is why we do not discuss the secondary necessity in detail, although much could be said about it. It suffices to

7. In *Ton und Wort*, 212ff. (see chap. 33, p. 384, n. 8, above).

8. [Editors' note: On the term "Romantik," see also the discussion in the essay, "Beethoven," in Dietrich von Hildebrand, *Mozart, Beethoven, Schubert* (Regensburg: Habbel, 1964), 46ff.]

point out this inherently interesting phenomenon. To avoid misunderstanding, let us add that historical necessity does not, as such, guarantee any kind of artistic value. Certainly, a work that possesses this historical necessity will not be weak, badly constructed, or unsuccessful. It will not be a boring, nondescript work. But it may perhaps be a trivial work with a negative value in artistic terms, a work that would better have not seen the light of day.

We come now to the second dimension of necessity, namely, that of the inner logic of a piece of music. This is related to the totality of a piece of music, its construction, to all the steps taken in realizing it, and to its artistic unity.

Every melody must possess a certain necessity of this kind so that this new structure can be constituted at all and not remain a mere stringing together of notes. The necessity required for this is not yet an aesthetic value, but it is indispensable if a melody, which is a bearer of aesthetic qualities, is even to be constituted. It is no less indispensable for a popular tune than for a noble and glorious melody.

The necessity of inner logic, by contrast, is a pronounced aesthetic value. It is a feature of the melody, not the indispensable precondition for the coming into existence of the melody. It can inhere in one melody more than in another. The more inspired the idea, the more powerful also is this necessity of the logic of a melody.

In what follows, we are interested in the essential conditions [*Sosein-Müssen*] for the necessity of inner logic, not in relation to melodies and themes but primarily in relation to an entire piece of music, whether this consists of one or several movements.

The logic in the construction of a piece of music is analogous to logic in thinking, that is, to logic in the sense of reasoning. It is not by chance that analogies between music and mathematics have often been pointed out, as was done already by Pythagoras and by St. Augustine in his work *De Musica*. This analogy concerns first of all the material of music, such as the musical scale, and so forth. But the analogy to logic that we mean here is of a different kind. It is displayed in the construction of a musical piece, in the treatment of its melodies and themes, in its progression

and realization. Just as the conclusion of a logical inference necessarily and meaningfully follows from the premises, so, analogously, the music progresses meaningfully in a work of art, in contrast to a chaotic or a disintegrating piece of music that does not attain any unity.

Inner logic can be developed to a greater or lesser degree. It can fall short or it can exceed all expectations, like in Beethoven where the inner form, as Furtwängler discusses,[9] represents a new invention in every moment.

We must also draw a distinction between inner logic and inner necessity. The antithesis to the inner necessity of a piece of music is the boringness of a structure that has taken its form by chance, where one feels that it might just as well not have been composed. Not every piece of music that possesses inner logic need be full of inner necessity. This necessity has a convincing character: "Yes, that is how it is, how it must be!" It is found in all the arts, and in nature too. It is something deeper and more central than the inner logic, but in music it presupposes the inner logic.

It is extraordinary when the unfolding of a piece of music, the progression of its themes, the alternation in its rhythm, the harmonic modulations, and the cooperation of its voices have this convincing logic and make the impression of something absolutely necessary. This applies eminently to Beethoven, but we find the necessity of unity and the logic of construction in all the masterpieces of the great composers, whether in Bach's suites, Brandenburg Concertos, and organ works, or in Mozart's 38th, 39th, 40th, and 41st symphonies, and in his important piano concertos. There are varying degrees of this necessity, though certainly it is realized to a very outstanding degree in Beethoven's oeuvre.

The necessity of the unity of a work or of the logic of its construction is a great artistic value since it contributes very significantly to the artistic beauty of the entire work.

It must be explicitly emphasized that this necessity has nothing to do with an academic clarity. Indeed, it is the opposite of this. A merely

9. "Beethoven und wir," 226ff.

mechanical execution, a construction that has nothing illogical and is not chaotic but follows a clear and academic rule, certainly lacks the necessity of inner logic. This necessity is not an empty norm imposed from the outside but an organic coherence, a construction demanded, so to speak, by the themes and melodies and a living progression. It appears in a great variety of forms and types and is as such an important bearer of artistic beauty. What delight this logic imparts in Bach's fugues!

An organic construction leaves room for many surprises, such as the glorious, serene theme in the final movement of Schubert's incomparable String Quartet in C Major, Opus 163, or the new theme in Brahms's first symphony, which begins very broadly with the strings in the final movement.

This necessity of the inner logic and the organic unity is always sustained by an inspiration. It is a *genitum* (begotten), not a *factum* (made). It attains its high point when, as in Beethoven, it is like a continuously new invention. Furtwängler has written very beautifully on this subject in his book *Ton und Wort*.[10]

The "life" in music [Das Leben in der Musik]

Linked to this necessity is another element of a musical work of art, one opposed to all that is academic and mechanical, namely, the fullness of life—a phenomenon *sui generis* in a piece of music.

We are not thinking here of the vital, which can possess a special kind of animation, occurs only in certain pieces of music, and is a characteristic trait of a particular kind of music. We have referred already to this kind of liveliness and brightness in the compositions of Carl Maria von Weber.[11]

We are thinking of something much more general that can occur in a great variety of forms, namely, the inner life a piece of music must possess if it is to be a true work of art. What a fullness of life we find in Bach's works for the organ! What an inexhaustible wealth in Beethoven's

10. See "Die Weltgültigkeit Beethovens," 184ff., and "Beethoven und wir," 237ff.
11. See chap. 34, p. 392.

sonatas or in Mozart's chamber music! The life of music need not consist in a vital animation but is contained in every potent musical work. It is the opposite of the boring, impotent piece of music that lives only in virtue of the fact that it was composed, printed, and performed. Such pieces of music are dead. They do not exist as autonomous structures. They resemble nondescript, barren utterances and theses that have no other existence than the fact that someone has asserted them and they lack the weight they would have if they were true.

Certainly, the fact that a piece of music is not dead in this sense is no guarantee of its artistic beauty. But every true musical work of art possesses this life. If all the other presuppositions for a true work of art are fulfilled, this life of its own [*Eigenleben*] of a piece of music is a lofty aesthetic value.

Unified character [*Einheitlichkeit*] and contrast

Related to the necessity of the unity of a piece of music is its unified character [*Einheitlichkeit*] as such. This applies both to an individual piece of music and to a work that consists of several movements. A unified character is again a fundamental artistic value. A work can contain many beautiful ideas and yet not be unified. Although this does not destroy the beauty of those ideas, it is unquestionably an artistic flaw.

A unified character can be of a more formal nature, but it can also concern the unity of the "world," the ethos of the work as a whole. To be unified in this latter sense is much more essential. It is a great and unfortunate artistic flaw when a theme or transition completely alien to the "world" of the piece suddenly occurs, let alone causes this world to sink from a noble height into triviality.

Having a unified "world" is one of those elements that is a value only in the framework of genuine beauty. If a piece of music is unified in its triviality, this is certainly not an artistic value. There are qualities in the moral sphere, such as energy and consistency, that are capable of heightening both good and evil, making the morally bad person even worse and more dangerous, but the good person morally even better.

Similarly, being qualitatively unified in the realm of art (and hence also in music) is a heightening asset. Doubtless this unified character is itself an aesthetic value, but if the crucial artistic value, namely, beauty in the narrower sense, true power and depth, is lacking, then it is no longer an asset. Not only does it fail to save a musical work that is nondescript and boring, it also fails to confer any value on the work, which remains something neutral. In a piece that is trivial and artistically disvaluable, it even heightens the disvalue.

If a unified qualitative character ensures that everything in a genuine work of art stands at the same level, it constitutes a great artistic value. If the power of the ideas remains, so to speak, constant at every moment, then the work possesses a lofty artistic perfection. This is not even the case with all the works of the great masters, who sometimes composed weaker pieces. Nothing else could be expected, and this is no argument against their greatness and significance as artists. Not only are there many occasional works that an artist decides to execute only under compulsion and without full commitment, one cannot expect that an artist will be equally inspired every time.

There is something particularly glorious when every movement and every passage in a great and significant work possess the same power, beauty, and necessity, and when there is this unified character with respect to the rank of the value [*Werthöhe*]. This applies to innumerable great musical works, although not always to the same extent, since there are various degrees here too. Once again, Beethoven's entire oeuvre is the example in which this is realized to the highest extent. And of all his works, the ninth symphony reaches a special pinnacle.

Completely different from the unified character of the rank of the value is the unity of style and atmosphere, which certainly need not always be present. In some pieces of music, which are fully unified in the first sense of the term, completely different atmospheres contrast with one another. If the unified character of the style and the atmosphere belongs to the very meaning of the "word" that is spoken in a work of art, however, then its realization is both a great achievement and a high artistic value.

Contrast is another element capable of bearing lofty values in every domain of art. At first glance, it might appear that this is incompatible with a unified character, but that would be a great mistake. The compatibility that encompasses a unified character must not be confused with similarity. If, however, similarity is understood in terms of artistic rank, namely, beauty and power of an equal level, then it is indeed a precondition for being unified, for remaining on the same level. But *this* kind of similarity must be completely distinguished from qualitative similarity.

Contrast involves a qualitative difference. Contrasts between forte and piano, adagio and presto, legato and staccato are important in every piece of music. They belong to the life of the piece, and it is obvious that they do not disturb but build up the unified character.

The qualitative variety of an artist's ideas has a high value and is a bearer of the wealth of a musical work. But this presupposes that this variety is compatible in a special manner. Contrast, in which not just different but antithetical elements meet one another, is an extremely important factor in art in general. It allows each of the contrasting elements to shine forth more strongly in its specific character, and a new aesthetic phenomenon is born. Consider here the color contrast in many pictures, or the contrast in *Macbeth* (already mentioned) between the murder of Duncan and the scene with the porter. The horror of the night and this terrible deed are uniquely heightened by the porter's speech, which is full of classical comedy; indeed, their contrast is itself the bearer of special beauty.

It is clear, however, that this true artistic contrast encompasses not only the antithetical difference but also a profound and meaningful connection or, better, an artistic compatibility. The contrast of colors in pictures, which is a bearer of beauty, consists not only in an antithetical difference but also in a meaningful compatibility, in distinction to a clash of colors. Certain antitheses in colors cry out that they are irreconcilable. This is not a contrast but rather a pronounced dissonance. True contrast, which is an important means in art and the bearer of a high aesthetic value, by no means stands in contradiction to being unified.

We find this contrast in Beethoven's "Pastoral Symphony" between the thunderstorm and the incomparable theme that follows it—first the

agitation and the violence of the storm, and then the phenomenon of brightening up, the establishment of peace and serenity. But not just contrast is a bearer of lofty aesthetic values. Variety in general—the wealth of the artist's ideas, the themes, phrases, harmonies, and transpositions—is not in any way an antithesis to being unified. It constitutes an antithesis to monotony but also comes together with being unified. Only in association with a unified character can variety unfold the wealth of music in all its splendor and abundance. Variety will never be able to flower as an artistic value in its own right if the wealth of artistic ideas and their variation are only juxtaposed or even chaotic. In a work of art, variety also requires a profound organic unity, a composition, and the inner meaningful connection and harmony of that which is different.

If this requirement is met, then difference represents abundance and is profoundly united to the inner life of the work of art.

Importance [Bedeutsamkeit], confession [Bekenntnis], and ethos in a work of art

Another element, also a bearer of the artistic beauty of the whole work, is importance [*Bedeutsamkeit*]. This quality need not play a special role in every great and beautiful piece of music. "Importance" here does not mean the significance of which we have spoken, which is linked to the depth, beauty, and potency of a work of art. Nor do we have in mind the importance that belongs to all values, in distinction to the neutral and the indifferent.[12]

We refer here to a quality, or rather to a value of a special kind, that includes a certain explicitness, a consciousness with which the artist speaks his word, whether in literature or in music. There are sentences in literature that possess a special weight and possess this importance both because of their content and the place in which they are spoken. This importance is a quality of the work of art, but it is also an expression of the conscious intention of the artist. This importance also occurs in music.

12. In our *Ethics* (Chicago: Franciscan Herald Press, 1972), chap. 3, we have characterized values, in distinction to other categories of importance, as that which is important-in-itself.

It is the characteristic of certain works and constitutes an antithesis to music that naïvely flows along.

This importance is related to the necessity we mentioned above. It is as if the composer were reaching back to the beginning of things [*als hole der Komponist weit aus*], as if he were uttering a conscious, explicit word. Some conductors have a special talent for bringing out this importance to the full. Furtwängler had this talent, and it made him the conductor of Beethoven *par excellence*, since this importance is especially characteristic of Beethoven's music.

It is, of course, found in many works by Bach and Mozart too. We have only to think of Mozart's unsurpassed String Quartet in G Minor (K. 516) and the adagio of his Piano Concerto in C Major, no. 21 (K. 467). We also find it in many passages in Wagner and Bruckner.

This importance, through which the composer, as it were, calls to us, "Wake up!", perhaps reaches its highpoint in Beethoven's ninth symphony.

Naturally, this summons by the composer, this objectified announcement, must be justified by the greatness, depth, and beauty of the word that is spoken. The importance can be the bearer of a lofty value if the "word" spoken, the summons that lies in the appeal, is completely fulfilled. If it remains only an unfulfilled intention, the result in fact is a definite aesthetic disvalue or artistic flaw. Then we have a false importance, a presumptuous claim, an empty gesture that at best is ridiculous.

This brings us to another essential element that is not a specific value like importance, but rather a particular characteristic of certain pieces of music and not a requirement for the full artistic value of a piece of music. This is the fact that there are many musical works of great beauty that do not possess this importance and for which it belongs to their specific character to lack it.

In general, a requirement for all authentic works of art is that the intention given objective expression in the work is fulfilled, that the artist succeeds in giving what he wants to give in a work, and that there is no disproportion between the intention and what is realized. The artist need not inform us in any way about his intention, of course. Rather, this is

perceptible and objectified in the work itself. There can be many reasons for a discrepancy between intention and fulfillment.

Let us mention one other specific characteristic that occurs in music and has much in common with importance. A musical work can have a confessional character [*Bekenntnischarakter*]. If the content of the confession is a bearer of a metaphysical beauty, and the form of the confession is specifically artistic, this element can be profoundly moving and a lofty and artistic value. But its lack is by no means a disvalue.

We must draw a clear distinction between confession and the ethos that permeates a piece of music. Every piece of music necessarily contains a particular ethos, the depth, height, and nobility of which are essential factors for the value of the work of art. The music of many operettas, operas, and other works is marked by an impure ethos. There is also music the ethos of which is weak, lacking objectivity, self-absorbed, or awkward. All of this is incompatible with a true work of art. The sublime, angelic ethos in Mozart's music, the profound, moral, pure, heroic ethos in Beethoven, the ethos of gentleness, kindness, and delightful ease in Haydn belong essentially to the artistic greatness of their music. The intertwining of the moral and the artistic world of values is of great importance.

It should be noted that we are not speaking of the ethos of the artist in his life—not of the ethos of the person whom we come to know through biographies. Our only concern here is the ethos of the work of art, which is a completely objective quality of the work and in which no element directly recalls the character of the artist. Nevertheless, the metaphysical beauty of the moral sphere and artistic beauty are profoundly interwoven.

By contrast, the personality of the artist manifests itself in the confessional aspect. It does not necessarily reveal what he has completely realized in his character, but it does disclose his ultimate intention, his interior orientation.

This confessional character operates through purely artistic means. It has nothing in common with the tendency to make a work of art an instrument of propaganda; indeed, it is completely opposed to this. It is

not in any way required for a great work of art, but where it does exist, it is the bearer of a specific and even artistic value that affects us in a very special way and moves us personally.

It is a great error to interpret this confessional character as a subjective element, as a disturbance of the full objectivity or objective realization of a work of art. That would be correct only if the confession were purely subjective, a note of self-importance, ingratiation, and nothing but the artist's need to pour out his heart to us. But this would be an embarrassing, subjectivist form of confession due to both its content and manner. We find such pseudo-confessions in sentimental works that are "romantic" in a negative sense of this term and contain a sort of self-indulgence.

The confessional character as such is the antithesis of this subjectivism. It is completely objective. It contains a profound analogy to the confession of Socrates, as we find it in the *Apology*, *Gorgias*, and *Phaedo* of Plato. This confessional character pervades the work of Søren Kierkegaard. We find it in the most moving manner in Michelangelo's *Deposition from the Cross* in Santa Maria del Fiore, the cathedral of Florence. This confession is a specifically objective message, but it presupposes a special consciousness in the artist. Donatello's glorious works do not have the confessional character of Michelangelo. Beethoven's music bears it in all his important works;[13] it is not found in Mozart.

The artistic quality of "being stimulating" [Anregendheit]

A completely different artistic value quality in musical works is a specific way of "being stimulating" [*Anregendheit*], a brilliant way of being interesting. Beyond all the value qualities mentioned above, it can lie in the way a theme is developed and a new theme suddenly begins. This stimulating quality is in fact a decidedly artistic quality. It possesses a certain analogy in literature, for example, in the works of Dostoevsky, but also in certain philosophical works, such as those of Kierkegaard.

13. See also "Beethoven," in *Mozart, Beethoven, Schubert*, 67ff.

This quality manifests a specific creative achievement [*Geistesleistung*] of the author. It is a delight afforded to us by the genius of the author, though we are not thinking of the personality of the author, but of the stimulating quality in objective form [*objektivierte Anregendheit*]. This quality reveals itself in its special effect on us. While beauty in the narrower sense moves us and makes us deeply happy, and while greatness and power fill us with enthusiasm, the quality of "being stimulating" has a completely different effect. It enchants us and gives us wings, it transports us into a world of that which is intellectually interesting in the best sense of the word, into the world of brilliant ideas and the charm of artistic talent.

This quality of "being stimulating," which is a unique value all its own, is not a requirement for the artistic value of a piece of music. But when it is present, it definitely has the character of a real artistic value. In many works it is surpassed by beauty, depth, and seriousness, but it can also be united to these, as in Bruckner and Schubert, and, of course, in Beethoven.

CHAPTER THIRTY-SIX

The Lied [*Das Kunstlied*]¹

The heightening of expression through the union of word and music

MUSIC AND WORD can contract a unique "marriage." In its various types—Lieder, opera, music drama, oratorio, Gregorian chant, and Masses—this union often leads to works of art of the highest perfection.

Many people believe this union could never produce anything as great as what is produced in the sphere of pure music and pure literature. They assert that this union is always a concession, either on the part of the music or on the part of the poem. Schopenhauer regards it as an indispensable condition that the word must serve the music and take a subordinate position.²

There is no basis whatsoever for the idea that a union of music and word sullies the music and thus represents a compromise, as if this union would prevent the music from freely unfolding its own logos.

1. [Editors' note: The title of this chapter is "Das Kunstlied," literally the "art song." Because "Lied" is widely used in English, we have decided to preserve "Lied" and its plural, "Lieder," untranslated.]

2. "This is the origin of the song with words, and finally of the opera. For this reason, they should never forsake that subordinate position in order to make themselves the chief thing, and the music a mere means of expressing the song, since this is a great misconception and an utter absurdity." Schopenhauer, *The World as Will and Representation*, 325.

This idea is just as erroneous as the position that every marriage, even one that grows out of mutual and profoundest love, is a limitation on the freedom of the individual and on the full development of his or her true self, and thus that marriage is a compromise.

It is, on the contrary, a special gift of God that these two spheres of art, which convey their artistic content with such different means, can unite so wonderfully, and that something so great results, something neither sphere on its own could afford. While the union of these two arts does not grant us something greater than either art on its own, it does give us something completely new and equally great.

It is not as if, after the full development of music without words, people suddenly had the idea of attempting this union as something special. On the contrary, the most original form of music is surely song, in which words and music are combined.

Our starting point must be the heightening [*Steigerung*] that singing can represent relative to speaking. In song, the hovering, rhythmical, poetic element that sometimes lies in the spoken word is heightened. The transition from the spoken to the sung word is an ascent of a specific kind, a formal rising up, a striving to get beyond the mere practical function of communication, an unpragmatic way of expressing oneself. Sometimes it is a heightening of solemnity, at others a heightening of the expressive element in a word; and at still others, an elevated form of speaking and of the dignity contained in speaking.

Above all, however, singing is a heightening of the expression of the inner processes of joy, sorrow, yearning, and love that are described in words. *Cantare amantis est*, says Saint Augustine, "Singing belongs to the one who loves."[3] It is not by chance that this highest stance of the human being, the praise of God, the expression of his love for God, was already heightened among the Jews through the singing of the Psalms, and that Gregorian chant is a unique expression of the ascent from speaking to singing, a supremely organic union of word and sound. We recognize clearly in this heightening the "pre-established harmony" between word

3. *Sermo* 336, *In dedicationem Ecclesiae*, I.I.

and sound. Just as meter in poetry, epic, and drama in a sense represents a heightening relative to prose, all the more so is there a heightening from the spoken to the sung word.

This must not be taken to mean that the domain of literature, in the absence of music, lacks works of ultimate greatness and beauty. The addition of music to drama in an opera does not necessarily heighten the value of the drama, that is, its artistic beauty, even if the music in itself is beautiful. Nor is the beauty of a poem always heightened when it is set to music, even when the music of the song is very beautiful. Certain poems are suited to this complement, others not, because their form and content are of such a kind that they exclude this musical complement, that is, they lose rather than gain through it.

Basic elements of the union of word and music

Let us begin with general factors that apply to every form of this union, that is, with the general enrichment it brings about. The very first element is the human voice, a unique factor over against all instruments, firstly, as a sound [*Klang*], and secondly, because only a human being can bring it forth. It is true that every instrument is played by a human being, but song is united to the singer in a new way because it is the singer's own voice and thus has a human note lacked by an instrument. This contributes a new background to the expression of affective attitudes in music, a background that comes closer to expression in the literal sense of the word. Although the song does not express the real feelings of the singer, he or she nevertheless identifies with the feelings of the character whom they are portraying, especially in opera. This is nothing other than the unique identification that is also to be found in the good actor. The simple fact that the singer portrays a person, with all his or her feelings, passions, and characteristics, gives a new quality to the affective expression of the music.

Thirdly—and this is of decisive importance—song is necessarily united to words. It is only the spoken word that can make the sound of the voice into a true song. If all we have is the repetition of "la, la, la," the

song is in many respects incomplete and, if drawn out, unserious and almost ridiculous.

Already in purely phonetic [*lautlich*] terms, the sung word is a new phenomenon compared with just singing scales. The tonal beauty of the human voice is united to the phonetic beauty of the word. Not all words have the same phonetic beauty, and some languages are superior to others in this regard. Nevertheless, the word itself is a phonetic structure *sui generis*, as we recognize already in the fact that it is composed of vowels and consonants. As such, it already has a "face" that often possesses a certain beauty. It is something articulated, in distinction to mere noises.

In the sung word, the phonetic beauty of the sung notes is united to the beauty of the word. They penetrate each other in a way that has a purely phonetic charm lacking in the spoken word, the pure sound of the voice, or the individual notes in the scale. Above all, the notes acquire a new kind of articulation in the sung word. The notes gain the phonetic quality of the vowels and consonants, and the articulation in the word adds a remarkable new articulation of a musical kind to the melody.

The fact that each word in a sentence represents a unity of its own grants a new structure to a melody. This structure is of a completely different kind from the mysterious unity that makes a particular sequence of notes a melody. This articulation is not at all imposed on the music from without, any more than the inner structure of the melody is imposed upon the unity of the sentence. On the contrary, without disturbing each other, they form an organic union, which, however, is bound to certain conditions. The words and the music must be compatible. A drastic example where the phonetic logic of the sentence and the music contradict each other is Beckmesser's song in the second act of *Die Meistersinger*, "Den Tag seh' ich erscheinen" ("The day I see appearing"), which prompts the response of Hans Sachs, "Besser gesungen" ("Better to sing").

The phonetic quality of the vowels combines with the tone and the sound of the song. The specific aesthetic quality adhering to each vowel is also present and combines with the sound of a melody.

In addition, consonants have a function of their own, although they are, as such, just a certain audible property and do not belong to the same

domain of sound as vowels. Nevertheless, each consonant has a clearly defined character; they are very precise and unambiguous compared with mere noises.

The soul of a word is its meaning. But already the phonetic sound of the word has a certain expression, which is heightened in the sung word, although, of course, primarily in connection with the meaning of the word. The central dimension of expression in music, through which the metaphysical beauty of victorious joy, noble sadness, and so forth, is added to the immediately given beauty of music, gains new significance in its union with the word. The expression of human feelings thereby becomes much more precise and unambiguous than in absolute music. It comes much closer to expression in the narrowest sense of the word, namely, the expression in a person's face of their affective experiences and personal character traits.

In a song, and all the more so in an opera, music can express distinctly and precisely and with unparalleled immediacy and vividness the joy and sorrow, yearning and love of a human being.

A widespread error holds that music itself is incapable of expressing anything and that its union with the word generates nothing more than associations in the hearer. It is claimed that because the text—for example, in Tamino's aria, "Dies Bildnis ist bezaubernd schön" ("This image is enchantingly beautiful") in the first act of *The Magic Flute*—speaks of love, one associates the music with love. The music on its own has no connection to the expression of love, but because of the text one thinks of love, and one connects music and love through sheer association.

This thesis is full of shallow errors. Were it correct, it would not matter which beautiful music was composed for the words. According to this thesis, Gluck's music for Orpheus's lament over Eurydice, "Ach, ich habe sie verloren" ("Alas, I have lost her"), would just as well fit the words in Tamino's aria. But the appeal to mere associations is always highly questionable; it evades the problem at hand and ignores the facts to take refuge in this "jack of all trades." We have already demonstrated on several occasions[4] the true function of association and the unmistak-

4. For example, in *Aesthetics*, vol. 1, chap. 1, 43.

able difference between a real association and a completely different, far deeper, spiritual relation that is erroneously interpreted as an association.

One might suppose that everyone who truly understands something of music would grasp expression and the metaphysical beauty of that which is expressed in absolute music. Unfortunately, pseudo-philosophical prejudices, shallow philosophical chatter, and commonplaces picked up from newspapers, have a blinding effect on many and block what is clearly apprehended in immediate experience. This is why we sometimes hear such theories even from the lips of very musical people. The moment one abandons all prejudice and remains faithful to the state-of-affairs clearly given in immediate experience, one understands what music is capable of expressing. One grasps the noble sorrow in the adagio in Beethoven's "Harp Quartet," the profound recollection in the third movement of his String Quartet Opus 132, and the joy in the first movement of his seventh symphony.

The quality of an affective attitude conveyed exactly through words in poetry can thus form a deep organic unity with expression in music, thereby actualizing in a unique way the potentiality contained in the music. Poetry, through the object that it has intentionally selected, calls for a kind of music whose expressive power corresponds to the quality of the object. The theme of a poem excludes music whose expression in a general way qualitatively contradicts this theme. But beyond all this, word and music unite in such a way that what is expressed in the music expresses the world of inner experiences far more distinctly than pure music, and the theme of the poetry becomes present far more vividly, intimately, and strongly than in pure literature.

The arie antiche *and the leading role of the words*

Let us begin with the Lied as a primordial type [*Urtypus*] of the union between sound and word,[5] and in fact with a form that is not yet prop-

5. Since we are not writing a history of music (for which we lack the knowledge and the academic training) but an aesthetics, we need not spend time here on the historical development of the union between word and music.

erly speaking the Lied, namely, the "arias" of the sixteenth to eighteenth centuries. Like the typical Lied, these arias stand on their own feet and possess their artistic value independently of other pieces of music that may surround it.

In the *arie antiche* from Monteverdi, Carissimi, Lotti, Scarlatti, Handel, and Gluck down to Pergolesi, the music plays a supporting role to the word. The music may be far more beautiful than the text and artistically much more significant, but the music has an ancillary role because it is the text that leads, while the music represents or, better, expresses with musical means all the feelings of sadness, love, joy, tenderness, despair, or yearning that occur in the text. The music of Caccini's beautiful song *Amarilli, mia bella* expresses the reverent, tender, chaste love of the text. Or consider Lotti's beautiful aria *Pur dicesti bocca, bocca bella*. In all these examples, we see a profound organic unity between the text and the music, with the music following the text in the unity of the style and what is expressed. In the glorious aria, "O del mio dolce ardor," ("You are the object of my desire") in Gluck's *Paride ed Elena*, the music is incomparably more beautiful and significant than the words, but it follows the text and takes it seriously. The text indicates the theme.

Sometimes a dramatic scene is portrayed, as in the aria *Pastorello, non t'inganni!* The music in a special way characterizes the person who speaks these words, which express her flirtatious mockery and enjoyment of her influence over the shepherd who is in love with her.

This kind of union of music and word have the following important characteristics.

First of all, the music formally adopts an attitude of serving the text, although in artistic terms the music can be much more significant and beautiful.

Secondly, that which is expressed in the text is heightened and elevated with musical means.

Thirdly, the principal beauty of the music consists not only in representation, in the sense of the adequate expression of the affective attitude found in the text, but in the pure beauty of the musical idea. Nevertheless, representation remains a central theme.

Fourthly, the text contains nothing artistically negative. It need not be significant, but it must be free of all artistic disvalues, such as sentimentality and triviality.

There are other arias where this supporting role on the part of the music is completely abandoned, and the words possess a character that is utterly inadequate to the sublimity of the music. The words of the famous "Largo," the aria "Ombra mai fu" ("Never was a shade") in Handel's opera *Xerxes*, form nothing more than a basis for the song, and their phonetic quality is more important than their meaning. Their object is the praise of a tree and the shade it gives, while the music is one of the most beautiful, profound, and most sublime pieces ever written.

Sometimes the word has the leading role, insofar as it determines the expression of the music, and the theme of the text is taken with complete seriousness by the music. At other times, the word is used only to give the music the possibility of unfolding in song.

There is a special quality in the sung word as the song of a human being and in the union of word and music, quite apart from the meaning of the words and the affective content of the text. A purely musical intention may call for words to convey through song something that cannot be done in the same way with instruments. This union is justified even when the words have only an ancillary function and the musical expression is not contained analogously in the word.

Naturally we do not mean that the words can be cheerful and the music deadly serious. The music may not contradict the meaning and content even of a completely ancillary text. It may not express as jubilation the words of a lament for the dead, though the music itself could remain beautiful, because its beauty is independent of the word.

Often the words and the object of which they speak are completely secondary, and the music, far transcending the content of the words, is not only of great beauty but also employs the words for purely musical reasons. This is primarily because of their phonetic function, but also because the music is intended as song and the words belong to it. A song that merely repeats "la, la, la" is in many respects quite deficient and, if sung at length, even frivolous.

The classical Lied: Haydn, Mozart, Beethoven

In the Lied in the proper sense, a deep cooperation is intended between word and sound, not only in a phonetic sense but also in the affective expression, the atmosphere, and the mood and poetry of the whole.

There are numerous types of Lied and various degrees of excellence with respect to the intimacy and perfection of the cooperation between word and music. These degrees, however, need not correspond to the hierarchy of musical beauty.

Let us note, in very general terms, that the Lied in the full sense of the word, in distinction to the *arie antiche* we mentioned above, is explicitly intended as a special type of the union between word and music. It constitutes a work of art *sui generis* and possesses a style of its own. This applies to simple Lieder, like those of Haydn, to playful Lieder, as we find in some of Mozart's compositions, and also to the most highly developed and fully distinctive Lieder, such as those of Schubert and Hugo Wolf.

We find a first type of Lieder in Haydn. Their texts are appealing and delightful; they have a certain poetic charm. Considered purely as poems, they are insignificant and their anonymous character makes them vulnerable to being forgotten. They lend themselves, however, to being elevated and heightened through the music, which expresses above all their mood and poetic world. The music does not enter deeply into the text, which offers no possibility for such an involvement. The Lieder *Eilt, Ihr Schäfer aus den Gründen* and *Jeder meint, der Gegenstand* are works in which an enchanting music not only fully expresses the poetic mood of the poems but elevates and surpasses them.

In these and other Lieder by Haydn, we find the charm of the Lied that elevates the poem in a simple and almost humble manner, fully actualizing its poetic potentiality. Although the beauty of the music is the main thing, the style of the Lied, that of the simple sung word, belongs to this beauty. These melodies would not come into their own in the same way in a string quartet or a symphony. They belong to the Lied. This is a noteworthy fact. Even with the relatively loose union of word

and sound in these Lieder, whose texts do not offer opportunities for great expressive unfolding, a unity comes into being that is the bearer of a special value. The words, as we have said, are charming and equipped with an anonymous poetry; but as poems, they are clearly insignificant. The expressly lovely and beautiful music calls for this marriage in a Lied, in which this music comes into its own more fully than in a piece of music without words. It is permeated by the Lieder style; it is something sung, and only as such can unfold its full charm. This is noteworthy, because it sheds a special light on the artistic possibilities of the union of word and music in the Lied and confirms the *raison d'être* of the Lied itself in this simplest form.

We find a new type of Lied, a heightening of the mutual involvement of the music and the words or a more intimate union of the two, in some of Mozart's Lieder, such as *Das Veilchen* ("The Violet") or *An Chloe* ("To Chloe").

Goethe's poem "Das Veilchen" has a complete poetic value in its own right. It is not one of his great, significant poems, but it is certainly beautiful and constitutes, in itself, an enrichment.

Has the value of Goethe's poem increased through Mozart's beautiful, lovely music? Is it elevated and enriched by this music? The musical idea lends itself to being fully used in pure music too; indeed, it is found in part in the adagio of a string quartet. Although the poem and the music—at least, the melody—both stand on their own, the music enters deeply into the poem. It works together with what happens in the poem and expresses both its specific poetry and the feelings in the individual passages. It serves the poem, which takes the leading role. The whole is the bearer of a value of its own, which neither the poem nor the music alone possesses. Indeed, the union of the two represents an increase relative to the value of the poem and the music taken individually.

On the whole, Mozart did not take the Lied form very seriously. None of his Lieder attains the stature of his arias, such as the one from *Il re pastore*. While this opera on the whole does not yet reflect Mozart the great dramatist as he will show himself to be in his operas from *Die Entführung aus dem Serail* to *The Magic Flute*, this aria possesses a great-

er beauty than any of his Lieder. There are, indeed, Lieder by Mozart that are very beautiful, such as *An Chloe*, which opens "Wenn die Lieb' aus deinen blauen, hellen, offnen Augen sieht" ("When love shines from your blue, bright, and open eyes"), and the roguish *Die Verschweigung*, "Sobald Damötas Chloen sieht" ("As soon as Damoetas sees Chloe"). Unlike *Das Veilchen*, these are not a new type of Lied, but rather a typical union of music and word that we have already encountered in Lieder by Haydn. In the Lied *An Chloe*, however, Mozart plumbs far greater depths than Haydn ever did in his Lieder. In itself this text is not a viable structure as a work of art. But as a passionate love poem, it provides the opportunity for a musical expression of a new kind in which the music enters much more deeply into the words.

Beethoven's Lieder *An die ferne Geliebte* ("To the distant beloved") are of special interest for the lofty artistic values that a Lied can realize. There can be no doubt that, in pure beauty, their music surpasses every other Lied that has ever been composed. It must be affirmed as decisively as possible that this music can only have the form of the Lied. It calls for the word; indeed, it can unfold only with the word and as a Lied. It would be unthinkable as absolute music.

The music enters deeply into the text, thereby giving expression in a unique manner to the nature of love and yearning. In one respect, the poems are ideal texts for Lieder. True, they are not among the significant poems and would on their own soon have been forgotten. But they contain nothing disturbing and possess special potentialities for the Lied. They are full of a noble ethos of love and yearning, and they display various important aspects of love. They enable Beethoven to create one of the greatest artistic expressions of love in its depth, ardor, and yearning, the pain of separation from the beloved, and love's victorious hope. The expressed metaphysical beauty of love and the pure beauty of music are united in these Lieder in an incomparable manner. The expression of the metaphysical beauty of love reaches a new dimension through its union with the word. It becomes much more concrete and distinct than would be possible in absolute music.

This should not be taken to mean that a love poem could not possess

a beauty as great or even greater than any Lied. But a certain dimension of this expressed metaphysical beauty of love in an artistic transposition can be attained only in the union of word and music. Add to this, as we have said, that the uniquely beautiful music of the Lieder in *An die ferne Geliebte* specifically calls for human song. Nevertheless, the artistic possibilities of the Lied are so varied that although these Lieder are certainly the most beautiful in musical terms, they are far from exhausting all the artistic possibilities of the Lied.

It is not by chance that, apart from *An die ferne Geliebte*, Lieder have a secondary place in Beethoven's oeuvre as a whole. He did indeed create a number of beautiful and moving Lieder, but it is not in them that Beethoven's greatness, which makes him the king of music—though not the king of Lieder—finds expression, as we see when we compare them with the symphonies, string quartets, sonatas, *Fidelio*, let alone the *Missa solemnis*.

The Schubertian Lied

While the union of word and sound had already reached the highest level in oratorios and operas, the Lied as an artistic form of its own was brought to unparalleled perfection by Schubert. He created a new type of complement and mutual penetration of music and word, but also a new kind of piano accompaniment, to which a specific role is entrusted in the rendition of the mood and atmosphere of the poem. The expression in the accompaniment sometimes also constitutes an important contrast to that of the singing voice. This new type of Lied has a further characteristic: in working with the more significant poems, Schubert knows how to transport himself into the spirit and world of the poet. He has the unique gift of composing Lieder wherein he enters just as fully into the world and style of Goethe as of Shakespeare. This, however, is also a manifestation of the new marriage between word and sound. And while our theme is not an appraisal of the Lieder of Schubert, Beethoven, and Mozart, but the analysis of the characteristics of this specific form of art and of its special possibilities, we cannot fail to mention this element of completely entering into the spirit of the poet.

The artistic form of the Lied in its consummate form employs various new means for the realization of their artistic content. Schubert's Lieder represent a significant part of his entire oeuvre, though certainly not, as is often supposed, the high point of his creative activity. This lies rather in his chamber music, above all in the Octet, in the Trio Opus 99, in the Quartet Opus 161, and in the Quintet Opus 163. In his Lieder, we find not only the perfection of the Lied *qua* Lied, but also a unique variety of different kinds of Lieder. We are able to see just how vast is the range of which the Lied is capable, not only on the spectrum of perfection but also in the variety of expressive possibilities, atmosphere, and mood.

The Lied *Gretchen am Spinnrade* ("Gretchen at the spinning wheel") offers an example of this new way of entering into the poem. Gretchen's ardent love, heart's anguish, and tragedy in this poem by Goethe are uniquely conveyed in the music. The poem is not only a great work of art in itself but is also an organic part of the drama *Faust*, Part I. Its beauty is further heightened by the way it is framed by the work as a whole. It belongs to this drama, and its wonderful lyric and dramatic beauty is inseparable from the figure of Gretchen.

One might think this poem unsuitable for a Lied, but the opposite is true! Schubert's Lied is of deeply moving beauty. While it does not heighten the beauty of the poem as a part of *Faust*, Part I, the Lied is a new entity that stands in itself, a self-contained bearer of lofty artistic values. The composer succeeds in allowing the profound tragedy of the figure of Gretchen to shine forth in the music, employing musical means to portray the unique poetry, this eruption of a heart that loves but is tormented and profoundly perturbed.

The new function of the piano accompaniment emerges in this Lied. The accompaniment is no longer just musically required but now an essential factor in the overall content of the Lied. The whirring of the spinning wheel is entrusted to the piano, but not only that: its calm, untroubled progression forms a moving contrast to the excitement and anguish of heart expressed in the singing. Of course, the accompaniment also fits the song and the words, but what the piano plays by itself at the beginning, middle, and end is an important part of the artistic invention.

AESTHETICS

Thus we have in this glorious Lied a new, independent structure, even though one would think such a uniquely beautiful poem, given its essential place in a larger drama, could not be augmented by any composition.

Song cycles

Some composers have constructed a more comprehensive whole, a song cycle, out of several Lieder, each of which is a unity in itself. Examples are Schubert's *Winterreise* ("Winter journey") and *Die schöne Müllerin* ("The beautiful miller's daughter"). This is a very interesting new form of totality, a loose unity from a purely musical point of view, that cannot be compared to the unity of the various movements of a sonata, string quartet, or symphony.

The connection is given first and foremost in the poems, which, so to speak, in their sequence narrate a story. In the music, the connection is expressed primarily through the stylistic unity of the series of Lieder. The song cycle *Die schöne Müllerin* reflects a definite story with its various stages and situations. By fully entering into each individual poem and its place in the story, the music fully participates in the unity. In musical terms, the structure is *sui generis*, albeit very loose. Contrasts, changes in tempo and in forte and piano, play their part as well.

Formed out of individual Lieder, the whole contributes something new to the artistic value and content of the individual Lieder, despite the musically loose connection. The whole is the bearer of a particular value. Already the fact that, when the song cycle is performed, we are continually drawn into a particular world, mood, and atmosphere, and that we allow ourselves to be borne by the rhythm of the overall construction, signifies an enrichment all its own.

Though the Lieder in Beethoven's *An die ferne Geliebte* do not comprise a song cycle but clearly parts of a whole that in purely musical terms forms a strict unity, the opening theme is taken up anew in the last section.

Hugo Wolf's *Mörike-Lieder* represent a very special case of a complete union of poetry and music. Mörike's poems stand fully on their

own and have their own poetic value. But the unique marriage of the music with the overall poetic world of Mörike, with his special spirit, is a high point of the interpenetration of poetry and music, which realizes an artistic value possible only in the Lied. It is quite remarkable that despite this complete interpenetration of music and poetry, despite the music fully serving the poem, the child of this marriage is a completely new entity and in fact possesses a new and characteristic atmosphere.

The perfect interpenetration of poem and music in the Lied

The potential marriage of poem and music, as we find it in the example of *Gretchen am Spinnrade*, presupposes the following characteristics in the music.

First of all, the music is immersed into the poem in a unique way. With the words playing the leading role, the music enters in an incomparable manner into the affective attitudes contained in the poem. It expresses these in a specific, detailed, and clear way that is possible only in union with the word.

Secondly, the music enters deeply into the spirit of Goethe and the kind of poetry that is peculiarly his. The marriage of word and sound goes so far here that this Lied becomes more than a universal expression of love, heart's anguish, unrest, and passion, and not just in the way the figure of Gretchen is fashioned, but even in the way the genius of Goethe is given form. In the music, we come in contact with the genius of both Schubert and Goethe.

Thirdly, the beauty of the musical idea, that is, the beauty that lies purely in the music, is an absolute precondition.

Fourthly, the important and significant function entrusted to the piano accompaniment, which it takes on in the construction of this new entity, makes itself felt, particularly in the contrast it plays with the voice and in the realization of the very specific atmosphere of this Lied.

It is interesting that poems of a beauty that cannot be surpassed through the union with music in a Lied are nevertheless capable of this marriage. Such Lieder are bearers of a beauty that is not greater than that

of the poems but nevertheless constitutes a great enrichment. It would be a pity, say, if Goethe's "Ganymed" did not also exist as a Lied.

Other very beautiful poems possess no potentiality for marriage with music. We might say that they resist being used in a Lied. Shakespeare's 29th Sonnet, "When in disgrace with fortune and men's eyes," ought not to be set to music. The same applies to the poems of Hölderlin.

From the perspective of the Lied as its own art form, the best case occurs when a poem of greatest beauty and music equal or superior to it interpenetrate in the most intimate fashion, as in what may be Schubert's most beautiful Lied, *Suleika*. The text by Marianne von Willemer is so astonishingly in keeping with Goethe's spirit that he included it in his *West-Eastern Divan*, and everyone thought it was a poem by Goethe. Schubert's music has a wonderful poetry and depth. The unity of word and sound, the full elaboration of the artistic possibilities inherent in the Lied attain a high point in this Lied.

Even though the music is even more beautiful than the poem, each needs the other. This music is possible only as a Lied. The marriage is one between equals, but the result far surpasses what each individual could be on its own. It surpasses the poem qualitatively, and it surpasses the music because it is conceivable only as a Lied.

The artistic possibilities of the Lied come to expression in innumerable Lieder by Schubert, even when the poems lack artistic value of their own, but their content provides the music with an opportunity to develop the expression, mood, and ethos. This applies, for example, to the Lieder of *Winterreise*.

The text is certainly not merely a basis for the music, which enters into the text with all conceivable depth and empathy. The music thereby gives form to something completely new that is possible only as a Lied. Compared with what the Lied realizes as expression, mood, and depth, the poem is only a tool.

We want to emphasize one other important characteristic of the Lied: both a significant and an insignificant poem can stimulate a composer to the productive creation of something new.

Many composers never composed Lieder, even after the emergence

of the Lied in its typical intimacy. One example is Bruckner, for whom the Lied would not suit his entire makeup and character.

On the other hand, some poems invite certain composers to turn to this special art form. A talent and an organ are actualized, and a new dimension of their creative activity is opened up. For many composers, the Lied is only a small and relatively secondary part of their creative activity, while for others, like Schubert and Schumann, it is a very important part. For still others, like Hugo Wolf, the Lied is by far the most important part. The possibility of a *sui generis* inspiration by poems of a special kind of musical creation is not only interesting in itself, but also sheds light on the important problem of the conditions that make a poem a potential Lied, and why one significant poem allows the union with music, while other, equally significant poems do not.

The intimate character of the Lied

The final characteristic of the Lied to be mentioned is a certain intimacy. In the sphere of the union of word and sound, the Lied is the most intimate form. It is, as a general matter, interesting to ask what public a work of art normally addresses. We have in mind here the spheres of music and literature, although analogies to this also exist in other arts.

Poems are by their very nature more intimate than plays, and even than novels. One can indeed read plays, but it is only on the stage that they find their full realization. They require not only to be read but also to be seen and heard. Through the stage, they address a wide public. Novels can only be read, or perhaps read aloud. When one reads them, they address one individual; when they are read aloud, they address a small group. A poem can be read or recited. In a certain sense, it demands to be read aloud, simply because of the special function of the tone. The one who reads aloud usually addresses a small group.

In an analogous manner, an opera and a symphony address a wide public. Chamber music has a much more intimate character. But in the sphere of sound and word, the Lied is the most intimate of all.

CHAPTER THIRTY-SEVEN

The Folksong

Its anonymity and popularity

THE FIRST CHARACTERISTIC of the folksong is its anonymity, which is not, however, due to the fact that the author is unknown. It has an anonymous character in distinction to the Lied, which was created by a musician as a work of art, bears the stamp of his unique personality, and presents entirely different demands. In contrast, the folksong strongly reflects the specific character of the country and epoch in which it originates.

A second characteristic of the folksong is its simplicity. Folksongs always have markedly simple melodies that are easy to learn and sing. This simplicity contributes to their modest character.

A third important characteristic is the primarily social character of the folksong. It is an invitation to sing together. It contains a unitive element, creates a communal atmosphere, and brings people together. This social function must be sharply distinguished from the ability of great works of art to penetrate into the depths.

All high values have a *virtus unitiva*, a "unitive power."[1] This may

1. See *Metaphysik der Gemeinschaft*, chap. 8.

439

take the form of an inner community, even with people we do not know, when we hear a glorious symphony, a significant opera, or a great and profound music drama. Or it may consist in the shared experiencing of a moving drama or a morally stirring event. Or it may be in the religious sphere, above all in the shared celebration of the Holy Sacrifice of the Mass.

What we find in the folksong is not the *virtus unitiva* of lofty goods that permeates all spheres, but something much less deep, something not even determined by the beauty of the folksong. It possesses a special quality that invites one to join in singing. It does not lead us into the depth and in this way to community. Rather, it appeals to a benign, friendly sense of togetherness. This type of community plays a great role in the life of a people and is closer to the prevailing communal element in popular dances and festivals.

The typical folksong is something that has grown organically; it lacks the character of having been consciously created that dwells in all true art. This comes to expression in the way a folksong is spread and maintained through tradition. In this respect, it resembles something like the *Fairy Tales* collected by the Brothers Grimm rather than something made up and published by an author, such as those by Hans Christian Andersen, Wilhelm Hauff, and others. Unlike the Lied by a great master, the folksong does not address a public. And unlike the Lied, it does not spread through its significance and beauty. Rather, it becomes established in an anonymous, unreflective form through a typical tradition. This is possible because of its simplicity and its highly popular character [*Volkstümlichkeit*]. It belongs in a special way to the people, and the author is unimportant.

This does not prevent a Lied by a famous artist from possibly becoming a folksong with the passage of time. Still less does it prevent the melodies and themes of folksongs from often being used in great musical works of art. But in these cases, they cease to be folksongs. Not only are they musically modified and enriched, becoming something new through the context into which they are inserted; they also become, in wholly formal terms, a part of a work of art with all its specific character-

istics: its conscious character, the claim it makes, its individuality. Such a song loses its anonymous, "innocent," social character. It no longer lives on the basis of a certain tradition. If it is a true work of art, the song, of course, gains enormously from an aesthetic point of view. Its melody acquires a much deeper and more serious character, and it becomes the bearer of a true artistic beauty. But this is not what interests us here. The point is that it loses its typical character and existence as a folksong and is incorporated with its melody into a work of art or, rather, serves this work of art in the construction of its artistic beauty.

The contrast between the folksong and Schlager[2]

It is particularly interesting to compare the popularity, the authentic life of the folksong that people usually learn and know already in their child-hood, with the popularity of *Schlager*. Like the folksong, the successful *Schlager* has a great and specific popularity. It creates a certain communi-ty of a very peripheral kind and has a different though also specific form of anonymity.

First of all, a *Schlager* lacks the element of tradition. Its popularity is generated artificially. This does not mean that it need not possess spe-cial musical qualities in order to become a genuine and widely diffused *Schlager*. But it appeals to other strata in the human person. As such, it frequently has a frivolous tone. It aims explicitly at the periphery, and the connection that it creates between people has nothing in common with the "innocent," harmless togetherness that is brought about by singing a genuine folksong.

Secondly, a *Schlager* is a typical child of fashion. Like fashion, it ex-presses above all the zeitgeist, but, of course, in a peripheral stratum. Its lifespan is short; it will very soon be replaced by another *Schlager*. It lives

2. [Editors' note: "Schlager" is the original German word used by Hildebrand. It appears un-translated in the text as there is no good English equivalent. "Pop music" comes close, but it is both too broad and too recent (Hildebrand says *Schlager* has been around about a hundred years). For all the similarities *Schlager* may have with better known American genres, such as country or easy listening, it is, in the end, a genre all its own. It is not difficult to see that much of what Hildebrand says about *Schlager* applies as well to much contemporary popular music.]

in a specifically interpersonal space. As with fashion, the attraction of the hit song is linked to its novelty.

The folksong lives from its permanence, from its tradition which stands apart from every fashion; it has the character of something long-known and long-established, and it does not in any way share the ephemeral character of the *Schlager*. *Schlager* has something sensational in its popularity, while the folksong certainly does not appeal to sensationalism. The *Schlager* has a great success, and its short-lived diffusion is a kind of triumph. It conquers a peripheral interpersonal space for a brief period. The folksong has no success and celebrates no triumphs. It attains its popularity and diffusion, not through this peripheral conquest but in an organic process and on the basis of its own qualities. Its unassuming character allows it to exist alongside other folksongs. Unlike a *Schlager*, it does not contain any competitive element. It is not by chance that to create successful *Schlager* is very lucrative, whereas the popularity of a folksong has no inherent relationship to the acquisition of money.

Schlager changes, as fashion changes, but the folksong resembles the old national costumes in their stability. The *Schlager* is a child of fashion, the folksong that of custom. Not only does the folksong exist as a communal experience, but it also grows out of specific situations in life and community and varies in accordance with these.

The various types of folksong

Let us begin by mentioning folksongs the theme of which is of a religious nature, such as the veneration of the Blessed Virgin. Singing together is an expression of the religious community, and this communal situation naturally imparts a qualitative characteristic of the folksong. Its melody must possess qualities that allow it to be an expression of this situation. Religious folksongs often lack any true sacrality, neither that of Gregorian chant nor the sacrality in certain sublime pieces of music—not just works with a religious content, such as in Bach's *St. Matthew Passion* or Beethoven's *Missa solemnis*, but also in Bruckner's symphonies. The qualities required for religious folksongs are much more modest.

The point that chiefly interests us is that there are folksongs in a variety of styles, in keeping with the theme of the text and with the situation for which the folksong is intended or out of which it grows.

The soldier's song is a type all its own. Here the rhythm is important, since its task is to make it easier to march and to keep the soldiers in a good mood. The overall situation, especially in war, also comes to expression in this type. It possesses all the qualities that we have mentioned as essential traits of the folksong in general, and it has a special character that marks it precisely as a soldier's song. The text plays a decisive role in this difference, of course. Indeed, it influences the character of the soldier's song even more strongly than the music. One soldier's song in which the text is particularly prominent is the famous *Ich hatt' einen Kameraden* ("I once had a comrade").

In keeping with its simplicity, the union of music and word in the folksong is much less differentiated than in the artistic Lied. The words play an important role. All folksongs possess a strong mood [*Stimmung*], and it is the quality of this mood that distinguishes the various genres of folksong. What is thematic for a folksong is not beauty but the mood that is determined by a particular situation and by the text. The folksong aims above all at a certain expression. Its popularity is determined by its ability to suit the situation and by its strong expression. If it is beautiful and truly poetic, this is a precious bonus, but it is not explicitly the theme of the folksong, as it is in the artistic Lied. Its modest, ancillary character is its *raison d'être*.

Student songs resemble folksongs. The community is formed by the context of university studies, by the joyful anticipation of the life that lies ahead of the students, and by the independence of the young person who has grown out of his or her earlier upbringing with its restrictions. This usually gives student songs a cheerful, joyful quality. Unlike the soldier's songs, they have no auxiliary function but are more a free expression of the student's overall situation, of this period in life and the community it creates.

Yet another type is to be found among the charming lullabies that seek to calm a child and get him to sleep. Their character is colored

by the situation. They do not create a community, and by their nature they are meant not for singing in common but for solitary situations. Nevertheless, they possess the popularity and the anonymous and modest character of the genuine folksong. Their words are filled with the expression of emotional security.

Children's songs are meant for singing in common and have a full communal character. They introduce the child into the world of music or, rather, of singing, which for most people is a primordial need [*Urbedürfnis*]. Besides this, they serve to build up community. These songs are not limited to the time of childhood. They are mostly folksongs that can be sung at every age and are also suitable for children, at least from their sixth year onward. Their texts are about a great variety of things, especially nature and the great themes of life. Examples include *Der Mai ist gekommen* ("May has come"), the French folksongs *Au clair de la lune* ("In the light of the moon") and *Les lauriers sont fanés* ("The laurels are faded"), and the Italian *Tutti la notte dormano* ("All night they sleep"). In most instances, these folksongs, since they are not formed by a particular situation, have a markedly poetic quality.

Finally, we must mention all the folksongs that are about the great, central theme of life, namely, love. *Cantare amantis est* ("singing belongs to the one who loves") applies in the modest context of the folksong too, where it is not a question of the love of God or of the artistic depiction of all aspects of the great and profound love between a man and a woman. The sweet, delightful light of love, which suffuses life, sometimes as expectation and yearning, sometimes as fulfillment, finds its expression in the folksong, just as, of course, unhappy love, the tears of love, do as well.

The folksong is an expression of the primordial need to sing, a need that is alive in everyone who is not completely unmusical—even in those who sing out of tune. The longing to raise one's voice in song, this most basic expression of true feelings, makes itself felt in a special way in the folksong. This longing is much more thematic in the folksong than is beauty, which is the primordial theme of all artistic music.

The value of the folksong is not primarily an aesthetic value

It would be completely wrong to see in the anonymous, modest character of the folksong a special aesthetic value. We have indeed emphasized that the value of a work of art certainly does not consist (as many people hold) in an objective expression of the personality of the artist. On the other hand, one should not regard as a disvalue the fact that the specific character of an artistic and also human personality finds expression in a work of art. On the contrary, this belongs entirely to a genuine work of art.

Many—not only the adherents of the *Blut und Boden* ("Blood and Soil") theory—confuse the objective artistic value that a genuine work of art possesses independently of its reflection of a personality, with anonymity. They believe that the advantage of the *genitum*, "that which is born," over the *factum*, "that which is made," is connected with anonymity. Hidden behind this view lies a collectivism. The community, as that which is nobler, "more innocent," and less subjective, is contrasted with the individual person. This is obviously a terrible error. As a conscious person, the individual personality stands on a higher level than all merely natural communities. To regard it as something subjectivistic, on the grounds that only the individual personality can degenerate into the disvaluable attitude of subjectivism, is just as foolish as if one were to place the human person below the animals, on the grounds that only a person is able to commit sin and to be stupid, mediocre, trivial, and tasteless in the full sense of these terms. This is to forget that the qualitative values and disvalues of a being are greater the higher its ontological status. This means that the human person—who as a free and spiritual being is from an ontological point of view incomparably superior to all apersonal beings—may also corrupt and renounce the truth and turn to sin. But this possibility does not affect the ontological superiority of the human being, nor his or her ability to be the bearer of incomparably higher qualitative values.

All these aberrations lurk, often unconsciously, in the cult of the anonymous, modest, organic character of the folksong. In reality, the

folksong has certain limits from an aesthetic point of view. It can never rise to the value of a real work of art. Its modesty is also a modesty from the perspective of its artistic value. It does not claim to be a work of art, and it can never possess the beauty, depth, greatness, and perfection of a work of art. It would be unjust to the folksong to expect of it something artistic in the full sense of the term. Just because a melody and its text are beautiful and poetic does not make it a work of art like the Lied by a great composer. Indeed, part of the charm of the folksong is that it does not, in principle, claim to be a work of art. If a folksong degenerates into pure sentimentality and facile triviality, it is far less grave than in the case of a Lied that was created as a work of art. A folksong does not thereby completely lose its significance, its social function, and so on, since its theme is precisely not artistic beauty.

This is not in any way meant to deny the charm and value of the folksong. It is only to say, first, that its value is not an artistic one and, second, that it belongs to a family of values that, as a whole, is much humbler than that of real artistic values. It is also interesting that there is no counterpart to the folksong in the visual arts. In conclusion, we must say that the value of the folksong is not even a typical, exclusively aesthetic value.

Popular local songs

We have already mentioned *Schlager* and its radical difference from the folksong. We now wish to discuss a third type of popular music, which differs both from the folksong and from the typical *Schlager*, namely, popular songs that above all depict the atmosphere and charm of a city, that is, of the life that takes place there and its distinctive quality. Of course, not all cities have a countenance that is distinctive in this regard. Innumerable Viennese songs and some Parisian songs convey the charm, the completely distinctive, differentiated, strong cachet of these cities. It would, indeed, be an interesting task to identify the cachet of the capital cities of various countries, the specific quality and atmosphere that are expressed in their cultural life, architecture, history, and whose significance for a country extend to the customs, clothing, and cuisine of

their inhabitants. We must limit ourselves to the songs that convey the atmosphere of such a city. They are analogous to the dialect spoken in the given city, and their texts are usually written in this dialect.

Local songs do not have an anonymous origin but are the invention of well-known persons. They hone in on the character of a city, its distinctive mark, its sense of life. The charm of its world (for example, the world of Vienna) may be depicted more or less well, but to depict it is the real *raison d'être* of such songs. It is true that in word and music something is always created that possesses an independent new theme, but these songs must embody the spirit of the people of a given city; they must emerge from this spirit and represent it in a typical manner.

The value of such local songs depends, firstly, on whether the atmosphere of a city in its popular stratum has a genuine charm, whether it is aesthetically appealing and enchanting, so that it fascinates us.

When we speak of this cachet and this atmosphere, we do not refer to the higher spiritual content that some cities exude. There is a lofty and intoxicating spirit in a city like Vienna, with its glorious architecture and great cultural history. It is the city of Haydn and Schubert, the city in which Mozart, Beethoven, and Bruckner worked, the city of Prince Eugene, the city of Nestroy and Hofmannsthal. This city and its history are themselves a wonderful monument in their cultural unity, a glorious encompassing cultural milieu [*Gesamtgebilde*].

The *Fiakerlied, Mei Muatterl war a Weanerin, Ich hab mir für Grinzing an Dienstmann engagiert*, and many other songs about Grinzing and Vienna do not, of course, embody this grand, exalted world of Vienna, but rather a stratum of the life that takes place in this city and possesses a less sublime cachet. But this is a popular, endearing, and indeed enchanting world that finds expression in the way people speak, in the dialect and inflection, in the kind of entertainment, in jokes, in the specific sense of life, and in the kind of humor.

What charm Paris possesses in this regard! How one is captivated by its individuality, its unparalleled spiritual vitality, when one walks through its streets! This brings us to an important element in the countenance of a city: under certain circumstances, it becomes something

personal, so to speak, that we address as a "you," that we love, and, indeed, that we can fall in love with. We have in mind not the love that grows from the fact that this is our own hometown,[3] but the strong, individual atmosphere of such a city and the personification that derives from this objective atmosphere.

In many countries, it is not the capital that has this pronounced, personified countenance. For example, in Spain, we find it not in Madrid, but in Valladolid and Seville. In many cases, such cities, with specific countenances of their own, were once capitals: in Italy, in addition to Rome, we have Venice, Milan, Siena, Florence, and Naples. In Austria, this full individuality exists not only in Vienna but also in Salzburg, Innsbruck, and Graz. In Germany, in addition to earlier seats of royal power such as Munich and Berlin, cities such as Cologne also have this strong individuality.

In all these cities, we breathe their own particular air. For the first and decisive factor in the value of local songs, not only is a strong, personified atmosphere important, but also the kind of charm and poetry they possess.

We must distinguish between the cachet of these cities and the beauty and lofty spiritual world that they possess through their surrounding landscape, their architecture, and their history. With regard to the beauty and nobility of the whole city, those we have mentioned in Italy surpass most other cities in the world, but this has no decisive influence on the popular songs. Only in certain cities—in Italy, above all in Naples—does the atmosphere and rhythm of life find expression in local songs.

The second determining factor for the value of these popular songs is, of course, the extent to which their creator was able to embody this charm in them.

The third factor is the extent to which a song is successful in both its words and music, in distinction to boring, unsuccessful popular songs.

Local songs are unpretentious. They do not aspire to be artistically valuable as a piece of music or as a text. They do not aim at beauty,

3. See *The Nature of Love* (South Bend, Ind.: St. Augustine's Press, 2009), chap. 8, 185ff.

and still less at beauty of the second power. Rather, their intention is to transpose us into the world, the feeling of life, and the humor of the city. In the case of Vienna, they also intend to amuse us. These songs are a form of light music that appeals to a legitimate center in us—neither to sensationalism and sentimentality, nor to impurity and an embarrassing "letting oneself go."

Popular songs have a *raison d'être* and a specific value. They belong not to the realm of art but to that of real life. They enrich the peripheral life of given city; as a definite aesthetic value they strive to reflect the charm of this city and in a particular way to make us happy.

They differ from typical *Schlager* in many respects. First of all, *Schlager* address a center that is more or less illegitimate. *Schlager* are characterized by a certain specific worldliness, a certain triviality in the text and music.

Secondly, *Schlager* characterize an epoch rather than the atmosphere of a city. Certainly they can betray their origins from a particular city, but in themselves they stand on an international level. The way they reflect an epoch is not an embodiment of the atmosphere and the sense of life of a city. They do not genuinely reflect the atmosphere of a specific period, and their relationship to the epoch in question is much looser. Although there is an unmistakable difference between *Schlager* from the end of the nineteenth century and those from the 1920s, one cannot say that a *Schlager* typically depicts the respective epoch.

Much more striking is that *Schlager* by nature is ephemeral. Its characteristic specific effect, its public quality, the fact that it is fashionable and sung everywhere for a certain period, that it is known to everybody, and celebrates a cheap triumphal procession—all these factors permit it to exist only for a short time, like fashions in clothing. A *Schlager* is a flash in the pan. People dance and listen to it as light music in cafés and restaurants. It is sung and whistled on the streets. As Furtwängler emphasizes,[4] *Schlager* brings about a cheap community where people meet at a peripheral though nevertheless shared level and in a superficial mutual understanding.

This essential ephemerality not only constitutes the utter antithesis to

4. On this, see his 1939 lecture "Anton Bruckner," in *Ton und Wort*, 114.

great, timeless music; it is also foreign to popular local songs. These too may indeed be better known for a certain time, as long as they are new, and less well known at a later date. But according to their meaning and nature, they are not bound to this ephemerality. They belong to the tradition of a particular city, and they retain their meaning and value even when they have become part of a tradition. They do not aim to triumph on the international stage. They have an intimate character.

Above all, the aesthetic character that is their distinguishing mark is completely different from that of the typical *Schlager*. The popular local song often possesses a gracefulness and a delightful charm that is precisely the charm of a city's atmosphere of life, but this is impossible for the *Schlager*, which does not even aim at this. *Schlager* not only stands even further removed from all art, it is in fact antithetical to artistic beauty. Although the popular local song also stands outside the world of art, it is not antithetical to this world.

Popular local songs have existed for a long time, although their musical character has changed greatly over the course of time. *Schlager*, by contrast, have probably existed only for about a hundred years. Local popular songs have their full *raison d'être*. When they are truly successful, they are a special enrichment of life in certain cities. Their aesthetic value is modest, but it does exist. It is as far removed from beauty as mere elegance.

That the existence of *Schlager* is an enrichment is not an assertion we wish to make. Their antithetical character to the world of art suffices to make such an assertion seem questionable. To determine whether they inflict more damage than positive entertainment, one would have to analyze precisely the need for *Schlager* and the effect that they have. One can say with certainty that *Schlager* songs in most cases are definitely trivial and thus constitute something negative from the perspective of artistic beauty. But must they be trivial in order to be good and effective *Schlager*? Do they not contain an element of impertinence, or does this hold good only of certain *Schlager*? Do they not draw us into the periphery in the negative sense of the word? What function do they fulfill? To discuss all these questions is unfortunately not possible in the present context.

Opera

In a literary work, where not just the author but the characters speak, a new connection comes into being between the words and the persons. The figures characterize themselves. This applies especially when the character in a novel and above all in a play utters sentences that are an expression of his feelings or a declaration of his affective responses. Through this connection with the fictitious person, what is said becomes something uttered by a particular human being.

The representative power of music in opera

In opera, the music participates in the concrete, immediate connection with the fictitious-real human being. Unlike words, music does not have to pass through the intellectual process of rationally meaning something in order to establish a link to the affective sphere of the human being. Music can express this sphere immediately, and this gives a special character to the close union with an individual character in the opera. Not only are the words sung by this character linked much more precisely to the affective sphere than in absolute music, they are utterances of a particular personality. When Figaro in Mozart's opera sings, "Se vuol

ballare, Signor Contino" ("If you wish to dance, my Lord the Count"), this aria appears as something uttered by a particular human being, something united to his feelings, responses, and moods. This can be seen even more clearly in Cherubino's aria, "Non so più cosa son, cosa faccio" ("I no longer know what I am or what I am doing"). The expression acquires a new reality through the music, which, moreover, characterizes this figure in an extremely vivid way.

This brings us to a highly central dimension of music in opera, namely, its dramatic potentiality in the narrower sense of the term, the potentiality that discloses to us the "pre-established harmony," not only of word and sound, but of music and drama. We have in mind music's ability to use its own means for the artistic representation of a personality, characterizing him completely and making him come alive.

When we compare the figures of Figaro and Cherubino in Beaumarchais's comedy with those in Mozart's *The Marriage of Figaro*, we apprehend clearly the decisive role played by the music in these figures in their full charm and sharply defined character. It is the music that gives them their full life. This is even truer for Leporello in Mozart's *Don Giovanni* and for Don Giovanni himself. In comparison with these two artistically enchanting characters in Mozart's opera, the Don Giovanni and Leporello in da Ponte's text are only weak figures; Don Juan in Molière's *Le festin de pierre* is only a foreshadowing compared to the "true" Don Giovanni in Mozart's opera.

This, of course, does not mean that a drama can be perfectly fashioned [*dramatische Gestaltung*] only with music, or even just that the artistic fashioning of a personality is always heightened through music. On the contrary, it is obvious that the dramatic fashioning of a personality can reach the greatest heights in spoken drama. We have only to recall Shakespeare's characters, Hamlet, King Lear, Macbeth, Julius Caesar, Cordelia in *King Lear*, Viola in *Twelfth Night*, Rosalind in *As You Like It*, Portia in *The Merchant of Venice*, or Falstaff in *Henry IV*, and Gretchen in Goethe's *Faust*, to see that the pinnacle in the dramatic fashioning of personalities has been attained by the word alone. Music is often incapable of heightening the fashioning of the drama; on the contrary, these

figures would in fact lose something if music were added. As felicitous as the marriage of word and sound can be in opera and music drama, it is not possible with every play. Only very particular plays are suited to this marriage. For many plays of highest perfection, it would be a disaster.

This applies not only to the fashioning of characters in a play but also to its artistic content, to the dramatic structure of the whole, the atmosphere, the tragedy, the comedy, and much else. Consider the poetry of the situation in the forest of Arden in Shakespeare's *As You Like It* or the dramatic tension in *Macbeth* when Banquo's ghost appears to Macbeth as he sits at table.

But when a play has a character that meets certain preconditions, the music has an unparalleled dramatic ability, not only for giving unique expression of the affective sphere but also for fashioning the individual characters.

We have recognized the highly important function of expressed metaphysical beauty [*ausgedrückten metaphysischen Schönheit*] in several artforms. We do not find it in literature, where instead we find metaphysical beauty as such in the characters, in their personalities, their attitudes and deeds, when the representation is entirely successful and the necessary artistic transposition has occurred. Expression in the narrower sense does not even come into question since a novel or play presents personalities and their inner life only insofar as they are described [*rein geistig*]. Expression in the narrower sense exists only in a play performed on stage, that is, in the expression of an actor's face, sound of voice, inflection, and gestures.

In music, on the other hand, expressed metaphysical beauty is united with the immediately given beauty of the music itself. The term "expression" should no longer be understood here in the narrower sense.

We have also seen that the outstanding value of living characters in a play does not always presuppose their metaphysical beauty. The representation of evil characters, terrible passions, and appalling deeds can also make an essential contribution to the artistic greatness and beauty of a play. In the same way, comical figures with weaknesses of all kinds and characters in their profoundly human imperfection are a source of great artistic values when they are appropriately represented.

Music is capable of wonderfully representing such characters. We are not attracted to Don Giovanni in Mozart's opera by any metaphysical beauty, or by the fascinating power of attraction he possesses for Donna Elvira and Zerlina, but by the artistic treatment of this figure. We are fascinated not by his boldness, immense vitality, and zest for life, which as extra-moral values attract and deceive many people in the real world, but by the figure with all these qualities, with his great moral disvalues, as presented in the opera *Il dissoluto punito ossia il Don Giovanni.*[1] The figure of Don Giovanni is primarily constructed through the music. This is especially true for Leporello, in whom we find masterfully presented a unique combination of traits that recall Sancho Panza but with a timorousness and skullduggery completely foreign to Sancho, all given through the music. This music, however, is always music with words. Absolute music could never present such a figure of Shakespearean vitality, classicism, a character so perfectly captured.

What a gift—apart from the beauty of the music as such, as in the arias of Don Ottavio and in the final aria of Donna Anna in *Don Giovanni,* a beauty that can be expressed to the highest degree in music alone—that there are operas in which this entirely new artistic value of the dramatic fashioning of characters through music comes into its own. Undoubtedly this applies not only to the fashioning of characters but also to the representing of the "world," the atmosphere of the drama. How wonderfully in *Figaro* the unique world of the castle, with the servants, the garden, and the many elements of nature is given through the music. How incomparable the stylistic unity of the music that makes this work a perfected whole of highly distinctive character, a fully individual work through which the world is enormously enriched.

The music also makes a decisive contribution to the fashioning of situations and their dramatic development. The atmosphere of a situation in a drama or play, both the poetry and the dramatic tension, can be given by the music in a unique way. Let us take the second act of *Figaro* as our example: the disguising of the page, Susanna's aria, the arrival of the

1. [Editors' note: "The dissolute man who is punished, or Don Giovanni," a reference to the full name of the opera.]

Count, the page hidden in the adjoining room, and all that ensues until the gardener comes and complains. First, we have the poetry in Susanna's aria, and finally the incredible intensity of the dramatic heightening in the music with the incomparable theme, "Consorte mio, giudizio!" ("My wife/husband, be careful!"), also in the orchestra, and somewhat later in the theme, "Mente il ceffo, io già non mento." ("My face may be lying, but not I"). The dramatic content of these themes is of exceptional power. Apart from the beauty of the music as such, the fashioning of the situation by the music possesses its own value, a value that absolute music cannot have. When Susanna emerges from the locked adjoining room and sings, "Quel pagio malnato, vedetelo qua" ("That low-born page you see before you"), there is a special charm in the incomparable theme that expresses surprise in this dramatic situation. This charm would be completely absent if the theme occurred in a symphony or a string quartet.

All of these examples show us clearly the special value that adheres to the fashioning of drama through music. This does not mean that a drama, play, or comedy are incapable of expressing an ultimate beauty that no music could heighten. The same is true of absolute music. There is no more intense poetry than the first theme in the first movement of Beethoven's seventh symphony, in the second movement of his String Quartet Opus 132, or in the "Danza tedesca" in Opus 130.

Music also shares in the overall construction of the drama, according to the degree of the interpenetration of music and drama. We shall see this shortly when we discuss the fundamentally different types of opera, that is, the different types of connections between music and drama. At present, we simply want to point out the fundamental ability of music to take part in the inner construction and in the course of what happens in the drama and to represent these in a vital manner, as in operas like *Figaro*, *Don Giovanni*, and *Fidelio*, and in Wagner's music dramas, especially in *Tristan und Isolde*.

In a perfect opera, the music of the first act belongs only in this act. The same pieces of music could not occur in the second act. Just as the windows on the first or second floor of a palace belong there, and not on the third floor, so too this music belongs in the first phase of the opera,

not later. The music that introduces the third act of *Tristan und Isolde* necessarily occupies this place, which is a special phase of the drama. What a difference between the representation of the sea and its surging waves in the third act and the representation at the beginning of the first act.

The special quality of music is uniquely capable of structuring the inner development of the drama. Nothing would be more absurd than to believe that the text merely provides an occasion for beautiful music. The music in an opera or music drama is capable of expressing the same things that the words utter; in fact, it can do all this in a way that far surpasses the words—but not outside the drama or, rather, not as absolute music. Even in passages without words, music is capable of expressing exceptionally the special atmosphere of the drama as a whole and all its individual phases.

The ability of music to represent the elements of nature [*Naturwelten*] also occurs in opera. As we have seen, absolute music sometimes reproduces natural phenomena brilliantly. One example is the thunderstorm and the carefree delightful tranquility after the storm in Beethoven's "Pastoral Symphony." It would be wrong to regard this as a mere imitation. On the contrary. Not only is the external natural phenomenon illustrated, but also the deep mystery and the worlds therein are wonderfully represented with purely musical means. Even though the immediately given beauty of the music remains the main theme, the treatment of this natural phenomenon, its representation, is nevertheless the bearer of a special artistic value.

The capacity of music to represent natural phenomena and their profound contents naturally gains new possibilities for development in the context of opera; the same is true for all the dimensions of expression we have already mentioned. We have only to recall how the primordial phenomenon of flowing water, of waves, of the sun as reflected in the Rhine, are given at the beginning of *Das Rheingold*, or how the thunderstorm at the end of the same opera.

The union of sound and word is indeed the wellspring of a whole wealth of artistic values. It makes possible the realization of an immeasurable wealth of new artistic values that can unfold only in this way. In

addition to these new expressive dimensions in music, we have already pointed out music's unparalleled power to construct a drama, to fashion personalities vividly, and to express the innermost genius of a drama.

All this will emerge still more clearly when we discuss the various types of operas in which the union of text and music take entirely different forms.

Of course, we can consider only some principal types that merit special interest from the essential standpoint of the union between word and sound, and that shed special light on the specifically new element in opera as distinct from pure music and from drama without music. Important also, beyond the relationship of music and text, will be the various degrees of perfection of an opera *qua* opera.

Recitative, aria, and melodrama

Compared with a text that is only read, one that is spoken aloud is heightened in a unique way; it gains in importance. This is true above all in the liturgy.

A further degree of heightening lies in recitation *tono fermo* on a particular note. The articulation of the sentence is here less differentiated, however, on account of the unchanged note, much like the sound of an organ. While the individual word loses gravity, the overall solemnity is enhanced. The accentuation and varying intonation of speech is replaced by a special stability and an increase in the tonal element. The sound of the word is joined by a new kind of audible element: the musical note, which represents a particular enrichment. In a purely literary work of art, recitation would be completely inappropriate. It would have a disturbing effect on the reading aloud of a poem or novel, or on the performance of a play. At most, it might come into consideration in the case of an epic. This form of union between word and sound is appropriate in the liturgy during the recitation of the Psalms, and also in oratorios.

A heightening over and against the *tonus fermus* occurs in the sphere of sacred music with a certain stylized [*stereotype*] modulation, which periodically raises and lowers the note. We find this in many readings and

in the words of the Gospels, the Lord's Prayer in solemn divine office, and in the Holy Mass.

From here, one path leads to the full development of *melos*, the sung musical line, in Gregorian chant and another to Passion music and oratorios.

In the present context, we are interested in the line that leads from the *tonus rectus* to the recitative[2] in opera. In the simplest form of recitative, the recitation of the text stands entirely in the foreground. This is not a heightening of the solemnity, as in the *tonus rectus*. Rather, the modulation of the notes follows the meaning of the words and lends them a special quality through the notes that are sung. This simplest, stylized recitative has neither a melody nor a theme; it is a mere modulation and thus has no real expression. The notes vary only in a formal and stylized way through height and depth and through forte and piano. While this recitative has a certain inflection, it lacks the fullness and differentiation of inflection in the spoken word. In many respects, it actually constitutes a loss in comparison with the spoken word.

This recitative, which is found in operas by Handel and prior to him, is justified by the fact that the opera as a whole emerges from the world of the spoken word, and that one remains in the world of the sung word for the sake of certain stylistic requirements and to avoid the harsh transition from the merely spoken word to the aria, duet, or chorus.

We must distinguish between simple recitative and the *secco* recitative, which is similar to it in many ways but displays a new and stronger stylization, a more decorative character, and thereby perhaps also a stronger atmosphere of its own. Already in purely musical terms it has a certain atmosphere, although one that remains quite formal and stylized. We find *secco* recitative in eighteenth-century Italian opera and, above all, in many of Mozart's operas.

2. [Editors' note: Recitative follows the natural accentuation of speech. It differs from pure music in that it lacks the fixed division by bars, that is, the exact rhythmic organization by means of temporal units. The changing pitch is, however, prescribed. In *secco* recitative, the singing voice is supported by short (dry) chords. It takes the place, so to speak, only of the spoken word, as in Mozart's *Figaro* and *Don Giovanni*. In *accompagnato* recitative, the accompaniment takes on a greater importance, and the singing voice can at times be given a melodic shape.]

Completely different from these two forms of recitative, which re-
place the spoken word for the sake of stylistic unity, is the *accompagnato*
recitative. This represents a marked musical creation and has a new char-
acter, depending on where it appears, whether in Bach's oratorios and
cantatas or in Mozart's operas. This type of recitative bears an analogy
to the prelude. It has a full melody, though in a form other than the aria,
and it can be a bearer of the highest musical beauty. The term "recitative"
is in fact misleading here, since it is a radically different musical structure
from the two other types of recitative we have just mentioned. "Recita-
tive" expresses only its particular union of word and sound, in distinction
to the aria, duet, trio, or chorus. Let us consider the glorious recitative
in Johann Sebastian Bach's *Christmas Oratorio*, "Nun wird mein liebster
Bräutigam" ("Now my dearest bridegroom"), which precedes the aria
"Bereite dich, Zion" ("Prepare yourself, Zion"), or the moving recitative
in the *St. Matthew Passion*, "Ach Golgatha, unsel'ges Golgatha!" ("Oh
Golgatha, calamitous Golgatha!"), or "Am Abend, da es kühle war, ward
Adams Fallen offenbar" ("In the evening, when it was cool, Adam's fall
became manifest"). Clearly these are musical structures of the greatest
beauty and significant musical ideas. The relationship of word and sound
is different from that in the aria that follows. The same is true of the two
glorious recitatives Donna Anna sings before the aria, "Or sai chi l'onore"
("Now you know who tried to steal my honor from me") and before the
final aria, "Crudele? Ah no, mio bene" ("Cruel? Ah no, my love") in *Don
Giovanni*.

What formally distinguishes a recitative of this kind and the aria
that follows? Is the recitative another type of union between word and
sound? Certainly, the text is of greater importance in the recitative. In
the aria, the music in formal terms stands more in the foreground. In
the *accompagnato* recitative there still remains an element of recitation
[*Deklamierten*], while the ensuing aria is completely sung. The element of
the spoken word disappears in the aria, and the logic proper [*Eigenlogik*]
to the melody unfolds without any hindrance. This is even the case when
an aria gives highest expression to the theme and to the meaning of the
words. Even when an aria in an opera gives powerful expression to the

experiences of a character in the drama, indeed characterizing this figure in his or her specific quality, and so in a certain respect engendering a much deeper unity of word and sound, a greater interpenetration of music and drama, the purely formal difference between this fully musical *accompagnato* recitative and the following aria remains.

At the same time, this *accompagnato* recitative has the task of introducing the aria, just as analogously a prelude introduces a fugue. In its preparatory role, it has both a purely musical relationship to the aria and also, within the opera, the function of heightening the dramatic situation.

A melodrama[3] is a collaboration of spoken word and musical accompaniment. While it is far from having the same importance as the various forms of the recitative, it is an interesting possible collaboration of word and sound in which (unlike all their other unions) they remain completely separate. This unity consists exclusively in the special character that word and sound acquire in being side by side. This juxtaposition is such that it engenders a uniform effect, an enhancement of the mood. To be sure, melodrama has often been misused and in such cases can have an embarrassing, inartistic character. But it can also be a bearer of the highest beauty and have a powerful dramatic function in opera, as in the second act of *Fidelio* when Rocco and Leonore climb down into the underground chamber. The situation calls for this melodrama, which is the bearer of a great dramatic beauty.

We find a completely different union of word and sound, drama and music, in the Wagnerian music drama, which lacks both recitatives and arias. We shall discuss this kind of union in detail after we have investigated the principal types of opera, in each of which the union of word and music has a new character.

3. [Editors' note: Hildebrand is using the term "melodrama" in an older, nonpejorative sense.]

CHAPTER THIRTY-NINE

The Principal Types of Opera

FOR AN HISTORIAN of music, there are very different types of opera, and he will correctly identify many phases in its development. For a philosophical aesthetics, however, it suffices to identify those types of opera that present a fundamentally new union of word and sound.

The operas of Handel and Gluck

We have already mentioned the matchless aria at the beginning of Handel's *Xerxes*, the "Largo," one of the most sublime pieces of music ever to have been written. As is well known, the "Largo" is composed to a text, "Ombra mai fu" ("Never was a shade"), that does not in any way correspond to the content of the music. Even among the operas of Handel, this discrepancy is an exception.

Admittedly, the union of music and drama is very loose in Handel's *Julius Caesar*. The arias, choruses, and other pieces do not have a full dramatic function. The music of the arias fits the text according to whether it is joyful or sad, but with regard to the opera, it is rather the case that the text offers the opportunity to write a beautiful aria than that the

music shares in fashioning the characters, situations, and the dramatic construction. The union of word and sound reaches only to the point that the arias and choruses express musically the meaning of the words and feelings. The music itself does not share in the drama. This is all the more astonishing considering the strong interpenetration of music and word in Handel's oratorios. How uniquely the celebrated music from *Judas Maccabaeus* expresses the solemn, victorious character of the text! Above all, there is an incomparable marriage of word and sound in his *Messiah*.

We do not claim that the loose union between word and sound is found in all Handel's operas. In this regard, *Acis and Galatea* perhaps differs from *Julius Caesar*. Our aim is simply to indicate a particular type of union between music and text in which the music does not yet amount to a drama. That said, the music of the arias and certain expressive possibilities in the music are often inspired by the words and situations in the libretto of *Julius Caesar*.

We find something completely new as regards the union of music and drama in Gluck's operas *Orfeo ed Euridice*, *Iphigénie en Tauride*, and *Alceste*. To begin with, the music conveys the world of the drama in a potent manner. Gluck succeeds in transporting us into a Greek world, but not the world of Homer or the Greek tragedians, nor that of Aristophanes, but a strong atmosphere full of poetry, nourished by the spirit of classical antiquity as seen with the eyes of the Baroque period. It is not by chance that Gluck chose only classical material and that his music certainly would not suit the world of Shakespearean dramas such as *Othello*, *Romeo and Juliet*, or *Twelfth Night*. Each of these operas by Gluck, as well as *Iphigénie en Aulide*, has a uniform style that cannot be detached from the world of Greek antiquity.

Furthermore, the music fashions the situations in *Orfeo ed Euridice* in a significant way. How splendidly the music expresses the contrast between the chorus of the Furies and the moving song of Orpheus, full of gentle grief! It is a grand, dramatic contrast that the fashioning power of the music [*Gestaltungskraft*] brings out fully. Consider also the expressive intensity in the first chorus at the beginning of the opera! How remarkably the music expresses the atmosphere of grief, including the

classical aspect of death! How the music conveys the unique poetry of the situation!

One of the most striking traits of this opera is the unique spiritual beauty of the music itself, the beauty of the second power (which absolute music can also possess to the highest degree).

For our present context, the factors of critical importance relate to the union of music and word, that is, of music and drama.

In *Orfeo ed Euridice* we experience how powerfully the music, itself so sublime, can fashion the drama [*formgebende Kraft*], how it far surpasses the text in conveying the particular mood of mourning in the drama, how intensely it expresses Orpheus's pain in the wonderful aria in the first act. The expression in the scene with Amor, who announces the consoling message, is completely different. It is true that the music of *Orfeo* does not yet possess the ability to form and depict living, fully delineated, individual figures like Mozart's Leporello or Cherubino. But the figure of Orpheus, as fashioned in the Greek world and depicted on reliefs in his poetry and as the classical representative of the grieving, loving husband, is perfectly captured in the music. The music does not form Orpheus, but, being already fashioned in myth, depicts him in a wonderful manner. It fulfills the demands presented by this figure.

How matchlessly the world of Elysium is given in the second act, with the idyllic beatitude and its poetry unfolding in the music in such a contemplative way. The expressive function of the music here is extremely significant for the representation of the situation presented in the text. This representation is fully present even in the musical interludes where there is no singing. Quite apart from their purely musical beauty, these interludes also bear the value that is the worthy and powerful representation of Elysium. All this culminates in the glorious chorus, "Torna, o bella, al tuo consorte" ("Return, fair one, to your husband").

The third act is not so rich in situations as the first two. The recitative, which is of the first, more stylized form, is almost always something of a filler. The full dramatic power of the music comes to expression in the celebrated aria, "Che farò senza Euridice?" ("What shall I do without Eurydice?"). This is not simply an aria of great musical beauty but

Orpheus's aria *par excellence*, his true voice, a full expression of his character, completely integrated into the overall style of the drama.

One could show something similar in the case of *Iphigénie en Tauride*, especially in Pylade's two arias, and of *Alceste*, especially in the great aria of Alceste.

For our present purposes, it suffices to point out the new type of union between music and drama in *Orfeo ed Euridice*, in which the music in many respects constructs the drama and exercises its depictive power. Certainly, this encompasses neither all the expressive dimensions of music nor its overall capacity for fashioning dramatic figures. But *Orfeo* already represents a marriage of word and music in which the music uniquely conveys the atmosphere of the entire piece and thus constitutes an important factor from a dramatic perspective. The artistic value of dramatic representation is already fully present here and complements the pure beauty of the music. What we receive in *Orfeo ed Euridice* could never be communicated by absolute music, which may be able to offer us something still more beautiful, but not this particular artistic value as realized in Gluck's *Orfeo*, since this can only be conveyed through the union of word and sound.

Mozart's operas

With Mozart, we have the start of a new type of opera. In reality, we find in Mozart four different kinds of union of music and libretto: the first in *Die Entführung aus dem Serail*, the second in *The Marriage of Figaro* and *Don Giovanni*, the third in *Così fan tutte*, and the fourth in *The Magic Flute*.[1] We will limit our discussion to the interpenetration of music and drama that in a great variety of modifications is characteristic of these works, especially in *Figaro* and *Don Giovanni* where it takes a completely new form.

In *Die Entführung*, the characters speak between the sung parts. Does the fact that the plot advances by means of the spoken word diminish the

1. On this, see *Mozart, Beethoven, Schubert*, 9ff.

unity of music and drama? Is this a weaker interpenetration? Is the music entrusted with a lesser share in fashioning the drama? Not necessarily, for it depends on the kind of drama. What is more, the music does not play a greater role through the use of *secco* recitative. All that one could claim is that the through-composed [*Durchkomponiert*]² music drama, as introduced by Wagner, presents a greater interpenetration of music and drama. But there are other reasons for through-composition, which we shall discuss when we look at Wagner's music dramas.

In the case of operas where the breaks between the arias, duets, trios, and so on, are filled by a stylized recitative [*stereotypes Rezitativ*] or a *secco* recitative instead of the spoken word, one cannot claim this guarantees a more intense interpenetration of music and drama. The fact that everything is sung does not as such equal a heightened interpenetration of music and drama. This depends much more on the style and spirit of the opera. A comparison shows that *secco* recitative, which is appropriate in *Figaro*, does not suit *Die Entführung*. The appropriateness of one or another recitative depends on the style, the ethos of the libretto, and on various other elements, that is, how the music in formal terms [*formaler Hinsicht*] fashions the drama. The spoken word has a dignity that neither the stylized recitative [*stereotype Rezitativ*] nor the *secco* recitative possesses. The stylization [*Stilisierung*], especially in the latter type, deprives the words of a certain seriousness. The intonation disappears, and the word becomes less expressive one in respect.

The libretto of *Die Entführung*, its special ethos, and the specifically personal quality of the music (this opera in a certain sense is a personal confession of Mozart's love for Constanze) exclude *secco* recitative. This conclusion is interesting, because it is characteristic for the general relationship between music and drama. It shows us the variety of factors that play a role from an artistic point of view, and the differentiation of the elements that are necessary for a happy marriage of music and drama.

For works such as *Die Entführung* and *Fidelio*, there are only two

2. [Editors' note: Wagner replaced the traditional division of opera into arias and recitative with a continuous flow of singing and orchestral music.]

alternatives, either through-composition[3] or words spoken between sing-ing. This should not be taken as expressing regret that *Die Entführung* or *Fidelio* are not through-composed like *Tristan* or *Die Meistersinger*. This would be a meaningless fiction, and they are as they should be. We mean only that a certain way of taking things seriously, an ethos of personal confession in the drama and in the music, is incompatible with *secco* recitative.

With respect to the interpenetration of music and word, we find in *Die Entführung* a completely new dramatic dimension of the music com-pared with Gluck's operas. The figure of Osmin marks the introduction of the dramatic representation of characters. It attains an even higher level in *Figaro* and *Don Giovanni*. This dramatic representation is closely tied to the presence of humor in the music, an element that plays no role in the type of opera that Gluck composed, even less so in Handel.[4] What a humorous note in the song of Konstanze and Blonde at the end of the second act, "Wenn unsrer Ehre wegen die Männer ... das ist nicht auszustehn!" ("When men become suspicious ... it is unbearable!").

Pedrillo and Blonde are living characters fashioned by the music. By contrast, the protagonists Belmonte and Konstanze are not fashioned into individual personalities, though love is wonderfully expressed in their arias. This expression is much more differentiated than in Orpheus's laments in the first and third acts. Without words, the music could never express concretely this ardor of a deep and noble love, filled with lofty moral nobility, above all in Belmonte's second aria. In Konstanze's aria, "Ach, ich liebte" ("Oh, I loved"), the music movingly expresses the moral nobility of her character.

Pedrillo's serenade, "In Mohrenland gefangen" ("In a Moorish land imprisoned lay"), is full of the dramatic power for shaping situations. How splendid the poignant musical theme in the scene where Belmon-te and Konstanze are captured and awaiting death. The music attains a tragic greatness, especially in the theme, which possesses a specifically

3. [Editors' note: Meaning an unbroken flow of singing.]

4. Humor already exists in operatic music, although not in such a pronounced form, in Pergo-lesi's *La serva padrona*.

dramatic power. Only in opera and music drama is music capable of this particular artistic value, which shows us the enrichment that the existence of opera represents from the musical point of view.

We have already pointed out the full development of the dramatic fashioning by the music in *Figaro* and *Don Giovanni*. These works attain a highpoint in the interpenetration of music and drama; not the absolute pinnacle, but an ultimate perfection of a dramatic kind. The music in these operas unfolds all its expressive possibilities and realizes in consummate fashion the characters, situations, worlds, and dramatic construction. Both works possess a Shakespearean potency.[5]

To offer one example, consider the graveyard scene in *Don Giovanni* and the confrontation between the Commendatore and Don Giovanni at the end of the opera. The dramatic power and depth of this music are indescribable. The music does not present the clash of these two worlds— of the Commendatore and Don Giovanni—independently of the text but instead, thanks to its greatness, raises up the text to its height. Thus, a perfect dramatic unity comes into being. One no longer thinks of the text and the music as separable. The drama in its totality stands before us in unparalleled, deeply moving power.

The importance of the libretto and its marriage to the music

This brings us to a central point, the importance of the libretto in the work as a whole [*Gesamtwerk*], to use an unattractive expression. To what extent does the libretto contribute to the artistic value of the whole? What value does it have in itself? To what extent does it give the music the opportunity to unfold all its dramatic expressive possibilities? What demands does it require the music to fulfill?

In all operas before Gluck, the text is of limited value.[6] It has more the function of giving the music an opportunity to unfold in the sung parts and to complement the beauty of the music itself with certain ex-

5. See *Mozart, Beethoven, Schubert*, 17ff.
6. We have in mind a type of opera like *Julius Caesar*. We do not assert that this applies to all of Handel's operas, for example, to *Acis and Galatea*.

pressive possibilities through union with the word. Music and drama remain relatively unconnected; the text makes only modest demands of the music. The entire artistic value lies in the music. The text constitutes nothing more than a basis. It is not a work of art in its own right, and it contributes relatively little to the beauty of the opera. At most, it creates a general atmosphere, which is also given through the historical framework of the opera. Despite the beautiful music, there is no genuine union between music and text. The result is not a real opera.

In Gluck's opera *Orfeo ed Euridice*, however, the libretto already attains a higher level. Its poetic treatment does not yet stand on its own artistically, but the underlying tale is itself of great poetry. The tale had already been set to music before Gluck, notably in the beautiful work by Monteverdi.[7] The myth itself has a certain classicism and is a bearer of artistic values. This is why this tale makes great demands of the music, which forms the opera as a whole and fashions it into a magnificent artistic structure. Although the music does not yet develop all dramatic possibilities, it fully realizes the possibilities offered by this tale, such that a significant dramatic work comes into being.

In itself the poetic setting is insignificant and would never be viable as an artistic structure of its own. It does not, however, contain anything that prevents the development of the story's central theme through the music. On the contrary, it gives the music an excellent opportunity to unfold this genius in all its classicism, poetry, and depth. This already constitutes a much closer union of music and libretto.

With Mozart, the libretto in *Die Entführung*, and even more so in *Figaro* and *Don Giovanni*, is of a different nature. It is not itself a work of art, and even as a pure story it does not possess an artistically autonomous character [*selbstständigen Charakter*] like the myths of *Orfeo ed Euridice* and the two *Iphigénies*. But the libretto of *Die Entführung* is written to be complemented by the music and as such is completely successful. It contains a deep moral content, an enthralling dramatic plot, and characters that are particularly suited to being developed through music. In this re-

7. [Editors' note: A reference to Monteverdi's opera, *L'Orfeo*.]

spect, it is superior to the poetry of *Orfeo ed Euridice*, although it lacks the classicism and power of the tale of the latter. Nevertheless, it fulfills all the requirements for the new dramatic function of the music. The kind of poetry in the libretto of *Die Entführung* permits a profound interpenetration of music and text. Although the artistic value of the whole derives in an incomparably higher measure from the music, and this music is the soul of the full reality, viability, and beauty of the opera, the text marvelously fulfills its task. It is indispensable and satisfying, making an important contribution to the spirit and beauty of *Die Entführung*.

The text in *The Marriage of Figaro* is more autonomous. Mozart had da Ponte revise Beaumarchais's comedy *Le mariage de Figaro*, which even without music is fully alive in its own right. But Mozart made something incomparably greater out of it: he took a delightful, amusing comedy, full of charm, to create a great masterpiece of ultimate beauty and poetry, spirit and depth. This comedy is uniquely suited for such a perfect musical creation. The music not only transcends all the demands of the text but also fashions a perfect dramatic structure out of the libretto. The music, of course, rises to heights that are incomparably superior to what the charming comedy offers. But quite apart from the beauty of the music itself, from a purely dramatic point of view everything in *Figaro* develops in a new way. The music does not use the text as a mere opportunity to unfold. This is of great significance. Rather, text and music interpenetrate completely. The music takes the text with full seriousness and makes it into something incomparably more perfect. We have here the rare instance of an ideal marriage between music and poetry, although the music is immeasurably superior. The music not only uses the text; it fully integrates the poetry into the great work of art that is the opera *The Marriage of Figaro*.

In general, an autonomous literary work will to a greater or lesser extent be edited for use in an opera; some changes, both smaller and larger, are made. This fact sheds light on what makes for a felicitous collaboration between music and drama. The modifications necessary for the collaboration between word and sound reveal how many conditions must be met for a happy marriage between music and drama.

Don Giovanni differs from *Figaro* in that this libretto by da Ponte is not based on a drama that can stand on its own, although there are several plays with the same story, such as Molière's *Le festin de pierre* and *Don Juan Tenorio* by the Spaniard Zorilla. Da Ponte's libretto is not merely a modification of this story, but something new. The story of the rake who gets punished has an important content that makes demands of both the poetic creation and the music. It contains an immense potential for artistic development. Da Ponte's libretto is explicitly written to be fashioned by the music. It is thus neither a play nor a work the only purpose of which is to enable beautiful arias, as in operas prior to Gluck. The libretto is brilliant insofar as it enables the music to unfold the full range of its dramatic powers and its expressive dimensions. This particular setting of the story holds a great dramatic potency, which the music can actualize in an ideal manner. This is why the libretto is treated with complete seriousness by the music, and functions as the backbone, so to speak, of this great and moving drama. Sound and word interpenetrate totally. In Mozart's most important operas, the choice of the libretto is itself a revelation of his genius.

Beethoven's Fidelio

The libretto of Beethoven's *Fidelio* is not a play that would be viable as a purely literary work. But it has a high moral content and a human depth that offer the music a unique possibility for development. It is exceedingly characteristic of Beethoven that he chose this hymn in praise of wedded love as the theme for his opera.[8] This libretto, which is less refined and dramatically formed than those of *Figaro* and *Don Giovanni*, has an enormous dramatic potency and provides the music a basis for a completely new expressive dimension. Particularly interesting is that the music "speaks" a completely different language and unfolds a different kind of dramatic art from that in Mozart. The characters are not fully

8. Gluck's *Alceste* is likewise a song of praise of heroic married love, but it lacks the sharp antithesis between good and evil. The breath of morality does not breathe through the whole work, as it does through *Fidelio*.

fashioned dramatic figures, as in *Figaro* and *Don Giovanni*, though the character of Leonore is infused by the music with a greatness and depth that we do not find anywhere in Mozart. The injustice of the evil Pizarro, the sufferings of innocent captives, the benevolence and nobility of the Minister—all proclaim the ultimate significance of the moral sphere.

In *Fidelio* the metaphysical beauty of the moral sphere is expressed through the exclusively artistic means of music with a depth that is truly extraordinary. This also applies to Florestan and even to Fernando. What is more, there is also an intimate union between the pure beauty of the music and the metaphysical beauty of the moral world as we find it in Leonore's profound love and fidelity and in Florestan's sufferings for the truth. Here we encounter a new style of dramatic art, a new language that touches our hearts to the core and moves us in a deeply personal way. What a voice of ultimate moral nobility we hear in the prisoners' chorus and in Florestan's recitative and aria in the second act.

In *Fidelio*, there is an incomparable interpenetration of text and music and the subject matter they share. The music treats the theme of the text with complete seriousness. The drama fashioned in this opera is of immense proportions. In it we find for the first time an articulated form of an inner or contemplative drama [*innerer oder Kontemplativer Dramatik*], which sharply distinguishes itself from outward drama [*äußeren Dramatik*]. In speaking of the "dramatic," one usually envisages, correctly, a suspenseful plot dynamically pressing forward, since this is an essential trait of the dramatic. But alongside this grand, dynamic form of drama, there is also a contemplative drama in which the suspense moves entirely to a deeper plane and the drama unfolds through intensity and depth. Consider for instance the scene in *King Lear* with the blinded Gloucester and Poor Tom (his son Edgar, whom he does not recognize), and also the nocturnal scene in Juliet's room in *Romeo and Juliet*.

In opera, we find an example of this contemplative drama in *Fidelio* in the duet, "O namen-namenlose Freude!" ("Oh inexpressible joy!"). This follows the scene, which is immensely dramatic in the dynamic sense, "Töt' erst sein Weib!" ("Kill first his wife!"), and the trumpet call—a moment of highest suspense conveyed indescribably by the music

with this signal. The world "vanishes" in the loving gaze [*Ineinanderblick*] of Florestan and Leonore, in the contrast of their bliss and the terrible sufferings they have endured. This joy expresses itself in boundless jubilation, both in its inner dynamism and in the full contemplative expansion of bliss, in the passage, "O Gott, wie groß ist dein Erbarmen!" ("Oh God, how great is your mercy!"). We find the inner drama again in the wonderful passage, "O Gott! O welch ein Augenblick!" ("Oh God, what a moment!") at the end of the opera.

Even though in the type of opera represented by *Fidelio* not all the characters are dramatically fashioned in the full Shakespearean sense as they are in *Figaro* and in *Don Giovanni*, nevertheless, *Fidelio* attains a highpoint all its own in the interpenetration of drama and music. The figures of Leonore and Florestan are not indeed figures in the Shakespearean sense, like the Countess, Susanna, and others in *Figaro*, but in another respect they are much more significant and profound than any character in Mozart. In their moral nobility, they are the soul of the entire dramatic progression. In the depth they manifest, they are representatives of a lofty moral world. This air of moral greatness is conveyed through purely musical means in a consummate artistic transposition.

A *secco* recitative would be utterly unsuited to the style of *Fidelio*. Only the spoken word could do justice to the style of the whole, to the extent that breaks between the music are even necessary. The transition from spoken to sung word makes for a tremendous impression in the first act, when Rocco says to Fidelio, "Meinst du, ich könnte dir nicht ins Herz sehen?" ("Do you think that I could not see into your heart?") which is followed by the wonderful quartet, "Mir ist so wunderbar" ("I feel so wonderful"). This organic transition and ascent from word to music has a particularly strong effect, in the best sense of the term. In union with the word, the music is able to express things for which the word alone would be inadequate.

We have already referred to the importance of the melodrama in the second act of *Fidelio*. The many fully formed *accompagnato* recitatives are sublime examples of this noble union of word and sound, this preparation for the unconstrained flow of the melody in the arias. We have in

mind Leonore's recitative, "Abscheulicher, wo eilst du hin?" ("Oh monster, where do you hasten to?") and, above all, Florestan's recitative in the second act, "Gott! Welch' Dunkel hier! O grauenvolle Stille!" ("God! How dark it is here! What terrible silence!").

Compared with Mozart's operas, the orchestra has a greater importance in *Fidelio*. It forms this drama extensively and therefore has a different relationship to what is sung from that in Mozart. The overture to *Fidelio* fulfills its dramatic function in a manner completely different from Mozart's overtures, which are themselves wonderful. Certainly, Mozart's overtures introduce us to the spirit of the opera, though not all to the same extent, the overture to *Figaro* least of all. The overture to *The Magic Flute* is less an introduction to the spirit of the opera than a significant piece of music in its own right.

The overture to *Fidelio* has a much more direct relationship to the drama. The full seriousness and the breath of moral greatness already sound in the overture and reveal the spirit of the opera as whole. The same is true of the orchestral interlude[9] at the beginning of the second act. The dramatic situation, the somber and eerie character of the dungeon, and the tragedy of Florestan, how remarkably all this is given! In these passages, the orchestra attains an unparalleled power of fashioning the drama.

We have already mentioned the power of music to fashion without words in the second act of *Orfeo ed Euridice*. The lyricism of this musical intermezzo is very meaningful for the world of Elysium. In *Fidelio*, on the other hand, the orchestra is fully integrated into the new way of shaping the drama. In every situation, in all the arias, including the duet between Rocco and Fidelio, "Nur hurtig fort" ("Make haste"), and especially in Florestan's reply, "O Dank dir!" ("Oh, thank you!"), the orchestra has been entrusted with an extremely important task in the construction and advancing of the drama. This has often been interpreted erroneously. The assertion that "Beethoven was not a dramatist like Mozart" is completely incorrect. It is true that Beethoven did not possess the specific

9. [Editors' note: Hildebrand has in mind Beethoven's "Leonore Overture No. 3," which is sometimes performed within the second act of *Fidelio*.]

dramatic gift that enabled Mozart to use musical means to thoroughly fashion his characters in Shakespearian manner. But Beethoven created a completely new dramatic dimension, which includes giving the orchestra a much larger task in the construction of the drama. This dramatic dimension is the bearer of a high artistic value and connected to a new form of the interpenetration of sound and word. Let us not forget that Beethoven felt himself compelled in what may be his greatest work, the ninth symphony, to introduce in the last movement a union of music and word that is a unique example of their interpenetration and the new concrete expressive possibilities that arise through this union. This by no means entails only the inclusion of human voices and the expression they possess in contrast to all instruments, but also the union of sound and word.

The conclusions to various operas is a further help in delineating the type of opera that *Fidelio* represents and the function of the music in the construction of the drama. The ending in *Figaro, Don Giovanni, Così fan tutte*, and also in *The Magic Flute*, is a return to a state of tranquility, a stylized fading away of the whole. In *Figaro*, the sublime and profound "Contessa, perdono!" ("Countess, your pardon!") is followed by a charming and cheerful roundelay. In *The Magic Flute*, after the glorious "Die Strahlen der Sonne vertreiben die Nacht" ("The rays of the sun drive away the night") there is likewise a kind of stylized fading away. These endings perfectly fit the framework of the stage to which Mozart adhered in a special way. In *Don Giovanni*, the grand scene with the Commendatore and the terrible downfall of Don Giovanni is followed by the wonderful, serene conclusion, which incorporates the world of human life in its full reality, with its radiant poetry. This ending strikes us as even more beautiful than those of *Figaro* and *The Magic Flute*. It restores the bright light of day in a brilliant manner, brings all the characters back on stage one last time, and wonderfully depicts how life goes on. Given the context of the stage, which entails a certain distance from the onlooker, this is a profoundly fitting conclusion. It is only in *Die Entführung*, which is closely related to the *Fidelio* type in many ways, that the conclusion, "Wer so viel Huld vergessen kann" ("Whoever can forget

such grace"), in keeping with the ethos of the whole, is less of a fading away and a return to the framework of the stage. The conclusion to *Fidelio*, on the other hand, is something completely new. It is a highpoint. The apotheosis of marital fidelity shatters the framework of the stage. It is not a fading away but a victorious and glorious final resounding of the profoundly moral ethos that fills this entire work.

From a dramatic perspective, the role entrusted to the orchestra in *Fidelio* certainly justifies the insertion of the great "Leonore Overture No. 3" following the duet, "O namenlose Freude!" ("Oh inexpressible joy!), a practice begun by Gustav Mahler.[10] "Justifies" strikes us as too weak, since this insertion in fact is a particularly beautiful complement. Following the high dramatic suspense of the events on stage and the profound ensuing inner drama, the contemplative rhythm already present here comes to full expression with this insertion, which presents the figure of Leonore with purely musical means. Since the music of this overture is completely filled with the spirit of Leonore, it makes for a wonderful insertion that leads us to immerse ourselves contemplatively in this character and immerse ourselves in her spirit.

The function of the stage

In our discussion of the interpenetration of music and drama, the next step would be to speak about Wagner's music drama, which achieves a perfect unification of sound and word. Before doing so, however, we must make some fundamental observations about the stage and its role, which we have just mentioned indirectly in our comparison of opera endings. Besides this, we wish to point to one type of light opera and the so-called grand opera, which is in many ways an infelicitous term.

Our first remarks concern a qualitative element of the stage in opera. Our concern is not with the role of the scenery (for example, the extent to which it ought to be realistic or only symbolic), but with a certain framework [*Rahmen*] into which an opera can be especially integrated.

10. [Editors' note: This practice may have predated Mahler.]

Beyond the overall effect of the stage, this framework includes the con-
sciousness of being in a theater and being entertained.

This aspect of the stage is found in its highest form in Mozart. It
belongs to the stage that it addresses the public, attracting, amusing, and
enthralling it. Mozart knows how to fill this framework with the deepest
and most sublime content. By adhering firmly to the framework, Mozart
is able to say that a particular passage will certainly evoke a great "Bra-
vo!" and that the singer or singers will receive several curtain calls in the
hope they will give an encore.[11] To work within the framework of the
stage while presenting music of ultimate dramatic greatness and angelic
beauty is something unique and extraordinarily delightful. And indeed,
as Walter Braunfels said, it takes a certain humility to offer something of
uttermost depth in light vessels.[12]

On the other hand, there is something great and glorious when this
framework of the stage is burst open from within, as in *Fidelio*, or, in a
completely fundamental manner, when it is replaced by a new concep-
tion, as in the Wagnerian music drama.

The light framework of the stage, which allows the singers to show-
case their achievements and also contains an element of amusing and
entertaining the audience, has never been filled with content of such
ultimate depth as by Mozart. We sometimes find charming works full of

11. On this, see the letter Mozart wrote to his father on July 3, 1778: "[J]ust in the middle of
the first Allegro there was a passage which I felt sure must please. The audience were quite carried
away—and there was a tremendous burst of applause. But as I knew, when I wrote it, what effect it
would surely produce, I had introduced the passage again at the close—when there were shouts of
'Da capo'. The Andante also found favor, but particularly the last Allegro, because, having observed
that all last as well as first Allegros begin here with all the instruments playing together and gener-
ally unisono, I began mine with two violins only, piano for the first eight bars—followed instantly
by a forte; the audience, as I expected, said 'hush' at the soft beginning, and when they heard the
forte, began at once to clap their hands." In *The Letters of Mozart and his Family*, vol. 2, ed. Emily
Anderson, 2nd ed. (New York: St. Martin's Press, 1966), letter #311, p. 558.

12. [Editors' note: After his studies in Munich, Walter Braunfels (1882–1954) was appointed
director of the Academy of Music in Cologne, together with Hermann Abendroth, in 1925. He
was dismissed from this post by the Nazis in 1933 but reappointed by Adenauer in 1945. The most
important of his nine operas are *Prinzessin Brambilla*, *Die Vögel* (based on Aristophanes' *Birds*), *Don
Gil von den grünen Hosen*, *Die Verkündigung* (based on Paul Claudel), and *Die heilige Johanna*. He
also composed orchestral works, especially the *Phantastische Erscheinungen eines Themas von Hector
Berlioz*, which is frequently performed, an important *Te Deum*, choral works, Lieder, string quartets
and quintets, and other chamber music. Braunfels was married to Hildebrand's sister, Bertele.]

grace and artistic perfection the content of which does not, as with Mozart, greatly surpass this frame but instead fills it in a highly satisfying way. An excellent example is Rossini's *The Barber of Seville*, a masterpiece of the light format in which it was created, and one that does not make any claim to great depth. *The Barber* entertains us continuously and enchants us through its perfection, through the complete interpenetration of music and poetry that balance each other in their artistic importance. It enchants us through the dramatic forming of the characters and the many beautiful musical ideas. It is a highpoint of light opera and fulfills all the requirements of the stage in this sense. But it is not difficult to see what a world separates *The Barber* from Mozart's *Figaro*.

The overall situation of an epoch or a country has a great influence on the function of the theater and the stage. It is interesting to note how this function changes based on whether it is a drama without music or an opera. Our concern here is limited to opera: not its historical development but its fundamentally different types. The Italian stage with its *secco* recitative is a clearly defined type. Mozart accepts this *qua* stage, though in no way being bound to its spirit, in *Figaro, Don Giovanni*, and above all in *Così fan tutte*, but not in *Die Entführung* and *The Magic Flute*. This Italian stage—though not the stage in the time of Gluck and before—is characterized by a particular relationship between the public and what is performed on stage. The aim is to please the public, and it is the public, not individual persons or humanity, who are addressed. There is no effort, no reverent *sursum corda* demanded of the public. The theater belongs rather to that part of life in which one relaxes and enjoys oneself. The public represents a social unity of its own. The elegant seating, the boxes and so on, also offer the opportunity for a social encounter. The satisfaction of the public, in its function as a judge, also plays a role. Whether a work is successful or not is an essential question, although it is not uncommon for works that initially failed to please to be subsequently the most frequently performed. The question of success is of highest importance for the theater and its meaning; it "hangs in the air" and gives a particular immediacy to a performance, especially a premiere.

In this context, we must not forget the singers. Their achievement is

highly important, not only for the sake of a perfect rendition and worthy presentation of the work (although this is quite legitimate) but also because of their purely vocal "achievements"—such as the extent of their vocal range, how long they are able to hold a note, the technical perfection with which they perform a coloratura passage.

All of this characterizes the age of "grand" opera, in which the works themselves were infected by this spirit and saw a decline in artistic terms. In the original Italian stage, all these elements were much less in the foreground, even though much was already noticeable in a milder form.

The stage of the Romantic period is a completely different type. The impulse to the marvelous and fabulous that fills this period also conquers the stage, changing its outward appearance. This can already be heard in *The Magic Flute*. The operas of Carl Maria von Weber present this completely new type of stage, which is closely tied to Romantic opera and its new union of music and poetry.

Weber's masterpiece, *Der Freischütz*, is particularly instructive. It contains a profound interpenetration of music and poetry. The music unfolds its expressive possibilities in the representation of the terror of the Wolf's Glen, the sacred atmosphere of the hermit, Agathe's purity and piety, the fresh world of nature in the choruses of the hunters and foresters, and in the maliciousness and eeriness of Kaspar. Weber fashions a very particular poetry of nature, a quality of freshness, also in the figure of Ännchen, but a radically different type of drama from what we find in *Figaro*, *Don Giovanni*, and *Fidelio*. The point of fundamental importance is to see how various are the dramatic expressive and formative possibilities of the music in *Don Giovanni*, *Fidelio*, and *Der Freischütz*.

The congruency of framework and content

A special characteristic of Romantic opera is a certain modesty in the framework [*Rahmen*] of the whole. The relationship between the framework that a work of art intends to fill and the actual filling of this framework is a general factor in art. It is a definite artistic flaw when a work of art aims to offer something that far surpasses the content it

actually presents. We do not need to know the intentions of the author; rather, this aim makes itself felt within the framework of the work itself.

With respect to opera we want again to mention the general artistic value of congruency between the framework and content or intention. This congruency does not, of course, guarantee that the whole will possess any artistic value, since the intention may aim at a cheap effect and even at kitsch. If this intention fully succeeds, not only does the product in question not acquire any positive artistic value, but its disvalue is in fact heightened. Despite its superiority in other respects, an effective, successful *Schlager*, in which the triviality of its atmosphere and its music is particularly pronounced, has a greater disvalue in artistic terms than a weak and impotent *Schlager*.

Our interest here lies only in works with true artistic intentions. The artist can aim at something great and profoundly moving or restrict himself to a more modest theme. If Goldoni had set out to fill the framework of Molière, his work would have been a failure. He had the wisdom to choose a much more modest framework, and his comedies are full of charm, wit, gracefulness, and poetry. If Carl Maria von Weber had chosen the framework of *Don Giovanni*, *Fidelio*, or *Tristan*, he would have failed. His *Freischütz* has a framework that is much more modest yet completely filled, and it is a masterpiece of its kind.

Something analogous applies to *The Barber of Seville*. Although this opera is very different from *Der Freischütz* and belongs to the previously mentioned type of light stage rather than to the Romantic stage, and although it has a certain lightness that forms an explicit contrast to the intimate character of *Der Freischütz*, both works have in common the choice of a more modest framework that they are capable of filling. Both are masterpieces, since they completely fulfill the genuinely artistic aim that they intend. *Der Freischütz* is musically much more significant and deeper than *The Barber*, but this does not alter the fact that both works have a framework that they fulfill.

It is interesting to compare Rossini's *Barber* with his *William Tell*. The framework chosen for the latter work is far too large. Rossini's music

is not all capable of filling it and so, with regard to framework, *William Tell* is definitely unsuccessful.

Smetana's *The Bartered Bride* in many respects resembles *Der Freischütz*. Although we must emphasize the musical superiority of *Der Freischütz*, which among other things is exemplified by its much greater depth, the stage in Smetana bears a greater similarity to the specifically Romantic stage than to the Italian stage. More importantly, there is an analogy with respect to the more modest framework chosen from the outset and completely filled by both operas. Although the expressive dimensions actualized in the two works are very different, and the role of music in the dramatic construction of the whole differs greatly, the "word" spoken in both fulfills a similar function.

In *The Barber of Seville*, the more modest framework is linked to a certain character of the Italian stage. The content attests to a lightness that corresponds to this framework and is less deep, artistically speaking, than the depth and artistic greatness of *Figaro*. In *Figaro*, a tremendous depth and fullness of content are presented in a light vessel, whereas the artistic content in *The Barber* is in keeping with this vessel, and certainly in an entirely positive way. The framework of *Der Freischütz* and *The Bartered Bride* is different from that of *The Barber*, and their content lacks the lightness of *The Barber*. Although *The Barber* is more potent than *The Bartered Bride*, *Der Freischütz* surpasses them both.

We mention all this only to present a type of opera in which from the outset the demands are more modest, and in which the framework objectively aspired to by the work is filled (or filled in) perfectly.

This more modest framework does not, of course, guarantee that it is actually filled out. Many operas are set within a small framework and have a markedly light character; but they are weak because they do not really fill out this framework in artistic terms. This type is widespread among operas of the first half of the nineteenth century; it lacks both music of significance and beauty and the dramatic fashioning of the text through the music. A completely successful musical piece, such as the celebrated quintet in Donizetti's *Lucia di Lammermoor*, cannot rescue this opera as a whole.

Even more modest is the dramatic achievement of the music in the typical "grand" opera, for example in Meyerbeer, Halévy, Bellini, and others. The point that interests us is not just the deficiency of beauty in the music but the unhappy marriage of music and drama. In Bellini, the problem is a weakness in the fashioning of the drama; in others, the vocal achievements or the exciting plot are far too dominant. In Gounod's *Faust*, the framework is incredibly overtaxed. Gounod attempts to transform into an opera one of the greatest and most profound works of literature, Goethe's *Faust*, Part I, a poetic text that is probably not at all suited to a marriage with music. The music entirely lacks the power to shape this drama. What it expresses is radically different in qualitative terms from the content expressed in Goethe's *Faust*. Its ethos is completely different from that of the poetry.

Berlioz captures the spirit of Goethe much better in his *La Damnation de Faust*, in which, with great artistic wisdom, he refrains from using Goethe's poetry as an operatic text.

This criticism of Gounod's *Faust* should not be taken to mean that a composer must be fully equal in artistic potency to the author of the drama for the opera to be a masterpiece. Verdi was a great genius, but he was no equal to Shakespeare, who among composers can be compared to only Bach, Mozart, Beethoven, or Wagner. Nevertheless, Verdi's *Otello* is a great masterpiece, a wonderful marriage of music and drama.[13]

There are some operas that, while unsuccessful as a whole, contain certain passages in which the spirit of the work comes to expression in an intense and potent way. Beyond their great musical beauty, such passages often unfold a lofty dramatic power. While they cannot salvage the opera, what they offer is a much higher artistic value than merely a completely successful interpenetration of text and music on a superficial level.

The best examples of this type of opera are the works of Berlioz, in which individual passages of great beauty or brilliant power are like oases in a desert. The aria of Hylas in *The Trojans* is so intensely poetic, it captures the world of classical antiquity so masterfully and deeply, that

13. See chap. 40 below, pp. 493–495.

it alone represents a much higher artistic value than the entire *Barber of Seville*. But it does not save the opera as a whole. From an artistic perspective, the creation of such a passage is a more momentous occurrence than the creation of a small masterpiece of a lighter kind. The same applies to the tremendous duet between Aeneas and Dido in *The Trojans*.

Berlioz's opera *Benvenuto Cellini* is likewise unsuccessful, taken as a whole, but the Jugglers' Chorus is of brilliant power and expresses the atmosphere of this work in a potent manner, "Venez, venez, peuple de Rome ... venez, venez, voir l'habile homme, Qui va monter sur le tréteau!" ("Come, come, people of Rome ... come see the great man, who will appear on stage!").

Dance in opera

The role granted to ballet and dance in opera is characteristic of how the stage, theater, and opera were generally conceived in the period of the so-called grand opera. The work had to entertain, whether through the music or the plot, the accomplishment of the singers, or through a good ballet. Neither the composer nor the public was disturbed by the fact that this was often completely incompatible with the seriousness of the plot and the seriousness at which the music at least aimed. The composer may have inserted the dance reluctantly, but he believed that this was an indispensable concession to the wishes of the public if he was to be successful. These dances, for example, in Gounod's *Faust* and even in a work like Verdi's *Aida* that is otherwise so beautiful, strike a discordant note in artistic terms. They neither fit into the work as a whole nor appear at points that are suggested by the plot.

The ballet in *Faust* is not music for the people's dance in the scene of the walk on Easter morning, but an "obligatory" insertion at a much later point, where it is quite out of place. How radically different is the dance in *Figaro*, which grows in a completely organic manner out of the dramatic situation and is in fact a special enrichment of this situation, thanks to the beauty of the music. Not only is it meaningful in the context of the wedding celebration, since it heightens the festivity of the

situation, but it also has a convincing character. This dance is completely different from the "obligatory" dance that is "owed" to the public to amuse them. It is a meaningful, organic part of the plot and the music. *Figaro* is the only opera in which Mozart includes dance.

The great dramatist Verdi, in whom music and drama interpenetrate and whose music thoroughly shapes the drama, included few ballets in his operas. *La Traviata*, *Rigoletto*, and *Un ballo in maschera* do not have "obligatory" ballets. Strangely enough, ballet occurs precisely in *Aida*, the last opera he wrote before his great artistic turn. The solemn occasion for which this opera was created, the opening of the Suez Canal, is probably a factor here. *Aida* was conceived to be performed in a particular situation and for a wide public who could not be assumed to have any great understanding of art. Nevertheless, it remains surprising that this work, which is so rich in music and drama and contains many very beautiful passages, contains this compromise.

Music Drama

Wagner's music dramas

IN WAGNER'S MUSIC dramas we find a new kind of interpenetration of word and music, one that enables completely new expressive dimensions in music and is involved to such an extent in the construction of the drama that it is no longer possible to detach the music from the words. The plot does not present a skeleton that the music brings to life. Rather, the drama is constructed by word and music acting in complete unity, despite the fact that the music is artistically on a much higher level than the poetry.

This unification of music and word is aided to an extraordinary degree by the fact that the author is creator of both the music and the poetry. Each music drama in its totality is the invention of the artist. The words are never conceived independently of the music, nor the music independently of the words.

The unity of music and word already exists in the first sketch, in the fledgling desire to create something, in the initial vague conception, in the idea of a tale that Wagner is drawn to shape dramatically. Wagner is never inspired by an existing drama to compose the music and create

an opera. The saga of the Flying Dutchman, for example, inspires him for the creation of this music drama. Although Wagner conceives the poem before he composes the music, every word is conceived in view of the music drama as a totality. Of course, this totality becomes ever more fully realized the more fully the distinctive character of the music drama is developed in Wagner's creative work: more so in *Tannhäuser* than in *The Flying Dutchman*, still more in *Lohengrin*, until it is fully developed beginning in *Das Rheingold* and on through *Parsifal*.

This interpenetration of word and music is characterized by the following outward features.

First, there are no longer any arias, duets, and so on. There are no individual, clearly defined pieces of music that stand out from the plot and the music is never interrupted. Recitative in all its forms is entirely absent. Music and poetry form a unity that is never interrupted throughout the entire drama; the word never appears on its own. On the other hand, pieces of music without words play a very important role, not only as overtures but also as intermezzos between acts and as instrumental passages when the drama calls for the voices to fall silent. This through-composing has important consequences for the unity of music and word and for the power of the music to form the drama fully. It grants the music new possibilities for pure musical development, which resembles the exposition of themes in a symphony, and at the same time serves the unfolding of the drama. This is also connected to the principle of the leitmotif, which we shall discuss below.

Secondly, a much larger task is entrusted to the orchestra, which never functions as mere accompaniment of the voices. Very instructive here is a comparison with Verdi's operas from his younger period, such as *La Traviata* and *Rigoletto*, in which the essential is entrusted to the singers who are accompanied by the orchestra. In Wagner's music drama, by contrast, the collaboration between the orchestra and the singers is profound. The orchestra has a central share in forming the drama, not just in particular moments (as is generally the case in Mozart), but in expressing the spirit and atmosphere of the whole drama. This is already true of *The Flying Dutchman*, though in another respect this opera is

not a fully developed instance of the music drama, since it still contains arias and spoken texts. But its first theme is primarily entrusted to the orchestra. Already the overture potently conveys the world of the sea, the uncanny atmosphere of the terror of all the seas, and the tragedy of the Dutchman. It forms a splendid contrast to the second theme (that of Daland's sailors), which represents the carefree, joyfully enterprising aspect of the world of ships and seafaring, and plays a great role above all in the sailors' chorus.

Thirdly, the themes in Wagner are more important than the melodies. Obviously, there is a profound link between the weightier role of the themes and the through-composition. Similarly, it is impossible to separate the heightened task entrusted to the orchestra from the preponderance of the themes. Above all, the predominance of the themes over the melodies is decisive for the unification of music and drama. The musical treatment of the various elements in nature [*Naturwelten*], the individual characters, and the variety of great human themes leads naturally to an emphasis on the themes and to musical structures that express a particular content in compact form.

This function of the themes finds expression above all in the musical and dramatic invention of the leitmotif, which is often entirely misunderstood.

This brings us to a fourth feature of the Wagnerian music drama. The leitmotif is a theme that potently represents a particular meaningful content [*geistigen Gehalt*] and is taken up in the music whenever this content recurs in the plot. The music of the leitmotif is simultaneously a dramatic invention, for it originates in the spirit of the meaningful content that has a specific function in the drama. This explains why the leitmotif possesses fully the specific expressive power that music acquires only in union with the word, that is, with the drama.

Consider the theme of disaster in the *Ring*, how intensely the mysterious character of disaster is expressed! How remarkably the bright and sublime world of the gods is conveyed in the Valhalla theme; the special quality of awakening love and its bliss in the love theme of Siegmund and Sieglinde; and the tragedy surrounding this family in the Volsung

theme! These themes possess an extraordinary expressive power and belong profoundly to the essential content of the drama from which they cannot be detached. Even when these themes sound only in the orchestra, they display that very particular, concrete expressive dimension that music alone lacks and that presupposes the union of music and drama. Wagner achieves the ultimate interpenetration of music and drama in his greatest work, *Tristan und Isolde*, a work standing apart from all others by unfathomable depths, in which the unique inner drama fully unfolds in a contemplative manner.[1]

The leitmotif has often been entirely misunderstood. It has been regarded as an abstract link between a musical theme and a meaningful content, as something externally imposed on the poetic text, making the music, at best, a mosaic of leitmotifs. This is totally inaccurate. In reality, there is nothing abstract about the link between a musical theme and a meaningful content, be it a person's fate, a given character's love, redemption and passion, or a phenomenon in nature. The element being represented is given in an immediate, intuitive expression that fulfills its dramatic function. Anyone with a true sensitivity for music and the union of word and music, for the interpenetration of music and drama and the new expressive possibilities of music revealed here, will be immersed in the contents of these elements when hearing and being affected by the music drama, even without knowing the names of these elements.

The leitmotif is in no way imposed on the poetic text from the outside. It has no illustrative function. It grows organically out of the dramatic inspiration. This does not make the music drama a mosaic of leitmotifs. Rather, these themes are entirely integrated into the music's inner logic as its flows on organically, and, thanks to the marriage of music and drama, they attach themselves to the subject matter of the poetic text, without disturbing the music's inner logic. In *The Flying Dutchman*, for example, the entire drama is structured through the leitmotifs of the Dutchman, the world of the sailors, and redemption.

Although themes outweigh typical melodies in Wagner's music dra-

1. [Editors' note: Among Hildebrand's posthumous papers is a longer study of Richard Wagner. The Hildebrand Project is preparing it for publication.]

ma, this does not at all mean that Wagner does not also use melodies for the construction of the drama as a whole. Walther's various songs and the glorious chorus in *Die Meistersinger*, "Wach auf, es nahet gen den Tag" ("Wake up, the day is near") as well as Lohengrin's song in the last act of that opera, when he reveals his identity, are definitely melodies, as are many other passages.

We must especially emphasize that countless themes that function as leitmotifs can be combined to form a great melody simply by dint of their musical quality, as happens in *Tristan* in a wonderful way in the "Liebestod."

The problem of the total work of art [Gesamtkunstwerk] and the stage

Wagner's theater, of course, is radically different from the theater described in the previous chapter. The element of entertainment is completely absent, as are the social dimension and the corresponding manner of addressing the public. The role of the stage has completely changed.

We are not speaking here of the stage as a part of a *Gesamtkunstwerk*, that is, as a product of the visual arts. It is highly questionable whether a drama or music drama is enhanced when the visual display [*Bild*], the scenery and the characters as they move about, address us as a work of visual art, directing our interest to the beauty of this display. The happy marriage of music and drama is possible only between the two genres of literature and music. No matter how different they may be as such, there is a "pre-existing harmony" between them. Whether a union of this kind can exist between a music drama and the visual arts is a separate question.

We already saw the importance of being drawn into the world of a novel or play in such a way that we "dwell" in it and cease to be absorbed by the circumstances, worries, preoccupations, anticipated joys surrounding us in our real lives. The events and people we read about in a novel must be so vivid to us that we live in them, so to speak. But this entering into the world of what is depicted is not the same as in the case of real events. We are presented, rather, with an illusion, in which

we do not confuse what is depicted with reality and with our real con-
crete life. A work of history, in which we apprehend something of past
reality, requires that we regard it as real. By contrast, it actually belongs
to reading a novel that we not regard it as real while being so captivated
and engaged by it that we "live" in its world and forget the reality that
surrounds us.

The progression from reading to performing a play marks a further
stage of the illusion, and we are drawn into the drama in a new way. In
this case, we come into contact with the drama not just through the me-
dium of literature—through the word in its indirectness—but we see and
hear the characters directly, we see the surroundings in which the drama
takes place, such as in a room or countryside. The scenery shows us this,
and we recognize the gestures and facial expressions of the actors and
hear their tone of voice. All this establishes a new contact with the work
of art and heightens the illusion, without ever leading to a confusion of
the stage with reality.

If such a significant illusion and new level of living contact with the
play or music drama is to be possible, it is clear that the actors must
wear costumes befitting the period into which we are transported by the
plot. It is also clear that the scenery should correspond to the style of
the period in which the piece is set. And it goes without saying that the
stage must not present any aesthetic disvalues, nor can it be tasteless or
detrimental to the poetry of the drama.

In all this, the ancillary function of the stage and the scenery must
not be forgotten. They do not address us in the same way as a work of vi-
sual art, which has a completely different theme and draws us by its own
power into a world of rich content. The stage neither can nor should bear
the lofty artistic values that can adhere to an image, sculpture, or work
of architecture. The stage should not step outside its ancillary function
and attempt to convey artistic content through means belonging to the
visual arts. Its only function is to encourage our absorption in the drama
or music drama and to heighten the illusion. The transmission and real-
ization of the artistic content must be left to the work of art, that is, the
play or music drama.

But is not the theater of classical antiquity, the arena, also of great beauty as a work of architecture? And the glorious landscape of the surrounding region and the noble theater building, were they not elements that also contributed significantly to the beauty of a play?

This is not actually an objection to our assertion that the stage has an ancillary function. With the theater of antiquity it is not a question of the beauty of the stage but of the real surroundings in which the play was performed, that is, something that does not belong directly to the play itself and that remains the same when different plays are performed. It is not a matter of the visible artistic value of the stage, but the real surroundings in which a play is performed, in other words, something that does not serve to heighten the illusion. This background exists for us in reality, but not for the particular world and atmosphere of the play.

Undoubtedly, it is a special delight to hear wonderful music in a noble space fashioned by glorious architecture, such as in the courtyard of the Pitti in Florence or of the former episcopal palace in Salzburg, or in an enchanting Rococo room. The same is true for the beautiful interior of a theater. But these elements form only a framework. They bear no relation to the heightening of the illusion or to the particular world of the drama being performed. Even so, an open-air production, such as in the Arena in Verona or in the Baths of Caracalla in Rome, naturally has a great charm.

How beautiful the first covered theater buildings were, like Palladio's enchanting Teatro Olimpico in Vicenza! Still, it is clear that these buildings have an entirely different role from what the stage is meant to have in a *Gesamtkunstwerk*.

In Laurence Olivier's film of *Henry V*, for example, there is a risk that the landscape and lighting in the early morning scene, where the king encourages the troops to fight, become dominant in presenting the poetic situation. We see the beauty of the visible and delight in it. At this moment the film appeals to other sensibilities than the play does. The artistic content that the play communicates in its own way is not heightened by the cinematic images but instead replaced by the poetry of the visible landscape.

Finally, we want to emphasize that the ancillary function of the scenery in no way requires, as often happens today, that it should be interpreted only in a symbolic manner, still less, that the scenery should be disregarded completely. Nor should one perform the plays of Molière or Shakespeare in modern dress.

Fortunately, the latter practice is an exception. But one need not go that far. Instead of using the stage to heighten the illusion, the stage can be presented in quotation marks, in such a way that the audience at every moment is reminded that all they see is a stage. It is as if the attempt were being made to trivialize the illusion and continually to remind the public, "You are only in the theater!" This is surely a great error and a totally unhealthy attitude.

Let us return to Wagner's conception of the theater and the stage. Due to their unification of music and drama, Wagner's music dramas require an appropriate stage as had existed before the artistic reforms of Wieland Wagner in Bayreuth and in every theater where Wagner was performed. These were never "total works of art" [*Gesamtkunstwerke*]. The stage retained its ancillary function, and it was not fundamentally different from the stage of *Fidelio* or of Mozart's operas. True, the stage presents greater challenges to overcome in the *Ring*, for example, than in *Fidelio* or Mozart. But the challenges in fashioning the stage satisfactorily have nothing to do with the fact that the notion of the *Gesamtkunstwerk* remained only an idea and that the stage fully retained its classical, ancillary role, allowing the music drama to unfold its effect in a full and undeterred manner.

The conception of the theater in Wagner differs completely from that of the Italian stage and of the "grand" opera. It is a heightening of what we find in *Fidelio*. The element of entertainment is completely lacking, and a reverent attitude is required on the part of the public, whose listeners must open themselves, be prepared to participate without reserve [*ganz mitzugehen*], and take the music drama seriously as a work of art.

This, of course, is the only right attitude toward any great and profound work of art. Curiously enough, we often find an inappropriate attitude in the case of the theater. Many people go to the theater to be

entertained. Other interpersonal and social elements also play a role. At a vaudeville, this attitude is fitting. In any case, for many reasons beyond our present scope, including historical ones, the theater has generally taken on this character, above all in the case of opera.

The question that interests us here is the extent to which a work presupposes this participation [*Mitgehen*] and cooperation on the part of the public if its content is to be apprehended and understood at all, or whether the work through its exceptional content engenders the attitude of reverence and a readiness to open oneself. The conventional theater seeks to entertain. The great works that "accept" this sort of stage, however, are able through their content to draw a person of true artistic understanding into a reverent and profoundly receptive attitude.

In Wagner's new theater, on the other hand, this attitude of reverent and deep accompaniment of the work is presupposed for the audience from the outset. This is why Wagner wanted to create a theater of his own for his works. It was the purpose of the *Festspielhaus* in Bayreuth, which was to be distinguished from the conventional rhythm of a theater in which Flotow's *Martha* or Offenbach's *Tales of Hoffmann* is presented one evening, and *Fidelio*, *Don Giovanni*, or *Figaro* on the same stage the next evening. Wagner's theater was to function as a place for great works and so to share in the seriousness that all great art possesses.

Verdi's music dramas Otello *and* Falstaff

We conclude our analysis of the music drama with a reference to Verdi's two masterpieces, *Otello* and *Falstaff*. It is a unique occurrence in the history of opera that a master, after a life of great productivity, suddenly ascends at the age of seventy to an act of artistic creation far surpassing all his earlier works, both in the union of music and drama and in its purely musical quality. Already in his *Requiem* we find a spirit that surpasses everything he had previously created. Verdi's earlier works contain many passages of musical beauty and are full of ideas of a dramatic kind, but the *Requiem* in its depth and sublime artistic beauty cannot be compared to what preceded it.

In *Otello* and *Falstaff*, Verdi created two music dramas of a high dramatic creative power, a completely original type of the interpenetration of music and drama, different from that in Wagner. Of course, one cannot overlook the formal influence of Wagner in many regards. Both these music dramas are through-composed, without the arias so typical of the earlier Verdi. The orchestra has a much greater importance and the leitmotif too is present to a certain extent.

These music dramas, as is generally known, derive from Shakespeare. The mighty tragedy *Othello* is such a consummate masterpiece in its own right that its performance never leads one to think of a possible union with music. Shakespeare's play is of such perfection and greatness that one cannot say the music of Verdi's *Otello* heightens its artistic value.

Nevertheless, this music drama is a masterpiece. The existence of Verdi's music drama in addition to Shakespeare's play means a great enrichment for art.

This brings us the general question, namely, which dramas, plays, and comedies are even suitable to be united with music. We are thinking only of works that stand on their own [*eigenständige Werke*] that are not just viable but also possess a high artistic value. This question does not arise with Wagner, not just because poetry and music derive from the same author, but because they are conceived from the very outset in view of their union and mutually complement each other. This question also does not obtain for mere librettos that are unviable in themselves.

It is very striking that the texts of Shakespeare's *Othello* and Verdi's music drama are not identical. Boito altered Shakespeare's work in certain places and made it suitable for a music drama. The first act in Venice, which is very important for the play, is omitted. Secondly, the figure of Iago is somewhat modified through the insertion of the diabolical "credo." In Shakespeare, Iago is an incarnation of villainy and moral baseness. In the music drama, he becomes a fundamental representative of evil and acquires a kind of diabolical greatness. Finally, the insertion of Desdemona's "Ave Maria," a musical highpoint, is indeed profoundly in keeping with the Shakespearean character, but it is nevertheless an alteration.

This means that certain alterations are essential in order for achieving the interpenetration of music and drama and for the perfection and effect of the music drama. Boito displayed great artistic wisdom here. As the creator of *Mefistofele*, he was himself not an unimportant operatic composer.

In Verdi's *Otello*, we find an intense interpenetration of music and poetry, for example, in the second act, when Iago describes the dream of Cassio that he claims to have overheard. This is a passage of supreme musical-dramatic power. How unsurpassably the music captures the character of the dream. How expressively it fashions Iago, how incomparably it expresses the alleged love of Cassio for Desdemona. How it expresses the insubstantial and ultimately evanescent character of the dream. This is preceded by Othello's deeply moving song, "Della gloria d'Otello è questo il fin!" ("This is the end of Othello's glory!"). How powerful when he swears his revenge at the end of the second act!

There is a completely different relationship between poetry and music in Verdi's *Falstaff*. Shakespeare's comedy *The Merry Wives of Windsor* stands fully on its own, and Boito's plot sticks closely to it. But the music drama *Falstaff* is a far greater work of art than Shakespeare's comedy. The figure of Falstaff, a magnificent artistic creation in *Henry IV*, is presented even more fully and potently by the music than in *The Merry Wives*. The second act, with Mistress Ford, Falstaff, the return of Master Ford, and Fenton's visit, has music of extraordinary power in purely musical and also dramatic terms. The music is also highly poetic in the theme of the love between Fenton and Nannetta.

In the chapters about opera and music drama, we emphasized the great artistic possibilities for development attained by music through its union with drama. This form of the work of art cannot create any higher artistic values than absolute music and pure drama, but it can realize other values that neither music nor drama is capable of giving on its own. And these values are just as high as those of absolute music and of drama.

Stand-Alone Overtures and Program Music

THERE ARE SOME DRAMAS that do not lend themselves to being set as operas or music dramas but can be enhanced by an overture or a musical intermezzo. This applies, for example, to Goethe's play *Egmont*. It is dubious that *Egmont* would be suitable as an opera or even as a music drama. But both Beethoven's glorious *Egmont Overture* and the music he wrote as an introduction to the transfiguration of Egmont at the end of the play not only are extremely beautiful as pieces of music but also have a significant dramatic function. Through purely musical means they present aptly the spirit of the drama and the figure of Egmont, and immerse us in drama's central idea and atmosphere. The potency and beauty of this music perhaps even surpasses that of Goethe's play. This music has an elevating and enriching function. Even when performed in concert independently of the play, it is a work of art all its own and magnificent and delightful even for someone who does not know Goethe's *Egmont*.

These pieces by Beethoven are interesting because they represent a new kind of union of music with the spirit of a drama, that is, not as a union of sound and word, not as the sung word.[1] A wholly viable dra-

1. Except for the lyrical verses.

ma the full effect of which is achieved without music, Goethe's *Egmont* is
united to music that, as a pure musical piece, likewise stands completely
on its own and, independently of its inner relationship to the world and
spirit of the drama, is a work of great and striking beauty. Nevertheless,
it possesses a profound inner relationship to the drama and expresses its
spirit in an outstanding manner. Indeed, it may even surpass the drama
in its fashioning of the basic idea and the noble personality of Egmont.

This example is instructive in many respects. First, it shows us a type
of the happy marriage of music and drama that does not involve the
union of sound and word. Second, it shows us a different kind of enrich-
ment of a drama through music. A drama suitable for this enrichment
need not be suitable as an opera or music drama. Third, the drama is not
dependent on the music for attaining its full effect, though the music can
even surpass the drama in purely artistic terms (to the extent that the
value of a purely musical piece is strictly comparable to that of a poetic
text). Finally, a piece of music can convey the special value and ethos of a
drama, even when it is performed in concert independently of the drama.

We find a similar union of music and drama, one lacking any union
of sound and word, in Mendelssohn's Overture to Shakespeare's *A Mid-
summer Night's Dream*. In this case, however, the poetic text in its artistic
quality is far superior to the music. Two questions arise. First, does the
spirit of the music really correspond to the spirit of the poetic text? And
second, does it not draw us into a completely different atmosphere and
distract us from the Shakespearean poetry? The second question does not
depend on whether the music is superior to the value of the drama or its
equal. It asks only whether the value of the atmosphere that prevails in
the music and the world into which the music transports us corresponds
to that of the drama. Is there a homogeneity of atmosphere and spirit? It
is conceivable that music between acts of a play might be on par with the
value of the play and yet not be fitting because it immersed us in another
world. Such a discrepancy would, of course, be increased if the artistic
level of the music were far below that of the drama.

Strangely enough, this discrepancy does not have the same effect
when the music is artistically far superior to the drama, even when it

transports us into another world. Beethoven's wonderful *Coriolan Overture* is not conceived for Shakespeare's late great play *Coriolanus*. The drama by Heinrich Joseph von Collin for which this overture was written is insignificant and now forgotten. Nevertheless, there is a link between Beethoven's *Coriolan Overture* and the historical tragic figure of Coriolanus, and this link is not merely a title, still less a mere association. The music, however, would be disfigured if it were to be performed together with Collin's unsuccessful drama. Where there is no congruency of atmosphere, it is better to perform the worthwhile drama without the music, or the worthwhile music without the drama.

This brings us naturally to the problem and justification of program music.[2] Is there an organic link between title and music, as in Richard Strauss's *Also sprach Zarathustra* ("Thus spoke Zarathustra") and *Tod und Verklärung* ("Death and Transfiguration")? Do these titles really indicate something that finds expression in the music, or do they lack any inner connection to the music?

Let us take examples that are closer to the above-mentioned overtures, such as Berlioz's glorious *Romeo and Juliet* symphony. Prescinding from the significance and beauty of a purely musical kind, is there any inner relationship to Shakespeare's eponymous play? Clearly the title of another Shakespearean work would not have been equally suitable. This symphony has a certain affinity to Shakespeare's tragedy; it is a representation of love and the tragic. Its "world" fits the atmosphere of Shakespeare's play. We have only to compare this work to Tchaikovsky's *Romeo and Juliet* overture to see the inner (if loose and imprecise) connection in Berlioz. Tchaikovsky's music, which is weak in purely musical terms, has nothing in common with the world of Shakespeare's *Romeo and Juliet*, which, indeed, it contradicts. Not only does it fail to fit this "world," from which it distracts us, it is in fact antithetical to the entire world of Shakespeare.

But neither Berlioz nor Tchaikovsky aims in these works at the kind of union we find in the music for *Egmont* or *A Midsummer Night's*

2. [Editors' note: "Program music" seeks to be about something, in contrast to "absolute music," which seeks to be simply music.]

Dream. Neither of these pieces was intended as an overture or an inter-
mezzo to Shakespeare's play; there was no expectation that they would
be presented in connection with a performance of the play. These works
of Berlioz and Tchaikovsky involve the completely different and much
more abstract relationship between music and drama in program music,
in which the literary theme to a certain extent can find expression in the
music, even if much more indirectly.

The difference between Berlioz's music (of which one is tempted to
say it is "about" *Romeo and Juliet*) and Tchaikovsky's overture is that the
former is beautiful and successful, while the latter is deficient in beauty
and, above all, unsuccessful. The expressions "successful" and "unsuccess-
ful" refer here to the music's connection with the drama. The fact that
one can even call a piece of music "successful," independently of its pure-
ly musical value, shows us that a union with the drama (albeit a loose
union) can exist in certain types of program music. This union entails
more than the fact that a dramatic work stimulated the composer to
produce this composition, for then it would be a union of a purely psy-
chological, genetic kind and would not constitute an objective connec-
tion. Nor does it involve the kind of relationship we find in an occasional
composition such as *Aida*, which was composed to mark the opening of
the Suez Canal. No, as we have already said, we have here a loose, impre-
cise union of an inner kind.

This also differs from the relationship to a historical event that takes
on what we might call an illustrative character, as in Tchaikovsky's very
successful *1812 Overture*. The music quotes themes such as the Marseil-
laise and the Russian national anthem, and it describes what happens on
the battlefield. Actually, the *1812 Overture* is not really program music at
all but its own illustrative type that, when successful, conveys something
of the atmosphere of a given historical moment.

Which contents can legitimately become themes in program music?
In the case of plays like *Romeo and Juliet*, an organic union is in princi-
ple possible, but in the case of philosophical works like Nietzsche's *Also
sprach Zarathustra*, the connection with the music will be of a purely
associative kind, a mere title. In Richard Strauss's *Till Eulenspiegels lustige*

Streichen ("Till Eulenspiegel's Merry Pranks"), a certain meaningful con-
nection is still possible, given the involvement of a literary character. As
a whole, however, program music must be regarded as an unhappy union
of drama and music. This does not prevent a composition from having
value as a work of pure music. But it neither gains nor loses through the
title.

It is interesting to compare the titles of program music and of sym-
phonies. The titles of many Haydn symphonies are either pure descrip-
tions of their contents, or else they refer to the place where they were
composed or to the person in whose honor they were written. The ti-
tles never represent a theme or a program that claims to be reflected in
the music or of which the music represents a paraphrase. Haydn's title
"Oxford Symphony" is an unpretentious, simple dedication, while the
title of the "Military Symphony" alludes to the character of one of its
movements. This is exactly opposite of the relationship between title and
content in program music. The same applies to the titles of the "Linz,"
"Prague," and "Haffner" symphonies of Mozart. The name "Eroica" re-
fers to the spirit of this symphony by Beethoven. It is a purely musical
work that, as is well known, was originally dedicated to Napoleon and
received this name only at a later time. In a similar way, the title "Pasto-
ral" for Beethoven's sixth symphony indicates the unique representation
and depiction of natural phenomena, their atmosphere and poetry, but
not an abstract program.

Schumann's *Rhenish Symphony* and Mendelssohn's *Italian Symphony*
are also in no way program music. In Mendelssohn, the titles *Italian* and
Scottish symphonies contain at most an allusion to the atmosphere of
these two countries. The same is true of his *Hebrides Overture*.

Let us conclude by pointing out the principal danger of abstract pro-
gram music. It stimulates the mind and imagination in a way that is
linked to the music in a purely associative manner. This easily leads to
confusion in the listener since it entices him while listening to the music
to focus on what the title refers to. It seeks in a dishonest way to bestow
on the work a significance it does not possess in purely musical terms.
When people are filled with enthusiasm and admiration by Nietzsche's

book *Also sprach Zarathustra*, the pseudo-depth of which is surrounded by the halo of great fame, they will credit Strauss's eponymous music with the brilliance of Nietzsche's book, even though the music is quite incapable of expressing its philosophy. Through its title, the musical piece, so to speak, adorns itself with borrowed plumes. It hardly needs to be said what a profoundly inartistic and illegitimate undertaking this is. Even so, the music itself can be beautiful and would only stand to gain if the distracting, pretentious, and abstract title were dropped.

CHAPTER FORTY-TWO

Sacred Music

SACRED MUSIC REPRESENTS its own kind of union between word and sound. We use this term as a designation not only of music that has a sacred ethos, like many of Bruckner's symphonies, but also of the music that is composed to sacred texts, for example, those of the Mass or other parts of the liturgy, such as the Magnificat.

From the outset we must draw a clear distinction between oratorios that have no sacred character and the music set to sacred texts in its various forms. We limit ourselves to the latter. We shall discuss Gregorian chant, religious cantatas, Bach's *Christmas Oratorio* and *St. Matthew Passion*, Mozart's unfinished Mass in C Minor, and Beethoven's *Missa solemnis*.

These works contain a different relationship between music and word, since the theme is no longer only artistic. It is above all a religious theme, something that belongs to the liturgy.

Gregorian chant and polyphonic church music. Thematic and unthematic beauty

Among all the Masses that have been composed, those sung in Gregorian and Ambrosian chant occupy a unique position because they do not

have an artistic theme of their own. The Holy Sacrifice of the Mass is the theme, and the attitude of prayer permeates everything. The singing is primarily a solemn, elevated manner of speaking. The words have an absolute primacy as pure prayer, as the praise of God, and the singing participates fully in this prayer.

This kind of music is not in any way a representation or depiction but an expression, by the group of cantors and the choir, of the attitude of prayer. It varies in its connection with the words of the liturgy, according to the feast or liturgical season. Even someone who does not sing along is drawn into the spirit of the prayers. For both singers and non-singers, the music of Gregorian chant is something enacted [*ein Vollzogenes*], that is, it does not address us as listeners, as even the most sublime and qualitatively loftiest sacred artistic music does. Rather, the singing of the Gregorian Masses is completely united to the performance of the sacred rite. The only function of the sublime beauty of the chant is to give wings to our sharing in the enactment of the mystery of the Holy Sacrifice and of Holy Communion.

It is characteristic of this beauty to be unthematic.[1] Plato's dialogues are of great beauty, but the theme is not this beauty but truth, just as truth is thematic in St. Augustine's *Confessions*. Anyone who treated such works primarily as works of art would fail to do justice to them. He would misunderstand them profoundly. By contrast, even as great truths are uttered in *Hamlet*, its theme is the artistic beauty of the drama.

We have seen in an earlier chapter that the depth and degree of the beauty of a work do not depend on whether its beauty is thematic. The great beauty of Gregorian chant does not alter the fact that it is not thematic but purely ancillary.

Polyphonic Masses

Something completely new is involved in polyphonic Masses, in which only the fixed parts (the "Ordinary"), not the changing parts (the "Prop-

1. On this, see *Aesthetics*, vol. 1, chap. 13.

er"), are set to music. Originally, they too were wholly at the service of the enactment of the sacred rite, but the music increasingly acquired a function of its own. Consider the Masses that, from an artistic point of view, are greatest, Mozart's Mass in C Minor (K. 427)[2] and Beethoven's *Missa solemnis*. These polyphonic Masses are much more extended than the Masses composed in Gregorian chant. Each part represents in an unsurpassed manner the spirit of mystery, the greatness and holiness of what happens in the Holy Mass. But the music is no longer exclusively the praying of the liturgical words raised up in song. It is also itself an unsurpassed representation of the content of the individual words and indeed the mystery of the Holy Mass.

What fullness and heart-melting sweetness we find in the "Christe eleison" of Mozart's Mass in C Minor! What a representation of the beauty of the sacred humanity of Christ! How this music envelops us with the breath of mercy! How the glorious "Et incarnatus est" expresses the contemplative immersion in the tremendous mystery of the Incarnation! How we are touched by the breath of the ineffable sweetness of the Blessed Virgin! Obviously, something more is here than just an inspired, highly solemn enactment of the creed. Rather, the content of the words is represented through artistic means, in which certain parts of the text, when their meaning calls for it, take up a much larger space in the music than others.

This representation of the prayer's content in the music is a new element that clearly distinguishes these polyphonic Masses from Gregorian chant. It is true that a polyphonic Mass too is conceived for the act of worship; its music has only an ancillary function, and the theme remains the purely religious theme, the mystery of the Holy Mass. But the union of word and sound is new when compared with Gregorian chant.

The music unfolds its various expressive possibilities so as fully to express the religious text by way of artistic transposition. The believer is, so to speak, drawn through the music into the world of Christ. This sacred artistic beauty provides a new way to draw the souls of believers *in con-*

2. This judgment is not altered by the fact that parts of the Credo and the Agnus Dei are completed using other Masses of Mozart.

spectum Dei ("before the face of God") and to immerse them in the holy mystery of redemption. This is not antithetical to participating in the celebration of the sacred rite. Anyone who has experienced this Mozart Mass in the liturgy will surely agree on the fully organic harmonization of one's inner participation in the celebration of the Mass and one's being drawn into the sacred atmosphere through the artistic beauty of the music and through the musical representation of the religious content.

This does not alter the fact that Gregorian chant is the most appropriate music for the celebration of the Holy Mass. Already the fact that the sections of a polyphonic Mass are much more time-consuming skews the proportions of the Mass that enable inner participation.

Mozart's Mass in C Minor, which unfortunately remained unfinished, is in itself a great work of art that can be performed in the concert hall. This specifically sacred work of art appeals from the outset to an attitude completely different from *The Marriage of Figaro* or *The Magic Flute*.

This prompts the question: Is the beauty of this work thematic, or is it unthematic, even when performed in a concert?

This composition is an exceptional case, because Mozart did not intend it as a work of art, where artistic beauty is thematic and constitutes the *raison d'être*, but for the liturgy, the theme of which is the sacred celebration. It is, nevertheless, also a great, sacred work of art.

There can be no doubt that the artistic beauty is thematic in a concert, although in its quality this beauty is profoundly sacred and wholly united to the words of the Holy Mass. Even in the concert hall, one must never forget that this composition is meant for the Mass. Above all, one should understand that the music employs artistic means to represent in an extremely intense manner the meaning of the liturgical texts and the world of the sacred. It gives glory to God through its spiritual quality, and it represents a form of prayer.

In the still more perfect polyphonic Mass, namely, Beethoven's *Missa solemnis*, the representation of the mystery of the Holy Mass with artistic means is accomplished in a unique manner. The sacred seriousness that pervades everything, and the deep involvement with the text, above all with the meaningful content of the text, make it the polyphonic

Mass *par excellence*. This is why it is also an entry to the world of Christ, which could lead someone with a real artistic openness to conversion. The "Sanctus" draws us perfectly into the attitude of trembling reverence immediately prior to the consecration. The restraint and profoundly liturgical character of the music for the words "Sanctus, sanctus, sanctus Dominus Deus Sabaoth" is also the perfect expression of these words. What exultation in the "Pleni sunt coeli!" This music, so closely united to the word, unfolds its highest expressive possibilities. This is followed by the sublime Interlude. In the "Benedictus" after the consecration, the music reaches its highpoint, when through artistic means it represents the mystery of redemption, grace, and mercy. This "Benedictus" breathes in an incomparable manner the spirit of Christ the Redeemer. In it we find not just a perfect realization of the union of word and sound, but also of the penetration of the music by the nature and meaning of the Holy Mass.

The *Missa solemnis* likewise has an ancillary character. It fits wonderfully into the framework of the celebration of the Mass. At the same time, it cannot be denied that it is above all in the concert hall that it unfolds its full artistic greatness and its deep sacrality. It is a work of art, but a sacred work of art. It is primarily an artistic representation—even *the* representation—of the spirit of the Holy Mass. Its sublime artistic beauty is fully thematic; but, on the other hand, it is so unambiguously sacred and so much a religious confession that one cannot do justice either to Beethoven's intention or to the spirit of work if one listens to it as a pure work of art, that is to say, with the same attitude with which one listens to a symphony. Despite the thematic character of the artistic beauty, the theme of the whole remains purely religious.

Bach's St. Matthew Passion

A further kind of sacred music is Passion music. Bach's *St. Matthew Passion* is a work conceived for the liturgy. Its theme is clearly religious, namely, the Passion of the Lord. With regard to the union of word and sound, we must distinguish between music composed for the text of the

Gospel; for the recitatives, arias, and choruses to a text by Picander (also known as Christian Friedrich Henrici) written for this *Passion*; and for the chorales, some of which have texts by Paul Gerhardt.

This music is completely formed by the spirit of the Gospel. The *St. Matthew Passion* is a highpoint of representation; indeed, it attains a unity with the spirit of the Passion of Christ that we can hardly still call "representation." When the Gospel is involved, the text is granted absolute primacy, whether in the music of the Evangelist or in the passages in which Jesus himself or another person speaks. But the passages of the Evangelist are not everywhere mere recitative, but sometimes attain a great expressive power through the pure beauty of the music, such as when the Evangelist repeats in German the words of Christ on the Cross, "Eli, Eli, lama sabachthani!" When Christ himself speaks, the music has sublime beauty and great expressive power simply *qua* music. When the crowd cries out, "Barabbam!", the full power of pure artistic expression is revealed to us. But in all this the word remains in the foreground. Sound and word interpenetrate, but the word has the leading role.

The situation in the *St. Matthew Passion* regarding the poems written by Bach's contemporaries is different. Here, the music has an absolute primacy. Its beauty and greatness rise far above the words. The music represents the world of the Gospel much more deeply and adequately than the text; it is united with the text in such a way that it draws it up far above its own value. The music has absolutely the leading role. The text serves the music to permit it to unfold the immeasurable wealth of its expression and to draw us fully into the world of the Gospel.

In the chorales, with their liturgical character, music and word are equal in rank.

Here again the question arises: What is the theme of the *St. Matthew Passion*, its beauty or the liturgical participation in the Passion of the Lord? Doubtless the latter is the theme and also Bach's intention.

At the same time, the *St. Matthew Passion* is also a consummate work of art. It appears—as in the case of the *Missa solemnis*—that the question of the theme is much more complicated. Even though the Gospel far surpasses in beauty everything else that has ever been written, its only

theme is divine truth and revelation, not beauty. In the *Missa solemnis* and in the *St. Matthew Passion*, the answer is obviously not so clear. In their theme, they are fully at the service of the liturgy and the adoration of God. In their content, they fully represent the sacred. At the same time, both are great works of art, and as such beauty is thematic in both as well.

We need not investigate again the difference between the union of word and sound in these works and as it occurs in opera and music drama. Absent is the fashioning of a cast of characters, gone is the stage. But the comparison is instructive, since it shows us that artistic beauty is clearly the theme and *raison d'être* in opera and music drama. In a certain sense, the *Missa solemnis* and the *St. Matthew Passion* have two themes. The first is the theme intended by the artist, the purely religious theme. Both these works present a purely religious musical treatment of this sacred world. But since this representation presupposes a great artistic transposition, we have also the birth of a work of art in which by its nature beauty is thematic. Thus, there are two themes, each thematic in a different sense.

Bach's Christmas Oratorio *and cantatas*

Bach's *Christmas Oratorio* is clearly dedicated to the liturgy. Unlike the *St. Matthew Passion*, there are more arias and choruses than recitatives of the Evangelist. But this oratorio too is an example of the unique interpenetration of music and the representation of a mystery, in this case, the birth of Christ. The sinfonietta radiates with great intensity the world of the shepherds of Bethlehem on Christmas night. Words fail to express how powerfully this work represents the atmosphere of that grace-filled night of Bethlehem and of the entire Christmas season.

At the same time, the *Christmas Oratorio* is a great work of art, employing purely artistic means to immerse us into the mystery of the birth of Christ, even when performed in a concert hall. It is a representation of the sacred world and atmosphere of this supreme event, and an expression of the faith and the adoration of believers.

The twofold theme of the purely religious and liturgical, on the one hand, and of artistic beauty, on the other, can also be found in Bach's cantatas. In the context of the liturgy, they are fully at the service of the celebration of the religious ceremony. At the same time, they express the atmosphere of the feast and the theme of the texts. The artistic treatment of the religious content by the sacred beauty of the music makes them structures in which the beauty not only is a metaphysical beauty grounded entirely in other values but also bears the character of artistic beauty. We have here not just the metaphysical beauty of the religious content, nor just the metaphysical beauty of the religious content wonderfully expressed through artistic means, but also a purely artistic beauty of the music. Since beauty is thematic in the cantatas, they can be performed as works of art in the concert hall.

In addition to the Masses of Mozart and Beethoven we have already mentioned, Bach's Mass in B Minor, Schubert's Mass in E flat Major, the *Requiem* of Mozart and of Verdi, Bruckner's *Te Deum*, and his "Great" *Mass in F Minor* are significant works of art. If we think also of Bach's many cantatas or the sublime music of Mozart's *Ave verum* and *Laudate Dominum*, we see again how music in union with a sacred theme rises to the ultimate artistic heights.

Many dramatic expressive possibilities, such as fashioning characters in opera and music drama, do not exist in sacred music. In polyphonic Masses, the texts have the absolute leading role, and the same is true of oratorios when the music is united to words of the Gospel. This does not apply to the texts in Bach's oratorios written by his contemporaries, and even less in his cantatas. Here the music has the leading role. The words are more of a basis on which the music can unfold its expressive possibilities. That which is represented is the object of which the words speak. But the form and the treatment of the object in the words is secondary in comparison with its representation in the music. In the glorious aria in Bach's cantata *Vergnügte Ruh', beliebte Seelenlust* (BWV 170), the music is entirely in the lead. It is incomparably more beautiful and profound than the text, which merely offers an occasion for what is sung. The music freely represents the religious content, without binding itself to the text.

CHAPTER FORTY-THREE

The Performance of Musical and Literary Works

IN CERTAIN ARTISTIC GENRES, the realization of a work of art has various stages. The first is the creation of the work of art; in music, this means writing down the score, in literature, it means putting the drama on paper. A new stage is reached when the music sounds or the drama is read. But the full realization intended in these works of art is the *performance*, which marks the onset of an important factor for which the author is no longer directly responsible, namely, the rendering, the reproduction, the artistic sphere of accomplishment, whether of the pianist, members of a string quartet, conductor, singers, the actors, director, and so forth. This broad field of genuinely artistic activity, for which there is nothing analogous in the other artforms, demands a very specific talent, which is entirely different from that of the composer and writer.

We will attempt to investigate the nature of performance [*Reproduktion*], which is obviously decisive for the full realization of these spheres of art. The term "reproduction" is very inadequate; "rendition" is a step in the right direction. "Reproduction" gives the impression of something secondary, a repetition of a particular kind. Actually, we are touching on something that belongs essentially to the full, intended realization of such a work. Indeed, it is something highly essential.

"Technical" elements in the worthy performance
of musical works of art

To render a composer's work appropriately[1] presupposes a specific talent. At the same time, this rendering is a clearly ancillary task, an entering into the spirit of the musical piece.

We begin with an analysis of the elements that are necessary for a fully satisfactory, meaningful, and worthy rendering. Certain elements characterize the person engaged in rendering the work of art, even independently of any relation to the work in question. For pianists, violinists, and so on, this includes mastery of their instrument, their technique and musicality; for singers, the beauty of their voice, the purity of their tone, their diction and musical memory; for opera singers, their acting talent, outward appearance, and so on; for conductors, their ability to lead and inspire the orchestra, their technical evaluation of all the details, and their temperament.

These important factors are what we might call technical preconditions for a worthy rendering, especially of a great and profound work of art. They pertain to the true understanding of the work, the depth of apprehension for its genius, and the ability to render it in all its details. In music, rendering reaches from the right tempi, legato and staccato, crescendo all the way to the significance and depth of the rendition; it encompasses the entire sphere of artistic conception. Rendition in this fullest sense admits of predicates like "significant," "unimportant," "profound," "superficial," and "moving." In fact, in the act of rendering lies the artist's true service to the work of art.

Regarding the first kind of preconditions for an ideal rendering, we must distinguish between certain talents that are pure gifts and others that result from study. Voices like those of Caruso, Gigli, Melchior, Pinza, and Wunderlich, Berger, Flagstad, and Mado Robin are pure gifts. Of course, appropriate study is essential so that the beauty of these voices can be fully manifested. Similarly, a musical ear is a pure gift: not just to

1. [Editors' note: Hildebrand uses the word "adäquat" not in the sense of "good enough," as the English "adequate" suggests, but of realizing what is called for by a work.]

sing with musicality but the ability to hit the note cleanly. We are not thinking here of the elementary ability to hold a pitch, nor the ability to sing in tune rather than obviously out of tune, but of the purity of the note, the lack of all extraneous sounds and fluctuations.

A musical memory is again a pure gift. This does not mean that practice is not required for all this, nor that memory cannot be improved by practice and study. But the decisive precondition remains a gift. Where this is lacking, it cannot be acquired by study.

Another factor is good diction, which plays a special role in the correct union of word and sound. It is much more acquirable through study than the preconditions mentioned above.

It is obvious that all these elements are of decisive importance for the worthy rendering of a piece of music, even if they are mere preconditions.

The visible appearance of the singer is itself more a bonus than an important precondition for the worthy realization of a work of art— though on stage it takes on a greater importance.

For instrumentalists, of course, physical dexterity depends primarily on practice and study. The sound of most instruments, especially the strings, is generated and dependent for its purity on the player. Thus, not only the fine sense of hearing but also the strength of the fingers (in the case of some instruments) and of breath (in the case of wind instruments) are natural preconditions. Mastery of technique through study is an acquired factor, but this too can be largely a gift, as in the case of any child prodigy. We have only to recall the incident with Mozart as a child when he wanted to play violin in a string quartet, although he had never learned. When he was finally allowed to play, he moved his father to tears because he could do it so excellently without any preliminary practice.

In the case of the piano, some of the conditions and gifts just mentioned are not factors since the sound is not in the same sense generated. But musicality is certainly indispensable. A certain shape of the hand and mobility of the fingers, as with Liszt, may also act as an exceptional precondition that is not acquired.

For our analysis of the elements that are presupposed in a great pi-

anist, violinist, and so on, it suffices to indicate the difference between innate talents, which are gifts, and those that are acquired through study.

Virtuosity

With respect to the difference between the mere prerequisites of the good pianist, violinist, or clarinetist, and those abilities that are properly artistic, between technique and artistic conception (that is, the ability to render a work of art), it is instructive to look at accomplishment at the level of the virtuoso, which itself is completely different from the accomplishment of a genuinely artistic performance. A person can be a great virtuoso as a pianist, violinist, or clarinetist, without being able to render worthily the sonatas of Beethoven, the "Chaconne" from Bach's *Partita in D Minor*, or Mozart's Clarinet Concerto. What we admire in the virtuoso has nothing do with the worthy realization of a work of art. We praise not the profound, significant, memorable realization of a musical work of art, but technical ability, astonishing skill, mastery of the instrument as such. This is doubtless a value, but it is wholly different from the value of worthily rendering a work of art. Paganini was one of the greatest virtuosos of the violin, but it is highly questionable whether he could have rendered the Beethoven violin concerto or the violin solo in the "Benedictus" of Beethoven's *Missa solemnis* as worthily as Hubermann or Menuhin. The fact that certain great works of art in passages presuppose virtuosity in the artist who performs them does not at all alter the fundamental difference between the value of the virtuoso's accomplishment and the value of a worthy conception of the musical work.

Virtuosity is a specific sort of accomplishment that is analogous to a phenomenal memory or a technical acuteness of intelligence. Indeed, it possesses a distant analogy to the tightrope walker or other extraordinary accomplishments of a physical kind, as in the artist or athlete. Much less is required to apprehend the value of virtuosity than that of the rendering of a work of art. It is much easier for the virtuoso to have the success he seeks, since he does not have to give himself in service of

the full realization of a work of art. The mastery of the instrument is his primary theme.

There are also pieces of music that are written only in order to offer the virtuoso an opportunity to display his skill. These are usually devoid of value from an artistic point of view. What stands in the foreground when these pieces are appropriately rendered is not the realization of artistic values but a virtuoso technique.

Passages that presuppose virtuosity on the part of the performer sometimes occur for artistic reasons in genuine and great works of art. In this case, virtuosity is not thematic as a value of its own, but as a purely ancillary technical precondition in order to render the work appropriately.

We find something analogous in the case of the virtuoso coloratura singer. If she also possesses a beautiful voice, our enthusiasm and admiration may be kindled by her purely technical accomplishment, even when the piece she sings is artistically insignificant or even lacking in value. A beautiful voice has a much more pronounced aesthetic value than the virtuoso coloratura. It bears a genuine beauty of the first power. The virtuoso coloratura sometimes has no real beauty of its own, but can be a typical instance of something pleasing.

The virtuoso singing of a coloratura passage has a theme completely different from that of a musically worthy rendering. But this accomplishment can also be an important ancillary factor, a prerequisite for the rendering of a great work of art. If a coloratura passage possesses a lofty artistic beauty, as, for example, in the "Et incarnatus est" of Mozart's Mass in C Minor, then also its technical perfection provides an important foundation for the worthy rendering and full realization of the work. But in that case, its virtuoso perfection is no longer an independent theme. Indeed, it is no longer thematic in any way, but is only an ancillary prerequisite for the full sounding and appropriate rendering of the work of art.

The beauty of the human voice

As we have said, a voice can itself be the bearer of a genuine beauty, quite apart from its great importance for the performance of a beautiful Lied, glorious aria, or music drama. When an insignificant piece of music sounds from a glorious voice, the beauty of the voice, as such, remains fully intact. The pure beauty of the sound and expressive character of the voice is a specific, clearly aesthetic value. Unlike expression in the proper sense, which is manifested in the artistic conception of the work, this beauty adheres to the voice itself. Unlike instruments, the human voice always possesses not only a sound but also an expression. This expression can be embarrassing, affected, or vulgar. It can be noble, pure, or elegant. It can even be angelic. Instruments, for their part, have more than a merely beautiful sound. Rather, this sound is united to a certain expression. The power and solemn monumentality expressed by the trombone is characteristically different from the sweetness expressed by a flute or oboe, and from the specifically spiritual and sublime quality of a violin. But this expression does not have the human character that belongs to the voice. It is obviously meaningless to say that an instrument has an awkward, affected, or vulgar sound.

Some factors, from purely technical perfection in the mastery of an instrument to virtuosity and a good memory, are not as such bearers of beauty. The value of accomplishment, taken by itself, is a pure precondition for the artistic rendering and is certainly not thematic.

Other factors, however, can as such bear beauty, such as the sound and expression of a voice. They function as ancillary elements for the performance of a work of art. Although their beauty is not itself thematic, it is united in a completely proper and organic way to the artistic beauty of the work, which is a beauty of the second power.

We are not yet speaking of that expression in the voice that is encompassed in and demanded by the work itself. This already belongs to the conception of the artistic rendering. We are thinking only of the beauty of the voice as such and of the particular expression that the voice possesses independently of the piece of music that is sung. Although its

beauty is very different from the beauty of the music, the two are united organically. The beauty of the voice, with all its special qualities, is not only, like the technique of singing, an indispensable prerequisite for a worthy rendering. It also collaborates in the full unfolding of the musically artistic beauty and satisfies a requirement contained in the work of art. All this also applies by analogy to the beauty of the sound of an instrument.

Orchestral and chamber music

We now turn to the pure prerequisites of the orchestra, namely, those elements that allow us to call an orchestra good, excellent, or less good and even poor. The accomplishment of each orchestral musician is clearly a first prerequisite. The greater each individual's mastery of his instrument, the better the orchestra will be.

The ability to cooperate with the rest of the orchestra is something new and indispensable. And this second factor makes itself felt not just in the orchestra, but perhaps even more strongly in the collaboration of the instruments in chamber music, and between singer and piano accompanist in Lieder. This element of reciprocal responsiveness, of affinity—not yet with regard to the conception but as a pure technical accord—is especially important in the accompanist, who has a definitely secondary function. This element is more important in chamber music than in an orchestra, where the technical ability and perfection of the conductor is decisive for the organic collaboration of all the members of the orchestra.

This brings us to a third characteristic of the good orchestra, in contrast to one that is less good, namely, its ability to react to the intentions and directives of the conductor. The attentiveness in playing one's instrument, and the humble willingness to let oneself be led and to understand the conductor's intention, constitute the third factor in the technical perfection of an orchestra.

The artistic personality of the performing musician

Of special interest are those technical prerequisites for the conductor that reveal the pronounced difference between a great and significant conductor and one who has mere technical brilliance. We will briefly touch on the gifts and abilities that distinguish the brilliant but insignificant conductor from the true performing artist without making any kind of claim to completeness.

The first prerequisite is the appropriate musicality. There is a technical musicality that extends from absolute pitch to musical memory, from the deep understanding of the structure of an orchestra to the complete knowledge of a score, and much else besides. We must distinguish this technical musicality from the depth with which a musical work of art and its value are understood, from the clear, unambiguous sense for the difference between a lofty, noble work and a brilliant, trivial work, from the appreciation for the hierarchy among genuine musical works of art— in other words, from artistic musicality. This musicality manifests itself in the sphere of artistic conception and worthy artistic rendering.

The second technical prerequisite is a special talent for conducting. Even highly musical people need not possess this talent, though they may be great pianists, violinists, or cellists. This is a gift all its own, the ability to take note of all the details, to have an overview of the orchestra, to be its master, to inspire it, and to have it firmly under one's control. Human qualities are also required: on the one hand, a winning affability in dealing with the musicians, which makes it easier to gain their full cooperation; on the other hand, the energy and rigor that does not permit any sloppiness, the power to assert one's own vision, and so on.

It is not our intention to discuss the specifically technical talent of the conductor, that which distinguishes the brilliant conductor from the weak and incompetent conductor. We wish to emphasize primarily the factors that distinguish the great and significant conductor from one who is merely brilliant.

The performing artist has an important place in the realm of music, because a musical work of art cannot attain its full realization without

him. It is only through him that the music resounds and becomes accessible to the hearers. Not only does the enrichment and delight that the beauty of the work is meant to pour into the spirit of the listener come to be through the artist, the music attains its full reality only when it sounds. The performing artist is a collaborator of a unique kind, lacking an analogue in any of the other arts, except in drama. The great pianist, violinist, singer, and above all the great conductor, are all artists in their own rights. Their activity carries an artistic value of its own, even if it has a clear ancillary character in that it is entirely filled by the theme of the worthy realization, the full coming into being of a musical work of art.

As is well known, it is possible to be a great man [*großer Mann*], a person of great stature, in the exercise of certain professions. Naturally, we are not thinking of the greatness that a person can possess because of his moral and religious qualities, quite independently of his profession. Balzac wanted to be a great man while he was still very young. When his father destined him to become a notary, Balzac told him that this was a profession in which it was impossible to become a great man. There are many capable notaries, but there is no notary of greatness and stature. It is undoubtedly true that the perfect exercise of a profession bears the character of greatness and importance only in certain professions, such as in science, statesmanship, the conduct of war, philosophy, and art.

The performing artist has the potential not just to be a great man [*großer Mann*], an eminent figure, but also one of a specifically artistic greatness. This is particularly interesting because it allows us to see clearly the depth and nobility of the performing artist's task. He has an indispensable role in the realm of music. But he is also more: when he makes music in a consummate fashion, this too is the bearer of an artistic value all its own. He is an artistic personality.

The great pianist who fulfills the technical prerequisites is characterized both by the depth of his penetration into the spirit of the sonata or piano concerto and by his true appreciation of this piece of music. There are, of course, many differences of degree here. It has often been discussed whether there can be several equally justified, or at any rate justified, conceptions of a musical work, or whether there is only *one* entirely

appropriate conception that fully corresponds to the composer's intention, or is at least the conception called for by the work, the conception
that is objectively the most beautiful. Surely there are certain renderings
that contradict the spirit of the composer and of the work, ranging from
an insignificant, boring rendering to a mutilation, a caricature, or a distortion of the work.

A great pianist not only performs. He also produces [*er ist auch produktiv*],[2] although in a different sense from that of the composer. He
is a creator. The stage of realization that is possible only through him
contains a creative element. He has his own share in the artistic event
that is the sounding of the sonata or piano concerto. No matter how
much he subordinates himself to the composer and intends only to serve
him and only to render the spirit of the piece of music, the significance
of the pianist and his musical personality nevertheless find expression in
the rendering. Precisely in the depth and worthiness of the rendition is
his musical personality actualized. There is a unique unity, indeed a unification, between the activity of a worthy rendition and the work of the
composer. The more the spirit of the composer speaks to us, the more we
hear his authentic voice, the more too does the artistic personality of the
pianist unfold before us. He incarnates the composer, in a certain sense,
and this ability is a high talent, a significant act all its own.

Despite this close union and fusion in the full realization of a piece of
music, the two gifts, that of the composer and that of the pianist—that is
to say, of the musician who renders the music—are completely different.
Often they have been united in one and the same person. Bach was a
great organist, and Beethoven a great pianist. But when they played their
instruments, they primarily rendered their own works or else they improvised. In others, such as Chopin, Mendelssohn, Schumann, and Liszt,
the two gifts, that of the performing artist and of the creative artist, occur
in a single person, although the distinction between the two gifts is not
at all blurred. They remain two completely different gifts, and the pres-

2. [Editors' note: The contrast Hildebrand draws between "produktiv" (literally: productive)
and "reproduktiv" (to perform) comes very close to the contrast made when saying that a musician
"performs" the piece "created" by the composer.]

ence of the one, in all its various degrees, certainly does not guarantee the presence of the other. This applies above all to the great pianist and conductor, or whoever the performing artist. No matter how significant he may be as a performer, he need not be more capable of composing music than any non-performing artist.

The question arises: To what extent does what we have said about the significance and greatness of the performing artist, whether he is a pianist or a conductor, apply to every kind of performing musician? Obviously, it also applies to the great singer and violinist, though here we find the onset of a gradation in the stature of the performing artist, which depends on which instruments lend themselves to solo parts in concerts. Only relatively seldom has an important piece of music been written for one single instrument, such as Bach's "Chaconne" for the violin. But there is a rich literature of important pieces of music in which one instrument has a leading role. A few outstanding examples include Haydn's beautiful trumpet concerto or his cello concerto in D major, Mozart's clarinet concerto or his concertos for flute and violin, or the violin concertos by Beethoven or Brahms: in each case, the solo instrument has the same importance in shaping the piece as the piano in a piano concerto. But there are no concertos for timpani.

The significance of a given instrument in performance varies according to its place in the musical literature. The degree to which an instrument is capable of independently shaping and fully interpreting the music varies according to the role it can play as a solo in the context of a musical work—not as an isolated solo but as a leading instrument together with others. Apart from the piano and the organ, all the other instruments have a relatively limited significance without the accompaniment of other instruments. The pianist is able entirely on his own to perform a rich literature containing supreme masterpieces. The same is true of the organist, who in Bach especially will find a great quantity of glorious works, including the organ preludes and fugues. Even the organ literature, however, is by far not as rich as that for piano. Pieces for solo violin or cello are a rarity, while for many other instruments there is no literature at all. At the same time, many instruments have solo passages in orchestral works.

The violin has a field rich in various forms, not only in the violin con-
certo but also, of course, in the sonatas for violin and piano. Something
similar is true of the cello.

Chamber music, in the narrower sense of the term, is a realm of its
own. No one instrument takes the leading role in the string trio or string
quartet, the piano trio or piano quartet, the quintet, sextet, or octet. No
single instrument determines the conception of the piece of music, the
spirit of the rendering, or how the totality is fashioned. Nevertheless,
two performances may be technically perfect yet clearly different in the
way they render and conceive the piece of music. Here again we find the
creative-productive element. It is, of course, usually the case that one
player in the quartet inspires the entire interpretation, usually the first
violinist or the cellist, if he is a great musician like Pablo Casals. If one
of the players is an exceptional musical personality, he will lead the way.
But an artistically worthy rendition of a quartet or trio means that each
of the players has his own specific form of giving shape to the work, even
if only through full collaboration and attentiveness to the other players.

When several exceptional musicians collaborate, for example, in a
piano trio, the worthy shaping of the work requires a special consensus,
a "pre-established harmony" in the personal conceptions of the various
artists. Regardless of whether the artistic fashioning derives from one
leading personality or from the special collaboration of several outstand-
ing musicians, everything we have said about the unique union of per-
forming artist and composer applies here.

In this context, the artistic accomplishment of the conductor is of
particular interest. We have already indicated the elements that empower
the great conductor to make an artistic, worthy rendering: a profound
understanding of the work, a penetration into its spirit, and the creative
power by which he brings this work to full realization.

What interests us now is the mysterious union between the conduc-
tor and the composer and his work. The fact that the great performing
artist is a significant musical personality, and that his pure service to the
work is at the same time an actualization of his own significance, finds
expression above all in the conductor. On the one hand, unlike the pia-

nist, he is not able to make the music sound directly and to realize the piece of music fully. He depends on the orchestra, since he can do this only through the orchestra. In this regard, he has a position and task completely different from the pianist, because he does not immediately bring forth the music. On the other hand, the creative fashioning of the work takes complete precedence with the conductor. His union with the composer and his work is all the more mysterious. Not only will he inspire the orchestra in a purely technical manner, but he can infuse into the musicians the spirit of the music and his own conception and fashioning of the work. In this way, he can bring about, through the musicians, the full realization of the work of art in an appropriate manner. His relation to the composer and his work is particularly direct. In one sense, the conductor does not realize the work directly, unlike the pianist, who himself brings forth the sounds. And this is precisely why the conductor has a very direct relationship to the spirit of the work, a relationship that is concentrated on the purely artistic rendering. That he succeeds in getting such a complicated and diverse apparatus as the orchestra to accept his conception of the work is itself quite astonishing. This is why the great conductor is perhaps the most distinctive artistic personality, the most creative among all the performing artists.

The brilliant conductor already differentiates himself from the mediocre one in that he has an overview of everything that happens in the orchestra. He tolerates no sloppiness and takes every small detail seriously. But there is an additional element that is characteristic of the great conductor, namely, that he brings to light, so to speak, the beauty and significance of every individual part in the musical piece. His deep penetration into the piece also includes allowing many things to come alive that the audience could easily fail to hear and apprehend. In this way the great conductor realizes the piece of music in a truly complete way, opening everything up, without violating the hierarchy of the individual themes and passages of the work. He brings everything to expression, and in this way achieves a very deep and differentiated rendering.

Thus, the conductor has a unique position in the realm of music. The dimension of creativity in performance, the collaboration of a signifi-

cant musical personality and the personality of the composer, reach their highpoint in the conductor.

Such a conductor certainly need not do equal justice to all the great composers. Rather, he will usually render the works of some composers more worthily, profoundly, and beautifully than those of others. The understanding of a work, the depth of the penetration, and the congenial realization calls for a certain spiritual affinity between the conductor and the composer and his work. Mottl was unsurpassed as a conductor of Mozart and Wagner, Berlioz and Bruckner; Furtwängler the ideal for Beethoven, Wagner, Brahms, Bach, and Bruckner; and Toscanini the ideal for Verdi.

Even if one and the same conductor can offer a wide range of great masters in ideal renditions, it remains true that a certain affinity between conductor and composer is decisive for and mysteriously involved in the full, worthy realization of a piece of music. Indeed, this affinity makes possible the collaboration of the musical personalities of conductor and composer.

The singer

Singers fashion a piece of music in completely different ways in Lieder, in opera, and in oratorio.

Let us begin with the singer of Lieder. We have already pointed out that a musical personality, and indeed an entire human personality, is manifested in a singer in a different way from an instrumentalist. The fact that it is his voice, which, apart from the expression required for an appropriate rendering of the Lied, contains an expression of his personality, brings about an especially close connection between the one who performs and what is performed. The collaboration of performer and composer is heightened by the diction and emphasis on the words, since the Lied is not absolute music but a union of word and sound.

Also determining of the appropriate expression are the words. The singing of a Lied includes a recitation [*Deklamation*], which requires not just the correct pronunciation of the words but also the appropriate

emphases and delivery as required by the meaning of the sentences and their atmosphere.

The accompanist too has an important task for the worthy, full realization of the Lied, but this is normally a secondary task. He is, after all, accompanying. But this does not prevent the accompanist, if he is a significant musician, from taking on the role of leading the singer and so providing the appropriate conception of the Lied.

For the singer of Lieder, additional factors necessarily include his personality, his external bearing, and certain qualities such as the refinement of his demeanor, his gracefulness, nobility, and so on. The individuality of the singer who is personally present in a concert hall or in a private circle inevitably makes itself felt in his external being too. An individual human being sings and addresses the audience. The man or woman singing need not be beautiful, but they must not come across as repulsive, trivial, or tasteless in their outward appearance. Even when a singer performs Lieder gloriously, an awkward facial expression, a trivial ethos, or common, unrefined movements are truly capable of impairing the rendition and of generating an atmosphere that clearly contradicts the Lied and its noble atmosphere. This shows us the special kind of close interpenetration, the "incarnation," of the Lied that takes place through the singer.

As we will shortly see, this kind of harmony in the relationship between the individual person and what he sings is not required in the same way of the singer in an oratorio. The same is true in opera, where the individual personality does not emerge directly, since he or she appears on stage as a character in the opera. The situation of the Lieder singer is special in this respect. In an oratorio, the singers appear less as individual personalities since they are integrated completely into the work as a whole. There have been singers with angelic voices and an angelic delivery who sang in an incomparable manner arias like "I know that my Redeemer liveth" in Handel's *Messiah* and the "Et incarnatus est" in Mozart's Mass in C Minor. But if one met them in society, they appeared common and vulgar; they had appalling manners and awkward facial expressions. Since all this escaped notice in the oratorio, it did

not in any way impair its atmosphere. In Lieder singing, however, this embarrassing atmosphere of a personality would absolutely have made itself felt.

The worthy rendering of an oratorio and of other sacred works places specific demands on the singer. While he is much more in the background than the Lieder singer, fully entering into the sacred style of the oratorio, especially in musical settings of the Passion, in Masses, and in religious cantatas, entails a much greater responsibility.

The task of offering a worthy rendering entrusted to the singer in the overall framework of the work and its stylistic unity has special consequences for the full realization of the work. To enter into a work as a whole presents the singer with different demands from those involved in fashioning a single Lied. Here too, of course, the meaning of the words and the expression that they require, their emphasis and pronunciation, are important.

The requirements for a worthy rendering reach their highpoint in the musical settings of the Passion with the figure of the Evangelist and above all with Christ himself. The role of the Evangelist demands of the singer a specific attitude, a certain restrained objectivity in the expression. Only certain very particular singers are suited to this task. This is especially true for the role of Christ, which imposes on the singer a special way of stepping aside as individual personality that is utterly different from that required of the Lieder singer. The worthy rendering demands a special style. On the one hand, the role entrusted to the singer is ineffably sublime. On the other hand, he must not in any way attempt to present Christ like a character on the stage. He has a completely different task from that in the performance of a popular [*volkstümlichen*] Passion play, like that in Oberammergau.

The situation of the opera singer is totally different from those we have mentioned so far. A special form of union with the work comes into being here, a close collaboration of performer and composer. This is due, firstly, to the new dimension of the rendering, that is to say, to the playing of a role, the presentation of a personality in a drama. This dimension is found above all in the performance of a drama without music.

A second factor is the new degree of realization, the special illusion of reality engendered by all that happens on the stage. While opera represents a higher degree of realization than the performance of a symphony or a string quartet, something completely new is present, something that addresses not only our ears, the understanding of the words and sentences, but our eyes too. We have already pointed out that the full realization of opera and music drama constitutes something without parallel. Thanks to the illusion of seeming real, thanks to our being drawn into what takes place on the stage, Figaro, Leporello, Cherubino in *The Marriage of Figaro*, Leonore and Florestan in *Fidelio*, and Beckmesser and Sachs in *Die Meistersinger*, stand before us—and not the singers who play them. We do not confuse this illusion with reality. The world of a given opera or music drama is clearly distinct from the reality of the theater and the audience. It is not easy to characterize this illusion. On the one hand, we ought, as it were, to forget that we are sitting in the theater and live completely in the world of the opera. On the other hand, we ought not to confuse the world of the opera with reality, like the simpleton who calls out to Othello during the performance and warns him not to believe Iago.

We are interested above all in the new kind of rendering that the singer must accomplish. A specific theatrical gift is required if one is to play the role of Figaro, Susanna, or Leonore. The great opera singer must become completely the character whom he portrays. Surely, this gift does not have the same importance for an opera singer as it has for an actor. In the important, artistically great operas, the characters are formed primarily by the music, and this is why song is the principal means for the vivid rendering of a character. But without a talent for acting, the opera singer cannot do justice to his task. The aspect of the rendition deriving from the theatrical element encompasses a new meaning for the full realization of the opera or music drama. The rendering of a character is a specifically productive element, and the union between singer and composer is particularly close.[3]

3. There are, of course, many operas in which there is no genuine dramatic fashioning of the characters. The singer is meant to unfold his virtuosic skills, to let the beauty of his voice be heard,

Even though the conductor holds the most important position for the full, worthy realization of an opera or music drama, a unique task is entrusted to the singer, especially to the principal performer. He achieves a kind of self-identification with the work of art, a specifically creative realization all its own. The conductor leads and fashions the entire work; the opera singer only portrays one character in the drama, but he identifies himself with this character. His cooperation in the realization of the whole varies, of course, in accordance with the importance of the character he renders in the opera or music drama as a whole. In *Fidelio*, the character of Leonore is so central that the worthy realization of the entire work stands or falls by how she is rendered. This even is more so the case with the characters of Tristan and Isolde, who dominate the music drama. Since we cannot go into questions of detail, let us only point out that the dramatic fashioning with regard to the distinctiveness of the characters is very varied in the individual masterpieces. It is obvious that Leporello is a Shakespearean figure—thanks to the music—in a sense quite different from Leonore or Isolde. To discuss this, however, would take us beyond the scope of the nature of performance.

The performance of literary works of art

We also find performing artists in the field of literature, although not for the novel, since it is just as fully realized when it is read silently as when read aloud. It is, indeed, true that the recitation of an epic poem adds something over and above a silent reading. The "music" proper to the epic, the meter, rhythm, and in some cases rhyme, are realized more fully when it is read aloud. However, the difference between the resounding of a piece of music and its mere state of being realized in a score is incomparably greater than the difference between an epic that is read aloud and an epic that is conveyed exclusively through reading—not only because relatively few people can read a musical score, while very many people can read a book, but also because, apart from everything else we

and so on. There were innumerable works of this kind in the age of the so-called grand opera, but they are devoid of any artistic value of their own.

have mentioned, in reading the crucial thing is the meaning of the words. This allows us to recognize clearly the radical difference between the realization of a work of art in the performance of a piece of music and in the recitation of an epic.

Nevertheless, one can say, albeit in an analogous sense, that the epic recited represents a fuller realization. This is shown in the fact that, with the exception of classical antiquity and the Orient, this recitation does not constitute a profession analogous to that of the performing musician. It is, quite simply, not essential to read an epic aloud. Usually, the professional reciters do not read aloud well, and they thereby disfigure the epic.

Something similar applies to the poem, which as such also calls for being suitably read aloud. Sound and rhythm are more important in a poem than in an epic. The worthy recitation of a poem is analogous to the performance of a work of art, one step in its full realization. Nevertheless, it is impossible to overlook the distance between the activity of the Lieder singer and the one who recites a poem.

By contrast, the function of a different performing artist, namely, the actor in a drama, is highly significant, constituting not just a distant but a full analogy to the performing musician.

The performance of a drama is not as essential as that of an opera. The step from a play that is read to one that is performed is smaller than the step from the score that is read to the piece of music that is performed. Nevertheless, as regards the illusion and the new degree of realization, the step from being read to being performed is just as decisive as in the case of opera.

This is why the actor in an eminent sense is both a creative *and* a performing artist, in whom the element of identification with the character of the drama attains a special highpoint. Since the significant factor of music is not present, and the absence of song weakens the difference between what appears on the stage and the rest of life, the facial expressions and the entire demeanor take on an even greater weight. The purely theatrical rendition permits a more thoroughgoing degree of differentiation. On the one hand, the lack of the expressive dimension of music and the fashioning of the character through the music means an impoverish-

ment of the role of the performing artist. On the other hand, the theatrical function becomes much more differentiated and important. Thus, the close collaboration between rendition and the work of art emerges clearly, and the actor becomes Romeo, Hamlet, Othello, or Lear. What a broad range of characters the actor has in which to fulfill his creative artistic task! What rich potential for nuance through the profundity of the actor's conception, nobility of rendering, and persuasive power!

Quite apart from the beauty and artistic importance of a work, the talent and the accomplishment of the actor are an object of our admiration and our enjoyment. This enjoyment is on a higher artistic level than the enjoyment of the virtuosity of a singer or of a violinist, pianist, or flutist. The activity of a great actor manifests itself even when the play is insignificant. The theatrical accomplishment acquires a completely different value, of course, as soon as it is a significant work of art that is performed and the perfect portrayal by the actor completely at the service of the work. The greater the work of art, the higher the demands that are made of the actor, the more outstanding he must be as an actor, the deeper as an artistic personality.

It is interesting that the actor's theatrical mastery itself stands on a higher artistic level than the virtuoso mastery of the musician. The beauty and sweetness of a voice, the nobility of delivery of a male or female singer, is certainly itself a value, quite independently of the artistic value of what is sung, and this value is likewise of a higher kind than the mere virtuoso accomplishment on an instrument or the coloratura virtuosity of a singer. But the accomplishment of the great actor, even in the performance of an unimportant work, is still more separable as a value in its own right.

Absent in drama is the decisive role of the conductor, that is, it lacks a corresponding performing artist. The stage director bears a certain analogy to the conductor. He can, as in the case of Max Reinhardt and Jacques Copeau, exercise a decisive influence on the rendering of a drama, especially on its revival. Interestingly, his work is a preparatory activity that unfolds, apart from the actual staging, in the process of learning the play and in the rehearsals. During the actual performance, the director

recedes into the background. He is neither the inspiring figure who leads the whole, nor does he directly influence the performance while it is on-going. His activity is quite often limited to the stage design such that he does not even direct the theatrical rendition by the actors.

The absence of performance in the visual arts

There are no performing artists in the visual arts, and hence no analogy to this activity that is decisive for the realization of many works in the spheres of music and literature.

A work of visual art is fully realized the moment a building stands, a sculpture is finished, or a picture is painted. The difference between a completed and an uncompleted work, for example, between Michelangelo's *Dying Slave* in the Louvre and the not fully completed *Slave* in the Accademia in Florence, has nothing in common with the degrees of realization that lie between the finished score of Beethoven's ninth symphony and its performance. The difference between the finished and the unfinished work of art, which, of course, exists in all the arts, including in literature and music, moves along a completely different axis. The performing artist has no real artistic task within the visual arts.

Even less can one draw an analogy between copying a great work of painting and performing by a musician or actor. The copyist in no way brings the work of art to full realization; rather, he produces something new, namely, a copy, that is to say, a picture that has no new content of its own but is only a repetition of the original.

It also is clear that any work of restoration in architecture, sculpture, and painting presupposes gifts other than those of the performing artist in music or literature. The work of the restorer is extremely important for the conservation of the work of art and for its continued existence, but this stands in a completely different relation to the work of art than the work of the performing artistic in music and literature, since the activity of restoration aims at the reconstitution of the original.

One might be tempted to think that positioning a picture or a sculpture in the place with the right lighting, and many other things that are

a part of the work of a gallery director, are analogous to the conductor's work as a performer. This too would be wrong. The accomplishment of someone who hangs the pictures in an appropriate manner, who finds the best light for them, does indeed contain a certain analogy to the performing of the conductor, singer, or pianist because he enables the work to achieve its full effect. But there is nothing beyond this very formal analogy. Hanging pictures correctly is not a new stage of realization. As an activity, it contains absolutely nothing of the above-mentioned essential characteristics of the genuine performing artist and his profound penetration of the work of art. It is a onetime service on behalf of the work of art, in which the person who carries it out remains completely outside the work of art. This activity also does not constitute its own profession.

Finally, one could regard the appropriate introduction to a work of visual art as something analogous to the work of a conductor. But this service on behalf of the work of art again moves in a direction completely different from the full realization called for by the work of art. To provide an introduction to works of art in every artistic sphere is a particular talent all its own rather than a professional occupation. Its aim is to help others to become more perceptive of values, to open their eyes through explanation, and often indeed through a mysterious, direct personal influence, disclosing to them the specific character, beauty, and depth of the work of art. This talent usually comes into play in personal contact, when people look at a picture together. Beyond this, being together with a person who has a profound receptivity to art and is truly competent in his or her judgment can open our spirit to works of art. In certain circumstances, this is also possible through lectures and books. The gift of opening works of art to other people presupposes a profound relationship to particular spheres of art, an intimate knowledge and a true familiarity with the work in question and the ability to make it come alive through words. A certain pedagogical gift is also required. One could add many other conditions for this activity of disclosing values, such as the true ability to kindle genuine enthusiasm, which clearly differs from pure infection or from being swept along by means of suggestion, which

never leads to a genuine relationship to the matter in question, namely, the work of art.

So-called guides in galleries, palaces, and cities are often caricatures of real guides. They usually find greatest favor with the general public, but at best they provide information that describes characteristics of the work of art. Seldom do they reveal its true value.

Similarly, professional musical critics often lack the gift for providing a true introduction to art. Their journalistic task distracts them, and a propagandist agenda often colors their objectivity. Above all, many critics are influenced by contemporary fashions, which they reflect more than the spirit of the work. Their journalistic work and the study that has prepared them for this branch of journalism gives them neither a genuine understanding of art nor the competence to pass appropriate judgment, and even less a true relationship to works of art, which they must possess if they are to open other people's eyes and ears.

How much more worthy and profound are the words of one great musician about the work of another, especially one from an earlier time. Consider Wagner's glorious words about Mozart, whom he called a "genius of light and love," or what a great conductor like Furtwängler in his book *Ton und Wort* has to say about Beethoven, Wagner, and about Weber's *Freischütz*.

A true and worthwhile introduction to each of the fields in art is, as we have seen, entirely different from the role of performance in the spheres of music and literature, particularly drama. There is no analogy between the two. Thus we must conclude that the important and interesting figure of the performing artist exists in an analogous manner only in the spheres of music, opera and music drama, literary drama, and in poetry suited to being read aloud.

The Viability of a Work of Art

A CHARACTERISTIC ELEMENT of literary and musical works is their viability. They must be works of art that stand on their own [*selbständige Kunstwerke*]. Viability is by no means identical to artistic value; it is important above all in dramas and operas, but in a broader sense also in all music, literature, and the visual arts.

The life of its own [Eigenleben] proper to a work of art

We begin with a very general requirement for every genuine work of art. It must be an entity that stands on its own and possesses an artistic reality. If it is merely a well-intentioned work that expresses the idealism and the earnest endeavor of the artist, if it cannot speak for itself without a commentary, or if it is only the imitation of another work and is thus, so to speak, second-hand, it is not a viable work.

It is a remarkable fact that this "life of its own" [*Eigenleben*] is not restricted to works with artistic values such as genuine beauty, profound poetry, or tremendous power and potency. It is found even in works of questionable beauty and artistic nobility. It is present not only in works that differ greatly in the rank of their beauty, such as *Don Giovanni* and

535

The Barber of Seville, or Cervantes' *Don Quixote* and Eichendorff's *From the Life of a Good-for-Nothing*, but also in a work such as Bizet's *Carmen*, despite its many trivial passages.

This life of its own is a mysterious element presupposed in all genuine works of art of lofty artistic beauty. Its presence, however, does not guarantee the beauty of a work. It is bound up with a very particular kind of power: a certain successfulness [*Gelungensein*], formal perfection, and also a certain skill [*gewissen Können*]. Only a procreative capacity, as it were, can bring forth living offspring in the artistic sphere. It is irrelevant whether these children are beautiful or ugly, whether they have great and important aptitudes: they must be viable, possessing an existence that is independent of their parents. This last point is especially important. If a work is only the expression of an artist and only interests us as his utterance, rather than speaking for itself, it lacks independent existence.

The viability of a work must be clearly distinguished from its success. As numerous examples in history show, important works of art often went unrecognized for long periods, and brilliant works of lesser value that were certainly viable likewise had no initial success. Few of Bach's contemporaries recognized the singular greatness and sublimity of his music. Even *Carmen* was a flop on its first performance.

We must distinguish three factors here. First, there is the objective standing in itself, the inner viability of the work; secondly, there is the success, and the life that the work takes on in people's minds and unfolds in people's spirit, the interest, enthusiasm, the desire for its enjoyment, and the role that it plays in the cultural life of a country or a cultural sphere, like that of the West.

We must, of course, distinguish between the range of a work's role and its depth. Depth presupposes works of artistic significance and beauty, while range, or rather popularity, does not necessarily require a work that is deep but all the more so one that is successful and effective.

A third factor is the longevity of a work. Many works are so timeless and supranational that they can be forgotten for a period, but are then time and again rediscovered, and remain alive for all time.

What are the reasons that make a work objectively viable? It is

scarcely possible to answer this question. All we can do is to indicate the characteristic traits of viability as an objective feature and to distinguish these from the real artistic value, namely, the beauty of a work. The source of this viability is a mystery, just like artistic talent.

We begin by looking at the second factor, namely, the life of a work in the sense of its success, and consider this in the context of drama in the modern era, especially opera, for which this factor for various reasons is much more important than for other art forms.

Success is of course important for any works intended for the theater, that is, their ability to remain on stage. Their message, the word they address to people, reaches them only when the works can persist on the stage, instead of disappearing from the program after two or three performances.

We have already spoken of the specific world of the theater, of this step in the formal imitation of reality, of the new kind of illusion [*Illusion*] it represents. In one respect, there is an enormous step from the illusion involved in reading a novel or a play to the illusion involved in the performance of a play on the stage. Although there is a great difference between the form of a play and that of a novel, the greatest step with regard to the illusion occurs between a drama that is merely read and a drama that is performed. It is no longer only the words that communicate the illusory reality, but real human beings who play the characters, people whose facial expressions and gestures we see, whose voices and intonation we hear.

We are dealing here with a fundamentally new degree of representation, a general and primordially important phenomenon that occurs in painting and in sculpture, and, in another form, in literature too. A performance on stage, however, is a representation *sui generis*, the highpoint of representation with respect to illusion or the imitative function. On stage, real human beings carry out all the movements that occur in real life. They act, speak, and express themselves, and yet we know this is the performance of a play, not an event embedded within the real course of our lives. It is indeed true that we are not meant to see in the actor Josef Kainz, David Garrick, or Alexander Moissi when they play Hamlet,

Romeo, or Lear. Rather, we are meant to be fully occupied with the characters that are represented. It is they who should fill our imagination and move us. But we experience all this against the background awareness that this is the representation of a drama, not something taking place in our own life.

In a play that is performed, we reach the highest degree of illusion in a manner not found elsewhere. This must not be misunderstood, however, to mean that this kind of reality has anything to do with a naturalistic tendency in the work of art. On the contrary. We are focused here not on the specific character of a given play, but only on that of the stage, on the form of the rendering and presentation of the work. This does not affect the artistic transposition in the drama itself, nor its relationship to real events.

The importance of a work of art in the interpersonal sphere. *The appropriate and public performance*

Performance on stage, this formal new degree of illusion, is of particular importance for the question of a work's life of its own in the interpersonal sphere and in the minds of individual persons.

A drama that is never performed but is only read by individuals remains an unborn child—independently of its artistic viability and its full realization as a work of art—because it is not, as it were, brought forth into the world. This brings us to the very general and important problem of the significance that the work of art possesses for human beings apart from its purely artistic life of its own. This is the whole dimension of being received, enjoyed, admired, and loved, by which we mean the dimension of reality that lies in its being seen, heard, and understood, a dimension that extends into the interpersonal sphere. This is a highly significant and important phenomenon.

Let us suppose that due to special circumstances a glorious ancient sculpture had always remained hidden and had never been seen. Naturally, it exists as a work of art, but it lacks a form of realization that it acquires only when it is discovered. Schubert's great ninth symphony in

C Major was discovered ten years after his death by Schumann. Even in its hidden state, of course, it existed as a real work of art. But it came to be fully alive in a completely new sense when it was performed by Mendelssohn.

We cannot discuss in greater detail the two realities of a work of art, the reality that begins with the creation of the work, with the existence of an entity that stands on its own feet, and the reality in the mind of the public. Instead, we turn to the various modes of reality the work of art takes on in literature and music.

In the case of the epic, the second kind of reality, namely, its existence in the mind of human beings and in the interpersonal sphere, presupposes the following: it must be sung or recited, and it must live on in the consciousness of human beings either through the manuscript or through the tradition of the sung or spoken word. The latter applies to Homer, Virgil, and also to the *Divine Comedy*. Until a hundred years ago, it was customary in Tuscany for the father to recite from memory a canto of the *Divine Comedy* to his family and the farmhands in the evening. He himself was probably scarcely able to read or write. Thanks to tradition, the epic remained alive in people's consciousness. Following Gutenberg's invention, the normal form in which the epic, the poem, the short story, and the novel live on is, of course, the printed book, which is accessible to everyone who can read.

For dramas, however, this is an incomplete kind of continued existence. They are meant to be performed on stage, and it belongs to their full life to be put on in the theater. When a play disappears from the stage, from the perspective of its outward existence it means a kind of falling asleep. It can no longer function in the form of realization for which it is created.

A string quartet that exists only in the score but is never performed in a concert or in a private house is even more bereft of its external life than a play that is accessible only as a book. Only musicians in the full sense of the term can get to know the work, delight in it, and appreciate it by reading the score. The intended degree of realization is attained only when the piece resounds. While in literature, alongside many other

factors, contact with the content is established through the word and its meaning, in music, the resounding belongs essentially to its realization, since the world of the audible speaks to us in a way that is directly given in experience. This is why the distance between a score and the music that resounds is incomparably greater than the distance between a play that is read and its performance on the stage.

A whole world lies between reading the notes of a piano sonata and the sonata that is actually played on the piano. Certainly, there is also an important difference in the realization between the piano reduction of a string quartet or even of a symphony played on the piano and the actual performance of these works. But this cannot be compared to the aforementioned difference. Music becomes fully real only when it resounds in some form or other. A score is a full reality, yet the work of art is not yet alive in it, having not yet taken on the form of being proper to it.

In music the decisive step into "life"—beyond the objective existence of the individual work of art—is when the music sounds. A further step would be to sound in a derivative way, for example, to play the piano reduction of a symphony, string quartet, or an opera. Only in a performance, for which the piece of music is written, can it unfold completely.

In the context of these secondary steps, the greatest distance lies between the piano reduction of an opera, even when the vocal parts are indicated, and its performance on stage.

The lowest starting point for the outward life of a piece of music is reading the score. The work begins to live insofar as it is apprehended in the minds of other persons. This initial stage of life, however, is incomparably weaker for music than for drama. Beyond the reading of the score, the resounding of the music is the decisive step to a new form of existence.

From here on out, there are many further degrees that differ less and vary in accordance with the kind of piece of music. For example, a piano sonata receives the highest degree of realization when it is played on the piano.

Performance and its appropriateness, its greater or lesser perfection, touches on a new dimension of artistic realization, which we discussed in the preceding chapter.

A further difference in the form of existence occurs when the sonata is played only in a small circle of friends or in a concert before a broad public, or in many private circles, thus becoming well known and popular.

More important for our present considerations is the fact that a string quartet that resounds only in a piano reduction does not yet attain its full realization.[1] As a string quartet, it must resound on the appropriate instruments. This is even more the case for a symphony.

If we limit ourselves to the sounding of a work, we find in opera various degrees of realization that are appropriate and required by the work. Although a concert performance of an opera is much more real than playing a piano reduction, nevertheless it remains far removed from a performance on the stage. In the concert performance, the orchestra plays and all the vocal parts are sung, but the new degree of reality is lacking, the new illusion provided by the performance on stage which the opera demands.

For opera we must also draw a clear distinction between two dimensions of its outward life: first, the degree of realization required by the work, and secondly, the dimension of the life of a work in the experience [*Geist*] of human beings and in the interpersonal sphere. The first dimension is already attained when an opera is performed in the theater before only a few people or, indeed, even before a single person. The second, by contrast, refers precisely to how many people are in the theater and the extent to which they are swept up in the work, understand it, are impressed by it, and absorb it with real understanding. But the second dimension, our actual theme here, to a certain extent presupposes the first dimension.

One could object that all this has changed, thanks to the invention of new methods of reproduction. Even when a symphony is no longer

1. The difference between the piano reduction of a string quartet and a quartet that is played on the appropriate instruments is, of course, quite essential, since the instruments, their sound, and so on, are of the greatest importance. In the second instance, the entire importance of the sound, which is central for the music, is present; in the first instance, there is a formal realization, but not in the original instrumentation. This difference is of a kind other than that between a play that is read and a play that is performed, and it moves in a different direction. Both of these differences exist between an opera that is performed on the stage and its piano reduction.

performed, innumerable individual people can hear it as played together by all the instruments, and thus in its full realization. But in this case, its continued existence depends on the production of the relevant recordings. If a work loses its popularity, the recordings will scarcely be produced any longer.

We prescind as yet from the social dimension that distinguishes the rendering of a symphony in concert from this kind of sounding on a recording, which lacks the solemnity of a performance of the symphony, the immediacy of the here and now, the act of addressing the public, and also the communal element. Even the best recordings cannot allow us to look at the conductor and the orchestra, or at the music-making that is being carried out by human beings at this moment.

In the case of opera, this of course applies to a completely different degree. Hearing a recording of an opera and experiencing its performance in the theater are evidently worlds apart. The former lacks the new degree of reality of the illusion. One sees neither the singers nor the stage scenery, and one does not experience the real persons and their actions.

It is true that the depth of experience can be greater for an individual person when he hears the recording of an opera or music drama, especially after he has already experienced a performance on the stage. But the depth of the experience depends on factors that have nothing to do with the full realizing of the work of art and the attainment of the degree of reality intended by a given work of art, such as the depth of the person, his artistic understanding, and his disposition in a given moment, which is conditioned by many bodily and mental factors. But it cannot be doubted that a performance as such represents a higher degree in the outward life of an opera or music drama than what can be communicated even by the best reproduction.

In film and on television, the presentation of a drama comes much closer to the presentation on stage. The illusion is largely the same, but the actors are not really present and the three-dimensionality of the stage is lacking, as is the real contact between the actors and the audience. In a theater performance, the actor plays before an audience and for this

audience, and there is a real contact between the two. The audience sees and hears the actor in the very moment in which he speaks, but in film and television the recording is usually made at an earlier time and without an audience. All that one sees and hears is a repetition of the real performance. The simultaneity between the real performance and the seeing and hearing by the audience no longer exists.

The same applies to the rendering of an opera in film or on television, which is obviously a degree less real than an actual performance.

Let us return to the second dimension of the life of a work of art. It is characteristic for a form of life closely bound up with success and the whole dimension of outward existence that plays, operas, and music dramas take place in the theater. Whether a work continues to be programmed is determined primarily by its success, by the popularity it has acquired. Indeed, its continued existence on stage, the fact that a work is periodically fully realized, is, in itself, different from its continued existence in the experience of human beings and in the interpersonal sphere. But the two are closely connected.

The continued existence of a work of art in the minds and hearts of those who understand art

With regard to the success of a work in the cultural sphere, we must distinguish between the degree of its popularity as such and its standing among those who truly understand something of art.[2] We do not mean experts or professors of the history of literature and music. Least of all do we mean music critics. Rather, we have in mind that public[3] whose members have a genuine artistic appreciation, and whose immediate contact with the true beauty of a work moves them profoundly. It is this public whom Beethoven addresses in the dedication of his *Missa*

2. Further interesting questions arise here, such as: What influence a work of art has on other artists? Although this question belongs to the general history of art, it is interesting, from a philosophical perspective, to investigate the form of reality that this represents.

3. We use this term [*Publikum* in German] in Wilhelm Furtwängler's sense. See his lecture *Der Musiker und sein Publikum* (Zurich: Atlantis Verlag, 1955), or "Chaos und Gestalt," in *Vermächtnis* (Wiesbaden: Brockhaus, 1956), 136ff.; see "Beethoven und wir," in his *Ton und Wort*, 248 ff.

solemnis: "Von Herzen—möge es zu Herzen gehen" ("From the heart—may it touch the heart").

The life of a genuine work of art in the minds and hearts of this public—which exists in every generation, even if it is less extensive in certain epochs—is, of course, much more important than the popularity of works that are successful, potent, but trivial. For purely practical reasons, this popularity has a stronger influence on the continued presence of a work on the stage, but in itself is incomparably more peripheral und unimportant.

The profound importance of a great work of art in the minds and hearts of those who have a true understanding of its beauty does not prevent the work from enjoying great popularity. The favor enjoyed by a great work of art presupposes its objective value, genuine beauty, and true nobility, while popularity presupposes only the success and the outward life of a work. Since most true works of art are also well-crafted and possess a life of their own, they can, thanks to their powerful effect, have success with the general public, even when many people fail to understand their deeper value.

Fashion, success, and zeitgeist

There are other factors that also determine whether a work remains sufficiently beloved and popular to continue to be performed in concerts or on the stage. First of all, it cannot be denied that superficial popularity is very strongly influenced by fashion. We cannot here investigate the fascinating question of fashion—a very interesting phenomenon from a philosophical point of view. We must, however, mention it as a factor that is important for the outward life of a work of art, at least, for its temporary popularity and subsequent unpopularity. It is obvious that this is largely independent of the objective character of a work.

Fashion is a sociological phenomenon. The reasons why something becomes fashionable can be of very various sorts, but an emotional "infection" always plays a role. One picks up the vibrations of something in the air at a particular time and tags along with it. One does not want to be excluded; the herd instinct comes alive in the person. This applies

especially to ideas, movements, and trends that possess an historical-sociological reality in an epoch, but also to fashions in clothes, hats, and so on, the origins of which can clearly be traced to those trying to drum up business.

One may ask whether it is possible by means of propaganda to make an unsuccessful, weak, and ineffective work fashionable on the stage or among readers. If works of literature and music are to become fashionable, does this not presuppose at least a certain measure of "turning out well" [*Gelungensein*]? Can one say that a very effective and well-constructed [*gelungenes*] work could stop being in fashion after some time? Does its objective turning out well guarantee that it will remain in fashion? Does it need this turning out well to become popular and thus also to become fashionable? If it were an utter failure, does this mean that it could never become popular, regardless of what was fashionable?

Our reply must be that an excellent title suffices to make many books bestsellers, even when the book as such is neither potent nor effective. In the case of pieces of music, plays, and operas, newspaper criticism can greatly help an impotent work to achieve success and attain a pseudo-popularity along the lines of Andersen's fairytale "The Emperor's New Clothes." It appears, therefore, that it is possible by artificial means to bring about temporary success even for a work that misfires and lacks potency. No doubt a certain success can be achieved artificially.

Far more important is the influence of the intellectual climate on those persons who are open and receptive to genuine artistic values. As one is unfortunately compelled to observe, receptivity to great works of art is often impaired by the zeitgeist, such that many people do not understand and respond to works that are new to them or are blind to works from past epochs. For example, the second half of the nineteenth century saw a deep understanding for the great works of the Renaissance, while understanding for Gothic was astonishingly defective. But there are always people who remain untouched by the influence of the zeitgeist and are deeply impressed only by the greatness and beauty of a work of art, regardless of the epoch from which it comes.

Some people have a deep relationship to many great works of art

but are blind to other important works. What we have in mind is not a special personal affinity to the ethos of a work of art. The specific orientation of a personality to particular great works of art, such as a deeper relationship to Bach than to Beethoven, is an interesting phenomenon. This need not influence the judgment of this person in such a way that he refuses in principle to acknowledge the greatness of another artist. A certain artist speaks more to him; thus he loves this artist more and enters more deeply into this artist's work. This factor is grounded in the individual personality of the listener.

What we have in mind is the constricting, blinding effect of the zeitgeist in people who otherwise have an understanding for art. How is it comprehensible that such a musical person as Elisabeth von Herzogenberg, who was a friend of Brahms and had a great understanding of Mozart and Beethoven, should have pronounced a decidedly negative verdict on Bruckner's wonderful seventh symphony after its premiere in Leipzig?[4] Hermann Levi, the great conductor who discovered Bruckner and gave this symphony its first performance in Munich, apprehended its beauty so deeply that he raised his glass to Bruckner after the performance, when he was with him and many musicians in the Allotria Artist Society, and said, "I drink to the greatest symphonic composer after Beethoven." Levi was free of the constrictions of the zeitgeist, and he apprehended this symphony in its true value.

Conrad Fiedler was certainly a man with an exceptional understanding of the visual arts, but he scarcely responded to the glorious Gothic cathedrals in France. Or take a great spirit like Jacob Burckhardt, who

4. See Conrad Fiedler's letter to Adolf von Hildebrand on January 6, 1885, "Herzogenberg's criticism was theoretical and pedantic. It was convincing in what he said, but left open the possibility that in spite of everything, the symphony might be a good thing. The criticism by his wife Liesl was delightful and moving, like everything that comes from her. She regretted in her innermost being that she could not avoid finding the music bad. She was distressed that such incomprehensible differences of opinion were possible in the world." Quoted from *Adolf von Hildebrand und seine Welt. Briefe und Erinnerungen*, ed. Bernhard Sattler (Munich: Callway, 1962), 279.

Elisabeth von Herzogenberg wrote about this in a letter to Johannes Brahms on January 14, 1885: "[B]ut no one takes away one's sadness that in this world, which has apparently been 'made so cultivated,' there are still so many, many people who are impressed by what is utterly hollow and exaggerated, provided only that it is 'staged' in the right way." Quoted from *Johannes Brahms, Briefwechsel*, vol. 2, ed. Max Kalbeck (Tutzing: Hans Schneider 1974), 54.

had a much deeper understanding of Raphael and Titian than of Piero della Francesca.

A given zeitgeist can impair the relationship to certain great works of art, thereby temporarily reducing their popularity and their life in the experience of many artistically open people. But true works of art are dethroned only for a time. Their importance for humankind will revive again and again. Even great dramas and operas can disappear from the stage for a time, but they will return.

Factors that determine the viability of a work of art
Successfulness [Gelungensein] and high artistic rank

What are the traits that characterize the objective viability of a work of art, especially a piece of music and an opera? Let us now seek to answer this question.

As we have said, it is impossible to answer the question where the life of its own of a work of art originates. But we can apprehend the particular character of its viability and describe its essential traits.

We have already established that, while the objective quality of viability is necessary for a genuine work of art, it by no means guarantees that a work will possess a true artistic value. A drama or opera as a whole can be a completely successful and genuine work of art with the life of its own required for this, or it can be a successful and genuine work of art only in its individual parts, while the work as a whole is unsuccessful and unviable. Thus, for example, there is one aria of great beauty in Mozart's *Il re pastore* that possesses a full life of its own as a musical structure, but otherwise this opera is relatively unimportant. Something similar is true of Mozart's opera *La clemenza di Tito*. Although it has some very beautiful passages, it is not successful as a whole. Sometimes, however, the power of one or several passages salvages the whole work.

Another factor in the life of its own of plays and operas is that they must be suitable for realization on the stage. An unsuccessful libretto can, as far as the viability of the work is concerned, do great damage to beautiful and significant music.

On the other hand, the beauty of certain dramas, such as *Faust*, Part II, comes much more into its own when read than when being seen on the stage. In such cases, one must distinguish the full life of its own possessed by a work of art, along with the lofty artistic values realized in it, from the viability of the drama performed on the stage.

The kind of viability that derives from "hitting the mark" is something other than the primary artistic value, as can be seen clearly in the fact that works of marginal artistic value that are filled with neither a great and noble world nor a delightful modest poetry, but rather border on the trivial in many passages, nevertheless often possess the character of having turned out well and a full life of their own. Bizet's opera *Carmen* is separated by a whole world from Mozart's *Don Giovanni* and Wagner's *Tristan und Isolde* with respect to their artistic beauty, spiritual depth, and greatness. We can speak of *Don Giovanni*, *Fidelio*, and *Tristan* in the same breath because these works, for all their differences, possess an ultimate artistic greatness and depth; but with *Carmen* we enter a completely different world. And yet, when a survey in the United States asked people to name the most perfect opera, *Carmen* came in first place, *Don Giovanni* second, and *Tristan* third.

It is not surprising that *Carmen* should be mentioned first, as far less is required to respond to this kind of music. It does not presuppose a genuinely artistic sensibility but grabs the audience by its amazing mastery and its unique effect. It is nevertheless interesting that masterpieces of the highest artistic beauty should occupy the second and third places.

To speak of turning out well [*Gelungensein*], of artistic viability, and potency of effect in the full sense is to speak of perfection in the sense that the poet or musician perfectly realizes his intention. The artist gives wholly what he wants to give, and the work is the expression of a clear talent. The opposite of the viable piece is the weak, boring, unsuccessful piece that does not stand on its own, like a vaudeville or operetta or trivial opera, and even less as a genuine work of art. This moment is thus an interesting phenomenon, because it has nothing to do with fortuitous success, fashion, propaganda, and so on. On the one hand, it is a real

characteristic of the work, and on the other hand, it can be found not only in real works of art but also in decidedly trivial pieces.

We have here a certain analogy to energy in the moral sphere. Vitality is a value, but not a moral value. Even the greatest scoundrel can possess it, and it makes his wickedness still more dangerous and virulent. But vitality is itself an extra-moral value. In the morally good person, it brings about an increase of the moral value of his personality. The same can be said of courage. An evil person can be very courageous, as we see with Macbeth and Richard III. Courage is a value, but not yet a moral value. Nevertheless, the lack of courage, especially of intellectual courage, can be a great detriment to the moral value of a given person. Moral perfection also presupposes courage.

As we have said, the opposite of viability is the boring, the weak, in a great variety of forms. A work can be simply boring and nondescript. This is a fatal flaw both for works that are meant seriously and are motivated by noble intentions, and for trivial works that aim at mere cheap effects. Even great, sublime artists have composed some unsuccessful works, in which they momentarily lacked inspiration. This failure is especially catastrophic in the case of operetta given the dubious character of its guiding artistic intention.

Secondly, the non-viability of a work, despite noble and lofty intentions, can be due to the lack of a genuine artistic transposition, as in Newman's *Callista*. Newman was a towering mind. As a theologian, he had the stature of a doctor of the Church, and he was also a highly cultivated man, a significant stylist, a man who could write sublime words about music, a creative spirit. But he lacked the gift of artistic transposition, and his novel *Callista*, despite its glorious subject matter, is weak, not a work of art in its own right.

Thirdly, non-viability can be caused by the fact that the author runs out of steam after producing a successful part, so that the piece displays many "gaps." Constancy of inspiration is an important factor, apart from the loftiness of the intention and the striving for truly artistic values.

Fourthly, another factor that plays a role in the viability of an opera is the extent to which the work suits the stage. Does it come into its own

on the various kinds of "stages," or does it, rather, despite the beauty of its music, have the character of an oratorio? In the case of genuine, great works of art, this factor in no way undermines their artistic, objective existence; they are still able to have a full reality as works of art. But their viability on the stage on which they were intended to be realized is impaired.

In the case of any lighter works with genuine artistic values, it is decisively important, if they are being presented in the world of the theater that seeks to entertain, that they are suitable for the stage. To be viable, they need to be fully effective on the stage.

This is much truer for those works the purity and beauty of which are dubious, works the strength of which consists only in being well made, successful, and skillful. They depend heavily on their effect on stage, which naturally includes the music that has been created. For every kind of music drama, viability must include a congruence of poetry, libretto, and music.

Die Fledermaus by Johann Strauss is a complete success. Despite a number of more or less trivial passages, it is in its own way a masterpiece that is fully viable. *Carmen*, on the other hand, aims at much more: it seeks to be a tragic opera, but in many passages it borders on the trivial. Its overall atmosphere lacks a genuinely artistic character. It possesses no true poetry. Nevertheless, it remains in its own way a brilliantly successful masterpiece. There is a succession of ideas, and everything "hits home" fantastically. The work stands fully on its own, and it has an extraordinary effectiveness. It is anything but boring or weak. There can be no doubt that it is viable, a real, objective entity that fully belongs on the stage and fulfills all that is required to be effective on the stage.

Is this viability, this perfection, truly the same phenomenon as that which compels us to call *Figaro* a masterpiece? From the perspective of true artistic value, of beauty, depth, and noble poetry, *Carmen* and *Figaro* represent extreme antitheses. Are not the success, the "hitting the nail on the head," and the viability of the two operas so different that one can speak of them only in an analogous sense? To the extent that we are speaking of an expression of talent, this question must certainly

be answered in the affirmative. Surely the necessary, supreme brilliance required for *Figaro* is completely different from the talent that enabled Bizet to write *Carmen*.

While there is obviously an enormous quantitative difference in talent, the difference is above all qualitative. Just as there are various talents for spheres such as mathematics, technology, and philosophy, so there are also varied gifts for the particular artistic spheres. Yet these talents are not determined by the object, but are of a qualitative kind, ranging from a minor talent to one of the highest degree. The talents required for the composition of an opera will completely differ in qualitative terms depending on the artistic depth intended and fulfilled in the opera. The success of what is intended in formal terms, the formal ability to create a structure that is perfectly made and stands on its own, depends largely on whether true artistic values are intended and realized. This is why, despite formal analogies, we must treat separately the viability of genuine works of art and the viability of works defined only by being clearly well crafted.

It is clear that, in addition to the artistic beauty of the work, the fundamental values of depth and perfection[5] are also a presupposition for objective viability in the sphere of great and noble art.

We also find pure viability and the character of being well crafted in works without high artistic values and, indeed, even in works that are definitely trivial and anti-artistic—and yet meet with tremendous success [*Treffer*]. What sort of value is this "hitting the mark" [*Getroffensein*]?

We can certainly enjoy it, even though it is not linked to fully artistic values. To enjoy a work under the aspect of its successful character is tied to an appreciation of a value that is different from artistic, genuine beauty in all its various levels. This value has a certain aesthetic character and many gradations. When a work, say Bizet's *Carmen* or Puccini's *La Bohème*, is completely successful, attains this unique realization of intention, possesses a strong atmosphere of its own, and is perfect in its own way, then it bears a value that belongs to the aesthetic value family.

The opera *La Bohème* conveys a very particular world of Parisian bo-

5. See chap. 35 above, pp. 402–405.

hemian society that has a strong poetic quality. It has an excellent libret-
to. But the waltz-like theme in the second act, Musetta's theme, is defi-
nitely trivial. And yet, one could not wish that this work had never been
written. In its own way, it represents a decisive enrichment. Compared
with *Carmen*, its overall world is more poetic and aims less at effect.
Nevertheless, *Carmen* is incomparably more powerful and supremely
successful. While it does indeed contain many trivial passages, it also
has delightful melodies, such as when the gypsy women play cards in the
third act. *Carmen* aspires to be a tragic opera. It is much more ambitious
than *La Bohème* and thus the best example of the divergence between
genuine artistic beauty and being masterfully put together.

Here, we must point out the great danger for an artist, namely, that
he may succumb, for the sake of outward success, to compromises that
appeal to illegitimate centers in the person. The difference between the
viability of a genuine work of art, on the one hand, and a work that is
merely well crafted, good, even brilliantly constructed, on the other, is
tied to such compromises.

For the genuine artist, the interest in success is a temptation. It is
easier to ensure success for a work through certain concessions, such as
to the zeitgeist or to fashion. As we have mentioned, it appeared at one
time essential to offer the audience one or more ballets in an opera. Re-
gardless of whether they fit the plot or the overall atmosphere, they were
inserted so as not to disappoint the audience and thus risk a failure.[6]

In general, great artists will now allow themselves to make such com-
promises thanks to their artistic conscience. Sometimes, however, the
conflict that can arise between success and artistic value emerges clearly.
Stefan George fought for a complete disinterest in success, for a consis-
tent refusal to compromise. Hans von Marées, who as a young man was a
very popular painter of battle scenes, withdrew completely from this kind
of painting, abandoning his popularity altogether, so as to be uncom-
promising and free in his striving to create genuine, profound works of

6. The ballets in Verdi's operas were due less to a compromise for the sake of success than to his
susceptibility to influence by the zeitgeist.

art. He consciously avoided the cheap superficiality and the great "skill" which had made him successful.

So, we arrive at those compromises that no longer reflect the zeitgeist but rather consist in ensuring success through cheap and artistically illegitimate means. This worst of artistic "sins" may consist in appealing to the audience's craving for sensation or in inserting sentimental phrases to which inartistic people react strongly. This is a betrayal of artistic genius, a conscious appeal to a susceptibility in the audience that is not only non-artistic but in fact anti-artistic.

The true artist will scarcely allow himself to be guilty of such an error, though it is certainly possible that gifted writers and composers will feel this temptation. Cheap effects are found above all in operettas, especially since Lehár, and even more strongly in *Schlager*, which to a certain extent depend on them for their existence.

Index

Index of Names, Places, and Works

Mendelssohn, Felix, 498, 501, 539
Merchant of Venice (Shakespeare), 325,
 329–330, 332
Merry Wives of Windsor, The
 (Shakespeare), 495
Mertens, Karla, xxvi
Messiah (Handel), 398, 462
Michelangelo, 31, 33, 105, 162, 176, 180, 183,
 187, 191–192, 193, 194, 196, 201, 248,
 253, 418
Midsummer Night's Dream, A
 (Shakespeare), 164, 498
Midsummer Night's Dream Overture
 (Mendelssohn), 498
Minster (Strasbourg), 106
Mirabell Garden (Salzburg), 143, 181, 202
Miraculous Draught of Fishes (Raphael), 249
Missa solemnis (Beethoven), 505, 506–509,
 543–544
Modena cathedral, 117
Molière, 306, 338–339, 353–354, 359–360
Mommsen, Theodor, 319
Mona Lisa (da Vinci), 235, 242
Monreale (Sicily), 122
More, Thomas, 232, 242
Morgenstern, Christian, 295–296
Mörike-Lieder (Wolf), 200, 434–435
Mozart, Wolfgang Amadeus, 14, 17, 69,
 200, 376, 377, 379, 381, 392, 397–398,
 401–402, 405, 408, 410, 416–418, 425,
 430–431, 451–452, 454–455, 464–467,
 468–469, 470, 473–475, 476–477,
 476n11, 480, 501, 505, 506, 513, 524,
 533, 546, 547, 550–551

National Library (Vienna), 98, 110, 114
Naturgeschichtliches Alphabet (Busch), 296
Neptune (Giambologna), 30
Newman, John Henry, 15, 165, 549
Nietzsche, Friedrich, 500, 501–502
Night (Michelangelo), 248
Nimmersatte Liebe (Wolf), 200

Odyssey (Homer), 298
Of the Life of a Good-for-Nothing
 (Eichendorff), 69
Olivier, Laurence, 491
Orcagna, 105
Organon (Aristotle), 401
Orpheus and Eurydice (Gluck), 397, 425,
 462–464, 468
Orpheus and Eurydice (Naples), 196
Orsanmichele (Florence), 60, 104
Orte, 126
Orvieto, 127
Orvieto cathedral, 116
Otello (Verdi), 481, 493–495
Othello (Shakespeare), 166, 345, 346–347,
 494
Ottobeuren, 114
"Oxford Symphony" (Haydn), 196

Palace of Justice (Rome), 97, 115
Palace of the Doges, 60
Palazzo Corsini, 83
Palazzo Farnese (Rome), 76, 97, 98, 125,
Palazzo Medici-Riccardi (Florence), 105
Palazzo Pubblico (Siena), 80
Palazzo Rucellai (Florence), 79, 91
Palazzo Strozzi (Florence), 79
Palazzo Vecchio (Florence), 60, 80, 96, 97
Palazzo Vendramin (Venice), 79
Palazzo Venezia (Rome), 97, 98
Paride ed Elena (Gluck), 427
Parma cathedral, 116, 117
Parthenon, 30, 81–82, 106–107, 142, 181
Pastoral Concert (Giorgione), 112, 234, 235,
 243, 244, 247
Pastoral Symphony (Beethoven), 388,
 414–415, 456
Père Goriot, Le (Balzac), 358
Pfänder, Alexander, 270n1
Phaedo (Plato), 7, 266, 418,
Phaedrus (Plato), 266
Piano Concerto No. 5 (Beethoven), 183

CPSIA information can be obtained
at www.ICGtesting.com
Printed in the USA
FFHW020314230219
50621249-55997FF

9 781939 773104